Michael Korda

CHARMED LIVES

MICHAEL KORDA

CHARMED LIVES

A Family Romance

RANDOM HOUSE NEW YORK

The author is grateful to the University of Wisconsin Press for
permission to quote from *United Artists,* by Tino Balio, Copyright
© 1976, The Regents of the University of Wisconsin System, and
to International Creative Management for permission to quote
from *The Third Man,* by Graham Greene, Copyright © 1950 by
Graham Greene, Introduction © Graham Greene 1976.

Library of Congress Cataloging in Publication Data
Korda, Michael, 1933–
Charmed lives.
Includes index.
1. Korda, Alexander, Sir, 1893–1956. 2. Moving-picture pro-
ducers and directors—Great Britain—Biography. 3. Moving-pic-
ture producers and directors—United States—Biography. I. Title.
PN1998.A3K587 791.43′0232′0924 [B] 79–4762
ISBN 0-394-41954-5

Manufactured in the United States of America
Typography and binding design by J.K. Lambert
2 4 6 8 9 7 5 3
First Edition

In loving memory of my father,
Vincent Korda,
and for Margaret, with love

TO HAVE ENOUGH IS GOOD LUCK,

TO HAVE MORE THAN ENOUGH

IS HARMFUL.

———

CHANG-TSE

CONTENTS

PART ONE

LONG SHOT

CHAPTER 1

~~~~~~~~~~~~~~~~~~~~~~~~~~~~~~~~~~~~~~~~~~~~~~~~~~~~

IT SEEMED to me when I was young that the three Korda brothers led charmed lives.

When my uncle Alex traveled, he was driven straight to the steps of the airplane in his black Rolls Royce Silver Shadow after all the other passengers had boarded. If he was late the airplane was held until he arrived; ships and trains waited for him, customs and passport formalities were arranged to suit his convenience, officials rushed to make his arrivals and departures effortless and pleasant, swiftly chalking a customs mark on his white calfskin Revelation luggage and on the brass-bound morocco traveling humidor with a dovetailed sliding lid and his initials, "A.K.," stamped in the fragrant leather. As a child, I kept pencils, rubber bands and toy soldiers in his cigar boxes, and there was always a faint aroma of cigars and cedar wood in the nursery, like a lingering presence of Alex, though it was not in fact a place he ever visited.

My uncle Zoltán traveled in lesser state, but at great inconvenience to himself and everyone else, for his health required him to move with a variety of private stores and equipment—an oxygen inhaler, plastic bags of fresh and dried California seaweed ("Vair is my kelp?" he was once heard to ask a bewildered porter), a sling so that he could hang

himself from hotel doors to stretch his spine, and a suitcase full of medicines.

It could not be said that Zoli enjoyed traveling, but neither did he enjoy staying put. In any case, he was condemned to perpetual travel by the postwar tax laws of the United Kingdom and the United States (the former his adopted country, the latter his official residence), counting the number of days allowed to him each year in either country, and longing for the simple security of a house in Switzerland, where he could live quietly and pay no taxes, increasing his collection of gold coins and stamps, and endlessly revising the script for Daphne Du Maurier's *The King's General,* which occupied his attention for the best part of ten years without engaging anyone else's enthusiasm.

Zoli had no choice. Alex found it convenient to have one American resident in the family. At the time British subjects were forbidden to take more than fifty pounds out of the country, and this sum would not have gone far to maintain the 120-foot yacht at anchor in Antibes, on which a captain and a crew of four lived in comfort and idleness the year round, the villa at nearby Biot, with its orange groves and terraces, or the intricate network of foreign film companies, with which Alex insured himself and the family against misfortune, revolution, inflation and Acts of God.

No, Zoli had to travel endlessly, like an ailing, grumbling Flying Dutchman, just as Vincent, my father, the youngest brother, had to have a chauffeur because Alex didn't trust him to drive himself. A benevolent tyrant Alex might be—benevolence was perhaps his most visible quality—but a tyrant nonetheless.

When I was small, and we were living in London before the war, the three brothers seemed to me remote and awesome figures, my father included. His temper was the subject of many family legends. When he was a baby his tantrums were so fearsome that his exasperated parents placed him between the two frames of the traditional Central European double-windows to cry until he was too cold or tired to continue, and had been astonished when he managed to howl and shriek, unheard from behind the glass, for a whole day. These exertions turned his face red, and he was known to those who remembered the Kordas' childhood days as "the Red One," a phrase which puzzled many people in England, who waited in vain for some expression of Communist sympathies from my father.

Since he left the house for the studio at dawn, unwillingly chauf-

feured on Alex's orders, and returned long after I had been put to bed, I saw very little of him. His temper, if in fact he had one, was never discharged on me; on the contrary, I saw the lavish and disruptive side of his nature, for he usually arrived home accompanied by Hungarian film people—scriptwriters, cameramen, set designers—mysterious and exotic characters who spoke little English. They occasionally appeared in the nursery late at night, to the indignation of Nanny Low, bearing gifts that were usually judged "inappropriate" for children of five. These nocturnal visits were encouraged, sometimes even planned, by my father, partly to annoy Nanny, partly because he disliked the thought of children being disciplined, regimented or deprived of anything they wanted, no doubt a legacy of those hours he spent crying between the double-windows.

Nanny Low's views were more traditional. She protested, she argued, sometimes she even cried, but she gave in. She had brought up the children of peers of the realm; photographs of her charges in intricate filagreed or shagreen frames, Christmas gifts from Asprey's and Mappin & Webb, covered her dresser. Sometimes she would look wistfully at the faces in those frames: young Edward in the ribboned frock coat of the Household Brigade, the Hon. Alice just before her wedding in St. Margaret's (Nanny had pressed one of the wedding flowers under the glass in one corner of the frame), young Lord Robert, looking pudgy and cross, with his dark hair slicked back (Nanny's favorite child for some inexplicable reason). Life in her previous posts had been different, and at times Nanny looked back on it as a Golden Age, but in the Korda atmosphere she was gradually corrupted. My father and his friends turned their lavish charm on her, brought her small presents, introduced her to Hungarian cooking, sometimes even persuaded her to take a glass of wine, with the result that I was often allowed to sit at the dinner table until midnight, eating strudel ("Oh, Mr. Korda, it's not right, he'll be sick in the morning!") while my father and his friends argued in Hungarian, waiting for the magic moment when my mother, breathless, beautiful and smelling of Schiaparelli and grease paint, returned home from the theater and instantly became the center of attention. Then Nanny was dismissed, and I could sit with my mother and listen to her laugh. She would carry me upstairs and put me to bed after everybody had gone, while my father stood in the doorway of the nursery, momentarily domesticated.

I seldom saw Zoli, the middle brother; usually he was referred to as

"poor Zoli" when it was a question of his temperament, his quarrels with his actors and film crews, his Promethean refusal to abide by Alex's wishes or his numerous obsessions. Nanny Parker, who had charge of cousin David, Zoli's son, brought whispered tales of life in Uncle Zoli's household and exchanged lengthy confidences with Nanny Low about the difficulties of working in a "foreign" atmosphere. Together the two nannies, mine solid, plump and wrinkled, David's tall, thin and severe, endlessly discussed the Kordas' peculiar domestic arrangements over their afternoon tea in the nursery, or on a bench in the park. Alex, of course, they never criticized. He was God, seldom seen, but always present, awesome even to nannies. He dispensed presents with a lavish if impersonal hand. At Christmastime his secretary, the patient Miss Fischer, would ask people what they wanted, and Bailey, the chauffeur, would bring the boxes around in the Rolls on Christmas Day, a practice which once prompted my mother to ask for a mink coat, which arrived in due course, to my father's fury.

ALEX WAS REPUTED to dislike children and dogs. My first clear memory of him is of a tall, uneasy, well-dressed gentleman standing on the lawn of his Bel Air house in 1940 while Auntie Merle's Chow snarled around his ankles. Since in later life I was to learn that Alex detested Southern California and was not at that time happy about his life there, the dog and I may not have been entirely responsible for his gloom, but we certainly did nothing to alleviate it. As a child I was taken to visit Alex on formal occasions, but seldom for more than five minutes and always with fierce preliminary coaching from Nanny: "Stand up straight, say please and thank you, don't speak until you're spoken to . . ." If Alex invited these audiences, he did not seem to enjoy them, and I rather think that they were forced on him. The first one I remember took place at the St. Regis Hotel in New York, where Alex asked how I was and gave me a hundred-dollar bill. "Oh, Sir Alex, you mustn't spoil the child," said Nanny. Alex looked at her over the rims of his thick glasses, and turning to me, he said, "I want you to go out right now and *spend* it. If I hear you have saved it"—he shot a warning glance at Nanny, whose belief in the moral value of savings accounts was notorious—"I shall be very unhappy."

BEFORE THE WAR, the whole family was seldom together. Alex was busy creating the British film industry and beginning the series of financial coups that made the rest of his life a one-man juggling act; Zoli traveled from England to America to India to Africa, appearing in London only to cut *Sanders of the River* or *The Four Feathers* or whatever film he had completed; my father, who always preferred a good hotel to home, was either at the studio or at the Ritz in Paris, the Hôtel de Paris in Monte Carlo, Monsieur and Madame Vial's Hôtel de la Bouée on the Plage de la Garoupe at Cap d'Antibes, or elsewhere. Sometimes Nanny and I accompanied him, Nanny boiling the water in every foreign city and huddling under the shade of a beach umbrella to prevent sunburn.

I rode a donkey on the beach at Deauville, fed the squirrels in the Parc Monceau and learned to swim in the salt-water pool at Eden Roc, on the Cap, harnessed to a long bamboo pole held at the other end by Monsieur Alexandre, the *maître de natation*. He had taught the old Aga Khan the breaststroke, and his wife ran a restaurant in the square at Antibes where the municipal band played every Wednesday and Saturday night in the season and an elderly clown did tricks and somersaults on a bicycle, zipping in and out between the tables and honking a red rubber bulb-horn. There were colored lights and little French flags strung out among the plane trees, and every evening I was carried back to the waiting car fast asleep.

War assembled the family in one place for the first time, in a huge rented manor house in Denham, close to the studio that Alex had built to Vincent's designs. Here we were to be sheltered from the bombing raid that would destroy London in one night. This apocalyptic event had been prophesied by H. G. Wells in *The Shape of Things to Come*, a film version of which Alex had spent hundreds of thousands of pounds on, and in which he apparently believed. Bored by the country, he looked anxiously to the east every night for the flames of the great conflagration which he and Vincent had brought to the screen so convincingly, and which now obstinately failed to materialize.

However large the house, it was a tight squeeze: Alex's household, Zoli and Auntie Joan, my cousin David (Zoli's son), my father, my mother and myself, Nanny, David's Nanny (Nanny Parker), Alex's butler, Alex's valet, three chauffeurs, Miss Fischer, the resident house-maids and Alex's French cook, who lived in fear of a summons to rejoin

his regiment in France. There was only one telephone. Hot water was in short supply; breakfasts were served throughout the morning, to the irritation of the servants, starting with my father's black pumpernickel toast, yogurt and *café filtre* at seven, and ending with my mother's breakfast in bed at noon, while dinner took place as a kind of relay race, the servants first, then the nursery and finally the adults. Within a week, the cook was making arrangements to get back into uniform, happy to exchange his job for an infantryman's *képi* and Lebel rifle, and relationships between the wives were poisonous.

The horses in the stable, the mulberry bushes, the topiaries held no charms for Alex. Hitler and H. G. Wells had failed him. He had done his best to save the family from immediate destruction, but a long-drawn-out siege was more than he could stand. One night Alex and his two brothers huddled at one corner of the great mahogany dining-room table quarreling violently in Hungarian, while the rest of the family sat in stony silence after a difficult scene about hot water, which Alex had been called upon to arbitrate. Nervous tension was so high that my mother, in an agony of embarrassment, peed at the table, seated in a pale-gray velvet dining chair. When everyone left the table, Gertrude was unable to rise, and it was some minutes before her absence was noticed by the others, who had retired to the sitting room to continue the nightly quarrel until the ladies withdrew with migraine headaches to huddle in their beds and long for the *Luftwaffe* to put an end to their misery ("Oh, where *is* that wretched Göring?" my mother moaned one night as she came upstairs).

My uncle Alex came to look for her and found my mother sitting at the table, scarlet with shame and streaked with tears, but determined not to get up from her chair until it had dried. At first, Alex feared that she had been paralyzed, but with his legendary ability to draw people out of themselves, he soon had the truth. It was clear to him that nobody was happy. My mother's misfortune seemed to him in some way symbolic, and the next morning we all went back to London, to our separate households. I was sent to a boarding school on the Isle of Wight (Nanny was put up in a nearby village), which ironically was the first place in the United Kingdom to be bombed. The bombs, rather small ones, exploded harmlessly in the sand, destroying only the barbed-wire entanglements with which the Royal Corps of Engineers had defaced the beaches. H. G. Wells would have been disappointed by the spectacle.

Alex recognized failure when he saw it: the family was never assembled again in one place, even on those rare occasions when the three brothers found themselves living in the same city. At one point we all settled in Los Angeles, while Alex bought United Artists (a financial coup which failed to hold his attention), but Alex lived in Bel Air, with Merle and the Chow, my father rented a house in Beverly Hills and Zoli commissioned an architect to build him a triumphantly modern ranch house with glass walls on a hill above Hollywood, in which he refused to have furniture or curtains, so that one sat on wooden benches built into the walls, slept on the polished redwood floors and exposed oneself to passers-by when using the bathroom. No suggestion was made that we should share a house—Denham had cured Alex of that fantasy.

EVEN SEPARATED, we remained a close family. No decisions were made until they had been discussed with Alex and approved by him. He regarded his younger brothers as wayward children, unreliable and improvident, and took a strong, but erratic, interest in the welfare of their families. When my father refused to buy my mother a car, on the grounds that she didn't need one and was a reckless driver, Alex soon heard of it and the next day sent around a brand-new scarlet Chevrolet convertible, with a white top and red-leather seats.

Education was one of his major concerns. He was fluent in countless languages (always with a Hungarian accent), stupendously well-read and familiar with every classic. He distrusted the bohemian attitudes of his brothers and feared their children would be brought up "like wild bloody Indians." Ponderous battles were fought out behind the scenes over the question of his nephews' schooling, and my life moved according to their progress, for my father had a vague belief in "democratic" education and a hatred of snobbery and discipline, while Alex was an unapologetic elitist. A victory for my father: I was sent to public school in Beverly Hills. A victory for Alex: I was removed from public school and sent to a private military academy near Will Rogers Park, where each child knew exactly how much money his father made a year and we all wore comic-opera uniforms of pale-blue serge, with gold embroidered stripes and white cross-belts.

Alex's attention having been momentarily diverted by his return to England, I was shipped to New York and enrolled by my father in P.S.

6, on Madison Avenue, until Alex flew back and discovered that I knew no Latin and couldn't speak French. Within the week I was at Riverdale Country School, but only temporarily. Alex had seen enough to decide that America was unsuitable, and on his return to London he made arrangements to bring me back across the Atlantic for a European education. By the time I had settled into Riverdale, my first-class ticket on the *Queen Mary* had already been issued, headmasters of the great public schools of England found themselves unexpectedly invited to elaborate dinners at Claridge's, and the advice of such people as Winston Churchill, Viscount Bracken and Lord Beaverbrook had been sought on my behalf.

Yet the closeness was deceptive, or more accurately, exclusive. The closer the three brothers were to each other, the farther away they were from everyone else. Bitterly as they sometimes fought, they loved each other with an intensity that virtually excluded their wives and children. Born in a remote Hungarian village, they had helped each other to survive their father's death, their mother's illness, the First World War, Béla Kun's Red Terror, Admiral Horthy's White Terror, the collapse of Central Europe, the lean years in Vienna, Berlin and Paris, trusting in Alex's star, and later, hesitantly, their own. The brothers were survivors, unable to free themselves from the ghosts of their past. Success could never make them completely happy; perhaps the way to it had been too harsh, the fears and the sacrifices too great; perhaps like all successful gamblers they simply knew their luck must someday run out. For whatever reason, what they built with one hand, they eventually destroyed with the other.

IN 1947, WHEN I RETURNED to Europe at the age of thirteen, this fatal flaw was not yet apparent to me. Five years had passed since I had seen my father and his brothers. The very name Korda had taken on a distant glow. Having deposited their families in Los Angeles in 1941, they returned to England as soon as they could. My mother divorced my father (for "mental cruelty," as the custom was in those days, alleging that he made fun of her cooking). Alex was divorced. Only Zoli remained behind, filming *Sahara* with Humphrey Bogart in the deserts of California. My mother resumed her stage career in New York under her maiden name, Gertrude Musgrove, and I followed her there. For

the first time in my life, the family legend flickered and dimmed. In England, the Kordas were famous figures, their films, business adventures and family scandals front-page news; in Hollywood their names meant something—they were eccentric, unreliable adventurers, less securely established and rich than men like Louis B. Mayer, or Harry Cohn or Sam Goldwyn, but still respected in their own way. In New York it was different. Few people asked me whether or not I was related to "*the* Kordas"; my schoolmates were not impressed with my connection to them, their films were seldom played. Any notoriety that attached to my person was because Merle Oberon—a movie star!—was my ex-aunt. I did not resent my obscurity, on the contrary it seemed to me natural, and on the rare occasions when I was summoned to the St. Regis to see Alex, I did not feel in any way related to this tall, exotic figure, with his guttural accent and long cigars.

I spoke like an American, I was dressed like an American, nobody had bothered to point out to me that I was not, in fact, an American. Alex—urbane, clever, learned, charming, foreign—was obscurely glamorous but in no way connected, as I thought, to my fate. I envied other children's parents—stable, ordinary people who lived at home, worked at jobs I could understand and took houses at Point Lookout or the Hamptons in the summer. I felt myself to have been abandoned by the Kordas, and scarcely even remembered them. Yet in the middle of his busy life, Alex brooded on my fate, and persuaded my father to take action.

Alex knew his duty as the head of the family, and my father, who was then living happily in a small flat on Wilton Place with his mistress, was unwillingly prodded into the resumption of his paternal obligations. Any doubt I might have had about my nationality was dispelled by the arrival of a dark-blue passport with gold lettering, proclaiming me to be a British Subject by birth. Detailed letters arrived with instructions to equip me with a blazer, a navy-blue suit and gray-flannel trousers. My personal possessions were discarded, and on a sweltering morning in late summer I was delivered into the hands of the chief purser of the *Mary,* my mother tearfully sending me off with the warning never to wear brown shoes with a blue suit. "You'll be Sir Alexander's nephew," the purser said, nodding his approval. "A wonderful gentleman, and his brothers too."

My excitement at rejoining the Kordas was mixed with a certain

amount of resentment at their having left me behind in the first place, together with the fear that I might not measure up to their standards, whatever those might turn out to be. In the meantime, the *Queen Mary* offered me a renewed glimpse of Korda luxury, and I prepared to sit back and enjoy it: by my second day at sea, I was already introducing myself as "Sir Alexander's nephew" and discovering that it opened all doors, including that of the swimming pool, to which unaccompanied boys were not normally allowed, and the bridge itself, where the purser introduced me to the captain. All the same, at night, alone in bed, I felt like an imposter.

AT SOUTHAMPTON I was efficiently disembarked before any of the other passengers—the Korda touch—and led through Customs quickly by Bailey, Alex's chauffeur since before the war, and a dignified former Royal Navy captain, Jack Russell, who among other things supervised all the Korda travel arrangements. No member of the family was present—as I was to learn later, the Kordas were willing to go to enormous expense and trouble to see that their dependents traveled in comfort and were spared the delays and annoyances of ordinary voyagers, but they themselves disliked leavetakings and were embarrassed by the polite sentimentalities of arrivals. Vast sums were spent and countless orders given to ensure that the Korda wives need never stand in line with their passports or wait for their mountains of luggage, but it was Bailey who usually greeted them, impeccable in his dark suit and his Rolls Royce chauffeur's cap, sometimes holding a bouquet of white roses in one gloved hand as a symbol of Alex's long-distance affections.

Captain Russell, like so many of Alex's employees, was in effect a kind of pensioner. During a wartime crossing of the Atlantic Alex had fallen asleep in the bomb bay of an R.A.F. aircraft without remembering to connect the hose of his oxygen mask. Russell, a naval officer on his way back from Washington, noticed that his fellow passenger was falling into a coma, and reconnected Alex to the oxygen system, thus saving his life. When peace came, he was rewarded with a job at London Films, where a good many of his fellow employees had also saved Alex's life, in Budapest or Berlin, or given him a job when he was an unknown and ambitious young man, or fed him when he was

penniless, or financed him in the days when they were wealthy and he was not. The payroll at London Films was full of people whom no one but Alex would employ, and Alex was once heard to remark, when told that one of his former benefactors was starving, "Give him a job—but for God's sake don't let him *do* anything!"

Captain Russell's job was in fact more demanding than it looked: He could and did produce a chilled bottle of vintage Dom Pérignon champagne to greet an actress arriving in Colombo, Ceylon. He was responsible for seeing that Alex always got exactly the same suite at every one of his favorite hotels. He handled the travel arrangements for film units on overseas locations, ensuring that two hundred people arrived together in South Africa or Scotland, along with all their equipment, and were provided with hotel accommodations suitable to their importance, interpreters, motorcycle dispatch riders to take the day's film to the airport so that it could be returned to London for processing, and anything else that might be needed—from a foam-rubber padded brassiere for a star whose bust proved disappointing in a tropical sarong to a tame monkey who had to be sent to India when the local ones proved unwilling to perch on an actor's shoulder while he paddled a canoe. Russell's life was not made any less complicated by the necessity of running a kind of personal courier service for Alex; at a moment's notice, arrangements might have to be made to bring a kilo of fresh foie gras from Fauchon in Paris, or four dozen Baccarat wine glasses, or a roast of beef suitable for twelve persons. For the England to which I had returned was living in the Age of Austerity, and a large part of the Kordas' glamour came from the fact that they appeared immune from its restrictions.

To understand just how glamorous they appeared in those days, you would have to have some idea of what England was like in the late forties. Even from the car, as we sped north from Southampton to London, its drabness was remarkable. Everything looked shabby, run-down, in need of a coat of paint. Peace had not brought prosperity to the English—on the contrary, they were living on even more meager rations than they had received during the war, coupons were still necessary for clothing, liquor hard to come by, cigarettes rationed and eggs a rare luxury. The vast social revolution promised by the Labor Party seemed to have produced nothing but endless queues and discomfort. Electric fires glowed a dark, cheerless red, if they worked at all.

Buildings could not be repaired without materials and a permit, neither of which could be obtained. Lines were painted on bathtubs indicating the few inches of hot water which the law allowed. Britain had lost her overseas investments, was forced to maintain a large and expensive military force all over the world and seemed unable to export enough to keep the nation going. The national spirit was that of the Blitz, without the excitement of the war or the hope of victory.

In one area, at any rate, Britain moved forward with great but misplaced confidence. Backed by the British government, Alex was creating a transatlantic Hollywood, building a movie industry which would, it was hoped, break the American monopoly, so that British theater owners would show British films and no longer have to spend "hard currency" to import American ones. The nation's slogan was "Buy British!" (in truth, import taxes and government regulations made it exceedingly difficult to buy anything else), and Alex had managed to link his fortunes with those of the country, in what many people regarded as a gallant fight against the American Goliath, a Battle of Britain fought with plots, actors, story properties and cameras. Like a successful racehorse owner, Alex appealed to the sporting instincts of his adopted country. His new studio at Shepperton, largely financed by the government, appeared in the newspapers as "Hollywood-on-the-Thames!" His cigars, identical to those of Winston Churchill, seemed a familiar and comforting omen of success. The luxury and lavish consumption of his life radiated a confidence in the future and an enjoyment of the present which few other Englishmen felt at a time when dukes found themselves conducting guided tours of their own houses to pay their taxes, British athletes were losing every international contest because, it was claimed, they did not have enough orange juice and milk, and British tourists, limited to twenty pounds of foreign currency, were despised equally by their former allies and enemies.

From his duplex flat on the roof of Claridge's or his new office at 144–146 Piccadilly, Alex cast his spell on the press, the public, the government, even on the King and Queen, who, having no screening room of their own, drove over from Buckingham Palace once a week to see a movie at Alex's. To one and all he spoke of grandiose plans for the future: He would make *War and Peace, The Life of Marlborough* (for which Winston Churchill, then in need of money, had in fact

written a script before the war, at Alex's invitation), *The King's General* (which Alex gave to Zoli as a present, with unfortunate results), *Bonnie Prince Charlie* (which, even more unfortunately for everyone, was already in production, consuming enormous amounts of money, its fate as unhappy as that of the Bonnie Prince himself) . . .

THESE CONCERNS, though they were to play a large part in my life, were unknown to me. A small, fat and somewhat timid child, obstinate but eager to please, I had endured the transatlantic crossing stoically, spending as much time as possible in my cabin and trying hard to escape being noticed. The England to which I had returned was strange and foreign to me. I had been shipped across the ocean like a package, and the effect was to numb me into a state of comatose resignation. Nothing I saw was calculated to raise my spirits, and I had a vague premonition that I was likely to prove unequal to whatever lay in store for me. The fact that Bailey remembered me as a child of six did not help matters—I had no memory at all of *him*—and Captain Russell, however charming, was not at his best with children, and soon gave up any attempt to find a common ground for communication between us, to my relief.

Slowly the great car moved through the grimy streets of South London, crossed the Thames and turned Hyde Park Corner. We passed Apsley House and stopped in a narrow courtyard before a magnificent white building, with marble steps and a huge ornate entrance. For a hallucinating instant I wondered if this was home, but Bailey opened the car door for me and kindly said, "I expect Mr. Vincent will be waiting for you at the office." So led I climbed the steps, passed the polished mahogany doors and stood in the huge entrance hall, with its curving staircase and glittering chandeliers.

Alex had always believed in display, both because it satisfied his imperial tastes and because it created an atmosphere in which it was possible, as one detractor put it, "to charm money out of an empty safe." He was fond of saying that the best way to go about launching any new enterprise when you were unknown and penniless was to take the largest suite at the best hotel in town, be seen in public with the most beautiful women, rent the largest possible chauffeur-driven limousine and eat every night in expensive restaurants. "Use what money you

have to tip lavishly, so that you get good tables and good service," he would add, "then when you run out of funds completely, you can always borrow from headwaiters and the *concierge*, who understand these things. Keep on doing this and sooner or later you will meet somebody with a business proposition. After that, everything is easy."

Following this sound principle, Alex had purchased the house in which King George VI had lived while he was still Duke of York, then bought the house next door and converted these two Edwardian white elephants into the offices of London Films. To one side was Apsley House, the residence of the Duke of Wellington, to the other an even larger mansion, soon to be converted by John Mills into Les Ambassadeurs, the most expensive and elegant dining club and casino in London. The houses faced Buckingham Palace, and behind them was a small private garden, with an ornamental fountain and paved walks. The interiors of the buildings suffered few of those changes that customarily deface elegant old buildings converted into offices. Upstairs, where the servants had lived in gross discomfort, the clerical staff now labored in cramped, cold quarters. Downstairs, the great paneled rooms, with their windows looking out on the garden or on Green Park, remained untouched. The original fireplaces, good enough for the Duke and King-to-be but not for Alex, had been replaced by Adam mantelpieces, in each of which there burned an inefficient electric-bar heater—even the Kordas were unable to overcome the traditional English reluctance to accept central heating.

A formidable commissionaire, with gold-embroidered sergeant's stripes and a row of battle ribbons, waited downstairs in the hallway to summon cars and turn away unwelcome visitors (later I was to know him better as he sat with his tunic unbuttoned and his cap off, drinking his tea in the chauffeurs' basement waiting room; from him I eventually learned to handicap horses). Saluting me, he led me upstairs to a small room, where I sat down to wait for my father, who was thought to be on his way from the studio.

Here there were strewn, as in an archeological dig, layer after layer of my father's occupancy: round tins of Player's cigarettes, dozens of boxes of Swan Vesta wax matches, many with notes, plans for movie sets and odd drawings inked on them, knives of every conceivable shape and style, hundreds of pencils, erasers, paintbrushes and drawing pens, countless bottles of India ink, most of them unstoppered, and a large

cardboard box full of pieces of string, rubber bands and drawing pins. This litter was scattered over the desk, the drawing table and the floor, covering great dusty piles of blueprints, heaps of dog-eared 8" × 10" glossies of odd architectural bits and pieces, enough unfiled letters to fill several filing cabinets and at least a dozen checkbooks, all apparently in regular use, but with the stubs left blank. The chairs were covered with books, one whole corner was taken up by a vast stack of Piranesi etchings in crumbling leather bindings, and the walls were hung with plaster casts, drawings and sketches. On the desk, rising above the chaos, was a cardboard model of Hyde Park Corner, the original of which could be seen out of the window.

It was not just curiosity that made me take an inventory of the room's contents—I had not seen my father for many years, and it seemed to me that somewhere here, since I was to wait for him, there might be some clue to his personality, some sign of who he was. But beyond the fact that he was not a neat man (which I dimly remembered), nothing here was useful to me. There was an electric burner on the window sill, and beside it were several mysterious-looking aluminum cylinders with two black wooden handles and a spout. I refrained from touching them. A bowl of water stood on the floor by the desk. Once, as I prowled around, the telephone rang, but I didn't have the courage to pick it up. Vaguely, I felt that I was an intruder and might be thrown out if I were discovered here. I cleared a space for myself and sat down. Since my father never carried a watch, however many he was given, he was likely to be unpunctual for everything except airplanes and dinner at Alex's, in both of which cases he usually went to the other extreme and arrived an hour early. I dozed for a while, then the door flew open and my father walked in, accompanied by a medium-sized dog whose ancestry clearly included a collie and a retriever of some sort, and whose presence explained the bowl of water.

"Well," said my father. There seemed no reply to this, and we stood for a moment looking at each other as if we were strangers waiting for someone to come along and introduce us.

The Kordas felt emotions, even strongly, but seldom in a positive way. They could weep with old friends, mourn people they had known twenty or thirty years before, suffer for each other's failures and defeats. Yet within their own families, they were somehow held back from any display of emotion. They found it difficult to touch their children, and

had a curious reticence toward them—my father never discussed money with me and I do not ever recall his mentioning sex at all. Family intimacy did not appeal to them, and they each developed a method of avoiding it: Vincent's silences, Zoli's travels, Alex's work. The brothers insulated themselves against the possibility of disturbance from their dependents, and when the right phrase or gesture might have spared them subsequent anguish, they stubbornly refused to give it. They wanted their wives and children to *guess* at their feelings, to anticipate their wishes. When one offered them affection, they turned it away, with a joke or a frown; if one did not offer it, they brooded.

So there was nothing much my father and I could say to each other, loving strangers as we were. I had even forgotten what he looked like, and was therefore unprepared for this stocky, powerfully built man in a disgracefully shabby gray-brown tweed suit (the kind of heavy tweed that looks and feels as scratchy as a Brillo pad), his shirt collar frayed and the buttons of his green wool cardigan in the wrong buttonholes. I wasn't even sure what to call him. In letters I had always been told to address him as "Dear Dad," but somehow it seemed ridiculous to *say* "Dad." "Father" was clearly too formal and "Vincent" unthinkable.

"Hello," I said, avoiding the issue, as I would for the rest of my childhood.

My father nodded. He had neglected to take off his battered hat. "Nuisance," he said.

I was not at all sure how to take this. Was my presence a nuisance? Possibly, but it seemed unlikely that he would say so. Was he apologizing for the fact that he had kept me waiting? That too seemed improbable.

I had forgotten how strong my father's accent was. Like Alex he spoke at least five languages, all with a Hungarian accent. Gabriel Pascal—the Hungarian who eventually succeeded in charming the movie rights to *Caesar and Cleopatra* out of George Bernard Shaw— once said of him, "Vincent speaks every language, but badly—except Hungarian, which he speaks terribly."

The three brothers were fluent in English without having mastered its grammar or pronunciation, and learned it at too late an age to develop any pretensions about it. They knew they sounded like foreigners, and didn't care—in fact, they rather made a point of it. Still it took

a certain amont of practice to understand them. Some sounds, like "w," always eluded them, and they usually said "vould" for "would," or "vy" for "why," while perversely saying "wale" for "vale," or "west" for "vest."*

When my father moved to a street in London in fact *called* "The Vale," he found it almost impossible to make taxi drivers understand where he wanted to go. "Tventy the Wale," he would say, and they would, after several attempts to find it, say, "Ah, the Vale, guv, right?" to which my father, exasperated, would reply, "That's vhat I said, the Wale."

"Nuisance," my father repeated, with some impatience. "He seems to like you. Otherwise sometimes he bites."

So Nuisance was the dog. Indeed, he did seem to like me. He took a quick drink, then stretched out on the floor with his head on my feet, lazily wagging his great feathered tail.

"You want a coffee?" my father asked. I shook my head. Coming from America I was a milk-and-orange-juice child, either of which would have been welcome.

"I make one for myself anyway," my father said, going to the window sill and picking up some of the aluminum cylinders I had noticed.

"What's that?" I asked.

He stared at me. "You don't know? It's for espresso. I have them everywhere, at home, in the studio, here. You put it on, like this, on the fire, then when it boils, you turn it upside down."

"I've never seen one."

My father thought about this, his eyes closed as if in pain. Clearly if I had not seen an espresso machine, there must be a great deal more that I was ignorant of. "I teach you how to make it. You should know how. There are lots of things you should know. I telephoned to you to say I would be late. Did you get the message?"

"I didn't answer the phone."

---

*I am sparing the reader any attempt to reproduce extensively a Hungarian accent. In addition to pronouncing "w" as "v," Hungarians tend to put the stress on the first syllable of every word, as it is in Hungarian, while running words and phrases together. Hence, "New York" is "NEW-york," "Piccadilly" is "PICK-ah-dilly," "Miki" is "MEE-key," "Graham" is "GRAY-hem," "United Artists" is "YOU-nitidartists," etc. "That" is pronounced "Zat," "the" something like "de." You can simulate the effect by emphasizing the first syllable of any word or phrase, and swallowing the rest.

"I wish I never had to answer the bloody thing myself." With that, it rang, and my father picked it up. He listened, then said firmly, "Vat the hell, I already told you what to do. Alex doesn't want to shoot in Hyde Park Corner—it's too much problems and it doesn't look right. You build it at the studio, the whole thing, life-size. The Arch, the statues, the trees, everything. Only, you have to make it look like it was sixty years ago. And it's got to be strong. I don't want it blowing down in the wind or have the plaster melt in the rain. Just do it. It's Alex's worry how much it costs, not yours." He banged down the receiver, turned the espresso pot upside down and poured himself a cup of coffee. "You have to make sure it goes through," he said. "If you pack the coffee too tight, it doesn't drip. I drink this, then we go home."

Home was, of course, a relative concept. I felt that I had just left home, in New York, and had already been warned that I would certainly be going to boarding school at the end of the summer, a prospect which filled me with dread. My father, as I was soon to discover, was even less enthusiastic about the idea than I was. He disliked schools of all kinds, and boarding schools in particular, and having brought me across the Atlantic, he was already beginning to have guilt feelings about sending me away again.

Nor had he faced up to admitting that there was a woman in his life, that in fact they had been living together for years, and that the three of us would be sharing a flat. I see now that he must have been uneasy about my reaction to the situation, and about what effect I would have on her. I can imagine that he foresaw the possibility of endless domestic interruptions. However much he loved me, his comfortable bachelor existence was about to end, and the prospect disquieted him.

Gathering some papers and drawings (it seemed to me at random), my father led me out of the building and across Hyde Park Corner, at a brisk walk, followed by Nuisance growling along behind us. Home, I knew, was a flat on Wilton (or "Vilton") Place, which he had bought during the war, after growing tired of living in Claridge's Hotel. The only homes I remembered were our house in Beverly Hills, with its guava tree and the endless nighttime noise of the lawn sprinklers, and later my mother's apartment on 86th Street and Madison Avenue, with its long corridors and cheerful furniture. Nothing in my experience prepared me for the strange, high-ceilinged flat my father ushered me into, whose every wall was covered by huge, dark, packed bookshelves so high that library steps were necessary to reach the top.

The living room contained an unruly mass of objects and furniture: Chinese screens, refectory tables, wing chairs, enormous sofas, a wooden horse that was almost life-size, marble columns bearing plants or bronze busts, ormolu clocks of every size, all ticking, architect's lamps, great china bowls and vases, several easels and many piles of newspapers, magazines, catalogues and books. At the far end of the room a corridor led to a brightly lit kitchen. There a tall thin old gentleman in a white chef's hat and jacket was dexterously chopping onions.

Behind him stood an attractive young Englishwoman with bright, cheerful eyes, her dark hair pulled back in a bun. She smiled and waved at us. "Say hello to Leila," he said, without making it at all clear to me who she was, or what role she played in the household. He merely made his way into the wide corridor, where a table had been set for dinner, covered with what seemed like the entire contents of a food shop: pâtés, radishes, more kinds of bread than I had ever seen before, fresh and preserved fruit, smoked salmon and trout, herring, half a dozen jars of pickles, a box of dates, figs, and the inevitable Hungarian salami that accompanied all my father's meals.

Profusion was, in most things, the Korda style. Each of them, even Alex, who often breakfasted on cold duck, beer, *pâté de foie gras du Périgord* and salami, claimed to have "simple" tastes, but simplicity usually meant having the best of everything all the time. The best fresh Strasbourg pâté was served on an earthenware plate, in a big block, like butter, and spread on thick slices of black pumpernickel bread. It was called "goose liver," as if it were the most common food in the world. By contrast, what the Kordas disliked most was "chi-chi"—elaborate or fancy serving. To have placed the foie gras in a little silver bowl surrounded by carefully cut curls of thin toast, to have made a fuss over it, indeed to have called it "foie gras" instead of "goose liver" in the first place, would have been, in their eyes, "chi-chi."

It was simple taste to buy the best—Sulka shirts, Knize ties, Lobb shoes, Locke hats—but it would have been "chi-chi" to wear them elegantly or worry too much about the total effect. Small servings of anything were "chi-chi," as were tea at the Ritz, many restaurants and hotels, all jewelry for men (including cufflinks), most pastry, small dogs and umbrellas. The list of "chi-chi" objects was endless and mysterious, but generally it was safe to say that whatever the Korda wives liked or wanted was "chi-chi," and held in contempt by the Korda brothers.

Alex had somewhat fancier tastes than his brothers. This was held to be the fault of his wives, whom Alex had grossly overindulged and pampered, in my father's opinion. Alex himself enjoyed ostentation for its own sake, either because it was part of his public image, the stock-in-trade of a successful entrepreneur, or because it kept his wives quiet for a time, or perhaps both; but he frequently fled to his brothers for "a good, simple meal," which meant a vast feast of rich food, most of which he could eat with his fingers, at a table where all the conversation would be in Hungarian.

There was always champagne, for Alex was fond of it. My father thought champagne "chi-chi" when served on special occasions and poured into the proper glasses, but usually turned it into something simple by drinking it out of the old jam jars he used as water glasses.

Only those who have known starvation can appreciate the feeling of security that the mere sight of food in large quantities produced in the three Korda brothers. Even Zoli, who suffered from poor health and a weak stomach, liked the sight of a good table and could usually be persuaded to break whatever fad diet he was on to cut himself a slice of salami, and in his younger days was in the habit of arriving at dinner parties with a piece of bread in one pocket and a piece of salami in the other, to protect himself against "chi-chi" English cooking.

My father now removed a large clasp knife from his pocket and with the salami in one hand and the knife in the other, cut himself a thick slice. (The ability to do this, as I was later to discover, is something of a badge of manhood among Hungarians—peasants can cut a slice of bread, a piece of salami or *Kolozsvári* bacon and an onion in one movement, without dropping anything, cleaning the knife on the bread as they finish slicing. Like the Frenchman's ability to speak with a Gauloise pasted to his lower lip, it seems to be a national talent that is inbred.) He then sat down and removed his shoes. "That is Mr. Fagyas in the kitchen," he said. "Go say hello to him. He remembers you from before the war." So Mr. Fagyas did, and talked about it volubly as he cut up cubes of beef for the *Bográcsgulyás*, but our reunion was somewhat spoiled by the fact that he spoke no English and I spoke no Hungarian—he talked, while I smiled.

Shortly after eight, the doorbell rang. My father put his shoes on without lacing them and threaded his way through the living room to open the door. From where I stood, I could smell the aroma of a

Havana cigar, the unmistakable sign of Alex's presence. And indeed, there he was, a tall man, running somewhat to fat (though his carefully tailored double-breasted suit concealed the fact), with a gray face, silver-gray hair, a gray suit and a silver-gray tie. He could not be called handsome, but he had presence to an extraordinary degree.

What I remember most clearly from that evening was his feet. Alex had the smallest, narrowest feet I have ever seen for a man his size. All his shoes were narrow, soft, glossy slip-ons, with elastic sides (just as Alex hated cufflinks, he hated the bother of tying shoes) and paper-thin soles. No matter how much money I have spent on shoes myself since then, they have always seemed clumsy and shapeless by comparison with the memory of Alex's. No amount of polishing could produce in them the fine, glowing patina that cast a kind of halo around Alex's feet. Perhaps Alex's bootmaker kept a special kind of leather in stock, or perhaps his valet had some ancient domestic secret for polishing shoes, but no combination of Kiwi, spit and elk bone ever duplicated that shine for me. Of course, Alex never *used* shoes the way the rest of us do. His shoes were never dusty, or muddy, or wet. Why should they be? The Rolls took him from door to door, so there was no need for him to walk; Alex hated walking.

He also hated climbing stairs, which probably explained why he stood for a few minutes in the middle of the living room, breathing hard and talking to my father in Hungarian about the stupidity of living in a house where the elevator could not be relied on. It was my first glimpse of Alex as the head of the family. There was no doubt that he was insisting on my father's doing something about the elevator—his lower lip stuck out, and he glared over the tops of his thick tortoise-shell-framed spectacles. My father, as was *his* habit, was clearly trying to change the subject, or turn it into a joke.

Alex turned away. He was not prepared to have the matter turned into a joke. "Vincikém,"* he said, in English, "don't be silly. Get it repaired." With the brothers, quarrels always took place in animated

*First names in Hungarian are used with diminutives expressing affection or a close relationship. Vincent's name in Hungarian was "Vince," and "Vincikém" is one of several possible diminutives that can be tacked onto the name. Zoltán was sometimes referred to as Zoli, but when the brothers were in a sentimental mood, they would call him Zolikám, just as Alex was Lacikám.

Hungarian. The conclusion was usually in English, as if they wanted to hide any disagreement from foreigners, wives, children and employees. Sometimes one could guess at the topic by listening for a key word or name in English, like "studio" or "Merle" or "a million dollars," but it was difficult to know whether the argument was about something major or a comparatively minor item of domestic interest. The level of emotional intensity was equally high in either case. Korda quarrels also had a tendency to grow rapidly in time and space—starting with a simple matter, like Vincent's elevator, the brothers could move on to a whole range of more important subjects, and if Zoli were present, backward in time to resurrect every childhood complaint and injury, including the fact that Alex got first pick of the goulash after the adults had been served, leaving soup without meat for Zoli and Vincent.

This was not a complaint my father ever made himself. His view was that Alex, as the eldest son and the family wage-earner, had a right to be served first, and in any case had sometimes surreptitiously passed pieces of meat down to his younger brothers.

Zoli had felt this to be unfair as a child—he felt no better about it as a grown man. Alex no longer dealt in soup, but the principle remained the same. He built up a vast (if shaky) international film organization, and carefully passed down to his brothers everything he could spare, on the understanding that he might someday have to call on them to return it, in an emergency.

Fiercely independent, Zoli resented Alex's generosity and feared as well that a good many of Alex's schemes for transferring money to him were illegal and self-serving. What Zoli wanted was financing for his pictures and total control over them—and equality between himself and Alex. In his heart, Zoli loved Alex, passionately and ferociously, and would allow nobody outside the family (and only a few people *in* it) to criticize him, but he himself felt crushed by Alex's fame, reputation and success. He thought himself unappreciated by his brothers, and because he had settled down in Los Angeles to make pictures, instead of returning to England, he brooded heavily, feeling in some way "left out" and imagining conspiracies against him whenever anything went wrong.

*"Celui qui est absent a toujours tort":* When Zoli visited England he brought with him a long list of grievances, mostly of a practical nature, but sometimes odd fragments of his childhood resentments.

This did not endear him to his brothers, and particularly annoyed Alex. It was not possible for the brothers to explain to Zoli the everyday details of Alex's complicated, troublesome affairs. From 6,000 miles away, matters might look simple to Zoli, but Alex and Vincent had usually long since forgotten having made the decisions that Zoli was complaining about. Alex and Zoli would fight over almost anything; my father's role was to act as peacemaker. Sometimes his patience failed, and he would shout, "What you know about it, Zoli?" which never failed to produce a flow of angry Hungarian, followed by Zoli's slamming the door on his way out. Zoli would not take orders, criticism or insults from *anyone;* Vincent would only take them from Alex.

Alex now caught sight of me and smiled. He was always prepared to find children charming (not babies, though) until they proved otherwise, as they usually did. When his uneasiness with children became manifest during a visit to Deauville, David's Nanny Parker once said to him, "But Mr. Alex, I thought you *liked* children." Alex looked indignant: "I like them, I like them, Nanny. But just keep them away from me!"

He was slightly more tolerant of his brothers' offspring—who can be a patriarch without children? Yet he viewed them with many misgivings. Like my father, he went to immense trouble to see that the Korda children were spared the grim deprivations of his own youth, while at the same time believing that an unhappy childhood was essential to success. Paradoxically, because we had not suffered he was unable to take us seriously.

For this and many other reasons, Alex had no intention of founding a dynasty. He had put together a huge and complicated enterprise, but he kept most of its secrets in his head, thus ensuring that it would last his lifetime and no more. Heirs he might have; successors, none. All this gave him a somewhat melancholic air and increased his tendency to reckless gambling in business and larger investments in production. Since he did not expect his house to outlast him, he added on to the top stories with mad extravagance, while doing nothing to shore up the foundations. "It will collapse when I am gone," he once told Brendan Bracken, the mercurial owner of the *Financial Times,* who constantly urged him to consolidate, to go public, to create a management that would hold things together in the event Alex had to retire. But Alex had no intention of retiring, and rather liked being, as he put it, "the

head of a one-man band." Politely he listened to Bracken, but he did nothing to follow his advice.

His pleasure in seeing me was, I think, limited but genuine. After all, he had prevailed on my father to have me brought here, and he gave the impression of someone who wanted to confirm my arrival with his own eyes, in case my father was lying about it, or had been fobbed off with the wrong child by mistake. Satisfied with my identity, he lost interest in me for the moment, and sat down at the dining table. "Where's Leila?" he asked. My father looked vaguely around the flat and shrugged. Alex gave a characteristic snort of annoyance. (Whenever Alex was astonished by something my father had done, he would blow through his nose like an angry horse, looking over the tops of his half-moon spectacles with a fixed, staring gaze, then exclaim slowly, "*Ré-ally*, Vincent!"—pronouncing the "e" and the "a" separately, and rolling the "r.") Rising to his feet, Alex walked to the kitchen and pulled Leila through the doorway. He said to me, "This is your father's friend. You are to be nice and respectful to her . . . And if you don't start *kissing* women you will never get anywhere in life."

With this advice given, Alex returned to the table and announced that he would stay to dinner. This was in itself a rare event. Alex hated dining out and lunching out, and never went away for weekends. He was a generous host but a reluctant guest, and liked to have people visit him, with the result that there were seldom fewer than ten people at table in his penthouse flat at Claridge's on any evening. When he did dine out, it was usually with people like Churchill, Bracken or Lord Beaverbrook, whom he could not refuse. Dinner with my father was in a different category. Here Alex could relax, provided the conversation stayed clear of certain flammable subjects: Auntie Maria (his first wife), *Bonnie Prince Charlie*, the failure to complete *I, Claudius*, Zoli's plans for the future and Vincent's desire to buy land on Cap d'Antibes and build there.*

---

*This was one of the rare occasions when Alex was completely wrong; a plot of land next to that which Monsieur Sella, the owner of the Hôtel du Cap, had bought around his hotel would be worth a fortune today, even without a house. "What do you need a house for?" Alex asked Vincent. "You can always stay in a hotel." And indeed, when Alex finally bought himself an estate in the South of France, near Biot, he seldom stayed there, but would sometimes be driven over from his yacht or the Hôtel du Cap to look at the house. It gave him, I think, a sense of despair to look

This evening Alex was at this best: charming, witty and kind, he pulled Leila and me together and made us friends for life—a clever thing to do, for Leila might easily have felt me to be a threat and an intrusion. However much she wanted to marry Vincent, she can hardly have been pleased at the role of unofficial stepmother. Nor was my father all that eager to marry Leila. He had managed to put off doing so for nearly four years, but Alex had decided that it was improper for me to be living in a small flat with my father and his mistress, and had set his mind on a quick, convenient marriage—nothing "chi-chi," of course, but perhaps a nice little ceremony of some kind to please Leila.

The Kordas were reluctant family men at best. Alex had married early, and disastrously; Zoli and Vincent had both married late and unwillingly, possibly discouraged from the prospect of marriage by the awful example of Alex's. In any event, by the time they did marry, they were confirmed bachelors and too old to change their ways. Neither Vincent nor Zoli confided in their wives, and both of them fiercely resented even the most innocuous questions. Vincent, for example, hated to be asked whether or not he would be home for dinner, even what he wanted to eat. If my mother asked my father what time it was, his reply was quite likely to be, "What you need to know for?" All three brothers hated noise, chatter, conversation, fuss, fixed mealtimes, shopping, in-laws and the opinions of women. Zoli and Vincent were so sensitive to noise that they refused to have celery or toast served at the table, and my mother complained that in all the years of her marriage she had to suck radishes for fear of crunching them with her teeth and annoying Vincent. As for Zoli, his feeling about noise was apocalyptic: He was reputed to have reached across a restaurant table to throttle a young woman who kept on eating Melba toast after he had warned her to stop. The sound of a potato chip snapping in the distance brought an immediate frown to his face. Even Alex, by far the most tolerant and civilized of the brothers, disliked noise, and the spectacle of women

---

at his enormous villa, with its rows of orange trees and elaborate, terraced gardens, and know that he *owned* it. He disliked putting money into real estate, believing, like many Central Europeans, that in times of crisis, you should be able to carry as much of your wealth as you can on your person. The sight of his own gardens gave him no sense of proprietorship—Alex much preferred those of the Hôtel du Cap, which were Monsieur Sella's responsibility, not his.

eating. Korda wives learned to eat quietly and to pick at their food, and saved their appetites for secret meals in the kitchen.

The truth was that the Kordas liked the idea of domesticity more than the reality of it, and would have been happiest if their women could have been kept quietly out of sight in a harem.

Though I was almost fourteen, I was neither expected nor encouraged to join in the conversation, and so had ample time to think. What I thought scared me. In his shy, gruff way, Vincent no doubt loved me, but it was already obvious to me (and probably to him) that we were unlikely to become close as father and son.

Alex, on the other hand, fascinated me. I felt awesomely inadequate in his presence—he was sophisticated, clever, worldly, rich, elegant, and I longed to be like him in every respect, which of course meant being unlike my father. Vincent's eccentricities of speech and dress were interesting, but nothing I could then admire or wanted to emulate. I yearned to have shoes like Alex's, to be famous like him, to have clothes that fitted like his, and hoped a miraculous spurt of growth would make me as tall. In the years to come, I dreamed of *being* Alex, and was haunted by one specific image of a man, elegantly dressed, standing on the deck of a ship (an ocean liner? a yacht? the cross-Channel ferry?), a velvet-collared coat thrown over the shoulders in the European fashion and one arm around a very beautiful woman whose face, mercifully, eluded me in my sleep. It was Alex and it was me— his features and mine shifted apart and coincided, like the image in the range finder of a Leica.

Alex did not pay much attention to me that night at dinner—his mind was on other things, and I was not the only object of his visit— but in my case it was a kind of love at first sight. I had found out what I wanted to become, and I couldn't take my eyes off him. Alex, whose gestures I quickly learned to imitate, was pointing his finger at Vincent, who was becoming increasingly nervous.

He could be wily, duplicitous and evasive when he wanted to be. He could also be blunt. Once the four of us were seated—Vincent in his shirt-sleeves and Alex in his jacket (Alex was seldom, if ever, seen in his shirt-sleeves or in anything informal, except in the South of France)—Alex helped himself to a piece of salami, turned to my father, and said in English, "Vincent, why don't you marry Leila? It's time you did."

There was a long pause. Leila blushed and gazed into her lap. I pretended to be absorbed in reading the label on a jar of pickles. My father frowned (he had the kind of light, bushy eyebrows that make for spectacular frowns). "We'll talk about it later," he said.

"We'll talk about it now," Alex replied.

My father looked at me. "Go into the kitchen," he said. "Leila too." We went. "Oh, dear," said Leila, "this isn't at all the way I thought it would be."

Looking back, I can see how difficult an evening it was for Vincent. After four years of freedom, he was faced with the arrival of his own son, by now a stranger, and the presence of Alex intent upon making him marry. Vincent was never able to refuse Alex in anything—before the war, when Alex had been in one of his frequent financial binds, Vincent had given Alex every penny he had, without hesitation and without telling my mother, who was horrified to discover that what she had thought of as the family security could be recalled by Alex on demand, never to be seen again. To Vincent it was perfectly natural: Alex's needs came first always. Vincent was, therefore, unable to refuse to marry Leila, if that was what Alex wanted.

Over the noise of the cooking, we could hear bursts of Hungarian, then Alex appeared and beckoned us back to the table. He was beaming. "That's settled," he said, kissing Leila. "Next Saturday. Now let's eat."

Late that night, my father sat on my bed in silence for several minutes. He sighed. "Vat the hell, maybe it's all for the best," he muttered.

But he did not seem convinced.

SO LESS THAN A WEEK after arriving in London, I attended my father's second marriage.

Leila and I drove to Caxton Hall, the fashionable London registry office, at eight in the morning in her ancient black Austin, its mudguards frilled and scalloped by numerous collisions.

During the war Leila had been, for a time, Lady Mountbatten's driver, as a Volunteer Ambulance Driver, and acquired some notoriety for the reckless speed with which she drove through London in the blackout. When she was eventually demoted back to ambulance driv-

ing, it was said that she frightened to death more people than she saved, and certainly she carried into postwar civilian life a terrifying *élan* at the wheel of an automobile, navigating through London at top speed, taking corners on two wheels and parking her car to the accompaniment of shattered taillights and crumpling bodywork. My father, probably the slowest, most cautious and most inept driver in the history of British motoring, refused to be driven by her at all, and always said that they met in the blackout when she knocked him down on a pedestrian crossing at Eaton Place with Lady Mountbatten's Daimler. On the occasions when Vincent defied Alex's prohibition and drove himself, he went straight down the middle of the road in second gear and began signaling for a turn and braking several blocks before reaching it. Alex had never mastered the automobile himself, though he had once bought himself a Cadillac in Hollywood in 1926 and driven it straight from the showroom into a royal palm tree on Sunset Boulevard, his first and last experience at the wheel of a car. Zoli had never learned to drive at all, and was suspected of having married Auntie Joan so she could drive him wherever he wanted to go.

Zoli, who had flown from Los Angeles for the occasion, was waiting for us at Caxton Hall. Alex himself had cunningly flown to New York, having made sure that everything would go forward as arranged. My father was due at the studio at nine, so he arrived in his own car, a new blue Hillman saloon, driven by O'Bannon, the chauffeur, and accompanied by Nuisance.

For a minute or two we all stood on the sidewalk, my father looking at once impatient and disconsolate. Then Zoli gave a sign, and took Leila by the hand. "Poor Leila," he said—the Kordas were inclined to look upon marriages as other people might funerals—and led us into the gloom of Caxton Hall, where, at that hour of the morning, Vincent and Leila were the only couple waiting to be married. The entire ceremony took less than fifteen minutes. There was an awful moment when Zoli was unable to find the ring Vincent had given him, but once he had separated it from the change in his pocket, the registrar declared Vincent and Leila man and wife, and Zoli and I signed as witnesses. (For years afterward Vincent was to claim the marriage was invalid on the grounds that it had been witnessed by his brother and by his own son, who was in any case a minor.) By 8:20 Vincent was on his way to work, a married man again, while Leila and I returned to Wilton

Place for breakfast. Alex, naturally, had sent masses of flowers, but otherwise nothing had changed.

A week later, my father took Leila on what he called, somewhat inaccurately, a "honeymoon trip," but which in fact was to conduct me to boarding school in Switzerland. It was a journey remarkably deficient in romance, even for a second marriage. On our first night we stopped in Châlons-sur-Marne (Vincent was determined to reach Switzerland via Vienne, where he intended to lunch at La Pyramide, the famous restaurant where the specialty was a hot brioche stuffed with cold foie gras) and had to share one bed together. Few honeymoons, as my stepmother afterward said, begin with three people in one bed, but my father merely complained that I ground my teeth and that Leila snored, and from then on made sure that we each had our own room.

# CHAPTER 2

I N 1961 I FLEW to Los Angeles for Zoli's funeral, a melancholy journey that began in a New York snowstorm and ended in the warm, humid, honeysuckle-scented garden of the Beverly Hills Hotel, where I waited for Vincent, who was art-directing *The Longest Day* for Darryl F. Zanuck, to arrive from Paris on the polar flight. The sprinklers swished steadily on the dead-looking lawns, under the ghastly pink lights and the dry rustling of the palm fronds. I had been away for a long time, but nothing had changed: Once you have lived long enough in Southern California it always seems like the real world when you return. From Sunset Boulevard and South Rodeo Drive, New York, Paris, London, Venice—indeed anywhere east of Palm Springs and west of Malibu—appear insubstantial and unreal. It has always seemed to me natural to feel lonely in Los Angeles. In New York I get desperate when I'm alone, and seek out strangers in bars, or begin telephoning friends at odd hours of the night, but I *expect* to be lonely in L.A., and don't mind it, since everybody else appears to be as well.

Zoli's death had occurred unexpectedly (for everyone except Zoli, who had been predicting his own demise for years), so it had been necessary to gather the family together in haste, with the result that I was now standing in front of the lobby of the hotel, searching each car for Vincent's face.

I dreaded his arrival. Alex's death in 1956 had shattered my father's world: Always given to bouts of gloom, he became increasingly depressed, as if in some way he could not forgive himself for living on after Alex. He had always liked to pretend he was an old man. His hair had turned white early in life, making it that much easier for him to feign age, with all its small privileges of eccentricity and convenient deafness, but now, quite suddenly, he *was* old. He moved like an old man, his deafness was real and painful to him, not just a trick to avoid questions he didn't want to answer, his eyesight had deteriorated sharply and his clothes were no longer merely negligent, but noticeably frayed and dirty.

Zoli, who was older than my father by two years, had aged less, living in seclusion in Los Angeles and taking care of himself. Having outlived Alex, he seemed determined to live on forever, watching his diet, taking careful walks and still restlessly revising the script of *The King's General.* He was bitter at what he had always conceived to be the injustices of the past, beginning (and perhaps ending) with the fact that he had been born the second son, and thus been condemned to a life in Alex's shadow, but he was not consumed by loneliness and regret as Vincent was. Now Zoli was dead, and as I saw my father's face, hideously altered by the pink floodlights of the Beverly Hills Hotel and the fatigue of a long flight, I wondered if Zoli was not perhaps lucky.

We embraced silently and walked into the Polo Lounge, which seemed to be full of bright, cheerful people. Gus the barman, recognizing my father, and knowing all the news even before it reached *The Hollywood Reporter,* rushed forward to seat us at a table. "I'm sorry to hear about Mr. Zoltán," he said, placing one hand on my father's sleeve and the other over his own heart. "He was a very great man. I saw *The Four Feathers* on television last week. They don't make pictures like that anymore. But I hear *The Longest Day* is terrific. How is Mr. Zanuck?"

In Beverly Hills even death could not dampen curiosity about a movie in the making.

"He's fine," my father replied.

Gus nodded. "He's a very great man," he intoned, as if Darryl Zanuck were dead too. He flicked his napkin over the table and cased the house—clearly he had given us enough attention. "I'll send you your usual," he said, and sure enough a waiter soon appeared with a pot of espresso coffee and a double brandy, and asked what I would like;

I had not reached the eminence at which Gus deigned to remember what my "usual" was.

Vincent sat silently for a time. "Poor Zoli. He would have hated being put together with Zanuck. I wish I could have talked to him before he died."

"What would you have said?"

"I would have told him not to be so bitter about life."

The Polo Lounge's elderly midget messenger-boy came over with a telephone, plugged it in and handed it to my father, who listened quietly, grunted and said, "First thing tomorrow morning."

"Who was that?" I asked.

"A rabbi."

"A *rabbi*?"

My father looked at me with an expression that was half sheepish and half angry. "*The* rabbi. He wants to talk to me about what he should say at the funeral."

"But why a rabbi?"

"Because Zoli asked for one."

"But Zoli wasn't Jewish."

"Zoli thought he was."

I turned this over in my mind. It would not have been likely for Zoli to have converted to Judaism, even in the lush religious growth of Los Angeles. Clearly, if Zoli had turned toward Judaism at the end of his life, it must have been connected with the beginning of it. This was puzzling, but explained a great deal. The Kordas had always been reticent about religion, allowing their children to be brought up as Anglicans, in the English tradition, but taking no interest in it themselves. They always described themselves as Hungarian, which was sufficiently exotic to forestall all questions. It was difficult enough to have succeeded in England as Hungarian emigrants, and Alex had no doubt found it more convenient to be a Magyar than to make his way in a foreign land as just another Central European Jew. His accent and manner were already distinctive—there seemed no reason to accept a further handicap—and since the question was never asked, he did nothing to provoke it.

This sensible policy was all very well, but created a certain unease in Korda domestic life. Years later, my mother still found it difficult to believe that her former husband was Jewish, and thought Zoli's funer-

ary wishes the final example of his eccentricity. My father, more obedi-
ent to Alex's wishes than Zoli, never mentioned the subject to me, or
to his children by his second marriage, while Zoli, after Alex's death,
made a point of telling his children. As for Alex, he made such a
mystery of his origins that some people assumed he was either a Hun-
garian aristocrat or not Hungarian at all.

IT IS A LONG WAY from Piccadilly to the flat plains of Hungary. There
is no statue to commemorate the birth of this distinguished, if short-
lived, dynasty in the small market town of Túrkeve, some ninety miles
east of Budapest, though a museum has recently been opened there to
house some of Vincent's paintings and drawings. The problem is not
so much indifference, or even politics, but the thorny difficulty of the
fact that the brothers' family name was not, as it happens, Korda at
all, but Kellner.

Henrik Kellner, their father, was a soldier, a retired sergeant of
Hussars.* A quiet man of melancholy appearance, he became the
overseer of the great Salgó family estates outside Túrkeve. "Overseer"
has a ring of Simon Legree to it; it would be truer to reality to call him
an "estate manager," more involved in accounting and maintenance
than in the discipline of the rebellious peasantry. That he was Jewish
is incontrovertible: the children's birth dates were recorded with the
registrar of Jewish births in Túrkeve, and Alex attended the Jewish
school there.

By all accounts, the dominant person in the family was not the gentle
Henrik, but his wife, Ernesztina Weisz Kellner. Her sons never forgot
her strength, courage and love, nor failed to point out how far short
their wives fell of her standards. Even in photographs, her face is
stronger than her husband's, with a firm chin and clear, steady eyes.
In one surviving photograph, she sits with a book in her hand, a solid,
cheerful, broad-shouldered figure, smiling happily. To her left sits Alex
at the age of ten, already debonair, one leg crossed over the other,

*For much of the detailed information about the Kordas' youth and Alex's career,
I am indebted to the painstaking research of his biographers, Karol Kulik (Alexander
Korda: The Man Who Could Work Miracles) and Paul Tabori (Alexander Korda), as
well as to the good memory of my father.

relaxed and cheerful, with the same eyes and broad smile as his mother. Behind Ernesztina stands her husband, with his heavy cavalryman's mustache, looking moody and withdrawn. To his right young Zoli stands, his face a miniature of his father's, while Vincent, a small child, sits staring at the camera, clearly ill at ease. Looking at the photograph, one can see that Zoli took after his father and Alex after his mother, one can also see in these children their later adult selves—Alex is the self-confident, elegant figure he later became, Zoli looks suspicious, as if he resented the fact that Alex had preempted a place on the wooden bench, and my father, who has a seat on it, looks as if he wants to get off.

Through Alex went to school in Túrkeve, hardly a metropolis itself, the Kellners actually were born and lived at Pusztatúrpásztó, a small settlement on the Salgó estate, in the very heart of the Kunság, the great central Hungarian plain, a featureless land of small villages and wide fields, where long windbreaks of poplars and willows are the only marks in an otherwise monotonous landscape. It is farming country, not unlike parts of the American Midwest, but poorer. Even today, there are more horses and wagons than automobiles, and the traveler soon finds that every village is strikingly similar—the narrow road, muddy in winter, dusty in summer, runs between two rows of low white cottages with small gardens and high walls. Geese and chickens scatter at the approach of a car. There is a small shop, a church, a cemetery, then one is out in the open country again, surrounded by the dark fields and grasslands, with an occasional well, marked by a long wooden pole for bringing up buckets of water.

Theoretically, the *puszta* (which can either mean "prairie" or a cross between what we would call a large farm and a ranch) is the heartland of the Magyars, the largest, indeed the basic, ethnic group of Hungary, a fierce, independent and unassimilable people, whose ancestors were the invading Huns of Attila, and whose language, along with that of the Finns, forms the only non-Indo-European tongue in Europe. Magyars live in Europe, but are not European: their high cheekbones and narrow eyes, their curious language and volatile temperament are all links to an Asiatic past. They are warriors and nomads by nature, despite centuries of settlement and farming, and their intolerance of non-Magyars, whether Germans, Austrians, the Hapsburg monarchy, Russians, Poles, Ruthenians or Jews, was and is legendary.

The fact that the overseer of an estate in the *puszta* was Jewish should not be taken as a sign of tolerance or advanced thinking. Jews were better educated than the Magyar peasantry, and thus more suited to the job. Also, the Magyars' dislike of Jews would naturally prevent the overseer from forming close personal relationships with the local peasants, and perhaps conspiring with them to short-change the landowner. A Jewish overseer would need his employer's protection, and would therefore have little incentive to cheat him or to overlook the small dishonesties dear to a peasant's heart in matters of weight, tithes or obligations to the landlord.

The Jews have been in Hungary for almost as long as the Magyars, but the relationship between them has never been an easy one. It was unusual for a Jew to be an overseer on a rural estate, but most Jews fell into a special social class—shopkeepers, clerks, artisans, a kind of sub-middle-class separated from the Magyars by race, religion and names.

Names were always a special problem for Jews. In the beginning they had such cumbersome names as Isaac ben Levi (Isaac the son of Levi), and they continued to use this archaic system well into the eighteenth century. There was no reason to change; in the ghetto, everyone no doubt knew whom you meant, and even when Jews left the ghetto, it was still possible to specify Isaac, the son of Levi, the fat corn merchant in Magyaróvár, for example. What is more, this system of identification, ponderous and unwieldly as it might seem, had many advantages —it made for great difficulties in taxing and drafting the Jews. Central governments throughout Europe made fitful and apathetic stabs at dealing with this problem, but it was Napoleon, in a burst of modernity, who delighted what we would now call "liberals" by giving the Jews in the territories he had conquered family names, thus bringing the Jewish communities into the modern world, and incidentally subjecting them to the census, taxation and military service.

After his downfall, the ancient, creaking autocracies of Europe took this lesson in social reform to heart, since it produced revenue and soldiers. The Austro-Hungarian government dispatched commissions throughout the Empire to give the Jews names, a task which was done with the maximum of brutality, corruption and inefficiency, in keeping with the tradition of Hapsburg bureaucracy (once accurately described as "despotism humanized by stupidity"). The unwilling Jews were made to appear before the commissions to receive a name, and needless

to say, a bribe in the right place secured a "good" name, like König or Weisz, while the wrong attitude or lack of money would result in a name like Hundfleischer—something long, unwieldly and connected to some disagreeable function. A famous Central European play, in fact, is based on a poor man's efforts to raise enough money to buy a decent name for his family—a dilemma which must have faced a good many Hungarian Jews in the early nineteenth century.

Since the Austro-Hungarian bureaucracy was heavily weighted in favor of "Austrians" (i.e., German-speaking nationals), and since the Austrians hated and feared the Magyars almost as much as they hated Jews, the Hungarian Jews were given German names. If there was anything the Emperor Franz Josef disliked it was nationalism, and he saw no reason to "create" more Hungarians in changing the names of the Jews.

This was all very well at the time—the Hungarian Jews were not displeased to take on German names, which had a modern, cosmopolitan sound, as if one's real birthplace were Berlin or Vienna rather than provincial Csokonyavisonta or Hódmezővásárhely. But the rise of Hungarian nationalism and the increasing hatred of all things Austrian turned Hungarians back toward their ethnic roots, even in the middle and upper classes. Those who had despised the backward Magyar peasantry and spoke German and French at home suddenly vaunted the Magyar virtues, rediscovered their roots and insisted that more Hungarian be taught in schools and less German. The Jews found it necessary to change their names again, this time legally adopting either Magyar names or Magyarized versions of their newly acquired German names. Under the circumstances it is hardly surprising that Alex should have decided to change his name from Kellner to Korda, when he first appeared in the great world, or that his family should have followed his example so easily. Hungarian names were protective coloration for the Jews, and until quite late in the Second World War a Jew who did not look too obviously Jewish, did not make a show of practicing his religion and had a Hungarian name could go very far in Hungary, even under the reactionary and anti-Semitic rule of Admiral Horthy. It was only the pressure of the Nazis and the arrival of the S.S. and Adolf Eichmann in 1944 that forced the Hungarian government to put into practice the Final Solution—in their lax way, the Hungarian nationalists had always thought it was sufficient to *dislike* the Jews; extermina-

tion had not occurred to them, if only because it was too much trouble.

In any event, the Kellners were Jewish and seem to have made no effort to conceal the fact, since they kept their German name and never bothered to Magyarize it. Perhaps names were troublesome to them. When Alex was born on September 16, 1893, a horseman was sent to Túrkeve from Pusztatúrpásztó to register the birth of Kellner Sándor (the Hungarian equivalent of Alexander), Henrik's choice of a name for his first-born.* When Ernesztina was informed, she was furious. She wanted her son to be called László (the Hungarian equivalent of Leslie), so the horseman was sent cantering back to Túrkeve, a sixteen-mile round trip, to make the change. Alas, the bureaucracy of the Austro-Hungarian Empire was not to be moved by the whims of a distressed mother. The unfortunate horseman could only persuade the registrar to add László as a second name, and he was therefore listed as Kellner Sándor László. Mrs. Kellner stubbornly insisted on calling him László, and almost everybody in the family, as well as all Alex's early friends, called him by a diminutive of László, "Laci" or "Lacikám." Alex himself, all his life, preferred to use the name his father had chosen, in one form or another.

Ernesztina Kellner must have been a woman of considerable will, and though Henrik was an ex-soldier, his seems to have been the gentler and less aggressive character. By comparison with Ernesztina he made little impression on his children, and in 1906, when Alex was just thirteen, Henrik fell ill with a ruptured appendix, first wrongly diagnosed, then ineptly treated. It must have been agonizing to be transported to Budapest from Túrkeve with peritonitis in that era—and the effort was in vain.

The three young Korda brothers were now fatherless, and the Korda family penniless.

ACCOUNTS DIFFER as to whether or not Alex was a good student. He himself merely said that he was "neither a prodigy nor a dunce," while later admirers describe him as "a brilliant scholar with a fabulous memory." (Everyone agrees that Zoli spent most of his school days picking fights, and that Vincent seemed to most observers to be a

*In Hungarian, the family name always comes first.

cheerful, but possibly retarded, youngster.) Though claims have been made that Alex enjoyed sports as a youngster, this seems unlikely. In the first place, an improperly treated eye infection (Túrkeve seems to have been a town cursed with incompetent physicians) very nearly blinded Alex in one eye and compelled him to wear enormously thick spectacles. He found it necessary to hold books up to his nose to read, and his long-distance vision was less than acute. Nor is it at all easy to imagine Alex devoting himself to sport at any time of his life. (Years later, at Cap d'Antibes, on an afternoon of scorching heat when the sirocco was blowing from North Africa, Alex came down to Eden Roc in his dark-blue linen sport suit and watched the *beau monde* swimming in the clear water of the Mediterranean without enthusiasm; perspiring, he wiped his forehead and said, "It's so hot the only place to be is in the water; I'm going back to the hotel to take a cold bath.")

He himself made no claim to any excellence at sports, and had no interest in them, though Zoli was a lifelong soccer fan and claimed to have been a pugnacious center-forward as a child, which, given his disposition, may well have been true. It is possible that the two younger Kordas (or Kellners, as they were then) played and fought and ran through the fields of rural Hungary, and came home with the usual scraped knees and bloody noses. But Alex, the oldest, was always conscious of his mission: He dreamed of success—political, financial, literary. Even when Alex was a child, he felt he was destined for higher things (as did his mother), and there was an element of seriousness in his character which was most un-childlike. In later life, he often complained that he had never had a real childhood, which may explain the depth of his friendships with men like Churchill, Bracken, Wells and Beaverbrook, who, like him, had become adults too early, and had felt miserable and "different" as children. For Alex, making movies and money were substitutes for the games he had never played as a child —as politics was for Churchill.

Alex the child looked beyond the horizon of the Kunság to Budapest, Vienna, to the "Western" world beyond the Danube—Berlin, Paris, London. His favorite reading was the novels of Jules Verne, particularly *Around the World in Eighty Days* (which he later tried to turn into a film time and time again, only to finally sell the screen rights to Mike Todd). He loved the civilized fantasy of Verne (and years later, he could still remember the description of Captain Nemo's quarters on the

*Nautilus,* in *Twenty Thousand Leagues Under the Sea).* Unlike most
children, however, he did not dream of living out such adventures
himself—he dreamed instead of *creating* them. It was Verne who
interested him, not Phileas Fogg or Captain Nemo.

He read insatiably, devouring the limited supply of books available
to a schoolchild in Túrkeve. What he read, he remembered. History
interested him, as did the biographies of great men, but he had a
particular love of adventure stories and books about travel, from the
"Western" novels of Karl May, the German Zane Grey, to the great
stories of exploration. Even as a child, the flat plains of Hungary bored
and stifled him; he dreamed of mountains, jungles—and especially of
seacoasts and of great rivers and lakes.

In the Kunság, there was not much in the way of water—a few
streams that dried up in the summer, a village duckpond, green and
slimy in the winter, muddy in the summer—and water became a
lifelong fascination for Alex. At the end of his life, when he built a
large, ocean-going yacht himself, it was the completion of a childhood
fantasy, acquired in the schoolroom at Túrkeve, than which there are
few more landlocked places.

Alex's thirst for adventure communicated itself to Zoli. In the long
evenings, he would read aloud to his younger brother, particularly a
Hungarian translation of the journals of Livingstone's discoverer,
Henry Morton Stanley, which no doubt explains why a boy from
Hungary should spend his life making movies like *Sanders of the River,
Elephant Boy, The Four Feathers, Sahara, and Cry the Beloved Coun-
try.* Zoli remembered sitting in the small house around the great tiled
stove, which had seats built into it for warmth and comfort, listening
to Alex talking about "elsewhere" (the name he later gave the yacht).

Alex used to walk with Zoli to the edge of the village at sunset, where
the dirt road led to Budapest, and from there to Vienna. To the west,
across the flat fields, was a world of unimaginable splendor—Rome,
Berlin, Paris, the Atlantic, America; to the east, there was nothing but
more plains, more farms, more peasants. Alex always walked to the
western edge of the village, never to the east.

Shortly after Henrik's death, travel in fact became a necessity; root-
lessness imposed itself on the Kellner family. Henrik Kellner had not
owned his house—it went with the job of overseer, and on his death
it had to be vacated for the new man. The Kellners thus found them-

selves without a home, and were obliged to move to Kecskemét, where they lived with Henrik's father, Károly. The three brothers remembered the old man chiefly for the beatings he gave them. Whenever my father had to deal with any disobedience on my part, he would explain that his own experience at the hands of grandfather Károly made it impossible for him to beat me. Károly's specialty was a leather razor strap. Early in the day he would announce the time and place at which the beating was to take place. If the victim hid (Zoli once ran away for a whole day), Károly simply waited until he turned up, then doubled the beating. Obviously as a result of this upbringing, Henrik had never beaten his own sons, in defiance of contemporary custom.

Alex was determined to escape from his harsh grandfather and this agricultural backwater, known mainly for the manufacture—and consumption—of apricot brandy, and eventually to extricate his family. He persuaded his mother to send him to Budapest, to live with his cousins. With the train fare she had given him, he left—never to return.

BUDAPEST WAS at that time a very great city indeed, perhaps the most beautiful city of Central Europe. With its broad avenues, its cafés, its river views and bridges, it had a gaiety and spirit of its own, so much so in fact that even the Viennese thought of it as a romantic, frivolous and charmed city. Though it was part of the Austro-Hungarian Empire (or Dual Monarchy, as it was officially known), its soul lay elsewhere. Those inhabitants of Budapest who could afford to looked toward Paris, not Vienna, as their cultural center. They despised the officious Austrians and their plodding, arrogant German allies almost as much as they hated the cautious and inelegant Czechs, or the uncouth Slavs of the Emperor's rebellious southern provinces. The Hungarians accepted the Empire, dreamed of dominating it and nurtured a vast list of grievances against it, though their special position in it was a recognized—and much-resented—fact.

The Emperor himself was in theory King of Hungary as well as Emperor of Austria-Hungary, and every imperial function was divided into various cumbersome categories to signify the duality of the monarchy and to pacify the Hungarians. Certain things were "Kaiserlich"—

that is, they had to do with the Imperial government. Others were merely "Königlich," and took place only in the more or less imaginary Hungarian "kingdom." Inevitably, some things were "Kaiserlich-und-Königlich" (usually referred to as "K.-und-K.," or in Viennese slang "Kakania"), and involved both realms. The railway and the army, for example, were "K.-und-K.," as were the postal service and most major governmental institutions except for Emperor Franz Josef himself, who remained unmistakably Austrian and disliked all his non-German-speaking subjects, especially the Hungarians.

It seems appropriate that the Oedipus complex was discovered in Vienna; the Emperor's family rebelled against him by courting the affection of the Hungarians, and since the Emperor's relationship with his family was poisonous, the Hungarians came to represent for the Emperor everything that he had to put up with in the way of ingratitude and lack of respect at home. Decades of ill-tempered quarreling, livened up by the occasional revolution, had forced the Emperor to make many concessions to his Hungarian subjects. At first, the beautiful Empress Elisabeth had persuaded her husband to take a more conciliatory attitude toward Hungary, but the Empress then separated from the Emperor, and went off to live there, surrounded by her beloved horses (she was the greatest horsewoman in Europe, and perhaps the most daring and courageous rider of either sex) and fêted by the Hungarian gentry and magnates, who shared her taste for hunting, horse racing and all-night parties, and admired her remarkable beauty.

This did nothing to endear the Hungarians to Franz Josef—from his point of view, they had become involved in his marital problems—but he could hardly withdraw the concessions he had made. Rigid and obstinate, he was forced to defend the status quo, however unappealing. He feared that change of *any* kind might bring the Empire down, and for this reason the Imperial Army had been forced to fight the Prussians at Sadowa with ancient muzzle-loading rifles, and been soundly defeated. The Emperor, to the end of his days, refused to have flushing water closets or electric lights in Schönbrunn Palace, on the grounds (as he told his daughter-in-law) that "It begins with water closets and ends with revolution."

Budapest was to some degree protected from Hapsburg obscurantism. The Hungarians were patriots for Hungary, not for the Em-

peror,\* and looked forward to a "greater" (that is to say, larger) Hungary, under the Crown of St. Stephen, perhaps with an Austrian archduke wearing it as a formality. In the meantime, Hungary's fields provided grain for the Empire, the one indispensable blessing that kept the senile and ramshackle collection of races and states together under one crown (or rather two). Because of the grain, Budapest was a glittering capital, and Hungarians were allowed a freedom of speech that would never have been tolerated in Austria itself, or in the more openly rebellious provinces of the Hapsburg *Hausmacht.*

The city to which Alex came as a schoolboy was full of idealists, poets, liberal orators, socialists, visionaries of every kind—for it was evident to everyone of any intelligence that the Dual Monarchy could hardly outlive the Emperor, and that in Hungary a nation might one day be formed from scratch, perhaps even a republic. Everything was a subject for heated debate and polemics.

It was hardly surprising that years later Alex was to say, "When I was a boy in Budapest, I learned the most important thing of all—how to be a good talker. Only later in Berlin did I learn the next most important thing—how to be a good listener. You have to be older for that."

ALEX'S ARRIVAL in Budapest in 1908 had a legendary quality when described by his brothers, perhaps because it is the first of the myths which the Kordas created about themselves.

A good many years later, I went to Budapest myself, as much in search of Alex's past as anything else, and tried to imagine what it must have been like for this tall, gangling young man, with all his responsibilities and his confused and demanding ambitions, to confront a great city for the first time. Was he afraid? If so, he never mentioned it when he was old. He was certainly impressed by the city, and determined to become—somebody.

---

\*Who hated patriotism. When his ministers recommended a certain civil servant for promotion on the grounds that he was a patriot, Franz Josef replied, "Yes, but is he a patriot for *me?*" In the end he was right: There were Czech patriots, Magyar patriots, Croatian patriots, Jewish patriots, even Austrian patriots, but no patriots for the Hapsburgs.

No doubt the city itself was not so very different then, indeed traces of its former elegance still remained when I was there, obscured by two wars, ten years of Communism and a revolution in progress. I wondered, had Alex stood in front of the Gellért Hotel (where he was one day to come very close to being executed), and yearned to enter it? Had he walked past the Astoria Hotel (now The Red Star) and admired the chandeliers and the huge gilt mirrors? His films sometimes had the quality of a young man's dreams of luxury and wealth, detailed renderings of a sixteen-year-old's fantasies, and he was always happiest with stories that required a rich, *mondain* setting, glamorous gowns and expensive dinners. Naturalism and films about poverty and unhappiness depressed him.

He visited the coffeehouses, I know, because he described them, the famous Café New York, home of the journalists and writers, with its mural of the New York skyline and its fountain, where it was possible to sit for hours over a cup of coffee, reading the newspapers and seeing the men who wrote them, and the Café Balaton, places which still today form an essential part of Budapest's intellectual life. Alex used to say to me that the coffeehouses had been his university, and to the end his skills were those of a gifted conversationalist—he talked his ideas, he did not write them. He needed the flow of argument, anecdotes, humor and personal contact.

In this ambience he grew up fast; he learned about politics (mostly radical politics, for the coffeehouses were naturally anti-Hapsburg), he learned about journalism and he may even have seen his first example of film making, in the shape of a nickelodeon show projected on an old tablecloth at the Café Velence.

For the moment Alex was obliged to remain a schoolboy, though he soon found work tutoring other students in his spare time. By 1909 the rest of the family had followed in his wake—Mrs. Kellner settling down to the grinding work of running a boardinghouse. Budapest, like all Central European cities, suffered from a housing shortage—industrialization had brought the peasants into the cities in large numbers, while the Hapsburg fear of change prevented new building and city planning. Most of the working-class and lower-class population had a room in an apartment, or even shared one. The Kellners' domestic arrangements, however disagreeable, were not unusual. They shared their small apartment with transient lodgers, Vincent and Zoli sleeping on the floor of

the hallway, while Alex slept and worked in the maid's room, which was so small that it was filled by the bed.

From these unpromising surroundings, Alex went out every morning to put in a long day of studying and tutoring. He had transferred from the *Gimnásium* (high school) to a commercial school on Mester Street. Soon he had the good fortune to be noticed by an older man, with a strong personality (a pattern which was to repeat itself over and over in his youth), who treated the adolescent, in his shabby, ill-fitting suit, as if he were already an adult.

Oskár Fáber was a Catholic priest who had abandoned the Church to become a teacher and a Christian-Socialist. Progressive, persuasive and iconoclastic, Fáber was admired by his students and disliked by the authorities, and Alex found in him both a mentor and a father figure. He imposed on the young man a degree of mental discipline, and transformed the omnivorous reader into a scholar, for the time being.

Perhaps Fáber, not unlike Captain Nemo, appealed to Alex's strong romantic streak. After all, Fáber was a rebel and a political activist, and under his influence, Alex joined various left-wing intellectual clubs, and even took part in political protest meetings. More important, Fáber, who understood the Kellners' precarious financial situation, found Alex a job in the editorial offices of the *Független Magyarország* ("Independent Hungary"), a prestigious liberal daily, and persuaded the newspaper to publish some of Alex's articles and stories.

Since students were not supposed to work nights in a newspaper office (particularly of an opposition newspaper), nor become published journalists, Alex wrote under a pseudonym, and perhaps as a tribute to Fáber, took as his nom de plume "Sursum Corda" ("Lift up your hearts"), which coming as it did from the Roman Catholic mass, must have had a particular significance both for Fáber and for his youthful Jewish admirer. Because Alex's work as a reporter soon came to be more important to him than his studies, it is not surprising that his pseudonym quickly overwhelmed his real name. After all, he was beginning to acquire a reputation as "Corda"—why should he not benefit from the fame? Yet "Corda" was not quite right somehow; it did not look Hungarian, nor did Alex feel altogether at ease in abandoning his own initials. So he substituted the Kellner "K" for the Latin "C," and appeared in print, in 1909, for the first time, as "Korda Sándor"—Alexander Korda.

In later years, Alex was to change the names and identities of his

leading ladies (and two of his wives) with the special self-confidence of a man who had performed the same operation on himself. It amused him to meet people who claimed to be relatives after he became famous, pointing to a common descent through some other branch of the "Kordas," without realizing that the family name had never been Korda in the first place. "After all," he once told Leslie Howard, who had changed *his* name, and was taking a haughty attitude toward this foreign director, "why should we two fight when both our families go back for hundreds of years—more or less?"

If Alex and his brothers were reticent about the name change, they were always explicit on the subject of the family's poverty. All three brothers regaled their children with stories of how poor they had been, possibly in an effort to prevent us from taking things for granted—but also to impress on us the fact that there is nothing wrong in being poor. Indeed, Vincent and Zoli took the position that it was *better* to be poor. My father used to remark that no meal ever tasted as good as a bowl of hot soup when he had been a starving art student, and Zoli claimed not to be able to sleep in comfortable hotel beds, surrounded on all sides by the bloody rich.

Alex did not share this passion for poverty, perhaps because he had suffered the most acutely from it, but whenever he could be persuaded to talk about the past, he would always sigh and begin, "Ah, then we were very poor . . ."

A contemporary describes him as a thin, handsome young man, wearing a suit that exposed his wrists and ankles, with lively eyes and prominent high cheekbones that gave him a look of perpetual hunger. He was, in fact, perpetually hungry, for the Korda family was living on what he could make, and though Mrs. Kellner would slip her own piece of bread into his pocket in the mornings, he would often divide it secretly with his younger brothers, so that each of them had a share. Years later, whenever someone criticized Alex, my father would stare into space and say, "When I was a young boy he shared his bread with me," and that was that. Alex himself once told me that he disliked the end crust of a loaf of bread, because he had so often had to content himself with it as a child, leaving the middle pieces for Zoli and Vincent, and one of his definitions of luxury was to tear his piece of bread out of the middle of the loaf. When I said that I preferred the ends, he shrugged and said, "That's because you've always had the choice."

WHILE HIS IMAGINATION may have been fired by seeing a primitive movie "short" shown in a Budapest coffeehouse, it is more likely that he began writing about the cinema simply because nobody else on the *Független Magyarország* could be bothered to. He could not afford to go to the university, and he could not survive on the pittance he received as a part-time journalist. Only a dramatic breakthrough could change Alex's life, and he determined to bring it about. In 1910, armed with a letter from his newspaper and what little money he could borrow, he left for Paris.

It was Alex's first great gamble, and it failed. Years later when we were in Paris, Alex would look around him, sigh, and remark, "It's not like the first time I was here . . ." He told me how he had cried once, watching someone eat a *bifteck aux pommes frites* through the window of a restaurant, and how he had suffered so badly from the cold that he had wrapped his feet in old newspapers before putting his shoes on. He had learned to love paintings, he said, because he used to take shelter in the Louvre to get warm. He had actually been tempted to eat the bread that was thrown down on the pavement to feed the pigeons.

For over a year he sent back glowing letters about life in the great city. In fact he starved in misery, except when a fellow Hungarian émigré took pity on him and invited him to dinner. In spite of this, he learned to speak French and to love France. He may have discovered the way to the Pathé Film Studio and watched the production of some of the great epics of the day. In the end, though, the Austro-Hungarian Consul in Paris was obliged to send him back to Budapest as a charity case. His family was astonished at the emaciated and haggard apparition that emerged from the train, particularly after receiving so many triumphant letters from the *enfant prodigue*. Vincent never forgot the sight of his famished older brother, in a threadbare suit at least two sizes too big for him, gratefully wolfing down chunks of bread and salami, his first decent meal in months. It was always this image of Alex that he saw and cherished behind that of Alex the opulent success.

All the same, Alex's year in Paris was the turning point in his life. In Budapest it was enough simply to have been in Paris, and if Alex had not met all the great people he claimed to have, who was to know? A young man who had spent a year "working" in Paris and had seen the famous Pathé Studio was listened to with respect. Alex knew better

than to tell the story of his misery and starvation to anyone but his family. He went back to work on the newspaper, bought a new suit and a Homburg hat, and took up the habit of smoking large cigars. Within a few weeks, a new mentor, Lajqs Biró, a well-known Hungarian dramatist and novelist whom Alex had interviewed and impressed, introduced the young man to Mór Ungerleider, the co-founder of Projectograph, the first Hungarian motion picture company. Ungerleider hired Alex as secretary of the company, on the understanding that he could continue to write for the newspaper, and Alex soon found himself running Projectograph's publicity department, writing the advertising and translating the subtitles of foreign films, while at the same time founding Hungary's first film journal, the weekly *Pesti Mozi* ("Budapest Cinema"). He was not rich, but for the first time he was able to live in what was to become the Korda style, and to taste the joy of being known.

What Alex's emotional life in this period was like is difficult to ascertain, since he never talked about it. That he picked up a lifelong habit of working too hard is certain. He continued to live at home, no doubt for reasons of economy. Even at that age Alex had fewer rough edges than Vincent and Zoli, possibly because he was exempted from military service for weak eyesight. Not that he would have wanted the dubious privilege of serving in the K.-und-K. Army, whose spirit has been perfectly captured in *The Good Soldier Schweik.*

In the meantime, Vincent, in his own dreamy but determined way, was developing his artistic talents and adopting those bohemian habits which Alex was still criticizing forty years later. Zoli, pugnacious and rebellious as ever, was attending commercial high school with many complaints and much truancy. No doubt Alex felt the burdens of fatherhood long before he actually became a father.

Years later, when Alex was a rich and successful man, he would complain that his ambition had always been to write, either a great novel or perfect poetry. Probably he did feel this at the age of eighteen, if only because it was a respected profession. In Hungary, as elsewhere in Europe, writers had status, and there was a certain romantic quality to literary life that would naturally have appealed to Alex.

But no evidence exists that he ever seriously tried to write, and it is likely that his wistful references to a lost career as a literary figure were simply another manifestation of the Kordas' notorious inability to be content with their own fate. Vincent became one of the most success-

ful art directors in the movie business, an achievement he affected to despise, and spent the rest of his life complaining about his work, always planning to give it up and return to the simple life of painting, this year, next year, and in the end, never. Zoli hated the film industry and dreamed of writing, when he was not speculating in gold coins and stamps. Alex toyed with the idea of retiring from the motion picture business to learn Greek in his old age. Strangely reluctant to let their children see where the money came from, they did what they could to keep them out of the business. I was sixteen before I ever saw a Korda film, and then by accident. Certainly none of the famous Korda films was ever screened for me.

Alex loathed spending time with his fellow motion picture magnates, and preferred the company of actors, actresses, writers and politicians, while Vincent not only refused to appear in person to receive his "Oscar," but when it was mailed to him he hid it, and finally gave it away. Zoli spent most of his time in Hollywood with Aldous Huxley, and avoided members of "the industry" like the plague, unless they were Hungarian.

From the beginning, Alex had doubts about the film as a "serious" profession, understandable in one who began his career as an errand-boy and flack for Mór Ungerleider in the makeshift world of Hungarian cinema before the First World War. No doubt Ungerleider's films, and constant flirtation with bankruptcy, would explain Alex's diffidence about his new career. He certainly clung to his old job as a journalist for as long as he could, and as late as 1915 was still working for the newspapers in his spare time (even launching a new film journal), well over a year after he had directed his first film. He saw the medium as a stepping-stone to something more solid and respectable.

*Pesti Mozi* did not limit itself to reviewing movies. In keeping with the ferment of the times, its focus was political. It became something of a radical weekly during its brief life, and included short stories, political journalism, art and cartoons, introducing, among other young talents, the work of Marcel Vertès, later to become successful in his own right as a painter. Though *Pesti Mozi* died of financial difficulties, Alex continued to start new film magazines, first *Mozi* ("Movie") in 1913, then the new and much more ambitious *Mozihét* ("Movie Week") in 1915, while continuing to work as the editor of Alexander

Incze's *Szinházi Élet* ("Theater Life") at the same time, and also maintaining his relationship with Ungerleider.

In a very short time, Alex had become a well-known young man. Budapest was a city where the motion picture business was intimately connected with the theater, art, journalism, literature and politics, for everybody frequented the same cafés. One reason why Alex hated Hollywood, when he finally got there, was its insularity. "What a sad place," he wrote to a friend. "In Europe, or even in New York, there is stimulation. Here people only ask two questions: What did it gross? And do you like orange juice?"

That Alex should have eased into directing films is not extraordinary. Considering the nature of the craft in those days, he was at least as well qualified as most. The techniques of film making were simple enough so that it was anything but intimidating. Films were shot in a few days, using actors who were more respectably employed on the stage, but happy enough to pick up a little money by working during the day as well. The camera was primitive, and not easily moved, and most movies were simply adaptations of stage plays. Directing was hardly a profession at all, let alone an honorable one, and directors mostly operated on *chutzpah*, dominating their hastily collected casts by bravado, mystification and sheer force of personality. One actor remembers being persuaded to spend two days working on a film, and realizing as he emoted toward the director and his magic box that all the film was cascading out of the camera as the cameraman turned the crank, lying like shiny Christmas wrapping ribbons at the director's feet. He was reluctant to stop and say anything, for fear of exposing his ignorance, but strongly suspected that something was wrong. When the take was over, he politely asked the director if all was in order, pointing at the floor. The director glanced down at the ruined film, and replied, "We are experimenting with a new effect called 'overexposure'; now we will shoot it again in the normal way!"

Alex was at least as well qualified as most directors, and though he has been described as "shy," "diffident" and "sensitive," he was by most accounts remarkably articulate, persuasive and resourceful for his age. Something of his relentless, driving ambition to succeed shows in early photographs of Korda Sándor before the First World War. Young and awkward he might have been, but he was determined to get ahead.

No doubt Alex would have found his way into the movies sooner or

later, but the outbreak of war speeded up his progress. Alex, with his poor eyesight, was of course exempted from military service, and felt no regrets at being spared from conscription. Hungarians were not strongly moved by a war fought on behalf of the Austrian monarchy and the Germans, against the French and the British, whom they admired, so no shame attached to those who were lucky enough to avoid military service. It was rightly assumed that the Empire would collapse whatever happened, and the Hungarians, despite their reputation for courage and martial spirit, were openly discussing to whom they should eventually have to surrender as the troops marched off to the front. However heroic they might be, most of the Hungarians' fighting had been against the Turks and Austrians, who were now their allies and masters, and it was difficult to appeal to their glorious history and the heroes of the past without reminding them of their present servitude.

Zoli, and later Vincent, had no medical problems to save them. Zoli joined the army with some relief. He had finished commercial high school with difficulty, only to end up as a freight clerk for a coal merchant, while Alex, always the brilliant eldest brother, moved at ease in the world of intellectuals and journalists, already a man with a reputation. Vincent, the ever-lucky youngest brother, had escaped from the threat of a career as a pharmacist with Alex's help, to become first a student at the College of Industrial Art, then a pupil of the distinguished painter Béla Iványi Grünwald. Once again, Zoli felt bitter and discriminated against, and went to war with a certain masochistic satisfaction.

For Alex, the war provided an opportunity. The Central Powers were cut off from many of the countries that provided their film product, and it was suddenly necessary to increase national film production to fill the gap, not just in business terms, but also because films were already recognized as a means of propaganda. When the well-known Hungarian actor Gyula Zilahy turned up at the Budapest Pedagogical Film Studio (a kind of municipal film enterprise, devoted to making instructional shorts for the Budapest schools) and offered to produce films, he was therefore greeted with enthusiasm, particularly since he had given his virtually nonexistent company the resoundingly patriotic name of Trikolor Films (the Hungarian national flag is red, white and green). Unfortunately, Zilahy himself had never directed a film, nor did

Trikolor, insofar as it existed at all, have any directors under contract. Zilahy cast around among his café acquaintances, and chose the congenial young Korda Sándor to help him direct the films he was now committed to make. As the editor of *Pesti Mozi* and as the translator of subtitles for Mór Ungerleider's films, Alex at least knew what other film makers were doing. (Later he was to recommend to an aspiring director that he should see all the great classic films, "Because you may as well learn from the best.")

Late in 1914 Alex stepped onto the floor of a movie studio (which he always described as "an old tram-horse barn") and began his career with three films, none of which survives. He was, with perfect symbolism, exactly twenty-one years old.

ONCE, WHEN ALEX was talking to me about the need to choose a profession, he described this moment as one of the happiest of his lifetime. "Suddenly," he said, "I knew what I wanted to do with my life, and I knew I could do it!"

If he hoped to encourage me, he failed—no such miracle was to occur in my life—and in fact Alex was never quite sure that he himself had made the right decision. When I went to Budapest it proved to be impossible to find the place in which this dramatic moment in Alex's life took place, but drawings of it confirm that it looked very much like a barn. Photographs of Alex taken at the time have a certain romantic quality to them, perhaps increased by the fact that he had removed his spectacles for the photographer, either from vanity or with the beginnings of a new sense of public relations. The effect is to give his eyes a certain hypnotic quality.

With his Homburg hat, his cigar, his cane and his fashionable new ankle-length overcoat, Alex was now in a position of authority and power, giving support—and orders—to actors twice his age, revising shooting scripts, inventing or adapting stories and beginning his life-long search for financial backers. He thrived on the daily atmosphere of chaos and crisis that is an inseparable part of moviemaking, heightened by the fact that most of his cast had to be out of the studio in time to appear onstage, and that most of these early films were shot in a few days, with minimal financing and in primitive conditions.

One of Alex's first major films, *A tiszti kardbojt* ("An Officer's

Swordknot"), was filmed in less than three days. It represents some-
thing of a milestone in Alex's career, partly because he had already
found a new financial backer (Zilahy had returned to the stage) in the
person of Miklós Pásztory, a prosperous Budapest florist who had ven-
tured into film production as a kind of hobby, but mainly because Alex
himself was already the entrepreneur and producer of the film. Having
promised Pásztory a film, he went to Budapest's Café New York and
sat there over a cup of coffee until Gábor Rajnai, the star of the
National Theater, appeared. Introducing himself to Rajnai, Alex sat
down at the marble-topped table and quickly invented the plot for a
patriotic war movie: "A captain of Hussars is cashiered because of his
gambling debts; war breaks out; he enlists as a private, is promoted back
to his old rank in the field for heroism; later he is wounded, and falls
in love with his nurse—a happy ending!"

Rajnai succumbed easily to Alex's enthusiasm, and turned up for
work the next morning, dressed as a hussar, at the Kelenföld rail-
way station, where Alex waited with a taxi, a cameraman and a
camera. There Rajnai was filmed as he marched alongside the
troops entraining for the front. The next day, Rajnai, Alex and the
cameraman went out to the Rákos maneuver field and filmed "bat-
tle" scenes among the recruits who were being trained there. On
the third day, Alex borrowed medals, a pair of officer's epaulettes
and a sword from a nearby pawn shop, then filmed the interiors (a
hospital ward and a gambling den) in the Pedagogical Film Studio,
with a cast hired the night before from among the out-of-work ac-
tors and regular patrons of the Café New York, including the head-
waiter, a particular friend of Alex's.

An Officer's Swordknot established Alex firmly as a director and a
resourceful deal-maker as well. By 1916 he had attracted the attention
of Jenő Janovics, another habitué of the Café New York, who was
looking for someone to take over direction at his Corvin film studio in
Kolozsvár, Transylvania. At last Alex had a position, and money. His
salary was 18,000 crowns a year, rather more than that of the Hun-
garian Prime Minister. He was not quite twenty-three years old.

Alex was already aware that he could not function as anybody's
employee for long. He wanted power as much as he wanted money,
perhaps more, and he was willing to pay the price of taking on total
responsibility. He respected Janovics and was fond of him (later he

often brought Janovics to London as his guest), but he refused to take orders from anybody, and insisted on making all the decisions himself. "Alex, even when he was young," said a survivor of these intramural battles over scripts and budgets at the Corvin Studio, "would prefer to be wrong by himself than right with somebody else's help." The relationship with Janovics could not last.

In 1917 Alex returned to Budapest, sought out Pásztory the florist, and together they purchased Corvin from Janovics. Alex was no longer an employee, but a partner. He had discovered that you can get somebody else to put up all the money for a company, still own half of it yourself, *and* manage it as you please! This was a lesson he never forgot; however talented he might be as a director and producer, his genius lay in persuading people to invest in companies that he would control.

Now, with the plump Pásztory as the first of these optimistic "angels," Alex proceeded to lease offices and studio space for the new Corvin Films. With a capital of 1,000,000 crowns to draw on, Alex designed and built a studio in the suburbs of Budapest, with the help of such distinguished designers as László Moholy-Nagy. Lavishly decorated and ambitiously planned, the Corvin Studio, like others that Alex would build later, was decades ahead of its time, so much so in fact that it was both an architectural and a cinematic wonder in its own day, and remains even now the nucleus of Hungary's modern Malfilm Studio complex. Alex's investors always got their money's worth in terms of architecture, even if they eventually lost their shirts, and Corvin's new offices on Rákóczi Avenue, in the most fashionable part of central Budapest, were luxurious enough to satisfy Alex, and to give Pásztory some hint of the expenditures to come.

Probably no period in Alex's life was more productive. Within less than a year he directed four major films, while supervising the production of those Corvin films he did not himself direct. It was also significant for another reason: Alex at last moved out of the family apartment and into the elegant Hotel Royal, where he took a suite and began to live in the grand style which was to be his hallmark for the next forty years.

Married or single, his idea of domesticity was to be a good hotel and room service, and he was to sum up his early success by saying, "Always go to the best hotel and eat at the best restaurants—and sooner or later someone will appear who will give you money."

His suite at the Royal was the best, the biggest and the most expensive in the hotel, his suits were faultlessly tailored by Knize of Vienna, his shoes were handmade, and there were fresh flowers every day in his office and at home, as there were to be for the rest of his life. (Alex's film studios were always provided with a gardener and a greenhouse, for his own use and because he hated to see artificial flowers on sets.) When his adaptation of Sardou's *Fedora, Fehér éjszakák* ("White Nights") became the first Hungarian film to be shown outside Hungary it was clear that the young Korda Sándor was on his way to international success, and might bring the entire Hungarian film industry along with him. After all, in those days before sound, theoretically Budapest could be a film capital as easily as Los Angeles.

But as was so often to be the case in Alex's life, world events were about to overwhelm what he had built. Kolozsvár, where he had worked for Janovics, was already occupied by Rumanian troops, the Austro-Hungarian Army was showing signs of collapse and mutiny, and it was apparent to the subjects of the Emperor that the Dual Monarchy was not going to be preserved by a German victory, that in fact both empires might very well go down together. As a young nationalist, Alex had looked forward to the collapse, with the possibility of creating a new Hungarian nation, but as a budding capitalist entrepreneur, he found to his embarrassment that he had a stake in the old order, and more to lose than to gain from the chaos of defeat.

At least his brothers were safe. He had followed their military careers with intense anxiety, not yet having reached a position of power sufficient to protect his family. Zoli, always unlucky, saw combat on the Galician front as a lieutenant, the scene of a humiliating military disaster in which several Hungarian regiments marched over to the enemy with standards flying, "voting with their feet" against the monarchy and the war. Zoli himself fought in that doomed campaign, and was wounded, gassed and decorated, returning to convalesce from the first of his many ailments. Vincent, who had been plucked by the army from his painting (he was living in Kecskemét, the Hungarian equivalent of the Barbizon art colony, as Béla Grünwald's pupil), spent six unhappy months in the ranks of an infantry regiment until his talent was discovered and he was put to work with the rank of sergeant, painting portraits of the colonel's mistress (a former washerwoman) and of the colonel himself. Neither brother was now in immediate

danger of death, but there is no doubt that Alex, with his strong family feeling, missed their presence. Despite his many friends, he was essentially a lonely man, with a deep need for companionship, and in their absence, he was about to make one of the great mistakes of a lifetime.

Early in 1918, Alex fell in love with an actress. ("The only thing worse than a director in love with his leading lady," he later said, "is a director in love with his leading man.") He saw her standing on the stage one day when he was filming, and was so struck by her that he asked an assistant to find out her name. He learned that she was called Antónia Farkas. He quickly wrote a small part for her into the film. Antónia, it turned out, was her stage name, which she had chosen because it sounded more "classical" than Maria, and because it seemed to match her own blond, classic beauty. There was no doubt that she was very beautiful, a little heavier than is fashionable today, perhaps, but with a profile that survived even the ravages of old age and temperament. In later years she was to describe herself as the Hungarian Garbo, but unfortunately she did not share Garbo's passion for self-effacement and anonymity. From the very beginning, she was determined that Alex would make her a star. He had found at last someone whose need for luxury and fame were equal to his own.

Almost everything about Maria is somewhat mysterious, from her age to her birthplace (variously given as Déva or Cegléd), since she was an inveterate destroyer of records and a self-romanticizer of epic proportions. She was born (maybe) in 1898, though she changed this date frequently. Her ambition was enormous. Indeed, it was that quality Alex saw and admired from the very beginning—she was a challenge.

How great a challenge she was to be, he could hardly have imagined then. He was excited by the prospect of *making* her a star (he was to do this again with other women, as if he could only love someone he had created himself) and fascinated by the prospect of a new partnership—he would be Europe's greatest director, she would be Europe's greatest film actress.

Maria, however, did not share this vision—she saw Alex as her competitor, not her partner. Alex was a pragmatist, a compromiser, a realist; Maria was a romantic with a minimal sense of reality, demanding, unreasonable, sometimes pathetic in her pretensions, but always bigger than life. This excess of passion made Maria attractive to Alex when they were both young and when it was directed toward him, but

it enraged him in time, particularly as it was turned against him. Ultimately Maria, even when she was far away, became a constant threat, an unseen presence always able to destroy Alex's happiness and peace of mind with a letter, a cable, a telephone call or a newspaper interview. Hungarian is a language ideally suited to invective, and Hungarian women are famous for their ability to reach a high pitch of rage and sustain it. The sound of a Hungarian woman in anger is unique and unforgettable, as anyone who has heard it can attest, even when she is not a professional actress, as Maria was, and helps to explain the role that coffeehouses play in Hungarian men's lives. Maria enjoyed making scenes; Alex did not. Whatever discords might lie beneath the surface, he liked to present to the world a picture of amiability and agreement; she sought the limelight, and vented her explosive discontent in public.

Vincent would always argue that Alex had been trapped by the first beautiful woman to make a play for him, and there is possibly some truth to this. Alex was young and had been too involved in the progress of his own career to form any long-lasting liaisons. This lack of experience probably contributed to his rather hasty decision. Maria was certainly intelligent enough to see that Alex offered her a chance to grasp fame and fortune. But she was also genuinely in love. What Alex miscalculated was the strength of that love, which was to become unwavering, obsessive and ultimately destructive.

Old Mrs. Kellner gave her blessing, reluctantly. Zoli, following a pattern which was to repeat itself with all of Alex's marriages, became Maria's friend and supporter in order to retain an influence over Alex. Vincent, also following what was to become a lifelong habit, retreated to his painting and refused to be enchanted by the new addition to the family. Alex, in any event, was happy. He loved spending money and loved to be seen in public with a beautiful woman at his side. He was now in a position to have all this and more, and before long Maria had moved into the suite at the Royal.

Alex had moved from the world of the coffeehouses to a much more exalted social level. He not only had a luxurious place in which to entertain people, but a beautiful hostess who was a famous actress in her own right. Now he was able to entertain many of Hungary's most important political leaders (or aspirants to leadership) in his suite at the Royal. His influence and reputation soon spread far beyond the world

of film making and journalism in which he had succeeded so rapidly. When he lived, later on, at Claridge's in London, with a whole floor to himself, he used to say that the Royal had taught him one thing: A good hotel is the best home.

BY THE AUTUMN of 1918, with the termination of hostilities, Hungary was clearly headed toward a period of revolutionary change. The Hungarians had been unwilling participants in the war, but unwilling or not, they were now among the losers, and unlike the Czechs they did not have a democratic leader who could appeal directly to President Wilson and dissociate them from the consequences of defeat.

The Allied Powers stood on their western border, while the Rumanians invaded them from the east, and it was urgently necessary to produce a government that could negotiate a viable independent existence for Hungary, most of whose neighbors were intent on carving her up.

Hoping that a democratic Hungarian republic would prove equally acceptable to the Allies, the Hungarian Parliament chose Count Mihály Károlyi to head the new government, a sensitive, intelligent and somewhat fatalistic landowner who had unwillingly become the leader of Hungary's liberals. He believed in peace, democracy, law and land reform, and it was hoped that Woodrow Wilson would find in him a kindred spirit.

Károlyi even had a Wilsonian solution to the problem of Central Europe—a "Trans-Danubian" federation of states, strong enough to survive on their own against the pressure of Germany on one side and Soviet Russia on the other. The Allies were not interested. They had commitments to Poland, Czechoslovakia and Rumania, and intended to honor them at the expense of Hungary. When their representatives arrived in Budapest to give Károlyi a foretaste of Hungary's new borders, the Hungarian Deputy Foreign Minister fainted at the sight of the map, and Károlyi, well aware of the hostility from the royalist right wing and the Communist left, decided to keep the matter secret while he played for time.

Alex knew Károlyi well, and had great respect for him, sharing his pacifistic views. Alex's closest friend and most trusted screenwriter and story advisor, Lajos Biró, became Károlyi's Foreign Minister, and much

of the new government's foreign—and film—policy was discussed at dinners in Alex's suite at the Royal. Károlyi even appointed Alex himself "commissioner of film production," thus confirming his position as the leader of the Hungarian film industry. Alex's articles in *Mozihét* took on a decidedly leftist tone. "No one should struggle against socialism," he wrote in December 1918, presumably from his suite at the Royal, where life went on as usual. It reveals something of his state of mind, however, that he sent a letter to Adolph Zukor, the head of Paramount, obviously thinking ahead to a career in exile. In the meantime, he adapted to socialism. But it was not socialism that interested Alex so much as survival. He had struggled to reach his present position in Hungary; it seemed to him stupid to abandon it.

While Károlyi hesitated, Alex pursued his duties as commissioner of film production with an equal lack of vigor. Biographers on both sides of the Iron Curtain have attempted to portray Alex as a spokesman for "nationalization as the best way to deal with the economic inequalities of the capitalist system," describing him as a "radical bourgeois." In fact he had already benefited very considerably from these "inequalities," and he intended to benefit even more. If he lent his name to the campaign for nationalization it was partly because Károlyi was determined to break the stranglehold of the film distributors and exhibitors over the producers, who were draining off too much of the producers' profits. (This feeling was shared in America by such conspicuous non-Communists as Louis B. Mayer, Harry Cohn and Adolph Zukor.) The collapse of imperial authority and the weakness of the Károlyi government created a situation in which real power was gradually assumed by the Hungarian workers and soldiers, who formed councils similar to those which brought Lenin to power in Russia. The councils controlled industry, the cities, the railroads, what remained of the army and the movie industry. With the example of the Russian Revolution only a year earlier to guide them, and with the return of large numbers of Hungarian prisoners of war from Soviet Russia, they turned increasingly toward Communism. Like Kerensky in a similar situation, Károlyi agonized, attempted to placate both sides (his weak land reforms forced the aristocracy into exile and opposition without in any way satisfying the peasants) and waited in vain for foreign support, or even attention.

So did Alex, but since Zukor never replied to his letter, he stayed put, joining mildly in the revolutionary fervor. While Maria was

tempted to play the role of a revolutionary heroine, her instincts were deeply bourgeois. She disliked the proletariat, took no pleasure in going to the noisy, smelly and endless meetings of the Workers and Soldiers' Councils, and thought that Károlyi was a weakling and traitor to his class. The revolution seemed unlikely to provide her with the social standing and glamour she craved, though it did in fact provide her with jewelry and furs. (Hungarian currency was worth almost nothing in Hungary, and less than that in the rest of the world, so Alex wisely put whatever he had in the way of savings into articles that could eventually be carried abroad and were, by their nature, inflation-proof.)

By January of 1919, the situation of the Károlyi government was hopeless. Lajos Biró, the novelist turned diplomat, had been unable to negotiate any kind of territorial settlement with the Allied Powers. Károlyi, who lacked the fiery enthusiasm and the oratorical qualities that might have won him the support of the Hungarian people, was unable to control the country. The Allies, irritated by Károlyi's inability to make a deal, invaded Hungary and presented Károlyi with an ultimatum. Since he could neither renew hostilities nor accept an unsatisfactory territorial settlement, Károlyi resigned, hoping that the councils would form a government strong enough to stand up to the Allies and win back some of Hungary's lost territory. The councils did nothing of the kind. Károlyi had merely spared them the necessity of overthrowing a bourgeois democratic government. Károlyi was replaced by a Communist government under the leadership of Béla Kún, which instantly proceeded to establish a proletarian dictatorship, to the confusion and horror of the Allied Powers.

Kún lacked the single-minded ruthlessness of Lenin. He has gone down in history as something of a monster as a result of later attempts to justify the right-wing terror that followed his régime, but in fact he was a rather gentle and humane person, as revolutionary leaders go. He was Jewish, and relied on rabbinical persuasion and explanation to secure his government, rather than the firing squad. This streak of humanity, together with a certain amount of pessimism, probably cost Kún his revolution. What help he received from Russia during the four-and-a-half-month life of the Hungarian Soviet Republic consisted mostly of letters and envoys from Lenin imploring him to take ruthless action against the enemies of the people before it was too late. Little else came from the east in the way of aid, since Lenin had troubles of

his own. As a result, Kún, who suffered from the same lack of charisma as Károlyi, was left to his own devices and failed.

Though in later years there was every reason for Alex to be circumspect about his past relationship with the Communist leader of Hungary—particularly when he reached Hollywood and when he was being considered for a knighthood—he was fairly open about his involvement. Once when I was discussing a rather orthodox right-wing history of Central Europe with him, he remarked that Kún wasn't nearly as bad as people had made him out to be—he just wasn't up to the job.

In any event, Alex and his friend Biró both accepted appointments to the Communist Directory for the Film Arts, established by the Council of Commissars, where they were joined by a well-known actor from the National Theater of Budapest named Arisztid Olt, who later achieved world-wide fame in the role of *Dracula* under the name of Béla Lugosi. Hungarian film production was now nationalized, under the overall direction of Béla Paulik, a political commissar, who proceeded to set up a cumbersome bureaucracy to plan and carry out a vastly ambitious film program. This involved a script directory, an actors' registry (where 41 actors and actresses were delegated to play "leading roles," and 253 were divided into various categories, all of them assigned to roles by a complicated system) and a whole separate directory which reported to the Commissariat of Education.

Kún lavished a good deal of attention on the Hungarian film industry, which he might better have directed toward diplomacy, finance or national defense. Plans were made to film the great classics of world literature, including Gorky's *Mother,* Tolstoy's *The Power of Darkness,* Shaw's *The Devil's Disciple,* Dickens' *A Christmas Carol,* Stendhal's *Le Rouge et le Noir,* Verne's *Mathias Sandor* (no doubt a suggestion of Alex's) and Ibsen's *Rosmersholm.* None of these productions were realized. Only thirty-one comparatively minor films were completed during the life of the Directory for the Film Arts, a good many of which had been begun as bourgeois projects before the revolution.

Alex himself directed three films, one of which had already been in production before the nationalization. The other two, *Ave Caesar!* and *Yamata,* were overtly propagandistic. *Yamata* was the story of a Negro slave's revolt against his cruel master, while *Ave Caesar!* was about a Hapsburg prince who persuades his aide-de-camp to kidnap a beautiful Gypsy girl for his pleasure, an adroit combination of political indoctri-

nation and native operetta. Gábor Rajnai, Alex's old stand-by, played the leading roles in both these films. It is revealing to note that Rajnai had made his debut as a film star playing the patriotic young officer in Alex's first film, *A tiszti kardbojt*: Rajnai, like Alex, had gone from making patriotic movies on behalf of the Empire to propaganda films for the Soviet government in four years, but as Alex said, "Film people must make films if they're going to earn their bread, whatever the government."

Through all this, Alex's life style scarcely changed at all. He received a monthly salary of 5,000 crowns in "blue money." (Hungarians used two forms of currency, the "blue money" of the old régime, which was the only kind anyone would willingly accept, and the worthless so-called "white money," so described because one side of Kún's banknotes was left blank in an economy measure.) He could live quite luxuriously, indulging Maria's extravagances, which were all the more demanding since she had not been registered among the forty-one "leading players" of the actors' registry.

On August 1, 1919, the Communist government collapsed. The Allied Powers had been unwilling to negotiate with it, and Kún had no Trotsky on hand to create a Red Army and liberate Hungarian territory in the name of the proletariat. Communism vanished in Hungary as ineptly and timidly as it had begun, and Kún, together with his luckier followers, fled to the Soviet Union, where they were treated with universal contempt and for the most part eliminated in the Stalinist purges, except for a handful who survived in Siberian prisons to return to power as camp followers of the Soviet Army in 1945. Budapest was occupied by Rumanian troops, while the Hungarians attempted to put together a national government with which the Allies would agree to negotiate.

These efforts were forestalled by the arrival of Admiral Miklós Horthy's counterrevolutionary army, whose existence was supported by the Allies on the grounds that it might be able to "restore order." As the "White" troops marched into Budapest on a hot summer morning, driving the Rumanians before them, few people were under any illusion about what that "order" would entail. Those Communists unfortunate enough to have remained were systematically arrested (it was said that half the population of Budapest was informing on the other half) and taken to the banks of the Danube, where they were executed. Their

bodies were pushed into the river, which was a mistake, because they collected in ghastly human logjams at the piers of the Danube bridges in the heart of Budapest, swelling and stinking in the hot August sun, an unwelcome indication that Horthy did not suffer from the scruples that had cost both Károlyi and Kún their power. Soldiers were hastily dispatched with long barge poles to the bridges to break them loose so they would be free to float downriver toward Belgrade and the sea, no doubt providing a convincing sign to the Yugoslavs and Rumanians that Hungary was once more in the hands of a strong leader.

Horthy's troops were frankly and enthusiastically anti-Semitic, and their activities were widely admired (and later imitated) by many European politicians and adventurers, including Hitler himself. For once, Hungary was in advance of the rest of Europe: She had produced the first full-scale Fascist government. The soldiers wore a crane feather in their caps, as the symbol of counterrevolution, discreet torture chambers were established, and an alliance of landowners, industrialists, aristocrats and officers was formed to give supreme power to Admiral Horthy, with the blessing of the Catholic Church.

If the film industry had fascinated Béla Kún, it played a negative role out of all proportion in the imagination of Horthy—perhaps because movies represented exactly the kind of thing that Horthy, a traditionalist at heart, hated most.

Sándor Pallós, who was unlucky enough to have directed the film version of Gorky's *Chelkash,* with its leftist message, was tortured to death, and the process of systematic persecution began in earnest. The terror was directed against Communist sympathizers and Jews in general, and against film makers in particular, many of whom were in fact Jews.

Alex had received an offer to work in Sweden, but Sweden seemed a long way away, and in the wrong direction. Besides, he was reluctant to leave his family and his friends, and feared reprisals against them. Now, with the consolidation of Horthy's power, it was more difficult to leave. Alex was a recognizable person, something of a celebrity even. He had many contacts in Vienna but Horthy's troops stood between Budapest and the Austrian border. Flight was not exactly out of the question but was a risky undertaking, and Alex had no taste for romantic adventures or disguises. Gloomily, he continued his work, completing an apolitical romantic love story in which Maria played a starring

role as a Turkish beauty. He did not like the Horthy régime, but it had not threatened him personally, and he had numerous friends in Horthy's camp. What is more, Maria, whose career had languished under the Communists, was once again a star, and received many flattering attentions from the officers who took their apéritifs in the lobby of the Royal. Though Corvin had been deprived of its two cinemas, it was re-formed as a new company with British, German, Italian and Austrian capital, and a board of directors that included the mysterious Brigadier Maurice (a member of the British Military Mission with an unmilitary interest in films), a Horthy politician and a collection of rather shady financiers. Now that the Whites had reinstated capitalism, they intended to profit from it, and Horthy's intimates, like those of the Führer, were adept at carving off slices of the private sector in the name of patriotism and party rule.

The new directors of Corvin appointed Alex as production chief. In the meantime Horthy had heard of him. While he was suspicious of Jews and film makers, Horthy was aware that Alex already enjoyed a considerable reputation, and hoped to make use of him. He gave orders to have Alex's films screened for him. Unfortunately for Alex, the two films chosen for Horthy were those he had made for Béla Kún's Communist Directory for the Film Arts, rather than his traditionally patriotic wartime efforts, and the Regent's judgment was abrupt and severe. "The man who made these films must go to prison," he said, with a certain degree of regret. A sergeant was sent to the Royal to arrest Alex.

Maria was so astonished that she did not have time to stage a scene, and Alex kept her calm by displaying perfect composure. The sergeant was young, polite and awed by Maria, and the arrest took place so quickly and quietly that it was over before the full implications of it were apparent to her. Sensibly, she paused to don her most glamorous dress, made herself up, put on a superb hat and her fur coat, and went in search of Zoli, who had been learning the cinema trade as an assistant director and film cutter, under Alex's supervision. Zoli was in the Kellner apartment, around the corner from the Café Balaton, which Alex used as a messenger service and a bank (he kept his money with the headwaiter). Maria was reluctant to frighten Mrs. Kellner by announcing Alex's arrest, much as the dramatic impact might have appealed to her. Instead, she wisely sent over a waiter from the café, with the message that Alex wanted to see Zoli, and he learned the bad

news at the Café Balaton, where Maria was waiting for him. Zoli found out that Alex had been taken to the Gellért Hotel, one floor of which had been converted into cells for "political" prisoners, with a torture chamber conveniently located in the wine cellar.

On the assumption that a wounded ex-officer and a beautiful film star could probably gain entry anywhere, Zoli hired a car and drove at once to the Gellért, where they were met with total indifference. None of the officers in the lobby would admit that Alex was there, or even that he had been arrested. It was obvious that he was going to be held in secret, possibly to suffer the same fate as Sándor Pallós. At last Maria found herself in the right place to stage a scene. Her voice rising, her magnificent bosom heaving, she demanded to be taken to the commanding officer's quarters. Horthy's officers were no more able to resist the storm than Alex was, and after a quick telephone conversation, Maria and Zoli were shown to the elevator. As they stood there, two young Horthy officers stepped in, resplendent in their gleaming riding boots and breeches.

"What are you doing tonight?" one of them asked the other.

"I'm going to dinner at the Countess'," replied his companion, "but first I'm going to beat the shit out of that Communist kike, Korda the film producer, and teach him some decent manners."

To Maria's credit, she restrained Zoli from attacking the two officers by embracing him as if they were lovers and whispering in his ear to shut up. Now at least they knew that he was in the Gellért and so far unharmed. They rode back down in the elevator, and began a desperate attempt to find some way of reaching Horthy himself. Zoli appealed to one of Alex's friends, Jenő Heltai, a well-known writer, for help, and Heltai managed to get Zoli an appointment with the Regent's chief aide-de-camp, a jovial *bon vivant* who admired Alex's films and his wife, and promised to do what he could. "However," he said, "it is still a pity His Excellency saw those two films, and I imagine it wasn't an accident."

Now Zoli knew that Alex's rivals and enemies in the Hungarian film world had made his arrest a certainty, which meant that Alex's position was probably even more dangerous than it seemed: There were *business* reasons for eliminating him. As Zoli was later to say, "If people want to kill you for political reasons, it can happen or not happen, but if they want to kill you for money, you are already dead."

He gathered Maria from the waiting room, and together they paid a visit to Brigadier Maurice, who was variously described as the representative of MI-5 in Budapest, the British government's secret link to Admiral Horthy and as an adventurer, profiteer and speculator. Maurice may have been all these things; certainly the Horthy forces had received secret financial aid from the West, where the Allied Powers were beginning to realize that Bolshevism might be even more dangerous than the Kaiser had been, and Horthy had been forced to agree to a great many demands for foreign participation in Hungarian industry in order to secure both the forces and the Allied carte blanche he needed for his coup. In return for money to support his troops and the promise of Allied non-interference, the Admiral and Regent was expected not only to secure order in Hungary, but to offer exceptionally attractive opportunities to foreign investors and banks, rather like the aspirant head of a banana republic junta.

Behind all the patriotic hysteria of Horthy's movement, there was a solid foundation of greed and exploitation, and if the Hungarians had been liberated from the Communists, they had also been sold on the open market to the bankers of Germany, England and France. It is altogether possible that Maurice was the go-between. His influence was far greater than would have been normal for a mere member of the British Military Mission, and the fact that he became a director of Corvin and was given a profitable movie theater as a birthday present by Horthy seems to confirm his somewhat special status as an *éminence grise*.

In any event, Maurice was no fool. Alex was a valuable property as a film maker, and a man of some fame. Neither Maurice himself nor the foreign investors had anything to gain from public disorder and brutality, and the Allied Powers, having discreetly financed a right-wing coup, were anxious to put a good face on the result. No doubt, the torture of one motion picture director would not materially affect the confidence of foreign investors, but Maurice had only to look at Maria to know that she would scream bloody murder—and since she was already something of a star outside Hungary, attention would be paid. If Maurice had any doubts on that score, Maria put them to rest. With all the considerable passion at her disposal, she made it clear that she would do her best to turn Alex's arrest into an international scandal.

Maurice listened, kissed her hand and went off in his car to see

Horthy. He returned a few hours later with Alex, who was unharmed. Taking him aside, Maurice advised him in French to get out of Hungary. "It will be announced," he said, "that they picked the wrong man, that they were looking for an actor named Korda, but the fact is, the Regent can't always control his own men, and most of them are *plus royaliste que le roi,* so the next time you may not be so lucky." Maurice paused. "If I were you," he said, "I would go to England. You would do very well there, and I know people who could be of help to you. There's a great deal of money to be made in films, but nobody in England seems to know how."

"Perhaps," Alex said, "but I don't speak English."

"My dear fellow," Maurice replied, "I don't speak Hungarian, but I've done very well here. In any case, you and the beautiful Mrs. Korda had best get out of Hungary while you can, and just to make sure that none of your friends from the Gellért Hotel stop you on the way, I think we'll provide you with a little discreet British protection."

So Alex and Maria left Budapest in the autumn of 1919, never to return, traveling first class in a wagon-lit to Vienna, with newly issued Hungarian passports and a compartment full of Maria's trunks. Alex was dismayed at losing the position he had gained in Hungary, and worried about how he would be able to support himself abroad in the style to which he had grown accustomed. He was not bitter about his arrest, though he was determined never again to live in a country where it might be repeated. His films continued to be shown in Hungary; he contributed articles to *Mozihét* and absolutely refused to become a spokesman against the Horthy régime or to play the role of a professional exile and martyr. Once the excesses of the White Terror had passed, Horthy made every effort to persuade him to return, and gave considerable publicity to his successes abroad. He was treated, in effect, as a valuable Hungarian export, and once commented that "Hungary is mostly famous for its paprika and its expatriates." He did not forget Maurice's advice, or his contacts, but he felt obliged to begin his career abroad on more familiar ground, and since his German was excellent (German being the mandatory second language of the Dual Monarchy), it seemed sensible to begin in Vienna, where his reputation was comparatively well established.

His major asset was sitting beside him: Maria's features were instantly recognizable to most European filmgoers. Alex was still only

twenty-six years old, and though he had grown a neat Vandyke beard and sported a monocle to make himself seem more mature, it was Maria who commanded instant attention as they arrived in Vienna, much to Alex's annoyance.

A fundamental change had occurred in their relationship, one which would affect Alex until his death, preventing him from ever breaking Maria's hold on him. She had saved his life. Whatever her excesses, whatever their incompatibility, however incomprehensible his concern might seem to strangers or new wives, Alex was to be henceforth in Maria's debt, and both of them, as the train pulled slowly into Vienna, were aware of it.

# CHAPTER 3

~~~~~~~~~~~~~~~~~~~~~~~~~~~~~~~~~~~~~~~~~

THE VIENNA to which Alex came was not the dreamy city of Franz
Josef's era. Defeat had eroded the social conventions that had made
Vienna seem gay and charming, exposing disagreeable realities.
Austria was reduced to a tiny state with a huge capital city, rather as
if Paris were the capital of Switzerland. Austrian agriculture could
not produce enough to feed the capital, so the farmers hoarded their
produce. Austrian industry was almost nonexistent, since most of the
Empire's factories had been in Bohemia, which was now the separate
—and hostile—country of Czechoslovakia. The collapse of Austria's
currency had led to rampant inflation, in which the savings of the
middle class, together with their pensions, insurance and dreams,
were instantly erased.

The streets were full of soldiers without jobs, wounded veterans,
respectable middle-class housewives turned prostitute and importun-
ing currency speculators. Though the Austrians had never wanted
to merge with their fellow ethnic Germans of the *Reich* (the cha-
otic condition of Germany made this notion even less attractive
now), the mere fact that the Allies had forbidden them to do so
created a vociferous minority in favor of *Anschluss,* many of whom
followed with great interest the right-wing putsch that ended the

Bavarian Communist Republic in a bloodbath, and brought to public notice for the first time a fiery right-wing orator and former *Gefreiter* named Adolf Hitler.

Anti-Semitism was as much a part of Vienna as the white horses of the *Spanische Reitschule,* and in the present circumstances it could only increase in volume and intensity, for, as the mayor of Vienna was heard to observe, "Anti-Semitism is the Socialism of the gutter."

Alex went straight from the station to the opulent Grand Hotel and took the largest and most expensive suite. He also gave further thought to his name. Sándor Korda sounded Hungarian, and Vienna was full of Hungarian refugees from Horthy's Budapest, mostly Jewish. He registered as "Alexander" Korda, and thus, with a stroke of the pen at the *concierge*'s desk, acquired the name by which he would be known for the rest of his life. Maria, who was determined not to succeed in the shadow of her husband, made a change of her own. Unwilling to share the name Korda with Alex for professional purposes, but not quite courageous enough to adopt something altogether different, or to forego the advantages of retaining some connection with him, she decided to call herself Maria *C*orda, thus creating a confusion which has plagued the family ever since in one form or another, and been the subject of many disputes and lawsuits.*

At the Grand Hotel, Alex patiently waited for the telephone to ring. Every night he and Maria dined out at the most expensive restaurants, Sacher's or the Drei Hussaren, Alex *"en smoking,"* with his cigar and his monocle, Maria in a succession of bold and extravagant evening gowns, while a liveried chauffeur waited outside for them with a gleaming black Daimler-Benz. None of this was paid for. But Alex always tipped lavishly, and in cash. "The great mistake people make," he was fond of saying, "is to put the tip on the bill. That means the waiter, or *maître d'hôtel,* or *concierge* has to make you pay the whole thing to get *his* money. You put him in the position where his interests are the same as the management's. That's foolish. You must make him your accomplice instead. Any waiter would rather get five or ten dollars every day for a week, in cash, for himself, than to stop you from coming back by refusing to let you sign a check. So long as you tip everybody

*From time to time Maria called herself "Maria de Korda," or "Maria de Corda," laying claim to a nonexistent aristocratic connection.

well, you can count on being treated like a king, whether you pay your bills or not. Better than a king, in fact—kings are notoriously poor tippers."

By the end of his second week in Vienna even he was beginning to worry about the mounting unpaid bills and wonder whether it might not be a good idea to move on to Berlin and start all over again at the Adlon Hotel. Apart from daily deliveries of flowers from men who had seen Maria and admired her, the Kordas had attracted very little attention. Alex's faith in his own approach to life was finally saved by a telephone call from a man who shared his own lavish tastes, but could afford them. Count Alexander ("Sascha") Kolowrat-Krokowsky was an Austrian nobleman with an amateur's interest in films, who had wisely married the heiress to the Upmann cigar fortune. Kolowrat was a gargantuan man (he weighed over three hundred pounds), with an unlikely passion for automobile racing, who drove his own specially constructed racing cars, sometimes with a dwarf as his engineer-mechanic in order to even out the handicap of his weight. It amused him to finance films, perhaps because there was very little else to invest in during the immediate postwar era, except night clubs and political parties. Soon Kolowrat joined the Korda/Corda couple on their extravagant nightly rounds, happily picking up the checks. Maria was the first to benefit, for Kolowrat was able to introduce her to several film producers who were more than eager to use her.

In the meantime, the two Alexanders, one tall and thin, the other tall and hugely fat, both of them smoking the best cigars, discussed an endless succession of stories, and eventually settled on Mark Twain's *The Prince and the Pauper*. Alex sent for his old friend Biró, the former diplomat, who had also fled from the Hungary of Admiral Horthy, and in June 1920 began to film *Seine Majestät das Bettelkind* ("His Majesty the Beggar Child"), a Korda/Biró collaboration which curiously resembled their later triumph, *The Private Life of Henry VIII* in England.

There is a myth that Alex got the idea for *Henry VIII* when he arrived in England in 1931 and heard a taxi driver singing Harry Champion's famous music hall song:

> "I'm 'Enery the Eighth, I am.
> 'Enery the Eighth, I am, I am.

> I got married to the widder next door.
> She's 'ad seven 'usbands before.
> All their names was 'Enery.
> She wouldn't 'ave a Willie or a Sam.
> I'm her eighth old man named 'Enery.
> I'm 'Enery the Eighth, I am."

Alex is supposed to have asked the taxi driver who Henry VIII was, and decided then and there to make a movie about the life and marriages of the king. This story was much beloved in England, and Alex repeated it so often that it became part of his legend. Winston Churchill used to tell it to people with glee, and even mentioned it to Stalin when he brought a print of Alex's *That Hamilton Woman* to Moscow (for years the only British film Stalin would allow to be played in the U.S.S.R.), though he had to explain to the Marshal who Henry VIII was and sing the verses of Champion's song, to the Russian guests' bewilderment.

Unfortunately, none of this can be true. As early as 1920, Alex was fully familiar with the life of Henry VIII, because Alfred Schreiber's performance in the role was widely praised in Europe, and strikingly resembled Charles Laughton's later interpretation of that un-merry monarch. When Alex decided to make a movie about Henry VIII thirteen years later, it is more likely that he chose the subject because he had done it before, and successfully at that. Besides, there was something about Henry VIII that appealed to him. On the one hand, he was amused by the paradox of Henry's being henpecked by his wives like any ordinary husband; on the other, he admired the king's ability to rid himself of the problems of marriage by ordering a beheading. It is probably no accident that Alex's fantasies were turning toward Henry VIII; Alex, unfortunately for him, had no such means at his disposal for ridding himself of Maria.

Luckily, she spent a good deal of the year in Italy, resuming her career, so that Alex was able to work in comparative peace and quiet. *Seine Majestät das Bettelkind* was completed quickly, and become an instant success, only slightly marred by the fact that Alex and Kolowrat had neglected to buy the motion picture rights to Twain's novel, having assumed that it was in the public domain, or perhaps simply having decided to ignore the fact that it wasn't.

Already, some of the major elements of Alex's later films are present: the use of lavish costumes and sets, the love of "period" backgrounds, the retelling of history on a human scale, making discreet fun of the great historical figures whose "private lives" (a phrase which was to recur in the titles of many Korda films) were shown to be in sharp contrast with their historical images. Mark Twain's story was an ideal choice, since it enabled him to show how a pauper could become a prince and carry the role off better than the prince himself—the kind of literal rags-to-riches story which must have seemed very close to Alex's own life. There was nothing very striking about the film technically—Alex was a conventional film maker in the sense that visual innovations did not interest him—but the story is brilliantly handled. The film also has a glossy surface that was rare in European moviemaking of the time. It was much commented on abroad, for in the age before sound, it was only necessary to translate the titles to make a film accessible to a foreign audience.

A series of lawsuits did nothing to hinder the popularity of the movie, but did contribute to the growing tension between Alex and Sascha Kolowrat. Kolowrat was jealous of his director, and as determined to interfere in the making of movies as he was in the design of his racing cars. Alex liked having a patron, and enjoyed Kolowrat's company, but he wanted to have his own way in the studio. The success of *Seine Majestät das Bettelkind* proved to each of them that he was right. From Kolowrat's point of view, it showed that his involvement was necessary; from Alex's, that he had succeeded despite Kolowrat's constant interference. Alex's discontent was made more severe by Maria's sudden ascendancy. At this point, she was still more famous, and making more money, than Alex—so much so that when Alex created his own film company he named it the Corda Film Consortium, both to capitalize on Maria's growing reputation and because he needed some of her earnings to finance it. Two more small pictures (both of them sea melodramas in the Jules Verne manner, filmed on the Dalmatian coast) eventually brought an end to Alex's relationship with Kolowrat, and he found himself once again unemployed and alone, since Maria was back in Italy, filming. It was on one of the trips he took to visit her in Rome that he learned, to his astonishment, that Maria was pregnant.

THE IDEA of being a father did not displease Alex, though it could scarcely have happened at a less opportune moment, when he was, in his own words, "living like a Gypsy." He was apprehensive about the idea of Maria as a mother, though, because it would put her out of work for a time. Alex returned to Vienna and did the sensible thing: He sent for his own mother, who shortly arrived with Zoli.

In the meantime, Alex needed work. He found a new partner in the person of Dr. Szücs, a Hungarian film distributor who had fled to Vienna to found a film-production company called Vita-Film, presumably with just those distribution profits Alex had complained about when he was in Hungary, and the Corda-Film/Vita-Film companies were hastily joined to prepare *Samson und Delila,* a Biblical extravaganza—and extravagance.

It is difficult to understand why Alex should have wanted to make a Biblical spectacle. He had no interest in religion, and it was to be his first and last entry in the field. There is no doubt that he had been impressed by D. W. Griffith's *Intolerance.* Also, he was almost certainly bored with directing pirate melodramas; one of his reasons for breaking up with Kolowrat was the count's insatiable taste for boys' adventure stories. Alex wanted to achieve a serious international reputation, and it was not to be won making sea movies in Ragusa. A big movie might do it in one jump, and Alex could then name his own price for going to Hollywood. At the same time, he could make Maria an international star, since he could hardly fail to give her the leading role in a movie that was to be financed in part with her earnings.

Alex secluded himself with Ernest Vajda, a Hungarian novelist, to prepare the script for what was to be the most ambitious epic in the history of European silent movies. Their completed work suffers from many of the same problems as Griffith's *Intolerance,* the chief one being a refusal to stick to the story. Alex decided to tell the story of Samson and Delilah within the story of an opera singer who refuses to sing the role, thus giving Maria the chance to play two roles, the reluctant opera singer and Delilah herself. The Biblical scenes were somewhat clumsily worked into the contemporary plot, rather like those in *Intolerance.* They were presented in a didactic way by a Jewish scholar attempting to interest the opera singer in the life of Delilah. This unpromising nonsense would not normally have appealed to Alex,

but as a new father and a man in need of a big success, his judgment seems to have been temporarily clouded, nor was Dr. Szücs any help in restraining him; like most distributors, he had never taken much interest in movies, or even seen many.

The difficulties of staging a Biblical epic with the comparatively modest resources available in a Viennese movie studio may have prevented Alex from taking any very active interest in his son. The later events of this father/son relationship can be traced to this period, when Alex was no doubt too busy to pay enough attention to the infant Peter.

It was especially tragic that Mrs. Kellner, who might have been able to give a child the right care and stability abruptly became ill, and was taken to the Loew Sanitarium, where she died, despite excruciating and expensive treatment. Alex was deeply shaken and depressed. He had loved his mother as he would never love anyone else (to the end of his life, her photograph, in a small, oval gold frame, stood on his night table). He felt himself for the first time truly homeless.

It was not the most auspicious frame of mind with which to approach *Samson und Delila,* which called for, among other things, the largest set ever built in Europe, several hundred extras, four hundred false beards and several teams of oxen to help Samson pull down the columns of the temple. The role of Samson was played by a former chauffeur with a weightlifter's chest and arms. Everything went wrong. Samson was unable to topple the temple, even with the help of the oxen pulling away out of camera range. After stubbornly refusing to collapse, the temple finally did so of its own volition while the entire company was at lunch. Maria made endless difficulties about her costumes, her roles, her leading man and the way in which her husband was directing her. Dr. Szücs, having discovered that the movie would cost nearly 13,000,000 crowns (perhaps $6,000,000 in today's money) and might take as many as 160 days of shooting time, hung around the set infecting everybody with his despondency. Alex's only escape was to sit and talk with Zoli, whom he had hired as a film cutter, but even Zoli's presence could not cheer him up, or disguise the fact that *Samson und Delila* was going to lose Dr. Szücs a great deal of money. "Other people's money, to be sure," as Alex once remarked, "but money all the same."

IN JANUARY 1923 the Korda/Corda *ménage* moved to Berlin, partly because it was a larger city than Vienna, and the obvious next stage for Maria's career, partly because Alex had exhausted any further sources of financing in Vienna. Once again, Alex went through his lavish ritual to find backers. He took a suite at the Eden, ate every night in the Bristol or at Horcher's, had his suits made by Stavropoulos and bought (on credit) a new and even more fabulous wardrobe for Maria. Germany was, if anything, in even worse straits than Austria. The French had occupied the Ruhr in an attempt to extract reparations, and the German economy had collapsed (or, in the view of some, committed suicide, to avoid paying the war debts). The rate of inflation was dizzying. Ordinary daily necessities soon cost millions, then billions and finally trillions of worthless marks, to the point where a suitcase full of marks was necessary to buy a pair of shoes. The savings and pensions of the middle class were instantly wiped out, speculators made fortunes and those who could plunged into every kind of pleasure, as if the end of the world were at hand, as in a way it was. Alex found a thirteen-room apartment on the Kurfürstendamm, and the Kordas moved in to assume a life of luxury. For once, their sweeping disregard for the realities of personal finance seemed altogether normal: The entire German nation had embarked on a drunken spree. Since money was worthless, there seemed no point in saving it. The same meal which cost 10,000,000 marks at lunchtime might cost 25,000,000 marks at dinnertime. Those who could were happy to pay off their debts in meaningless paper money, thus plunging most business establishments into bankruptcy. In the circumstances, the Kordas' extravagance passed for once unnoticed.

Alex swiftly found new backers, who were eager to hire Maria and willing to let Alex direct if that was part of the deal. To his distress, he was known as "Maria Corda's director." Still, he was at least working again, and his first film in Germany, *Das unbekannte Morgen* ("The Unknown Tomorrow"), was a profitable success. Its moral was that a man who devotes too much attention to his work and neglects his wife will eventually come to grief—a lesson which Alex himself never learned. *Das unbekannte Morgen* confirmed Maria's reputation but did little to establish Alex as a director, or—to use the present-day term—a "bankable property."

He was able to find backing from two more Hungarians, and pro-
ceeded to make an expensive movie about Mayerling *(Tragödie im
Hause Habsburg)*, starring Maria as the voluptuous and ill-fated Maria
Vetsera, who committed suicide along with Crown Prince Rudolf, the
heir to the Austrian throne. It was a critical success, and displayed
Maria to her best advantage, since it called for a certain amount of
petulance and *Sturm und Drang*, both of which came to her naturally.
It bankrupted its backers, however: the sets and costumes had been
made on too lavish a scale. Thus Alex's next film was correspondingly
modest, this time starring Maria as a dance-mad flapper, in what
amounts to an early European version of the role which was eventually
to make Joan Crawford famous. Joining once again with Lajos Biró,
Alex resigned himself to the task of turning out "vehicles" for Maria,
first *Eine Dubarry von heute*, a contemporary version of the story of
Madame Dubarry, chiefly remembered because it introduced Marlene
Dietrich in a small role, then *Madame wünscht keine Kinder* ("Ma-
dame Wants No Children"), which was produced for Fox, whose
blocked German earnings had to be ploughed back into German pro-
ductions.

This movie at last brought the Kordas the offer they had been
waiting for. In 1926 they sailed for America, under contract to First
National, which had acquired Maria as M-G-M. had bought Garbo,
Alex filling much the same unwelcome role that Mauritz Stiller had
played in Garbo's contract. She was to be the star; he was to be given
a few films to direct as part of the deal.

ALEX'S ENTHUSIASM for the move to Hollywood was short-lived. He was
impressed by New York, but the endless trip West merely reminded
him of his childhood on the *puszta*. The Kordas settled down in
Beverly Hills, and Alex made his first and last experiment as a driver.
In this and other respects, he was unable to adapt to Southern Califor-
nia standards. He refused to sunbathe, continued to wear a monocle,
and dressed in his Knize suit and homburg hat, as if Hollywood and
Vine were the Ku-Damm. Never an early riser, he was enraged by the
working hours of the studio, which required him to be onstage by
8:30 A.M.

His first assignment was to shoot a screen test for Barbara Stanwyck,

in which she delivered both her own lines and those of the leading man, since no actor was available. The test won Miss Stanwyck three roles in Frank Capra's movies and eventually a contract with Harry Cohn, but it did nothing to advance Alex's career. He made several "contract" pictures, only one of which, *The Private Life of Helen of Troy,* had any real impact or was more than mediocre, and even that was too sophisticated, ironic and "European" to be a major financial success.

Alex was bored, restless and lonely. He suffered profoundly from homesickness and culture shock. In Budapest, in Vienna, in Berlin, he had been a respected director. Headwaiters hissed at their subordinates to prepare the best table for the distinguished *Herr* Korda. Film journalists sought interviews with him, he talked art with artists, politics with politicians, literature with writers and finance with financiers.

Now he sat in a monstrous semitropical garden, waiting for a call from the studio. He took one look at the house that had been rented for him, with its Spanish tiles, its rustling palm trees and its lush, pungent tropical bushes, and remarked, "My God, I feel like Kurtz in *Heart of Darkness.* " He went inside to find shelter in the darkest room in the house, away from the intrusive sunshine, and brood on the madness that had brought him to Los Angeles, 3,000 miles from the nearest outpost of civilization, for in New York they at least published a real newspaper.

California seemed very far away indeed in the age before air travel was common. The train trip from New York to Los Angeles took four and a half days, with a pause in Chicago during which it was necessary to switch to the Atchison, Topeka & Santa Fe's *Super Chief* from New York Central's *20th Century Limited,* each of which arrived and departed from different stations. A hog, it was said, could travel across the United States without switching trains, but a person couldn't.

To get from Los Angeles to Europe required at least ten days of continuous traveling—very comfortable traveling, if one took the *Super Chief,* the *20th Century Limited,* stayed overnight at the St. Regis Hotel in New York and sailed in the morning first-class on the *Berengaria,* the *Mauretania* or the new *Ile de France,* with its dazzling art-deco mirrored *grand salon*—but still a major undertaking. Once you were in Los Angeles, you might as well be in Australia, or so it seemed to Alex.

Nor did Los Angeles in the late twenties resemble in any way

the city we know now. It was before the Age of Air Conditioning. The houses of the rich were built with thick walls and small windows, as the Spaniards had done for centuries, to keep the heat and sunshine out. When the dry Santa Ana wind began to blow, igniting brush fires in the hills and sending the local suicide rate soaring, half the city retired to nurse a migraine, while the rest huddled in bars seeking relief in heavy drinking and the occasional murder. Before the widespread adoption of air conditioning, the whole sweep of the Southwest, from Palm Springs through Las Vegas and on to the Rockies—now covered with homes, swimming pools, motels, casinos and shopping centers—remained the preserve of a few scattered Indian tribes and the occasional crazed dirt-rancher, a searing, hot wasteland which served to reinforce the feeling of isolation. Los Angeles was a series of loosely connected, sleepy and sometimes bizarre townships, clustered around a center so shabby and rundown that it seemed to decay as it was built.

The dazzling streets of shops in Beverly Hills did not exist, nor had Wilshire Boulevard been transformed into a business center. The San Fernando Valley was still mostly farms and small towns. Sunbathing had not yet become fashionable. The La Brea tarpits and the studio tours vied as the only cultural attractions in the city. Westerns could still be filmed in the gullies and canyons north of the Beverly Hills Hotel, where people like Frank Sinatra and Irving Lazar now have multimillion-dollar "homes" (to use the favorite California word for what are known in the East as "houses").

In this unpromising and arid wilderness, real estate speculators and the influx of people drawn there by the movie business had set out to create a world of luxury, first in Beverly Hills, then, when that became too ordinary, Bel Air, with its fortresslike walls, its imposing gates and armed guards. Even here there was the occasional reminder that the frontier was close—the odd rattlesnake in the topiary, a sudden brushfire, visitations of locusts or ants, scorpions in the palm trees. This was not a land that lent itself easily to human habitation. It fought back, with earthquakes, mudslides, floods and drought. All this contributed to the general uneasiness of a population most of whom had come from somewhere else. Every year a number of people committed suicide in the Pacific. Alex sympathized with these unfortunates, who waded into the Malibu surf leaving only their jackets behind them on the beach, neatly folded over with a hat on top and a note in the breast

pocket. "After all," he remarked to a friend, "where else do you go from here, if you can't go back?"

For himself, he had no sooner looked at Los Angeles than he began to think about going back. It was not just the city that bored him, it was the way they made movies here. Their technology was brilliant, but the "system," the accursed studio system, drove him crazy before he had even begun. Alex had never been a technician—he was happy enough to leave camera shots to the cameraman. He was interested in story and acting, and assumed that directing involved controlling the two. His greatest strength had always been in his collaboration with Lajos Bíró, who filled the function of what was known in Hungarian film making as the *"dramaturg,"* a kind of story-advisor, scriptwriter and literary/theatrical father-figure, whose job it was to get the story, the dialogue and the actors' and actresses' parts firmly worked out before shooting began. Once Alex and Bíró had selected a story, they would sit together for weeks, or even months, turning it into a screenplay, writing dialogue, acting out scenes, discussing who could play each part, turning the story into a reflection of Alex's own interests, sense of humor and view of the world.

Alex loved paradox. He also believed that audiences enjoy seeing great people cut down to size, which explains why the pauper becomes more princely than the prince himself in Alex's version of Mark Twain's story, why Helen of Troy becomes stronger than any of the men in her family, and why Henry VIII is turned into a timid, henpecked husband. Years later, when Alex was making *That Hamilton Woman*, he wrote into the final screenplay a line for Vivien Leigh: "The Queen of Naples is the only man in the Kingdom!" This line somehow represents Alex's style; it is a little cynical, very literary, and a witty, though rather obvious, paradox.

It was not the kind of line (or the kind of thinking) that was wanted in Hollywood. From the very beginning, executives complained that Alex was "stuck up," misinterpreting his poor English, his charm and his literary allusions for arrogance. Alex was only too eager to please, but when he courteously greeted Joseph Kennedy, the financier and father of the President-to-be, on the First National lot one morning with a bow, the great man, only just arrived in Hollywood himself, ignored him completely, and was heard to remark to an assistant, "Who does that guy think he is, some kind of fucking baron or something?"

Alex could not tolerate being treated as a hack director. He had not realized that the film director was here reduced to the role of technician. Power was in the hands of the producer. In Europe a director created a film, conceived and executed it himself; he was a venerated figure. In Hollywood the director was often assigned to a movie on which the script had already been completed, and it was even possible to change directors in the middle of a movie—unthinkable in Europe. Harry Cohn had once taken a director off a movie in the middle of a scene, and had him thrown off the Columbia lot by guards, and David O. Selznick was to change directors so often during the making of *Gone With the Wind* that many weeks had to be spent deciding how the directorial credits should run.

In one of his daily letters to his old friend Biró, Alex complained that directing here was like working on an assembly line. You were given so many pages of script to turn into so many feet of film every day, and the person who could do it the most cheaply and quickly became the best director.

Alex missed the leisurely pace of European film making, he missed the respect to which he was accustomed, and above all he missed his independence. "Here," he complained, "the stupidest producer on the lot can give orders to a director, and everybody's nephew is a producer. I should have come here as a producer myself, I think, or better yet, as a nephew."

Maria, whose own career was soaring, did nothing to improve Alex's mood. In an interview she was quoted as saying, "At home . . . when it is dinnertime, or time to go somewhere, then Mr. Korda takes direction from me . . . We do not argue the matter, for he recognizes that in the home—I am the director!"

Far from recognizing this, Alex did everything possible to avoid it, spending a great deal of his time with his European "cronies" in the Little Hungary restaurant. He and Maria fought at every possible opportunity, but Maria had the advantage of enjoying the fights, which he did not. Sometimes she would break all his cigars in half or cut off the sleeves of his Sulka shirts. At other times she would stage dramatic reconciliation scenes, which were, if anything, even more distasteful to Alex than the fights. For a time Alex had the company of Lajos Biró to console him, and eventually he brought over Zoli. (Vincent had moved to Paris to continue his career as a painter and a bohemian.)

Still, he was discontented. Maria's demands that he perform some miracle that would make her "the number-one star" did little to brighten his days and nights. His marriage was disintegrating. In Europe he would have escaped to the coffeehouses for good conversation. But in Los Angeles people stayed at home or visited other people, and Alex had no desire to do either. At home there were quarrels, and in other people's houses there was merely "trade gossip." Anyway, movie people went to bed early because they had to be up at dawn. "Boredom," Alex wrote to a friend in Berlin, "terrible boredom. It's hot, I have insomnia, Maria is impossible. At night there is nothing to do, nowhere to go, it's like being in the Foreign Legion at Sidi-bel-Abbès, waiting for one's enlistment to run out."

One morning Maria came downstairs while Alex was eating breakfast, and began to complain, once again, that she was not happy. Alex, sighing, looked out at the manicured lawn, the gleaming pool, the carefully tended trees, the Japanese gardeners turning on the sprinklers, the clear blue sky of yet another beautiful, perfect, intolerable Southern California day. Throwing his half-peeled orange to the ground, he stood up and shouted, "Happy? *Happy?* Who the hell is happy in this bloody paradise?" He stormed out, and had the chauffeur drive him to the Farmer's Market, where the fruit and vegetables ("The only real things here," as he said) sometimes soothed him.

He retained all his life a country boy's fondness for fresh produce, and had a connoisseur's appreciation of cheeses, meat and poultry. He would return home with great baskets of food which eventually rotted or were given away to the servants. Somehow, buying food seemed to soothe him, as if it were a kind of return to the basics, but even the Farmer's Market at last no longer consoled him: he hated Hollywood, despite the discovery of avocados, which first interested him, then made him sick.

World events were once more to adversely affect Alex's fortunes. For once in his life, he had saved his money, since there was little to spend it on for a man of his tastes in Los Angeles. As the great bull market took off, he joined the rest of the country in speculating, hoping to accumulate enough capital to return to Europe and form his own company. The crash wiped him out, further shaking his faith in America as the land of opportunity.

Nor was that all. The sudden advent of sound, while it did not affect

Alex, who had learned enough English to direct with the help of Charles Vidor, put a swift end to Maria's career. She had not bothered to learn much English and nothing could disguise her heavy Hungarian accent. Overnight she was transformed from star to has-been, to her rage and bewilderment. She held Alex to blame, since he was the easiest target.

In the meantime, Alex completed his contract with First National, and moved to Fox, where he was offered $100,000 a year by Winfield Sheehan, who had consolidated his own position as head of the Fox Film Studio by conspiring to take control away from William Fox. Since First National had briefly been controlled by Joseph Kennedy, Alex had already acquired a certain insight into the casual brutality of the studio system. (Kennedy's tenure at First National was described by Alex as "a four-week reign of terror"). But nothing prepared him for the treatment he was to receive from Sheehan and his production supervisor, Sol Wurtzel, who between them combined sadism and stupidity to an extraordinary degree. The one was tall, thin and humorless, like an Irish cop out of uniform; the other a cigar-chewing vulgarian, who was reputed to make Harry Cohn look like a gentleman by comparison.

As was so often the case, neither Sheehan nor Wurtzel wanted Alex or knew what to do with him once they had him under contract. He was submitted to a series of embarrassments at their hands, ranging from Sheehan's refusal to say "Good morning" to Wurtzel's assigning him to the worst stories on the lot. Sheehan evidently resented the presence of this apparently supercilious European intellectual on the Fox lot, and set out to break him. First he was given a string of pot-boilers to direct (including a particularly awful one called *The Princess and the Plumber*), then he was forced to make endless and pointless changes in accordance with Sol Wurtzel's whims.

Finally, he suffered the ultimate humiliation. Wurtzel had *The Princess and the Plumber* screened one Sunday morning while Alex sat in the screening room behind Wurtzel and his twelve-year-old son. At the end of the movie Alex asked Wurtzel what he thought of the picture. The elder Wurtzel took the cigar out of his mouth and asked his son, "What do you think of it?" "It stinks," the boy said. Turning back to Alex, Wurtzel dismissed him with a wave of the cigar. "You heard the kid," he said. "It stinks. You're through."

This was too much for Alex. He had been lethargically waiting for his fortunes to change, but now he could wait no longer. He was determined to make a new start, and swiftly moved to break out of his present trap. In other circumstances, he might have laughed away the incident with Wurtzel's son, but coming as it did on top of a great many other humiliations and disappointments, it was climactic. If Alex had had enough of Hollywood, he had certainly had more than enough of Maria. He owed her his life, it was true, but even a debt like that can eventually be paid off, and Alex, for the moment, felt it had been discharged in full.

He took advantage of California's divorce laws, so much more liberal and modern than those of Europe, and steeled himself for what he thought would be the final scene between himself and Maria. She naturally accused him of being in love with another woman. Years later he was to remark that no woman ever believes a man would leave her except for another woman, and Maria was no exception. But it was not true. Alex had simply come to the end.

Like a drowning man intent on survival, he was determined to make one last effort to swim to shore. Maria was no longer an asset, and had long since ceased to be a pleasure. The decision to seek his fortune again in Europe was an excellent opportunity to rid himself of her. He handed his affairs over to a lawyer, signed what then seemed a very generous separation agreement, sold the house on North Rodeo Drive, settled his contract with Fox, found Zoli a job, put his belongings in storage and borrowed the money for a first-class ticket home. But where *was* home? Budapest was out of the question; Vienna and Berlin were in turmoil; he knew no one in London. Even as he bought his tickets, he was unsure of his destination ("Just out of here," were his directions to the travel agent). But once he reached New York, where he could breathe again, he decided to go to Paris, mostly because it was everything that Los Angeles was not.

PARIS WAS a logical choice for many reasons, one of them being that Berlin had become increasingly dangerous. Alex was under no illusion about the gathering storm in Germany and had no wish, as a Jew and a foreigner, to be at the mercy of bands of roving Brown

Shirts, or to experience another White Terror. He encouraged his friends to leave Germany, helping them with money he could ill afford.

He refused to believe that the Nazis had peaked. Like the Hungarians in 1919, the Germans had anticipated a bloodbath for so long that it could hardly fail to happen—one look at the senile Hindenburg and the collection of Georg Grosz caricatures who passed as his advisors was enough to convince Alex of that.

He went to Berlin for several weeks after his arrival from America in 1930, long enough to persuade him that he was right to have chosen Paris. He had gone there to talk to Max Reinhardt, Lajos Biró and Gabriel Pascal about a multifilm deal. In the end he persuaded them to leave eventually, and returned to Paris with Biró to see what they could find in the way of financing.

As usual, he took a suite at the Ritz, dined at Maxim's and Fouquet's, and waited for the telephone call. As usual, it came—this time from Robert T. Kane, the head of Paramount's French studio.

Like most of the American film corporations, Paramount had to spend its profits in the countries where they had been earned, and was therefore obliged to produce movies in Europe, it being the custom then to shoot a single movie with different sets of actors, one after the other, creating an English, a German and a French version simultaneously. Alex was clearly well suited to this polyglot task, and set to work at Paramount's Joinville studio, directing German versions of French movies.

His luck was about to change at last for the better. Paramount-France had purchased the screen rights to Marcel Pagnol's phenomenally successful play *Marius* and had been obliged to give Pagnol approval over the film adaptation. Pagnol was so anxious to preserve the integrity of his work that he refused to approve anything, and in sheer desperation Kane offered Alex the job of dealing with him. Alex set out to calm Pagnol's fears. Night after night they went to see the play, then repaired to Maxim's for dinner to discuss how it might be turned into a film.

Alex agreed that the original cast should be used (thus giving Raimu and Pierre Fresnay their start as film stars), and also agreed not to change the dialogue or alter the Meridional accents in which it was delivered. What he could not accept was the sets, which looked noth-

ing like Marseilles to him. Since Vincent was then painting in the village of Cagnes-sur-Mer, Alex sent him to Marseilles to make sketches, then brought him up to Paris—still in his denim pajamas, espadrilles and a straw hat—to build the film sets. Casually, but with a certain inevitability, Alex had started Vincent on his forty-year career as an art director.

It might seem implausible that Alex should be the ideal director for a story about a Marseilles café owner's son who falls in love with a fisherwoman's beautiful daughter and abandons her to go to sea, particularly since *Marius* is regional, richly sentimental and comic in a peculiarly French way. But in fact, the humor of Marseilles and Budapest are not so far apart. Both are the cities of subject races, with an insurgent, underground and radical culture of their own, that have learned to transform anger into humor, and tend to play tragedy as comedy. What is more, Alex was naturally sympathetic to the role of Marius himself. How well he knew the young man's yearning for broader, wider horizons, the lure of the steamship sirens! He understood Marius, and was able to convince Pagnol of this. The movie he made is remarkably simple and uncluttered, without any of the glossiness that had characterized his earlier films.

Alex astonished Kane and Pagnol by completing *Marius* in record time, and then shot it over again with a German cast as *Zum Goldenen Anker,* thus effectively giving Paramount two films for the price of one. As a result, Alex was offered the job of running Paramount's British studio, which was in poor shape. *Marius* had reestablished his credit as a director, but he was as reluctant as ever to work for anyone, and determined to have his own company. In the meantime, running Paramount's British subsidiary seemed as good a job as any, and Alex accepted. He arrived in England in November of 1931, at the age of thirty-eight, and went straight to the Savoy Hotel, took a suite and went to work.

ALEX'S DECISION to settle in London is the subject of as many legends as is his choice of Henry VIII as his first independent film there. Alex had already been invited to England by Brigadier Maurice as early as 1919, and doubtless remembered the incident well, but there seems no reason to believe that he had England in mind as his permanent home

when he left Paris in 1931. It has been alleged that he was already planning to build a film studio in England as early as 1929, when he was working for First National in Hollywood, but this too seems unlikely. Indeed, he was attracted to England, as most Hungarians of his generation were. English politics, English tailoring, Englishwomen and English literature (in fact everything English except English cooking) were widely admired on the Continent, which explains why so many great hotels had English names—the Bristol in Vienna, the Eden in Berlin, the St.-James et d'Albany in Paris. A further advantage, from Alex's point of view, was that the British film industry was hopelessly weak and bereft of talent. It could hardly compete with Hollywood, and British audiences mostly wanted to see American films, and on the whole resented the fact that government regulations required British distributors to play a certain percentage of British-made films, which were known as "quota quickies." There was nobody in England with Alex's experience and energy, nor had anyone as yet tapped the major sources of financing on an ambitious scale. Alex may have arrived in England by accident, but everything he saw convinced him to stay.

He quickly made *Service for Ladies* (starring a fellow Hungarian, László Steiner, who was making a name for himself as Leslie Howard) and *Women Who Play* to fulfill his contract with Paramount. Then he sent for Lajos Biró, his indefatigable scriptwriter and idea man— and both his brothers. Zoli came without protest. California was good for his health, but he was bored there and eager to become a director in his own right. Vincent complained and delayed: He liked the unaccustomed luxury of the movie world, and was beginning to enjoy staying at first-class hotels and eating in good restaurants, but he was eager to return to his painting, and Paris and Cagnes-sur-Mer seemed to him more pleasant than London was likely to be. He had been peacefully putting down roots in France, where he was rumored to have acquired a mistress and fathered at least two children, and his reputation as an artist was beginning to grow. He loved painting, the sun, Paris cafés and the quiet life. The notion of living in England and sharing his brothers' exhausting ambitions did not appeal to him. True, he was poor, but so were most people there, and he had no great desire to become rich in any case—that was Alex's obsession, not his. But Alex was determined to have him, and using his unchallenged authority as

the elder brother, he sent a peremptory telegram ordering Vincent to leave.

Reluctantly Vincent obeyed. He kept his studio, in the hope that he would someday return, and set off for London by train in the *Golden Arrow* to join his brothers. Alex took one look at him and told him to go to a tailor. When my father refused to go, on the grounds that he was too busy and that no sensible man needed more than one pair of trousers, Alex had the tailor sent to him. Since Vincent still refused to be measured, an old suit of Zoli's was used as a pattern. The tailor was instructed by Alex to make up two in gray flannel, two in dark blue and two in tweed. Vincent was driven out to the studio, where he was confronted with the finished suits, which he refused to try on or have altered. My father consented at last to wear them, and kept to the same pattern for the rest of his life. Alex's twenty-year struggle to turn my father into a respectable man had begun.

Vincent's endearing vagaries of dress were to become something of a trademark over the years. The fact that his suits had originally been modeled after Zoli's measurements had the unfortunate effect of making the shoulders far too large. But Vincent was indifferent to fit and cut, and resistant to having the suits pressed. He seldom replaced missing buttons, and sometimes used a piece of knotted string as a belt. He liked his clothes to be old and frayed, and was most comfortable in them when they had reached the point at which anyone else would have thrown them away. Eventually tailors, hatmakers, shirtmakers and bespoke shoemakers grew fond of him, as the English do of eccentrics. Alex sent Vincent to the shops he patronized himself, but the results were unsatisfactory. Alex was always impeccable; Vincent, at considerable expense, always looked disheveled.

When Locke's, London's most exclusive hatter, saw what Vincent had done to the gray hat they sold him, they refused to sell him another until Alex personally intervened on his behalf. (Years later, when I bought a hat at Locke's for myself, the elderly manager took my measurements with a large iron instrument that looked more appropriate for brain surgery, and asked if I was Mr. *Vincent* Korda's son. I replied that I was. He looked at me warily and asked if I wanted a soft gray hat. I said I did not. He sighed with relief. " 'E's a lovely gentleman," he said, fitting me with a respectable Coke hat, "but it wouldn't be fitting to imitate his 'ats. Imitate Sir Alex's, is my advice.")

VINCENT'S "'ats" represented only one facet of his indifference to clothes. Despite pressure from Alex, he continued to replace buttons with safety pins, to use paper clips instead of cufflinks and to wear the trousers of one suit with the jacket of another. Most of the time Alex affected not to notice, but sometimes he saw Vincent out of the corner of one eye on the set, and would tell his secretary to order him a new suit, hat or shirts. This made little difference. Once, when Alex had recently forced a new suit on Vincent, he saw him on one of the sound stages at the studio, as shabby as ever. "Vincent," he shouted in exasperation, "where is the bloody new suit?" My father looked down at his ruined suit, smiled shyly and replied, "Lacikám, this *is* the new suit."

Vincent developed methods for dealing with new clothes: he would tear the lining out of his hat, roll it up in a ball, sit on it in the car and use the edges to blot up ink until it was ready for wear—identical, that is, to the one Alex had made him throw away. Still, Alex never gave up. Even when they were both in their sixties, and Alex was ill, he would sometimes look at Vincent, sigh, close his eyes in pain and shout, "Vincikém, this time it's too much finally—after all, you're my bloody *brother!*"

CHAPTER 4

~~~~~~~~~~~~~~~~~~~~~~~~~~~~~~~~~~~~~~~~~~~~~~~~~~~~~~~~~~~~

I WAS BORN on the opening night of *The Private Life of Henry VIII*, the film which launched Alex—and the family—to success, and was the foundation of the British film industry. Between my father's arrival in England and these two simultaneous productions, certain preparatory events naturally took place. The major one was that the three Korda brothers, hitherto separated and nomadic, developed a taste for domesticity. Somehow, by mutual agreement, they reached the decision to settle down at last in England. This in itself is surprising. Zoli, who suffered from tuberculosis, hated the climate, spoke the language badly and loathed English hypocrisy, stuffiness and conventions, all of which he resisted flamboyantly. My father hated the cooking, was unable to master the language, and found the whole country depressingly bourgeois. Only Alex was genuinely attracted to England, partly because he understood there was a place for him there. In California, Paris, Berlin, Vienna, New York, there were plenty of clever Hungarians. The stories about them were familiar folklore—"A Rumanian will sell you his own mother, but a Hungarian will not only sell her, he'll *deliver!*" Or "The Hungarian recipe for an omelette begins: First, steal a dozen eggs . . ." Or "If you have a Hungarian for a friend, you don't need an enemy." In England, Alex had before him what amounted to virgin

territory. No Hungarians had as yet made an impact on the English scene, Hungarian jokes were unknown, and Alex seemed to most people to be an exotic, charming and original "Continental," rather than that stock figure, the Hungarian adventurer. There is a wise Gypsy saying: "Never steal two chickens in the same village." On a higher level, Alex understood the wisdom of this. Everywhere in Europe and in America, the scheming Hungarian was already a familiar figure; here in England was a village in which nobody had so far stolen a chicken.

Alex prepared the way for a whole host of Hungarian entrepreneurs and imitators, Gabby Pascal, Steve Pallós, Alex Paál, endless contingents of people who had known Alex, or fed Alex, or financed Alex, or borrowed from Alex, and who soon followed him to the new Golconda by the Thames. But in the English national consciousness Alex remained a unique figure, a Hungarian who became more British than the British themselves.

He had the bearing and subtle intelligence of a Renaissance statesman, so much so that one English observer reported, "He would have made an ideal Pope, if only he had been Catholic, and not so interested in money and women." He was soft-spoken, confiding, a good listener and a superb talker, even in his imperfect English, and was endlessly interested in other people's problems. Years later, Ralph Richardson remarked that Alex was the most "magnetic" person he had ever known, even more so than Laurence Olivier, and went on to describe another side of Alex's complex character: his uncanny ability to turn every conversation to his own advantage and to get his way without argument. "I would go to see [Alex] with a problem," Sir Ralph remarked, "with a furious speech about what I wanted, and what I'd do if I didn't get it. And all the time he'd be staring at my feet. When I'd finished, he'd say, 'Where did you get those marvelous shoes? I'd give anything to have shoes like those.' And I would retire defeated."*

Throughout his life Alex was usually able to deflect the wrath he had caused. When a group of investors in Berlin objected to his high-handed refusal to account for the money he had spent, they sent a spokesman to threaten Alex in his own office. When the spokesman emerged, they crowded around him to ask if Alex had agreed to pay his debts. He shook his head mournfully. "No," he said, "I went in

*Ralph Richardson, as quoted in a *New Yorker* profile by Kenneth Tynan.

there prepared to be angry, but Alex began to talk about his mother, and how much he missed her, and I told him about *my* mother, who is very sick, and he made me promise to visit her and offered to lend me money if I needed help in paying the hospital bills, and then we embraced each other and he left by the back door."

Years later, when he had promised the English actress Ann Todd a part, then given it to someone else, she stormed into his office in a rage and told him what a wicked thing it was to do. "Ah," he said, "I *know* it was, but I wouldn't have done it to anyone else."

"Why not?" she asked, somewhat taken aback.

Taking her by the arm, he told her gently: "Because you and I are such good friends that I knew you would forgive me."

FEW PEOPLE were immune to Alex's charm, including children. Even as a child, I had occasional glimpses of Alex as a persuader. Once, when I was about twelve years old and living in New York, I was taken to see Alex, who had been informed that I was doing badly at school. He greeted me sadly, allowed himself to be kissed, and putting his arm around me, asked if I found school difficult. I replied that it seemed very difficult indeed.

He sighed. Then he said, very softly, "It was difficult for me too, and even more difficult for your poor father. But, you see, you *have* to do better because I'm counting on you to be the first Korda who is a good student. When you do your schoolwork, try to imagine that you're doing it for me, to make up for all the schoolwork I didn't do. It's a family debt, you see?"

Alex knew how to make even recalcitrant schoolboys feel a personal obligation toward him. He made his troubles *their* troubles, and never denied or justified anything he had done. He did not believe in self-justification. When people were angry at him, he simply agreed with them, thus disarming them completely.

NOW THAT ALEX was nearing forty, what he wanted most of all was to put down roots, to become respectable. He had lived like a millionaire for twenty years; now he wanted to *become* one, which was quite a different proposition.

To achieve that he would have to break away from the limitations
of finding financial support for one or two movies, and thus being
dependent on a patron. He had seen, at first hand, how powerful the
American film companies were, and how their immense financial and
technical resources gave them a secure advantage that European film
makers could only envy. To do what he wanted to do, he would have
to create a company and a studio that could compete with them.
Directing films had begun to bore him, and he was more aware than
his critics realized of his limitations as a director. He had learned how
to make films by practical experience; now he would learn how to
become a financier and a company promoter. The mustache, the mono-
cle and the cane were dropped in favor of Savile Row tailoring, and
Alex's face, which had always seemed that of a young man, began to
take on the stern, tired and cautious mask of his later photographs. He
contracted with Paramount to make a few "quota quickies" in order
to raise enough operating capital to begin. In 1932 he established
London Film Productions, with the help of Leopold Sutro, a City
banker, whose son John became a member of London Film's Board of
Directors, and a lifelong friend of Alex's.

Alex, as usual, did not find it difficult to recruit financial supporters
in a foreign country. His network of friends and fellow adventurers
provided him with names, and no sooner had he arrived in London than
he was giving carefully put together dinner parties, during the course
of which he would unveil his plans. He was good company, and took
great care to know more about his guests than they knew about him.
"Before you go anywhere," he once said, "always ask the people you
know who you should see when you get there. Before I go to New York,
I always ask people, 'Well, who should I say hello to in New York for
you?' "

In Paris, Los Angeles and Berlin, Alex had already acquired a list of
people to telephone when he arrived in London. He did not ask people
for an appointment—always a signal that you want something from
them. Instead he invited them to dinner, and told them who their
fellow guests would be, so as to put them at their ease. The real trick
was to provide bankers with enough actresses, writers and society peo-
ple to keep them amused and flattered that their company was welcome
in such unbusinesslike circles. "The thing is," Alex explained, "to make
the bankers feel like beautiful celebrities and the beautiful celebrities
feel like bankers. You have to offer the people with money a chance

to dine with beauty and brains, and you have to give the people with beauty and brains the opportunity to rub shoulders with money. After that, you can sit a banker down with a glass of brandy and a good cigar and propose to him something he wouldn't even *listen* to in his own office."

As Alex well knew, modest supplicants are usually refused. He once advised me that if I ever wanted to borrow money from a bank I should aim for twice as much as I needed—"Your request," he said, "will then go up to a much more intelligent man for approval." The important thing was to establish himself in a position of equality with those who could finance him, not to come hat in hand, but to broach the subject of financing as one man of the world to another, as if he were offering an opportunity to a new and valued friend. He therefore had very little trouble in putting together a distinguished Board of Directors, and by securing these directors he opened the way to even more powerful financial sources.

Almost immediately, Alex began to transform this corporation into a functioning movie company. He himself would produce and direct, for the time being; Vincent would handle the sets and studio planning; Zoli would advise on cutting; Lajos Biró would provide the scripts. Alex of course would handle financing in his own inimitable way. How much he confided in his brothers is open to question. He trusted them completely, but Zoli seemed to him impetuous and Vincent naïve, nor was either of them much interested in the intricacies of finance or company law.

As early as 1932, Alex had begun to build up a list of "contract" players, with the hope of turning them into stars. He had learned the lesson of Hollywood—a film company needs a pool of actors and actresses to draw on, as it is cheaper to create stars than to buy them. Among his first contract players was a beautiful young Tasmanian-born actress, originally named Estelle Merle O'Brien Thompson, whom Alex hired as one of the first of his "starlets."

Maria, in what was surely her last contribution to Alex's career, was among the first to notice the girl. She had come over to see for herself how Alex was getting along in his new venture (and possibly to attempt a reconciliation). In the studio canteen she grabbed him by the wrist so that he spilled a cup of coffee in his lap, and whispered, "Look at that one, you fool, there's a face worth millions!"

Alex, his trousers soaked with coffee, made his way over to her table,

introduced himself, and was instantly captivated. He returned to his office, telephoned her agent and signed her to a long-term contract. He did not even look at the tests. The face was enough. Alex was enthusiastic, and rightly so—she was to become one of his most valuable players —but he had doubts about her name, and to her fury announced to the newspapers that he had signed up "Stella Merle." When she objected, urging him to let her use the name Merle O'Brien, Alex answered that this was impossible—"All the bobbies in New York are named O'Brien," he explained. Finally Merle herself suggested Merle Oberon. On the card which listed her measurements, hair color, type ("smart crowd") and abilities ("promising") for casting, some prophetic soul wrote *In good demand—AK interested."*

INTERESTED HE CERTAINLY WAS. Merle's beauty was so striking and unusual that Alex could foresee a profitable future for her—and for him —as a major star, not only in England, but even in Hollywood, which was more important. Still, his first interest was in building up and financing his own studio, and for the moment Merle appeared in a couple of comparatively minor parts, replacing Ann Todd in *Wedding Rehearsal* as a secretary, after Miss Todd was injured in an automobile accident, and playing "a coed vamp" in *Young Men at Oxford.*

Two other discoveries of Alex's were to have a surprising and profound impact on Zoli and Vincent. It cannot be said that the two younger brothers "fell in love," in the conventional meaning of the phrase, but Joan was certainly attracted to Zoli, which was not incomprehensible, given his dramatic, dark good looks; while Gertrude was charmed and amused by Vincent, who was able to communicate with her in French.

Certainly, nothing in Gertrude's life had prepared her for this peculiar suitor, with his unpressed clothes and his guttural, halting French, though she was intrigued by him when they first met on the set of *La Dame de Chez Maxim,* based on a frothy and sentimental play by Georges Feydeau, which Alex directed in two versions, one in English with an English cast, the other in French with a French cast. Vincent was capable of gallantry, and since Gertrude was the youngest and smallest member of the cast, he took her under his wing, and she soon became part of his life. No doubt he had no intention of marrying her

—or anyone else—but he reckoned without the customs of his adopted country. Gertrude expected marriage, and when this was explained to Vincent, he acquiesced. He was not enthusiastic, he did not even take the whole thing seriously, but if that was the custom in England, he would go through with it. He had no wish to offend anybody's sensibilities, though he himself saw no reason for what he called "an imbecility."

My mother's career as an actress had been more or less foreordained by the fact that her cousin was Madge Evans, a famous and successful child star. My grandmother was determined not to be outdone by her sister Maud Mary, a woman of great strength and determination, and despite the misgivings of my grandfather, pushed Gertrude onto the stage, where she soon became very successful herself. A childhood spent in the usual purgatory of a convent school (following the British custom by which children are driven from home at an early age by their parents to ensure their future happiness) had miraculously failed to prevent my mother from becoming fun-loving and witty, as well as very beautiful. It remains something of a mystery that she could fall in love with a man of such obvious moodiness as my father, unless in their difficulty of communication they simply failed to take each other's measure. Even Alex, who dearly loved Gertrude, was surprised by their decision to marry, and advised my father to change his habits if he wanted to keep his young wife happy, a warning to which my father paid very little attention.

Though my grandfather Octavius had warned in vain for years about the dangers of a stage career, nothing prepared the Musgroves for the sight of their prospective son-in-law, who was a good twenty years older than their daughter, an artist, a foreigner who spoke no English and casually asked for whiskey at teatime. The questions parents normally ask were useless, even if my father could have understood them. Did he have any money? No, he indicated after Gertrude had translated this into convent French, but Alex did. Did he have a place to live, a *home?* Again, no, but doubtless one could be found, and what was wrong with hotels? Did he intend to become a British subject? What for? Vincent replied, Gertrude was already English. In any case, these discussions were pointless, since Gertrude was already pregnant, a piece of news which he indicated by drawing a bulge over her stomach with his hands.

This was not how my grandmother had expected to hear of her daughter's marriage, and there was a good deal of tension in the small house with the stained-glass windows, the stone gnomes in the back garden and the crazy paving on the lawn, where the Irish maids came and went with monotonous regularity as they invariably failed to measure up to my grandmother's standards. My father measured up no better, and though my grandfather, always the most agreeable of men, felt that Vincent was "not such a bad chap, underneath it all," my grandmother retreated into a state of shock that was to endure for several decades. Happily Vincent's understanding of English was limited, and he came away with the impression that he had been admired and approved. In any event, he saw no reason to repeat the experience. Having met his in-laws once, he felt he had done his duty—*more* than his duty—and whenever they expressed a desire to see him, he always asked, "What do they *want* from me?" The obligations of family life were mysterious and incomprehensible to him.

Since my father was evasive about his religion, if any, a formal wedding was out of the question. Gertrude and Vincent were married at Caxton Hall by the civil registrar, the bride's bouquet having been provided by Alex, always thoughtful about this kind of detail. Zoli and my father's Hungarian cronies sat behind Vincent and made lively fun of the proceedings, to my mother's distress, while Alex sat glumly beside her, perhaps remembering the disastrous consequences of his own marriage. My father took the ceremony lightly. Like an explorer in unknown territory, he was willing to submit to the mysterious tribal rites of the natives without necessarily believing in their validity. However, he went through another small ceremony, in his own secretive way, applying for British citizenship, which was soon afterward given to him. Unfortunately, by marrying a Hungarian citizen my mother had unwittingly lost her status as a British subject by the laws of Hungary and Great Britain. She was horrified to learn that while Vincent was now British *she* was Hungarian. All of Alex's influence was needed to calm her, and to persuade the Foreign Office to restore her British passport. It was the first of many similar problems, since Vincent never consulted Gertrude about his decisions.

Though she had pointed out to him that they could hardly start a home in a hotel, he did not tell her that he had bought a house in Wellwalk, Hampstead, close by the heath, until after he had done it,

and furnished it without consulting her. He took an almost perverse delight in surprising her, sometimes pleasantly, sometimes not.

Alex put down roots of his own by purchasing a large mansion on Avenue Road, north of Regent's Park. The reason for this sudden interest in real estate was very simple: *The Private Life of Henry VIII* had made the Kordas rich and famous overnight.

Alex had known from the beginning of his English adventure that he needed one big solid success to establish himself and open up the sources of financing he needed. He sensed that it must be a "national" subject, but sufficiently well known to have international appeal. Biró and Alex ploughed through Shakespeare and the English classics, but both of them were firm believers in "lightness," and needed a story that would lend itself to humor and irony. Henry VIII was, at the time, very much in the news, since Francis Hackett had just published a very successful biography of him (to which Alex neglected to buy the film rights, thus causing a lawsuit). Besides, Alex's choice was limited by his star. He had known Charles Laughton in Hollywood, and they had often discussed making a film together. Laughton's appearance and physical bulk obviously precluded the more "romantic" historical roles. His attraction to Alex was that he was an intellectual among actors, a clever man who enjoyed talking and thought out his performances as members of the Actors Studio were to do twenty years later. For the most part, actors bored Alex,* but Laughton challenged and interested him, and he was, in any case, available, one of the few English actors who commanded attention on both sides of the Atlantic.

Alex, who had already succeeded once with the monarch in *Seine Majestät das Bettelkind,* decided to try again. If the music-hall song had any significance for him, it lay in the fact that the English had already transformed Henry into a comic figure of folk legend, perhaps because the reality of him as vengeful and psychotic monster was difficult to accept for a nation addicted to its own royal family. Even during his own lifetime, the English found it easier to joke about Henry than to face the awful truth that he was probably mad. His was certainly a reign that could be dealt with humorously without offending most people, which would not, for example, have been the case with

---

*The major exceptions were Laurence Olivier, Ralph Richardson, Cary Grant and Raimu, all of whom were close friends.

Elizabeth I or George III. Alex and Laughton drove to Hampton Court and looked at the portraits of Henry VIII, and Laughton instantly recognized that with a beard, hose and doublet, he *was* Henry.

For once, Alex moved quickly and with economy. He had raised just enough money to complete the film, but there could be no delays or mistakes. Even Laughton, who was given to endless agonizing over each line of the script, worked with what was, for him, great dispatch, though the strain of directing him was so great that Alex decided he "would rather die than do it again" and complained that "Charles needs a midwife, not a director."

From the very beginning, it was clear that *Henry VIII* was a milestone in the English cinema, a movie that could withstand comparison with the best—and the most commercial—Hollywood had to offer. Indeed, so strongly did Alex believe in the film that he decided to open it in the United States. It was given its world premiere at the new Radio City Music Hall, in New York, in October of 1933, where it proceeded to make record-breaking box-office grosses, week after week.

In November it opened in London to almost unanimously good reviews, and huge audiences. *Henry VIII* earned Laughton an "Oscar," made Alex over half a million pounds on its first run, became the first British film to conquer the American and the world markets, helped to establish Merle Oberon firmly as a star, and inspired an ill-conceived rush to finance more British films and film studios.

Since *Henry VIII* was a significant moment in the history of British films, it is worth examining in detail, not least because it represents both Alex's virtues and flaws as a film maker to an extraordinary degree.

Like most classic movies, *Henry VIII* is more famous than seen—though occasionally it reappears on television, at odd hours on double-digit channels. Alex himself never thought of *Henry VIII* as a classic—in fact he went out of his way to prevent its being presented as one. He knew better than anyone that the film was a hasty attempt to put together all the elements that were available to him on a shoestring budget. Once he had succeeded, much to his own surprise, he spent the rest of his life selling the film, borrowing against it, buying it back and re-releasing it throughout the world. *Henry VIII* was his trust fund, and he had no interest in having it shown in film societies or enshrined in film libraries so long as people would pay to see it. Once when Alex and Lord Guinness were admiring each other's yachts and complaining

about the cost of running them, Guinness remarked that his vessel floated on a sea of ale and stout, and Alex said, "Ah, with you it's beer, with me it's poor Henry VIII and his wives who pay for the yacht."

Alex well understood the accidental nature of *Henry VIII*. There was no central vision behind it. He began with Laughton because Laughton was the only major international star whose services he could secure, and he picked the story because it was already familiar to him, and a relatively easy task for Laughton, who also suited the role.

Nor was *Henry VIII* typical of Alex's style; in fact paradoxically his most successful film was unique. He would never again repeat the simplicity and the Spartan production values of *Henry VIII*. His natural taste for opulence afterward became a kind of hallmark of his film making. There are no great crowd scenes in *Henry VIII*. Even the executions are *suggested* rather than made into spectacles, and the total effect is theatrical rather than cinematic. This had not been Alex's intention. He loved expensive sets, costumes, huge casts—the epic grandeur of a *Samson und Delila*. He simply lacked time and money.

Vincent built many of his sets overnight for fifty pounds or less, and his sketches make remarkable use of lighting, shadows and simple architectural shapes to suggest lavish sets, while real antique furniture, borrowed from museums and private collections, not only provided authenticity, but distracted the viewer from noticing the modest size of the sets themselves, which were kept tactfully out of focus. In order to save time and money, Vincent and his crew, communicating by means of sign language, since he spoke no English, worked through the night to turn a bedroom into a banquet hall, then through the next night to turn it into something else again. So tight was the financing that Vincent even urged the studio carpenters to pull the nails out carefully so they could be used again, and to stack the sawn-off ends of lumber so they wouldn't be thrown away or taken home by the workmen to be used as kindling.

The intellectual underpinnings of the movie are somewhat murky, but it has rightly been pointed out that *Henry VIII* "had little British about it except its subject, its stars and that it was made near London . . . [while] its story, direction, photography, settings and music were all by Continentals." In a later interview on the subject, Alex declared: "An outsider often makes the best job of a national film. He is not cumbered with excessively detailed knowledge and associations. He

gets a fresh slant on things. For instance, I should hate to try to make a Hungarian film, while I would love to make one about the Scottish Highlands that would be a really national Scottish film—and indeed I plan to do so."

Apart from revealing an unexpected and unfortunate gift of prophecy—fifteen years later Alex was actually to produce his "national Scottish film" in the shape of *Bonnie Prince Charlie,* which caused Alex and London Films grave financial difficulties—this statement is remarkably misleading. *Henry VIII* is not a "national" film, in the sense that Alex meant. It is a cynically humorous retelling of the international Bluebeard legend, with Bluebeard as the victim of his wives. It was Alex's genius to sense that the British, like the Hungarians and Austrians, were secure enough to be able to laugh at their own history. It is hard to imagine Eisenstein, for example, attempting to portray Ivan the Terrible in a humorous way, or poking fun at Peter the Great. Alex understood the English sense of humor, perhaps because it rather resembled his own—basically subversive and subtle. Maybe the reason he eventually failed with *Bonnie Prince Charlie* was that the Scots took their history seriously.

Instinctively, he turned *Henry VIII*'s story into the kind of comedy of manners he understood. The movie is constructed as a set of paradoxes, always stopping just short of the point at which the viewer might begin to feel real horror or fear. Laughton has been criticized because he plays Henry for laughs, but in fact he was too good an actor for anything so simple. Gradually he turned Henry, the tyrant and domestic monster, into a believable sympathetic figure, as in the scene in which the aging King, approaching with reluctance the bridal chamber in which the unattractive and unsophisticated Anne of Cleves waits for him, turns to his advisors (who persuaded him to undertake this dynastic match) and the audience, and exclaims, "The things I do for England!" Even at the very end, when the old King is shown chewing on a drumstick, in the famous scene, Laughton establishes a certain roguish complicity between himself and the audience, as if asking us to overlook his previous murders and transgressions because of his age and infirmities.

The script of *Henry VIII* is far from brilliant—both Alex and the indefatigable Lajos Biró suffered from a tendency to turn every line of dialogue into a witticism, a trick which only Oscar Wilde could have

brought off, even when the line might have had more meaning played straight. Also since neither of them spoke English well, they over-explained every turn of the story.

Technically it is not particularly innovative, though it is far more polished than were most English-made films of the time—the result of Alex's long experience as a director, and the command of his medium that he had gained so unwillingly in Hollywood. Perhaps because the movie covers such a long time span, a great many quick cross cuts are used, and the effect is to speed up the pace, so that *Henry VIII* suffers from none of the slowness that usually characterized costume drama of the period. Nevertheless, the construction of the film is very typical of Alex: plain, straightforward shots, reflecting his lack of interest in tricky visual effects or unusual camera angles. He was sympathetic toward later directors like Orson Welles (who put ceilings on his sets, so he could shoot up from a camera position on the floor) or Carol Reed (who had a thing for tricky staircase shots); yet he was usually content himself to specify a long shot, a medium shot or a close-up, and let the cameraman do the rest. The director's task was to work with actors, he believed, not with equipment, and he remarked that he didn't want to lie down on the floor or hang from the catwalks to look through the viewfinder. "I like the camera to be at my eye level so I don't have to stoop to see the shot," he said. As for the acting, while Laughton is superb, the other players are somewhat hampered by the problem of playing tragic roles within what Laughton, Biró and Alex had turned into a comedy, and Merle, though very beautiful and appealing, is thoroughly upstaged by Laughton's bravura performance. What the movie *does* have, however, is charm, like Alex himself.

Charm, as Evelyn Waugh wrote, eventually kills, and it had an unfortunate effect on both *Henry VIII* and Alex's career as a movie director. In Hollywood he had been expected to be charming; it was the stock in trade of Viennese and Hungarian directors, and when he was first called into a script conference, Sol Wurtzel merely wanted to ask him if it was okay for a Hungarian butler to click his heels and kiss a lady's hand when saying good morning (Alex gravely replied that it was indeed the usual custom in his native land). *The Private Life of Helen of Troy* positively dripped charm, but charm has the effect of killing emotion and disguising feeling, just as Alex's charm and good manners screened his deeper feelings.

There is an emotional vacuum in many of his films, an unwillingness to face the larger human problems, to reduce them by means of charm and humor in order to make them bearable. Something of his own pain is discernible in *Rembrandt,* and its failure at the box office made him shy away from tragic emotions for some time to come, relying more and more on huge sets and lavish productions, as in *Things to Come,* until the combination of war, his own relationship with Merle and the love affair between Larry Olivier and Vivien Leigh somehow liberated his own feelings sufficiently for him to make *That Hamilton Woman,* in which there are glimpses of true passion and tragedy.

The absence of these qualities in *Henry VIII* passed unnoticed—as did the fact that it could hardly be described as a turning point in the fortunes of British film makers, since it was essentially the work of foreigners. What Alex had done was to import to England a well-established formula and make it work, an event which was wrongly interpreted as the miraculous transformation of an industry.

ALEX WAS SUDDENLY a celebrity, and since there is nothing the English like better than a plucky winner, a very popular one. "It was," he said, "as if I had won the Derby with an unknown horse." Alex's accent, his cigar, his Homburg hat, were now recognizable signs of talent, if not genius, and financiers who had previously found him alien and glib now sought him out and listened eagerly to his schemes. It cannot be said that Alex's life style changed—he had lived like a millionaire for years or, as he was fond of saying, "better than one"—but it became some-what more solidly established. He had always used a limousine and a driver, but now he acquired his own Rolls Royce, and a Rolls Royce master chauffeur to go with it—Ernest Bailey, who would stay with Alex to the end. As the house on Avenue Road was completed, Alex added a butler, Saunders, and a private secretary, Miss Fischer, and the first of a long succession of French chefs. After a lifetime spent in hotels, Alex was at last creating a domestic establishment for himself, just as Vincent was doing on a more modest scale.

It would be tedious—except to those few people devoted to the history of British films in the thirties—to comment in detail on the entire production schedule of London Films in this period, much of which was ambitious and interesting, though the enormous financial

success of *Henry VIII* was not to be repeated. It should be noted, however, that Alex brought two major innovations to film making in England, both of which were well-known devices in Hollywood. The first was a simple matter of accounting: Unfinished films, finished films that were too bad to be released, and scripts and literary properties that would never be made could all be carried on the books as "assets." Thus every disaster could be used to improve the balance sheet, and the larger the disasters, the rosier the prospects of the company would seem.

This basic principle of accounting, which had hitherto been ignored by film makers, was exploited to the full by Alex, who even went so far as to buy up foreign films, which were then left to sit in the vaults at Denham Studio and be carried on the books for year after year as assets, thus enabling him to seek further financing.

The second innovation was that Alex bought the screen rights to almost everything in sight, though seldom with any real intention of making a movie. He did so because experience had taught him the value of owning the clear title to as many properties as possible (he would never repeat the mistake he and Sascha Kolowrat had made with *The Prince and the Pauper*). Buying screen rights also secured the support of journalists, playwrights and politicians for London Films. He happily paid 10,000 pounds for the rights to Winston Churchill's *The Life of Marlborough*—which Alex had no plan to make (also hiring Churchill to "advise" on a series of historical movies). He bid happily on the works of Maugham, Shaw and Wells, quite rightly assuming that most people are happy to sell the film rights to their work, and regard it as "found money." He knew too that, in the long run, the sale of these properties would be a major source of profit for him. In addition, they could be carried as assets, provided nothing was ever done with them. So successful was this innovation that City investors and the British government were still struggling to understand it over twenty years later, complaining that the more money Alex spent and lost, the more he seemed able to borrow, and trying to decide exactly what his assets consisted of. He had contrived to make an asset of his natural extravagance.

Oddly enough, the first major investor attracted by the success of *Henry VIII* was that doughty, conservative leviathan of British finance, the Prudential. "The man from the Pru" was a familiar figure in British

working-class neighborhoods, collecting "tuppence per person per week" as the only form of insurance available to most Britons. The Prudential's profits were so huge that they had over 1,000,000 pounds a week to invest. The British government, concerned that the Prudential might invest abroad, encouraged the giant insurance company "to take a position" in the British film industry, which obviously needed financing, and which, on the evidence of *Henry VIII*, seemed likely to offer substantial profits. Exactly how Percy Crump and Sir Connop Guthrie were persuaded to gamble the Pru's hard-earned money on Alex remains something of a mystery. Alex's friends in the City and the government certainly helped. (His policy of hiring debutantes as "extras" and purchasing the screen rights to such unlikely properties as Lord Uxbridge's history of the Angelsea family certainly also was wise, as was his announcement of a film based on the life of John Wesley in the middle of a list of other, more secular projects that were never to see the light of day.) In any event, the Pru agreed to finance London Films and to enable Alex to build Denham Studios.

Alex was determined to make Denham the finest studio in the world outside Hollywood, and he sent to California for experts to make it as efficient and modern as it could be, while trusting to Vincent to create a lavish exterior. A river was diverted to provide a pond outside Alex's office, and Winston Churchill stocked it with his own swans, having obtained the permission of the King, who by law had custody of all of England's swans, which were subjected to the ceremony of a yearly royal census called "swan-upping." Alex's office was furnished with antiques. A Hungarian cook was installed in the studio commissary. The studio contained everything from its own full-size symphonic recording hall to the largest private electrical generating plant in England. Alex, on his first tour of the completed studio, sat down to stare at his swans, his Homburg on his knees, buried his head in his hands and said, "I have made my greatest mistake."

He had built far too ambitiously. Knowing that the Prudential "thought big" he had doubled the original number of sound stages, having discovered that the larger he made Denham, the more money the Prudential was prepared to put up. Inevitably he found himself with more studio space than he could possibly fill or use, and an overhead that could only be met by a vast program of film production. Since there was no way in which Alex could direct or personally

undertake more than four films a year, he was obliged to bring in other directors, which not only meant that he would have to finance their films but also required him to become a full-time studio boss, wrestling day and night with problems that were not directly of his own making.

Alex's domestic life did not provide him with much in the way of peace. Gradually, he was falling in love with Merle, while at the same time trying to build her up as London Films' star actress, and this growing romance brought back into his life an increasingly angry Maria, who deeply resented being cut off from Alex's sudden new fame, now that her own was gone, and claimed that under Hungarian law she and Alex had never been divorced. The dubious validity in California and London of this Hungarian law, if it existed at all, did nothing to deter Maria. She saw herself as a woman wronged and described herself as "the only Mrs. Korda."

Nor was Alex's relationship with his son a source of comfort. Peter, now fourteen years old, lived at Avenue Road, largely ignored by his busy father. Alex lavished on his brothers and others the attention and the love that might have gone to his son. In a sense, Vincent and Zoli *were* Alex's children and were to remain so for the rest of his life. Besides that, he liked people who were famous, talented, beautiful or powerful, and found it hard to disguise his boredom with the more ordinary problems of a schoolboy's life.

Years later, when I was a small child visiting Alex in Bel Air, I asked for a second piece of cake, and Nanny gave me a warning shake of the head. Alex noticed—it was hard *not* to notice Nanny's warning glances—and firmly cut me a large piece of cake. "Ah, Nanny," he said, "the most difficult word in the world to say is 'No!' I have tried all my life to say 'No' to women and children. I'm too old to start now."

"You'll spoil him, Sir Alex," said Nanny.

"Maybe. Then let him be spoiled. He'll learn soon enough what 'No' means when he grows up. We're all the same, Nanny—his father, his uncle Zoltan and I. We were poor, and now we're rich. We were told 'No' so often as children, how can we say 'No' to our own? Miki will have to learn what 'No' means elsewhere, I'm afraid."

---

DESPITE CONSTANT family strife, Alex was to look back on "the Denham years" as a Golden Age. He was, after all, only forty years old, and on the threshold of a new and far more ambitious stage in his career. Only four years before he had left Hollywood penniless and humiliated— now he was in a position to treat the Hollywood moguls as equals. Indeed, on his return to Los Angeles, he was not only received like a conquering hero and given a banquet, but was offered a place on the board of directors of United Artists, where he joined Mary Pickford, Charlie Chaplin, Douglas Fairbanks, Sr., and Samuel Goldwyn. This assured London Films of a solid distribution vehicle in the United States and made it the first British motion picture company to have a reliable major American outlet. Louis B. Mayer invited Alex to dinner to discuss M-G-M's interest in England. David O. Selznick breakfasted at Alex's bungalow to discuss Merle's future. Darryl F. Zanuck made a graceful speech welcoming him back (and acknowledging how badly he had been treated at Fox) and Douglas Fairbanks, Sr., impressed by *Henry VIII,* agreed to come to England to star in *The Private Life of Don Juan.* Behind the flattery was the fear that Alex might indeed succeed in turning Denham into "Hollywood-on-the-Thames," and the suspicion that he might then, with his Continental connections, form a European film company that could compete with American studios on equal terms and dominate the world market.

THESE CONSIDERATIONS did not much affect the other Kordas. Zoli, though married to Joan, had begun his lifelong love affair with India and Africa, which was to result in a succession of remarkably fine pictures. Though Vincent was indifferent to politics, Zoli retained the liberal passions that he had shared with Alex in their youth, and was drawn to the "natives" of British Africa and India with fierce intensity and humanity. Alex was more than willing to indulge Zoli's desire for adventure, first of all because Zoli's health suffered in the foggy English climate, but also because Alex could see that the British Empire was not only a good subject, but also an undeveloped market for films, one which he was to be the first and last to exploit. On political issues, however, he and Zoli quarreled. Most of Zoli's films bear the unmistak-able stamp of the two brothers' disagreements, being uneasy compro-

mises between Zoli's love of the natives and their way of life, and Alex's desire to produce pro-Empire motion pictures in praise of the white man's burden. For years Alex had searched for an establishment that would accept him, and now that every door in English society was open to him, he was more than happy to adopt the politically conservative attitudes of his peers.

As for my father, he sought freedom in travel. Shortly after *Henry VIII* (and my birth), he took my mother to Spain for a holiday, bringing me along in a Moses basket. There, they quarreled after my mother had accidentally set the bed on fire in the Ritz Hotel in Madrid, tossing me out of the flames to my father, who fumbled the pass and dropped me. Vincent, never one to argue, placed me in the basket and together we flew from Madrid to Paris, leaving my mother behind. Once in Paris, he went straight to La Coupole to sit on the terrace and wait until someone he knew stopped by for a late-night drink. Since he did not know what to do with an infant in a basket, and surmised that I might have needs of my own, he took me down to the *toilettes,* and left me with "Madame Pipi," the elderly lady in the black dress who looked after the men's room and sat behind a small table, watching with a pair of beady eyes to make sure that every *monsieur* put a tip in her saucer. Madame Pipi, who had known M'sieur Vincent for years, showed no surprise at being left with a baby in a basket, but when Vincent, having found some congenial companions, failed to return, she was obliged to take me home when La Coupole closed at two A.M.

The next morning Vincent woke up with the uneasy feeling that something was missing. It took him some time to remember that he had arrived in Paris with a baby. But where had he left it? He could not remember. Assuming rightly that no baby will be left to starve or go unchanged in a Latin country, he went off to have lunch, when my mother appeared. She had followed him from Madrid, and had little difficulty in guessing where he could be found. My father offered Gertrude lunch. They were almost finished eating before my mother asked what had become of me. Vincent, with the honest simplicity that was simultaneously engaging and enraging, replied that he didn't know, and had in fact just been asking himself the same question before she arrived.

My mother was too shocked to be angry. Rushing out of the restaurant, dragging Vincent with her, she hailed a taxi and demanded to be

taken to the British Consulate. Here, my father's common sense pre-
vailed. As he pointed out, wherever the baby was, it would hardly be
found at the British Consulate, nor would it have had any way of
informing people of its nationality. My mother was not absolutely
convinced of this—she felt that an English baby would obviously *look*
English—but she was persuaded that the best place to start was the
Préfecture. Alas, the police regretted that no baby of any nationality
had been turned in to them, and were curious to know what this
well-dressed and attractive young lady, so obviously *une anglaise,* was
doing in the company of a disheveled bohemian with a strange accent.
To the story of the missing baby the *sous-officier* of the watch lifted
an expressive and doubting eyebrow. Were *Monsieur et Madame* mar-
ried? Was the *enfant* theirs or someone else's? A more senior officer
was summoned, and my father provided him with Marcel Pagnol's
telephone number.

A subdued conversation took place, and the officer hung up the
phone, clearly satisfied. *"Alors,"* he said, *"Monsieur est artiste,"* as if
that explained everything. After many apologies, much shaking of
hands and eloquent shrugging, a police car was provided to take my
father and mother on a tour of those cafés and night spots in which
my father might possibly have abandoned me. By the time they
reached La Coupole they were exhausted, and the police driver went
in to make inquiries, returning a few minutes later in triumph, holding
a baby against his uniformed chest, followed by Madame Pipi and most
of the waiters.

My father embraced the elderly lady (who had never before been
seen out of her subterranean lair), and handed her a wad of francs,
which she accepted with many protests. Not at all, it was no trouble,
she had cared for her own, after all, and for her grandchildren, abso-
lutely, it was the truth, she insisted, despite my father's refusal to
believe that she could be a grandmother—who would have believed it!
Madame Pipi, who had probably not been praised, or even noticed, by
a man for at least forty years, beamed, and put her arms around my
mother, who was now holding me. *"Ah qu'elle est belle, la petite,"* she
said approvingly. My father was a lucky man, and as for me, it was no
trouble at all, she had in fact enjoyed it: I had been a real little
gentleman, if a little wet, at the beginning.

Vincent shared an *apéritif* with the police driver, and we returned

to the Hôtel Raphaël, a united family once again. As late as the 1950's I was embraced like a lost son by Madame Pipi every time I visited the men's room of La Coupole, until the time when I found another old lady in her place, who turned out to be her daughter, and sadly informed me of Madame's death.

This adventure was wisely concealed from my grandmother, but it would not have surprised her, for she had little confidence in either of my parents. She was seldom allowed into the house, but she knew that my father had refused to hire a nurse (he did not trust English servants) and that I was cared for by the charwoman, a disreputable-looking lady with a bandana tied around her hair and a cigarette dangling from her lips. What she did *not* know was that my outings in the beautiful new pram from Lillywhite's (the same majestic vehicle, with white-walled tires and a sunshade, in which the little Princesses themselves had been aired) concided with opening hours, for it was Mrs. Crumm's habit to park me outside her favorite pub while she sat inside drinking until it closed. No doubt I got as much fresh air outside The Highwayman as I would have on the Heath, but this was not my grandmother's view when she recognized the pram, and went inside to confront a bleary-eyed and defiant Mrs. Crumm.

For the first time, my grandmother served an ultimatum on Vincent, in the person of Nanny Low, who arrived the next day with her trunks and valises, and instantly made the nursery into a fortress of proper English child-rearing. The "unsuitable" toys and pictures were removed, a strict and organized régime was instituted, and the starch in Nanny's cap and apron could be heard creaking on the third floor as she went about the business of raising "the poor little thing" (as she then called me) properly. Every morning and afternoon, Nanny wheeled the pram out for a *proper* walk, Nanny wearing her gray cape and a round gray nurse's hat, with a brim and a long flowing ribbon, stopping only to exchange gossip with similarly attired nannies, who rested on the benches around the model-boat pool at the entrance to the Heath. These benches were not marked with a sign reading "Reserved for Nannies," but they might just as well have been, since nobody else dared to sit there. Under Nanny's supervision, a succession of Hungarian chefs were taught how to make Shepherd's Pie, Toad-in-the-Hole and junket.

England had defeated my father, but it became swiftly apparent, to

everybody's surprise, that he *liked* Nanny. She had stood up to him, and dismissed his moods and objections by simply saying, "Really, Mr. Vincent, it won't do." As a result she acquired his respect. He sometimes insisted on having her join him at the dinner table, which made my grandmother almost as angry as she had been about his initial refusal to have a nanny at all. Nanny, who had originally been my grandmother's Trojan Horse, soon changed camps, and would take orders only from him (though she carried them out only as she saw fit to interpret them, so far as they concerned me).

Soon my father became bold enough to take Nanny abroad, and she learned to rather like foreign countries, though her happiest moments were spent in W. H. Smith's English Tea Shop on the Rue de Rivoli, in Paris, where they served real scones, "knew how to make a decent cup of tea" and spoke proper English. In the flat racing season they also had a bulletin board with the latest English race results. This was very important to Nanny, whose only known weakness was "punting," and who dearly loved to put a shilling on the favorite. In later years, when she was introduced to Winston Churchill, the great man advised her to put "a couple of bob" on one of his horses, which was running that afternoon. Nanny pursed her lips, good Conservative though she was, but Tory loyalty got the better of her caution, and she agreed to do so. Churchill nodded with satisfaction and began to turn away. Then he hesitated, perhaps because Nanny had the look of a shrewd judge of horseflesh, and wagging a plump finger at her, he whispered: "Both ways, mind you, both ways." It was Nanny's firm opinion that Mr. Churchill was the greatest man in the world (the King was of course very much greater, but he hardly counted, since he was next to God), but not nearly as clever with horses as the old Aga Khan. Nanny had been much impressed by the sight of His Highness the Aga Khan dangling by a harness from a long pole, as the swimming instructor at Eden Roc towed him back and forth teaching him the breaststroke. In those days, there was a famous advertisement for toffee on the sides of the London buses, whose headline was "Rich and dark—like the Aga Khan." Nanny was surprised to see that in the all-too-ample flesh, the Aga Khan was about the same color as Mr. Churchill, though perhaps a little less pink in the face. Both of them in fact rather resembled Charles Laughton, who was Nanny's favorite actor.

HE WAS ALEX's favorite actor too, but the relationship was never an easy one. Laughton was a cerebral performer and a complex personality. It required all of Alex's tact to coax a performance out of him. Now that *Henry VIII* was a world-wide success, it was urgent to find a new film for Laughton, if only because the Prudential expected it, and Alex agonized over the choice of a role. He rejected *Lear* as too depressing, and *Don Quixote* because Laughton could only play Sancho Panza, and there was no way to make him the hero of the movie. For several months he labored with Lajos Biró on a script for *Cyrano de Bergerac,* but Laughton was unable to accommodate himself to a false nose, and without the nose there was no story. Finally, Alex hit upon the idea of Rembrandt. He had always wanted to make a film about a great artist, and the physical resemblance between Rembrandt and Laughton was obvious. Vincent would have preferred a movie about Toulouse-Lautrec, but if Laughton would not wear a putty nose, he could hardly be expected to walk on his knees, so the choice was made and Vincent went off to Amsterdam to start designing the film.

Laughton was tortured about more than acting. Though he was married to Elsa Lanchester, at the very beginning of their marriage Laughton's homosexuality had been revealed in a shocking and brutal way: a boy turned up at their house and accused him of having failed to pay for his sexual favors. The marriage survived, but Laughton lived thereafter in a state of terror and guilt. Since Alex was a man of great understanding, it was not surprising that he became a kind of father figure for Laughton. It was, after all, the role Alex had been playing since the age of fourteen—except with his son. Laughton took his many troubles to Alex, and Alex was patient, understanding, helpful and supportive. For Laughton, however, the relationship was far more important and meaningful than it was for Alex. Gradually, he came to love Alex, who cared for him as his own father had never done, and who understood and forgave everything. What is more, Alex was a man of worldly culture and sophistication. Unlike most movie producers, he was well read, and enjoyed talking about books, ideas, literature and acting. Years later, when they were no longer friends, Laughton remarked, "Alex could be impossible, but never boring."

Laughton flung himself into the preparation for his performance with enormous enthusiasm, for it was obvious to him that the torments

of the great artist in many ways resembled his own. He grew a mustache, and trained it until it exactly resembled Rembrandt's, he sat for hours looking at Rembrandt's self-portraits. He persuaded Vincent to teach him to draw and paint, so that his hold on the brushes, his way of standing in front of the easel, his painter's *coup d'oeil,* would all be realistic. Vincent's sets delighted him (rightly, for they were the most beautiful designs of his whole career as an art director), and he was pleased with the costumes. Only the script troubled him, for while Alex wanted to portray the dark side of the artist's life, he was also anxious to make a commercial film, and therefore took several opportunities to "lighten" the story. He adamantly refused to include a scene in which Rembrandt is obliged to sell the grave plot of his first wife in order to pay for his second wedding. This was factually true, and a moment in which Rembrandt's poverty and anguish could certainly have been portrayed with remarkable intensity.

To Laughton, this scene became an·obsession. He took Alex's refusal to include it as a kind of betrayal. It began to seem to him that Alex had sold out, that he had given up his own integrity as an artist in order to become an entrepreneur, director and financier. In his eyes, Alex came to resemble the Dutch *burghers* who had persecuted Rembrandt. Laughton's own father had failed him, and now his father figure had done the same. He brooded about the scene and grew increasingly morose and bitter. Now he was convinced that Alex had never wanted Elsa Lanchester to play the role of Rembrandt's first wife, and took a vivid dislike to the presence of Gertrude Lawrence in another part, since she enjoyed exchanging dirty stories and theatrical gossip with Alex. It seemed to Laughton that Gertie Lawrence was taking up too much of Alex's time and attention and that Alex was snubbing Laughton by paying court to her. Her voice, he complained, got on his nerves, she talked out loud and laughed in an irritating way while he was preparing his scenes. Finally Laughton had Vincent place a pair of soundproof screens around him whenever she was anywhere near the set, and he would retreat there to sulk whenever he heard her voice.

By the time the film was finished, Laughton's feeling of rejection was complete. He deeply resented the fact that Alex had involved himself in the business of running a studio, and felt that Alex was no longer interested in his career. Most of all, he resented Alex's increasing and

obvious interest in Merle Oberon, for Alex was determined to make her
an international star.

Nor was Laughton cheered after the completion of the picture: it
was a resounding commercial failure. Stately, magnificent, but some-
what depressing, *Rembrandt* was simply too much of a *tableau vivant*
to interest the average moviegoer. Even Alex's daring offer to provide
free admission for anyone who could prove he owned a genuine Rem-
brandt failed to stir up much public interest. The theme of the film
suggested museums and culture, and even so great an actor as Laughton
could not overcome this barrier.

It is unfortunate that Alex should have decided to recoup his for-
tunes—and satisfy the Pru—by making a movie with Laughton *and*
Merle. He did not want to lose Laughton to Hollywood, and was
anxious to find a starring part for Merle, and when he read Robert
Graves's *I, Claudius* he decided he had the answer to both problems.
This time, however, Alex was determined not to direct the picture
himself. He had enough to do in trying to keep Denham's sound stages
full to cover the enormous overhead, and he sensed that the relation-
ship with Laughton had deteriorated to the point where he could no
longer direct him successfully. Since there was too much at stake to
delegate the direction to a relatively minor English director (with Alex
coming in at the last moment to direct the retakes, which had increas-
ingly become the pattern), he looked for a strong directorial talent.

At that very moment, the great Josef von Sternberg, who had pro-
jected Marlene Dietrich to stardom in *The Blue Angel* and *Morocco*,
lay ill in the London Clinic. On the assumption that he could do for
Merle what he had done for Dietrich, Alex visited him, with a basket
of fruit from Fortnum & Mason and a copy of *I, Claudius,* and swiftly
charmed Von Sternberg into accepting the project. There was another
reason for Alex's choice. He had made a movie with Marlene Dietrich,
*Knight Without Armour,* for which he had agreed to pay her what was
then the monumental sum of $350,000, $100,000 of which was still
owing to her. Miss Dietrich had suggested she might waive this final
payment if Alex could find something for Von Sternberg to do—either
she was grateful to her discoverer and old friend, or more likely she
wanted to get him off her hands.

Unlike Alex, who was an unusually patient and sympathetic director,
and something of a master at soothing ruffled feelings and restoring

other people's self-confidence, Von Sternberg had the style of a Prussian drill sergeant. He was, in fact, two persons—a decent and warm man in private life, and a demanding and cold autocrat on the set. Probably the last director to wear a special costume for his work, he usually appeared in the studio dressed in riding breeches, polished field boots and a leather jacket of the kind worn by Continental hunters or German generals on maneuvers. This was topped off with a patterned silk bandanna wrapped around his head like a turban. He had been enormously kind to Laughton on numerous occasions in Hollywood, and once even saved his life, in the Garden of Allah hotel in Los Angeles. Laughton mistakenly thought he had contracted syphilis, and intended to commit suicide. Von Sternberg patiently talked him out of it during three days and nights, forcing the doctor to re-check the diagnosis, with the discovery that the lab had accidentally exchanged Laughton's test tube for someone else's. Given that Laughton was distressed that Alex himself was not going to direct the film, Von Sternberg was perhaps the only person he would have accepted as a substitute.

Still, the role posed enormous problems. In characterizing Henry VIII, Laughton had been able to burlesque; in the case of Rembrandt he had identified with the painter's tragic feelings and artistic courage. Claudius, however, was a more puzzling figure. Now Laughton was required to play a cripple who used his physical infirmities to hide his shrewd intelligence in order to survive in a world of intrigue, plots and murders. Even more difficult was the fact that Claudius stammered, and that his stammering was an intrinsic part of the plot. No actor finds it easy to simulate a speech impediment, and for a man as fluent as Laughton, the task of stammering was immensely challenging. Dressed in a toga, he prowled through his house trying to feel his way into the role, but the characterization eluded him. Perhaps it frightened him as well, for Laughton was intensely conscious of his own appearance—the ungainly body, the heavy lips, the jowls. He had a horror of being thought ridiculous, and Claudius was intended to be portrayed as ridiculous. Furthermore, Laughton's homosexuality, which he felt it necessary to conceal (and sensibly so, in view of the prevailing attitudes), made him even more sensitive. He was anxious not to project any hint of homosexuality (hence his instant enthusiasm for the majestically masculine role of Henry VIII) and was very much on the alert

for any remark that might indicate someone suspected his homosexuality. Since Claudius is required to be a stammering fool, a clumsy cripple and a man who is innocent about women, cuckolded and sexually inept in the eyes of his wives and his court, Laughton was, to put it mildly, uneasy.

Von Sternberg himself was almost as distraught as Laughton. His career in Hollywood had shoaled; his relationship with Marlene Dietrich was almost over. Only a major box-office hit could save him. Had he been able to tell Laughton this, and ask for Laughton's help, things might have turned out differently, for Laughton was deeply in Von Sternberg's debt, and always responded with warmth and courage to other people's problems. Instead, Von Sternberg treated Laughton with disdain. No doubt he hoped to shame Laughton into coming to grips with the role and thought that softness would be a mistake. The result was disastrous. Laughton not only received no help or inspiration from his director, but also came to feel that he despised him, that his inability to "find" Claudius was in Von Sternberg's eyes a sign of weakness, that in essence Von Sternberg was treating him as if he were "a queer." Since Laughton had confessed his homosexuality during the medical crisis at the Garden of Allah, he now felt himself to be at Von Sternberg's mercy.

As shooting began, each day became a torture. Laughton flubbed his lines, dried up, refused to appear on the set, hid or wandered from one set to another trying to find a scene that would give him some hint of the part. Von Sternberg's growing contempt made him even more nervous, and the entire cast watched in horror as the movie began to collapse. For a moment Laughton thought he had found the key to Claudius' voice in a recording of the Prince of Wales' voice, but Alex put an end to any attempt to imitate or satirize a member of the Royal Family, which would have offended everybody he most wanted to please. In a desperate effort to get something usable on film, Von Sternberg had Vincent build several sets on the studio floor, and kept each of them lighted, with a camera ready, so that he could catch Laughton whenever the actor fled to another set to escape from the director. As the cost mounted up, the project began to attract the unwelcome attention of the men from the Prudential, and Alex was unwillingly drawn onto the stage to encourage the despondent Laughton and the raging Von Sternberg.

A *deus ex machina* saved the day. As she was being driven to a fitting, Merle's studio car crashed. She was thrown through the windshield and taken to the hospital with severe facial cuts and a bad concussion. Alex rushed to join her there. Both of them were terrified that she would be scarred for life, but the doctors managed to save her beautiful face. Alex discovered that he was even more in love with her than he thought. He also came to realize that this was a heaven-sent opportunity to dispose of *I, Claudius*. The film was instantly terminated on the grounds that Merle could no longer proceed with the picture and too much footage had already been shot with her in it to switch to another leading lady.

Laughton went off to Paris, to further test his courage and his psyche by playing Sganarelle in *Le Médecin malgré lui* at the Comédie-Française, in French. Von Sternberg returned to Hollywood, and Alex remained to explain matters to the Pru. He was not to see Laughton again for almost twenty years, when they met on the set of David Lean's *Hobson's Choice*, and reminisced about the old days together.

"We're both growing old, Charles," Alex said.

"Yes, and I'm glad," Laughton replied. "These are the good years."

Alex looked at the aging Laughton and turned away. "What's bloody good about them?" he said savagely, and walked off the set.

LUCKILY FOR ALEX, many of his ventures were more successful than *I, Claudius*, particularly Zoli's pictures for London Films. Zoli's career as a director of films with an "Empire" background began when Alex rashly financed the director Robert Flaherty to make a documentary about elephants. Flaherty's reputation was then at its height, since he had already made *Man of Aran* (and by this time his *Nanook of the North* had achieved the stature of a film classic), but the major Hollywood studios were either unenthusiastic about financing a full-length documentary or demanded too much in the way of control. They were also aware that Flaherty was quite capable of spending years on a movie, shooting enough footage for a dozen ordinary motion pictures, and ignoring letters, cables and messengers from home. Alex was entranced by him; he admired Flaherty as an artist and liked him as a man.

Flaherty needed money, and came to London to get it from Alex.

In an emotional scene, Alex embraced him and promised him whatever he wanted. Shrewdly, however, Alex retained his right to control the final product, which Flaherty overlooked in his eagerness to get back to work again. Alex also suggested a story, Kipling's *Toomai of the Elephants*, which he had recently been reading, and much admired. Flaherty was willing enough to go to India, and prepared to be interested in elephants. He endured several story sessions, in which Alex explained to him why the film must have characters and a plot if it was going to succeed, rather than being a straight documentary. Then Flaherty sailed for India with his wife, having left behind the script treatment, which he had no intention of following anyway. Alex had promised him a year's filming, and he vanished into the jungles of the Maharajah of Mysore in pursuit of the elephants.

In the meantime, Alex was informed of a book that had just been published in America, *Siamese White*, which he was told was about a ghost elephant. He promptly sent an emissary to India to suggest that Flaherty incorporate this into his film, only to discover that the book was in fact about a man named White who had lived many years in Siam, and that it merely contained a scene in which an elephant is white-washed in order to play a ghost. Flaherty was not about to include a white-washed elephant in his film, and silence once again descended on the Flahertys, this time for over a year.

In desperation, Alex finally sent Zoli to India, and there were soon two different units shooting elephant footage, each with a different notion of the story, and each in a different location. Flaherty wrote back in delight to announce the discovery of a natural actor in Sabu, the elephant stable-boy of the Maharajah of Mysore, but apart from that cheerful piece of news, Alex knew almost nothing about what was taking place, except that he signed a large check every month to cover the expenses.

At last Alex panicked, and recalled the company from India. Flaherty returned with nearly sixty hours of film, over 300,000 feet in all, none of which was apparently shot with any kind of story in mind, let alone Kipling's. Alex had no time to brood. He ordered Zoli to concoct a story and shoot it at Denham, using as much of Flaherty's footage as possible, and incorporating a ghostly "Dance of the Elephants" for which Zoli was ordered to construct what he called "rubber feets" for the elephants. Sabu himself was rushed to England to appear in the

new scenes, and was propelled to instant stardom, to his own, and Alex's, surprise.

Zoli, having discovered his own strength as a director, went on to make *The Drum,* and the phenomenally successful pro-Empire classic *The Four Feathers.* Much to Zoli's disgust, Alex was determined to avoid a repetition of the wasteful filming for *Elephant Boy.* The result was that *The Drum,* a melodrama about the British Army in India (with Sabu as a pro-British prince), was filmed in the hills of South Wales, with circus elephants and horses from the local riding stables, and an army of Welsh miners and sheep farmers in blackface to portray the troops of the evil Prince Ghul. To make up for this insult to Zoli's passion for authenticity, Alex allowed him to shoot *The Four Feathers* in the Sudan. Let loose on location, Zoli not only created a splendidly rousing film—one of the best remembered of all London Film productions—but shot so much footage that he was able to supply location scenes for dozens of Hollywood pictures over the next thirty years, and still had enough left over to remake *The Four Feathers* as *Storm over the Nile* in 1955. He had always argued that it never paid to save money on film.

VINCENT'S TRIUMPH as an art director was to come in a Korda film that far surpassed all others, including *I, Claudius,* in its cost and problems.

Early in his English adventure, Alex had met the beautiful and charming Baroness Moura Budberg, and recognized in her a kindred spirit. Moura had been a belle at the Court of Nicholas II, and as a young society beauty was married to Baron Budberg, the Czar's Court Chamberlain, who is best known for having negotiated the release of Cissy Patterson's daughter from captivity at the hands of her father, during the American newspaper heiress' European divorce scandal. Though Moura was a favorite of the Empress and well acquainted with Rasputin, she weathered the Russian Revolution, as her husband did not, and survived to become the lifelong friend of Kerensky and then the mistress of the great Russian writer Maxim Gorky. She thus became a member of the new Russian court, and something of a favorite of Stalin's, who allowed her to leave the Soviet Union after Gorky's death (though he begged her to stay). Moura, who knew everybody worth knowing intellectually and socially in Europe, had no difficulty

in surviving, and soon became the secretary of H. G. Wells, eventually replacing Rebecca West as his close friend. Since Gorky had died in her arms (and eventually Wells did too) cynical gossip had it that her approach to any great writer's sickbed would bring instant death, but in general Moura was loved and admired by almost everybody who met her, since she was courageous, life-loving, a wonderful raconteuse and a delightful companion.

Through her, Alex met H.G. (as he was known) himself, and quickly fell under the writer's spell. Wells, though he was a small, dumpy man, had a kind of animal magnetism, and once told an astonished W. Somerset Maugham that he could never write unless he had sexual intercourse with a woman after lunch and before dinner every day (to which Maugham replied, "And what do you do after tea?"). H.G. was equally fecund in ideas, and by the time Alex had arrived in England was already something of a respected prophet, achieving a world-wide fame that far surpassed his earlier success as a popular novelist.

Alex was fascinated by Wells, and determined to make a film with him. Together they chose one of Wells's most difficult books, *The Shape of Things to Come*. The book was an essay in futurism, in which Wells not only predicted the course of the next hundred years (including the Second World War and space travel), but also used his characters as puppets in the argument about the relative merits of science and the humanities. For Wells, there was no contest. Man the Scientist, rational and objective, would triumph over Man the Artist, caught up in the fears, doubts and ignorance of "little people." Science would make the cities of the future perfect, eliminate waste, need, greed, inefficiency and political stupidity. Wells, who in fact enjoyed the Riviera, the company and admiration of beautiful women and the pleasures of the table, predicted a future in which everything would be puritanically neat, clean and dull. Like all messianic thinkers, Wells assumed that things were very much worse than they in fact were, and having concluded that the end of the world was at hand, looked somewhat enviously at people like Stalin who had the power to do something about it. Wells, whose novels had celebrated the apotheosis of the "little man," and made the English lower middle-class a respectable subject for literature, had now become disenchanted with the idea, and took refuge in a kind of scientific elitism, which *The Shape of Things to Come* was meant to popularize. His idea was that a small élite would

tell the rest of humanity how best to live. Since the book was greeted as mere science fiction, Wells was delighted at the prospect of representing his message to the public in a new and more effective form.

Alex did everything he could to please Wells. He agreed to let Wells write the script. He agreed that the movie should be a collaboration. He hired Frank Wells, H.G.'s son, and he even let Wells do most of the talking at story conferences. As Wells pontificated, in his high, squeaky little voice, Alex gradually came to realize that H.G.'s presence might be more of a hindrance than a help, and he was one day heard to remark that "H.G. is a second Laughton." Unlike Flaherty, however, Wells was unwilling to relinquish control over his brain child. He wrote three screen treatments, and many months were spent explaining to him why they could not be made into a film. In the end, Wells had one more try, and Alex surrendered, with significant misgivings. He would make the film as he had promised, exactly as Wells "dictated." The result was a movie that suffers from Wells's own failings: It takes itself too seriously and concentrates on a problem that was more Wellsian than human ("Is it this or that? All the universe or nothingness, which shall it be, Passworthy, which shall it be?"). Most people were not then under the impression that it was necessary to choose between "the universe and nothingness," or that science and ordinary human concerns are necessarily incompatible, and it is perhaps this failure to connect Wells's concerns with those of the audience that doomed *Things to Come.*

Vincent labored long and hard to produce a world fit for Wells's heroes to live in. He accurately portrayed what London would look like after a prolonged aerial bombardment, thus inadvertently giving additional urgency to the opinions of the appeasers, who took the picture of London in ruins as an accurate portrayal of what would happen if Hitler were provoked to use the *Luftwaffe,* and also sustaining the belief of the Air Ministry and Winston Churchill in the efficacy of the heavy bomber. *Things to Come* became gospel for both sides in the dispute over armaments and foreign policy, and contributed greatly to the idea that air raids would destroy the enemy's will and plunge him back into the Stone Age. When Hitler saw the movie he was deeply impressed, and ordered Göring to screen the picture, as an indication of what the *Luftwaffe* must be prepared to do, while British Prime Minister Neville Chamberlain thought it a powerful argument for peace.

Vincent's greatest accomplishment as a set designer was the City of the Future (or "Everytown," as it is called in the film). It is a fairly accurate foreshadowing of the Aéroport Charles-de-Gaulle outside Paris, with its "people-movers" conveying the crowds through glass tunnels, its indoor terraces and its chilling inhumanity. Moholy-Nagy, the Hungarian futurist, was hired to act as a consultant, and the sets for Everytown emerged as extraordinary works of art in themselves. Wells was delighted with them, and made many minute changes, for he was determined that the movie should represent his vision of the future accurately. At one point, the movie shows a row of futuristic machines tunneling deep into the earth to excavate the site for the City of the Future, and Alex directed Arthur Bliss to write background music for the scene. Bliss produced a composition of appropriately machinelike atonality, and Wells was invited to watch the finished scene, with music, in the Denham screening room. He sat absorbed throughout the sequence, fidgeting slightly with displeasure, and when the lights went on, he turned back to Alex and wagged a reproving finger at him. "Very good machines," he said. "Very good, *but the machines of the future will make no noise!*" He fussed over the costumes, and worried about whether the airplanes of the future would have propellers or not.

Vincent endured all this stoically, busily ransacking the libraries for avant-garde furniture designs, architectural fantasies, helicopters and autogyros, monorails and electric bubble cars, television sets and space vehicles. The nursery in Hampstead became a repository for his rejected design models, and while other children were playing with trains and toy soldiers, I was playing with rocket ships, ray guns and flying wings. Even my mother contributed to this wave of futurism, by appearing on the BBC's first experimental television program, which we watched on a screen the size of a postcard, as a small, dim figure, hardly recognizable as Gertrude, sang and danced.

*Things to Come* opened to what may well have been the best reviews ever to be received by an English film—and became an instant box-office failure. Audiences either found the destruction of London by foreign bombers absurd or too terrifyingly real to sit through, and Wells's vision of the future seemed to most people cold and inhuman. The film did poorly in the United States, where, as one distributor said, "Nobody is going to believe that the world is going to be saved by a bunch of people with British accents."

The fact is that *Things to Come* is chiefly remembered for Vincent's sets and Wells's prediction of the Second World War. As a film it suffers from the pretentious and heavy-handed dialogue which Wells forced upon Alex, and from the fact that the characters are singularly lifeless and remote. Much the same fault can be observed in Alex's movie of *The Thief of Bagdad,* a few years later. He was not himself primarily interested in fantasy or polemics, and left the task of directing these complex epics to other people, ill at ease with films that contained no wit and no love affairs. The ambition to rival Hollywood in providing a broad range of films led him into projects he neither liked nor genuinely understood, and which did not represent his taste, and it was to be some years before he rediscovered his own strengths, with *That Hamilton Woman* and *Perfect Strangers.*

THERE WERE OTHER London Films productions, many of them, some memorable, some not, and Alex's role as the leader of the English film industry was uncontested. He discovered Vivien Leigh, and signed her to a contract for London Films, placing her in a movie with Laurence Olivier, and acting as father-confessor to both of them when they divorced, married and began the famous love affair that was to end in such anguish for everyone, including Alex. He also lent her out to Selznick for *Gone With the Wind,* thus earning a profit from the most successful movie of its time—much to Selznick's anger. He brought Robert Sherwood and S. N. Behrman to England to write *The Scarlet Pimpernel,* and produced in it one of the most enjoyable of all English movies, giving Leslie Howard his most memorable lines ("They seek him here, they seek him there, those Frenchies seek him everywhere! Is he in heaven, is he in hell, that demmed elusive Pimpernel?"), and providing another starring role for Merle. He bought *The Seven Pillars of Wisdom,* and began the endless search for someone to play the part of Lawrence of Arabia. He captured the American market with *The Ghost Goes West,* fought a return engagement with H. G. Wells in making *The Man Who Could Work Miracles.* He even persuaded John Barrymore to accept $60,000 to spend six weeks in London for a film version of *Hamlet.* Barrymore insisted on bringing with him the original black costume he had worn to play the Prince in his youth, and the discovery that he could no longer get into it so depressed him that

he journeyed on to India in search of Ayurveda, the ancient healing art, without ever appearing in front of the camera—a disappointment which made Alex unwilling to discuss *Hamlet* ever again, and thus lost him the chance to produce Olivier's film ten years later. Alex even made short subjects and cartoons, in neither of which he had the slightest interest.

His reputation had never been higher, but his financial situation was precarious. Naturally he continued to live as well as ever, but he had expanded far beyond his resources, or even those of his backers. In a series of tangled board-room struggles, he had become a partner in United Artists, at no expense to himself (thus enraging Mary Pickford and Charles Chaplin, who complained that he acquired a financial interest in UA worth at least $650,000 without contributing anything in the way of capital), and he was already involved in a long-distance war of nerves with Sam Goldwyn and Selznick that would eventually give Alex, for a brief time, the mixed pleasure of controlling United Artists himself.

All the same, London Films' products were not earning significant profits for United Artists, and Alex's fellow partners viewed with alarm the activities at Denham, fearing that they too might be dragged into the business of supporting that faltering giant. If Alex failed, they were afraid he might take United Artists down with him; if he succeeded, they were afraid he might have the resources to take over United Artists itself, given his reputation for intrigue and unorthodox financial manipulation. The partners of United Artists were all too aware that they were vulnerable. They disliked each other so much that they were incapable of forming a common front. Together, they could no doubt have resisted Alex easily enough, but they were unable to act in concert, being scarcely on speaking terms with each other.

They prudently explored what was happening at Denham, and the confidential report they received makes fascinating reading, though it must be borne in mind that the general pessimism of the document may have been intended to discourage them from any further involvement in the problems of London Films. In short, United Artists' informant was probably telling the directors of UA what he knew they wanted to hear. All the same, there is a ring of truth to the description of life at Denham:

The losses are shown at £330,842. The figure today would be the best part of £1,000,000. That may be an exaggeration but the Prudential people say they have advanced about £2,000,000 and that they are advancing on payroll about £20,000 a week. Everybody who presses gets his money; people who behave in a gentle fashion fail to get their money.

Korda keeps on grumbling about his having to work against such dead losses, but whose fault is it, if it is not his own? He gets a substantial salary which, I suppose, is paid to him week by week, but I know nothing about his own arrangements . . .

He enters into huge commitments which his colleagues only learn gradually months afterwards and there is no choice but to implement them. If he breaks a contract he does not let them know about it until long afterwards, and the company has to wriggle out of these obligations as best it can . . .

I have often said to him he signs anybody up on any kind of terms, and then so often absolutely disregards the written contract and, in most cases, he pulls it off because artistes are easy going souls and not only that, they are so desirous of playing the part in the film that has been suggested, they become of the most forgiving character . . .

However, reverting to the Balance Sheets I should think Korda and L. F. P. must be in a terrible way, but inasmuch as the Prudential are owed mortgages for £1,100,000 and are stated to have another £900,000 invested in the business . . . I have thought and still think that the Prudential are bound to see Korda through his troubles.

On the other hand, they are getting very sick of paying out month after month. . . . If they decide to stop financing L. F. P., then the whole show blows up immediately. . . .

Korda day after day is closeted with the Prudential people . . . If only he would devote himself to producing and directing pictures, not only would he make a fortune for himself, but would make a fortune for the company. His mind is mixed up with various promoting and financial problems such as studios, printing, laboratories. Any ordinary person would be worried to death over that but I do not think it is his nature to worry unduly about the company's indebtedness.

It is his own folly and the way he occupies his time that causes all his films to be so expensive. In the end they are made with undue rush. Also, I am sorry to say, owing to the way the whole studio is run, they are not made with that snappy perfection which characterizes the great Hollywood films. Many of Korda's great films are just a string of sequences. . . .

Now and then if he has a favour to seek he seeks that favour with a particular person and blames everyone else. The one person who is never at fault is Korda himself!!!

Whether Alex was at fault or not, he was certainly struggling to keep his head above water, and playing for time. But time was not to be had. Denham was a millstone around Alex's neck; the Prudential had to be repaid. Neither task was possible, and the more attention Alex paid to the former, the less he was able to personally produce those pictures which would earn the kind of profits the Prudential expected. By 1938 the losses at Denham amounted to well over a million pounds, and the Pru, patient until now, reacted briskly: Denham was removed from Alex's control. Later, he would idealize Denham, perhaps precisely because he had built it and lost it, but in fact there had never been a time when his energies were more strained and dissipated, or when he had begun a new enterprise with such premonitions of disaster.

Nor had the fault been entirely his. As is so often the case with booms, there was bound to be a bust. The huge investments made in British films had been based on the success of *Henry VIII* in the world market, but that success was never repeated. Though Alex was conspicuously more successful than most British film makers, the industry no longer seemed attractive to those who had invested heavily in it. The crash was inevitable, and when it came, Denham fell, never to recover: The sound stages, the swans and the beautiful lawns were no longer his, and, he knew, would no longer be preserved. Denham had been a dream; it was now to become merely another small English film studio, and eventually a factory.

ALEX WAS NOT altogether unhappy with this turn of events. If nothing else, he would now be free to concentrate on making films instead of running a studio, and he was shrewd enough to realize that he had at least managed to leave the Pru holding the bag. True, he complained to the newspapers that he had "nothing left but a few worthless shares," but Alex had never valued the shares very highly to begin with, and Denham's enormous liabilities were now the Prudential's problem. It was widely rumored in the British press that he was going to retire, and he encouraged the rumors by musing on his desire to write a novel, or learn classical Greek, or go and live a simple life in the South of France. In fact, he had little desire to do any of these things. Denham had begun to bore him, and he was no happier reporting to the Pru than he had been when he had to argue with Jenő Janovics in Kolozsvár, or Sascha Kolowrat in Vienna. The grim men with their starched

wing-collars and Freemason watch fobs had foreclosed on him, but he was happy enough to be rid of their presence. He quickly set about forming a new company and announcing a 1,800,000-pound production budget. Dining with Winston Churchill, he told him, "Well, Winston, now we are both out of office," and Churchill glumly pointed out that Alex's chances of returning to power were considerably greater than his own.

THE DEMISE of Denham gave my father more time to be with his family and certain modifications in the household routine were made to accommodate his temporary presence. My mother, whose stage career was increasingly successful, reacted nervously to the sight of Vincent, in the company of a team of laborers, installing a vast collection of stone statuary in the back garden, turning the Hampstead house into something like a miniature Bomarzo. Nanny reacted with indignation to the addition to our household of a wire-haired terrier named Jani, whom my father purchased full grown in a moment of boredom. For his part, Vincent was not all that happy being around the house. He hated stage people to begin with, so he found it intolerable to have his home filled with English voices every night, all of them chattering away about the theater and calling each other "Darling" (a word he hated) and my mother "Gertie," which my father would not.

One incident made matters worse. He had given my mother an extremely expensive gold broach from Cartier. It was a rose of which each petal was a separate piece of finely worked gold, built around a center of diamonds, and designed so that the diamond circlet in the middle could be removed and worn separately. My mother, knowing Vincent, assumed that this pretty object was a piece of costume jewelry, and in a fit of carelessness gave it to a girlfriend who was going to the South of France for an abortion. The girlfriend pawned the broach in Nice, and was somewhat surprised to receive rather more than she had expected. Shortly afterward, my father realized that he had better take the broach back for an insurance appraisal, and my mother learned to her horror its true value.

Hastily she cabled her friend to redeem the broach, but she had already spent the money and couldn't, so Gertrude had to confess to my father. He himself took the *Train Bleu* to Nice and bought back

his present. He brooded over the incident for some time. He was not often moved to such expensive and quixotic gestures of affection, and the unexpected results of this one depressed him. He attributed the entire incident to Gertrude's theatrical career and friends, and would either absent himself from dinner or sit silently, looking, as one partici-pant observed, "like Banquo's ghost." Whatever he had wanted out of marriage, it had not been a house full of actors.

Restlessly he took us all, Nanny included, to the South of France, where we stayed at the Hôtel du Cap. We ate every night at Monsieur and Madame Vial's Restaurant de la Bouée, on the Plage de la Ga-roupe, where I swam (under Nanny's watchful eyes) with Micheline, the daughter of the Vials, and played with Charly the bartender. Vincent sat for hours over his dinner or lunch, trying to cure his depression by eating huge meals and taking long siestas. We drove up to St.-Paul-de-Vence to visit Vincent's old friends, Monsieur and Ma-dame Roux, who had expanded a simple bar into the Colombe d'Or restaurant, and who had taken so many canvases from painters in return for a meal that they now owned one of the finest collections of modern paintings in Europe (though, as Madame Roux said, "You can't eat a painting"). Sometimes we would go fishing in the evenings, with Mon-sieur Ricardi, the jovial *maître pêcheur* of the Port of Antibes, a man so enormously fat that he could scarcely get into his own boat, with a wife and small sons even fatter than he. Monsieur Ricardi would take us to the Ile du Levant, and cook a bouillabaisse over an open fire on the beach, while Nanny and I ate less dangerous and spicy food from a picnic hamper. Monsieur Ricardi was of the opinion that there would be no war, as were the Vials, the Rouxs, the Baudoins (who owned the Bonne Auberge and were the only gastronomic rivals of the Rouxs on the Côte d'Azur) and almost everyone else. Under the influence of the hot sun and much garlic and *vin rosé de Provence,* my father's mood lightened.

It was always the custom for my father to see Alex as soon as he returned from abroad, and these appearances never failed to make him as nervous as a schoolboy summoned by the headmaster. Alex enjoyed surprises. His decisions were often reached in Vincent's absence just to avoid any discussion of them. This time, Alex had saved up three pieces of news for my father. First, he planned to make a huge fantasy film, *The Thief of Bagdad,* which could achieve the kind of success he

needed to reestablish himself on both sides of the Atlantic. Second, Monsieur Ricardi the fisherman, the Vials, the Rouxs and the Beaudoins were wrong: There was going to be a war. Alex, who moved in more exalted political circles than my father, could read the signs, and had the survivor's instinct for sensing catastrophe. He had known Ernst Udet, the German ace pilot who had done aerial photography for London Films. Udet was now a *Luftwaffe* general and second in importance only to Göring (whom he sometimes referred to as "Fatty"), and had made it very clear to Alex that the Führer was committed to war, whether Udet's airmen were ready for it or not. Churchill had already begun to involve Alex in his own private intelligence organization, consisting mostly of businessmen with international connections, and it was obvious from the various bits of gossip Alex had gathered that Churchill's gloomy view of the future was substantially correct.

Alex's last piece of news was that he intended to marry Merle. My father liked Merle, but had his doubts about marriage in general. Domestic life was an experience which he felt Alex ought to be spared. He trusted Alex in everything, but he had no confidence in Alex's judgments about women. Then too, the brothers were so close that Alex's marriage could hardly fail to change their relationship. Even the most timid wife would hardly put up with having Vincent and Zoli in the house at all hours of the day and night, arguing in Hungarian and relegating her to the kitchen or the bedroom. In Vincent's opinion, at Alex's age—he was then forty-five—a new wife would be difficult and disruptive. After all, Alex had tried marriage once, and been lucky enough to escape from it with nothing worse than an ex-wife who was trying to hound him to death and a son who disagreed with him, but why do it again? My father kept these views to himself, out of deference to Alex's feelings.

Alex, however, was determined. He had waited until Merle's own career was successful, perhaps because he wanted theirs to be a relationship between equals, and the approach of war convinced him that he had better reach for happiness now, given the kind of future H. G. Wells had prophesied. Furthermore, Alex's emotional life had been singularly barren since his divorce from Maria. He was rumored to have had an affair with Vivien Leigh, whom he had hired straight off the London stage at 1,300 pounds a year, but if that was the case, he quickly recognized the *coup de foudre* that passed between Vivien and

Larry Olivier, and retired from that entanglement, even delaying a film so the two secret lovers could go to Denmark together, to play *Hamlet* in Elsinore Castle.

Age seemed to have improved him. He was not fat, but he had filled out, so that he now presented a impressive, even majestic, figure. He always wore a perfectly cut double-breasted gray suit, cream silk shirts and plain gray ties, and now that his hair had turned gray, his appearance was startlingly monochromatic. His face too was heavier and fuller, for Alex enjoyed the pleasures of the table rather more than was good for him, but it projected a certain weariness and cynical wisdom, coupled with dignity and courage. Alex's smile was explosive and radiant, but his scowl, when he pursed out his lower lip and glared over the top of his shell-rimmed glasses, was terrifying. All in all, he was an attractive and intriguing man, hardly beautiful in the physical sense, as Olivier was, but with the commanding presence of a general or statesman.

But it was Alex's misfortune to have become a father figure in everybody's eyes, including his own. He had already acquired the leonine head, the slight stoop, the slow walk that were to give him the air of a distinguished elder statesman for the rest of his life. He, who had always looked for someone to replace his own father, had turned himself into a kind of surrogate father for everyone—Vincent, Zoli, Laughton, Olivier, Vivien—and it was a role he could not shake off, even though it weighed on him increasingly. He complained of his responsibilities and worries, but he did nothing to reduce them. Everybody around him became a kind of dependent, so that Alex's emotional energy was constantly channeled away from his own life and expended on other people's.

He spent his days in the highly pressured world he had created; evenings he spent at large dinner parties; he went to bed late and slept badly. He disliked being alone, and arranged life so that he was seldom in any danger of having to be, but the result was an ever-increasing inability to relax. Alex entertained almost every night. He would bring people back from the studio or the office to dine with him and discuss films until the small hours of the morning. Failing that, he would send for Vincent or Zoli to reminisce about old times and rehash the quarrels of the past.

Boredom—even the prospect of it—terrified him, but most of the

ordinary things that people do to alleviate boredom bored him even more. He did not enjoy physical exercise of any kind (though he once expressed a fleeting ambition to learn golf), disliked night clubs, refused to dance except when it was absolutely necessary, had no interest in spectator sports, showed no desire to garden or involve himself in pleasures of English country life and avoided concerts, the opera, ballet and the theater. He rose late in the morning (on Alex's films, the actors were dressed and made up by nine in the morning, but knew perfectly well nothing would happen until eleven at the earliest), and ate breakfast in his study, a huge, unhealthy breakfast which often included cold duck, pâté, several different kinds of sausage and thinly sliced ham. Alex liked to breakfast alone, before he had shaved or dressed, and went through all the morning papers carefully. Until he had done so, the studio could wait, and did, and whatever lady he was involved with (for he was by no means celibate, despite his loneliness) was either encouraged to sleep on until Alex had left, or was served her breakfast in bed. It was not a meal he shared.

His habits had become those of a bachelor. The prevailing atmosphere of the Korda family was in any case strongly masculine. All three brothers had male offspring, and except for Maria, who no longer counted except as an irritant, the Korda wives were young, foreign and actresses, and disqualified on all three counts from playing any major role in family deliberations. Though Alex had a hearty dislike of the English institution of clubs and refused to join one, he in fact lived in a somewhat clubbish atmosphere, and enjoyed sitting after dinner with Wells, or Brendan Bracken (then a rising young Tory politician who had won Churchill's favor and was reputed to be his illegitimate son), or Beaverbrook or Churchill himself.

Perhaps as a result, Alex rather feared that he might be less than romantic as a husband, and this was not a subject on which Vincent and Zoli were qualified to give advice. Certainly Alex was to complain later that his wives treated him as if he were their father, but he must also have recognized from the beginning that he had created the problem himself.

More complicated still, it was necessary for Alex to negotiate a role for Merle within the Korda family. Since 1932 Vincent and Zoli had had Alex pretty much to themselves, and the relationship between the three brothers, though frequently stormy, was almost incestuously

strong. They were not about to take second place to anyone. With great tact, however, Merle maintained good relationships with Vincent and Zoli—no easy task.

It was also clear that Merle, as Alex's wife, would take precedence in the Korda hierarchy. A certain degree of envy was perhaps inevitable. In the nursery Nanny Parker and Nanny Low, in whose eyes Alex could do no wrong, reverently discussed every detail of a romance so much nearer to home than that of Edward VIII and Mrs. Simpson, which had, until then, absorbed their entire attention. Merle's beauty and courtesy were much admired by the nannies, who hoped to see a new Korda nursery established at Avenue Road.

These hopes were not shared by Alex, who seemed to have no desire to repeat his experience with paternity. Sometimes he would talk about having another child, but a visit to his brothers' households would discourage him from the project.

ALEX CHOSE this difficult time to launch his most expensive and daring film venture, *The Thief of Bagdad.* He shrewdly sensed that the public wanted this kind of children's fantasy for adults, and was much impressed by Mervyn LeRoy's movie *The Wizard of Oz,* but he underestimated the difficulties of the project. A film of this complexity and size was not only expensive but taxed the British film industry's technical resources to the limit and beyond. Huge sets were required, it was necessary to shoot the movie in Technicolor, then an expensive and difficult process even in Hollywood, and the trick photography and special effects were far more ambitious than anything that had ever been attempted before in England. A further problem was that there was no role in it for Merle. Alex had toyed with the idea of making *Manon Lescaut* as a "vehicle" for her, but he was not happy with the idea, nor did *Madame Bovary* seem altogether suitable. Clearly it was going to be necessary to lend Merle out to the American studios if her career was going to move forward, and this prospect of separation depressed him, even though he knew it would be unavoidable and profitable.

In June of 1939, having left Vincent with instructions to start building the sets for *The Thief of Bagdad,* Alex left for the South of France on a holiday, taking Merle with him. They were married in the

*mairie* of Antibes in a quiet and very private ceremony. Almost immediately they prepared to return to England. Their haste was due to a warning from one of Alex's friends. Eddy Corniglion-Molinier had resigned from the French Air Force to become an ace in the Spanish Republican Air Force, then returned to resume his official duties as a French colonel. He told Alex that war was much nearer than anybody was willing to admit. "They will wait until the harvest is in," Eddy said, "but not a moment longer."

Alex nodded. It was just like 1914, when everybody had waited until the harvest was over before mobilizing. He toasted Merle, returned to the hotel and booked their passage back on the *Train Bleu* to Paris, and the *Golden Arrow* to Calais, Dover and London. It was time, he knew, to get to the far side of the Channel.

HE FOUND LITTLE there to comfort him. In that blazing end of summer, the English waited for war with the resignation of a condemned man. The exultant spirit of the following summer, when the nation stood united in a kind of orgy of patriotism, inspired by Churchill, Dunkirk and the Battle of Britain, was not only far away, but unimaginable. In July of 1939, England was as divided and as defeatist as France. Those who favored appeasement (including the Prime Minister) accused the "anti-Munichers" of provoking Hitler into a war he didn't want, while many of those who despised appeasement doubted Churchill's sanity or felt he had long since burned himself out. The Left was antiwar, anti-Chamberlain, anti-Churchill and anti-Hitler, and was widely assumed by Conservatives to be pro-Stalin. Anti-Semitism was on the rise, in a quiet English way, having broken out of cover with the attacks on Hore-Belisha, the Jewish Secretary for War. There was a general fear that England was being swept into a European war on behalf of the Jews. Children and even dogs had been fitted for gas masks, in deference to Wells's apocalyptic vision, sandbags had been piled up in front of the major public buildings and monuments, and householders were greeted in the morning by cheery leaflets in the mail advising them on how to construct a bomb shelter in their back gardens, or prepare for evacuation, or wash off poison gas droplets. A languid battery of Territorial gunners sunbathed just behind our house on Hampstead Heath, where they had dug an emplacement for their

anti-aircraft gun, and daily they searched the skies for the bombers
which would annihilate us in one stroke, as Chamberlain and Winston
Churchill warned us they would. As further evidence of Her Majesty's
government's preparations for Armageddon, the local parish halls were
discreetly stocked with coffins in two sizes (one for adults, one for
children) in anticipation of mass burials.

Spy scares were frequent. My father, who had gone to Cornwall to
shoot exterior footage for *The Thief of Bagdad* with a camera crew
consisting largely of Central European refugees and exiles, was sum-
marily arrested and charged with photographing destroyers at sea.
Luckily, intercession was swift, for Vincent had recently been invited
to stage a Royal pantomime, in which the little princesses performed
*Peter Pan* on an improvised stage at Windsor Palace, and had been
rewarded by an invitation to tea from the King and Queen. With many
grumbles, he obeyed the summons (his feeling about tea with the Royal
Family was not very different from that he had about tea with my
grandmother), and together with Cecil Beaton, who had designed the
costumes, he sat politely while the Royal Couple questioned him about
his work. After some time, Her Majesty, who was a shrewd judge of
character, noted that he looked uncomfortable, and asked him if any-
thing was the matter. "My feet hurt," he replied. The Queen slipped
out of her shoes, so that my father might feel free to do the same, which
he did, to his great relief. His enthusiasm for royalty had never been
great (when he was a child, his mother had taken him to the railway
station and hit him on the head as Franz Josef's train passed by, so that
he would never forget that momentous occasion, leaving him with
permanent antimonarchist scars), but he now became as firm a royalist
as Nanny, and even said that the Queen was exactly the kind of sensible
wife he would like to have himself, and that George VI was a very lucky
man, even if nobody could understand a word he said because of his
stammer. After all, very few could understand Vincent's English either.

Happily, a telephone call to the King's secretary was sufficient to
convince the Cornwall constabulary that Vincent was not an agent of
the *Abwehr*. However, his accent continued to create troubles as war
grew near and the British public moved toward that paranoia which has
always been characteristic of an insular race at bay. Those who had fled
from Hitler's Germany soon found themselves being interned along
with German nationals of frank pro-Nazi sentiment, and there were

innumerable scandals and problems as Scotland Yard's Special Branch attempted to sort out those foreigners who were "on our side" from those who weren't, made more complicated by the fact that any Nazi spy worth his pay would of course pretend to be an anti-Nazi refugee.

It was not a happy time, and it weighed heavily on Alex when he returned. He had lived through war, defeat, revolution and counter-revolution. The prospect of having to live through another such sequence of events depressed him. There was a particular cause for anxiety: He knew, probably through Udet, that the Gestapo had listed him on their *Sonderfahndungsliste Grossbritannien* for processing to Department IID5 (inquiries into anti-Nazi opposition activities) of Heydrich's dreaded *Reichssicherheitshauptamt.* Many of the Englishmen on this bulky list were either amused, surprised or proud to be there, but Alex had already been on Admiral Horthy's list, and only escaped by the skin of his teeth from "interrogation" at the hands of Horthy's officers. He was well aware that Hitler's SD would be more thorough and professional than Horthy's amateurs. It was all very well for Churchill to arm himself with a Colt .45 automatic and for the Queen to take pistol lessons, but Alex did not share these romantic fantasies of heroism. "If the worst comes," he said, "it will be dull, nasty and very German."

Worse yet, the immediacy of war made film production almost impossible. The studios were already being converted into makeshift factories, the younger technicians were either getting ready for mobilization or preparing to join the many conflicting documentary film units that were to proliferate during the war. The production of major movies began to seem increasingly irrelevant at a moment when the Army had suddenly discovered it was deficient in every necessity of modern warfare, including rifles and handguns. As the armorers scraped the grease off Enfield rifles that had been rejected for use in 1914, the priority of such projects as *The Thief of Bagdad* dropped.

Not that Alex was happy with what he had seen of it. When he first saw Vincent's huge set, he turned away in disgust and said, "Tear it down, build it twice the size and paint it red." Now there was some doubt that it could be built at all, despite the fact that a great deal of money had been invested in the film. Alex hastily pulled his crews off *The Thief of Bagdad* and with remarkable speed put together a patriotic low-budget movie about Britain's air power, *The Lion Has Wings.*

He cashed in his life insurance policies to finance it, and completed it in less than two months without any assistance from the government, which was as helpless in the field of propaganda movies as it was in the supply of rifles. He managed to find a role for Merle, as the wife of a Wing Commander of the R.A.F. (played by Ralph Richardson), put together a cast which included Ian Fleming, Miles Malleson and June Duprez, and secured Lowell Thomas to do the narration of the American version.

Thus the first major British propaganda film was made as a gesture of free enterprise, and was played in America with tremendous success, while a print smuggled into Germany produced from Hitler a threat to bomb the British movie studios. In England, the movie was widely regarded as overoptimistic, since the public did not as yet have any reason to believe in the efficiency or strength of the R.A.F., having been told by both the appeasers and the anti-appeasers that it was too weak to confront the Germans. The film was a tour de force but it did nothing to solve Alex's problems; he needed financing, studio space and access to talent, and in England all three were rapidly vanishing, along with Merle's future as a star. Despite Churchill's praise for *The Lion Has Wings*, Alex could see himself going bankrupt, nor was the alternative of turning himself into a documentary film maker one that appealed to his essentially grandiose and sedentary nature.

When war finally came, Alex heard the news in his office, and listened stoically to the Prime Minister's voice, as Merle, beside him, burst into tears. "I think another war will kill me," Alex was reported to have said, but in fact it was not so much the war as the fate of *The Thief of Bagdad* that weighed heavily on him. He considered moving the production to Canada, but it was obvious that Canada was even less well equipped for a movie of this complexity than England, and in any case Alex's interest in Canada was remote.

He took the radical step of renting a large house in the country and prevailed upon his brothers to move their families into it, with disastrous results for his own morale, and Merle's. He had expected a swift crisis, in keeping with the gloomy forecast of *Things to Come*, but instead England settled into the Phony War, and the Korda family grumbled and fought in the self-imposed discomfort of evacuation. Gertrude was cut off from her friends and the theater, Vincent was too far away from Soho to spend his evenings in the Csardas Restaurant,

Zoli complained of being a prisoner, the nannies missed their respective beats, and my cousin David and I were exiled to the nursery on the grounds that we were a perpetual nuisance. Merle was the first to flee from this conspicuously unhappy tribal gathering, since she had a contract with Warner Brothers, and was urgently needed in Los Angeles. Zoli, whose health had declined, soon followed her, hoping to find a cure in Arizona. Vincent sent Nanny and me to the Isle of Wight as a precaution against the possibility that Wells might turn out to be right after all, and moved back into Wellwalk, Hampstead, with great relief.

Alex returned to Avenue Road and his problems. He was lonely without Merle, and worried about the future of London Films, and Vincent, who was busy rebuilding the sets for *The Thief of Bagdad,* could do nothing to cheer him up. Alex hesitated, agonized and delayed, but he knew there was only one way to make the kind of ambitious movies he knew how to make: He would have to return to Hollywood.

HIS UNEASINESS with this decision was not just based on his unhappy memories of what he always called "bloody California." He was well aware that leaving England now would be interpreted as cowardice and defeatism. Yet if the British film industry were to survive as a major force, it would have to be moved to California temporarily, just as the Rolls Royce engineers were sent to the Packard motor plant in Detroit to set up a production line for the Merlin aircraft engine, beyond the reach of German bombers. Alex knew how harshly he would be attacked for his decision, and how much pain it would cause him. He decided not to defend himself, partly out of pride and partly because what he could not say was that Churchill and the government had requested that he go. The government was determined to continue motion picture production on a major scale, and eager to earn enough American dollars in film exports to pay for the continued imports of American films, and thus not only sanctioned but demanded Alex's departure and his ambitious transatlantic production program.

Churchill had other reasons. He wanted Alex to make major films that would subtly represent the British point of view all over the world, in a way which would seem patriotic but not propagandistic, and which

would not emanate from official sources. He also instructed Alex to set up offices in New York and Los Angeles, and to link them to a worldwide motion picture corporation. These offices would exist for their own sake as a moneymaking enterprise of Alex Korda's, but they would also serve as "cover" for British agents working in what was then neutral America. American isolationists had made it difficult for British intelligence operatives to work freely in the United States, but a movie company offered unparalleled opportunities for concealing intelligence work, and Alex could even himself act as courier. What could be more natural for a film mogul than to travel, and who would think twice about his eccentric hiring practices?

Alex conferred with Churchill, and spent many hours with the anonymous gentlemen of MI-5 and S.O.E., and it was made clear to him that certain risks were involved. The least of these was public criticism of his departure. More dangerous was the fact that he might come under the hostile scrutiny of the FBI and the United States Senate as a foreign agent, and would certainly be treated harshly by the anti-Roosevelt press. More dangerous still was the possibility that the Germans might discover what he was doing and arrange to have him killed. Alex was willing to accept these risks, and took on his new responsibilities in complete secrecy. Still, he delayed his departure for as long as possible. England had made him rich and famous and had offered him a place in its hierarchy of merit and fame. Now it had to be paid for. It was ironic that he had made *The Scarlet Pimpernel*, for he was about to play the role himself, in real life, and suffer the same torments.

ALEX ANNOUNCED that he was making a trip to Hollywood, to see Merle, who was already working on a movie. This was perfectly understandable to the press, since they had erroneously concluded that the Kordas' separation was the first sign of a divorce, leading Alex to hold a press conference in which he announced "Everything is all right!" though Merle announced on her side, "Everything is *not* all right, but we're going to talk it over." Alex's departure was thus presented as a familiar stage in any motion picture marriage, and it passed unnoticed that he had ordered Bailey the chauffeur to lay up the Rolls.

Before going, he had one more task to perform. Since Merle and Zoli were already in California, he felt it was necessary for Vincent to go,

both because he needed him and because Alex could not bear to be
separated from his brothers. Vincent was reluctant, but he did not
question Alex's decision. Alex had brought him from Paris to London,
and if he now wanted him in California there was nothing to discuss.
It did not occur to my father to tell Gertrude, since he knew perfectly
well she would object. He booked himself on one of the few clipper
flights to New York (the flying boats still made the crossing from
Southampton to Lisbon, from there across the South Atlantic to Brazil,
then north to New York, with a stop in Florida), and made arrange-
ments for his family to follow him by boat. The night before he was
due to leave, he told my mother, who was predictably furious. Like
Alex, she feared that she would be treated as a coward, and in any case
she was being asked to give up her stage career for a doubtful future
in Los Angeles, where she knew nobody. After a great deal of argument,
she gave in, though things were never to be the same between them.

Not that we were alone in having our lives disrupted. A curious
pessimism on the part of the government had imposed on a great many
English people the kind of refugee existence that is usually experienced
at the end rather than at the beginning of a war. Still haunted by the
vision of a brutal aerial bombardment, the Chamberlain Cabinet had
decided to evacuate as many people as possible from London, particu-
larly women and children, on grounds that were at once humanitarian
and defeatist. Something in the nature of a vast, mindless and ill-
controlled migration was taking place, and the train stations, which
ought to have been full of troops, were instead full of children, each
carrying a gas mask and wearing a large cardboard ticket tied to a
button by a string, announcing name, destination and any serious
allergies.

The Home Office had become a kind of Pied Piper of Hamelin, and
by the winter of 1940, a great many English families were trying to
trace just where their children had gone. Many children from the
poorer sections of London were sent into the English countryside and
settled with rural families, infuriating whole villages by their behavior,
language and lack of hygiene, and ensuring another generation's worth
of class warfare. Middle-class children were shipped off to Canada and
America, much as convicts were once sent to Australia, and an unwill-
ing Churchill was asked to pose with the "Head Boy" of a ship full of
children. Britain's greatest export was now children, and their arrival

abroad contributed to the world-wide opinion that it was already a beaten nation. Even the French, who were openly defeatist, had not evacuated their own children.

By means of adroit string-pulling on Alex's part, Nanny and I were assigned places in the evacuation plans, while my mother went on ahead (by some curious fluke of bureaucracy, nannies could accompany children, but not parents), and we soon found ourselves lost in a vast mob of wailing children on a train to Liverpool. The evacuation was awful, not because it was brutal or uncomfortable in itself (we were not, after all, being "resettled" by the Gestapo), but because the task of moving a thousand children at a time is almost impossible. Children cried, children got lost, children lost their identifying tickets (which was worse), children threw up, or failed to reach the bathroom in time, or lost their handkerchiefs or fought. By the time we reached Liverpool neither the children nor their guardians were in a cooperative mood. As boredom set in, scenes that foreshadowed *Lord of the Flies* began to take place, and we embarked on board *The Empress of Canada* like a defeated army.

Stringent precautions were taken to ensure that none of the little evacuees fell overboard, and any tendency to horseplay was discouraged by a rule that made everybody wear a heavy cork life preserver all the time, even in bed. Once a day, each child was issued a bar of chocolate, rather the way that sailors receive their tot of rum. The ship zigzagged across the North Atlantic, and gradually we lost our interest in food as she wallowed in the winter swells. The nannies, nurses and guardians sat reading their Bibles and talking about the sinking of the *Titanic*, a subject of conversation that became more intense as we skirted the coast of Greenland to avoid submarines, and saw icebergs constantly. At last we reached Montreal, where my mother, wrapped up in the fur coat that Alex had given her, waited for us. My father, she explained, had flown on to California ("Where it's warm and there are oranges everywhere"). We were to join him by train.

The first stage of our trip was slow and difficult. When we arrived at the border, we were taken off the train by the American immigration officials, who discovered that my mother had no visa allowing her to enter the United States. It was below zero and the middle of the night, and Nanny, whose enthusiasm for the journey to America had never been great, huddled on a bench in silent martyrdom, while my mother

attempted to charm the immigration officials, and failed. At last, they allowed her to place a collect call to Alex in Beverly Hills. He promptly telephoned the playwright Robert Sherwood (an old friend and collaborator) at the White House, and the White House called the border station. Within an hour we were on a train to New York, and two days later on our way West, first to Chicago, on the *20th Century Limited*, where Nanny met her first black, in the person of the Pullman car attendant (discovering that he too was a Methodist), then to Los Angeles on the *Super Chief*, across the great, flat plains, up the Rockies (where the train stopped to pick up pails of fresh, live rainbow trout for dinner), and on to the city where Alex had failed just ten years before.

# CHAPTER 5

M Y FIRST MEMORY of Los Angeles is that of an orange-juice stand in the shape of a gigantic orange, with a square window cut in it to serve from. My second is the sight of my father, inappropriately dressed in a thick tweed suit, standing on the lawn of the house he had rented on North Rodeo Drive in Beverly Hills, with a dog beside him that was the exact replica of the one we had left behind in England.

Vincent was already hard at work rebuilding the sets for *The Thief of Bagdad* on the lots of the General Services Studio, where they could at last be increased to a size that would satisfy Alex, and he had had little time to prepare for our arrival. He had chosen a house in that peculiar Moorish style of Beverly Hills, so unconnected to the prevailing outdoor culture, with small, iron-grilled windows, stained-glass panels and murky interiors full of carved wood railings and galleries and much lugubrious black wrought iron. Outside was a world of convertibles, open-air markets, swimming pools and drive-in movies; inside was the gloom of the Escorial, with a refectory table in the dining room, chairs of dark leather and carved wood, lamps in dim yellow parchment shades artlessly wired onto massive candelabra, oak buffets and chests that must have weighed half a ton and strange chandeliers that seemed to have been clumsily converted from wagon wheels. The front door,

with its wooden panels bound by massive strips of iron, looked capable of holding back any attack by the outraged peasantry, and the roof had parapets set among the earthenware tiles from which one could have poured boiling oil down on their heads.

My father remarked that the only comfortable room in the house was the garage, and he proceeded to transform this into a kind of studio retreat, to which he would vanish for long intervals to paint, nap, avoid conversation or flee from the telephone. It was one of the paradoxes of Southern California that a population of sun worshipers lived in houses as dark as caves.

Alex managed to avoid the Spanish Gothic style, which he had in any case learned to dislike on his first visit to California, and settled in the more rarified atmosphere of Bel Air. Merle, who at the moment had access to more money than Alex, purchased a vast white English country house, inappropriately surrounded by royal palms and guava trees, and overlooking an enthusiastic but inexact copy of the abbey of Hendaye, complete with a bell tower and a carillon. Naturally, Alex's house had a pool, but like most working people in Hollywood, Alex seldom saw it. He proudly joked that since Merle had bought the house he was now "a kept man."

Until his return to Hollywood, he had been happy enough to challenge his American rivals on a film-by-film basis, but now that he was back, memories of his past humiliations beneath these same arid palm trees fueled his ambitions. His immediate concerns were to build Merle up into a major star and to complete *The Thief of Bagdad,* but if he was going to stay here in California, he could only be happy by building up a big studio of his own, or acquiring control over an existing one. He was not about to take second place to Goldwyn or Mayer or Cohn or Selznick on their own turf, and the role of a minor independent producer, however successful, did not interest him at all. He cast around for an opportunity, and was soon deeply embroiled again in the affairs of United Artists, an ailing giant with problems of its own. Alex thus took on himself, almost from the day of his arrival, a task that would have strained a much younger man. Nor was he any happier in California this time than he had been in the twenties. Like Maria, Merle was more concerned with her career than with her marriage, and though Los Angeles was full of expatriates, Alex still missed Europe and found California depressing.

Memories of his previous life here haunted him: He had forgotten how much he disliked the big Hollywood parties, the pineapple slices on top of the cottage cheese in the studio commissaries (though at M-G-M the chicken soup with dumplings à la Louis B. Mayer was excellent) and the enervating heat. The idea of buying United Artists excited him, but even had he done so, he intended, eventually, to run it from England.

"Poor Alex," my father said to me one day on the way to school. "He's so lonely in that big house, you must be nice to him." He seemed to like seeing David, myself and our friends, and even took us out to dinner at the Brown Derby, where he nervously watched us gorge ourselves on cake. "Give them what they want," he told the head-waiter, but he carefully told us that if we were going to be sick, we should wait until we got home. He even gave a children's tour of the sets for *The Thief of Bagdad*, where Sabu did the Indian rope trick, and more cake was served.

Alex had taken office space on Las Palmas Avenue and spent most of his time there wrestling with the problems of *The Thief of Bagdad*, which by now had received the attentions of three directors, on both sides of the Atlantic, with the inevitable result that the footage was somewhat hard to fit together into a coherent whole. Alex's passion for size had been amply gratified, but the actors were dwarfed by the sets and the special effects, and the film was curiously lacking in warmth. He himself felt it was a "showman's film," but it suffered from much the same defect as a three-ring circus: There was too much going on, and a great deal of it was simply flashy spectacle for its own sake. *The Thief of Bagdad* represents what he thought the public liked, not what he liked himself, and in truth he was bored by it and quite happy to leave to Zoli the task of completing the final version, which despite its unevenness was to win the film an Oscar for special effects, and another for Vincent's art direction.

ONE OF THE curious effects of the Korda family's move to California was to increase Zoli's importance temporarily. In addition to directing *The Thief of Bagdad*, he was preparing to make Kipling's *The Jungle Book*, drawing on Aldous Huxley's advice to turn the stories into a screenplay. Zoli had also lived in Los Angeles longer than his brothers,

and liked it better than either of them. He argued forcibly that Alex should stay there, secure his position in United Artists and establish a Korda dynasty in California. If Alex returned to England, Zoli would once again be pulled between his home and family in Los Angeles and Alex's formidable presence in London.

"Look at the bloody climate," he told Alex, "it's clean, healthy, you can breathe the air. It's not like London. Here is a big, open country, not a little, snobbish one, with titles and class problems, like England." Alex resisted: He rather liked titles, and had no objection to the class struggle so long as he was in the upper class.

Zoli, who had found Vincent's house for him, attempted to kindle my father's enthusiasm for Southern California with some success, in the hope that two brothers would carry more weight than one. Vincent too began to sing California's praises to Alex—the sunny climate, the Farmer's Market, the Hungarian restaurant on Santa Monica Boulevard, the beautiful gardens—but Alex glumly replied, "Vincent, you've been listening to Zoli. Shut up."

Zoli took Alex to Malibu, in the hope that he would buy a house there, but Alex stared at the Pacific with undisguised hostility, and said, "It's not Antibes." He was equally resistant to the proposal that he should buy a house in Palm Springs. "It's a *kibbutz* with million-dollar houses," he complained, and refused even to consider it. Because of Merle's career—lending her out to studios was now a major part of Alex's prestige and income—he dined out frequently, but Chasen's and Romanoff's merely made Alex all the more homesick for Claridge's, the Ritz and the Savoy Grill.

Alex obstinately refused to put down roots. He had rented the house in Bel Air, and was evasive about buying one. His cigars were flown in from New York, from his private humidor at Dunhill's. He spent much of his day closeted with visitors from England, some of whom were couriers from the intelligence services, who used Alex's New York offices in Rockefeller Center as cover.

From this base, MI-5 set up an efficient espionage organization so that Churchill had an independent source of information on American policy and strategic realities. Alex was not only providing cover for the attempt to spy on German activities in the United States, he was also involved in the British effort to discover whether or not they were receiving accurate information from President Roosevelt and his emis-

saries. The potential for embarrassment to Alex—who at the same time was attempting to establish a beachhead for himself in Hollywood—was enormous.

A decade later, when I asked him about the rumors of his involvement with British intelligence, he smiled and replied, "I can't tell you, my boy, but they were the most difficult years of my life. Only four people knew what I was doing—Brendan Bracken, Max Beaverbrook, Churchill and myself." Alex worried that he might be declared an undesirable alien, or even indicted for espionage. He was a reluctant hero.

At the same time, his constant communication with England reinforced his determination to remain a visitor to Los Angeles rather than a permanent resident. "Last time I was here," he said, "I was a Hungarian émigré; this time I'm British." To Zoli's discomfiture, Alex's attention remained directed toward England. Despite the difficulties of wartime transportation, his shoes were sent back to Lobb's on St. James's Street to be repaired, carried in other people's luggage, and he continued to order his suits from London. He even managed to have oranges shipped over to Churchill, by air to New York, and from there to London by bomber, where they were gratefully received.

Apart from the need to use Hollywood studio facilities, what had been keeping Alex in Los Angeles was Merle's career as a major star. But Alex could not be content with the role of starmaker, and Merle's success inevitably presented the usual Hollywood problems. She rose at dawn to go to the studio, hours before Alex was even awake, and went to bed while Alex was still watching rushes and arguing about sets with Vincent and Zoli in the library.

He was determined to get back to England as soon as his obligations to Churchill and United Artists were discharged. Prudently, he concealed his intention for the time being. He liked to keep his options open. His suitcases remained within easy reach in his Bel Air dressing room, and he bought a heavy, fur-lined flying jacket from Abercrombie & Fitch, an unusual piece of clothing for somebody who lived in Los Angeles—unless he intended to do some long-distance flying. (Alex eventually gave this jacket to me, and I wore it to Budapest in 1956, thus returning a possession of Alex's to the place he had left more than three decades before.)

———

BY 1940 ALEX WAS already hard at work fulfilling his promise to
Churchill, at some personal risk to himself. He was well aware that an
isolationist Congress and press would almost certainly attack him for
making any kind of pro-British film in Hollywood. Nor was he at all
sure of the right subject. It would have to be something patriotic, but
the "message" would need to be artfully concealed. An ideal solution
would be a historical film with parallels to the present. He sent Vincent
off to the Los Angeles Public Library to find books on Wellington, and
for some weeks Vincent happily sketched plans for the Battle of Water-
loo and sets for the famous ball that preceded the Emperor's arrival at
Quatre Bras. When Vincent showed him what he had done, Alex was
enraged. "Throw it all away," he shouted, "I meant . . . What's his
name? The bloody admiral, not the bloody general!"

In fact, the decision to make a film about Lord Nelson had been
determined by the availability of a very special pair of exiles, Laurence
Olivier and Vivien Leigh. Long heralded as the most romantic couple
in the world (after the Duke of Windsor and Wallis Simpson), Larry
and Vivien had been stranded in the United States by the war and were
suffering from guilt feelings at being safely abroad. Film commitments
and stage engagements had kept them in America, and they were now
reluctant to return for fear they would be accused of cowardice or
defeatism. Vivien's great success in *Gone With the Wind* had made
her a valuable star—far more valuable in Hollywood than Larry, to his
chagrin—but neither of them was willing to be conscripted into the
kind of studio contract that was then normal in the movie business, and
both of them were determined to remain onstage and to play the
classics.

Neither of them could really take Hollywood altogether seriously,
except as a means of making money quickly when they needed it. Larry
was far too conscious of his own stature and genius as an actor to accept
conventional parts or go on repeating himself as a romantic hero. Los
Angeles bored and repelled him, just as it frightened Vivien. They had
fled from it to New York, where they had risked much of their own
money to put on *Romeo and Juliet,* and since their financial futures
were now wrapped up in its fortunes, they were unable to go home to
England and unwilling to return to Los Angeles. Even in peacetime,
Larry had never been comfortable in the company of his fellow British

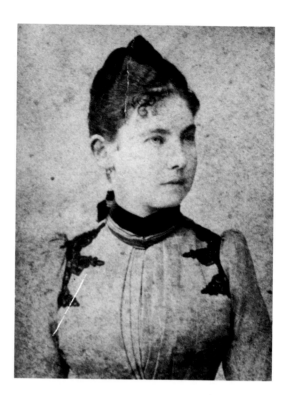

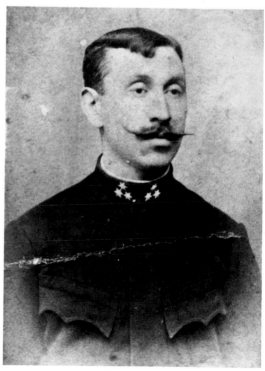

TOP: Ernesztina Weisz Kellner, at
the time of her marriage.

BOTTOM: Henrik Kellner.

TOP: The Kellner family. Alex (*at right, on bench*) is already relaxed and debonair at the age of ten; Vincent, looking shy and uncomfortable, is also sitting on the bench; Zoli, standing beside his father, looks angry that there's no place on the bench for him.

BOTTOM: *Left to right,* Alex, Zoli and Vincent.

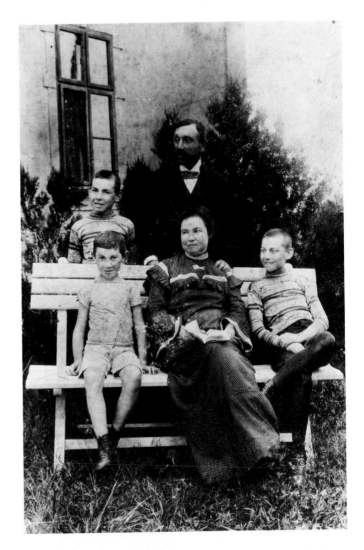

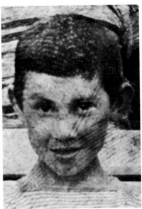

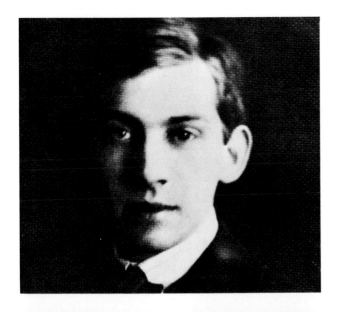

TOP: Alex as a young man, at about the time he set out for Budapest.

BOTTOM: Alex poses for a formal photograph as a rising young director.

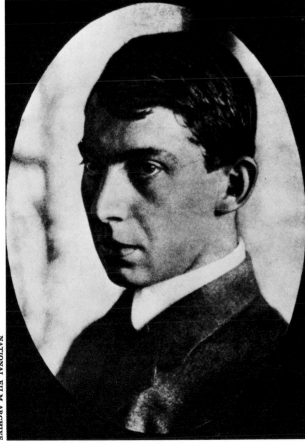

RIGHT: Maria, in a dark wig, poses for a publicity photograph in Budapest, at about the time Alex met her.

BELOW: Alex in Vienna, about 1922. He has shaved off his Vandyke beard and grown a mustache to make himself look older.

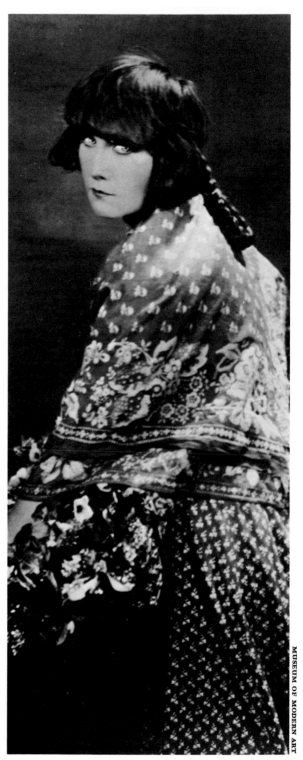

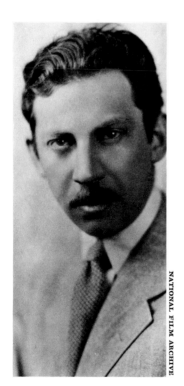

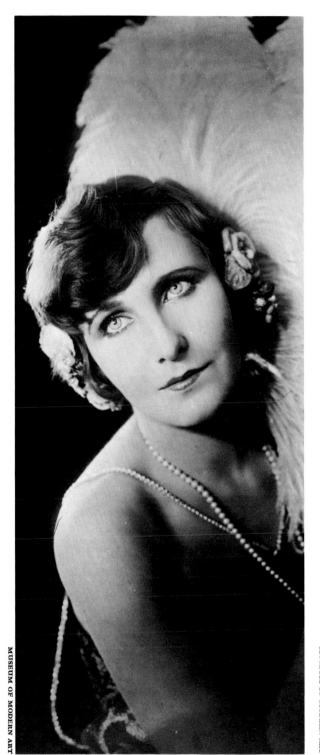

LEFT: Maria in Vienna, photographed with a plastic flower behind one ear and a lot of ostrich feathers.

BELOW: Alex, looking pensive, shortly after his arrival in Hollywood with Maria.

TOP: Alex returning to Europe from Hollywood in 1930, after leaving Maria. His face shows signs of strain and defeat, though within two years he had achieved fame and fortune with *Marius, Service for Ladies* (starring a fellow Hungarian, László Steiner, better known as Leslie Howard) and *The Private Life of Henry VIII*, his greatest success. Alex, though broke, is perfectly dressed, traveling first class and has three good cigars visible in his breast pocket!

BOTTOM: Maria, bosom thrust forward magnificently, stands on the balcony clutching the hand of Lewis Stone, in Alex's *The Private Life of Helen of Troy*. Alex sits beside the camera, at left, wearing a beret for what would seem to have been the first and the last time.

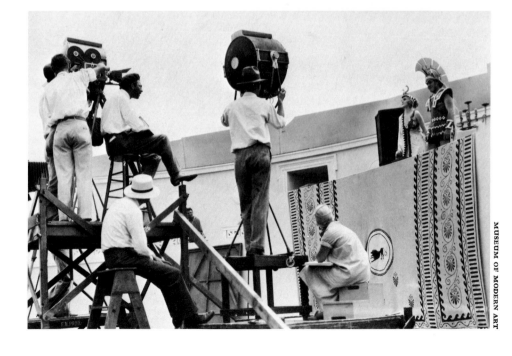

TOP: Vincent, photographed on the set of *Henry VIII*, a cigarette in one corner of his mouth, *à la française*.

MIDDLE: Alex and Charles Laughton, during a break from the filming of *Henry VIII*.

BOTTOM: Maria Corda and Ricardo Cortez in *The Private Life of Helen of Troy*. Maria looks uncharacteristically demure. Ricardo Cortez was once described by Louis B. Mayer as "the only man in Hollywood who ever named himself after a cigar."

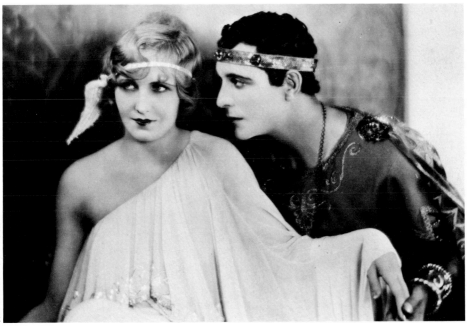

TOP: Alex, looking supremely bored, directs Douglas Fairbanks, Sr., in *The Private Life of Don Juan*.

BOTTOM: Zoli, looking dramatic and handsome, shortly after his arrival in England to work with Alex and Vincent.

OPPOSITE TOP: Charles Laughton plays cards with Elsa Lanchester (as Anne of Cleves) during the King's disappointing wedding night.

OPPOSITE BOTTOM: Vincent's sketch for one of the opening scenes of *Henry VIII*.

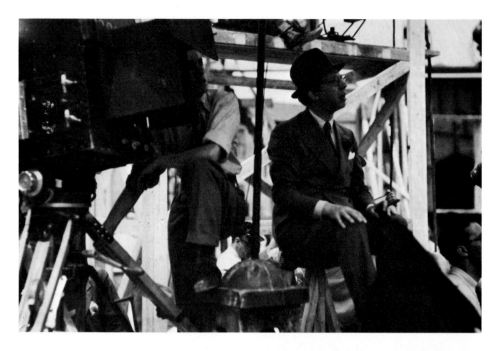

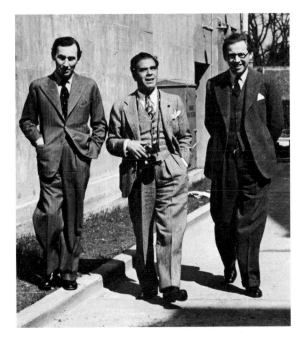

TOP: Three Hungarians who have made good stroll at Denham. *Left to right*, Zoli, Gabriel Pascal and Alex. All show evidence of British tailoring.

BOTTOM LEFT: Alex chats with H. G. Wells at Denham.

BOTTOM RIGHT: Vincent at Denham, wearing one of Alex's suits, which is much too large around the waist for him, and apparently buttoned wrong.

OPPOSITE TOP: Alex, a flower in his buttonhole, directs *Things to Come* at Denham.

OPPOSITE BOTTOM LEFT AND RIGHT: Merle Oberon, the first Lady Korda.

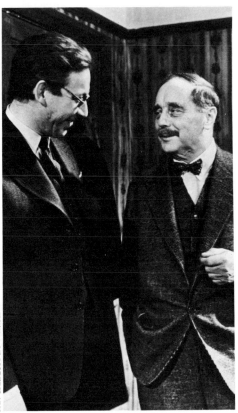

TOP: Gertrude and Michael, in the garden of the house at Well-walk, Hampstead, about 1935.

BOTTOM LEFT: Vincent, Gertrude and Michael on holiday in France, before the war.

BOTTOM RIGHT: Vincent and Michael, Beverly Hills, about 1941.

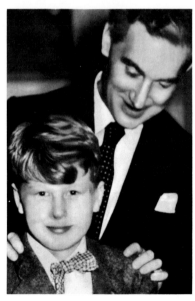

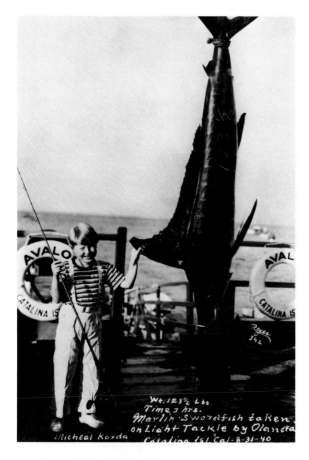

TOP: Michael Korda, age seven, with his first marlin, caught from the "Yolanda," Tom's fishing cruiser, Catalina, 1940.

BOTTOM: Alex with his associates at United Artists, which he almost succeeded in taking over. *Left to right*, Murray Silverstone, Sam Goldwyn, Mary Pickford, Charles Chaplin, Alex and Connop Guthrie.

PETER STACKPOL © 1940 TIME, INC.

TOP: A photo from *Life* magazine, in which Auntie Merle plays with her young nephews Michael (*left*) and David (*center*) on her Bel Air lawn. This is the photograph that so infuriated Vincent.

BOTTOM: Zoli, cane in hand and wearing a safari hat, directs Sabu in *The Jungle Book*. Note the rubber python in the foreground.

TOP: Laurence Olivier and Vivien Leigh in *That Hamilton Woman*.

BOTTOM: Alex, with his nephews, David (*left*) and Michael (*right*), and one of their friends, at a children's party in Los Angeles, 1941.

TOP: Alex directs Vivien Leigh, Los Angeles, 1940.

BOTTOM: Korda Sándor, now Sir Alexander Korda, emerges from Buckingham Palace after being knighted, September 22, 1942, with Merle Oberon, now to be (briefly) Lady Korda, beside him.

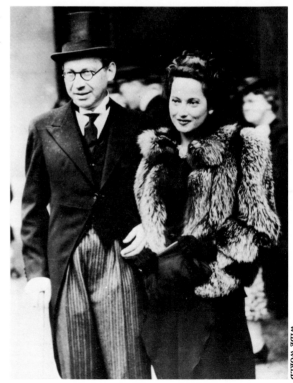

expatriates in California, whose Englishness had become both a caricature and a livelihood. He described them as British by profession, character actors whose own characters had been fixed forever by a Hollywood stereotype. There was something amiably ridiculous in the sight of these robust British figures, with their tweeds, their mustaches and their regimental blazers, sitting down to tea under the orange trees and palms of Beverly Hills, engaging in cricket matches and talking of England as "home" when most of them had lived in California for twenty years.

They resembled in many ways the *pukkah sahibs* of an earlier generation of exiles, and Ronald Colman was frequently heard comparing Beverly Hills to Poona. The sight of Cedric Hardwicke in a deerstalker hat and Inverness cape on Santa Monica Boulevard, or C. Aubrey Smith in a blazer and straw boater on his way to the Cricket Club no longer astonished the natives. Most of the British exiles were in fact very content to be in Hollywood—with rare exceptions, they were modestly talented and happy enough to exchange the rigors of the English stage, the dreary tours through the provinces, the low pay of rep, the occasional parts in minor films for the more glamorous and substantial rewards of Hollywood.

To an actor of Larry's ambitions, this *milieu* had little appeal. He was morose, and all the more so because his love affair with Vivien was no longer as satisfying as it had once been. It was not just that Larry was envious of Vivien's unexpected success as Scarlett O'Hara, which far outshone his own in *Wuthering Heights*—the nature of their relationship had changed since the days when Alex had acted as a kind of benign fairy godmother to their affair.

They had each left their marriages to be together and live in what one observer called "the limelight of adultery," perhaps the most beautiful and talented couple in theater history, but Vivien's fame and their involuntary exile had exacerbated the strains on their relationship, which had begun with such a burst of passion that it was almost bound to deteriorate. Vivien worshiped Larry, in the literal sense of the word —his strength, his power, his genius overwhelmed her. He was a king among actors, and she was determined to reign alongside him as queen, though her talent was more fragile than Olivier's. She was far less at ease in the classics than he was and knew her limitations.

*Romeo and Juliet* had proved to be a trying experience for both of

them, and it was not made easier by the fact that Vivien's obsessive devotion to Larry was no longer being returned, or even welcomed, by him. He was restless, bored, easily irritated, and the strength of Vivien's feelings toward him now seemed more and more to him hysterical, jealous and suffocating. He wanted more freedom, and she was terrified that if she gave it she would lose him. She brooded darkly on his close friendship with a famous American actor; she began to drink too much.

Alex, who remained deeply attached to Vivien, was determined to rescue them. A film in which they could play equal roles might restore the balance of their relationship. It would also end their worries about money, and if it was patriotic enough, give them an honorable reason for remaining in the United States and allow them to return to England with their heads held high. Alex toyed with the idea of Elizabeth and Essex, but the role of Elizabeth seemed wrong for Vivien, and the period remote. He knew of Olivier's interest in *Henry V,* but a Shakespearean film would be of doubtful value as propaganda, and a risky proposition commercially, nor would it provide a star role for Vivien.

It was finally Winston Churchill who suggested Nelson and the Battle of Trafalgar as subjects, and to Alex's credit he immediately understood that the key to his dilemma lay in Nelson's domestic life, as opposed to his career as a naval hero. By making Nelson's lover Emma Hamilton the center of the movie he not only provided Vivien with a potentially memorable and moving role, he also made the theme seem less blatantly political.

Vivien and Larry, bickering in Sneden's Landing after the closing of *Romeo and Juliet,* were persuaded to join Alex in Los Angeles, and Alex plunged into the preparations for *That Hamilton Woman.* Like *Henry VIII,* it had to be made quickly and cheaply, for Alex was financing it himself, and Merle provided the first money to get the film started. He was also worried that if the U.S. Senate got wind of the film's message, it might be stopped. Vincent hastily built one of his most lavish sets, the vast airy library of Lord Hamilton's house in Naples, with a sweeping view of the famous bay, and labored night and day to complete it. When Alex saw it, he was outraged. "Vincikém," he shouted, "it's a love story. I can't shoot it in a bloody library. Make me a bedroom!" So Vincent spent the night converting Lord Hamilton's library into Lady Hamilton's bedroom so that Alex could begin shooting the next morning.

Alas, there was one further problem. When Alex arrived onstage, he found Olivier only half dressed for his part as Nelson. "What's the matter?" he asked. "Alex," Olivier replied, "the costume is fine, but I have one question—which arm and which eye was Nelson missing?" There was a deadly hush. It was apparent that nobody knew the answer to this simple question. And since it was a Sunday there seemed to be no way to look it up. At last somebody remembered that there was an aged Hungarian opera singer living in Van Nuys who had played Nelson in a turn-of-the-century operetta which had briefly graced the Vienna stage. A studio car was instantly sent to fetch the old man, who had been living in obscurity and poverty for several decades; and when he appeared at the General Service Studios, he naturally assumed his career was about to be revived. "Old friend," Alex said, putting his arm around him, "when you played Nelson in Vienna, can you tell us *which arm and which eye were missing?*"

The old man stared at Alex, embarrassed and unsure. "Mr. Korda," he replied after some hesitation, "frankly, it's hard to remember."

"Try." said Alex. "Please try."

"Well," he replied, "it comes back to me that it got boring doing it always the same way, so one night I would cover the left arm and the right eye, and the next night I would do the opposite."

Despite delays, *That Hamilton Woman* was completed in less than six weeks, a remarkable achievement considering that it was necessary to construct a fleet of eighteenth-century naval vessels, each scaled down to the size of a dinghy in which a propman could lie concealed, firing the miniature guns and raising and lowering the sails, while a wind machine created waves on the studio's back-lot tank. Vincent supervised this elaborate recreation of the Battle of Trafalgar in a rowboat, as the propmen, wearing fishing waders, pushed the ships back and forth across the tank in water up to their chests. Alex, looking rather like an admiral, consulted with a retired British naval officer on the exact line-of-battle from a platform built above the tank. Vincent also constructed a vast machine that moved some of the sets back and forth to reproduce the movement of a ship at sea. As the simulated decks were tilted, it was soon discovered that Vivien suffered from seasickness. "Vivien," Alex pleaded, as she turned paler with each roll of the deck, "you know how in Victorian times women were supposed to lie back and think of England when their husbands wanted sex. I

want you to stand up and think of England." Vivien, with the help of Dramamine, did so, but several of her best scenes had to be shot again and again, when she would suddenly cry, in the middle of a kiss, "Oh, God, I'm going to be sick!"

Alex had done everything possible to speed up the film and had even paid Larry and Vivien half their salaries in advance in view of their precarious finances, but he had neglected to take the prevailing moral code into account. In the first place, Vivien and Larry were not yet married, and their situation drew attention to the fact that Nelson and Lady Hamilton's relationship was equally irregular. Alex, whose attitude toward such things was tolerant and European, was now under attack for both historical and real-life immorality, and was surprised to find himself obliged to deny that he was propagandizing for adultery, rather than for Britain.

Worse was to come: Alex had not presented the script to the Hays Office for approval for the simple reason that there was no script to show—it was being written day by day as each scene was shot. When the finished film was shown to Joe Breen, the censor, he refused to give it a Production Code Seal of Approval, on the grounds that it condoned adultery. Breen and Alex quarreled bitterly in the screening room. Breen, an Irish Catholic, said that Nelson and Emma could not go to bed if they weren't married: "I don't care *who* they are, they're adulterous." Alex argued that the relationship between Nelson and Emma was historical fact, but Breen was adamant, and as a compromise Alex was obliged to shoot a scene in which Nelson confesses that what he is doing is wrong. Alex resented doing this so much that he cut the scene out once the picture had been released.

It is possible that this movie was the best thing he ever did as a director. It contained all the elements he liked best—a love story, lavish backgrounds and an opportunity to explore the "private lives" of historical personages. Despite the occasionally intrusive propaganda that Alex felt obliged to insert in the movie, it retains even today a genuine warmth that sets it far apart from the more ambitiously conceived motion pictures which gave Alex so much trouble in the thirties, like *Things to Come* or *I, Claudius*. It is a very simple film. Unlike *Henry VIII* it does not attempt to poke fun at its own central characters. Alex indulged his taste for cynical humor in the portraits of the King and Queen of Naples and Sir William Hamilton, Emma's long-suffering

husband, but the two lovers themselves are meant to be taken seriously, both in the depth of their feelings for each other, and in the tragedy of Nelson's death and Emma's final disgrace.

There is probably no moment in any of Alex's films better remembered than the scene in which Lady Hamilton meets Nelson, whom she remembers as a dashing young naval captain, after many years of war. As he turns up the cabin lamp to look at her, she sees to her horror his ravaged face, his blind eye, his missing arm—and falls in love with him all over again. It is the kind of scene which Alex had perfected in *Henry VIII,* and which he apparently lost interest in during the thirties. Now, quite suddenly, his real gifts as a director, his sympathy for actors and actresses, his understanding of human emotions, his sense of drama, returned to him, as if war, exile and his own feelings about Merle had reawakened the romantic and the director in him, despite all the years of financial concern and studio politics that had kept him away from the sound stages where his career had begun. *That Hamilton Woman* is not just a monument to the love affair between Nelson and Emma—it is a monument to Alex's own love affair with film making, proof that when he chose to he could return to the skills and the passions of his youth. He himself remarked that making *That Hamilton Woman* made him feel twenty years younger.

*That Hamilton Woman* was immediately and hugely successful. American and British audiences shared Winston Churchill's enthusiasm for it, and in the Soviet Union it became the first non-Soviet film to achieve general distribution, many people standing in line for hours in besieged Leningrad to forget their fears in the romance and drama of a less barbarous war. However, it provoked an immediate negative reaction from the Germans and from American isolationists.

The America First Committee had been attacking the movie industry for making "pro-British" films for some time, and were particularly annoyed by *Mrs. Miniver.* America First had managed to secure the attention of several Senators, including Senator Gerald Nye, one of the more powerful and intractable proponents of isolationism. These efforts were supported very effectively by the German consul in Los Angeles, and the German ambassador in Washington, who tactfully suggested that the American movie industry had been infiltrated by Jewish money and British agents, and was being turned into a propa-

ganda instrument designed to drag innocent Americans into the war. The Nazi view of Hollywood was not very different from that of Senator Nye and his followers, and the Senator made it clear that the Senate Committee on Foreign Relations would take a very close look at the work of "British agents" in the movie business. The major movie studios instantly replied that they were innocent, but even the most timid of the studio heads were unable to point to any pro-German movies to prove the neutrality of their position, and since most of them were Jewish *and* Democrats, they expected the Senate hearings to be something on the order of a lynching. Happily for them, *That Hamilton Woman* diverted Senator Nye from his wholesale attack on the industry to a more concentrated effort against a single motion picture. Alex, to his great discomfort, became aware that he was about to be made the scapegoat for Hollywood, and that he might well be deported as a foreign agent.

He was vulnerable on two counts. The first was that he had included a long and deeply moving speech in *That Hamilton Woman*, in which Nelson pleads with Lords of the Admiralty not to trust Bonaparte's offer of peace, a speech that was not only an obvious piece of British propaganda, but in fact was reputed to have been written by Winston Churchill himself and inserted into the movie at his request.* The second, and more dangerous, count involved Alex's activities on behalf of British intelligence, and there was very little doubt in Alex's mind that the Germans could produce enough information to make it possible for Senator Nye to ask some very embarrassing questions indeed.

Alex was therefore apprehensive when he received a subpoena to appear before the Senate Committee; after all, he was under attack in his own country for having come to America, and now he was under attack in America for "inciting the American public to war." He felt, as he told Vincent, "like the man without a country,"

Events saved Alex. He had been subpoenaed to appear before the

---

*It reads in part: "Napoleon can never be master of the world until he has smashed us up—and believe me, gentlemen, he means to be master of the world. You cannot make peace with dictators, you have to destroy them ..." The entire tone of the speech is faintly Churchillian, and it is difficult to believe that Alex would have included a scene quite as unsubtle as this if he had not felt obliged to do so because of its authorship.

committee on December 12, 1941. Five days before that date Alex had reason to say that from the American point of view he had merely been "a premature patriot": Pearl Harbor had made the hearings irrelevant.

A FEW WEEKS LATER Alex made his first return trip to wartime England, secure in the knowledge that he could no longer be deported from the United States and that his film of Nelson's life had justified the expectations of Churchill. There was a good deal of criticism about his return, now that the danger of invasion had passed, some of it very bitter indeed, particularly since the enormous success of *That Hamilton Woman* made it seem to most people that Alex had produced a far more profitable and influential movie than his colleagues who had remained behind. These criticisms did not disturb Alex, for he had come back to learn that Winston Churchill had placed his name on the King's Birthday Honors List for a knighthood.

It was, even for Alex, an extraordinary moment. He was Hungarian, Jewish, under attack in the press, divorced, all reasons which would normally have precluded his being knighted. What is more, his was the first knighthood ever to be awarded to a member of the movie industry. While there has always been considerable speculation as to the exact nature of the services Alex was being rewarded for, the fact was that Churchill himself was determined to compensate Alex for the criticism he had received. At Churchill's request, he had gone to America and made *That Hamilton Woman* with his own money and every penny he could borrow; on Churchill's orders he had established large offices in New York and Los Angeles (far larger than he needed) to act as clearing houses for British intelligence, and by reissuing his films in the United States he was earning substantial sums for the British Treasury, which desperately needed dollars to finance arms purchases.

All these were excellent reasons for conferring a knighthood, but they were secondary to the simple fact that Churchill liked and respected Alex, and was grateful to him for many favors large and small. They shared a common distaste for exercise (Churchill went so far as to have his valet pull on his trousers and tie his shoes), and a fondness for brandy, cigars, good conversation and first-class food. Each of them, in his own way, was an adventurer, and although Churchill was a Duke's nephew, they were both self-made men who had been deter-

mined to live like millionaires from their earliest youth and had succeeded in doing so. Churchill had not only answered the British criticism against Alex by knighting him, he had given him something which no American movie magnate could aspire to. Henceforth Korda Sándor would be Sir Alexander.

IF ALEX'S KNIGHTHOOD surprised his English rivals (and angered some of them), it astonished his fellow moviemakers in Los Angeles. Louis B. Mayer was heard to remark that Alex would be impossible to deal with "now they've made the son-of-a-bitch a Lord," and there was a certain amount of confusion about the proper way in which to address Sir Alexander and Lady Korda, with the studio guards greeting Merle as "Your Highness" and headwaiters referring to Alex as "Your Excellency." False titles had been used for so many years in Hollywood, most of them bogus Russian or Polish, that nobody knew how to deal with a legitimate title conferred by His Majesty King George VI, *Rex, Imperator et Fidei Defensor.* In a society full of self-declared princes, Alex's title was, in Sam Goldwyn's words, "100 percent kosher."

He reveled in it. It amused him to see how quickly he was lionized by Hollywood society, and when somebody told him that he was looking much better than he had for years, he smiled and said, "Ah, but then I was only a commoner, you see!" He enjoyed poking fun at his own pretensions. One night, while playing in a particularly steep game of poker at Goldwyn's house, he won nearly $10,000 from Goldwyn, who sent him a check for the amount the next day, written in red ink, with a note attached that read: "Signed with my blood—Sam." The next night, Alex lost almost the same amount to Goldwyn. He sent over a check written in blue ink, with a note saying, "Dear Sam, This check is signed in *my* blood too!"

Alex liked to gamble, and as the years went by it became a habit, even an obsession, with him. In Hollywood gambling was an important part of the social scene. The mark of a man's position in the hierarchy of movies was the amount he could afford to lose. Men played gin rummy and poker all night, for stakes amounting to hundreds of thousands of dollars, while their wives spent the day playing bridge by the poolside for equally fantastic sums. The two questions most asked in the morning were "Did you get laid?" and "How much did you drop?"

The ability to play for high stakes was one of the few ways to win the respect of men like Mayer, Cohn and Zanuck, all of whom were capable of betting fortunes in card games, and would have killed their own children for an advantage. Alex, who had a magician's memory and almost supernatural head for mathematical calculations, was a cool, daring and successful gambler and gradually he discovered that only the highest of stakes would alleviate his boredom.

In other respects, too, his life itself seemed to be played for higher stakes. His position in Hollywood had been ambivalent until now, but the success of *The Thief of Bagdad* and *That Hamilton Woman,* coupled with his knighthood, raised him to a very much higher level of social acceptability. He and Merle now entertained on a lavish scale, and the house was seldom empty. Alex's hospitality was boundless and extravagant: When some of his guests mentioned that the water in the swimming pool was very warm, Alex went into his study to make a telephone call, and shortly afterward a huge truck pulled up to the pool and dumped several tons of ice into the water.

ALEX WAS THEN a remote figure to me. I had seen him seldom in England, and I now saw him even less. I was in any case fully occupied in adjusting to school in Beverly Hills. As the nephew of a movie star I was accorded a certain amount of grudging respect, even if I was a "limey" (a word I had never heard before), but prestige in Beverly Hills Elementary was determined by only two factors: athletic ability and parental income. (The first question I was asked by my fellow classmates was how much a year my father grossed.) In both categories I was judged deficient, and with the added disadvantage of a British accent, I usually came home from school with a bloody nose or a swollen lip. There is no cruelty like that of small children, and rich children are more cruel than most. Needless to say, there were no poor children in Beverly Hills, which then (probably) had the highest percentage of snotty brats in the Western world. Where else did the children of the rich go trick-or-treating on Halloween in chauffeur-driven limousines?

My father was rather too busy to notice my problems, and in any case he believed in democratic education, so despite my complaints, I remained for some time in the public school system, where I learned

nothing at all. Alex, whose own concerns were never so demanding that he could not spare time to examine his brothers' children for educational deficiencies, soon discovered my ignorance on one of my rare visits to Bel Air. My favorite food at that time was creamed spinach, and Alex had ordered a large portion of it for me. "Just one thing," he said, as the butler brought in a large silver tureen full of spinach, "before you have it tell me the capital of France." I looked at him blankly—France had never been mentioned in school at Beverly Hills, where the curriculum consisted of remedial reading, remedial arithmetic and remedial hygiene, but I knew it began with a P. Still, feeling I must say something, I mentioned the first city that came to mind: *"Pasadena!"* I shouted.

Alex assumed that I was making fun of him, the spinach was removed from the table, and shortly afterward so was I, protesting and in tears.

I had startled Merle early on by breaking a cup, and she sometimes looked away to avoid seeing whatever damage might follow in my wake (though the incident of the cup was never repeated), while at other times she kindly encouraged me into inactivity by feeding me chocolates from a huge box. Fortunately the house was so full of bric-a-brac that I was usually terrified to move for fear of bumping into a piece of porcelain or glassware.

Quite apart from this, I had been exposed to a disconcerting experience at Alex's house the very first day I had visited it. Vincent had been obliged to go there on a Sunday to discuss something that was worrying Alex, and not knowing what to do with me, he brought me along. Alex was angry and distracted, and scarcely noted my presence. He and Vincent sat down on a sofa and began to argue in Hungarian, Alex giving those impatient, downward, chopping hand movements which always accompanied any expression of his disapproval, while my father kept up an endless succession of shrugs to indicate that whatever had gone wrong was beyond human repair.

In the center of the coffee table there sat a large open box of candied fruit peel, a delicacy of which I was then very fond, and I carefully reached over to take a piece when a voice clearly said, "Don't *touch* it!" I dropped the candied fruit as if it had been burning hot, somewhat alarmed by the fact that I couldn't see anybody or even tell where the voice was coming from. After a few minutes, I tried again, and the

same voice repeated, "Don't *touch* it!" now from another direction.

Even my father had noticed it this time, and though he could see no reason why I should not have a piece of candied fruit peel, he turned to me and said, "You heard: Don't touch it!"

Then, looking around the room he asked Alex if Merle or anyone else was home.

Alex looked preoccupied. "No," he said. "Why?"

"Well, then," Vincent said, "who is telling Miki not to touch the fruit?"

"What fruit?" Alex asked, and seeing it on the table he reached across to get a piece for himself, at which point the voice told *him* "Don't *touch* it!"

"Damn," Alex said, handing me the piece of fruit, "it's the bloody bird!" And there indeed, in a large cage by the staircase, was an evil-looking myna bird, that had apparently learned to mimic the human voice. Alex had the bird, which had been left with Merle's maid by Barbara Hutton, removed and went on with his discussion. All the same, the incident made me very nervous about visiting the house in Bel Air.

"Poor Alex," my father said in the car, on the way home to Beverly Hills, "I suppose every time he picks something up in his own house, the bird says, 'Don't touch it!' Never buy an animal that talks. Barking is bad enough."

MY IGNORANCE of French geography festered in Alex's mind, and he eventually forced my father to cast around for a better school. Vincent asked everybody he met at the studio, and finally chose a prestigious Beverly Hills military academy, where I was promptly sent, and outfitted in a uniform appropriate to a lavish production of *The Student Prince*. Small, fat and blond, I was dressed in sky-blue trousers with a gold stripe, a blue tunic with many inconvenient gold buttons and much black braid, a white crossbelt with a gold-plated badge and the kind of shako worn by West Point cadets in parade dress, with an uncomfortable patent-leather strap under my chin. I particularly disliked the heavy marching shoes, which had to be kept to a high military gloss, since we paraded every morning before class, to be inspected by our commandant, a fearsome and unctuous retired colonel of the

United States Army, who went over our uniforms like General Patton taking the salute of a battalion of midgets. The older boys even had dummy rifles, painted white, with chromium-plated bolts and bayonets that had been thoughtfully blunted. We marched, did calisthenics, and were taught to sing, swim, conjugate Latin verbs and pledge allegiance to the flag.

In general, my father hated anything to do with the military, and had always taken the view that the Boy Scouts were only a step away from the Black Shirts or the Nazi *Sturmabteilung,* but once he had satisfied himself that the school was the best to be had, he felt he had done his duty.

Shortly after my first month at the academy, my father he asked me what I thought of the new school. I told him that it was the finest school in Los Angeles. He asked why. "Well," I replied, "the commandant says it's the best school in Los Angeles because there aren't any kikes there." My father burned my uniform in the incinerator at the back of the garden, had a stormy scene with the commandant and placed me back in the public school system the next day. "Better ignorant than a Nazi," he said, and my mind was put back in cold storage while I learned to swear, smoke cigarettes and bully servants, like the rest of my classmates.

One reason Beverly Hills was a difficult place to grow up in is that there was no place to hide. In small towns, children can always escape to the woods or fields or strange hiding places. In large cities there are parks, vacant lots and unsuitable, exciting places where children are forbidden to go. In Beverly Hills neither condition existed; children were highly visible at all times. Between Sunset Boulevard to the north and Wilshire Boulevard to the south, there was almost no place to hide, just row after row of expensive houses and lawns, where the sight of a strange child would provoke instant response. An adult would spot you, demand to know your name, and phone home, or worse yet, phone the police, and you were swiftly deposited back on your own lawn again. Adventurous exploration was not encouraged, and hardly even possible, and despite California's reputation as an open-air paradise, most of the children I knew spent their time locked safely in their rooms, smoking cigarettes, reading comic books and dreaming of escape. It was recognized that once you had made it to sixteen, your parents bought you a car and you were free, but this seemed a long way ahead to most of

us who were restricted to riding our bicycles around the block on the pavement, without ever crossing a street.

IT WAS A PRETTY GRIM place at first for my mother, too. After being a well-known actress in London, with a life and friends of her own, here she was trapped in a house, with no career and nobody much to talk to. Every day my father went off to the studio, driving at 20 mph down the middle of Sunset Boulevard in his new Dodge two-door coupe, the kind that had only one bench seat and a big trunk behind for salesman's samples. It was not exactly a family car (two adults could barely squeeze into it), and no doubt Vincent selected it for just that reason. In any case, once it had gone, my mother was effectively stranded. She argued for a car of her own. My father could see no sense in this, but word of the disagreement reached Alex, and within a day her Chevrolet convertible appeared in our driveway.

Her driving career had hitherto been modest, but she was a gifted, natural speeder, perfectly adapted to breaking the speed limit from Beverly Hills to Malibu Colony down the length of Sunset Boulevard. Together, we explored Farmer's Market, the La Brea Tar Pits, Griffith Park, Santa Monica and the desert, with the top down and the radio playing such hits of the day as "When Veronica Plays Her Harmonica, Down Upon the Pier in Santa Monica." My mother took up sunbathing, swimming, health food, exercise and Gaylord Hauser, then already becoming known as Greta Garbo's guru and advisor on nutrition, health and the natural avoidance of constipation. These pursuits gave my father even more reason not to come home. The sight of figs, cottage cheese, Melba toast and grated carrots on the table, or even in the kitchen, offended him, and he sought the company of his fellow Central Europeans in the Hungarian restaurant off Santa Monica Boulevard, where he could eat proper food and digest in peace.

Also, he was busy. Alex had ambitious plans. He had promised Merle a movie in which she could star, to make up for the success of Vivien in *That Hamilton Woman,* and he was committed to make *Jungle Book,* which Zoli had been urging on him. Both films presented major problems.

*Lydia,* which was the wedding present or consolation prize he offered Merle, required the actors to "age," and since it was mostly told in flashbacks it proved exceedingly difficult to make—even Ben Hecht

could not produce a screenplay that made any sense out of an old woman's reminiscences about her loves and lovers in the days of her beauty. Both Merle and Alex were disappointed with the results.

*Jungle Book,* based on Rudyard Kipling's tales, was even more complicated, since it involved live animals as well as people. An Indian jungle was created on the studio back lot. Vincent spent a great deal of money building Kaa, the enormous, talkative water python, who was made of rubber stretched over an articulated frame, and moved by propmen with a tangle of wires hidden under the water. Kaa came to haunt everybody, such were the difficulties of moving him in a realistic manner.

By some lucky chance, I witnessed a rather amusing maritime catastrophe involving this creature. Despite his feeling that I ought to be kept away from movie sets, Vincent placed *Jungle Book* in a different category, more like a visit to the zoo. We turned up early in the morning on the big outdoor set, in which a fast-moving river had been constructed to run between artificial rocks in a jungle of rubber leaves, with real trees and plants closest to the camera. Sprinkler pipes sprayed this foliage to simulate dew, while propmen, hidden behind leaves in duck blinds, manipulated the long wires that made Kaa swim in sinuous, pythonlike curves.

I stood with Zoli, the camera crew and a crowd of onlookers on the camera barge, under a screen of palm fronds and umbrellas, while the more adventurous of the propmen swam up and down disentangling the wires that animated Kaa and shining his glass eyes with neutral shoe polish. Vincent sat on the bank, apparently asleep.

Kaa's performance did not satisfy Zoli, and the morning passed in tedious retakes. Kaa was supposed to swim, open and close his mouth and stick out his long, forked tongue. He seemed unable to do these things in the proper sequence, and each take involved lowering him downstream on his wires, while the barge was winched back at the same speed. The wires for controlling Kaa's mouth and tongue had to be moved at the same time. After each take Kaa and the barge had to be moved back to their original positions. Most of the takes were spoiled by the wires, which naturally were supposed to be invisible. "Vatch the vires!" Zoli implored, shielding his eyes with an old safari hat, a souvenir of his days in Africa.

Around eleven, a Cadillac limousine pulled up and Alex appeared,

as elegantly dressed as ever. He looked at the scene with distaste, shouting to Zoli that there were too many people on the barge. Indeed, the barge was beginning to list, since everyone stood on the far edge of it for each of Kaa's descents.

Zoli ordered some of the onlookers off, including me—which is why I was standing onshore between Alex and Vincent when the barge finally capsized, with a solid splash.

"Oh, damn," Alex said, as the camera crew swam to shore. Vincent shut his eyes.

Zoli was shouting and spluttering in the river. He was within Kaa's reach, and for a moment I thought he might have forgotten the snake was a dummy. The propmen froze, clearly on the assumption that Zoli was swearing at them, and Vincent said sadly, "Poor Zoli is angry."

Alex nodded. Zoli's anger was nothing new to him. Anyway he was not displeased: He had been proved right about the barge.

Zoli continued to shout, and my father opened his eyes. "Alex," he asked after a moment, "can Zoli swim?"

Alex frowned. "I don't think so," he said thoughtfully. "When we were children, he didn't learn, I don't think."

"I don't think so either," said Vincent.

Alex was suddenly galvanized. "My God," he screamed, "Zoli is drowning! Rescue him, somebody!" He rushed to the bank and with the help of Vincent and the propmen saw to it that Zoli was fished out with one of the long poles that was used for mooring Kaa between takes.

Coughing and spluttering, Zoli stood up on the bank, wringing out his hat. "Vy didn't you bloody help?" he asked.

Alex stared at his muddy shoes. "You should have shouted in Hungarian," he said. "A cry for help should always be in your native language. Only your own understand."

He made his way back to the Cadillac, lowered the window and shouted: "Get the second unit director to do the bloody snake! If I wanted to shoot a sinking, I'd make a movie about the *Titanic!* It will be in *Variety* I drowned my own brother."

Vincent sighed, moved toward Zoli to comfort him, looked at his face and thought better of it. He put his arm around me and said, "My poor boy, this is a silly business, film making. I was happier painting. If I'd stayed in France I wouldn't be nursemaid to a rubber snake."

Slowly, he made his way down to the barge, gave orders to have it pumped out and refloated and walked about cheering up the propmen and the crew. He regarded all the workers on a set as his children, knew their names, and listened patiently to their troubles. Zoli was impatient, Alex was distant, but Vincent seemed more at home among carpenters, plasterers, gaffers and technicians, and defended them whenever Alex complained about their unions or their problems, referring to them as "his boys." Vincent had a deep respect for manual labor, and once outraged Darryl F. Zanuck by telling him that the studio carpenters put in a harder day's work than Zanuck did. He liked people who got their hands dirty, and enjoyed getting his own dirty, with a painter's indifference to mess and grime. Alex, who had spent a lifetime keeping his hands clean, could never understand this.

Vincent paused to knock out his pipe on Kaa's head, producing a quick flick of the forked tongue, and took me by the hand. "Let's go find lunch," he said. "Maybe there's something in the studio restaurant they don't put pineapple slices and cottage cheese on. Go say goodbye to the boys. Remember: The people who do the work are more important than the people who give the orders, and don't ever forget it."

THE LIVE ANIMALS presented problems of their own. A real tiger was placed in the "jungle" to provide the long shots of Shere Khan, contained in a cunningly constructed fence which was designed to be invisible. For closer shots, Zoli had demanded a tamer tiger who could be photographed in a normal manner, but no animal trainer was willing to guarantee the safety of using a tiger this way, and nobody except Zoli was eager to try.

My father, who had been charged with the responsibility of producing a suitably docile male tiger, finally went to the head propman and asked him if this situation had ever occurred before.

"Sure," he replied, "lots of times—tigers, lions, cougars, you name it, Mr. Vincent."

How was it done? my father wanted to know.

"Well," the propman said, "the way it's done is you take a trained dog, the biggest goddamn dog you can find, and you put him in a tiger suit, and make up his face with whiskers, then you shoot through a gauze screen, and put the people in later with a matte process, about half life-size. That way the dog looks about twice the size he is, and

the scale is right. With the right kind of lighting, you've got yourself
a tiger."

This made sense to my father, but he knew perfectly well it would
not make sense to Zoli, who was unlikely to accept a dog as a tiger,
however good the make-up and ingenious the photography might be.
Still, he had no choice but to go ahead, and told the propman to order
the appropriate dog and get him made up. On the morning of the test,
Zoli was anxiously awaiting the arrival of his tiger—my father had
decided not to tell him about the dog until it appeared—and Alex
himself had decided to look in on the production. He too was unaware
of the deception, and since nothing was happening, he withdrew to his
location trailer. It had a set of steps leading up to a screen door,
windows, a ventilating hatch in the roof, and was equipped inside with
a bathroom, a refrigerator, a couch and the usual furnishings of an
office.

In those days, a personal trailer constituted a much-envied status
symbol. Stars like Joan Crawford had trailers that were decorated like
lavish bedrooms, with one whole corner given over to a make-up table
and elaborate bars, and they would retreat to these between takes.
Producers and directors, if they were prestigious enough, had their own
trailers, and these were frequently manhandled onto the sound stages
to serve as mobile homes, as well as being towed hundreds of miles for
filming on location.

Alex settled himself in his to work on the script (which as usual was
being invented on a day-to-day basis). He happened to look out the
window. There, at the foot of his steps, lay what appeared to be a tiger.
Nobody else was in sight, the entire company having vanished for a
coffee break. Alex opened the screen door a fraction and shouted at the
"tiger" to go away. The animal growled and began to advance up the
steps. A man with better vision might have noticed that the tiger was
somewhat small for a full-grown male, but Alex had his reading glasses
on. Now he was unpleasantly aware that there was nothing between
him and the tiger but a screen door. He placed a chair under the
ventilating hatch, climbed out onto the roof of the trailer, and closed
the hatch behind him. To his horror, he discovered that the hatch
could not be opened from the outside—he was stuck on the roof of a
trailer with a tiger stalking around below him, and his initial anger and
irritation gave way to panic.

He began to scream for help, which made the tiger even more active.

He threw his hat at it, then his cigar case, then one gleaming shoe, but the tiger obstinately refused to go away. Just then a man appeared from behind a forest of rubber and chickenwire trees, patted the animal on the head, and fed it a dog biscuit.

"Who are you?" Alex inquired.

"I'm the dog handler," the man replied.

"But that's not a dog."

"Oh, yes it is," said the man, and casually ordered the animal to sit up and beg.

"Get me a ladder," Alex said, "and get me Vincent. And send the bloody dog to lie outside L.B.'s trailer!"

Soon he was on the ground, and my father, scarlet with embarrassment, was being attacked by both his brothers, Alex accusing him of a stupid and dangerous practical joke, Zoli protesting that he was not about to shoot a scene with "a bloody painted dog." The dog, nevertheless, won, and remained in parts of the movie, and Alex henceforth walked around the sets of *Jungle Book* as if they were booby-trapped.

AS A PARTNER in United Artists, Alex had a major stake in Hollywood, and for a time he actually took over the chairmanship, replacing Mary Pickford, but mediating between his own demands and those of Miss Pickford, Sam Goldwyn and David O. Selznick was a full-time job in itself, and one with very little future. Alex also busied himself making arrangements for Ernst Lubitsch's *To Be or Not To Be*, securing Jack Benny to play opposite Carole Lombard by putting up $100,000 of his own money, and toyed with the idea of making *War and Peace* with Merle as Natasha and Orson Welles as Pierre. He fought off a lawsuit from Maria, who once again attempted to prove that their divorce had been invalid (and who settled for an increase in alimony).

Alex was still a secondary power in Hollywood, and he was far too ambitious to settle for this. He did not plan to be a Knight in exile forever. It was remarked that for somebody who intended to stay in California, he was making the long and dangerous journey to England rather frequently, at a time when only those with the highest priorities could fly the Atlantic, strapped into the bomb bays of new aircraft being delivered to England for the R.A.F. Anybody who could have avoided sitting for fourteen hours in a cold and noisy Lend-Lease "Liberator" would normally have done so, and it is a measure of Alex's

boredom with Hollywood and basic orientation toward England that he made the journey again and again. It was rumored that he was to take up a government post, and that Merle was going to retire. In reality Alex was testing the water on the far side of the Atlantic, and preparing to resume what he considered to be his rightful place at the head of the British film industry.

Vincent was well aware of Alex's plans, if only because Alex had asked him to perform what amounted to a piece of industrial espionage. Since Vincent had an office at M-G-M, he was busily acquiring the blueprints and designs of M-G-M's unsurpassed technical facilities, with the intention of creating a new studio in England that would be the most modern and well-equipped facility in the world. He was also aware that Alex expected him to return to England in the very near future, and that his departure would almost certainly create an irreparable breach between himself and Gertrude. For Gertrude, for her own reasons, could not go back. She had left England when it was on the brink of defeat, with much misery and many misgivings, and the prospect of returning when it was safe was something she would not consider. If Vincent went back, he would go back alone.

Perhaps he wanted to go back alone in any case. My mother had managed to scandalize *her* side of the family by falling in love with her own cousin, Tom Evans, Madge's brother, a charming, talented and attractive photographer who had thrown over his girlfriend Yolanda for my mother. He shared Gertrude's taste for fun and adventure, and brought out the best in her at a time when she was particularly vulnerable. After all, she had never wanted to leave London in the first place, and by agreeing to go to California with Vincent she felt that she had ruined her career, abandoned her friends and betrayed her country. Vincent did little to help her, since he was busy at the studio all day and a good part of the night, and in any case thought her misgivings were silly. It was sunny, there was orange juice, she had a nice house in Beverly Hills—he couldn't see that she had any cause for complaint. Under the bright sun of Southern California, my mother gradually reached the conclusion that she would be better off living her own life.

Tom, with his easygoing charm, his good looks, his streak of wildness, his fast convertible and his thirty-foot fishing cruiser at San Pedro (still tactlessly named *Yolanda,* however), was a startling contrast to Vincent. Though he was stubborn (he fought an endless war, consisting

of rebellion and practical jokes, against Maud Mary, his mother, and Madge Evans, his sister, who had always outshone him as the child-star of the family), he was, by comparison with my father, a relatively pliable personality. Unlike my father, he not only loved Gertrude but *needed* her. He had gone out of his way to make Los Angeles interesting for his cousin Gertie and was unselfishly kind to me, even before he realized that he was in love with my mother. He took us to Catalina on the *Yolanda*, and when he discovered how much I liked Heinz tomato soup, he packed cases of it in the bilges as ballast. His life's ambition was to catch and land a broadbill swordfish, and we cruised the waters off Southern California in search of them, but no matter how many we sighted, none would take the bait, though we sometimes trolled flying fish under their very bills.

With Tom's help I learned about boats and about fishing, and actually landed a blue marlin three times my size. Tom was impulsive, reckless and endlessly enthusiastic. Once, when we were anchored off Catalina, he bet me a quarter that I couldn't swim the mile or so from the boat to Catalina Pier; I dived in, and made halfway before I looked down to find that I was being accompanied by a very large shark, swimming a few feet beneath me in the clear water. I let out a scream, but Tom and my mother, who were too far away to hear me, cheerfully waved me on from the flying bridge of the *Yolanda*. Since I was obviously not going to be rescued, I swam on, unable to remember whether sharks are attracted to noisy splashing or frightened by it. Luckily, my shark was indifferent, and as I desperately churned toward the beach, it rose to the surface and followed me at a steady, even pace. By now, I had gathered quite a considerable audience on the pier. Some of them had been following the progress of my long-distance swim with mild interest. Now the sight of a large shark fin behind me produced something of a sensation. I could see people running up and down the pier and waving at me. I kept swimming until I finally arrived on the shingle beach beside the pier, where several dozen people waded in up to their knees to haul me out. Somewhere along the way, the shark had lost interest and sounded.

Tom and Gertrude had watched all this excitement from the boat, and assumed that I was being congratulated by well-wishers, the way Gertrude Ederle was as she finished her Channel swim. It seemed to them a little odd that a swim of one mile would elicit such extraordinary

enthusiasm, but since anything is possible in Southern California, they got into the dinghy and made their way to shore to share in my triumph. To their surprise, they were greeted by people in the mood of a lynch mob, demanding to know what kind of parents they were to allow their child to swim in shark-infested waters, and to sit there, drinking Rum-and-Cokes, *watching*. The crowd's mood was not improved when Tom pointed out that I was not, in fact, his child at all, and we were soon surrounded by reporters and policemen, with the result that I made my first appearance in the Los Angeles newspapers in the form of a shark-escape story, much to my father's annoyance. He had a horror of child stars, and was more unhappy to read about me in a newspaper than he was at the fact that Tom and Gertrude had been photographed together as a couple, thus making their affair public.

Worse was to come in the same week. To Nanny's pleased surprise, I was invited to tea at Alex's house in Bel Air. My mother accepted, without bothering to tell my father, and left me there, apparently not noticing the presence of a team of photographers from *Life* magazine. *Life* had been anxious to do a photo essay on "The New Hollywood," in which, as they put it, stars shun "the fast, shady, phony, fly-by-night pretentiousness that once made Hollywood a cross between Babylon and a Wild West boom town," in favor of having fun with their children. My cousin David and I appeared prominently in *Life* the following week playing blindman's bluff with Merle, while Nanny Low and Nanny Parker, out of focus, could be seen in the background exchanging disapproving glances.

My father's reaction was explosive. Children, he felt, should be anonymous and invisible, and certainly not used as part of a publicity campaign. The incident added to his dissatisfaction with Hollywood in general, and my mother in particular.

Mostly to get away from home, he took me skiing, and spent more time with me than he had ever done in the past, or was to do again. He helped me ski the slopes of Sugarbowl, holding me between his own skis, let me sit up with him late at night in the hotel's bar, and allowed me to prowl around the hotel at night in my blue flannel pajamas. Though he was often silent, I learned from him that silence is not necessarily indifference or hostility. He simply had nothing to say.

I came back from Sugarbowl sunburned, and a few weeks later, we

drove to see Yosemite National Park, my father in his battered gray
fedora hat from Locke's and a pair of heavy Austrian hiking shoes. He
was not impressed by Yosemite—museums interested him more than
scenery, however spectacular—but he was delighted to discover that
the man who managed the campground was a fellow Hungarian, and
was content to sit under the redwoods with a glass of beer, talking
Hungarian and frowning at the bears, who interested him even less
than the landscape. At night we shared a single bed in a rustic log cabin,
where he was kept awake by the fact that I grind my teeth in my sleep
(he used to say that the thousands of dollars he paid for my orthoden-
ture would be well spent if he never had to hear that sound again).

On our last day, he took me for a walk in the woods, and sat me down
on a fallen tree trunk, clearly intent on saying something. He sat silent
for a long time, then he sighed. "Lots of things are . . . difficult," he
said. "You will understand, I think, later on."

I nodded, though I was not sure about the meaning of this cryptic
admonition. He searched for something more useful to add, then gave
up.

"Poor Miki," he said, taking me by the hand. We walked back to
the wooden cabin, with its log fire and its Indian blankets.

He had done his best, but what he wanted to say, he couldn't, which
was that the life we had known was coming to an end. He was returning
to the world of bachelorhood and work that he had always loved best.

He wanted my mother to be happy—other people's unhappiness
always filled him with dread and depression—and no doubt he hoped
that she would be all right with Tom. He believed he was doing the
best thing for everyone, though as was so often the case with the
Kordas, this coincided with what he wanted to do himself. I knew,
because I overheard them, the arguments he had assembled to justify
his departure: that I would be better off in California, that a boy my
age should be with his mother, that England was still dangerous, that
it would surely be a bad idea to transplant me again, that school in
England would be too harsh for a child who was used to Beverly Hills.

Still, nothing prepared me for the day when Vincent stood on the
lawn of the house, surrounded by his battered and much-traveled lug-
gage, and kissed me goodbye.

HAD MY FATHER been able to foretell the future, he might have decided to stay. Everybody was not destined to live happily ever after, as things turned out. Against his mother's wishes, and against Gertrude's, Tom joined the United States Navy as a combat photographer, and Gertrude followed him to the East Coast, to be near him, leaving me in Los Angeles with Nanny, where we lived for a time in a small bungalow at the foot of Zoli's garden. Tom, who had always said he was the lucky person of the Evans' family, contracted pneumonia, came home and shortly thereafter died.

Alex, on one of his flying visits to New York City, quickly took in the situation, told Vincent to double Gertrude's alimony, arranged to get her a large apartment on East 86th Street, opposite what was then the Croyden Hotel, then sent for Nanny and me, ordering me, during a brief interview, to cheer my mother up. But this was not easy to do. Despite my father's hopeful plans, I had been transplanted once again, shoved into yet another strange school, and left in the care of Nanny, who was in nominal charge of the household, a stranger in New York, but as adaptable as ever. Indeed it began to seem that she might have a lifetime job, for my father was now 3,000 miles away, and my mother alternated between grief and her theatrical ambitions, perhaps not really able to tell the difference between them. Under the circumstances, Nanny and I lived together rather like an old married couple, apparently stuck with each other until one of us should die. Much as I loved her, I began to feel that I might well be the first to go, and fiercely resented the fact that I was the only child in P.S. 6 whose nanny waited for him outside the schoolyard.

MERLE HAD NOW BECOME an international star. Her career was bound to Los Angeles; Alex felt the strong pull of England. No doubt he had hoped to keep alive the fiction that he intended to stay on in California struggling for control of United Artists by returning to England in gradual stages. By and large he succeeded. Each of his visits to London in 1942 was slightly longer than the one before. Zoli could not help noticing that while Alex traveled east with as much luggage as he could, he returned with nothing but an overnight case—he was gradually ferrying his clothes across the Atlantic to Claridge's.

As a result, it was difficult to say exactly when Alex had effectively moved his base of operations. He was still being invited to parties in Beverly Hills when he was in fact living in London, and nobody was ever quite sure of his ultimate intentions. There were no formal fare-wells—Alex was just seen less often.

ONCE AGAIN, Alex was leaving Hollywood—and a marriage—to trans-form the British film industry. He sent Vincent ahead to prepare the way, but still he needed a position from which to operate, studio facilities and financing. These he found by making a deal with Louis B. Mayer, who was providentially looking for someone to run M-G-M's British operation.

Alex regarded Mayer as an uncouth despot; Mayer had never made a secret of the fact that he thought Alex was a jumped-up Central European *Luftmensch* with intellectual pretensions. However, the two men shared a bottomless ability to hide their feelings in the interests of business, and the instinctive pragmatism common to men who have fought their way up from poverty to power. Alex put himself out to secure Mayer's support, which was easy enough to do, since for reasons of his own, Mayer was unwilling to have one of his own executives take over the London job and was therefore happy to propose Alex as chairman, managing director and production supervisor of a new com-pany, to be formed by merging Alex's London Films with the remnants of M-G-M (Great Britain) Ltd. into a single entity, which would have as its emblem a composite of London Films' Big Ben and the familiar face of Leo the Lion. Mayer and Alex journeyed to New York to sell this imaginative package to Nicholas Schenck, the head of Loews, Inc., which controlled M-G-M. Schenck agreed to it largely because he thought it would fail and that its failure could then be used as another weapon in his lifelong struggle to destroy Mayer. Schenck had a good deal of respect for Alex, who had done him out of a contract with Vivien Leigh in 1936, by winning the right to make her a first offer for a movie contract on a bet over dinner at the Savoy Grill.

Just as Alex had first arrived in England in 1931 to run the British subsidiary of Paramount, he was now coming home to run M-G-M's subsidiary, a fact which did nothing to cause good feelings among his rivals in Britain. For three harsh years the British film industry had

been working through the rigors of austerity, bombing raids and depri-
vation, and those who were now returning from a timely exile in
California were referred to in the press as "homing pigeons," and
worse.* It did not make matters better that Alex had elected to return
as the head of an American company, with the promise of major
American financing, and he was greeted, in many cases, by outright
hostility, despite his knighthood, or perhaps because of it.

How much Alex resented this is open to question. There was a
ruthless streak in his nature behind the façade of charm, and he re-
turned to England a little in the spirit of Ulysses sailing home to Ithaca,
determined not only to regain his rightful estate, but also to put his
rivals back in their proper places. When ego or self-interest were in-
volved Alex could be harsh, authoritarian and vengeful, and while he
did not enjoy publicly humiliating people who had offended him, as
Mayer and Cohn and many other Hollywood notables so obviously did,
he was a bad man to have as an enemy.

He did not take kindly to disagreement, and disliked being thwarted
or contradicted. Something of an actor himself, he was able to deal with
actors and their problems on their own terms; and as a director he
understood and sympathized with the problems of directors. But in
most other areas he was determined to have his own way; and when
charm failed, he was quite capable of rudeness, evasion and betrayal.
Once, when an English producer, astonished and angered that Alex
had failed to live up to a bargain, pointed out that they had "a gentle-
man's agreement," Alex shook his head, and replied, "Ah, but for that,
my dear friend, you need two gentlemen!"

ON HIS RETURN to England, Alex avoided the house on Avenue Road,
which had been bombed and which was in any case a repository of
many sad memories. He took the penthouse of Claridge's, and pro-
ceeded to decorate it with a lavish collection of antique furniture and
fine paintings. The Rolls and Bailey, the chauffeur, were restored to
service, and Benjamin, the rotund and long-suffering valet, who was to

---

*Vincent put an end to this, when he returned to England. Puzzled by the phrase,
he asked one of Alex's critics, "What is all this about homo pigeons, please?" a question
which produced so much laughter that it eventually stifled the criticism.

become a member of the household for years, was added to the retinue. For the next ten years, Alex was to inhabit perhaps the largest and most expensive hotel suite in the world.

He had no studio; it was by no means certain that the MGM/London Films connections would or could work; his relationship to United Artists was of doubtful value here in England; and most British talent was employed either in the war effort or under contract to J. Arthur Rank, the dour flour-mill millionaire whose real estate interests and passion for Methodist proselytizing had brought him somewhat reluctantly into the film business, where he remained because it seemed God's will. Rank was a pragmatist and a hardheaded businessman, with a romantic view of film making; Alex was a romantic, with very little interest in day-to-day business, but with a realistic view of film making (which he understood) and an infatuation with high finance (which he approached in the spirit of a talented amateur). Since each man envied the other's strength in one area without recognizing his own weakness, they were bound to become rivals, which is a pity. A partnership, however, was out of the question. Alex wanted to outdo Rank as a financier; Rank wanted to outdo Alex as a film producer. The notion of Rank as the financial man and Alex as the film man in a single organization was unthinkable to each of them, and after a few meetings, they referred to each other ever after as "poor Arthur" and "poor Alex."

Alex had no such ambivalent feelings toward L. B. Mayer, whose heavy hand he resented even at a distance of 6,000 miles. Swallowing his boredom, he had attended L.B.'s stultifying dinner parties (on leaving Los Angeles, he had remarked, "Thank God, no more roast goose!" referring to L.B.'s favorite dinner menu), and listened to L.B.'s interminable monologues about how he had always been right and everybody else—Thalberg, Schenck, Goldwyn, his sons-in-law Goetz and Selznick—had always been wrong, as well as disloyal and spineless.

Alex was not happy in the role of a "yes-man," but so long as he needed the M-G-M connection, he had very little choice, and on his arrival in England he actually announced plans to make *The Hardy Family in England* and an English addition to the *Dr. Kildare* series, both clearly invented as sops to L.B.'s ego, since Mayer had a personal commitment to these two staple items in M-G-M's product line, and regarded them as perfect expressions of family entertainment. Indeed,

he made a habit of showing the Andy Hardy films to new directors
and producers at M-G-M as examples of the kind of wholesome
American pictures he wanted to see—that the public expected to see
—under the seal of Leo the Lion. Mayer was quite capable of enact-
ing whole scenes from the movies, with tears running down his sallow
cheeks. Given a choice between Rank's Methodism and Mayer's
faith in the drawing power of sentimentality, Alex would no doubt
have chosen Rank, but he was now committed to creating an inde-
pendent English equivalent to the M-G-M production line at Culver
City. Since L.B. admired people who "thought big" (and destroyed
those who did not), Alex swiftly set about spending M-G-M's British
funds. He signed up whatever talent he could find, purchased a stu-
dio at Elstree (which remained in the hands of the Ministry of Sup-
ply as a storage facility) and leased a handsome house in Belgrave
Square as M-G-M's London headquarters.

IN THE FORTIES AND FIFTIES most people in England wanted to see
American films. Even had the public been willing to accept a steady
diet of British pictures, the British film industry could not have
hoped to supply enough product to fill the movie theaters of a nation
of 50,000,000 people.

As a result, American motion picture companies took out of England
many millions of pounds a year. These vast sums had a critical effect
on the nation's precarious balance of payments. Just as Americans are
now learning what happens when a country spends more on imports
(as in foreign oil, German cars or Japanese electronics) than it earns
in exporting its own goods, the British had to come to grips with the
brutal fiscal truth that their currency would collapse if they continued
to buy more goods in dollars than the value of their exports to the
United States.

Since Britain's exports to the United States at the time were few,
and with the exception of Scotch whiskey, relatively minor, while food,
gas, modern industrial machinery, tobacco, films and countless other
major needs could only be supplied by America, Britain's dollar balance
was announced by the Treasury every month with much the same
gravity as would be the pulse rate of a cardiac patient. The news was
usually bad. Though tobacco, whiskey and gas were strictly rationed,

the British still spent far more in the United States than they could ever hope to earn, and successive Chancellors of the Exchequer sought new ways in which to reduce and discourage exports that had to be paid for in dollars.

Under the circumstances, the $80,000,000 a year it cost to keep British filmgoers happy and the British movie theaters full was a subject of much criticism, scrutiny and debate. If the British movie industry were capable of selling $80,000,000 a year worth of British films to American exhibitors, then the deficit would be canceled out, but this was clearly a task beyond the scope of the British, who had neither the capital nor the facilities to undertake production on this scale.

There was a further problem which the government ignored: British mass audiences liked American films, but the American mass audience for British films was problematic—British films usually played in "art houses," not on general release.

Tempted by the possibility of vast dollar earnings, and horrified by the vast cost to the Exchequer in dollars of supplying the British public's need for entertainment, the government vacillated between providing capital to expand the British film industry and setting a limit on the amount of money American film companies could take out of England. Mayer and Alex had shrewdly prophesied that some kind of protectionism would eventually be imposed, and Alex therefore arrived home with a very tempting package. M-G-M would use a part of its British profits to produce films in England; these films would then be shown in the United States, where they would earn more dollars, thus easing the one-way flow of dollars in two stages. By spending M-G-M's money in England, Alex was performing a patriotic act; if his production plans were successful, he would return more dollars to the Exchequer. Everybody would be happy, on the condition that M-G-M made a profit somewhere along the line.

Given the shortages and difficulties of film production in wartime England, and the fact that the Ministry of Supply was unwilling to vacate the Elstree studio, Alex was hard put to make anything, let alone carry out the ambitious plans that he and L.B. had drawn up. Though he had sworn not to direct another movie himself, he made *Perfect Strangers,* starring Robert Donat, Deborah Kerr, Ann Todd and Glynis Johns, which had a remarkable success in England and even did quite well in America, considering that it is a rather quiet English marital

drama, but there could be no disguising the fact that he spent over one million pounds with very little to show in the way of earnings, and in Culver City the lion began to growl.

L.B. reached the conclusion that he had been taken, and there is some reason to believe he had. It is possible that Alex *intended* the MGM/London Films effort to fail. From his point of view, he had needed a means of returning to film production in England, and one which allowed him reentry on a grand scale. Now that he was back and once more established, he no longer needed L.B. and was in any case fed up with the steady stream of advice, admonition and threats from California. He was never happy as a subordinate, let alone as a subordinate to Mayer.

Sensing that the end was near, he returned to Hollywood to endure a weekend of recrimination with L.B., disposed of his holdings in United Artists, bought back his old films from the Prudential for a ridiculously low price ("Like one's grandchildren," he said, "they will keep me in my old age"), and reconstituted London Films. For once he was financing himself: The sale of his shares in United Artists had brought him nearly a million dollars. He began to build, as usual, on a lavish scale.

On the practical side, he purchased a studio at Shepperton, and set Vincent to the task of modernizing it. To ensure distribution for his films in England, he bought a controlling interest in British Lion, one of the few independent film distributors in England, and he even purchased the Rialto Cinema, on Leicester Square in the "West End," to give himself a major first-run theater.

Not content with that, he bought the mansion at Hyde Park corner which had belonged to the King when he was Duke of York, and in which the little princesses had grown up, and there, across the street from Buckingham Palace and next door to the Duke of Wellington's Apsley House, he constructed perhaps the most expensive head office that any movie company has ever enjoyed. Antique furniture was installed, the shelves were filled with leather-bound books ("My God," exclaimed one American visitor who had assumed they were fakes, "he even has real books!"), the chandeliers were cleaned and the main offices received magnificent Oriental carpets. A screening room was installed, as well as a canteen for the staff and the chauffeurs, and the halls were hung with huge Italian architectural paintings and land-

scapes, like a museum. Alex had always been a gambler, but he was now launching on the biggest gamble of his life: with the sale of his United Artists shares, he had put everything on the table.

THE WAR YEARS were hard, for if Alex had escaped the Blitz, he returned in time for the V-bombing of London, and went to bed every night very conscious of the fact that the penthouse of Claridge's was an exposed and dangerous spot to be in. The windows were frequently blown in by explosions, and the production of *Perfect Strangers* had been made exciting by several near-hits, one of which had nearly cost Alex his life. It cannot be said that he was exhilarated by the danger —on the contrary, he was both lonely and depressed—but he enjoyed the feeling that he was at last sharing the British war experience with his critics, and each bomb blast served as an answer to those who had accused him of running away to safety in California. He took a grim satisfaction in inviting the people who had been most vocal in their criticism to dinner at Claridge's, where they were obliged to sit eating as the bombs went off on rooftops all around them, since their host refused to take shelter in the cellar, their eyes glancing nervously at the ceiling as the chandelier tinkled and the plaster drifted down onto the table with each nearby blast. Alex was malicious enough to behave with exemplary courage, keeping up the conversation and gently urging more wine on his guests, though in fact he had a horror of being buried alive in a cellar, and preferred, as he put it, "to go out in my own flat at my own table in one big bang, instead of drowning or suffocating with the hotel staff."

The austerities of England bothered him less, since he managed to avoid them. Transatlantic visitors supplied him with cigars from his humidor at Dunhill's on Fifth Avenue (the duty was one pound per cigar), and his guests were always astonished to find that Alex had even the scarcest of items in abundance. When one lady complimented him on a magnificent *filet de boeuf* (at a time when meat was rationed to six ounces per person per week), he gravely replied, "Isn't it wonderful what a good chef can do with the ration?" Whiskey, then hard to come by since it was one of the country's few viable dollar exports, was kept in two red-and-white-striped eighteenth-century porcelain spirit kegs, and an understanding with the Soviet Embassy (where there was great

gratitude for Alex's gift to the Russians of *That Hamilton Woman*) ensured a steady supply of good caviar. All the same, Alex found London somewhat claustrophobic. He disliked being cold, and he hated the dark nights of the blackout, the gloomy dimming of the electricity and the general atmosphere of restriction and exhaustion. "Everybody has colds all winter long," he complained. "All you can hear at the studio is coughing and sneezing." He himself did not feel well; he was tired, under strain, suffered from colds himself, and was afflicted with a number of allergic skin problems, variously attributed to overwork, nerves, ration soap or the breakup of his marriage. He had occasional palpitations, which worried him, though not enough to alter his diet, his workload or the number of cigars he smoked.

In 1945 when he returned to California to work out the details of his divorce with Merle, he collapsed at the table during a dinner party at Romanoff's. Suspecting that it might be a heart attack, he decided to pay no attention to the incident. He had, as he put it, "too much at stake to become a bloody invalid."

THERE WERE THOSE who criticized Alex for the extravagance with which he launched, or re-launched, London Films. But Alex's appraisal of the situation seemed to compel this life style. In the first place, since he intended to compete with Rank and had nothing like Rank's capital to rely on, he was obliged to put on a dazzling show. No sooner had Rolls Royce reopened its car production line than Alex ordered one of the first of the new, postwar Rolls limousines, with a sliding roof over the chauffeur's compartment, pigskin upholstery, electric windows and matched burled walnut woodwork. He felt it was no more than an appropriate gesture for his new beginning.

More important was the fact that Alex's ambition was not to make films but to build up a giant film corporation. He had long complained that directing pictures was "like going down to work in a mine." He saw no reason to continue directing himself when he could spend his energy creating a motion picture corporation which could afford to hire the best directors in the world.

Finally, he knew that the size of his undertaking was a critical factor in its survival. The British government was irrevocably committed to expanding the domestic film industry to halt the dollar flow, and while

it might stand aside if a small company got into trouble, it could hardly fail to support a major film studio with hundreds of employees, should the need ever arise. His insurance was the very size of his gamble.

Alex, despite his predilection for grandiose press releases (he was still announcing the forthcoming production of *War and Peace,* though no longer with Merle as Natasha), was a pragmatist, like all survivors. It was H. M. Government which radiated optimism, as if films were a commodity—so many of ours for so many of theirs. To the Socialists who took office at the end of the war, after Churchill's defeat, Alex seemed like the perfect man to do the job. After all, he was not a capitalist and a mill owner like Rank—he was European, an intellectual; it was discreetly rumored that he had been a leftist in his native Hungary. And he knew more about the Hollywood motion picture business than anyone else in England. Surely if anyone could make movies in England that would break into the American mass audience, it would be Alex, whose transatlanticism was famous.

What few people understood was that Alex had never really given much thought to the American audience. He remained essentially European. His great successes in the United States—*Henry VIII, That Hamilton Woman* and *The Thief of Bagdad*—were accidental, rather than the result of any profound knowledge of American taste. During his unhappy experience in Hollywood from 1927 to 1930, he had been typecast as a director of "European" films. He was unlucky enough to have reached Hollywood just as the American movie industry's inferiority complex about foreign pictures was coming to an end. The days when a Von Sternberg or Von Stroheim could take the town by storm were over, and the Europeans, with their strange accents and costumes, their monocles, their haughty superiority and cultural knowledge, were becoming comic figures even before sound put an end to most of their careers.

It was a cliché that Hollywood people knew nothing about the land between Los Angeles and New York (known, after the advent of transcontinental flight, as "the fly-over"), but in fact most of the more successful producers, however European and/or Jewish their roots, had a deep and instinctive understanding of the American mass audience's taste and needs. That is not to say they did not make mistakes, but Mayer, for example, was not wrong in his enthusiasm for Dr. Kildare and the Andy Hardy series. He knew that certain formulas worked, that

Americans liked sentimentality, action, spectacle and stars, that they wanted to be comforted, not challenged or instructed, and that sophistication was a death blow to a movie's chances. The quality of a movie was less important than its being securely placed within an existing category, and certain categories had a better chance of working than others.

Alex's belief in the "international" film—a big historical drama about famous personalities or events—was sound enough, but his choice of subjects was still governed by European priorities, and his own cultural sophistication, as well as by a perfectly natural desire to please the English by choosing British stories, wherever possible.

Later, when in fact it was too late, he realized this was a mistake, and emerged with a group of less ambitious films like *The Third Man*, *An Outcast of the Islands* and *The Sound Barrier*. But his first instinct was to stake everything on the international spectacles he himself understood best. It was with this in mind that he committed London Films to making *Bonnie Prince Charlie* (starring David Niven), Oscar Wilde's *An Ideal Husband* (starring Michael Wilding and Paulette Goddard) and *Anna Karenina* (starring Vivien Leigh). London Films' production schedule in the early postwar years was far larger than this, and many of the smaller films were very successful, like *The Winslow Boy* or *The Fallen Idol*, but the success or failure of Alex's gamble would effectively be decided by these three films, if only because of their size and cost.

THEY REPRESENT a curious—and revealing—choice of subjects. The appeal of *Bonnie Prince Charlie* as a movie story is fairly obvious, a romantic historical subject if ever there was one, but someone more familiar with American audiences than Alex might have questioned the box-office appeal of the Stuart uprising. Had it been based on a best-selling novel (and had it starred someone more popular in America than Niven) it might have worked, but instead it was a semifictionalized retelling of an event of very little emotional significance except to the Scots themselves, who were bound to be bloody-minded and nitpicking about any movie based on the life of their hero.

*An Ideal Husband* represents Alex's love of irony and paradox—Wilde's dialogue reads like the quintessence of what Alex and Biró had

been aiming toward for thirty years—and combines a biting portrait of aristocratic life and morals with the possibilities of a lavish and expensive *fin-de-siècle* treatment. The cost of Cecil Beaton's costumes alone would have been enough to finance a small movie, and the sets were planned with reckless extravagance.

*Anna Karenina* was possibly Alex's way of admitting that *War and Peace* was too ambitious a project for the moment, and also an attempt to find a suitably grand starring role for Vivien Leigh, the only British female star whose name commanded respect in Hollywood or was known to American audiences, thanks to *Gone With the Wind.* Here, too, Alex's choice presented obvious problems. In the first place it had already been filmed, with Greta Garbo as Anna, in 1935; in the second place it could only have worked if Vivien had been able to play with and against Larry as Vronsky instead of the comparatively weak and unknown Kieron Moore, and finally the age of mass-audience interest in film versions of European classics was over, and would not reappear until the birth of public television twenty years later. Unfortunately Larry and Vivien declined to star together as lovers, and the failure to find a major star to play Vronsky doomed the movie.

With this ambitious program before him (luckily Alex could not foresee the results, although he had gloomy premonitions about *Bonnie Prince Charlie* from the moment he saw the tartans, which he hated, and heard the bagpipes which were to serve as background music), he was fully occupied, as was everyone around him. He complained that the film unions made it impossible to work in his old style, starting late in the morning and ending late at night; but in fact Alex, whose Tory opinions on the subject of trade unions were strongly voiced in private, got along well enough with them, mostly by delegating my father to run the studio and deal with the shop stewards. However cranky and stubborn the film crafts unions might be, they were far less powerful or troublesome than their Hollywood equivalents, and Alex, who had worked on both sides of the Atlantic, knew it. He was widely praised for his "sympathetic understanding" of the unions' problems, but in fact he regarded them as a nuisance, and deeply resented the existence of an authority parallel to his own at Shepperton. A decade of dinners with Brendan, Winston and Max had taken its toll, and Alex, who was perfectly at ease with Socialist Ministers, no longer had the patience to deal with the demands and disputes of the unions.

But part of Alex's problem was that he no longer *wanted* to. It was not that good living had spoiled him—he had always lived well, after all—but he was no longer the talented, ambitious foreigner trying to break into the establishment; now he *was* the establishment. Underneath the irritability and nervous strain that Alex now occasionally allowed to be seen was the fact that he was an unhappy and lonely man at last beginning to feel his age. He was fifty-three years old, no great age to be sure, but not an age at which most men expect to rebuild an empire.

He felt, somehow, cheated of what other people had—family ties, love, companionship, warmth, enthusiasm, and though he was reputed to have had an affair with Paulette Goddard (this may have been the reason for the otherwise inexplicable decision to cast her as Mrs. Cheveley in *An Ideal Husband*) and still acted as father confessor to Vivien Leigh, he was oppressed by the failure of his two marriages. The second bathroom in the flat at Claridge's always contained a new toothbrush, wrapped in its cellophane package, for any lady who might stay the night, as well as a selection of perfumes, bath salts and cologne, but however often the toothbrush was replaced (and only Alex's valet Benjamin knew), Alex usually slept badly and alone, forcing himself into an uneasy sleep with brandy, late-night reading and pills, waking at the slightest noise and ringing for poor Benjamin to open the windows or close them. It was often rumored that Alex, cunning as ever, had devised for himself an infallible method of seduction for those ladies who might be persuaded to stay overnight and use the guest toothbrush. Once they had agreed to stay for a drink, Alex would draw close, and explain in the most apologetic way that he was impotent. Nothing had helped, nothing *could* help, he explained, it was a great tragedy, but he had learned to live with it. Doctors in Zurich had failed, analysts had failed, there was nothing to be done about it . . . Most women were sympathetic (after all, how many men will admit to this kind of thing?) and not a few felt challenged. Alex would protest. The best, the most beautiful women in the world had tried and failed, it was no good, hardly even worth trying, why not have another glass of champagne instead? As the woman sought to prove that she could succeed where so many others had failed, Alex would smile, and whisper, "My God, I think something is happening! It's a miracle!" No doubt the "miracle" was repeated many times, but there was still no

constant companion to share the big penthouse at Claridge's, or to replace Merle.

Emotional failure preyed on his mind. He was the survivor of two marriages, one of which continued to plague him in the form of problems with Maria. Her demands for money alternated with shrill threats of scandal. She still claimed the right to be called Lady Korda, and Alex paid happily to keep her away from London ("Money well spent," he called it).

In the absence of warm relations with a wife and child, now more than ever he felt the need to gather together what he had in the way of a family. He wrote long letters to Zoli begging him to return, outlining the many virtues of a European education for David. Zoli resisted: He liked Los Angeles, Joan had made a life for herself there; the success of *Sahara*, which he had directed with Bogart as the star, increased his sense of independence.

With Vincent, Alex encountered less resistance. Vincent, in any case, felt guilty at leaving me behind, and could never say no to Alex. "After all," Alex said, "it's time for Miki to grow up, and a boy needs a father."

Repressing whatever doubts he may have felt, Vincent obeyed and sent for me.

# PART TWO

# CLOSE-UP

# CHAPTER 6

~~~~~~~~~~~~~~~~~~~~~~~~~~~~~~~~~~~~~~~~~~~~~~~~~~~~~~~~~

L̲VERY MORNING at ten Benjamin saw Alex to the door of the apartment, brushed off his jacket, gave him his hat (an immaculate gray Homburg from Locke's), helped him into his gray tweed overcoat, if the weather was appropriate, slipped a black morocco leather gold-monogrammed cigar case with two Dunhill Montechristo English Market Individuales into the pocket, rang for the lift, and said "Have a good day, Sir Alex." Alex seldom replied. He found conversation of any kind in the morning difficult to bear, and Benjamin, like most valets, was a relentless chatterer.

Benjamin, with his dark, plump, epicene face and his rotund figure in a black jacket and striped trousers, his tiny feet in patent-leather pumps, looked quite like a penguin, if you can imagine a penguin with jowls. He had the rolling gait of that bird, for that matter, together with the surprised eyes—for Benjamin's feelings were easily hurt, and he cried rather often, sometimes in front of guests.

About once a month Alex fired him, as on the occasion when Benjamin came into the living room during a dinner party holding up a necktie and said, "Oh, Sir Alex, you've dropped a spot on the lovely new tie I bought you at Sulka's. It's too bad of you!" He was fired when he forgot to pack Alex's cigars in his suitcase on a European trip, fired

for revealing to Vivien Leigh that Alex was suffering from a mild case of piles, fired for ordering a dozen silk shirts from Harvey & Hudson that were one size too small, then accusing Alex of putting on weight, fired for lisping, fired for drinking crème de menthe on duty, fired for wearing too much Pinaud Lilas Végétal or using scented soap, and fired for saying to Alex, "I hope we've enjoyed our bath" like a nanny or a hospital matron.

Each time he was fired, Bailey the chauffeur, a serious, silent man who had lost the tips of his fingers to some machine in his youth and whose dignity was as impressive as a bishop's, would intercede for him. "Ben's not a *bad* chap," he would say, on the drive to the office or studio, "and you know, Sir Alex, not too many people could look after you so well . . ."

He was right. *Nobody* could look after Alex like Benjamin, who served his master with an unrestrained passion that Alex found suffocating. Alex's shoes—dozens of pairs, each handmade by Lobb, each with a hand-carved shoetree with Alex's name engraved on a brass plaque —sat in neat rows, brought to gleaming perfection by Benjamin's magic touch. Alex's shirts—hundreds of them, from Sulka, or Knize, or Harvey & Hudson, cream silk, gray Sea Island cotton, pale-blue and off-white voile, each shirt monogrammed, each one with buttons on the cuffs (Alex hated cufflinks), each handsewn to measure—were stacked in specially made drawers, wrapped in individual cellophane envelopes. Alex's black silk socks, his faintly checkered gray silk ties, the Irish lawn handkerchiefs (double-size, so fine they would float in the air if opened and dropped, delicately embroidered with Alex's initials), the hand-made silk undershorts and the starched piqué evening shirts, all these things, and much more, were in Benjamin's care.

He dusted those objects too valuable for the maids to touch, poured Alex's bath (checking the exact temperature with a silver bath thermometer from Asprey's), filled the flat with flowers, put on his green baize apron to polish the silverware, kept the keys to the liquor closet and the cigar humidor, pressed and cleaned Alex's clothes, helped to serve at table (chattering with the guests when Alex was too preoccupied to notice), ordered the wine and liquor, bought most of Alex's clothes for him and brought Alex his medicines and pills on a silver tray.

He had only one major defect as a valet, except for his manner, and

that was his size and shape, which differed from Alex's, in that Benjamin was shorter and stouter. Alex was envious of Lord Guinness, whose valets always had exactly the same measurements as his lordship, and were thus able to take his place at tailor's and shirtmaker's fittings, and to wear his new suits for him until they had softened up a bit.

Alex constantly complained that Benjamin bought shirts for him a size too small so that *he* could wear them, leaving Alex to get along with the old ones. But this was unlikely; Benjamin's shirts were usually white and heavily starched—not at all the kind of thing Alex would wear—and all the more penguinlike on Benjamin. In any case, except for his occasional raids on the liquor cabinet, he was conspicuously honest. He was frugal (and protective) enough to make sure that guests were not served Alex's good cigars (unless they were very special, like Beaverbrook or Brendan Bracken), and when one guest reached toward one of the huge Dunhills in its individual cedar case inside a tin with an opener like that on a can of sardines, Benjamin tapped his fingers with the cigar cutter, and said, "Not that one, *if* you please. Those are for Sir Alex!" Benjamin pulled Alex's trousers on for him, leaned over, groaning and short of breath, to slip Alex's shoes on and made sure Alex had a brand-new package of Swan Vesta matches in his right-hand suit pocket.

Alex never carried money, since he seldom had any occasion to use it—on the rare times when he needed it for a tip, he borrowed a pound or two from Bailey, who kept a ready reserve in his pockets for just this purpose. Bailey always had the *Times,* the *Telegraph,* the *Express,* the *Daily Mail* and the *Financial Times* in the car, and of course the evening papers for the ride home. He also kept in the car cigars, matches and a bottle of Alex's heart pills. Whenever Bailey had to wait (like most chauffeurs he spent most of his life waiting), he polished the car until it reflected light like a deep black mirror, even on the grimmest of days. He was never idle: In the evenings he cleaned and checked every part of the engine, in accordance with the official handbook of Rolls Royce engineers, early in the morning he washed the car with soap and water, dried it with a piece of chamois, and polished it with a dry cloth. It never needed servicing—it was serviced every day, its oil changed as often as a cat's water, every bolt and nut tightened on schedule with the appropriate chrome-plated spanner from the velvet tool tray in the rear boot. It was widely assumed that if the Rolls

failed to start one day, Bailey would commit hara-kiri, but this was never put to the test, since it *always* started, promptly and without sound.

When Alex got into the elevator, a liveried servant took him straight down to the lobby, without stopping for other passengers, so Alex never needed to take his hat off or say "good morning" to anyone, or meet strangers (or worse, people he knew). As he walked through the lobby to Brooke Street, the staff bowed to him silently, the assistant manager signaled to the porter and the porter waved to the doorman, a giant of a man in a brown, braided greatcoat and a glistening top hat with a cockade, who swung the door open and at the same time nodded toward his assistant, a younger version of himself, to warn Bailey.

Hastily, Bailey would put away his polishing cloth, drop his cigarette to the ground (he always held it between thumb and forefinger, with the rest of his tipless fingers forming a tunnel around it, trench-soldier style), straighten his cap, and open the left-hand front door of the car, since Alex liked to ride in front with Bailey, arguing that even in a Rolls Royce, the chauffeur's seat is more comfortable than the one in back for the owner.

Bailey agreed, but felt it made sense: the driver spent more time in the bloody thing, didn't he? The door closed on Alex with the heavy clunk that comes only from perfect workmanship, heavy steel and a lot of money; Alex lit his first cigar of the day, gently making a hole in the end with a wooden match, then patiently warming it to a steady glow, picked up one of the papers, usually the *Express*, since he read the *Times* at breakfast, and went off to work like everyone else.

WHEN ALEX ARRIVED at the office on Piccadilly, or the studio at Shepperton, the Rolls waited outside, so one could always tell if he was there, rather like the Royal Standard that flies over Buckingham Palace or The Windsor Keep to show that the Sovereign is in residence. After Alex received delivery of his new Rolls Royce, he had Bailey deliver the old prewar Rolls to my father's house, with instructions that Vincent was to be driven from now on. Bailey recruited a young chauffeur, Pat O'Bannon, and when my father came downstairs to go to work in the morning, he found O'Bannon waiting for him with Alex's dark-blue 1937 Rolls Royce Park Ward sedan.

Vincent refused to get in it. With his determined democratic princi-
ples, he was embarrassed and irritated by show, and was not even happy
riding in Alex's Rolls, let alone being driven in one of his own. He
owned a small Hillman Minx, a cheap and tiny box of a car, and it
suited him very well, since he could drive to the studio and back in
second gear, straight down the middle of the road at a maximum speed
of 30 mph.

When O'Bannon pointed out that he was only acting on Sir Alex's
instructions, as passed down through Bailey, my father frowned, but he
was not about to give in. He unlocked the Hillman. O'Bannon opened
the door of the little car for my father, but he was almost in tears. "Mr.
Korda," he said, "you're doing me out of a job."

My father considered this, the two men standing beside the small
car. Vincent loathed being "fussed over," but he never wanted to do
anybody out of a job, and would go to great lengths to keep people on,
even after Alex had ordered them fired, in the hope that Alex would
forget all about it, or change his mind. "Do you have children?" he
asked. O'Bannon replied that indeed he had two small children. My
father sighed. "All right," he said, resigned to his fate. "Get in. What
the hell, you can drive me—but in *my* car, not the Rolls."

So poor O'Bannon squeezed himself into the driver's seat of the little
car, and became a permanent fixture in my father's life, incongruous
in his blue chauffeur's uniform and cap in the tiny Hillman (which he
had soon brought to a shine worthy of Bailey), with Vincent sitting
beside him, and Nuisance the dog filling most of the back seat. O'Ban-
non was happy to have the job, but he pined for the Rolls Royce. He
suffered agonies of humiliation every time he waited anywhere for my
father. Other chauffeurs flicked the dust off huge great, gleaming cars
—Rolls Royces, Rolls Bentleys, Daimlers, Lagondas, perhaps at worst
a Jaguar sedan (known among chauffeurs as "the Jew's Bentley"), while
he was stuck with a potty little car that an assistant bank manager
might keep in his suburban garage for a Sunday drive with the wife and
kiddies. He extolled the virtues of the Rolls to my father as they drove.
My father read his newspaper, sucked on his pipe, and turned a deaf
ear to O'Bannon, at any rate on this subject.

My father's position did, in fact, have some merit: He had to deal
with the studio unions, and he could hardly deny them a raise if he
turned up every day in a Rolls Royce. While Alex was willing to

concede this, and understood that it made sense, the Rolls had become symbolic of what he chose to call Vincent's "childish stubbornness." Every so often Bailey would turn up to have a cup of tea and explain to my father why he would be better off with the Rolls, now that he had accepted a chauffeur, but since he liked Vincent, and had a good deal of respect for his egalitarian position, Bailey's heart was no longer in the argument, and O'Bannon gradually came to accept his fate. Alex then moved the discussion to another plane. He became convinced that the little Hillman was not safe, that Vincent was endangering his life out of obstinacy. It was a piece of shoddy tin, it had no weight, what if it skidded in the rain, or God forbid, crashed? Since my father hated and feared automobiles to begin with, this was a more promising line to take, and O'Bannon now entertained my father every morning with stories about car accidents, in which the victims had died because they were driving in small cars. "Tin, Mr. Vincent, just tin. Criminal it is," he would say, banging the flat of his hand against the side of the Hillman, which, it was true, gave off a very tinny and insubstantial sound.

Bailey (or "Mr. Bailey," as O'Bannon always called him) finally hit upon a compromise that satisfied everyone, by producing an American four-door Ford V-8 sedan. It was not a Rolls, but it was big enough and fast enough to satisfy O'Bannon, and in those days American cars were rare enough in England to have a certain glamorous cachet. O'Bannon —whose feelings about America and Americans were best summarized in the British wartime complaint that the only trouble with Americans was that they were "overfed, overpaid, oversexed and over here"— became an instant enthusiast for things American. "You can't beat the Yanks for cars," he told his fellow chauffeurs, dismissing with contempt their old-fashioned Rolls Royces.

He proved his point by cutting fifteen minutes off Bailey's record time for the run from the parking lot of Shepperton Studios to the courtyard of 146 Piccadilly. My father liked the roominess of the car, and because of its suspension, he failed to notice that O'Bannon went through every speed zone at 75 mph, whereas in the Hillman he was constantly urging him to slow down and warning him not to pass other cars. Alex was mollified, though not completely pleased. He felt that he had won the first skirmish, but the Rolls was kept in reserve just in case my father finally changed his mind. The Hillman was given to my

stepmother Leila, who soon reduced its fenders to tattered frills, as if she were still driving Lady Mountbatten during the Blitz.

MY FIRST REAL contact with Alex—after that night he had ordered my father to get married—came shortly after this struggle over the car. Since I was about to go off to boarding school in Switzerland, he doubtless felt it necessary to give me a few words of advice, and I was instructed to meet him at Claridge's one morning. When Benjamin ushered me into his presence, he was sitting at breakfast, wearing a terry-cloth robe with his initials embroidered on the pocket and reading the *Times* through thick, half-moon reading glasses. He could only read without glasses by placing the paper almost under his nose, and even with glasses his face was drawn up into a frown of concentration and effort, which gave him a rather forbidding expression. Spread out across the table were the remains of his breakfast, a plate of smoked ham, some cold sliced duck, salami, toast and a bowl of fresh fruit.

He had now reached the stage where he was smoking a cigar, and drinking his last cup of coffee, and Benjamin was already standing nervously in the doorway with a pair of shoes in one hand and a pair of gray trousers draped over one arm, trying to catch Alex's attention. "It's nearly ten," he said. Alex frowned at him. "I know that," he retorted. "Well," Benjamin said, his face puckering up, "you *asked* me to tell you, Sir Alex." "Now I'm asking you to shut up," Alex said, and motioned for me to sit down, while he went off into the bedroom to be dressed.

"How are things going?" he asked through the bedroom door.

I replied that things were fine, but that I was worried about going to boarding school.

"That's nonsense. You'll see that it will be fine. A boarding school in Switzerland isn't like Harrow or Eton, you know. There are no beatings . . . Boys from every country . . . Skiing in the winter—I wouldn't mind going myself. Your father is afraid it's a little snobbish, but I don't see what's wrong with that, provided you don't take it too seriously. Most people worth knowing are snobs one way or the other, as you will soon discover. Anyway, at least you'll get a decent education, which is what matters. You must learn Latin. That's very important. Greek too, if possible."

Alex emerged from the bedroom with his shirt drawn over his head, while Benjamin hurried behind him, attempting to pull it down and get it buttoned. Alex's voice came through, muffled by the shirt, but still distinct, as Benjamin struggled. "You have to learn to speak French well. That's essential. Even your father speaks French and German. Despite what everyone says, the Germans are going to come back. Russian, I suppose you could learn too, but I'm too old, and anyway" —Alex's head now appeared and Benjamin proceeded to fasten the shirt collar—"I don't want to live to see us all living in a Communist society and talking Russian, though you may have to. Well then, languages, and of course mathematics, those are the most important things."

Alex held out his arms so Benjamin could slip on his gray flannel double-breasted jacket, then Benjamin went around him as he stood still, adjusting the knot of Alex's tie, flicking a brush over his shoulders, dusting an imaginary speck from the gleaming shoes. He stood back and admired his handiwork, and pronounced judgment on it. "Very nice, Sir Alex," he said, beaming.

Alex nodded, then looked at me. "Clothes," he said. "Has your father thought of that? I suppose not. You'll come with me to the office, and we'll talk on the way. Benjamin, you'll come too, then you and Bailey take Michael around and get him outfitted with whatever he needs for school." Alex turned to me, looking me up and down, and clearly dismissing my Brooks Brothers button-down shirt (Boy's Department), and my tweed jacket and gray flannel trousers from Peck & Peck. His eyes rested momentarily on my Abercrombie & Fitch loafers, with a penny in each strap, and he sighed. "Do you have a watch?" he asked.

I shook my head.

"Every boy ought to have a watch and a pocketknife." Alex went to his desk drawer and opened it. Inside were watches by the score, it seemed, for people gave Alex watches constantly and he himself never wore one, having no need to. There were Cartier watches, gold pocket watches with chains or fobs, paper-thin Vacheron & Constantin evening dress watches, Rolex Oysters and even ladies' watches. He selected a gold Universal-Geneva chronograph, with a stopwatch, a dial that showed the phases of the moon, and little windows for the day of the week and the date, and handed it to me. Benjamin shook his head. "I don't think, Sir Alex, that's an appropriate watch for a child," he said.

Alex frowned. "When I want your opinion," he said, "I'll ask for it. Here—it's yours."

I buckled it on, though the strap, designed for Alex, was so large that the watch hung down around my knuckles. Alex then rummaged through another drawer and produced a small penknife, in sterling silver, with mother-of-pearl handles marked with his initials. "You have to give me a penny," he said.

I handed him a penny, confused by his demand, and he gave me the knife.

"It's an old custom. If you give somebody a knife as a gift, he will become an enemy. If he gives you a coin, he has bought the knife from you, you see, and you remain friends. I want us to be friends, so I am taking your penny. I think it's a fruit knife, really, but if you want a proper Boy Scout knife, you can always buy one in Switzerland with your pocket money. Has your father talked to you about that?"

I said he had not.

"Typical. You ought to have a decent amount of pocket money. Not as much as the boy who has the most, but more than the boy who has the least. I'll talk to your father about it. There is no time in a person's life when five shillings one way or the other counts for so much."

Followed by Benjamin and myself, Alex made his way down to the lobby and out into the street, where Bailey was waiting. "Nice day, Sir Alex," he said. "Is it?" Alex asked. (He still had on his reading glasses, and could hardly see the street, let alone the sky.) Settling himself into the front seat, he picked up the paper, a sure sign that he was ending the conversation and wanted to be left alone. "I know what I wanted to say to you," he said after a moment. "Why do you think your father won't accept the Rolls I gave him?"

"He's afraid he'll look silly in it."

"So he will, but he still shouldn't turn it down. My advice to you is never to say no to anything worth having when it's offered to you. Life is difficult enough. You can't have too much of a good thing."

I nodded. Alex seemed to me right. I liked riding in his Rolls, and secretly, treacherously, I wished my father would accept *his*.

ONCE ALEX HAD been left at 146 Piccadilly, stumping up the steps as the commissionaire, in his glittering uniform, opened the door for him, Bailey pushed his cap to the back of his head. "Where to, Alec?" he

asked, lighting a cigarette. Benjamin, who loved to ride in the back of the Rolls, with Bailey driving up front, directed him to Savile Row. There, at Alex's favorite tailor, old Mr. Landsman himself waited for us, his pince-nez gleaming, rubbing his fat pink hands in front of him like a fashionable surgeon about to begin an expensive operation. He was not in the habit of waiting on adolescents, but as Sir Alexander's nephew I was an exception, and he circled me appraisingly, followed by an aloof young man with a notebook, and an elderly tailor with a tape measure and a pin cushion. Benjamin suggested that my school outfit might properly consist of two pairs of gray flannel trousers ("Perhaps not the cloth we have for Sir Alex, but something rather more practical"), a sports jacket ("One of those nice Harris tweeds, nothing flashy") and a blazer. Mr. Landsman nodded his approval. He flashed a roll of gray Harris tweed in front of me, Benjamin and Bailey exchanged glances and nodded, and I was measured. We then drove to Hawes & Curtis, where we looked at shirting materials, and Benjamin picked a stout blue cotton for me. The elderly shirtmaker showed me a few collars, and to my horror I realized that he proposed to make me shirts without collars, to which a separate stiff collar would have to be attached with collar studs. I asked if I couldn't have my shirts with collars sewn on them.

"Ah," he said, "I don't know about *that*. It can be done, of course, indeed it *is* done, but I'm sure your uncle would object."

"He wears shirts with the collars sewn on," I said.

"Quite. But would he want a young man like yourself, just starting out, as it were, to do the same? That's the question."

I appealed to Benjamin, who reluctantly caved in and whispered to the old man, "Sir Alex's nephew is *American.*"

The shirtmaker nodded and sighed. "Ah, well, that's quite another matter," he said, "if the young gentleman is *American* then I suppose it's all right, isn't it? Ordinarily it wouldn't do, but even the American *ambassador* has his shirts made that way. In fact, he wanted to have *evening* shirts made with the collars sewn on, but I told him that wouldn't do at all. When in Rome, I said, do as the Romans do, and quite right too, and he took a dozen evening shirts made the proper way."

Having ordered shirts, we drove to Foster's (even Benjamin felt I was still too young to have shoes made at Lobb's), and bought two pairs of

black lace-up shoes, leaving my loafers behind to be contemptuously thrown away, then to Aquascutum, to buy what Benjamin called "a mac," and finally to Simpson's, on Piccadilly, where I was to be outfitted in ready-made clothes while my made-to-measure finery was in the making.

I left Simpson's in gray flannel Daks, a white shirt, tasteful dark tie, and a brown tweed sports jacket, having fought off Benjamin's insistence that I buy an umbrella and a hat. He nevertheless seemed happy enough with his handiwork as we walked to the Rolls, laden with packages.

"I wouldn't say at all," he said, "that clothes make the man, but they *do* help. Your father, for instance, doesn't care at all about them, but he's an eccentric, and a true gentleman, if you'll permit me to say so. Now, Sir Alex—he's fastidious about clothes, but he doesn't really *care*, if you see what I mean. He doesn't ever want to try anything new, though he'd look very good in a nice checked suit, or a dark blue pin-stripe. But, no, it's always the gray suit, and that's that. He just won't *try.*"

The Rolls swung into the courtyard at 146 Piccadilly, and together we trooped up the huge staircase to Alex's office, where we waited outside until he could see us.

Finally Alex's secretary opened the door, and we stepped into the big room, which overlooked a small garden. The walls were covered in large Italian architectural paintings of the seventeenth century, acquired by my father at auctions, and apparently too big to be put anywhere else, the fireplace contained a cheerful fire, there were heavy Chippendale bookcases between the paintings, and an antique dining table served as a board-room table. Alex himself sat at a large, leather-covered Regency desk-table, covered in expensive bric-à-brac—a gold and ivory letter opener, a Fabergé magnifying glass, a crystal bowl full of flowers, a George II silver inkstand, a few small Renaissance bronzes, a pair of gold filagree scissors and a row of cigars, each of them wrapped in a torn piece of writing paper with an inked number on it. I stared at them —rather rudely, as I realized too late.

"My fool of a doctor thinks I smoke too much," Alex said, "so my secretary writes on the paper the time at which I can smoke the next cigar. When you grow up, never believe anything doctors tell you. One of the first signs of old age is when you begin to be interested in what

they have to say." Alex surveyed my new clothes and nodded his approval. "Better," he said, "much better. A decent haircut, and you will look fine. It's the kind of thing your father never thinks of, but that's his way, and there's no changing him. You must love and admire him, but you must not imitate him, do you see? Come, let me show you my new toy."

Alex stood up and walked to the window where, on a low table, was a box covered with a tan baize cloth. He pulled the cloth off, and there, in a glass case, was a perfect model of a large yacht, about three feet long. At the bottom of the glass case was a brass plaque on which was engraved:

T . S . M . Y . ELSEWHERE
SIR ALEXANDER KORDA
TEDDINGTON BOATYARD

Alex beamed. "I have always wanted a yacht," he said, "ever since I was a boy, and now I'm going to have one. It's a Royal Navy Fairmile torpedo boat, and I'm converting it. We're adding on about ten feet to give it a rounded stern, so it will be about a hundred twenty feet long, and we'll put bulwarks up, which you see here, so it will look more elegant. At the moment, it has three petrol engines, Rolls Royce Merlins, but that's too much for a yacht, and anyway, they don't leave any space and what *is* left has to be petrol tanks, so we're converting to twin diesels. There will be a motorboat on board, and a sailing dinghy. What do you think?"

I was awestruck, more by the precision and detailed perfection of the model than the idea of the real ship (I had always been a clumsy model-maker, inclined to building the wings of airplanes so that they failed to fit the fuselage). "What does T.S.M.Y. stand for?" I asked.

Alex frowned at me. "It means Tvin Screw Motor Yacht. But what do you think of her?"

"I like her very much."

"Good. You're the first member of the family who approves. Your father thinks it's crazy, though he has very kindly offered to help with the building and the decoration. I don't think that he is likely to sail

on her, though. Would you like to come with me on her one day?"

I nodded. I could think of nothing I would like better.

"Good. That's settled then. Go away to school, behave well, learn as much as you can, and when you can speak French, we'll go for a cruise together."

Alex gravely shook my hand, waved me toward the door, and selected one of his cigars—an hour too early, I couldn't help noticing, as I looked at the piece of paper he tore off.

"And don't forget to thank Benjamin and Bailey when you go out," he added. "People don't think that servants care about these things, but they do. There are enough people in this family who treat servants badly already, and I don't want you to be another one."

As I walked down toward the waiting Rolls, I couldn't help wondering who Alex was talking about. My father treated servants as equals, or better than equals, actually, and Zoli was if anything subversive, inciting them against their employers and urging them to stand up for themselves. Neither of them could be accused of treating servants badly. But, of course, I knew nothing then of Maria, nor did I understand why Alex was so anxious to play a paternal role toward me.

From now on, it was clear to me, I would have to be very careful. Alex had certain expectations about me. I wasn't at all sure that my father would approve of them, whatever they turned out to be, and I could see life would be very difficult if I was trapped between the two men. I had a good deal to think about as Bailey drove me home.

UNFORTUNATELY there was still some time to kill before I went away to Switzerland to follow Alex's advice. My father was busy, and his own suggestions about what I might be doing to keep myself occupied were not helpful. He himself, when he had leisure, spent his mornings at Sotheby's, his lunch hours at the Csárdás Hungarian Restaurant on Dean Street, and his afternoons at the Tate Collection or the National Gallery. He could see no reason why I should not do likewise, and it was difficult for me to explain to him that I had very little interest in Old Masters. Idleness, however, offended Vincent to the depths of his being. He therefore decided that I should accompany him to the studio every day, if only so he could keep an eye on me. "One thing," he said, "it will cure you of ever wanting to work in this bloody business, which

is good thing to find out early on, before you waste time in it, like me."

Thus encouraged, I set off with him one morning at six to spend the day at the studio, sitting behind with Nuisance. In an effort to home in on some interest I might have, my father had discovered that I was at least willing to admit to the possibility of *becoming* interested in photography, and this morning for the first time I carried one of his Zeiss Contax cameras around my neck, like a badge of office. He himself nearly always had a Leica somewhere in his pockets, and he would either photograph nothing at all or suddenly take three or four rolls of thirty-six exposures in one burst, for no apparent reason. He enlarged everything to 8" × 10" or greater, and left the photographs— pictures of odd bits of architecture, columns, cornices, windows, door- ways—sitting around in piles everywhere, in the hope that somebody would one day classify them in some kind of order. I was allowed, my father told me, to photograph anything I wanted to—except him.

THE DRIVE to Shepperton was long and uninteresting. My father smoked his pipe and read the newspapers, pausing from time to time to tell O'Bannon to slow down or to warn him of obstacles. Nuisance slept, secure in the routine of his daily trip to the studio. About an hour out of London, we passed through a small village and stopped at what might have been the gate of a factory. The studio policeman swung up the barrier and saluted, and we drove around the perimeter road of my father's private domain, for it was instantly apparent to me that here was the one place where he was at ease. We passed the huge sound stages, the prop warehouses, the long low red-brick row of cutting rooms and screening rooms (with their distinctive smell of film cement and emulsion), the carpentry department (run by old "Pop" Day, who was then in his eighties), the plasterer's sheds, the special-effects stages, the huge generating plant, the covered walkways to the performers' dressing rooms and then, crossing over a beautiful little stream, we swept into the courtyard of an old English mansion, surrounded by carefully designed grounds, with a view over a small lake, on which were a Gothic arched bridge, several ducks and a mass of lily pads.

As always, my father had managed to preserve what was there and build the studio around it. He liked traditional surroundings, as did Alex, and he was not about to sacrifice a good solid Victorian building,

however inconvenient it might be to work in, simply to replace it with a modern office. Shepperton Manor was his home away from home and he liked its mosaic tiles, the mullioned windows, its Ruskinian eccentricities of design, the baronial staircase, the minstrel's gallery and the conservatory, a kind of glassed-in, miniature replica of the Crystal Palace, in which a gardener now raised flowers and ferns for Vincent's sets and Alex's home and office.

Nuisance, apparently sure of himself, vanished on his rounds. My father took me in tow on his. First he went to the "canteen," a small private dining room for the directors, stars and executives, where, as he put it, "his boys" were waiting for him, one of them a small, worried Hungarian of my father's age, József Bató, the other a thin, elegant Englishman, Philip Sandeman.

Joined by his retinue, we set off on foot around the studio, first to the sound stages, where my father expressed his approval of what appeared to be a Scottish moor in the Highlands, but asked for more "fissles"—which puzzled everyone until he made a sketch of a thistle on the back of an old envelope—then to the plasterer's, where a ballroom was being constructed in sections, then out to a back lot on which a small army of workmen was constructing a full-size replica of Hyde Park Corner, with considerable difficulty. Having satisfied himself that everyone was busy, he set off at a brisk walk to look at several carriages, a real racing car, and a group of extras dressed as Highland warriors, in kilts, plaids and full Highland regalia. These filled him with dismay—he disliked the idea of men in skirts and hated the colors. "All this orange and green—it's awful," he complained, "on film it will look like a tin of marmelade." Sandeman explained that these were authentic tartans, and my father listened stoically. He had seen other tartans he preferred, but given the passion for authenticity which is a Scottish national characteristic, he was obliged to accept the tartans of those clans which had in fact supported Bonnie Prince Charlie, however unattractive they were. He then withdrew to his office to argue in Hungarian with Bató, leaving Philip and me to amuse ourselves.

As Alex surrounded himself with people who had saved his life, my father liked to surround himself with people whose lives he had saved. He had managed to get Bató out of Europe before the Nazis could seize him, and Bató, who had been a painter, became a set designer. Sandeman, one of the heirs to the English family of sherry and port import-

ers, had been a Second World War ace in the Royal Air Force and refused to go into the family business because he wanted to become a painter. My father had rescued him by putting him to work as his assistant. It was Philip's job to keep track of my father's ideas, translate them into English and in general comment on the authenticity of anything that had to do with English dress, conventions, social customs or costume. Both men clearly worshiped my father.

Philip, who was closer to my age than Bató, felt an obligation to make me feel at ease, and together we walked through the studio, which was beginning to come alive in the morning, while he explained to me exactly what everything was. He introduced me to "Pop" Day, ancient and irascible, whose crews could build anything overnight, and were frequently asked to. He took me to see Ned Mann, the American special-effects genius whom Vincent had stolen from M-G-M, and who had built in Shepperton one of the most modern process-shot departments in the world, making it possible to photograph almost any scene in the studio, then superimpose the background later on. He introduced me to the men who maintained the Mitchell cameras, to the sound men, to the propmen, the gaffers, the focus boys, to the dour representative from Technicolor, who alone understood the complex processes needed to ensure satisfactory color.

At about ten o'clock, we pushed open one of the heavy padded doors in Sound Stage A, passed under a blinking red warning sign, and stepped quietly out onto the floor. There was the blasted heath we had seen before, this time with more thistles, but also lit with a blaze of lights. Standing among the clumps of thistles were the Highlanders in their unfortunate kilts, and in front of them, looking disconsolate and ill at ease, was David Niven, richly dressed in the full Royal Stuart tartan and plaid, and holding a white china mug of tea.

Before him was a large cluster of people, surrounding the camera. Vincent stood to one side, squinting against the blaze of the lights and looking glum. Alex sat in a canvas director's chair (he refused to have his name painted on it, in defiance of movie tradition), wearing his Homburg hat and smoking a cigar. A make-up man crouched among the thistles, waiting to wipe away perspiration and add more powder, while the rest of the crew waited rather tensely for something to happen. Philip and I stood to one side of the camera, close to Alex, who was irritable and impatient.

"I still think the bloody tartans look awful," he said.

My father shrugged. "They are authentic, Lacikám. That's the way the bloody things are."

"Can't they be different? Why do they have to be so much in orange and green?"

"They are ugly, but they are right."

"I *hate* it. All that purple stuff, vat's it called? Feather? Then all this green and orange, and the blue sky, it makes me sick. It looks like a biscuit tin. And vat are these tings with spikes?"

My father shrugged again. "Fissles."

Alex gave him an unpleasant look—his bottom lip stuck out and he scowled, then he gave up. "Bugger," he said, "let's shoot the bloody scene again."

A man from the canteen rushed forward to remove Niven's cup, the make-up man rose up to give his face a few final dabs, the intensity of the lights increased, the focus boy checked the focus and the clapper boy stepped forward to stand in front of Niven and hold the clapboard up before the camera. "Scene forty-one, take six." *Clack!* Niven stepped forward, caught his socks in the thistles, lurched and stepped back again. "Cut!" Alex shouted, and the whole process started again. This time Niven stepped forward confidently enough, but a voice rang out from behind the camera and shouted, "Hold it, cut, mike shadow!" The sound men rushed forward to play around with the microphone boom, the lighting men ran up and down the latticework of platforms high above the floor, adjusting the lights, the man from the canteen appeared to give Niven a fresh cup of tea, and Alex lit another cigar. After a long pause, the scene was shot again, and this time Niven managed to draw his sword and speak a line of dialogue. Alex was not satisfied. He strode up among the thistles and spoke to Niven at length about the majesty of Scotland, the exuberance of the young pretender to the throne, the excitement of the moment. He rolled his eyes and gestured with his cigar as if it were a sword, then he sat down and peered at the set, willing the next take to be perfect.

It was, to everyone's relief except mine. For only I had seen, as everyone on the stage stared raptly at Niven, that Nuisance was walking across the skyline, behind the file of Highlanders listening to their prince, his collie-like shape and fluffy tail nicely silhouetted against the backdrop of loch and sky.

Alex stood up and stretched, noticing me for the first time.

"So," he said, "how did you like it?"

"Very much," I said.

"How do you think the scene went?"

I hesitated. I had no wish to make trouble for Nuisance, who had gradually attached himself to me, and I wasn't at all sure what would be done to him for ruining the take. I decided that Alex was not the person to tell, and expressed my approval. Alex walked off, and I whispered what I had seen to Philip, who put his hands over his eyes like a man in pain. He then went off to whisper to my father, who moaned. Alex looked at him suspiciously, and asked what the matter was.

"The dog," my father said.

"What dog?" Alex asked.

"The dog was in the take."

"I didn't see a dog."

"Miki did."

Alex glared at me. "You saw a dog?" he asked.

I nodded.

"Which dog?"

"Nuisance," I said.

Alex took off his hat and stared at my father, who looked bashfully at the toes of his shoes. "Oh, my God, bloody hell," said Alex. "We have to start again because of a bloody dog! I should have him put down, but I suppose in England that's a crime." He looked at me thoughtfully. "Since you're here," he said, "I'm giving you your first job in the movies. From now on the dog goes on a leash and you hold him. I make you personally responsible. I will pay you half a crown a week, and if I ever see that dog loose on a set again, I will not only fire you but disinherit you. Now go find him and get to work. If you fail I will have the bloody dog cooked and eaten."

NUISANCE HAD NEVER been subjected to the indignity of a leash and resented "being grounded," as Philip put it in R.A.F. slang. I spent my days wandering about Shepperton, more or less pulled by the dog in whatever direction he wanted to go, and trying to keep as much as possible out of sight. When Vivien Leigh first met me, in the canteen

at Shepperton, she expressed surprise that I appeared to have the full use of my eyes. She had seen me so often being led around by a dog that she had presumed I was partially blind, and had been too tactful to ask if that was in fact the case.

Even my father felt badly about my new role as Nuisance's guardian, and he eventually arranged for me to learn darkroom techniques in the studio's photolab, where Nuisance and I spent many happy hours, he sleeping by a radiator, I learning to process film, make prints and develop enlargements. Here at last I found a place where nobody could bother me, my fingers turned dark-brown from the chemicals, and I spent so much time in the dark that I began to think that Vivien might be right after all. My father was pleased. Now that I was in charge of Nuisance and safely locked away in the darkroom, he felt that I was out of reach of temptation. He had hoped the studio would bore me, and when it didn't he decided to move me as far away from it as he possibly could, while still keeping me busy. The last thing he wanted was a son involved in the "bloody business" of making movies.

ALEX WAS less scrupulous. His own experiences as a father had done nothing to shake his conviction that he knew what was best for children. He had never shared my father's vaguely egalitarian ideals, and the notion that it was possible to have too much of anything, at any age, seemed to him ridiculous. "Get used to the best," he would say, "and you will then have a good incentive to succeed—and anyway what's the point in getting used to second-rate things?" My father believed children ought to be brought up "simply," though how that was to be done in a family like ours was a problem he had never managed to solve. Children, he felt, were impressionable and should not be exposed to any variety of influences, including (but not restricted to) movie stars, the bar of the Hôtel Ritz in Paris, Lord Beaverbrook, tailors, late-night parties, lunch at Les Ambassadeurs, fashionable women and automobiles. Alex's Tory friends and society acquaintances particularly irritated him, and he worried about the possibility of my becoming one of those elegant young men about town whom he so much disliked. At the root of the matter, Vincent was a confirmed pessimist, in some ways not unlike the man who used to walk back and forth at Speaker's Corner with a placard announcing that the end of

the world was at hand. He was content to have the best of everything himself, but in his heart he doubted that it would last, and was anxious to prevent me from acquiring habits that I would afterward not be in a position to afford.

Vincent sensed how thin the ice was on which Alex skated with such flamboyance. The more Alex enjoyed good fortune, the stronger my father's forebodings became. On the one hand, he wanted me to have a university education, on the other hand he thought it would be safer if I learned some decent, reliable trade, like carpentry or bricklaying to fall back on. In his youth he had been a bricklayer's assistant for a time, and he talked fondly of the honest simplicity of carrying a hod and mixing mortar, though whenever he brought the subject up in front of Alex, his elder brother reminded him that he had in fact hated bricklaying and had dreamed of escaping from it to become an artist. Alex accused my father of having romantic illusions about poverty, and my father counterattacked by reminding Alex of his humble origins. I had the misfortune to be a test case for both of them.

Zoli felt that both his brothers were wrong. Always the most independent of the three, he continued to live in California, and his occasional visits produced acute anxiety in both Alex and Vincent. Zoli felt that Alex was involving himself too deeply in financial speculation and company management, and disapproved of his extravagant life style far more openly than my father did. Like Savonarola, whom he resembled in many ways, Zoli was a moralist, and saw it as his duty to tear Alex away from his false friends, and from all the reactionary social spongers whom he was trying to emulate.

He thought Alex's suite at Claridge's was pretentious, and the idea of Alex's building a yacht filled him with dismay. Zoli was a frugal man himself, though extremely generous, and whereas Alex's extravagance fascinated my father, who had, after all, a strong self-indulgent streak of his own, it deeply offended Zoli, who filled the backs of old envelopes with scribbled estimates of exactly how much Alex was spending. Yet Zoli, this confirmed believer in socialism and equality, was determined to put away enough money so that his sons would never have to work if they didn't want to, a contradiction which both Alex and my father were forever bringing to his attention. In effect, my father believed that Alex was wrong, but felt that as the eldest brother Alex had the right to do exactly what he wanted to, and that his authority extended to

every member of the family, while Zoli felt that Alex had an obligation
to consult his brothers, and that each of the brothers should be inde-
pendent but equal, perhaps with Alex being a little bit more equal than
the rest.

Whenever Zoli came to London, he would take me to one side and
give me his own view of my future, which was gloomy. Sometimes he
would summon me to his hotel room, where he would be suspended
from his back brace hung to a stout hook in the wall, like a suicide
victim, stretching his vertebrae. At other times he would take over a
room in the house, dismissing my father to the kitchen while he
whispered to me about the many problems that lay in store for me. Zoli
was far and away the best looking of the three brothers, but there was
something sinister about his hooded, slightly slanted eyes, his ferocious
beak of a nose, the heavy, Mephistophelian eyebrows and the jutting
jaw. Alex's face looked like a larger, but much softer version of Zoli's,
while Vincent, except for the distinctive Korda eyebrows, looked as if
he had been smuggled into the family by Gypsies, so different was his
face from his brothers'.

Zoli always began by telling me that England was a terrible country,
cold, wet, rainy, full of snobs. He did not trust the English; he had seen
too much of their bad side in the far corners of the Empire. If anybody
had listened to him, I would have remained in California, growing up
in a decent climate like his own two sons, David and Nicki, who were
going to be healthier, taller and equipped with better teeth than I could
ever expect to be . . .

"Your father," he would say, "is a sweet man, but he pays too much
attention to Alex. He should be putting money away safely, in Switzer-
land or in gold coins. Look at me. I collect gold coins, and one day
David will inherit them and he won't have to worry. He will have a car
and plenty of girls and be happy. What's wrong with that? I don't send
them to fancy schools where they will pick up stupid ideas. They should
grow up in a healthy atmosphere, without all the homosexuality that
goes on in boarding schools. Has your father talked to you about that?"

I indicated that he had not talked to me about sex at all.

Zoli sighed. "He is an innocent. Terrible things happen in these
schools, you will see. He should talk to you frankly about sex, the way
I do to my boys. It's better so. But here in England, they are not only
snobs but also prudes. Never marry an Englishwoman—they all grow

old to look exactly like their mothers, with huge bottoms and double chins. It's disgusting. I feel about it the way I feel about women who smoke. Imagine, you are in bed with somebody whose breath smells of cigarettes when she kisses you, who wakes up with that terrible, hacking cough in the mornings, whose lungs are full of black tar, whose fingers are yellow and smell of tobacco—it makes you want to throw up." Zoli vividly pantomimed a woman in a paroxysm of cigarette-induced coughing to emphasize his point.

Recovering, he resumed his earlier argument. "If you have to go to prostitutes, which is not such a terrible thing for a young man, you should always go to the best, and use a rubber. This is very important. There is nothing wrong with sex, but disease is stupid and unnecessary. Anyway, it's better to go to prostitutes than to fall into all these *vices anglais*. Be very careful about *everyone* in school, not just the boys but also the teachers. The teachers are often the worst, in fact. Of course in England it's considered normal. The whole country is full of queers, and nobody cares. Well, better you hear these things from me than from nobody. Alex is too busy to notice what is happening, and your father doesn't pay any attention, like an ostrich. I don't envy you."

Passionate, hot-tempered and resentful, Zoli was the only one of the Korda brothers who seemed capable of physical violence, though he was in fact gentle and caring in his singular way. Once when an actor had criticized him, Zoli had shouted at the top of his voice, in his strongly accented and unreliable English, "You tell me I know fuck-nothing, I show you I know fuck-all!" He was given to sudden rages and to bleak, smoldering depressions, in which he would sit for hours without moving or speaking, glaring into space, or at my unlucky father. When he wanted to be charming, he was one of the most charming men in the whole world, but this was seldom the case. My father, who loved him almost as much as he loved Alex, thought him a born troublemaker. In his heart of hearts, he shared Zoli's pessimism and nihilism, but Zoli's constant arguments with Alex seemed to him rather like a revolt against the gods, certain to bring down terrible punishment.

Zoli had become a successful director in his own right in California, and he now wanted Alex to finance his movies without interfering in them. Why, after all, should Alex not do for his own brother what he was willing enough to do for Carol Reed or David Lean? But this made

no sense to Alex. Carol and David were not his brothers, however talented they might be as directors, while Zoli, despite his success, was and remained Alex's younger brother. In the years when Zoli had been young and poor, Alex had always said to Maria, "How could I not help my own brother?" and he had brought Zoli out of Hungary, given him the best medical care available and pulled every string he could on Zoli's behalf. It was Alex who had brought Zoli into the movie industry, and it was he who had taken the risk of backing his younger brother's talents as a director, sending him to the far corners of the earth to shoot as much film as he wanted to, and defending him against everyone who said he was impossible to work with or too fond of the natives.

Now Zoli felt he had earned his independence. His early films, like *Sanders of the River* and *The Four Feathers*, were classics, as well as being valuable assets, but they were assets for London Films, not for Zoli, and Zoli brooded on the injustice of this. He was not sure whether he wanted more control over London Films on the grounds that it had been built up partly with the profits from his work, or whether he wanted Alex to provide him with an independent production unit, but since Alex would do neither, Zoli's resentment grew—magnified by the fact that he lived 6,000 miles away—and was stored up for his visits to London. Like the Bourbons during the Restoration, he had forgotten nothing and forgiven nothing.

Zoli loved to describe his adventures in Africa, where he had strayed so far from civilization that the director of his second unit once sent a native runner with a message that simply read "Where the bloody hell am I?" and where many years after he had made *Sanders of the River* he heard a group of fishermen in the remote reaches of the Congo singing the theme from the movie as they paddled their canoes upriver. It apparently had worked its way back to Africa in the form of folk music, though it was written by Mischa Spoliansky, who had never been to Africa in his life.

He described with relish how he had accidentally intercepted a telegram to one of the assistant unit managers during the filming of *Sanders*, thanking him for "the information received about Zoltán Korda," and promising it would be put to good use in throwing Alex off the board of directors of London Films. Zoli had threatened to shoot the informer on the spot, extracted the whole story from him, and rushed home by camel, train and plane to thwart an attempted

takeover of London Films, then proceeded back to Africa to finish the film. He hinted that Maria might have slept with one of Horthy's officers to secure Alex's release, but I suspect this remark was a combination of Zoli's malicious humor and his dislike of Maria—made in much the same spirit as his comment that Humphrey Bogart suffered from piles during the filming of *Sahara*. Alex, he believed, was killing himself by overeating, and he was also smoking too many cigars and drinking too much brandy, like Winston Churchill, the arch-imperialist whom Zoli hated. Zoli avoided Alex's dinner parties, where the guests and the elaborate food irritated him, though he would sometimes appear after dinner if there was someone he wanted to meet. "All dinner parties," he said, "are a waste of bloody time."

MY FATHER was less sure of this. He complained bitterly about having to go to dinner parties, but in fact he rather enjoyed them. He liked good food, he was happy in the company of beautiful women, and he was a gifted raconteur. In any case, to him an invitation from Alex was a command. He was somewhat surprised when that invitation was extended to me. It was evident Alex felt it was time for me to develop the social graces, or at least be exposed to them. There was a streak of Pygmalion in Alex that was never quite satisfied. He had failed to transform Maria into a lady, but succeeded in making her a star. He was never content to leave people as they were. Now he had nobody close to him to serve as clay, since he had long since given up any hope of altering his brothers. Under the circumstances, I must have seemed like a heaven-sent opportunity to him.

Alex's dinner parties always began the same way for us. My father would return home early from the studio, warn my stepmother not to be late, bathe, shave himself so carefully that he was soon covered in bloody scrapes and pieces of wadded up toilet paper to stanch the flow, put on a white shirt, a polka-dotted black Sulka tie and a blue suit, then go downstairs an hour before it was time to leave the house, to worry about whether Leila would be late. At intervals, Leila, who was always concerned about her appearance, and was never quite sure what to wear at Alex's, would appear to show Vincent what she had put on. "What the hell," he would say, "it doesn't matter, just hurry up," at which she would burst into tears and go away to change again. This process was

repeated until my father was actually standing in the hallway with his overcoat on, shouting out every five minutes and threatening to leave without her. "Bloody women!" he would mutter under his breath, putting his hat firmly on his head, as if that would bring her to the doorway. But it did no good. She was always late, and often had to go back at least twice for something she had forgotten, while my father, usually phlegmatic and seldom conscious of the time, was red in the face with anxiety and the fact that he had stood indoors by the radiator for half an hour or more in an overcoat. O'Bannon, on such occasions, was always ordered to drive as fast as possible, a request which my father would never ordinarily have made, and we sped through London with the tires squealing and the horn blaring, while Vincent, his eyes closed so as not to see the traffic, drummed his fingers on his knees and groaned.

At Claridge's, he was always greeted with great enthusiasm. On his return to London from California, Vincent had lived here for several happy months in what he described as "an expensive broom-closet," and his magic touch with the staff had not deserted him. All over the world there were hotel servants and *concierges* who greeted him as if he were a long-lost son, because he tipped lavishly, and always put himself out to be charming. Zoli too had lived in Claridge's at one time, but he hated it because the valet insisted on unpacking his things, ironing them and putting them away, which Zoli regarded as an intrusion on his privacy and a typical piece of English busybodying and snobbery. If he had wanted to unpack, he insisted, he would have done so, and he moved to a hotel where he could leave his things stuffed in an open suitcase, and rummage around in it for whatever he needed. The Claridge's valets, he complained, reminded him of the Gestapo.

The liveried lift operator took us directly up to Alex's penthouse, where Benjamin, in a black coat and striped trousers, his pale, plump face bearing an alarming resemblance to that of Georgi Malenkov, stood waiting to take our coats. "You're the first to arrive, Mr. Vincent," he always said, with a faint hint of accusation, and it was always true. No matter how much my father fretted about the time, no matter how many times Leila changed clothes, hair style or jewelry, we were always there at least half an hour before anyone else. Not that Alex minded. He liked to make a fuss over Leila, since he was well aware that my father seldom did so, and he enjoyed a quiet drink *en famille*

before the other guests arrived. Both he and my father were un-English enough to like their Scotch and soda with ice, and Benjamin reluctantly took their ice cubes from a silver bowl with a delicate pair of gold ice tongs, as if doling out a precious and exotic commodity. Alex was resplendent and jovial, in a burgundy velvet smoking jacket and a pair of black patent-leather slippers. He had just acquired, at my father's suggestion, a set of Constantin Guys drawings, and he and my father placed them on a sofa to admire them. Vincent was apt to go into a trance before any painting, and he always made a tour of Alex's collection when he had arrived, as if he wanted to assure himself that they were all there.

Together we walked around the rooms, while my father grunted at the pictures he particularly liked, complained about the lighting on others and nodded with pleasure at a Van Gogh still life. Over the years he had acquired for Alex a remarkably fine collection, including several Monets, a Pissarro, several very fine Renoirs, and a collection of Degas bronzes. How much Alex loved his paintings is open to question. He enjoyed owning them, and he was a knowledgable connoisseur, but he had none of my father's intense passion for painting, and took them rather more casually than my father would have liked—without going so far as the Hollywood producer who had a magnificent Blue Period Picasso installed in his living room and mounted on rails, so that at the touch of a button it would silently vanish into the ceiling to expose a movie screen behind it for home viewing.

Alex believed in owning the best of everything, whatever form it might take. His library contained leather-bound folios of a complete edition of Rowlandson drawings, the novels of Balzac bound in buttersoft yellow morocco, the complete works of Victor Hugo in an original first edition. My father was in constant communication with antiques dealers all over the world to provide Alex with new possessions, and he made sure that everything was impeccably authentic. In New York, Alex's old schoolfriend from Hungary, Alexander Schaeffer (whose apartment was so full of museum pieces that when you opened the drawer of any piece of furniture you usually found a written history of it and a price tag), kept his eye on the auctions and salesrooms on Alex's behalf. In England Bert Crowther, a world-famous antiques dealer, kept my father informed of Adam fireplaces, Chippendale

bookcases, bibelots by Fabergé, Regency chinoiseries and Grinling Gibbons paneling.

When Paulette Goddard played in one of his films, Alex decided she would understand her part better if she wore real jewelry, and obtained a priceless emerald bead and diamond necklace from J. S. Phillips, which cost a fortune in insurance alone. When asked how he could justify this kind of extravagance, Alex replied, "It makes her feel better." Expensive and beautiful things made him feel better too, and he saw no reason why he should not be surrounded with them.

"Tonight," he said, "we have a simple little party. Moura Budberg is coming, so we will have some caviar and vodka for her, and Brendan, Carol and Pempy Reed, a very important man from the Treasury with his wife—I think his name is Sir Percy Hogg, and it's very important to be nice to them—and Vivien is joining us after the theater. For God's sake, don't mention Larry. There's some more trouble coming there, I'm afraid. As for you"—he gestured toward me with his cigar —"try to keep quiet and don't say anything silly. When in doubt, keep quiet. Be particularly polite to Brendan, because he has been to a good deal of trouble to get you into a decent school, and is still rather upset that your father decided on Switzerland instead of sending you to Harrow or Eton. And Vincent, what have you done to your face?"

My father plucked nervously at the small pieces of paper still attached to his cuts, and carefully removed them, thus setting off several new areas of bleeding. Alex sighed, but decided to ignore it, and Benjamin broke the silence by arriving with a large silver tray on which there was a crystal bowl full of crushed ice, surrounding an open one-pound tin of fresh Beluga Malossol caviar. He carefully arranged lemon wedges and toast wrapped in napkins, inspected Alex's suit for lint, and withdrew to open the door for Moura Budberg, who burst into the room before he could announce her arrival. Alex and my father rose to their feet, and she gave them each an exuberant embrace, made all the more impressive by her bulk, for she was, at that point, perhaps the heaviest woman I had ever seen, though traces of her former beauty showed in her eyes, her mouth and her cheekbones. She was dressed in what looked like a black floor-length tent, with many floating panels of gauze, and carried a beaded black reticule and a gold lorgnette, through which she peered at me intensely. Her voice and accent were heavily Russian, and her vowels were drawn out until each seemed to

consist of several syllables; she might have seemed to be every child's image of a kindly old grandmother or aunt, except for the fact that her eyes were unmistakably shrewd and piercing, rather like those which De Caulaincourt complained were so disconcerting in Napoleon.

"D-aaaah-ling," she exclaimed, dropping like a dead weight onto the sofa beside me, "give me just a little *v-oooh-dkah* and a bite of caviar, just to restore an old lady who has had a terrible long taxi ride all the way from Kensington. So nice," she said, as she drained her glass of vodka in one gulp. "Perhaps another one, thank you. So this is the *enfant prodigue,* charming, with his mother's mouth, and unfortunately, his poor father's nose. Never mind, my sweet, don't be nervous. All these introductions to society are frightening, but you will get over them, trust Auntie Moura. I will *never* forget how terrified I was at my own début, imagine, not like this at all, but at the Winter Palace, in front of the Czar, with that old idiot Shcherbatov presenting me, and the Empress standing there like a china doll. *Bozhe moi,* what a long time ago! Inside it was *suff*ocating, what with all the candles and the flowers and the fires, everybody wore pads under their armpits to soak up the perspiration, and outside it was twenty or thirty degrees below zero, one arrived in sleighs bundled up in furs, and shawls and robes, and there were bonfires in the palace courtyard so that the grooms and coachmen could warm themselves up while they waited. It was all very beautiful, and I remember the poor Czar staring down my bodice when I curtsied, and the look the Empress gave him! So silly, when you consider she was already spending her afternoons with Rasputin. Little one," she said, pinching my cheeks until tears came to my eyes, *"that* was terrifying. A young swan surrounded by old frogs. Poor dear Gorky told me he felt quite the same when he went to Yasnaya Polyana to meet old Tolstoy, so you see everybody suffers from stage fright, and there's nothing to be done about it. One great consolation: You grow up and outgrow it, and afterward you wish you hadn't. Now," she said to Alex, "I am going to give you all the gossip."

Alex smiled. He loved gossip, and he could rely on the fact that Moura usually knew more of it than anyone. He had rescued her from poverty when H. G. Wells died, and made her his script reader, but it was widely rumored that Moura's real function was to bring him the gossip of the day, and to relate it to him in an amusing way. It was also whispered that she was not above arranging introductions for him with

attractive young women, and Zoli, during the course of one bitter quarrel over a script, referred to her as "that fraudulent Czarist procuress." All the same, even Zoli was fond of her. Moura was said to be the most intelligent woman in Europe. She was fluent in French, English, German, Italian, Russian, Spanish and several other languages. She translated from one language to another with style, elegance and a perfect grasp of idiom and slang. No book, article or poem was published anywhere that she had not read, heard about or met the author of, and her admirers, aside from Gorky and Wells, included Churchill, Bruce Lockhart (the famous English spy whose life she had saved during the Revolution), W. Somerset Maugham, Graham Greene, Stalin, Gabriele D'Annunzio and almost anyone else of any literary, social or political consequence. She arranged marriages, covered love affairs, kept secrets, and served as a kind of one-woman PEN Club.

Time had eroded Moura's beauty, but not the sharpness of her mind or her instinct for survival, in which Alex recognized a kindred spirit. Like an old warhorse, Moura pulled herself together for parties, however tired or ill she might feel, and was always brilliant, witty and ribald, her deep, knowing, Falstaffian laughter echoing through the room and marking her presence before one had even seen her. Her role in life was to amuse and entertain Alex, and to survive, Moura needed to perform on demand. Once, when she had a bad cold, she risked pneumonia by coming to a party, where she told me sadly, her eyes deeply sunken and glittering with fever, "If ever I become sick, or start to complain, I will be just another old woman, and who will want me then?" Always poor, smoking too much and determined to keep Alex happy, Moura, now that she was at last too old to be anyone's mistress, functioned as a courtier. After one particularly difficult dinner party, she was heard to mutter the famous remark of Madame de Maintenon about Louis XIV in his old age, *"Quelle horreur d'avoir à amuser un homme qui est inamusable."* ("How horrible to have to amuse a man who is unamusable.")

Tonight, however, she was in good form. Within a few minutes I had learned that Brendan Bracken was popularly assumed to be Winston Churchill's illegitimate son, which explained their closeness, although there was another, darker rumor inside the Tory party that Brendan's hold over Winston lay in the fact that he knew the secrets

of Churchill's homosexual affairs as a young man, which had led to a scandalous lawsuit early in his career. Carol Reed, she explained, was the illegitimate son of the great Sir Herbert Beerbohm Tree. Moura rattled off the parentage of most of the guests, leaving me with the impression that nobody at all in England was legitimate. She then went on to political gossip. It was rumored that Stafford Cripps, the ascetic and draconic Socialist Chancellor of the Exchequer, had taken a secret vow of celibacy after meeting Gandhi, though why this should cause any suffering on Lady Cripp's part seemed difficult to understand, Moura remarked, since he seemed singularly devoid of romantic qualities. "Still," Moura said, "it shows he's mad as a hatter. It's always the first sign of madness when men do that. Look at old Tolstoy locking himself in a closet so he wouldn't be tempted to go to bed with Countess Tolstoy, or Shaw, who everyone says ties a string around his penis at night because he's afraid nocturnal emissions will drain his genius . . ."

Moura's reflections were cut short by the arrival of the other guests, and I am afraid that I stared at them the way one might look at circus freaks, given the wealth of information and misinformation Moura had just provided about their secrets.

Brendan, I was alarmed to observe, startlingly resembled his putative father, Winston Churchill: the same protuberant eyes, the heavy lower lip, the snub nose, the whole bulldog countenance of his face—all were unmistakably (or perhaps mistakably) Churchillian, as were his red hair and his pale skin. Even his voice had that guttural, rasping quality of Churchill's, and like his mentor he spoke slowly, pausing from time to time to prepare his audience for a point he wished to make or a word he wanted to emphasize. Perhaps the most disconcerting thing about him was that he wore tinted blue spectacles, hexagonally shaped, which were certainly the most exotic and unusual glasses I had ever seen in my life, but which did nothing to diminish the ruthless, aggressive energy of the man himself. "Well," he said, as he shook my hand, "the Swiss scholar. I believe your dear father is making a mistake, but we shall see. You and I must have a long talk about your future one of these days, and I hope you'll pay more attention than your father or your uncle." He then made his way over to Moura ("Talking smut again, I suppose," he said as he leaned over to give her a kiss), and proceeded to tell Sir Percy Hogg in some detail why the present policies of the

Treasury were ruining the country. This he did with authority, since he was not only Churchill's *éminence grise,* but was also a member of Parliament, a former member of the Cabinet, a close friend of Lord Beaverbrook's, the leader of a kind of kitchen cabinet of right-wing Tories, and the new owner of the *Financial Times.* His voice had the booming ring of a man who is never unsure of his opinions, and he spoke with the natural bellicosity of a professional politician.

Carol Reed, by contrast, was perhaps the gentlest and kindest person I had ever met. He immediately put me at ease by telling me about the pet hedgehog he had installed in the garden of his new house. "We *long* to see it eat," he said, "but the funny thing is that you can leave its food outside its hutch for hours and nothing happens, even if you stay up all night, then if you turn away for just a moment, it's out like a shot and has gone back inside with its meal before you can turn around. You must come over and help us watch one night before you go to school. It's quite fascinating."

I was relieved to be placed next to Pempy at dinner, since she too had the bright, instinctive ability to put one at ease, and showed no inclination to make grandiose plans for my future. "You must find all this terribly boring," she said, "and I think you're being wonderfully patient about it, much better than Carol in fact. He would much rather be back with his hedgehog, you see, the poor darling, but he *does* adore Alex, and wouldn't dream of not coming." Carol, who adored children almost as much as he and Pempy loved animals, was beginning to work on a movie of Graham Greene's *The Fallen Idol,* and Pempy claimed that in Bobby Henrey, his child star, Carol had at last met a child he *didn't* like.

As the conversation ebbed and flowed around me, I wondered just what I was doing here, and for the first time began to look forward to boarding school as an escape. I did not feel myself to be English, like Carol, Pempy and Brendan (not to mention the Hoggs, stolidly making their way through the endless and elaborate meal like cattle chewing their cud), nor did I feel any kinship with the "foreigners," Alex, my father or Moura, with whom I seemed to have even less in common. For the first time since my arrival in England, I felt homesick for New York and California.

I was aware of the conversation, as it moved inevitably toward films. Carol was already discussing his next movie, which was to be shot in

Vienna and would be a spy story. For nearly three years, Alex had been after Graham Greene to write an original screenplay about postwar Europe, but Greene had been somewhat reluctant to do so despite the most tempting offers. Finally, exasperated by Alex's insistence, he had written the opening sentence of a story on the back of an envelope at dinner one night. It read:

I had paid my last farewell to Harry a week ago, when his coffin was lowered into the frozen February ground, so that it was with incredulity that I saw him pass by, without a sign of recognition, among the host of strangers in the Strand.

There was no writer Alex admired more than Graham, and few people he liked more—a feeling which was reciprocated on Graham's part, perhaps because they both had a sardonic temperament. It was altogether natural that they should share the same fascination with the mysterious situation Graham had created on the back of an old envelope, and which was to become, after innumerable meetings, many different versions and a blizzard of memos from David Selznick (who was putting up a part of the financing and arranging American distribution), the plot of *The Third Man.*

Carol was now casting it, and having great difficulties in getting Orson Welles to agree to play the part of Harry Lime. "He *wants* to, Alex," he explained, "but on the other hand he's bloody minded about it. He's stuck there in Italy with a film company, doing *Othello* or *Macbeth,* I forget which, and half the time they're out of money and the actors have to beg to eat, and none of them can get away because there isn't enough money to buy tickets with. Every once in a while he descends on Rome to scare up a little more capital, but when you talk to him about a part, he simply vanishes." Alex nodded. Orson's eccentricities were no news to him, but if Carol was determined to have Orson, then he would *get* Orson for Carol somehow; he gave my father an uncommonly shrewd glance.

From the balance of the conversation, it was clear to me that the matter of film financing was the reason for the dinner party, and explained the presence of Sir Percy Hogg, who seemed almost as out of place and confused by the evening as I was. I gleaned the following: We were in the middle of something that was called "The Great Anglo-American Film War," which had been caused by the British

government's decision to tax the profits of American movie companies in England by imposing a heavy customs duty on films imported from America. Once again, the British government was reacting to the tremendous outflow of dollars brought about by the British public's filmgoing habits, which were now costing almost $75,000,000 a year of precious hard currency. The American movie companies, which generally considered themselves to be sovereign states at least equal to the United Kingdom in power, had reacted with a boycott—they refused to send any films to England until the duty was lifted. The British government, already shaken by the concentrated fury of the British filmgoers, who were outraged at being deprived of American movies, urged the British film industry to expand production to fill up the gap with native product. Reversing their roles for once, Rank rashly plunged ahead with plans to spend nearly 10,000,000 pounds on feature films in one year, while Alex lagged behind, announcing merely a 5,000,000-pound production program, while actually expanding the number of films in production to a relatively modest degree.

Modest or not, it was to prove a mistake for both men. The British government, reacting to the pressure of a public which behaved as if it had been deprived of bread, caved in to the Americans, and the British cinemas were soon swamped by the sudden flood of American movies reentering the British market. Even if Rank and Alex had produced nothing but box-office hits, they would have been shaken by this sudden switch from protectionism to free trade, but in fact both of them had chosen to make "big" movies, designed to compete with major Hollywood productions on equal terms. In Alex's case, these included *An Ideal Husband, Anna Karenina* and *Bonnie Prince Charlie,* all of which were expensive flops. Alex would only agree that these films had lost "a certain percentage" of the total investment involved in their production, but when he was asked how much that investment was he merely replied "100 percent." In fact, both he and Rank had miscalculated. The British moviegoing public had become accustomed to seeing "small" British films, like the Ealing comedies, which were close to their daily lives and concerns, and many of these films did very well abroad, perhaps precisely because they were so very English. On the other hand, the British moviegoers were drawn to the movies from Hollywood for big, spectacular epics. Both Alex and Rank would have done far better to concentrate on smaller films, but Rank

wanted to prove England could do without Hollywood, and Alex was temperamentally uninterested in "little" films or British comedies. Curiously, the more modest British movies that London Films *had* produced did far better than Alex's own more lavish productions. The company's survival was in the end made possible by movies like *Mine Own Executioner, The Winslow Boy, The Fallen Idol* and *The Small Back Room.*

In fact, however, survival could only come from His Majesty's Government and the British taxpayer, hence the presence of Sir Percy, whose attendance signaled yet another, and more expensive, phase in the government's attempt to revitalize the British film industry and cut down the flow of dollars. Taxing the Americans' profits had led to the revolt of the British public; surrendering to the Americans now brought the British film industry to the brink of bankruptcy.

The Labour government was under pressure from the film trade unions to ensure that they were not deprived of their jobs, and from the film producers, who promised to commit suicide if they were not compensated for the outcome of the Anglo-American Film War. The delicate question was to decide who would receive the money, and whether the government would retain any control over what was done with it. Since Alex and Rank had lost the most, there was a strong argument to be made for giving the money to somebody else, rather than "refinancing failure," as one Member of the House of Commons put it. On the other hand, they had risked the most by attempting to respond to the government's request for increased British film production, and also had the major studios, and therefore the largest number of employees. Finally, the government was reluctant to base its rescue operation on individual merit, since it would then be in the position of a film critic, trying to decide which film, producer or director most deserved financing with public money. Brendan gave a tongue-in-cheek portrayal of the future, in which the Prime Minister and the Members of the Cabinet spent their spare time reading film scripts and auditioning actresses, and predicted that there would soon be casting couches in Whitehall, and that the Attlee government would finance a musical based on the life of Keir Hardie, or a romantic epic about Sidney and Beatrice Webb.

Because British Lion (which Alex controlled) had made substantial loans to London Films (which Alex owned), the government was faced

with the prospect of making good about 3,000,000 pounds of British Lion's losses or accepting the possibility that the largest distribution company in the country might go under, setting off a wave of other bankruptcies. It had been tactfully suggested that Alex should give up his control over British Lion, and confine himself to London Films, and he was agreeable to doing this, though pessimistic about the possibility of finding a replacement for himself. Eventually the friends and associates he had selected to watch after his interests on the board of directors of British Lion were persuaded to resign, and a new chairman was found in the person of a dour, hard-headed and tight-fisted City financier, who strangely enough inspired confidence in the Labor government, presumably because he looked exactly the way they thought a capitalist ought to. Alex, however, still owned the controlling interest in British Lion, and the new chairman soon succumbed to his charm and to the heady excitement of the movie business, so that he was shortly obliged to announce a further loss of 700,000 pounds, despite the government's 3,000,000-pound loan. The government, now that it had decided to subsidize British film production, was stuck with the problems of an industry which few outsiders had ever understood, and even Harold Wilson, then the precocious president of the Board of Trade, was unable to make much sense out of a business in which good luck and extravagance played so large a part.

In one sense, Alex had been rescued, which was good news. In another sense, he bore the burden of a 3,000,000-pound loan that could never be repaid, which was very bad news indeed. He knew that he could only survive by making smaller films and producing them more cheaply, but this was a prospect which frankly bored him, and he had no wish to direct or produce such pictures himself. He had played the role of financier and manager for many years, but now events were forcing him to become a full-time executive, with all the worries and none of the pleasures of moviemaking.

WE MOVED INTO the drawing room, the gentlemen lighting their Individuales (my uncle had given Benjamin a warning nod when he saw him trying to palm off a cheaper Havana on Sir Percy), and Moura too, as she always did, lighting a full-size cigar for herself. "At my age," she said, "one is confined to the pleasures of taste." We were interrupted

by the arrival of Vivien Leigh, who exclaimed as she saw me, "Ah, the blind boy with the dog!" kissed me rapidly, downed a large vodka (somewhat reluctantly offered to her by Benjamin) and burst into tears. Moura had explained at length during dinner the problems of the Oliviers' marriage, and had predicted its collapse, prematurely, as it turned out.

Alex took Vivien away to the study so that she could pull herself together. My father, who hated scenes, and knew that she was an expert at staging them, prepared to leave. Alex, who never minded my father's early departures, appeared as we stood in the hall, looking cross and preoccupied. He gravely shook my hand, then said to my father, "I want you to go and get Orson. Find him. Bring him back somehow. Try not to let him know how much we need him, but get him back here and I'll persuade him to sign a contract."

Vincent was hesitant. He had no tickets, no foreign currency, and no clear idea of where in Italy Orson was to be found.

Alex snorted. "The tickets will be ready tomorrow, there'll be as much money as you like waiting for you in Rome. Don't make difficulties. Take Miki with you. He has nothing better to do, and a boy should have more on his mind than looking after a dog."

With that he returned to deal with Vivien. Benjamin, who seemed to me to have been drinking (it was his habit to empty any wine left over in the glasses during the course of the evening, to calm his nerves), wavered back and forth before us, pulled himself together, and wished us good night, with his eyes closed. He gently shut the door, and we went downstairs to where O'Bannon waited, asleep in the car.

TO SAY THAT Alex's party was subversive would be putting it mildly. For all my stage fright, I was fascinated. I liked the apricot wall-to-wall carpeting, the superb furniture, the *semainiers* full of shirts, the fact that everything was new, clean and expensive. In Alex's bathrooms one never found an old, thin cake of soap, at the end of its life, firmly squeezed against the new one. Apparently, when someone used a cake of soap, Benjamin threw it away and put out a new one, just as the boxes of matches were always full, and the flowers always fresh.

It seemed to me that it would be wonderful to live like Alex; his elegance dazzled me. As we drove down Piccadilly on the way home my father dozed in the front seat, next to O'Bannon, or pretended to, and I sat in the back next to Leila, who put her arm around me. "It must be nice to be as rich as Alex," I said sleepily. She shook her head and sighed. "Don't tell your father that," she said in a whisper. "It's exactly what he was afraid you'd think."

TWO DAYS LATER my father and I flew to Rome in pursuit of Orson. Vincent was annoyed at being sent on an errand but was rather pleased to be getting away from home, and looked forward to some good meals, a few nights in first-class hotels and a little sun. He was happy enough to leave Leila behind, since she had just announced that she was pregnant, and he was still not sure whether to be delighted or angry about it. In the B.E.A. *Viking* first-class flight to Rome, he ate his caviar, drank his champagne, and told me that I would soon have a stepbrother. (The possibility of having a daughter did not occur to him.) "It's going to mean changes," he said, regretfully, since he hated change, "and a lot of fuss. Still, it won't be so bad, and we'll buy a large house, which I wanted to do anyway. It's not right for you to sleep on a couch in the living room when you will come home from school. All the same, I don't look forward to it—nannies, teething, all of that, I thought it was over . . ." He stared moodily at the passing Alps, and shrugged, resigned to his fate. He bore Leila no ill will; all women wanted to have babies, that was what they were for.

On our arrival in Rome, we were met by a driver from the London Films office, with an envelope full of lire, who took us to the Hassler Hotel, where my father had booked a suite. We went out for dinner, then stopped by the Grand Hotel, where Vincent assumed Orson would naturally stay if he were in Rome. There the *concierge* informed us that Signor Welles had only just left for Florence. "Ah," my father said, "one of my favorite cities—there's a marvelous restaurant there." He arranged for a reservation at the Grand Hotel in Florence, and went to drink a brandy on the Via Veneto. The next morning we went to Florence by train, and ate an excellent lunch in the wagon-lit dining car, arriving in Florence in the afternoon. We registered at the Grand, where the *concierge* informed us that Welles had just left for Venice,

went out to stroll in the Piazza del Duomo, dined magnificently on Florentine steaks, pasta and *zuppa inglese,* and made arrangements to leave by train the next morning for Venice.

In Venice we were met by a *motoscafo,* which my father sent off with the luggage, since he believed one should make one's arrival in Venice only by gondola. We registered at the Danieli, where we were informed by the *concierge* that Signor Welles extended his apologies to my father, but had been obliged to leave for Naples. We dined magnificently on *fritto misto* at the Taverna Fenice, strolled through the Piazza San Marco, admired the basilica and the Campanile, sat down to listen to the open-air concert, and went back to the Danieli to rest up for the next day. My father was beginning to enjoy himself, and remarked that with any luck Orson would end up in Paris, which was always his favorite city.

We flew to Naples the next day, only to find that Welles had left for Capri. My father was not upset. He liked a sea voyage, and we set off on the steamer for Capri, like a pair of pilgrims on some obscure religious quest. As we pulled into the dock at Capri, we looked over the side to see a motorboat heading out toward the mainland at top speed. In the back, waving grandly to us, sat Orson, surrounded by a mound of luggage, on his way, as we soon discovered, from Naples to Nice. At a day's interval we followed after him, now followed ourselves by a storm of cables from Alex, urging Vincent on. It is impossible to say whether these increased Vincent's zeal or Orson simply ran out of money and credit, but we finally tracked him to the Bonne Auberge, in Cagnes-sur-Mer, where Madame Baudoin, always my father's friend, champion and admirer, had informed us he could be found, eating the small raw artichokes of Provence, which were served with an anchovy sauce, before plunging into a steaming bouillabaisse and a roast chicken. Orson waved us to his table, ordered more food and wine, and resigned himself to his fate.

My father was never one to bear a grudge himself, and in any case, he had enjoyed a pleasant journey across Europe, even though it was a little rushed. He did not bother to explain why Orson would have to sign the contract. He knew perfectly well that Orson had no choice, so urgent was his need for money, and in any case that was Alex's job. Instead he got Orson drunk, took him in a taxi back to the Hôtel Ruhl, bribed one of the porters to stand watch over his door and arranged

with the *concierge* to hire a private airplane to take us back to London. "There's less chance that he'll slip away from us," he explained. "Otherwise we have to fly to Paris and change planes, and he'll be gone at Orly the moment we let him go to the toilet."

The next morning, Orson, my father and I journeyed to the Nice airport, where we boarded a small twin-engine airplane. My father sat up front with the pilot, lost in his own thoughts, while Orson and I squeezed into the two back seats, made more uncomfortable by the presence of a huge basket of fresh fruit, which my father had carefully chosen at dawn in the open-air market in Nice's Old City. (At the time, fresh fruit was hard to find in England.) The basket itself was enormous, and it contained almost every imaginable fruit—figs, grapes, melons, plums, pears, tangerines—all of them plump, glossy and covered in dew. Orson, who by now clearly regretted his surrender, glared morosely at the fruit as we took off.

Once we were airborne, my father fell asleep, and gradually Orson, having finished the *Nice-Matin* and yesterday's Paris edition of the New York *Herald-Tribune,* began to eye the fruit. Sleepy myself, I noticed him pick up a piece of fruit and fondle it, but when I woke up an hour or so later, I realized to my horror that he had systematically taken a single bite out of each piece of fruit, even the ones whose rinds made this a difficult proposition. Having effectively destroyed Vincent's fruit basket, he was now at peace with himself, and slept soundly, his immaculate appearance marred only by a few spots of juice on his shirtfront.

I thought there was nothing to be gained by telling my father about Orson's revenge, and when we landed and he saw his devastated fruit basket, he merely sighed and asked the chauffeur to deliver it to Mr. Welles's suite at Claridge's. Not a vindictive man, Vincent was always surprised that others were, though he made allowance for talent. "I give you a word of advice," he said, as we turned into Wilton Place—"never trust an actor!"

ALEX FELT MUCH the same way about the press. He avoided as much as possible the kind of gossip-column, movie-magazine publicity that surrounds the lives of most successful film people, no doubt because he was afraid of provoking a reply from Maria, who loved to display her

discontent in public. Generally speaking, he preferred to defend himself in the august columns of the *Times*, either by means of a Letter to the Editor or an exclusive interview. Alex argued that the reissues of good movies were his major long-term asset—one which was generally ignored, since most investors expected a quick return in the movie business. He pointed out to the readers of the *Times* that such films as *Elephant Boy, The Thief of Bagdad, Lady Hamilton, The Four Feathers, The Scarlet Pimpernel* and *The Private Life of Henry VIII* had earned London Films no less than 1,760,000 pounds since 1945, and enabled the company to show a profit of 283,000 pounds in the financial year 1946–47. What he did *not* point out was that these profits had largely been absorbed in the losses of films like *Anna Karenina* and *An Ideal Husband*, and that certain people, Zoli among them, drew the conclusion that he could very well live off the earnings of his classic prewar children (or his "grandchildren," as he called them), and give up making new films altogether.

Certainly Alex had a genius for exploiting his old movies—from 1947 to 1949, he made over 1,000,000 pounds in Germany alone, taking advantage of the fact that the Germans had been cut off from most of the successful international films since 1933. But Alex had not the slightest desire to retire from active film making. As a token gesture toward the government's refinancing of British Lion he had thought it prudent to remove the words "Alexander Korda presents . . ." from the titles of his movies—henceforth Big Ben would chime without his name superimposed on it. All the same, Alex felt the need to make his position better known to the British public, who were now financing him, however indirectly, and his name began to appear with more frequency in the popular newspapers, particularly the *Daily Express* owned by his old friend Beaverbrook. He formed a close friendship with David Lewin, the *Express'* film columnist and reporter, much to the horror of my father who did not share Alex's enthusiasm for newspaper publicity and had a deep distrust of reporters. Soon Alex was appearing in the *Express* with remarkable frequency, always photographed with a jaunty smile and big cigar, the language of his comments revised and downgraded to the *Express* house-style. He announced to the readers of the *Express* that he was no longer "a producer, but an administrator," and promised massive economies in film making, though as one observer of the industry was to point out, the only economy Alex could

think of when questioned was that a cheaper brand of toilet paper had been found for use in the studio.

He wrote an article for the *Express* (or somebody wrote it for him, since its English slang and general breeziness are clearly the work of Fleet Street) announcing that "The grand, slap-up funeral of the British film industry . . . is not going to take place," and laying the blame for the British film crisis at the feet of the distributors and exhibitors, while curiously insisting that he was merely "a film maker, not a film magnate or a film mogul."

With his natural sense of survival, Alex was clearly dissociating himself from the "money men" who had brought the British movie industry to its knees and were now looking to the Treasury for help; it was more expedient for him to join "the craftsmen in the studio, as a simple maker of films who is passionately interested in his craft." He generously predicted that the British film industry was "at the beginning of its greatest period," on the condition that it learned "to mend its economic ways," a remark which caused some consternation, since most people had assumed it was precisely Alex who needed to mend his ways. Formerly somewhat aloof, Alex now invited journalists to dinner and to little tête-à-têtes at Claridge's, at which he wined and dined them very successfully, determined to ensure that he would be seen as one of the victims of the movie industry's financial disaster, as opposed to one of the perpetrators.

The name Korda was now almost constantly in the news, one way or the other. This was so much the case that Maria, who had for some time restricted herself to attacking Alex by letter, cable and telephone, burst into the headlines again herself. She was fined five pounds (plus five pounds, five shillings in costs) at Bow Street Magistrate's Court for assaulting her part-time secretary, who complained that she was unable to type thirty letters for Maria between ten in the morning and noon. Maria had come to England to organize support for a religious epic in which she would play Bernadette, with "real miracles." She claimed to have spent ten years at Lourdes, and to be a frequent, intimate visitor with the Pope in Rome. "I take flowers," she said. "His Holiness is delighted!" Maria described her plans for an autobiography, to be called *When Heaven Speaks,* probably designed as a threat to extract more money from Alex, and proudly showed reporters a white leather gold-tooled notebook which contained plans for a pilgrimage she

planned to lead to Lourdes, and which she wanted Alex to film as the background for a movie "that will not be just another Bernadette, like that of the charming little Jennifer Jones."

Maria had clearly not lost her forthright way of dealing with opposition or disobedience. More disturbingly, she still insisted that she was not divorced from Alex, and was entitled to be called "Lady Korda," in deference to which she had changed her stage name from Maria Corda to "Maria Beatrix Korda," the middle name presumably a sign of her religious fervor. In what was to be the first of Maria's many appearances in the headlines of British newspapers, most of them revolving around her innumerable litigations, suits and countersuits, she managed to restrain herself from any direct attack on Alex. She was in any case in a difficult situation to maintain her claim about being Lady Korda, since she was receiving $1,250 a month as part of the divorce settlement that had been reached between Alex and herself in Los Angeles. If she succeeded in proving that the divorce was invalid, then she would be cutting off her own alimony. Faced with Alex's refusal to see her, she retreated back to France, to brood over new ways in which to embarrass him. She had, as Alex recognized with a tremor of unhappy anticipation, discovered the British legal system, in which even the most ridiculous of claims proceed through the courts at a leisurely pace and are fully reported by the press.

Nothing was more calculated to plunge Alex into depression than the prospect of Maria's reemergence as an avenging angel. He threw himself into his work, negotiated a deal with David O. Selznick to finance the making of *The Third Man,* and set himself to the task of building up a "stable" of talented directors, whose films he would finance, produce and sell. *Perfect Strangers* and *An Ideal Husband* were the last films he would ever personally direct, and he now had very little reason to visit the studio at all. In some ways, this was a misfortune. Making a movie is a vastly complex enterprise, and however much it exhausted Alex, it at least gave him something concrete to do, and got him away from his office and his problems. Now he was alone, dealing with the financial problems of the empire he had created, an increasingly remote figure who was expected to find money so that other people could make films.

It was not a role calculated to make him happy; however much he admired David Lean or Carol Reed, he was still a distinguished director

himself, and had to fight a natural inclination to make suggestions and interfere. Nor did he always understand the movies his directors wanted to make. *The Third Man*, of course, he understood perfectly. It was an espionage drama and a love story. It was set in Vienna. It was exactly the kind of thing he was most enthusiastic about. But he was not interested in a movie like *The Last Days of Dolwyn*, Emlyn Williams' understated film about a Welsh village threatened by the construction of a dam, or Robert Donat's *The Cure for Love*, an equally regional small film set in Yorkshire. He was, generally speaking, helpful, sympathetic and concerned to suggest some way in which these films, and others like them, could be modified to have some chance of earning money abroad, but his heart was not in them, and he complained about being reduced to the role of "a bookkeeper and father confessor."

THE LAST TIME I saw him before I went away to school he was standing by himself, in Carol Reed's garden, looking withdrawn and depressed.

Ever since my father's triumphant return with Orson Welles, I had found in the Reed household, on the King's Road, Chelsea, a welcome home away from home. It was not that the Reeds were saner than the Kordas, but at least they talked to each other civilly, and had some useful information to impart about the mysterious and strange country that I was now living in and knew nothing about. Carol, who for all his good humor and joking recognized alienation when he saw it, hired me to write my ideas for movie subjects at five shillings a piece, and was never too busy to discuss them with me. He was always enthusiastic and delighted, and whenever he had time to spare he would drive in his brand-new blue Jaguar to a small pet shop in the East End, to return with yet another exotic animal or bird. One wall of the Reeds' drawing room was built in the form of a gigantic aviary, in which dozens of birds of different kinds fought, screeched and defecated. To Carol, each one of them was thrilling and unique, and he would stand in front of the bars shouting out in his booming voice, "Look, *look*, Pempy, isn't it *marvelous?* The little blue one is eating a grape!" while a singularly malevolent blue parrot glared back at him. Carol's hedgehog remained a disappointment to him, and occasionally he chose the wrong kind of pet, as was the case when his two cranes made their way up the fire

escape of a nearby house, causing great consternation when they appeared in the bathroom of an elderly lady. Since the Reeds shared their garden with Peter Ustinov, they were spared most complaints, Ustinov's sense of humor being more than adequate to deal with most of the animal intrusions.

Alex was particularly apprehensive about Carol's "zoo." He disliked going to other people's houses—even houses without tortoises in the bathrooms and guinea pigs on the stairs. But he made an exception for Carol and Pempy. Now that he was obliged to woo directors to London Films, he found it was necessary to treat them like actors. Some directors he found difficult—his relationship with David Lean, for example, was admiring but hardly warm, perhaps because Lean's personality was too cold, too precise and too serious for Alex. Carol, on the other hand, Alex genuinely came to love, and it was difficult to say which one of them had adopted the other. Certainly, Carol saw in Alex a kind of father substitute for Sir Herbert, who had failed to give Carol (or his mother) his distinguished name. Undoubtedly there was in return a certain fatherly pride in the way Alex enjoyed Carol's success. They brought out the best in each other because Carol needed Alex in a great many ways that David Lean, for instance, did not.

Alex therefore came to parties at the Reeds', though he usually looked like a man preparing himself for a practical joke about to be played at his expense. Possibly the birds made him nervous—certainly, he stayed as far away from them as he possibly could—but his main concern was the garden, which he regarded as a death trap. When Carol had bought the house, it was covered in ivy. Charmed by the luxuriant thickness of his ivy, Carol refused to cut it back. Instead he encouraged it to grow, with the result that it eventually pulled one whole wall off the house, and brought it crashing onto the garden lawn, leaving the interior exposed as if it had been hit by a freakish bomb-blast, with one of the maids sitting in horror on the toilet, revealed to the world as if she were relieving herself on a stage set. Alex had heard enough about the wall to be apprehensive, and tried to avoid standing anywhere near it, while Carol, a creature of schoolboyish dares, always tried to coax Alex out into the garden. "You've simply *got* to see the ivy," he would tell Alex, "it's bloody wonderful the way it grows!" Alex was not to be moved. On this occasion he had planted himself in the drawing room, as far away from the birds as possible, with the result

that he had been collared by Sonny Tufts, the American actor, and was forced to listen to Tufts' plans for renewing his career.

Tufts had been the victim of a terrible remark, perhaps the only actor in the history of motion pictures whose career was ended by a single line. When Cary Grant had fallen ill before giving a speech, the organizing committee had replaced him at the last minute with Sonny Tufts, and the master of ceremonies, who had not been informed of the switch, announced to the audience of motion picture celebrities, "And now I present you with one of the truly great actors of the industry, a man who has been a star for many years, a distinguished actor and a great gentleman"—he glanced down at his program notes —"Sonny *Tufts?*" The roars of laughter echoed for many minutes, and Tufts never recovered. Now he was attempting to make a comeback in England. presumably in the hope that nobody had heard about the joke there, and Alex listened to him with growing impatience.

Tactfully he indicated that he needed another drink, and making his way to the bar he passed by me. He winked. "Sonny *Tufts?*" he said. "I don't know why I come out to these things, I would be better off at home. Is your father here?" I pointed to the garden. Alex nodded. "Your father has no sense of self-preservation. That garden is a death trap. Still, better dead than spending the evening with Mr. Tufts. You go to school next week?" I indicated that this was the case. Alex put his hand on my shoulder. "You'll see," he said, "it won't be so bad. I had great homesickness when I went to Budapest, and I was just about your age. It passes. Like everything else. Now I must go and be kind to poor Vivien, I think. I won't write to you, and you needn't write to me, but I will think of you sometimes, and one day we'll go on the yacht together, even if your father does disapprove."

He leaned over so I could kiss his cheek, then made his way over to a corner of the room, where I could hear Vivien's high-pitched nervous laughter, increasing alarmingly in intensity. At the top of the stairs I could see Pempy's daughter, Tracy, the child of her former marriage to Tony Pelissier, reputed to be the most handsome man in London, looking down from the small wing of rooms where she lived with her infant half-brother Max and their nanny. I waved and made my way out to the garden, where my father sat talking to Carol.

The Third Man, I knew, had already run into the usual difficulties involved in making any movie. Anton Karas, the zither player whose

theme song was to become world famous, had run off with the Reeds' maid. Orson Welles was writing his own dialogue and grossly enlarging his part. The Russians were being uncooperative about filming in their sector of occupied Vienna. A great deal of the action would have to be filmed in the sewers. Valli, the actress chosen for the lead role, had a disappointingly small amount of cleavage. My father was wearing a preoccupied frown, and even Carol, despite his natural buoyancy and jolliness, looked tired. My father put his arm around my shoulder and said, "Well, better to be in school than in the bloody sewers. By the time you come back, we'll have a new home. I found a house in The Wale, with a big studio for me to paint in, and a room for you, and room for a bloody nursery. We have to share a bathroom, but I hope you won't mind that. By that time we'll have finished this bloody film, and I suppose we'll be worrying about some other bloody film."

He yawned and stood up. He was not a man who enjoyed late nights, and it was only his love for Carol that brought him out to a party, when he could otherwise have been at home, in his own kitchen, with his shoes off, a bottle of brandy in front of him, and the newspaper in his lap. Pempy, seeing that he was ready to leave, came over to stop him. "Do stay, darling Vincent," she said. "Don't go yet!" He shook his head—Vincent loved Pempy, and sometimes said she was the one Englishwoman he could bear, but he was not about to stay past his bedtime. "Dear Vincent," she said, "all these people are having a wonderful time, and they're *dying* to meet you."

My father looked at the throng. He had already said hello to those he knew, and the ones he didn't know were of no interest to him. He allowed himself to be kissed by Pempy as he made his way toward the door, looked once more at the crowded drawing room, and said, as his final comment, *"Ach,* Pempy, vat the hell do dey know?"

CHAPTER 7

~~~~~~~~~~~~~~~~~~~~~~~~~~~~~~~~~~~~~~~~~~~~~~~~~~~~~~~~~~~~~~~~~~~~

W HAT THE HELL do they know?" I was to ask myself daily at
school. My first reaction to Le Rosey was that my father could hardly
have chosen a place less suited to his own ideas about education. Here
snobbery, respect for money, social position and what Vincent would
have described, rather accurately, as "chi-chi" had been developed to
the level of a living philosophy. My schoolmates included two nephews
of the Shah of Iran (who was himself an *"ancien Roséan,"* and gener-
ally regarded as the school's most prominent graduate), the King of the
Belgians' brother, the two grandsons of the Aga Khan (one of whom,
Karim, is now the Aga Khan), His Royal Highness the Duke of Kent
(the first member of the British Royal Family to be educated outside
England since the days of George III), the son of the deposed King of
Italy, the young Marquess of Dufferin and Ava, and a number of
Italians with more or less disputed titles as counts, princes and mar-
quesses. Somewhat lower on the social scale were the children of those
who were merely very rich, including the heir to the Heinz ketchup
fortune, the heir to the Nestlé chocolate empire, a Rockefeller and
several pampered French *"fils à papa"* of the *haute bourgeoisie.* Lower
still were the decadent and world-weary adolescent offspring of wealthy
South American families, swarthy youths who bought gold Rolex wrist

chronometers with their pocket money as if they were chocolate bars, and who spent their vacations making love to middle-aged bathing beauties on the Lido of Venice, or on Capri. The only familiar face I saw was that of Warner LeRoy, then a thin, bespectacled child whom I had last seen avoiding gym at school in Beverly Hills (and who is now, of course, the flamboyant owner of the Manhattan restaurants Maxwell's Plum and Tavern-on-the-Green).

My ability to integrate myself into life at Le Rosey was at first severely hampered by the fact that all conversation was supposed to take place in French, though actually English was the secret lingua franca of the place. Even when I began to understand a little French, I found it bewildering, after P.S. 6. Every night we dressed for dinner —suits and ties—and were served by smiling Swiss waitresses, then as we filed out of the dining room, we each paused to bow and kiss the hand of *Monsieur le Directeur's* comely wife. Our rooms were cleaned by maids, who also polished our shoes and took care of our laundry. We were allowed to smoke and firmly discouraged from discussing the war or international politics to avoid provoking anybody's national sensibilities.

Unlike most boarding schools, Le Rosey had no religious traditions, since too many religions were represented to make any kind of observance possible. The only event of note that took place on Sundays was the regular arrival of the old Aga Khan, who was driven over from Lausanne in his Rolls Royce, with blacked-out windows and discreet French *corps diplomatique* license plates, so that his grandsons could pay their respects to him. At noon precisely, the huge car would draw to a halt in the graveled courtyard, under the medieval clock tower. The two boys would walk over and fall to their knees, a black window would descend with a low, electric hum, and a pudgy hand would be extended from within the car. Each boy would kiss it in turn, and the hand would then distribute to each of them a single new Swiss five-franc piece; the window would be raised, and the car would silently move forward, circle around the fountain and vanish down the driveway. Luckily, Karim and Amin received a rather more generous allowance from their father, Aly Khan, and occasional visits from their stepmother, Rita Hayworth, which electrified the school, except for the more jaded of the South Americans, who claimed to have seen and done it all.

So luxurious was Le Rosey that it had not one campus but two. In

the spring and autumn, the school resided in a big château on Lake Léman, between Geneva and Lausanne, surrounded by vineyards and close to the famous Château of Chillon, romanticized by Byron. Our Saturday and Sunday afternoons were spent in Rolle, a small town which made its living off Grappillon, a sweet nonalcoholic Swiss grape juice, and the exotic demands of the Rosey boys. For a town of a few thousand agriculturists it had an unusual number of jewelry shops, even for Switzerland, all of them with lavish window displays of Rolex, Patek Philippe, Longines, Tissot, Movado and Vacheron & Constantin watches. It also had a tobacco shop which carried newspapers and magazines in every language, and did a brisk trade in solid-gold Parker 51 pens, then a potent status symbol. The harness shop carried Hermès brief cases and wallets alongside cowbells and farming implements, and the hardware store had displays of gold pocketknives and expensive SIG target pistols.

In the winter, the school body abandoned this rustic backwater to take up residence in three large chalets in Gstaad, then as now one of the most exclusive ski resorts of the Bernese Oberland, and here, for three hectic months, the Roséans skied, skated, played ice hockey and escaped from the none-too-rigid discipline of the lowlands. In Rolle, it was possible to apply at least some of the school's fairly liberal rules, but in Gstaad, where the chalets were close to the center of a famous winter resort, and within a few minutes' walk from the Palace Hotel, the bars and night clubs, it was hardly feasible. More dangerous was the fact that many boys' families descended on Gstaad to spend the winter skiing, so that the town was full of sisters, girlfriends—unattached young females of every nationality. Le Rosey lore was rich with stories of boys who had slept with famous beauties, of young women who had attempted suicide at the end of an *affaire* with a Roséan, of secret meetings on the ski slopes, all-night parties, gambling, drinking and expulsions. Our code of behavior was paradoxical: We were to be gentlemen, first and foremost, and also *"des types sportifs,"* which was not the same thing at all.

Being a gentleman was not that easy to define, except for Kent, who explained that it meant being an Englishman. As an Englishman myself, I was inclined to agree with him, and felt that while not all Englishmen were gentlemen, all gentlemen were English. Monsieur Johannot, the director, defined the school's ideal of "gentleman" as

being basically a fair, courageous, honest *"type sportif,"* the implication being that it required a certain amount of dash, style, physical skill and enthusiasm. Certainly the ideal Roséan, the *"chic type"* or *"type sportif,"* was truthful, but he was also daring (which meant that it was okay to break the rules if you did it with a certain amount of class), a sportsman (which meant that you didn't mind breaking your own bones or someone else's on the playing field) and open-minded (which meant that you shouldn't make fun of the Italian performance in the Second World War or mention what the Germans had done during the war). The Shah of Iran, Monsieur Johannot explained to us, was a gentleman, a *"chic type"* and a *"type sportif,"* the very model of what we should expect to become.

Kent was outraged by this example, and pointed out to me that no member of the British Royal Family could be expected to model himself on the Shah. "After all," he said, "the bloody man's father was a jumped-up sergeant-major of the British Cossack Brigade, who overthrew the government and invented the whole bloody monarchy, and the Shah himself wouldn't be there if we hadn't damned well put him back on his throne with a couple of battalions of British troops." I myself advanced the cautious opinion that the Shah was a rather unsavory dictator, and soon acquired the unenviable reputation of being a troublemaker and a radical, and found myself defending Lenin and Marx to a student body (and a teaching staff) which had not yet come to grips with the beheading of Louis XVI and Marie Antoinette.

Difficult as the definition of "gentleman" might be, Monsieur Johannot had even more difficulty with the question of money. It is very difficult to instill ambition in a youth who expects to become the spiritual and temporal leader of several million Moslems and gets weighed every year to receive his weight in gold, nor even in one who expects to come into a trust fund of several million dollars. Monsieur Johannot urged us to regard our money as a blessing that must be treated with responsibility, but being Swiss, he did not at heart feel that the rich have any particular obligation to the poor. Most of the parents had placed their sons in Le Rosey with the same confidence, and in much the same spirit, that they placed their money in the anonymous security of numbered accounts in the Zurich banks. In Switzerland there was no fuss about taxes, radical ideas or capital-gains taxes— money was treated with a quiet, solid respect, and no embarrassing

questions were asked about its provenance. This was true of Le Rosey as well, than which there could not be a more Swiss institution. The school was democratic in the sense that it opened its doors to the rich of every land, however or whenever they had acquired their money. Here there was no embarrassing distinction between "old" money and "new" money. Certainly a title was highly esteemed, particularly a royal one, but Monsieur Johannot was no snob, and proudly asserted his indifference to aristocratic pretensions, which as a decent Swiss citizen, he rather despised. It was enough that the parents of his boys could afford the school's fees, which were astronomical.

The social structure of Le Rosey held few terrors for me. Exposure to Alex had convinced me that being a Korda was better than being a duke, or even a prince. Here, out of my father's sight, I cultivated my imitation of Alex. The parents of other children might be kings-in-exile or multimillionaires, but I was not impressed—they were not Kordas. I was.

Alex had won at last in his battle with Vincent over my education, but luckily for me, my exposure to Zoli's opinions enabled me to retain an objective view of my new school. I was not surprised to find that the scion of a South American mining fortune had stolen my portable typewriter, that some of the Shah's relatives were arrogant and unruly or that one heir to a presumptive throne was widely suspected of being *"un peu pédale"* and therefore to be avoided in the showers. During my first week, a wealthy Mexican boy ran amok and shot up his room with a 7.65mm. automatic pistol, then made a run for Geneva and the border in the headmaster's Chrysler, condemning us to a long lecture on the obligations of being a gentleman and the niceties of the *"esprit sportif,"* in both of which he had been clearly lacking.

In one respect, however, Le Rosey was worth what it cost. Here it was possible to get the benefits of a solid European education. There were those who did not avail themselves of this opportunity, but for the few who were interested, it existed. I learned Latin (mindful of my promise to Alex). I became fluent in French. I was plunged into the rigors of geometry, European history, geography (how many people can name the cantons of Switzerland or its endless lakes?), French literature, German literature, English literature, drawing, art history, fencing, science and the virtues of the Swiss Constitution. I even learned to dance. We spent many long evenings mastering the waltz with each

other while the instructor flailed away at the piano, shouting out *"Un, deux, trois; un, deux, trois, messieurs."* We finished off our lesson with the rousing excitement of the "Radetzky March," the energetic conclusion to any dancing party in pre–World War One Austria-Hungary, a kind of Imperial military square dance that ends in exhaustion.

Le Rosey could hardly be said to be experimental; I strongly doubt that Monsieur Johannot had read about A. S. Neill's Summerhill, Rudolf Steiner's "Outward Bound" schools, or Dewey's theories on education. He kept to the straightforward philosophy of ensuring that his pupils were thoroughly tired by the end of every day. We rose at seven, breakfasted at seven-thirty on coffee, hot rolls, fresh butter and Swiss honey, were in our classrooms by eight o'clock, and stayed there until noon. From twelve-thirty to one-thirty we were served a large luncheon, from two until five we engaged in sports, from five to seven we studied, at seven-thirty we dined, and from eight-thirty until ten we studied again, until the lights were turned off.

Sports were not just compulsory, they were the very heart and soul of the school, and no slacking or lack of enthusiasm was permissible. We played soccer, field hockey, rugby football, tennis and lacrosse; we did athletics, gymnastics and *culture physique;* we went on hikes, runs and mountain climbs, we rowed on Lake Léman, learned to ride, and did archery, rifle shooting and pistol shooting on Saturdays. In the winter term at Gstaad, we moved on to ice hockey, bobsledding and skiing. The test of a true Roséan was his proficiency on skis. During the three months at Gstaad, competition reached a fever point; on good days the classes were suspended and everybody was sent onto the slopes. Each student was placed in a group, according to his skiing ability, beginning with the sorry *Groupe D,* and ending in the glory of *Groupe A,* whose members competed in slalom races, did the terrifying *"Windspiel"* descent in under four minutes and wore special blue sweaters with white stripes and a silver eagle. *Le Groupe D* was a motley collection of incompetents of all ages (it was also known as *"Le Groupe Sitzmark"*), and it was considered shameful and spastic to spend more than one term there, while *Le Groupe A* ate at a special table (where they received bowls of diced Spanish blood oranges for dessert) and held everyone else in contempt.

The mark of a Roséan during the winter was a deep windburn. The elite skiers cultivated a tan as assiduously as any bikinied Riviera vaca-

tioner. They did all their studying on the terraces of the chalets, even when the temperature fell below zero. We spent the winter in ski trousers and sweaters, and soon learned how to wrap a silk scarf around our necks to give just the right kind of sporting look, made even more effective by a pair of gold Ray-Ban aviator's goggles looped over the neck of our sweaters.

Since the chalets were somewhat separated from each other, it was even possible to ski down to breakfast, in the icy dawn, as the sun began to turn the looming mountains of the Bernese Oberland *massif* pink, and the stars faded in the sky. Conversation revolved around the merits of different wax bases, skiing techniques and brands of ski, the favorite then being the ultracostly Rossignol, which every Roséan either owned or was in the process of extorting from his parents. All of the teachers skied, even old Professor Loeffler, the formidable mathematics teacher, who exactly resembled the aged General Ludendorff. He had known Einstein at Zurich university, and he could be seen, every afternoon, making his way toward his favorite *Bierstube* in plus fours and knee socks, a huge muffler wound around his neck, on long Norwegian cross-country skis, smoking one of those curious Swiss peasant pipes, with a curved mouthpiece and a little hinged silver cover over the carved bowl. From Christmas to Easter, we virtually lived on our skis. By the end of every winter term, we prayed for the snow violets and crocuses to appear, signaling that the season was over.

My immediate social ambition was to rise from my lowly position as a beginning skier to something more exalted. I did not aspire to *Groupe A*, but passionately longed to reach *Groupe B*, which was at least respectable. On the whole, my social position at Le Rosey was somewhat anomalous. Movie people are commonly thought to be rich, almost by definition, and the fact that my father was nothing of the kind escaped everybody's attention, and was something I felt no need to dwell upon myself. Alex's celebrity carried over to my life, even here, and the fact that Merle Oberon was—or had been—my aunt, though it did not carry as much weight as being related to Rita Hayworth, nevertheless gave me some prestige. The Hollywood connection, which I shared with Warner LeRoy, gave us both a kind of glamour in our fellow students' eyes. Even those who expected to inherit thrones wanted to hear about life in the movie business, which seemed to them far more exciting than that of any palace. I therefore kept a photograph

of Merle on my desk, and Warner distributed signed pictures of the stars, sent over in bulk by his father.

Alex had been right in his appraisal of the importance of pocket money, though he had underestimated the amount that it was possible to spend as a Rosey student. Some boys carried great wads of Swiss francs in their pockets, like professional gamblers. Many maintained checking accounts at the local branch of the Schweizerei Handelsbank, and very few paid much attention to the school's system of doling out to everyone a small equal allowance. An even more pernicious loophole in the system, peculiar to Le Rosey, lay in the form of what were called *"bons,"* by means of which boys could draw a voucher enabling them to purchase almost anything they wanted. Since this system was rather loosely supervised, it was possible to buy anything from an expensive pair of skis to a new Leica, the general theory being that most Rosey parents would not want their children to deprive themselves of anything they desired, and that if a student abused this privilege it was a matter to be discussed between parent and child, rather than with the school. The rooms of most Roséans looked like a duty free shop at an airport or in Hong Kong. There has probably never been, among a comparatively small group of adolescents, a larger number of radios, phonographs, wire recorders, still cameras, movie cameras, typewriters, assorted firearms, watches, clocks and sporting equipment.

During these months I was both geographically and psychologically remote from both sides of my family. My mother, still in the United States, seemed to be receding from my memory. Neither of us was a great letter writer, and when I had last seen her, she was recovering from a gradual decline in her stage career, brought about largely by her own lack of confidence, for she remained a gifted actress. She had reached her peak in the American theater in the famous production of *The Three Sisters,* in which she played the youngest sister alongside Katharine Cornell, Ruth Gordon, and Judith Anderson, but she seemed unable to repeat this triumph. A couple of failures led to her retirement, perhaps because there was nobody to push her on. Her letters were uninformative, as no doubt mine were to her. I knew that she was spending some time in Lake Placid, where we had spent many happy times together, and suspected that she was in love with John Astarita, a generous and attractive man whom she had met there, and whom I liked very much myself. Yet she was silent about this, and any

inquiries on the subject to my father merely produced the remark, "Poor Gertrude . . ."

I gradually conceived the notion that I could either become a Korda or return to live with my mother, but that the two possibilities could not be reconciled, though I doubt that this had been Vincent's intention. The Kordas simply lived in a world of their own, which centered around Alex, and took it for granted that the sooner a boy was removed from his mother, the better.

Nor were my father and Alex very good correspondents. I felt lonely because of having been exposed to the Korda family and its concerns quite suddenly, and then just as suddenly cut off from them again. What I learned of the Kordas now was gleaned from English newspapers and the Paris edition of the New York *Herald-Tribune.* I read that Alex had been made an officer of the Légion d'Honneur by the French government for his services to France and the French film industry (Alex thenceforth carried the little red rosette of the order in his pocket and fastened it in his buttonhole before going through customs in France), that he planned to film a life of Caruso starring Mario Lanza (a project which never materialized), that he had been awarded the David O. Selznick Golden Laurel Trophy for "his contributions to international good will" (an ironic award, in view of the endless recriminations that accompanied Selznick's involvement in financing *The Third Man*), that Alex had crossed to New York on the *Queen Elizabeth* with the Duke and Duchess of Windsor, that Merle had announced her intention of becoming an American citizen, that Zoli had announced plans to film Aldous Huxley's *The Giaconda Smile,* that Alex had announced plans to film Thomas Mann's *The Magic Mountain* (screen rights to which he had just bought) and that Paulette Goddard had announced Alex was going to make a movie of Prosper Mérimée's *Carmen,* in which she would naturally play the title role and possibly even sing "if she could find time to take lessons."

In one interview Alex was quoted as saying, "Poverty brings out the best and worst in a man, and it brought out both in me; money, on the other hand, promises everything and gives nothing—but you first have to have it in order to despise it."

Experience, brief as it had been, taught me that the only significant story was a short one headlined "Film Industry Crisis!" in which the question of the 3,000,000-pound loan to British Lion was raised, and

in which the writer asked whether Sir Alexander had "made" the British film industry, or in fact set it on the wrong road.

I HAD BEEN spared my father's epic move to a new and much larger house on The Vale, in Chelsea, where for the first time (but not for long) he had enough space to hang his pictures. Whatever the Kordas' plans for the future were, as December approached they seemed to have made none for the Christmas holiday. That did not disturb me. Most of the Rosey students lived so far away that they seldom returned home for vacations, not seeing their parents unless the latter happened to be traveling in Europe, and a good many of my schoolmates spent Christmas in Gstaad, trimming the school's tree, skiing and making unauthorized visits to the hotels and bars. Warner LeRoy, I knew, was going to Rome, where his father was shooting *Quo Vadis* with a cast almost the size of the Italian army, and while I envied him, I was resigned to a Christmas at school. Alex, however, suddenly felt the need for a family celebration, and soon conflicting instructions began to arrive. I was to return to London, where we would all meet. I was not to come to London, since it would be easier for me to join my father in Vienna, where he was still working on *The Third Man*. Vienna was too depressing, and there was too much quarreling going on there, so we would meet in Monte Carlo. Finally, firm instructions arrived for me to proceed to Rome, and Monsieur Johannot gravely handed me my passport and tickets and sent me on my way.

Alex, I discovered as soon as I arrived at the Grand Hotel, was in the process of putting together a deal with Vittorio de Sica, in which Alex would finance *A Miracle in Milan*, while my father would do the art direction, and in general keep an eye on De Sica. Vincent was happy enough to be away from Vienna, a city he had never much liked and which was not improved by several years of relentless bombing. Worse yet, a great deal of his time was being spent below the streets in the sewers, and like everyone in the company he had developed a hacking cough and a fear of rats. He was delighted to be in Rome, and took off on a whirlwind tour of the art galleries, cathedrals and museums, dragging me along.

Alex was so busy with De Sica that we seldom saw him, but he did appear from his suite one day to suggest that it might be nice to

celebrate Christmas with a roast suckling pig. This, as it turned out, was not so easy to accomplish. Rome was still emerging from the rigors of war, food was scarce and there were no suckling pigs to be found. Even the *concierge* at the Grand, a man who could usually provide anything at a moment's notice, threw up his hands in despair, but after he had been suitably tipped, he put his mind to work. There were no suckling pigs in Rome itself, he repeated, he could vouch for that, but that did not mean there were none in Italy. The farmers were hesitant to send their produce into the city because they didn't trust the new lire, and because of the rate of inflation they preferred to barter than to sell for cash. No doubt if one were to send a car on a tour of the farm areas in *la campagna*, a suitable suckling pig could be found, particularly if one were prepared to pay for it in dollars . . .

Alex nodded. Having been brought up in the Hungarian countryside, he understood the peasant mentality. He handed over a thick wad of American money, which the *concierge* tactfully pocketed without counting, promising that he would send his own nephew, one of the barmen, a very reliable youth, in search of the pig. And indeed, that very morning he set off, in a rented Lancia limousine with a driver, for a tour of the farms. That evening we dined at the hotel, and just as we were about to order, the *concierge* came in, approached Alex, bowed, smiled and snapped his fingers. The orchestra paused, began the "March of the Toreadors" from *Carmen,* and the young barman, in his white starched jacket, came into the dining room holding a small live piglet, freshly shampooed, its trotters polished with black shoe wax, with a large blue silk ribbon tied around its neck in a bow.

The animal was dramatically carried around the room so that each lady could kiss it for good luck, in keeping with local custom. The idea of eating a suckling pig is one thing when it is presented to you roasted, crisp and with an apple in its mouth. It is an altogether different matter to contemplate when the creature is being carried around like a human baby, its eyes bright and happy, its mouth curved in a wide smile. My stepmother started to cry, and even Alex, who had very little patience for sentimentality toward animals, looked uncomfortable and downcast. He looked at the pig, and the pig looked back at him, and Alex was the first to flinch. Slipping another wad of bills into the *concierge*'s hand, Alex thanked him graciously and told him to take the pig home again.

The *concierge* raised his eyebrows. Was the pig not satisfactory in some way? The pig was satisfactory in every way, Alex explained. In fact it was an exemplary pig, but having met it, we no longer felt we could eat it, particularly the ladies. The *concierge* nodded understandingly— English ladies were crazy, he must have thought, but then everybody knew that, always rescuing donkeys and feeding the stray cats in the Foro Romano. Doubtless the pig could be returned to its natal farm, he said, but in that case the farmer would eat it, having already made his profit from it. Whoever got the pig would surely eat it. The pig's fate was sealed simply by its pigdom, and Sir Alex and his family might just as well do it themselves.

"Can't the pig be placed somewhere where it *won't* be eaten?" Leila asked.

Alex discussed this with the *concierge*, who was doubtful. A pig, after all, is not a pet, like a cat or a dog. Nor is it a rare animal that can be placed in a zoo. "The pig," the *concierge* explained, "is born to be eaten, it is his destiny."

The barman, who was still cradling the pig in his arms, then spoke up. He had a cousin, he said, who kept a small farm not all that far from Rome. Doubtless his cousin would take in the pig and keep it. Naturally, since the pig would be a boarder, it would be necessary to pay something for the pig's upkeep, a kind of *pensione,* since his cousin was a poor man, and could hardly afford to feed a pig that wasn't being fattened for slaughter. My uncle, who knew when he was beaten, sighed and handed over another wad of dollars, and the next morning the pig went off again in the Lancia, still wearing his ribbon, and also seeming to wear the expression of one who has beaten the odds.

On Christmas Day, we dined on chicken, and as Alex cut into his portion, he said, "This is the most expensive meal I've ever had. I had to buy the pig, then pay to send the pig back, and now the pig has become a pensioner. Since I may die before it does, I suppose I'll have to include it in my will. That will give Maria something to think about."

My father—who much preferred chicken to roast suckling pig anyway—disliked any discussion about wills and death, and tried to change the subject, but Alex was not to be stopped.

"No, no," he said. "I want to live a long time, but I think it is important to arrange matters sensibly before, while you still have time.

I would like the money to go for something useful, and to make people happy so they can enjoy life."

"Even Maria?" my father asked.

Alex looked down at his chicken, as if his appetite had suddenly vanished. "Ah well," he said, "perhaps that's not possible. Still, when I'm dead what can she do? Sue the pig?"

ALEX SEEMED to be in good spirits these days. It was apparent to him that *The Third Man* would be a success, and even though he had pre-sold a piece of it to Selznick in exchange for the American distribution rights, he was still going to make a good deal of money and reaffirm his place at the head of the British movie industry. Something else that cheered him was that the yacht he had dreamed about for years was even now nearing completion at Teddington, where in the time-honored tradition of British industry a series of strikes and mistakes had kept it in the boatyard for months. Still, Alex was delighted with it. He had succeeded in joining the elegant Royal Thames Yacht Club, second only to the aristocratic Royal Yacht Squadron, which entitled him to fly the coveted blue ensign, instead of the usual "red duster," and his Christmas present to me was a peaked naval cap from Gieves, with the gold bullion and red velvet badge of the R.T.Y.C. sewn on the front. "Mine," he said, "is fancier. Because I'm a member and an owner. It's like an admiral's. But still yours is very nice, and you'll wear it at Easter when we take the ship over for her acceptance cruise."

My father looked glum. He had never liked the idea of the yacht in the first place. He looked at my cap with disapproval. Like Le Rosey, it represented a retreat from simplicity, and the beginning of many temptations, and the prospect depressed him.

We went to Milan to watch De Sica shooting the crowd sequences of *Miracle* in a rubble-strewn empty lot, with hundreds of ragged slum-dwellers as extras. My father gradually brought order out of this chaos, sending to Hollywood for Ned Mann, his favorite special-effects expert, who was asked to construct a set on which a whole army of actors would be lifted by invisible wires to fly on brooms above the city of Milan, a technical problem that had been written into the script without De Sica's having first worked out a way to shoot it. We ate in small Italian restaurants, surrounded by De Sica and his enthusiastic

apprentices, who referred to him as *Maestro*, and after a few more days of exciting freedom, my father took me back to Switzerland.

"Have a good time," he said, "and try to learn something. And about the yacht: Don't get too excited. Alex can be very nice, and he means well for everybody, but he doesn't have much patience, and he gets bored easily. Don't count on anything."

IF I HAD LEARNED anything, I had learned that. Still, I went back to school in a relatively relaxed and happy state of mind. Le Rosey could be annoying, but the tenor of life was like that in a first-class hotel. It had all the attributes of Switzerland itself: It was secure, comfortable, it took itself a little too seriously and was just a bit dull. The students, since they were not Swiss, did produce a certain amount of excitement on their own—setting fire to a floor of the chalet by cooking fondue on a spirit burner after lights out, or smuggling a seventeen-year-old girl from a nearby finishing school into the dining hall one evening, dressed as a skier from a rival boys' school.

The term passed slowly, my skiing improved, and very little news arrived from the outside world to disturb me, although *Le Journal de Genève* noted that Alex was combining forces with Sam Goldwyn to make *The Elusive Pimpernel,* starring David Niven, and that Zoli was returning to England to make a movie of Alan Paton's novel about South Africa, *Cry the Beloved Country.* In an interview, Alex explained that the movie business was a process of trial and error, and complained that "there are really few Shakespeares in the industry," while elsewhere he was described as having bought "British Empire and European rights" to the Cinerama process from Mike Todd and Lowell Thomas, and to be planning with Todd an ambitious program of major productions in Cinerama, and the construction of London's first Cinerama theater.

In this as in other respects, Alex was ahead of his time. He had been among the first people to sell his movies to television, and was the first to make movies with television in mind.

In one widely quoted interview, Alex suggested that he might give up the traditional motion picture business for television, "where the future lies." In another he predicted quite accurately the widespread use of cable television and "home box office" devices. Uninterested in

technology himself, he was aware that you had to reach your audience somehow, and if the audience was going to stay at home, you would simply have to reach them there. In 1948 he had broken the deadlock between the movie industry and television by selling twenty-four of his films to WPIX, the *Daily News's* television station in New York, and he actually arranged to have Laurence Olivier's *Richard III* receive its American premiere as a one-night special on NBC-TV. The newspapers reported that he was forming a partnership with the Zenith Radio Corporation to set up a "Phone-vision" system throughout the United Kingdom, though rather more space was devoted to the fact that Alex had denied paying one million pounds for the film rights to Winston Churchill's autobiography, doubtless an attempt to jack the price up on behalf of Churchill.

I followed these matters distantly, being fully occupied with my own affairs as a schoolboy. Whenever I was away from the Kordas, they seemed to become in some way mythical, illusory, existing only in my daydreams. Le Rosey had become my home, more real to me than my family, and since it was so important to me to be accepted there, I worked hard to overcome my natural laziness and live up to its expectations. I skied until my ankles ached; I struggled with mathematics; I even mastered Latin. My only fear was growing up and having to leave this safe world.

Somehow, despite my admiration for Alex and my feelings about being a Korda, I was aware that I remained a bystander in the Korda drama. I had come back too late, and at the wrong age. I had missed too many of the Kordas' crucial years. They had been absent while I was growing up in Los Angeles and New York, and I had been 3,000 miles away while Alex and Vincent returned to wartime England to re-create London Films and make new lives for themselves. No sooner had I arrived back in the family than I was packed off to boarding school, and I therefore felt like a visitor at home, treated with great courtesy and hospitality, to be sure, but never quite part of the family circle. It seemed to me that now that Alex and Vincent had me back, they didn't know what to do with me, and that a long and expensive education abroad was the only solution they could agree on.

I was not, therefore, all that eager to return to London at Eastertime, but even Monsieur Johannot was unable to keep his pupils at school against their parents' wishes, so I reluctantly took the plane home from

Geneva to Northolt, where O'Bannon waited for me in the big Ford. As we drove through the London suburbs, I had the same sinking feeling I remembered when I first saw England after all those years in America. Was this really "my" country? Was there really a connection between me and these polite, drab, orderly people? Everywhere I looked, I saw some recognizable subspecies of British life: the young gentlemen in their dark suits, with their worn British warms (the mark of the real thing being the small holes in the epaulettes where one's stars had once been pinned), their bowler hats (the right one was Locke's Coke hat, with a dashing curled brim and a rough, furry texture), their umbrellas (which had to come from Swaine, Adeney & Briggs) and their regimental ties; the schoolboys in their funny round caps, their gray flannel shorts and their blazers; the navvies with strings tied below the knees of their corduroys and a bandanna handkerchief around the neck in place of a tie; the faceless, middle-class crowds, respectable, quick to recognize a foreigner, so very English in ways I could hardly even understand . . .

I was terrified by those few of my young contemporaries whom I met, self-assured Etonians, deeply knowledgeable about things I didn't understand, connected to huge families, to brothers who were in the Guards, or the House of Commons, or the House of Lords; to sisters with names like Tuffy, or Co-Co or Pooh, and were either debutantes, or attending finishing schools, or living at The Monkey Club, or engaged to young men who had also been Etonians. All of these people spoke in accents that I found paralyzing, and seemed to me witty, cruel, sophisticated and interconnected. Wherever I belonged, I had little in common with my English contemporaries, and hardly even shared a language with them, since they talked so fast and with so much slang that I seldom understood more than one word out of two.

I was not an outrageous foreigner, like my father, a confirmed eccentric, who lived on his own terms and affected to ignore all English customs and social distinctions, nor was I simply an American living here for a time. I carried a British passport, but such roots as I had were in Switzerland, New York and Beverly Hills. Even the money seemed to me strange and hard to decipher, as did the food and the social conventions. Besides, I didn't *want* to become English—I wanted to be like Alex, who wasn't English at all, but thrived there and was completely at ease in his own way.

It seemed to me that Brendan Bracken had been right, and that I should have been sent to Winchester, or Charterhouse, or Harrow or even Sedburgh, which he claimed to have attended himself. True, I would have hated the beatings; true, I would have been miserable; but doubtless I would have grown used to all that and emerged from the initial experience as an Englishman-in-the-making, at ease with stiff collars, collar studs, rugby football, cricket, firm in the prerogatives of my social position.

MY FATHER's new house did very little to cheer me up. It is hard to call a place home when you've never seen it before, and though there was certainly a room for me, as promised, I felt a stranger here. The chief feature of the house (and no doubt the one that had attracted Vincent) was a huge glassed-in studio, fifty by fifty feet and almost three stories high, around which the house had been designed by its first owner, a Victorian portrait painter. Some of his belongings still sat in the studio, gradually being submerged by the vast tide of my father's possessions. The most remarkable survivor of the house's former occupant was a life-size articulated wooden horse, complete with a saddle and stirrups, and designed so that the horse could be adjusted in any position—standing, trotting, even rearing up on its hind legs. A comfortable set of steps was attached to it so that the subject of a painting could climb into the saddle without effort, and the saddle itself was specially padded for long sittings. In this way Victorian military figures had their portraits painted on horseback, in the position of their choice. A specialist would later paint in the horse itself. A set of tailor's dummies stood against the far wall, on which the subject's uniform could be fitted, complete with all his decorations, so that the painter's students could add these laborious but essential details to the painting as finishing touches. The studio, in fact, constituted a kind of production line for Victorian official portraiture, in which the painter himself merely dictated the pose, drew the general outlines on the canvas, and painted in the face and hands. Two sittings were sufficient for a life-size portrait, in these circumstances, provided the subject gave all the necessary information about the type, color and general configuration of his horse, and left behind his uniform and his medals for a few days. This approach to painting fascinated my father, partly because it very closely

resembled a primitive version of moviemaking. He carefully preserved these relics of the past.

HERE, IN THIS VAST and inconvenient house, my father at last settled down, not only to raise a second family (for Leila was due in a few months) but to indulge himself in collecting. For once, there was room to be filled, and the challenge kept him busy. The garden was gradually encumbered with huge stone carvings and columns, mammoth architectural paintings of the Italian Renaissance appeared from Christie's or Sotheby's, pictures that nobody else could house because of their size, and which therefore went for low prices. Old "Uncle" Bert Crowther, my father's favorite antiques dealer, made his appearance almost every day to search for a corner that could be filled with yet another refectory table or bureau or a marble-topped table weighing a good half ton.

Bert was an elderly Cockney, dressed rather like a prosperous bookie, who bought and sold antiques in quantity. Nothing was too big for him. When the fountains in Trafalgar Square were replaced, he purchased the old ones, had them broken down into sections, and sold them to an American, only regretting that he couldn't buy Landseer's lions and Nelson's Column as well. His antique yard at Syon Lodge was a huge warren of open-air storage bins and sheds stacked with garden sculpture, paneled rooms, fireplaces, wrought-iron railings by the mile, and furniture. Everything in his house was for sale. Once he took a customer up to his wife's room while she was putting on her make-up, asked her to stand up for a moment, and sold her chair right out from under her.

He was a man of considerable charm, and though he had excellent taste (he kept a separate shop on Kensington High Street, in which some of his better finds were sold in what he called "a posh West End way" at astronomical markups), he really preferred quantity to quality, and delighted in the sheer size of his hoard, which spread over several acres. Only he himself seemed to know what was hidden there, and whatever system he used in storing things was in his head. My father spent many long and happy hours walking around the gardens of Syon Lodge with Bert (it was, conveniently, on his way to and from the studio), picking out things that interested him, while Bert, a gray

bowler on the back of his head and a flower in the lapel buttonhole of his checked suit, nodded and whistled in approval.

Occasionally I accompanied my father on these expeditions, but with some reluctance, since my kinship with the Crowthers on my mother's side made it necessary for me to pay my respects to Mrs. Crowther, whom my father avoided as much as possible. She had lost a son in the R.A.F. during the war, and for this or some other reason she was now somewhat "difficult," as my father tactfully put it. I noticed on my very first visit that she used two teapots when serving tea, and when she accidentally gave me a second cup from the wrong pot, I discovered that she was pouring neat gin for herself, which explained in part her wary and haunted expression.

It may not have been the only problem, as we were shortly to discover. Bert was always the most genial and cooperative of men, and when a customer wanted something that Bert couldn't find in his stock (probably a rare occurrence), he would put himself out to get it. The desk of his cluttered office was covered in loose-leaf binders full of photographs of furniture and architectural details. If you wanted an Adam fireplace a bit different from the dozen or so that Bert already had, you could leaf through these folders until you found one you liked. Bert would then try "to come up with something similar," and very often succeeded. He had furnished Alex with all the fireplaces for 146 Piccadilly, and Alex was delighted with them. He had found an entire paneled Grinling Gibbons room for one of Alex's friends in California, and sent a couple of the "boys" from his staff over to install it in Bel Air. He had provided my father with fireplaces, a staircase, antique marble flooring and most of the furniture for the house in The Vale.

How Bert performed these miracles was something of a mystery—one which his grateful customers did not want to examine too carefully. It was noticeable that Bert preferred to sell many of his larger works of art to Americans, and always seemed relieved to see them vanish across the Atlantic. At least one of my father's huge writing desks contained drawerfuls of someone else's correspondence, which should surely have been removed before it was sold . . .

Shortly after The Vale was furnished, the ax fell. Poor Bert sold a customer an antique fireplace that a guest recognized as his own, and a carful of detectives from Scotland Yard arrived to prowl around the gardens of Syon Lodge, in their bowler hats (the wrong kind) and

trenchcoats, looking as if they were searching for buried bodies like those which had been recently found in the garden at 10 Rillington Place. What they *did* find was that Bert had been filling his customers' orders by sending his "boys" off in the van to strip the fireplace or the paneling out of somebody's country house, a procedure that worked very well during and after the Second World War, when a great many country houses were shut up. Since the contents of these houses had usually been photographed in prewar issues of *Country Life* or *Connoisseur*, it was fairly simple to locate a suitable fireplace and produce it, particularly if the customer was going to have it shipped to Chicago or Los Angeles, where it was scarcely likely to be recognized by the previous owner.

Since Bert's clients were rich and powerful people, many of them English, it was hard to say who was the more embarrassed. It could even be argued that he had played a useful social role in redistributing England's antique treasures by moving them from the houses of people who didn't care about them to those of people who did, and one of the detectives argued that Bert's only crime was that "He couldn't ever bring himself to say no to a customer, poor sod." Despite his age, and the pleas of famous and titled collectors, poor Bert was tried at Old Bailey, where the judge refused to take his age into account, perhaps because he himself was in his eighties, and had recently remarked that he "never liked to go out to social gatherings, since whenever I meet a man I like I sooner or later see him before me for sentencing in the dock."

Whether that had been the case with Bert or not, he sentenced him to prison, and Bert was taken to Wormwood Scrubs, where Oscar Wilde had once been a prisoner, and where poor Bert shortly died.

My father missed him. Sometimes, when he had time, he would examine one of his treasures, some of which he had bought from Bert, and others of which Bert had given him, and as he ran his hand over the wood or stone he would sigh. "I wonder who it belongs to?" he would ask. When the head of Christie's once came to dinner at Vincent's house, he looked at a large carved wooden horse in the dining room, and said, "Ah, I saw that horse at Chartwell House; so you were a customer of Bert's too!"

NOT BEING all that interested in furniture and feeling even more out of place at home now that Vincent was starting a new family, I was drawn to Alex's competing project at Teddington, where *Elsewhere* was at last nearing completion. Since Alex himself was away in America, the final stages of building the yacht were left in the care of Captain Russell, who knew a good deal about ships, having commanded a destroyer in the Royal Navy under Lord Mountbatten (and, according to my father, run it aground), and my father himself, who was in charge of ensuring that the interior should meet Alex's specifications for comfort. Between Russell's suggestions for mechanical and nautical improvements and my father's interior-design changes, the Teddington shipyard was having some trouble in deciding whether they were building a naval vessel or a houseboat. *Elsewhere* was now floating in the Thames, while a small army of workmen sought to put the finishing touches to her, and I spent my days, in blue jeans and a R.T.Y.C. sweater, learning about ships and getting in the way.

Some of Alex's ideas about yacht design had clearly been mistaken, but it was too late to change them now. He had wanted a forward observation lounge, with big glass windows, in which it would be possible to have cocktails and watch the sea. This had been accomplished in a very rakish and seaworthy way, but since the ship's controls would normally have been here, it was necessary to give *Elsewhere* an open flying bridge, like a PT boat, which meant that the helmsman would get soaked in any storm. On a ship of this size, it is usual to duplicate the controls in an enclosed bridge or wheelhouse, but since in *Elsewhere* this space was taken up by the cocktail lounge, the crew would have to rough it. Alex had insisted on a large coal-burning Aga stove, of the kind that professional chefs use, but the installation of a piece of equipment this heavy called for an extraordinary amount of bracing below decks to bear the weight, and as a result the engine room was so cramped that it was almost impossible to stand upright. Since Alex did not expect to visit the engine room, he didn't care, but Russell viewed it with alarm, and predicted trouble with the crew.

Below the observation lounge, reached by a spiral staircase, were Alex's quarters: a comfortable, large bedroom, a study, a dressing room and a full-sized bathroom. Aft of that was an air-conditioned wine and spirits storage hold, a specially cedar-lined safe in which to store cigars

at the right temperature and humidity, the engine room itself and then the guests' accommodations: two large double staterooms, two single staterooms and four small bathrooms. The stateroom farthest aft was the most luxurious, but since it was right above the propellers and at the very end of the ship, it was also the most uncomfortable, tolerable only to those who never suffer from seasickness. The crew's quarters were in the bow, and included a captain's cabin, a cabin for the engineer, a cabin for the cook, a cabin for a steward, and bunks for three seamen. At deck level, there was the observation lounge, with its cocktail bar; the open bridge; a huge galley, designed so that nobody need ever suffer from the cooking smells that occur when the galley is placed below deck, as is usually the case in yachts; a crew's messroom; a serving pantry; a large salon and dining salon, with sliding glass doors opening onto the rear deck; and a special roof for sunbathing. Aft there was a speedboat on davits, and a small sailing dinghy.

Russell's days were spent dealing with matters like the generators, the two big diesels, the radio equipment (which had to be placed in the observation lounge with remote controls that led to the bridge), and the stowing away of the ship's endless list of equipment: searchlight, emergency flares, a full dress of flags, Aldis signal light, Very pistol, charts of the Atlantic and Mediterranean, spare parts, anchors, awnings, tarpaulins, foul-weather gear, loud-hailer, life-vests, binoculars (Alex had gone to Negretti & Zamba on Bond Street and bought a pair of binoculars for everybody, his own being a huge set of rubber-covered waterproof Zeiss marine glasses, suitable for the commander of a U-boat), chronometers, sextants, navigational equipment and fishing gear. Every day began like Christmas with the arrival of yet another vanload of packages to the Teddington dock, to be sorted, checked off, unpacked and placed away in exactly the right location; one day a combination safe from Chubb's (after all, Alex's guests would surely have valuable jewelry), the next day a full set of china from Asprey's, bearing the pennant of the Royal Thames Yacht Club and Alex's initials . . .

My father appeared more rarely and concerned himself with creature comforts. He brought with him upholsterers, carpenters from the studio, swatches of fabric and paint samples. He felt there was too much dark wood inside the ship, and proceeded to have most of it bleached or painted over, to make the cabins lighter and airier; he placed some

of Alex's less valuable paintings on board and fussed over the lighting. He had never much liked the idea of the yacht to begin with. Now that it was ready he hated it.

AT LONG LAST the only things left to do were to take the crew on board, provision the ship and undertake the trials. Captain Russell had suggested that the provisioning could best be done in full at Gibraltar or Malta, where there were no customs duties for supplies in bond or naval stores. As for the crew, it had been decided to experiment a bit. A full-time captain, experienced in yachts, was engaged, in the person of a lean and ferocious-looking Scotsman named Lamon, who appeared on board one afternoon with his kit, looking rather like Ahab taking command of the *Pequod,* and proceeded to inspect his new vessel with an expression that suggested trouble in store. Alex, who disliked change, had persuaded Bailey, his chauffeur, to act as engineer, while Benjamin, unwilling and complaining, was drafted as steward. A French cook, Pierre, was engaged with the highest recommendations of the French Line and the Hôtel Ritz in Paris, and Captain Lamon provided or shanghaied three seamen to fill out his working crew, all of whom looked like deserters from the Royal Navy. Neither Benjamin nor Pierre the cook felt he came under the command of the captain, and Bailey, as Alex's chauffeur and confidant, was not about to take orders from anyone, so the crew was effectively divided into two mutually hostile camps, and life in the fo'c'sle was tense.

We cast off one afternoon and swung out into the channel of the Thames with a whoop of our siren, bound for the Thames Estuary, where the ship would undertake its speed trials, and be formally handed over by the shipyard. Captain Lamon, Russell, the representatives of the shipyard and I all stood on the bridge as *Elsewhere,* which was a big ship for the narrow reaches of the Thames above Windsor, made its way carefully downstream, steaming slowly to avoid overturning punts, small sailboats and rowing skiffs. A very professional group we looked, the two captains in their Royal Navy caps and sea jackets, and the men from the boatyard in bowlers and macs, and I in my R.T.Y.C. sweater and cap, with my binoculars. We had been instructed to moor for the night at Tower Pier, in London, where Alex would join us for the trip to the Thames Estuary, and below decks Benjamin was busily

preparing for his master's arrival—airing sheets, checking the hot water, laying out Alex's pajamas (cream silk with crimson piping the initials A.K. on the breast pocket), his toilet kit, his slippers and his spare pair of reading glasses. Pierre, luckily for everyone, was not required to do anything but keep charge of the Fortnum & Mason picnic hampers for the rest of us, since Alex intended to board after dinner.

It was an impressive journey. However exciting it was to ride in Alex's Rolls and enjoy the envy of people standing in the rain for a bus, it was nothing compared to the pleasure of standing on the bridge of a 120-foot yacht and passing slowly through London, under the bridges where countless thousands of commuters were caught in the usual homeward traffic jam. Every once in a while, Bailey, who had doffed his chauffeur's uniform for a boiler suit, appeared from below deck to glare at the captain, but even he could find nothing wrong with the ship mechanically, and we made our way without incident to moor at the Tower of London and wait for Alex. A number of sightseers and journalists waited for us there—in those austere days, very few people were building yachts, and Alex's was one of the largest to be launched in England since the war, with the exception of Sir Bernard Docker's, which was so big that it was generally considered vulgar. *Elsewhere* was anything but vulgar. She had the fine, racy lines of a perfect seagoing vessel, and looked more like a naval ship than a yacht, which was hardly surprising since she had started life as a Fairmile MTB of the Royal Navy.

As night fell, we sat down to eat our dinner—cold chicken and turkey, and ham in aspic, with wine for the gentlemen and beer for the crew. Promptly at ten Alex arrived. He had returned from New York the day before, and traces of air-travel fatigue still showed in his face, particularly under the harsh arc lights of the pier, but he was obviously in high spirits. He had dressed for the occasion in a dark-blue shantung silk double-breasted suit, with the black embossed buttons of the Royal Thames Yacht Club, and was wearing a white silk scarf and the pair of U-boat binoculars around his neck. The cap of a full member and yacht owner of the R.T.Y.C. sat askew on his head, and on his feet he wore a pair of yachting plimsolls.

"That's the first thing I've learned," he said, pointing to his unusual footwear as he came up the gangway, "nobody comes on board in leather shoes. It's bad for the decks and it's wrong yachting etiquette.

I had dinner with Vivien, but she had to go on somewhere. However, she gave me a bosun's whistle. I have it somewhere here." He fumbled in his pockets, produced a gold whistle on a long chain, and blew into it, producing a high-pitched and unmusical shriek. "That can't be right," he said. "Anyway someone is supposed to play on it when I come on board. I give it to you, and you learn how. I hear that when Lord Camrose has guests on board *his* yacht, they are piped on deck, like the Navy. Well, that's the Royal Yacht Squadron for you. In the Royal Thames we can afford to be a little more—bohemian."

Alex made his way to the bridge, where he was greeted by the captain, shook hands with the dockyard representatives, inspected the galley and exchanged gastronomic gossip with Pierre, went downstairs to see his quarters, came back on deck, and announced his intention of returning to Claridge's for the night. "It's all wonderful," he said, "but I've got a perfectly good bed waiting for me at home, and I can just as easily have myself driven over here at ten. It's one thing to stay on board the yacht in the South of France or at sea, but somehow I don't like the idea of sleeping in the middle of the Thames, with all that mud and oil smelling everything up. All of you have a good night's sleep, and I'll see you tomorrow after breakfast."

With that he was gone to the waiting Rolls, driven by a substitute chauffeur.

Alex's departure seemed to offend the captain, who had probably expected to spend an hour or so with his new employer, and perhaps even hoped to dine with Alex. He announced his intention of getting a good night's sleep and went below. Russell shook his head. "A drinker," he said. "I'm sure of it, you can read the signs. Still, he may have the right idea." Certainly the dockyard's representatives prepared to enjoy Alex's absence by drinking the night away, while Bailey quietly jumped ship with Benjamin, presumably seeking a quiet bar where Benjamin could restore his flagging spirits.

THE NEXT MORNING, Alex arrived promptly at ten, dressed again in what was now clearly his yachting costume for home waters. The captain, who seemed not to have had a good night's sleep at all and was clearly suffering from a hangover, ordered the deckhands to cast off, and we made our way downstream toward Greenwich. Alex had ordered him-

self a captain's chair built on the bridge, and he sat there, looking more relaxed than I had ever seen him before, puffing on his cigar and resting one arm against the glass spray-screen of the bridge. Russell stood beside him, pointing out the various buoys and channel markers, while the captain glowered out at the horizon from beneath his bushy eyebrows.

Alex and the captain had not hit it off, possibly because Alex had said how fond he was of Scotland, and mentioned how much he had enjoyed making *Bonnie Prince Charlie,* a film which had caused grave offense to many patriotic Scotsmen by overemphasizing the Prince's relationship with Flora MacDonald, possibly because the captain simply disliked foreigners, possibly because Alex could smell the fumes of Scotch whiskey on the captain's breath. At Greenwich, we paused to take on the pilot, a small wizened man in a bowler hat and lace-up boots, whose job it was to guide ships through the Thames, then made our way, at an ever-increasing rate of knots, out into the broader reaches of the Thames to run the measured mile, where the ship's maximum performance would be tested against the dockyard's estimate. Having accomplished this successfully, we dropped the pilot lower down the river, and made our way out to sea, bound for Calais, where we would moor for the night, to return in the morning. As we crossed the measured mile, Benjamin appeared with a bucket of ice and a bottle of champagne, and we gravely toasted the ship. I noticed that Benjamin looked more pasty-faced than usual. Alex himself was what is known as "a good sailor" (as I am), and on occasions when he crossed the Atlantic by ship dined with a good appetite even when the dining salon was empty, his appetite unaffected by rolling and thumping of a North Atlantic winter storm.

On one occasion he had been the sole occupant of the Verandah Grillroom on the *Queen Elizabeth* for three nights running, except for one evening when he had eaten at the captain's table, as the captain's only surviving guest, while the cutlery and glasses slid from one end of the table to the other, and the stewards clung to the sides of the salon so as not to fall. On Channel crossings, when the rest of the passengers on the boat train took to their berths or huddled in the bar drinking and trying to remember the words of "Nearer My God to Thee," Alex walked the more sheltered of the decks, smoking his cigar and enjoying himself. Why a man from the landlocked heart of Hungary should have

been born with a stomach that an admiral might have envied remains a mystery, but it was a fact. Winston Churchill had once told Alex that the only two men he knew who were never seasick were himself and Admiral Fisher, and that Fisher was such a stubborn fool that he simply wouldn't admit it. "Now you know three, Winston," Alex said.

Churchill was in any case on his mind this late afternoon, as we steamed down the Thames. He had heartily approved of Alex's building a yacht for himself, and with his interest in naval matters had looked over the plans and given his approval. He had presented Alex with a navy chronometer, a magnificent instrument boxed in mahogany, which now sat in the chartroom, as Alex preferred to call the cocktail lounge, ticking away to Greenwich Mean Time.

"Winston would enjoy this," he said. "It's better than bricklaying. But I think he's more comfortable on something larger. He was on the Kaiser's yacht once, you know, and he said that it had marble bathtubs with gold fittings, and the main salon had a map of the world especially drawn to show that Berlin was at the center of it. I'm afraid that we wouldn't be able to provide the creature comforts Winston needs. Here we shall be roughing it, like real sailors." He glanced around at *Elsewhere*, with her French chef, the Baccarat glasses, the blankets which had been specially obtained from the Cunard Line, blue on one side and bright red on the other, with a coat of arms embroidered in gold thread at the top, the silver ice bucket with the ship's name engraved on it, and smiled with the contentment of a man who has at last attained the simple life.

It would be more than just metaphorical to say that despite Alex's contentment there was a cloud on the horizon; there was, in fact, a whole, towering wall of thunderheads before us. The sea itself had changed from a cheerful foam-flecked green to a dull gunmetal color, and the rising wind was rapidly building up that famous combination of chop and swell which has so effectively prevented any invasion of England since 1066. An occasional gust of gale-force wind began to hit us, sending sheets of spray over the bow and howling through the rigging. Alex seemed oblivious to this change in the weather, in fact he even seemed to be enjoying it, but I noticed that the captain looked increasingly nervous, and that he frequently left the bridge "to have a look at the charts," returning from each examination of them with a redder nose and more trembling hands. His sea legs were turning to

rubber, it seemed to me, and there was an ominous clink of glass in the pocket of his sou'wester every time he moved. By now we had all wrapped ourselves in the stiff bright-yellow storm gear that had been packed away in each locker. In the lulls between gusts, the only sound to be heard above the waves and the rumble of the engines was Benjamin groaning in his bunk. In the galleys, Pierre had conquered his seasickness by drinking a bottle of cooking brandy, and was now fast asleep, his head cradled in his arms on the chopping block and his chef's hat pulled down over his eyes.

"There's nothing to be worried about," Alex said to me. "These boats will go through any storm."

He was right. The Fairmile hull was notoriously indestructable, and British MTB's had survived epic storms that sank scores of larger ships. Less well known was the fact that the Fairmile hull was a bitch in any kind of a sea. Some vessels are good sea boats, others are not, and the Fairmile was decidedly in the latter category. *Elsewhere* was unlikely to sink or founder, but she rolled until her scuppers were deep in water, pitched until her bow seemed to be descending into the depths, like that of a diving submarine, while occasionally she would combine both movements into a kind of vicious corkscrew motion. The men from the shipyard huddled in the chartroom, playing cards and smoking, clearly confident in their own work, but I detected a certain degree of panic in the skipper, who was now swearing under his breath in a monotonous and unnerving manner.

"She won't take too much more of this," he said.

Alex looked at him with surprise, as if he were an actor who had spoken the wrong line. Until now, he had paid very little attention to the captain, and, I think, had mistaken his obvious hostility for the gruffness of an old sea dog. After all, Alex had read his Conrad, and was prepared for a certain amount of taciturn behavior; he was not prepared, however, for a captain who was drunk and frightened.

"I see no reason to believe we are in danger," he said.

"Then you're mad," the captain said, and began to laugh in a way that suggested that he might be more than a little mad himself.

"Perhaps we should turn for home," Alex suggested, more to Russell than to the skipper.

The captain shook his head. "If we turn in these seas, we'll be swamped." At that moment a large wave burst over the bridge, soaking

us all, and apparently sobering Captain Lamon, who held to the wheel
with a grip like that of a man in *rigor mortis.*

"What was your previous command, captain?" Alex asked.

"A tug," Lamon replied.

"I had been given to understand that you had experience of yachts?"

Captain Lamon nodded, his eyes rolling in their sockets as he did
so. "That was before. I served on a great many yachts, but lately I've
been in command of a tugboat."

"Which yachts were they?" Alex asked, scanning the black horizon
with his big marine glasses in the hope of seeing the French coastline
before we ran aground on it.

Captain Lamon steadied himself with a drink from his gin bottle,
checked his compass heading and opened the throttles up a bit. Liquor
seemed to restore his professional ability, and now that he was drinking
openly on the bridge, he looked much more in control of the situation.
Perhaps it was not his drinking that was his downfall, but the effort of
concealing it. "I served on Lord Camrose's yacht for some time," he
said, "and I was mate on Lord Rothschild's big steam yacht, the old
one."

Alex nodded. It was clear to him how Captain Lamon had descended
from these heights to skippering a tugboat, but he apparently felt it
necessary to humor the man. "What was Lord Rothschild's yacht
like?" he asked.

"Big. Bloody great cow of yacht, fireplaces in the salons, velvet
furniture, a wardroom for the officers. Just the kind of flashy thing
you'd expect the Rothschilds to have. He was a decent old sod, Roth-
schild—the old man, that is. Not a bad sailor either, for a Jew."

Alex stared at the skipper with frank distaste. Turning to Russell, he
leaned over and whispered, "Where did you find him?"

"He came with very high recommendations," Russell whispered
back.

"From whom? Admiral Doenitz? He has to go. If we ever arrive
safely, get rid of him."

From my position behind Alex and Russell could see a long streak
beginning to appear on the horizon, gradually resolving itself into
the shore of France. At least we had made it across the Channel.
The captain scanned the beaches for a recognizable landmark, com-
pared a steeple in the distance to one that was marked on the chart,

turned sharply to port and began to whistle, presumably from relief.

About an hour later, we steamed into Calais Roads, and signaled our intention to proceed into the port. Alex seemed irritated. "I don't know Calais well," he said, scanning it with his glasses, "but I can understand why Oscar Wilde was so depressed here. It's *grim.* "

It was pretty grim, I had to admit, in the overcast late afternoon, and I doubted that it would have seemed much more cheerful even on a sunny morning. The port itself was hideously scarred by the war—the quays were obscured by huge shattered concrete bunkers and gun emplacements, covered in mold, rust streaks and flaking camouflage paint, and here and there the rusty hulls of sunken ships appeared from the muddy, oilslicked water, their positions marked by equally rusty buoys. As for the town of Calais, large parts of it were either flattened or covered in heaps of rubble, while the rest seemed to have been designed with the English day-trippers in mind. Everywhere there were signs for Watney's Red Label ale, Player's cigarettes and Guinness stout, and a strong smell of fish and chips frying competed with the stench of mudflats at low tide and rotting débris. "At least we don't have to stay here long," Alex said, with obvious relief.

As we drew closer to the quay, the captain, lurching slightly, brought *Elsewhere* in to a mooring between two French fishing trawlers, putting on a last-minute virtuoso performance of seamanship for the benefit of a small crowd of onlookers, two policemen, the port officer and a couple of *douaniers* with their bicycles. All were waving and shouting with what Captain Lamon took to be enthusiasm as he worked the throttles back and forth to bring the yacht up against the quayside, rather like a man parallel parking a car in a space that is only just big enough for it. With a flourish, he waved to the crew to secure the ship fore and aft, rang to the engine room to shut down power, and beamed up at the quay, which towered above us since the tide was low.

"*Imbécile!*" shouted the port officer.

Captain Lamon, who apparently knew no French, looked at my Uncle.

"He says you're an idiot," Alex said, and asked the port officer why he thought so.

The port officer pointed behind us, toward the mooring lines of the French trawlers, which had not been visible as we made our approach. They could be seen now, particularly since they were drawn in taut,

straight lines, and had obviously wrapped themselves around our propellers.

The captain gave a howl of rage and rushed aft to have a closer look, though that hardly seemed necessary.

"How bad is this, Jack ?" Alex asked.

Russell stared aft. "Well, it all depends, but I think a diver will probably have to go below and cut those cables off the props, then the ship really ought to be drydocked so we can have a look and replace them if the blades are damaged. Of course, there's always a chance, mind you, that the propeller shafts are bent. In that case it's a big job."

"I see." Alex went below, had a word with Bailey, who was sent off to put Benjamin back on his feet, and reappeared very shortly in his blue suit, smoking a cigar and looking like a man who has reached a decision.

"Can one of you gentlemen call me a taxi?" he asked the two policemen above us in French, fastening the rosette of the Legion of Honor to his lapel as he spoke. They saluted, and one of them ran off down to the quay to find a telephone. *"Merci!"* Alex shouted, saluting back. Then he turned to Russell and me. "I'm going. Benjamin is packing my things and coming with me. We'll take a taxi to the Gare Maritime, then catch the next decent train for Paris. Jack, you put the shipyard people up in the hotel of their choice here in Calais, straighten out the business about the propellers, get rid of that idiot captain and send to England for a different one. If he gives you any trouble, you can always shoot him. I believe there's a gun on board somewhere. As for Miki, he can stay here with you and explore Calais. I believe Beau Brummell lived here in poverty here for years. He went insane. And Oscar Wilde once visited a brothel here, at Frank Harris' suggestion. He didn't like it, so perhaps you shouldn't follow his example."

The customs men lowered a ladder to the deck, and Benjamin appeared from below, green in the face and carrying Alex's suitcase.

"Oh, Sir Alex," he moaned, "never again!"

Alex waved him up the ladder. "You're right," he said as he followed him up. "Never again. The next time, you stay home, and we do it in quite a different way, with a proper crew, in a proper climate." The policemen helped him up onto the quay, waved away his passport and accompanied him to the waiting taxi.

"Ah well," said Russell, "isn't it always the way with trial runs?"

WHEN I RETURNED to London a week later, my father was in high spirits. The yacht's troubles filled Vincent with *Schadenfreude.* The misfortunes of the maiden voyage confirmed his original judgment. "So how is the new toy?" was his greeting to me, and he went on to explain how much better off Alex would have been to have bought an estate for himself in the South of France, where at least he could have a garden. I did not like to point out that Alex's interest in gardening was negligible.

Vincent was having problems of his own. The house in The Vale, it seemed, was next door to the residence of Sir Oswald Mosley, the self-proclaimed British *Führer,* who had spent part of the war in prison on the grounds that he and his small band of Black Shirts might play the same role in England that Quisling had in Norway. Before the war Mosley had lived in a large house on the Thames, where he had a bathtub on a dais so that it was possible for his followers to stand several steps below and report to him with the Fascist salute while he bathed. He now lived rather more modestly as our neighbor in the house of his aunt, Lady Ravensdale.

My father was annoyed several times a day by young men who rang our doorbell by mistake, hoping to meet the leader. "Just this morning," Vincent complained, "the doorbell rang, I open the front door, and there is this young man in a black leather trenchcoat who raises his arm up and shouts 'Heil Mosley!' I threw him down the steps, but sometimes they wait outside just to catch a glimpse of the bloody man, as if this were the Brown House in Munich! I put a cardboard sign up in the window that says 'To hell with Mosley,' but the rest of the neighbors objected." Vincent's strategies for dealing with the Fascists were much on his mind. He had several acerbic and fruitless conversations with Lady Ravensdale; he encouraged Nuisance to lift his leg on the Ravensdale front doorsteps.

He finally secured his revenge by arranging to have two enormous phonograph loudspeakers directed toward the Ravensdale house, through which he played at top volume a very scratched 78 r.p.m. recording of Caruso singing "La Marseillaise," to the accompaniment of what sounded like the massed brass bands of the entire French Army. This ear-shattering antiquity was my father's secret weapon. While he disliked noise of any kind (and he classed all music as noise),

he would sometimes play the record a dozen times on a Sunday, smiling with each crescendo and roll of drums. I bought him a recording of Tchaikovsky's *1812 Overture,* featuring real cannons firing salutes, but while he was grateful for it, it did not replace his affection for Caruso. (He would have been dismayed to learn that he would one day become distantly related to Sir Oswald's family, however remotely, but this, luckily, lay unseen in the future.)

"When do you go back to school?" he asked.

"In a week's time."

"Aha." My father looked at me speculatively. "Then you'll miss the birth of your brother. No . . . stepbrother? *Half*-brother. Or half-sister, of course. I don't suppose you will mind. These things are only interesting to women. For the man it's always a lot of fuss and noise. I'll cable you what happens, if I remember. How do you feel about it?"

"I don't know," I replied. This was true enough. I liked Leila, I had grown used to her pregnancy, but I hadn't thought much about the fact that I would no longer be the only child. So far there hadn't been much percentage in being an only child, it seemed to me.

It seemed to me mildly awkward and embarrassing for my father to be starting a new family at his time of life, but he was forever doing things that seemed to me odd and inappropriate, and I felt no more strongly about his fathering more children than I did about his keeping old pieces of string in his pockets.

My father sighed, knowing he had failed again. Luckily he had something else on his mind, and was therefore able to change the subject of conversation with some grace. Brendan Bracken, it appeared, had just been made a viscount, and in view of the many things he had done for me, it was appropriate that I should go and pay him my respects before returning to school.

"Poor Brendan," Vincent said. "He's a very lonely man, very clever, much cleverer than most people, but underneath all the success and the friends, he is sometimes like a little boy." He looked at me reflectively, and I understood, for a moment, what he was trying to tell me about myself, what he was warning me about but was unable to say outright. For Brendan lived in a myth of his own making. He had buried the story of his origins and created a legendary childhood as an Australian orphan—in part because he took a malicious, private pleasure in the rumors that he was Churchill's illegitimate son, rumors that Churchill

encouraged himself, largely because they annoyed Mrs. Churchill. Brendan had scores of close friends—political friends, Fleet Street friends, City friends, society friends—but with the possible exception of Churchill, to whom he was devoted, there was nobody who had ever been genuinely close to Brendan, or for whom he had expressed any deep feeling. Somewhere within the core of that enigmatic and mercurial man there was a tiny cold void, a nucleus of unhappiness that kept him on the fringes of life, a spectator of other people's emotional disarray and consuming passions. For once, I had no trouble at all reading my father's signal.

A VISIT to Brendan's house in Westminster was always a special occasion, even before his elevation to a viscountcy. Brendan had arrived from Ireland as a child. He was probably the only boy in the history of British education who had had the nerve to apply to most of the major public schools, then visit them in person to interview the headmasters and decide for himself which school seemed the most likely to fill his requirements as a pupil. So astonished were the headmasters of England's great schools at the arrival of this brash, self-confident and argumentative youth that Brendan found no difficulty in securing a place for himself in Sedburgh, where he persuaded the headmaster to alter the curriculum on his behalf and let him stay as a lodger with the headmaster's bewildered family. He absorbed every fact of English public life, and was even said to have memorized *Who's Who*, then descended on London society to hitch his star to Winston Churchill.

Perhaps the major mystery in Brendan's life was the simple question of just how he had known that Churchill, then in political disgrace and financial difficulty, needed a disciple and an admirer. Perhaps the answer lay in Brendan's incredible gift for hearing gossip and acting on it, but in a deeper sense, he had understood Churchill, even from afar. They were both men of the eighteenth century, sentimental, ambitious, moved by oratory, sharing in common a passionate admiration for the great Whig and Tory statesmen of the Augustan age. Even as a schoolboy, Brendan dreamed of emulating Edmund Burke, Charles James Fox and the other great voices of that fascinating period of English history when public life was everything. He saw in Churchill what Churchill most wanted to have seen in himself, and their friend-

ship was sealed at their first meeting and never wavered, despite the differences in their backgrounds, temperaments and ages.

Brendan was astute and independent enough to know that he could never be Churchill's friend unless they were equals, and he therefore went out into the world and made his own career. As a young man, he became a magazine editor, put together a growing press conglomerate that included the prestigious *Financial Times,* carefully amassed a small, secure fortune of his own and won himself a seat in the House of Commons at the age of twenty-eight, further obscuring his origins in the process by claiming that he had been born in Bedfordshire and educated at Oxford University, neither of which was even remotely true. It was commonly said that the facts of Brendan's birth and upbringing were never revealed because he knew so much about other people that nobody dared to make inquiries about him.

There is almost certainly some truth to this—Brendan was, among other things, a ruthless adventurer, with a sure instinct for the jugular and a deeply combative spirit. There was also some fear, particularly in Tory circles, that any real investigations into the background of young Brendan Bracken, M.P., would possibly confirm the rumors that he was Churchill's son, and therefore embarrass the party and destroy Winston's career. Even Churchill's enemies, and there were many in the Tory Party who frankly preferred the Socialists, did not want to go quite this far, so Brendan's mystery was preserved inviolate. The exception was Lord Beaverbrook, who put his staff to work on the matter, determined that Brendan had been born in Templemore, Tipperary, to a prosperous stonemason named Joseph Kennedy Bracken, and wisely locked the information in his safe, in case it was ever needed. It was not. Bracken and Beaverbrook became friends, they were fellow supporters of Churchill, they both served as Cabinet Ministers in Churchill's wartime government, and to the end of Brendan's life, Beaverbrook, who was Canadian, often referred to him as "my fellow colonial from across the wide Pacific," accompanying this fraudulent description with a knowing wink.

Given Beaverbrook's impish sense of humor, he was perfectly willing to allow the rumor about Bracken's distinguished parentage to flourish, and even argued that it could only do Winston's image good to be thought of as the father of an illegitimate child. "It's a human failing," he said, "but a manly and a generous one."

In the thirties Bracken had known everyone and pushed his way everywhere. He was an intimate member of that small group of Tory M.P.'s who looked to Churchill as their leader and were united in crying for an end to appeasement, but he moved in many worlds beyond that. He had been a close friend of the Prince of Wales, and deeply involved in the Abdication Crisis; he crossed the Atlantic to discuss British financial policy with Bernard Baruch; he made his way everywhere. When the governor of the Bank of England tried to avoid a confrontation with Brendan, Brendan found out that he was going to Scotland that night, booked himself on the sleeping-car to Edinburgh, and had himself placed in the upper berth in the governor's compartment, from which position he was able to keep the poor man awake all night with his suggestions about British financial policy.

On the weekends, his yellow chauffeur-driven Hispano-Suiza would carry him to the great country houses where policy was made and discussed: to Chartwell (to see Churchill); to Mereworth (to see Lord Rothermere); to Churt (to see Lloyd George); to Cherkley (to see Lord Beaverbrook); to Cliveden, where despite his opinions about Germany, he was a welcome guest—sometimes to all of these places in one weekend. The country as such held no appeal for Brendan. He went there to argue, persuade, dazzle and advise, and even in the South of France he wore a dark-blue suit, with a waistcoat and a stiff collar. Words and facts interested him, not scenery, and his only relaxation was reading the letters and speeches of the eighteenth-century politicians he admired, so that he remained happily unaware he had been caricatured as Rex Mottram, the Canadian adventurer in Evelyn Waugh's *Brideshead Revisited*.

He lived on Lord North Street, a perfectly preserved row of Georgian houses near Westminster, named after that long-suffering and even-tempered Prime Minister who had lost England's American colonies, and for whom Bracken cherished an uncritical affection. Here, Brendan had fashioned a house that sustained his own dreams, with a handsome library, dominated by Romney's painting of Edmund Burke, a collection of fine eighteenth-century antiques and silver. He loved his house, and these possessions, as other men love women, and despite his wealth and his responsibilities he spent as much time as he possibly could there. His health, I knew, was failing, and perhaps he was already pulling his house around him like a shell. For years he had been

ridiculed as a hypochondriac, but his imaginary ailments had finally given way to real ones, and he complained constantly of sinus troubles, coughs and tonsilitis. Perhaps he already knew what his doctors suspected but were unwilling to tell him, that he had cancer of the throat and was dying; perhaps he simply felt that the best part of his life had been lived. In any event, there was something frightening about Brendan now, an intensity that was unmistakable, even to me, as if he felt the need to drive home his advice as hard as he could, while he still had the time and the voice to do so.

His manservant showed me up to the library, where Brendan sat reading, as formally dressed as ever, his thick glasses (which had once been smashed during a fight that followed Randolph Churchill's addressing him as "my brother" at a dinner party) magnifying his eyes. He waved me to a chair, and nodded as I congratulated him on his new honor, in a rather parrotlike fashion.

"Thank you," he said. "These honors do not mean all that much, you know. I cannot say that I have ever wanted to sit in the House of Lords, but neither do half the peers who are there. How are you enjoying school?"

I indicated that I was enjoying it very much.

"So I should think," Brendan replied. "It's not what I would have chosen for you myself. I was in favor of Sedburgh, where I went, or possibly Winchester, an excellent school. But your uncle Alex and your father were too soft on you, I think. If you are going to live in this country, and that is obviously their intention and should be yours, you ought to be educated here. Going to school in Switzerland with the children of the international rich merely postpones the difficulties you will have to overcome here."

I nodded to indicate I understood. No reply seemed called for. "In any case, school won't last forever. Bear in mind the following: You will almost certainly have to do your national service here, in one of the armed forces. You look healthy enough, so there is no escaping that. Your father will surely try to find a way out of it for you, but you are not to let him. You will need to pass your examinations fairly soon, and you must then take the Oxford entrance exam. I believe you would do quite well at Magdalen College. It's not for brilliant scholars, like Balliol, and it's not a center of the fast set, like Christ Church. Magdalen will do you very well, I believe. You could do worse than to get a

good degree and go into the City. It's never too early to think about a career."

"What about the film business?" I asked.

"What about it? Your uncle is an unusually talented man, and so is your father, but I think it's time one of the Kordas put down roots in something solid. If you think you have a talent for the film business, by all means follow that talent, but do not suppose that you can count on joining the family business. In the first place, a young man ought to strike out on his own, and in the second place, I'm not at all sure you will grow up to find that there will be a place for you there. If you count on that, you may find you have nothing. Make your own way . . . Have you seen your uncle since his famous yachting trip?"

I said I had not.

"He enjoyed himself in Paris, I believe. Somebody took him to see Marc Chagall's studio, and he found a painting he liked very much indeed. He asked Chagall if it was for sale, and the old man blushed and said he didn't know, that he never thought about money himself, the whole subject was embarrassing to him. So he left the room, leaving Madame Chagall to deal with Alex, and just as Alex was leaning forward to talk to Madame, he realized that she could see Chagall in a mirror—he was standing just outside the room in the hallway. Chagall drew a dollar sign in the air, then held up the five fingers of his left hand so that she could see it in the mirror, then dropped it and held up both hands with all the fingers spread wide, indicating ten. Then he crossed both fingers to indicate that she should multiply.

"Alex was delighted by the charade. Before she could say anything, he offered her $50,000, and she looked at him with some surprise.

" 'Why, that was just the sum I had in mind, monsieur,' she said. 'How did you know?'

" 'Ah, madame,' he said, 'the painting speaks for itself!' "

Brendan laughed, choked a bit and began to cough. He recovered, lit a cigar (doubtless against his doctor's orders) and went on. "I told your uncle that he should have offered thirty-five, and let himself be talked up to forty, but he wouldn't have it. 'Not at all, Brendan,' he said. 'Sometimes you have to let yourself be cheated like a gentleman.' I daresay he's right, but the truth of the matter is that he's easily charmed. I worry about that. One should be very much on one's guard against being charmed past the age of fifty. It's very dangerous, very dangerous indeed, to be a romantic at that age. As for you, you had

better learn to talk up. You're much too quiet for your own good. When I was your age, I would have tried to dominate the conversation. It's important to know when to listen, but nobody ever got anywhere by listening alone. Now, be off with you."

I made my way downstairs, past the rows of portraits of England's statesmen in the reigns of George II and George III, and out onto Lord North Street, which was perhaps the shortest and quietest street in London, and whose real estate Brendan was said to control so that he could pick his own neighbors. In his direct and disconcerting way, Brendan had brought home to me a whole range of problems which I had been unwilling to face, and which, in the typical way of the Korda family, nobody was even willing to discuss.

The meeting had been oddly unsettling. I felt, deep inside me, the desire to be like him, to join that world of politics, high finance, power and English society which he had stormed at an age not much greater than my own. More than that, I felt a certain kinship with this large, ugly, lonely man, who had so clearly felt himself to be an outsider, and created a mystery about himself to which even he had long since lost the key. I could understand Brendan's love of eighteenth-century England, and I could respect his stoicism, his generosity and his reputation for unscrupulous behavior and outrageous rudeness. He had wanted to live among heroes equal to those in his books, and when he had found there were none, he manufactured them, and finally became one himself. He was the one thing he professed most to hate and distrust: a Romantic. It was only his common sense, his appetite for money and power and his reputation as a coldblooded businessman that concealed what his house so obviously revealed.

I understood that Brendan had looked inside himself for a certain kind of passion, and found it was not there. He sensed that without it he would surely never be an ordinary, happy man, married, with children; nor would he ever be Prime Minister, for that too requires a kind of passion. He had settled for friendships and money and a houseful of antiques, and he was afraid Alex could not do the same.

He was right. I knew it. Alex's epicurean philosophy, his stoicism, his carefully cultivated charm, common sense and wit were all part of a façade, a way to conceal the anger, the bitterness and the need for love that even the devotion of his brothers could not satisfy. Brendan had put himself out of harm's way by cauterizing his deeper emotions. Alex had not. He was still living in the danger zone.

# CHAPTER 8

~~~~~~~~~~~~~~~~~~~~~~~~~~~~~~~~~~~~~~~~

I T IS STILL dark when the *Train Bleu* reaches the Mediterranean from Paris, but the sun rises almost as soon as the train has turned east to run down the coast, flashing through the darkness of the tunnels into sudden, blinding daylight, slowing as it passes the small fishing ports and the less fashionable resorts on its way to Cannes, Antibes, Nice and Monte Carlo. Mysteriously, the villas of the very rich are compressed into the narrow strip between the sea and the railway tracks the length of most of the coast, so the train passes within arm's reach of these great houses, rattling the windows and smearing the whitewashed walls with greasy smoke. The rich prefer to live where they think they ought to, rather than choosing to live more comfortably in the wrong place. Alex was no exception. The yacht gave him the freedom to live anywhere, but most of the time he kept *Elsewhere* moored, stern to quay, in the long row of boats in the port of Antibes, in circumstances rather more crowded and noisy than that of any hotel.

I had spent the summer term quietly at Le Rosey, by tradition a time of lazy, halcyon days after the excitement of Gstaad, of long afternoons sitting in the grass of the playing fields overlooking Lake Geneva, which stretched into the hazy distance where France begins. For those who were approaching the examination of their choice or nationality, the

baccalauréat (or *"bachot"*) for the French, the Common Entrance for the British, the College Boards for Americans (and many South Americans) and the *Matriculation* for those who intended to go to a Swiss or German university, the summer term was a period of anxiety and tension, culminating in the awful moment when they were taken by bus to their own embassies or consulates to put a year's cramming to the test. This ordeal was a year away for me, and those of us who were not preparing for examinations were left happily to our own devices, while our elders labored through the nights on Virgil's *Aeneid,* the terms of the Treaty of Utrecht, the Pythagorean Theorem and the Table of Matter. The French suffered the most, since the *bachot* was notoriously the hardest examination of any nation. Each year its severity was judged by the number of French students who committed suicide—indeed their deaths were a source of national pride, as if they were *"morts pour la France,"* heroic proof that there was no decline in the Republic's famous academic standards. Even at Le Rosey, candidates for the *bachot* were treated like long-distance runners, while the Anglo-Saxons were left to prepare themselves for their less exacting sprints.

Mostly we talked about the long summer ahead, *"les grandes vacances."* Germano Gazzoni was going to his grandfather's palace in Tuscany to shoot wild boar; Prince Amin and Prince Karim were to spend the summer at the Château de l'Horizon with Aly Khan; Reinaldo Guzman y Sanchez would be on Capri, oiling the backs of fading beauties twice his age and dancing every night in *louche,* elegant little bars and *boîtes;* the Heinz family had taken a house (well, a *château,* actually) in the Ile de France; Graf Peter von Bock would spend the summer quietly in the family *Schloss* on the Traunsee in Austria, fly fishing, driving his father's prewar Mercedes SSK and chasing peasant girls at hay-making time; Dommen was accompanying his parents on a world tour, Peter Wodtke was to have the use of his parents' apartment in Paris, on the Avenue de la Grande-Armée; and Warner LeRoy intended to make a gastronomic tour of France, and was already hard at work annotating his copy of the *Guide Michelin* in preparation for it.

My own plans were somewhat less definite. My father had discussed the possibility of my spending the summer with my mother, but since she was touring the United States with a road-show production of

W. Somerset Maugham's *The Constant Husband,* that seemed un-
likely. My father's own plans were to take a leisurely trip through
France with Leila and my infant half-brother, whose birth had taken
place without any problems. The usual Korda difficulty with names had
been solved by christening him Alexander Vincent Korda (for some
reason all Korda children, including me, receive Vincent as a middle
name, perhaps because Alex would have been angered if Zoli's name
had been used and vice versa, whereas my father didn't care), though
it proved impossible for my father to actually refer to the baby as
"Alex," from the very beginning. No doubt he had meant to honor
Alex by naming the child after him, but since there was only one Alex
in his life, he swiftly accepted Leila's nickname for the infant, "Wee
Willie Winkie." My half-brother was thenceforth to be known as
"Winkie" to everyone but my father, who pronounced the name
"Vinkie." To this day, nobody in the family calls him Alex, as if the
name itself continues to belong to its original owner, and its use by
anyone else constitutes a taboo.

I had no real desire to accompany an infant and a nursing mother
on a trip through France in a small car driven by my father, and
Vincent was neither offended nor surprised by this. He liked to travel
at his own pace, surrounded by the evidence of his domestic life, like
the leader of a Gypsy caravan, and his route was determined by the fact
that he disliked driving, and drove very slowly, and by an itinerary
which would take him to every museum and three-star restaurant
within reach of a day's driving. Like Warner LeRoy, he had for his
companion a well-thumbed *Guide Michelin.* After breakfast, he would
supervise the packing, make sure the bags, the pram and the cot were
strapped to the roof of the car, then make for the nearest interesting
restaurant, where he would stop for a three- or four-hour lunch. After
a short siesta, he would drive to the next hotel with a good restaurant,
have dinner, spend the night, and start out again the next morning,
after a croissant and a pot of good *café au lait,* ready for the day's
gastronomic experiences. Under these circumstances, a trip from En-
gland to the South of France might take weeks, like a medieval pro-
gress, particularly since Vincent considered a journey of more than a
hundred kilometers in a day a superhuman feat of driving endurance,
and tended to zigzag across the country in pursuit of things he wanted
to see. He would have to stop in Paris for a few days, I knew, to stay

at the Hôtel du Rond Point des Champs-Elysées and see the museums, and his route would have to include Carcassonne, Avignon, Lyons (to eat the trout cooked in a sauce of fresh crayfish) and several dozen other sites of antiquity and restaurants which the *guide* marked with the coveted comment *"vaut le voyage"* (worth the trip). I was likely to be fidgety on a trip of this kind, even without the presence of a baby, and my father rightly thought we would both have a better summer if I made my way to the South of France alone.

Orders arrived for me to return to London, so that I could fly to Nice with Alex. Then Alex left for Nice earlier than expected, and I was instructed to fly from Geneva to Nice, then it was suggested that I might meet my father in Paris for a few days. Finally, I went to Paris by train, was introduced to my half-brother and had dinner with my father. I was to join Alex on the yacht, while Vincent made his way through *La France Gastronomique* to the Hôtel de la Bouée on Cap d'Antibes, where we had always spent the summers before the war, and where the Vials treated my father as if he were part of the family. "It's not very exciting," he said, "so perhaps you will have a better time on the boat. Anyway, Alex wants you to go on it. I told him I don't want to myself. I rather be by myself and do what I want. One thing I should tell you: Try not to make a nuisance of yourself. Alex is doing something very silly lately, so I can't tell what kind of mood he'll be in. If it doesn't work, you come to stay with us at La Bouée. The Garoupe beach is very nice, and anyway we can always go to the Eden Roc for lunch, and the Vials are fond of you. I always thought it would be good if you could one day marry the daughter, Micheline, who is about your age. Then I would always have some place to stay and eat lunch."

I was left wondering just what Alex had done that my father would think of as "silly," but the subject did not come up again, and the next night I took the *Train Bleu* from Paris, since Vincent intended to backtrack to Châlons-sur-Marne before proceeding south. In those days the *Train Bleu* still retained some vestige of its prewar elegance. The carriages really *were* blue, and those who took the train traveled with mounds of Vuitton luggage—not the small handbags and brief cases that have now become blatant status symbols, but the huge, brassbound steamer trunks and wardrobes that were the discreet evidence of real money. Most of the men were heavy, bearing their jowls and stomachs like a badge of honor, dressed in the peculiar clothes which the French

upper-bourgeoisie suppose the English wear *"pour le sport"*—soft, un-English, shiny tweeds with leather buttons and suede patches, green velour hats, pebble-grained golfing brogues and silk scarves. Most of the men wore the Legion of Honor in their lapels, and most of the women carried a pair of small poodles in their arms. Since my father did not feel that a child ought to travel in luxury, I went third class, which was in fact more interesting. As the train rattled south, I sat in the coach, with French families that had prepared for the journey by putting up great hampers of food suitable for a long expedition. Before the train was out of the station, they were uncorking bottles of wine, unwrapping sandwiches, tying napkins around their necks and preparing to sustain themselves for the rigors of the journey. I did not sleep, much as I wanted to. I was too nervous about the future, of which I could form no clear picture.

I felt, to use the appropriate word in the circumstances, *dépaysé*, out of place, and on my way to somewhere even more unfamiliar. At intervals the train would stop at stations, in the middle of the night, and groups of conscripted soldiers, not very much older than myself, would enter, cheerful, smelling of woolen uniforms, Gauloise cigarettes and sweat, each of them with a bottle of wine tucked into the front of his *blouson.* They sang, smoked and drank, only to be replaced at intervals by a new contingent of recruits, and I envied them their comradeship, the fact that they were older than I was and the possibility that they at least knew what they were. I usually told people who asked that I was *"un Américain,"* partly because I wasn't sure I could carry off an English impersonation, partly because Americans were then more popular in France than the English, for the simple reason that they had more money.

My eyes were gritty by the time we arrived at the coast, and they ached as the sun rose abruptly over the Mediterranean. Most of the third-class voyagers had left the train during the night, at Lyons or Marseilles, and only the very rich in the wagons-lits and a few students in third class remained. I stared out through the window at a world that seemed almost unreal, sunny, sharply-etched, brilliantly colored and lavish in a way that was very un-Californian. It is very seldom that anybody ever falls in love with a place, and I knew even then that it would be a cliché to lose one's heart to an old whore like the Côte d'Azur, but I suddenly understood why my father liked it here, and

what drew Alex here every year, even though he seldom took off his jacket. Perhaps it was the colors, which made me understand why Vincent had given up painting when he left here, or the fact that everything was on a human scale, designed for comfort, but even at dawn—as the first workers, bakers delivering bread, beachboys sweeping the sand into geometric patterns, farmers going to market with their melons, fresh figs, and green almonds in baskets—the South of France was instantly recognizable to me as the one place Alex and Vincent truly loved, and thought of as home.

The train paused in the Belle Epoque railway station in Cannes, the relic of a more leisurely age in which there were no automobiles and airplanes, made its way slowly past the Aga Khan's villa, doubtless disturbing the old man's sleep as it did every morning, skirted Cap d'Antibes and stopped in the station of Antibes. I descended, carrying my suitcase, and walked out onto the square, where an old man sprinkled the concrete with water, and looked down at the Vieux Port, where *Elsewhere* was moored in a long row of yachts, most of them much smaller, on one side of the harbor. The other side of the harbor, which was used by the local fishermen, was bustling with activity; the yacht side was silent, except for a few sailors polishing brass or fetching the morning's croissants. Clearly, I was too early. I had no idea when I was expected, or even if I *was* expected, and I knew better than to wake Alex up, so I made my way to the Place de la République, bought the *Nice-Matin,* the Paris *Herald-Tribune* and *Paris-Match* and sat down to waste a few hours, as you can only do in a French café.

In part, of course, I was simply delaying my arrival for as long as possible. I was not at all sure that Alex wanted me here, and even less sure that this was where I wanted to be. Being around him for any period of time was like undergoing one of those social examinations that were given to applicants for a commission in a good regiment before the Second World War, in which the young subalterns were invited to spend the weekend at a "house party" in the mess, and were judged on their deportment, their manners, the cut of their clothes, their ability to make conversation and their knowledge of when to shut up, and in general on the ease with which they conformed to the unfamiliar customs and traditions of the regiment.

It was possible to fail without ever knowing why. In one distinguished regiment a young man was turned down because he folded his

napkin neatly and placed it on the table after dinner, "like someone in a bloody boarding house," instead of screwing it up in a ball and dropping it to the floor, "like a gentleman who's accustomed to servants and knows it will be picked up, washed and ironed, and not saved for the next meal." In the words of one applicant, "People were turned down not only because of the way their hair was cut, but because of the way it *grew,*" and I had something of the same sense of free-floating anxiety about living under Alex's scrutiny. Exposure to Le Rosey had made me very conscious of what was then described as "U" and "non-U" behavior, and I was so anxious not to call a "napkin" ("U") a "serviette" ("non-U"), to say "I'll have a cup of tea" and not "I'll have some tea" and to put the laces in my shoes straight across, instead of criss-crossed (very "non-U") that I was frequently at a loss for words and unable to do anything but blush in social situations. It did not make matters easier that my father broke every one of these social conventions, assuming he even recognized their existence, and that Alex made his own rules.

Eventually, I could not sit in the Café du Glacier any more. The morning bustle of the square had begun, and I was obviously in the way. Besides, the disquieting thought had occurred to me that *Elsewhere* might be waiting for my arrival before lifting anchor, and that I had perhaps already inconvenienced Alex, who might even now be pacing the bridge in a fury, wondering where the hell I was. Suitcase in hand, I walked down to the port, through the huge arch, and out onto the quay to where *Elsewhere* was tied up. Reassuringly, Alex was nowhere in sight. The only person on deck was a small middle-aged Frenchman of athletic appearance, dressed in a pair of white trousers, white espadrilles, a white shirt and a white, wide-brimmed hat, who waved to me to come on board.

"So," he said. "The young nephew. Put your suitcase down. One of the boys will fetch it and unpack it for you. We sent someone up to meet you at the station, but apparently you weren't on the train."

"I was. I came third class."

He raised an eyebrow. "Indeed. Very commendable economy for a young man. That explains why he couldn't find you. He would have been looking through the wagons-lits. What have you been doing with yourself since? The train arrived hours ago."

"I stopped and had a few cups of coffee. I didn't want to wake anyone up."

"Even more commendable. At your age I would have done the same. Allow me to introduce myself. I am Edouard Corniglion-Molinier, a friend of your uncle's and your father's. I have known of you since you were a baby, so you can call me Eddie if you like. I am also a general, so you will hear people calling me *'Monsieur le général,'* and I am the senator for the Alpes-Maritimes, so all these people are my constituents. I think you could take off your coat and tie. Here we live rather informally."

I did so—it was already unpleasantly hot—and looked more closely at Eddie, who had a perfect face for his role, with a small, military mustache, a large Gaullist nose (the general's followers all seemed to uncannily resemble their leader in that respect) and the piercing eyes of a commanding officer. His cigarette, in the best French tradition, was glued to one corner of his lower lip, and he seemed to have no trouble keeping it lighted without getting smoke in his eyes.

"Who else is on board?" I asked.

"There is you, there is me, there is a lady who is a friend of mine, whom you will meet shortly and refer to as Madame, there is your uncle, and there is a friend of his. Other people may be joining us, but who can tell? Now I suggest you go below and change into more appropriate clothes. If you need espadrilles, you will find a pile of them in the closet, in all sizes."

I went below, found my small cabin, changed into blue jeans and a blue R.T.Y.C. T-shirt, selected a pair of espadrilles, from a pile which did indeed seem to cover every possible size of foot, and returned to the foredeck up the dark, narrow companionway. Eddie was no longer alone. Sitting beside him in a canvas deck-chair was an elegant lady in her well-preserved forties, wearing the first bikini I had ever seen, and more rings than I had ever thought it possible for a human being to wear. She held a glass of orange juice in one hand while she stroked the back of Eddie's neck with the other. This clearly was "Madame," and it took very little sophistication to divine she was Eddie's mistress. Opposite them sat a sulky young woman in her early twenties, wearing a pair of tight white shorts. Unlike Madame, who was thin in a chic and sexy way, the other, younger woman was if anything a little heavy, almost running to puppy fat. She had a healthy, glowing tan, dark-blond hair pulled back in a bun, a face with high cheekbones, a strong nose and beautiful lips, and wore, as I instantly realized, one of my uncle's gold watches and a cream silk shirt with the initials A.K.

embroidered in blue just below the heart, or, in this case, the well-rounded breast. I could see her nipples clearly.

In my usual paroxysm of shyness, I hesitantly shifted from one foot to the other, until Eddie put me out of my misery. *"Voici,"* he said, *"nous sommes complets.* Alex's young nephew, *le fils de Vincent, madame."*

I bowed toward Madame, who closed her eyes wearily.

"And opposite me," continued Eddie, "Mademoiselle Alexa Boy-cun, a friend of your uncle's from Canada."

I decided that bowing was out of the question—after all, she was not very much older than I was—so I shook hands instead.

"Très bien," Eddie said. "Now sit down, since your uncle is not yet up, and until he arrives we don't know the plans for the day."

"Did you have a good trip down?" Alexa asked, in an husky, American-accented voice with rather more enthusiasm than seemed necessary. I said that it had been fine. Madame sighed. "Altogether too much attention," she said, "is paid to the young. What does it matter if he had a good trip or not? *Il est jeune. Les jeunes sont forts."*

Madame was going to prove difficult. I almost regretted not having joined my father on his gastronomic tour of France. Also, it was clear to me just what the nature of Alex's "silliness" was, in my father's view. Even to an innocent like myself, it was obvious that Alex would hardly have given one of his shirts to a casual stranger. Alexa's presence revealed a side of Alex's character that had been hitherto concealed from me. If he had had affairs, they were kept very quiet, and his lady friends never appeared in his apartment when there were guests present, except as guests themselves.

Alexa was obviously in a different category. She rang a bell to summon the steward, and ordered him to bring another orange juice and vodka for Madame, whose glass was empty, with the kind of authority that comes from being the *châtelaine,* and her general manner was proprietary, rather than that of a guest on board. Even Eddie deferred to her, though in a manner which was at once ironic and flattering.

The general languor, I gathered, was due to the fact that they were all suffering from hangovers. They had dined out last night on board the yacht of an English industrialist, and were feeling the aftereffects. "A most disagreeable man," Eddie said, "very rich, which is nice, but with one of those great horse laughs that is so very English, and

surrounded by English nobodies. Not a successful evening. Your uncle hated it, and I don't think Miss Alexa enjoyed herself too much either."

Alexa frowned. "He kept putting his hands all over me. I was so bored that I fell asleep. Do you think he noticed?"

"I don't suppose so. He was very drunk. Besides, it is one of those rules of society that the young and the beautiful can do no wrong. If you had begun to snore it would have been taken for an act of the most ravishing charm and originality. It is only as one grows older that one has to make an effort to please."

"Ah merde," said Madame, and at that moment Alex arrived, dressed in a pair of blue summer trousers that looked like pajama bottoms and a dark-blue tennis shirt, and looking remarkably unkempt.

I stood up and he kissed me, leaning over to do so, then he sat down heavily in one of the deck chairs, while Alexa stood up in case he wanted anything.

"I can't think what I need," he said. "An *eau minérale* might be good, or perhaps one of those drinks that is supposed to restore one to life. What are they called? Prairie oysters? A Fernet Branca might be safer. Do you suppose that we are all suffering from lavish hospitality, or is it just that our host served cheap champagne?"

"Cheap champagne," said Eddie.

"I thought so too. I once knew a producer in Hollywood who served champagne at all his parties, and was thought to be tremendously extravagant. Then one day I went into the kitchen to see if I could get a glass of ice water for my hiccups. There was his houseboy, with a whole row of those siphons where you screw a cylinder of gas into the top to make seltzer water, filling them with California white wine so as to make instant champagne. He went bankrupt in the Crash, I think, and God knows he deserved to."

Alexa had returned with a bottle of Perrier water and a glass of Fernet Branca, which Alex took from her. She then sat down beside him and put one arm around his shoulders, which surprised me, since Alex did not generally like to be touched. He stroked the back of her head, drank his Fernet Branca with a grimace and lit a cigar.

"I thought we would have a nice lunch on board today," he said, "then tonight we can hire a car and drive over to Monte Carlo. We can have dinner at the Hôtel de Paris, then gamble a bit. How does that sound?"

Madame made a guttural noise that could have passed for assent, Eddie nodded and Alexa looked toward me.

"Can he get into the casino?" she asked. "Isn't he underage?"

Alex studied me thoughtfully, as if realizing that I was now his responsibility. "I don't see why not," he replied after a pause. "I'll have a word with the manager and fix it up, and if not I suppose Miki could always dress as a young woman and come in as somebody's mistress. Nobody asks women their age at Monte Carlo. Now," he said, turning toward me, "how are you going to amuse yourself and keep out of trouble here? Actually, you can do me a great favor. I have to talk to London, which means I have to walk across to Chez Félix au Port and use Monsieur Félix's telephone and promise him we'll eat there one night. Since that will be as boring for Alexa as it is for me, why don't the two of you go off and amuse yourselves? Take the car and go to Eden Roc. We won't have lunch before two."

We walked Alex to Félix's restaurant, where he sat down with a cup of coffee, a copy of *Nice-Matin* and a bowl of apricots and fresh almonds to wait for his call. We got into a small, black Simca sports car, so low that it was hardly necessary to open the doors. It did not seem like the kind of car Alex would enjoy riding in, and I said so.

"Ah," Alexa said, speeding off carelessly up the ramparts of Antibes, "Alex bought it for me. He's learning to sit in it without getting into a panic, and I think he may learn to like it in time. I wanted one in bright red, but this was all they had, so we bought it in Nice and drove away in it. What do you like doing?"

"I like swimming. And sailing."

"Not me. I like lying in the sun, but I'm not a swimmer. I'm from the Canadian prairies, and water makes me nervous. However, I *do* like Eden Roc, so I'll be happy to sit in the sun while you swim. Do you know how to drive?"

I said that I had learned how at school, though of course I didn't have a license.

"Neither do I. You can drive back. I don't really like driving all that much either."

As if to prove this, we skidded across the gravel at the entrance to Eden Roc, and stopped with a shriek of brakes just before the flower beds at the entrance, bringing several chauffeurs and the parking attendant to their feet in alarm.

We made our way down the steps to the collection of rocks on which the most expensive flesh in the world lay grilling in the sun, ordered two *matelas* and sat down. Alexa had a habit, I noticed, of sticking out the end of a rather small, sharp tongue, sometimes to dislodge a flake of tobacco from her lips, sometimes combining this gesture with a frown, obviously a sign of extreme concentration. Looking back across the years, I can understand her frown. She had managed very well so far—after all, here she was on Alex's yacht—but apart from a brief meeting with my father, Alexa had so far not been exposed to Alex's family. Doubtless she felt she was already well aware of the bond between the three brothers and of Alex's patriarchal instincts.

She knew enough about the Kordas to guess that Maria would be an implacable enemy, and that Vincent and Zoli would have to be dealt with very carefully. Since the divorce from Merle, they had had Alex pretty much to themselves, and were unlikely to welcome the prospect of having a young woman in a more intimate relationship with Alex than their own. If she kept Alex happy and did not interfere in family matters, his brothers might just possibly accept her, not as an equal of course, but as a suitable addition to the family. Alexa was well aware that her strength lay in Alex's sexual response to her, in the excitement of a man of nearly sixty who finds that a girl in her early twenties is in love with him. Yet, considering his age, it was possible that Alex might lose interest. It must give a woman pause to realize that her future is dependent on the continuation of a man's sexual desire for her. Alexa, who was nothing if not shrewd, was already thinking about a fallback position—it might be possible for her to win over Vincent and Zoli by an evident care for Alex's welfare and happiness.

I presented a rather different problem. As an adolescent, I clearly had no power, but Alex seemed to take a particular interest in me, while Vincent allowed me to move in Alex's orbit (and thus gave Alexa an opportunity of trying to influence Vincent through me). She probably assumed that because of my age, my upbringing as an American and my ambiguous relationship to Alex I might be an ally. Knowing Alex, I am not at all sure that Alexa herself was not being tested. He himself was no fool, and knew better than anyone else the dangers of such a relationship. If Alexa showed too much hostility toward the family, then perhaps it would be better she remained in the status of a mistress.

If she seemed able to adapt to the family, then her status could possibly be changed.

All this, I think, was going through her head as we sat on the rocks at Eden Roc, but even at the time I realized there was more at stake than just that. Alexa was not only greedy (and therefore nervous about the prize that lay just within her grasp, the chance to become Lady Korda and enjoy security and wealth beyond anything she had ever dreamed of for herself), but also bored. Her boredom was not necessarily sexual, though I would not have recognized the signs of sexual boredom at that age, but was in many ways the more simple-minded boredom of a person of twenty trying to share the life of a man of sixty. At just the age when most of her contemporaries were having fun, Alexa was learning to sit at the luncheon table for three hours, to be quiet in the afternoons so that Alex could have his siesta, to sit at the dinner table listening to Brendan and Max Beaverbrook talk politics.

She had learned some of the arts of a courtesan, like lighting Alex's cigar for him, licking the end in a way which was at once that of a seasoned cigar smoker and highly provocative in a young woman, but there would come a time when the smell of cigars revolted her, when she would wash her hair two or three times after a dinner party, unable to get rid of the heavy, penetrating odor. Alexa had not been bred to this life, and like an unbroken horse, she still had a streak of wildness in her. She liked practical jokes; she enjoyed raiding the ice box; children, dogs, cats and animals of all kind fascinated her; and she had not as yet learned to take herself seriously. When Alex had won heavily at the Casino Municipal, playing *vingt-et-un,* his favorite game, he had taken Alexa to the little Cartier boutique that stayed open all night to satisfy the whims of big winners, and offered her a diamond bracelet, which she refused. He was astonished and pleased by this, since no older man likes to think he is buying the affection of a young woman, even when he's perfectly willing to pay the price. In fact Alexa was simply bored by the whole thing (though she may also have calculated that when the time came to negotiate, her price would be higher than a small bracelet, and that her restraint at the beginning of the relationship would pay off handsomely later on). Still, boredom was a factor. Had she been athletically inclined, tennis lessons might have helped, but she was not, and a great deal of her life was now spent waiting—waiting for Alex to wake up, waiting for Alex to finish his phone calls,

waiting for Alex to finish his siesta, waiting for Alex and his friends to smoke their last cigar and drink one more brandy. I do not think Alex can have realized that each moment she waited would eventually have to be paid for, like a taxi that is kept downstairs with the meter running.

"Do you like it here?" Alexa asked.

"Yes," I replied. "I think I always have. We used to come here before the war."

Alexa frowned. All the members of the Korda family seemed to have been doing luxurious things for years, in Alex's case for several decades. Alexa was not a virgin in the conventional sense of the word, but she was a virgin to this kind of luxury. As a newcomer she was afraid of being thought unsophisticated. At the same time, she realized that Alex delighted in introducing her to his world, and would not have derived nearly as much pleasure from a young woman who had spent her childhood having tea at the Ritz in Paris or dining at La Tour d'Argent.

"I get a little bit bored by it," she said at last. "Is there anything around here that's fun?"

I thought about this. I knew there was a "fast set" on the Côte d'Azur, but I was too young to be a part of it. The only young person I knew was one of my fellow Roséans, Christian Delmont, whose family had a house on Cap d'Antibes, halfway between the Plage de la Garoupe and Eden Roc, but I doubted that Christian's life here was any more glamorous than my own. However, I mentioned his name, being anxious to please, and suggested that such life as there was could probably be found in Juan-les-Pins, then as now a collection of night clubs, bars and pickup joints for the young, the poor and the rich who had a taste for slumming.

"We'll go there one night," Alexa said, her eyes gleaming. "You phone your friend, and we'll go out on the town."

I had a swim, we changed back into our yachting clothes, and true to her word, Alexa allowed me to drive back to the yacht for lunch. Nothing could have been more calculated to win me over to her side, since my father was very determined to keep me from the wheel of a car for as long as possible, and I was at the age when driving seemed to be more important than sex, or perhaps I simply equated them. In any event, I was a sound, if inexperienced driver, and doubly happy because the Simca was exactly the kind of car that should not have been placed in my hands. It was fast, racy, noisy and flashy, a sports car with

five forward gears and hard, tight suspension. Nor was Alexa the appropriate companion, since she constantly urged me to go faster, and when I hesitated to pass on a blind curve, shouted out above the roar of the motor, "Go *on,* you can make it!" It struck me that she had a great deal in common with California teenagers, as she sat listening to the radio as the car swept around the ramparts, her face totally devoid of any expression.

I was therefore surprised when she transformed herself at lunch into quite another person, attentive to Alex, calm and very much older in manner. Clearly Alexa could play her adult role very well when she had to, and I admired the fact that she could be two people, depending on circumstances, without realizing that it was simply the difference in our ages that made it possible. When Alex asked how we had spent the morning, she winked at me, and I realized that from now on we would be sharing a number of secrets, and was suitably flattered.

When Alexa had peeled some fruit for Alex and lit his cigar, they went off together to the forward stateroom for a siesta, and I was left alone with Eddie and Madame, who lay in the sun preparing to digest the substantial meal that Pierre had served. The new steward, Freddy, a very attractive young man whom Alex had hired away from the Hôtel de Paris after Benjamin had decided never to set foot on the yacht again, served us coffee, cleared the table, lowered the awning, and left us to our own devices. Eddie opened one eye and looked at me.

"You are planning on a siesta?" he asked.

"I don't know what else to do."

Eddie's eyebrow shot up. *"Monsieur* doesn't know what else to do? On the Côte d'Azur! Take the car, go find something to do. No, don't tell me—I can guess you have already been driving it, that the beautiful lady Alexa gave you the keys. So long as you don't kill anybody, your uncle won't mind, and if you do any damage use my name with the police. A young man your age shouldn't be sitting here having a siesta. And another word of advice. Mademoiselle Alexa is very charming, and not all of us were blind to the little wink at the luncheon table. Take care that there are no misunderstandings. There are plenty of girls your own age on the beaches. *Va t'amuser!"*

"Perhaps I'll take the sailboat and see if I can get to Eden Roc and back."

"An excellent notion. There is enough wind to make it dangerous,

and therefore amusing. At your age, danger is an excellent pastime."

"Eddie," Madame said firmly, *"tais-toi."*

"Oui, chérie," Eddie replied, giving me a solemn wink, and waving me on my way. As I cast off the sailing dinghy, I could see Madame leading *le général* down the companionway to their stateroom, obviously determined to have her own siesta after Eddie had performed what he referred to as his "exercises."

IN LATER YEARS, it was always said that Alexa was a talented young opera singer from Canada whom Alex had met at a party and instantly taken a liking to. Further questions were discouraged, both by Alex and Alexa, but it was remarkable that her interest in the opera, if it had ever existed, vanished almost immediately. Certainly she had been taking singing lessons in London, but basically she was one of those attractive young women about town who appear at parties and are expected to make themselves agreeable to the guests. In fact, it was Moura Budberg who arranged to introduce Alex to Alexa, though not before the idea had occurred to several other people who were always on the lookout for young talent for London Films. The promise of a screen test had brought Alexa to London, but she had no real interest in a movie career.

Alexa's parents were Ukrainians, and though Alexa herself spoke neither Ukrainian nor Russian, she attracted Moura's attention, perhaps out of some basic Slavic affinity, perhaps because Moura had been tipped off about her by someone. Alexa had escaped from life in provincial Canada to London, and had been seen in the company of several older men, but nothing of a permanent nature had presented itself to her, and her education as a singer took up very little of her time or interest. It seemed to Moura that Alexa might amuse Alex, who was more than usually lonely and depressed, and she carefully arranged to have them meet, having briefed Alexa on just what Alex liked and didn't like. What he *didn't* like were women who were interested in motion pictures—after all, he had been married to two movie stars— and what he did like was to be amused, admired and found attractive as a man. Also, he distrusted elegance.

From their first meeting what he admired about Alexa was her awkwardness, her youth, her vitality and her untutored taste in clothes. "All her dresses look like very stiff tents," he once said, "but one can

see that when she takes them off she is very beautiful." No doubt this was a pleasant change from many of the women in Alex's life until now, who, like Vivien, spent fortunes on clothes and looked beautiful until they took them off, at which point the signs of wear, tear, age and emotional distress were all too evident. Alexa wore such high spiky heels that she always looked as if she were about to fall over, and most of her jewelry was heavy and plastic, looking like something that had come out of a bathroom cupboard, and totally unbecoming. This amused Alex, and gave him full scope for his ambitions to play Pygmalion all over again.

In any event, they had become "close friends," in the traditional gossip-column phrase, and Alexa was a frequent visitor to the apartment at Claridge's, though still discreetly rushed in and out by Benjamin. Alex was seen with her in public, dining out, going to parties and movie premieres, but she was not yet a permanent fixture in his home, and Benjamin still placed a new toothbrush in its cellophane wrapper on the washbasin when she came for the night, instead of allowing her to keep her own: a gesture designed to show that *he* at least knew what her place was, and intended to see that she was kept there.

In this, Benjamin was overconfident, much to his own subsequent distress. In any fight for Alex's attention and interest, Alexa had more going for her than poor Benjamin, who failed to take into account the potent attraction of Alexa's femininity. Bailey, wiser in the ways of men, swiftly accommodated himself to Alexa's presence, and treated her with courtesy, doffing his cap and rushing to her side of the Rolls to open the door for her. Benjamin, on the other hand, behaved as if she were a rival, and soon found himself exposed to a variety of defeats and snubs. Her toothbrush was soon placed defiantly in its own holder, next to Alex's, and was followed by her underwear, a dressing gown, a few changes of clothes and several pairs of shoes.

It was clearly expedient to give Alexa a closet of her own, and to Benjamin's indignation he found himself doing what he called "ladies'-maid work," which he strongly felt to be beneath his dignity as a manservant. Worse was to come, from his point of view, since Alexa pointed out that it was surely inconvenient (and a ridiculous expense) for her to keep her own flat if she used it so seldom, and Alex, who was beginning to enjoy this first tentative reexposure to domestic life,

agreed. To Benjamin's horror, the extra bedroom was converted into a room for Alexa, her belongings were packed up and brought over to Claridge's and she moved in. Alex bought a large, sensual Renoir nude to hang on the wall facing the bed; one of Bert Crowther's "boys" produced a Louis XV dressing table, which reputedly had belonged to Madame de Pompadour; and the refrigerator, which normally contained only champagne and a few tins of caviar, was soon full of candy bars, nuts, cheese, ice cream and delicatessen, since Alexa was an inveterate late-night ice-box raider.

Benjamin did not exactly suffer in silence—he sighed a lot, and occasionally cried in a furtive, snuffling sort of way which invariably irritated Alex. Whenever anything went wrong, Benjamin would point out that it was "Miss Alexa's" fault. If Alex's shoes had not been properly polished, it was because Benjamin had been asked to press something for her. If there was no Cointreau in the house, it was because Benjamin was too busy running errands for her. If Alex's coffee was not hot enough, it was because Benjamin now had to prepare two breakfasts instead of one. At the same time, Benjamin fought a small-scale guerrilla war against Alexa. Her panties mysteriously vanished in the laundry (she jokingly suggested to Alex that Benjamin was probably wearing them, but given the difference in their sizes that seemed to Alex unlikely). She complained that her bottle of Schiaparelli toilet water was emptied rather more rapidly than it ought to have been. Her make-up table went undusted because, as Benjamin complained, he couldn't be expected to straighten out the mess of all those cosmetics or know how to put them back in the right place ("Nonsense!" Alex said, "I'm sure that he makes himself up with them while we're out"), and her clothes came back from the dry cleaners' with buttons or the belt missing.

None of this greatly perturbed Alexa. Once she had established herself in Claridge's she was willing to bide her time and allow Benjamin to make such a nuisance of himself that Alex would eventually sack him without her even suggesting it. She was confident enough to go to the trouble of defending the irreconcilable valet from time to time, even though Alex knew how much she disliked him, thus gaining for herself an enviable reputation for fairness, tolerance and mercy.

The major asset Alexa had was quite simply that Alex was having fun, for the first time in years. He no longer felt old. He had been leading a cloistered existence, seldom going out, giving large dinner parties for people he had known for years ("The same old faces as usual," Benjamin would sigh as he took one's coat in the foyer). Now he wanted to show Alexa that there was life in the old dog yet.

Alex, who had always argued that he could eat better at home than in any restaurant, was soon eating out at Les Ambassadeurs, Mirabelle and the White Tower, showing Alexa off, and was even seen going to night clubs from time to time, beaming in his dinner jacket and black tie. He looked twenty years younger.

His friends were impressed and envious. Alexa took good care to be very quiet in their presence. She did not talk politics, raise her voice, argue or interrupt, and they soon came to accept her presence as if she were one more expensive possession, like the paintings or the furniture. What is more, Alexa had a good deal of girlish appeal. She charmed Brendan, which was no easy thing to do; she got a pinch on the cheek (and, she swore, on the buttocks) from Lord Beaverbrook; she was kissed by Winston Churchill, who pronounced her "delightful" and took a good, long look at her bosom as she leaned over to say goodbye to him.

Alex had always liked buying things, but he had rarely had the time to do this in a conventional, personal way. Benjamin ordered his clothes, and his secretaries dealt with presents, while most of his furniture and artwork was bought by my father. Alexa changed this pattern. She dragged him out of his office and into the Rolls to buy glasses from Baccarat. She went to the tailor and the shirtmaker with him, and suggested more youthful-looking fabrics. She persuaded him to go to Christie's and bid on furniture, and he was delighted. As far as art was concerned, he still deferred to my father, but for the first time he suggested things he wanted to buy: first the Renoir, which Alexa had seen was up for sale, then a series of Degas bronzes, which particularly appealed to her. In both cases my father was enthusiastic—he approved of the works themselves, and also thought they were sound investments —but the spectacle of Alex on a spending spree somewhat disturbed him. Until now, he had had to persuade Alex to buy a work of art, explaining just why this particular painting or sculpture was a unique opportunity. Now he found himself in the unusual position of having

to restrain Alex, something he had never been any good at in the first place.

Together, Alex and Alexa cruised the antique furniture shops, ordering things on consignment, and sometimes returning them if they didn't seem to fit in once they were at home, buying priceless silverware and giving each other expensive little presents. Alex had Alexa's bathroom painted pale blue (a color he himself hated), because it was *her* favorite color. They took a weekend trip to Paris to order her a wardrobe full of underwear (all of it also in pale blue) from a small shop off the Rue de Rivoli which made lingerie and lace for ladies who probably did not even know such things could be bought ready-made in the basements of Bloomingdale's or Harrod's. All the same, Alexa was clever. She asked for very little for herself. The furniture and artwork were, after all, Alex's. She refused jewelry and resisted his suggestion of a visit to Chanel or Balenciaga, and expressed no interest in the fur coat which Alex felt was appropriate to her new position.

She even tried to put some order into his household, doubtless as another blow to Benjamin, and insisted on going over the bills, making small economies here and there in that vast area of extravagance, and winning Alex's admiration for her devotion to his best interests. Brendan himself, when he heard about this (for Alex proudly told everybody that she was saving him a bloody fortune), remarked that Alexa "had a good business head on her shoulders," and Alex's friends were doubly impressed by the fact that he had not only acquired at his age a beautiful young mistress but one who was prudent, careful with money and undemanding. Thus by the time Alexa reached the yacht in the South of France, she was very securely established as a part of Alex's life, and even my father was forced to admit that Alex could have done worse, and made conciliatory and optimistic noises when Zoli rang up from Los Angeles in alarm to ask what the hell was going on. That is not to say that Vincent liked or trusted her, but at least she was not a fashionable society woman or an obvious gold-digger, and if she made Alex happy, as was clearly the case, who could object? Besides that, he liked pretty young women, and was always at his most amusing in their presence. All the same, he was watchful. Alexa as Alex's mistress was one thing; Alexa as a new Lady Korda would be quite another.

ON THE WAY out to Eden Roc I had time to reflect on the unimaginable
changes that would take place in our family if Alexa were to become
the third Lady Korda. In those days, privileged clients were allowed to
anchor their yachts or tie up their boats at the Roc. It was also an
interesting excursion, since most of the great houses on Cap d'Antibes
could only be seen from the sea—from the road they presented a blank
wall, or were simply invisible, like the huge villa of the Dubonnet family
(makers of the famous *apéritif*), which actually had a swimming pool
blasted into the rocks, or the vast estate which had been used as a
Luftwaffe officers' rest home during the Second World War.

I moored, swam, brooded and sailed back to the port, arriving just
in time to change into a blue suit. Eddie, I saw, was wearing a white
suit, with the red rosette and gold bar of a Grand Officier of the Légion
d'Honneur (Military) in the lapel, and the narrow red and green ribbon
of the Croix de Guerre, while Madame was dressed in what even I
could see was a Balenciaga, and covered in the kind of jewelry that is
so dear to the French, designed so that the stones are as large as possible
and can be levered out of their settings with a pair of nail scissors to
be hidden away in case of war or revolution. Alex wore a blue-linen
yachting suit and Alexa wore a dress that was simple and unflattering,
as Madame tactlessly pointed out.

A big Delahaye limousine had been secured for us by Freddy, the
steward, and we squeezed in, Eddie gallantly taking the jumpseat next
to me, the two ladies in the back and Alex up front with the driver.
Alex was in good humor—he enjoyed excursions like this, he liked
gambling and he was satisfied with his new crew. The captain was a
quiet fat Englishman who kept out of Alex's way and seemed content
enough at the prospect of spending most of his time in Antibes. "I
think he's got a mistress in Antibes," Alex said (I noticed Alexa
frowned at the use of the word). "He doesn't speak a word of French,
but he seems very happy here, and when I asked if he'd like to bring
his wife down here for a holiday while we're not on the boat, he turned
pale and said he didn't think so. Freddy is a nice boy, and Pierre is a
good cook, though he has to be watched. The other day he made a
sauce that tasted very unusual, and when I asked what it was, he told
me that he'd accidentally poured Pernod into it instead of white wine,
and didn't have the courage to tell us. Actually it wasn't bad. He has

a nasty temper, he drinks and I imagine he has private deals going with every merchant in town, but what cook doesn't? What I like best is that he comes in every morning with his menu book while I'm having breakfast and tells me what's in season, what looks good in the market-place and what he feels like cooking. I find it very soothing. I enjoy thinking about food, speaking of which, I rang up ahead to ask for a lemon soufflé for all of us tonight."

Madame nodded her approval. Alexa, I could see, was bored and restless, seated in the back of the old limousine, with its polished veneer trim, its doeskin upholstery and its small cut-glass vases, each of which contained a single rose. Food did not interest her much, since she basically liked junk food and was in any case one of those women who always think they should be dieting. Like most people who eat between meals, she was firmly convinced that it was only what you ate at table that produced fat, and was quite capable of eating a huge salami sandwich in the middle of the afternoon, then refusing one of Pierre's elaborate desserts at night, something which Alex, who only ate at mealtimes, could never understand.

We made our way past the Baie des Anges and into the streets of Nice, then up to the Moyenne Corniche, past the Château de Madrid, one of Alex's favorite restaurants. Alex had recently dined there with Willie Maugham, whom he knew well, and rather disliked, despite the fact that Maugham was a close friend of Churchill's.

"One of these days," Alex said, puffing on his cigar, "we ought to pay old Maugham a visit, but I find him very disagreeable. I bought several stories from him, but somehow I never made one of them into a film, I don't know why. I hear that he has gone to what's his name? —Niehans?—the doctor in Zurich who injects you with bull's glands. Someone said that before the injections he was impotent but still a wonderful writer, and now he is randy as a bull but can't write at all. Perhaps I should see the doctor, what do you think?" Alex chuckled, and turned around to look at Alexa.

"I don't think you need to," she said, demurely enough, but with just a hint of crossness. She did not like to be reminded of the difference in their ages, or of her status as mistress, I judged.

Madame was not amused. "Why is it," she asked, "that men are always talking about these things? It's always the same, So-and-so has had miraculous results from eating yogurt flown directly from Yugo-

slavia. So-and-so has discovered a root from China that you buy in Hong Kong and mix in with your tea in the mornings. So-and-so goes every year to Zurich to be injected with God knows what. *Enfin,* sex is not alchemy and does not come from the butcher's shop, it's all a question of desire, passion, love, *n'est-ce pas,* Eddie?"

Eddie shrugged. *"Bien sûr, mon amour,"* he said, not about to quarrel with Madame in public, but I could see from the expression of interest on his face that he was contemplating a trip to Zurich all the same. After all, if it could work miracles for an old *pédéraste* like Willie Maugham, what would it not do for a French general?

By the time the car swept silently up to the steps of the Hôtel de Paris in Monte Carlo it was already late, which was just as well, since we had eaten a heavy enough meal (by anybody's standards except Alex's) at two o'clock. We stood in the huge ornate lobby, a kind of fantastic blend of architectural excesses designed to appeal to the tastes of Russian grand dukes and Edward VII, and touched the knee of the horse on the small bronze statue of Louis XIV that is supposed to bring luck to gamblers, and is now worn thin and shiny by a million hands and fingers. We entered the dining room, which has probably the most elaborate decoration of any room in Europe, possibly excepting those in Schloss Neuschwanstein and the Vatican. There we were joined by Freddy Lonsdale, the aging English playwright-author of such sophisticated plays as *The Last of Mrs. Cheyney,* who resembled W. Somerset Maugham remarkably, in age, manners and speech, and Marcel Pagnol, the author of *Marius,* who had given Alex his first chance on his return from Hollywood to Europe over twenty years ago. Pagnol, whose plays had made him a rich man, now lived in Monte Carlo, having persuaded the Portuguese government to make him their Consul and Plenipotentiary Extraordinary to the Principality of Monaco, thus relieving him of any need to pay taxes. He had a large, handsome house overlooking the sea, on which was affixed a polished brass plaque that read, in three languages:

CONSULATE OF PORTUGAL
DIPLOMATIC MISSION
For all enquiries and services
please go to the Portuguese
Consulate in Nice

His car bore Monégasque diplomatic plates, allowing him to travel through customs without being stopped. His liquor and cigarettes were purchased free of duty and taxes, and his only obligation consisted of attending the annual *levée* of the diplomatic corps in the Castle of Grimaldi once a year, to pay his respects to His Serene Highness the Prince of Monaco. Quite what Lonsdale was doing there, I don't know. He seemed to me to be about eighty years old, had a face which someone once described as resembling "a cracked, worn-out crocodile handbag," and was given to telling obscene anecdotes from his youth in a cracked, Edwardian voice, as if the phrase "dirty old man" had been invented on his behalf.

Shortly after we had made ourselves comfortable for dinner, a strange apparition presented itself to us in the dining room. A very old man, possibly the oldest man I had ever seen, appeared, pushed in a wheelchair by a buxom woman in her mid-thirties. He was dressed in a rather shabby dinner suit, while she wore an unfashionable evening gown, cut so low in front that her ample cleavage seemed to go on forever. With the help of the waiters, the old man was transferred to his table, and a plaid steamer robe tucked around his legs. He sat hunched up on one side of the table, looking like a corpse, while his companion sat opposite him, looking around her with lively interest.

"A candidate for the bull's glands," said Madame.

The candidate for the bull's glands ate sparsely, and with a feeble hand, taking a spoonful or two of soup, a bite of minced veal, a piece of bread rolled and kneaded until it was soft, while his companion cheerfully made her way through a mighty dinner. Lonsdale, whose attention had been diverted from Alexa's bosom to the mysterious and unlikely couple, informed us that they were the old Baron de Rothschild and his nurse.

"He's lived here since the Year One," Lonsdale said. "He moved here from a hotel in Nice after quite a fuss. It seems that for years he had the same room waiter, and every morning this waiter brought him his breakfast tea. Then one day the waiter died, and the baron complained that his tea didn't taste the same; in fact it was dreadful, no taste at all. The management rushed about trying to find out what had gone wrong. It happened that old Baron de Rothschild was a miserable tipper. He hated parting with money. In revenge the old floor waiter used to piss in his teapot every morning, starting I suppose with just a few drops, until old Rothschild gradually got used to it. When the

waiter died, the new one was bringing Rothschild perfectly good tea, of course, but it just didn't taste the same because he'd gotten used to piss. There was a terrible row when the whole thing came out, and he moved here."

As our own meal drew to a close, I noticed that the old man was becoming increasingly animated, as if, finally, his evening was about to reach its climax. I wondered if he had a taste for dessert, and was expecting something lavish and extraordinary after his frugal meal, but I was surprised to see the maître d'hôtel arrive with a single orange on a silver plate. Deftly, he stuck a fork in the orange and showed it to Rothschild, who nodded in approval. Taking a knife the maître d'hôtel skillfully cut the rind of the orange in one long loop, and placed the fruit in front of the baron with a flourish. Rothschild, by now quivering slightly in anticipation, tore the orange into segments with his palsied fingers. It seemed to me improbable that an orange could cause so much pleasure in any man, but who can tell what a man who likes piss in his tea will be excited by. I watched him place one segment of the orange in his mouth, roll it around, chew at it and swallow. Then, to my astonishment, he very precisely spat the pips straight out across the table, where they landed between his companion's breasts. She took no notice and continued to smile. He snuffled with pleasure, wiped his mouth and took up another orange segment, and proceeded once more to spit the pips out into her cleavage. She looked around the room as if nothing were happening. I squeezed Alexa's hand and pointed, and we sat breathlessly as he disposed of the whole orange and its pips, never once missing his target. Then, when he had finished, his companion rose, took away his napkin, checked his rug and wheeled him out of the dining room, bowing majestically to the staff, while the baron sunk back into a comatose lethargy. Clearly it had been the high point of his day.

Unfortunately Alexa and I were the only ones who had noticed this performance, and when we started to giggle, we attracted the attention of our entire table. Nor was Alexa able to stop. Her giggles became more acute, then turned into laughter, then turned into strangled gasps.

"I don't see what's so funny," Alex said, obviously annoyed, and fearful that either Alexa or I might be drunk. But Alexa was unable to

explain, perhaps because she thought nobody would believe us, and had to be taken to the *vestiaire* by Madame to recover.

"What happened?" Alex asked me.

I explained, as best I could, what we had seen, and for a moment I thought Alex was not going to believe me. But Freddy Lonsdale gave one of his cackles. "Quite true," he said, "quite true. I'd heard he does that, but I've never seen it, and I'm sorry I missed it. They say that he also likes to go down to the kitchens and shape all the ice cream and parfaits into perfect little spirals by licking them. I've never been able to eat a parfait since."

"Well," Alex reflected, "I suppose we shall all have to find new pleasures at a certain age, God knows. In a way one can envy him."

We joined the ladies, touched the bronze horse's knee, and took the elevator down to the long underground passageway that connects the Hôtel de Paris with the Casino, since both are owned by the Société des Bains de Mer, or the Company for Sea-Bathing, an odd name for a business venture that exists on gambling. Originally, the tunnel had been built for those guests who were too old to walk two hundred meters across the flowered square and struggle with the steps of the Casino, and it had the disadvantage of depriving one of making a truly grand entrance. But in this case, Alex had persuaded one of the directors of the casino to overlook my age, and he felt it would be inappropriate to enter through the lobby. Still, the Casino was grand enough once we were in it, with its huge, mirrored rooms, its gold-painted decorations and its general atmosphere of *fin de siècle* luxury. Eddie, who was not a gambler, took a seat by the bar and settled down to look at girls while Madame played for small stakes at the roulette wheel in the *cuisine*. Alex made his way to the Salle Privée, reserved for heavy gamblers, and sat himself down at the baccarat table with a large pile of 1,000-franc chips. Alexa, I could see, was tired, bored and fretful. She did not like gambling, no doubt because it seemed to her wasteful and dull. It was one of the pleasures she could not share with Alex.

Alex loved it, he always had. It was the essence of what he was, of what he did. All his life he had gambled for high stakes, and now that he had won, with his title, his yacht, his collection of paintings, his fame and his young mistress, only gambling could revive his need to take risks. It was not the money that interested him, it was the possibility of testing whether or not he was still a winner, of trying to find out

if his luck still held. It was confirmation of that luck he sought, not a pile of chips to cash in at the end of the night. Alexa, whose run of luck was just beginning, could hardly be expected to understand just how crucial a need this was to Alex, and like most women who are kept up late at night watching something that bores them, she either assumed that Alex was avoiding going to bed with her for some reason, or wanted to impress her with the amount of money he was willing to stake.

Alex drank brandy and played, while Alexa sat beside him, one arm around his shoulders, "for luck," as he put it. And indeed he was as lucky as usual. The bank passed to him, the cards came up again and again in his favor, the *plaques* mounted up until the 1,000-franc squares were replaced with 10,000-franc ones, and still Alex played, lighting a fresh cigar every hour or so, occasionally calling for a bottle of Vichy water, but concentrating firmly on his game. Alexa had ceased to interest him. He was busy winning, and nothing else mattered.

Then, gradually, he began to lose. I could see that he was getting upset, injudiciously doubling and trebling his bets to make up for his losses, running through handfuls of *plaques* with each turn of the shoe, until he was now buying more *plaques*, dropping 10,000- and 20,000-franc bills on the table from the great wad of money in his pocket, furiously determined to win back what he had lost, while Alexa, by now exhausted, tried to persuade him to stop, to give up, to go home. She whispered something to him, and he turned, his face no longer happy, healthy and smiling, but angry, set and withdrawn.

"Leave me alone," he said. "Can't you see I'm playing? Take some *plaques,* go play roulette in the big room."

Alexa turned and left, and I joined her, sitting down next to Eddie, who was as relaxed as ever.

"I can't stand it when he's like this," Alexa said. "What does it matter whether he wins or loses ten thousand dollars? It's a waste of money, of course, but it's meaningless."

Eddie signaled the waiter and ordered a bottle of champagne. "You have to let him do what he wants to do," he said. "I don't like gambling all that much myself. I'm a flyer, I gamble in the air, but men like Alex need to take risks. It's the most important thing for them."

Alexa, I could see, was not convinced. She herself wanted to take no

risks at all, and could hardly understand why somebody like Alex, who had everything, would risk any of it.

"You're a woman," Eddie said, "you want security. But Alex is bored by security. Every time he makes a fortune, he risks it on something else. It's his nature."

"It's not mine."

Eddie nodded. "That is very apparent. Try to make sure it isn't so apparent to Alex."

Before Alexa could reply, Alex appeared, looking depressed and strained, tipping the *personnel* with cash as he left the Salle Privée, instead of giving them *plaques* as one does when one is a winner.

"1,500,000 francs! A ridiculous amount of money to lose, but I'm too tired to go on. It must be two or three in the morning and I can't play any more. Bugger! I was ahead twice as much two hours ago, and now look." He sat down, and ordered a glass of brandy. It must have been, I imagined, the fifth or sixth he had drunk during the night, and his hand was trembling slightly as he lit his cigar.

Alexa patted his hand, trying to make up for the fact she had left the table. "Never mind," she said. "Lucky at cards, unlucky in love; lucky in love, unlucky at cards."

Alex looked at her over the tops of his half-moon reading glasses, his eyes gray and expressionless. He moved his hand away from hers. "I had hoped," he said, "to be lucky with both. I should have stopped when I was ahead. One should always know when to stop, but somehow one doesn't. Let's go home and get some sleep."

Lonsdale and Pagnol had vanished, so we made our way down the great marble steps, Alex walking wearily, with Alexa and me behind him, back to the waiting Delahaye. We drove in silence all the way back to Antibes. Madame, who had won a few thousand francs, slept soundly, as did Eddie. Alexa stared ahead of her, while the only sign of life from Alex was the red, glowing tip of his cigar.

I WONDERED if he was beginning to think that he was losing his luck in both areas. I knew he was inclined, like most gamblers, to take the turn of the cards as a judgment of fate, and since he regarded them as a test of his luck, a loss always seemed to him a kind of warning. Certainly, as we stepped out of the car, just as the Antibes fishermen

set off in the early dawn, he looked unusually thoughtful and subdued.

For a moment he stood on the after deck of *Elsewhere*, his arm around Alexa's shoulders, looking out to sea. She whispered something to him and laughed, but he was not to be charmed out of his bad mood, or at any rate not so easily as that. He turned, and together they walked forward toward the master stateroom, and as the door closed, I heard Alex say, "All the same, the older I get, the more I hate losing . . . Losing is like a kind of death, by small degrees . . ."

I went to bed to sleep for an hour or two, and as I lay there, listening to the waves lapping against the hull, the motors of the fishermen's boats and the general and his mistress snoring in the cabin next to mine, I realized to my horror that I had just seen the picture out of my own recurrent dream, that of Alex (or myself as Alex) standing on the deck of a ship, with his arm around a beautiful woman, only the woman now had a face, and it was of course Alexa's . . .

I got up, put on a pair of jeans and a sweat shirt and went up on the bridge to sit and think, uncomfortably aware that my subconscious was operating on dangerous ground. It seemed to me that I would do better to leave the yacht, but that would be hard to explain to Alex, impossible to explain to Vincent, and anyway I didn't want to. I had reached no conclusion, when I heard a noise behind me and Alexa appeared, wearing a pale-blue pair of lace-edged panties, a low strapless brassiere and an old velours dressing gown of Alex's around her shoulders.

"I didn't know anyone was up here," she said, pulling the robe around her.

I offered her a cigarette, and she took it, producing one of Alex's gold lighters from the pocket of her robe. She clicked it a couple of times, but the early morning wind was too strong for it, so she handed the cigarette back to me, and I lit it for her, cupping my hand around the match in what seemed to me a competent, masculine way. She took the lighted cigarette from me, inhaled, then sat down beside me in a moment of quiet, almost sexual intimacy so strong that I was reluctant to break it by speaking.

"Why can't you sleep?" she asked.

"It's too late or too early, I'm not sure."

Alexa brushed the hair out of her face, and stared across the harbor at the dawn. "I can't sleep either," she said. "I hate it when Alex gets

like that. Who cares whether he wins or loses at cards? The whole thing
is silly. He loves me, you know."

"Do you love him?"

"I think so. It's all a little scary, but I think I do. Not that he's an
easy man to love."

"Isn't he?"

"No. Well, there's the difference of age, and a lot of other things,
you see?"

"I'm not sure I do. I don't think I know much about loving people."

"Well, you love your father, don't you? And your mother? And Alex
too, I would have said, judging from the way you look at him."

"Maybe. I'm not *sure* about my father. If you think Alex is a difficult
man to love, wait till you know Vincent better—he's *twice* as difficult.
As for Alex, it's hard to say. I'm supposed to love him—everyone in
the family does—but the problem is that I want to be like him, and
that makes him hard to love. Does that make any sense?"

Alexa threw her cigarette over the side into the water. "I guess it
does, but you're making a big mistake. I'm not sure Alex has as much
fun being Alex as you think he does. I see him a little closer than you
do."

"Admittedly I'm not sleeping with him."

Alexa frowned, stood up and leaned on the chart table. "Don't talk
about things you don't understand," she said. "That wasn't a nice thing
to say."

I stood up myself and gave her a kiss on the cheek. "I'm sorry," I
said. "I didn't mean to say it, and I shouldn't have said it. It's as
complicated for me to be here as it is for you to love Alex. I wish I were
a couple of years older, or you a couple of years younger. That might
help."

Alexa gave me a hug, turned and went down the ladder to the deck.
"It wouldn't help at all," she said, "and if you *were* we'd be accused
of necking, so it's just as well you're not. How about a trip into Cannes
this morning to buy some clothes while Alex makes his telephone calls?
If we can find a bar with a pinball machine, we can have a hamburger
and play some pinball."

"That sounds okay to me."

"It's a deal, then."

She was gone, back to Alex's cabin, and I was alone again—as usual,

I thought. And for the first time, I detected in myself ambivalent feelings about Alex. I wanted to be rich like him, yes, I admired him, I wanted to be as elegant, famous and charming as he was, but at the same time I hated him for making my life a constant challenge to catch up with him, and because I never could, and because he had everything I wanted—including Alexa, who was, by now, back in his bed rather than mine. I decided not to go back to mine, and went off for an early-morning swim.

IT WAS NEVER certain how Alex would spend the day when he was on *Elsewhere*. There was a restless quality to his life in the South of France which came from the simple fact that he himself did not know where he was going. Some mornings he would rise late and do nothing, happy enough to sit in the sun and make plans for an excursion to St.-Paul-de-Vence to have dinner at La Colombe d'Or, other mornings he would sit at Chez Félix au Port and make endless telephone calls to London, or have himself driven to Cannes or Nice to meet with David O. Selznick, or Darryl F. Zanuck or Sam Goldwyn. The burden of the 3,000,000-pound loan worried him, but what worried him more was that he no longer understood or liked a good many of the films he was producing. *The Third Man* had been a huge success, so great in fact that it was like a repetition of *Henry VIII*. It was also the kind of movie he liked himself, though not one he would have directed personally, since it lacked spectacle and fantasy, but the smaller, more "English" movies that London Films was now producing, like Launder and Gilliat's *Folly To Be Wise* and *Belles of St. Trinian's*, or Emlyn Williams' *The Last Days of Dolwyn* (which starred a young actor named Richard Burton in his first major role), held very little interest for Alex.

Certainly they were profitable, and certainly London Films needed this kind of product if it was to cover its overhead, but they were like gambling for small stakes. At best they could be modestly successful (and most of them were), but none of them was likely to achieve a huge international success, or beat the Hollywood motion picture giants at their own game. Alex explained his attitude by saying, "A film that costs 90,000 pounds and earns 100,000 pounds, that's an economy I can't afford; a film that costs 500,000 pounds and earns 1,000,000 pounds, that's the kind of extravagance I like!"

But this was an oversimplification, and he knew it. Alex had not come back to England to make small, safe films, nor could the problems of London Films and British Lion be solved by a series of modestly profitable successes. He needed a big score, and nothing less interested him. He had already suggested to Carol Reed that his next film should be Conrad's *An Outcast of the Islands,* and Alex spent several hours a day reading and rereading Conrad's novel, and trying to visualize it as a film. For years, he had wanted Zoli to make it, and no doubt Zoli could have done it easily enough, with his knowledge of India and his experience of filming there, but Zoli had never liked the book, did not share Alex's admiration for Conrad and in any case was deeply involved in a project of his own, which Alex had agreed to finance, a movie of Alan Paton's *Cry the Beloved Country.* One reason that my father was so dilatory in making his way to the South of France, I soon discovered, was that he knew Alex was going to ask him to go to India, and was hoping to put the matter off for as long as he possibly could. *An Outcast of the Islands* excited Alex—it had the makings of a big movie, and of course all the difficulties of one as well.

He was also interested in David Lean's plans for making *The Sound Barrier,* a major movie about an aircraft manufacturer (eventually played by Ralph Richardson) and his ruthless quest for higher speed, which had certain philosophic undertones of *Things to Come.* Alex was well aware that in Carol Reed and David Lean he had England's best directors, and was proud to have them both working for London Films, but while he liked Carol, and treated him like a favorite son, he found Lean cold and distant, with the result that he interferred too much in Carol's projects, and not enough in Lean's. All the same, he recognized Lean's abilities, and was playing with the idea of giving him a vast spectacle to make, perhaps the story of the Taj Mahal, which had always fascinated Alex. He discussed the possibility of sailing the yacht to India to do the research, and once even sat down with the captain to plot out a course that would take *Elsewhere* around the world, but in the meantime, he was content to make the occasional journey to the islands off Cannes, where one could anchor in the clear, shallow water, have a good lunch under the awning in the cool breeze, and watch the activity on what was then the only nudist beach on the Côte d'Azur. Not that Alex was all that interested—it was Eddie who took up the binoculars whenever Madame was not watching him—but he liked the

feeling of lunching at sea, and felt he owed his guests a chance to swim from the yacht and enjoy themselves.

These lunches were an agreeable part of the routine of Alex's holidays, and his guests included Lillian Hellman, Graham Greene (always Alex's favorite companion), Ingrid Bergman and Roberto Rossellini, Ronald and Benita Colman, Randolph Churchill and Orson Welles. For these occasions, Alex would put on his yachting cap and direct operations from the bridge, explaining the proper technique for anchoring and in general behaving like an admiral. Sometimes we took a longer cruise, eastward to the Iles d'Hyères, off Toulon, or westward down along the coast to Monte Carlo, or overnight to Calvi, in Corsica. Vivien arrived as a guest for this particular excursion, which created a certain amount of tension, since Alexa resented Vivien's fame, sophistication and long friendship with Alex, and Vivien was by no means happy to undergo comparison with a woman twenty years younger than she was. Not that Vivien need have worried, since she was perfectly capable of securing center stage for herself under any circumstances. Her presence seemed to grate on Alexa's nerves far more than Alexa's did on hers.

All of us were put on our best behavior for Vivien's visit to the yacht. She had just completed filming *A Streetcar Named Desire,* and Alex, who was a member of the board of directors of Laurence Olivier Productions, Ltd., had been deeply involved in the discussions which preceded the Oliviers' decision to play together in "the two Cleopatras," in which they would do Shaw's *Caesar and Cleopatra* and Shakespeare's *Antony and Cleopatra* on successive evenings. Alex privately thought the strain of two such demanding roles, in which Vivien would have to play a young girl, then age twenty years to play the older Cleopatra, would be more than Vivien could bear, but in view of her enthusiasm he reluctantly agreed. He also feared that given the state of the Oliviers' marriage and Vivien's mind, the strain of playing a romantic role opposite Larry onstage might bring about another of Vivien's hysterical episodes, or worse. It was to calm these anxieties that Vivien was invited on board, inadvertently putting Alexa in the shade by her presence.

Charm was Vivien's secret weapon, as if the nuns had drummed it into her along with cleanliness and good manners. She went swimming and fishing with me, played gin rummy with Alex, inspected the engine

rooms with the engineer and took the helm at the captain's direction, charming the poor man so effectively that we made our landfall in Corsica at least twenty miles off course. She was, as Alex said, "the only person in the world who could be charming while she was throwing up," for Vivien suffered from seasickness and was unwilling to admit it for fear of hurting Alex's feelings.

When we arrived in Calvi Bay, Alex decided to eat onshore. After a few apéritifs, we got into the motor launch and made our way to the harbor. We made a rather exotic spectacle in this simple fishing village, which few but the most penurious tourists ever visited, the launch flying the blue ensign and Alex's personal flag, Vivien dressed in a flowing Arab kaftan and a huge straw hat, Alex in his yachting cap and Alexa in her revealing shorts and halter top. Having come from *Elsewhere*, which rode at anchor in the bay, looking like the very symbol of glamour and wealth, we attracted a small crowd as we sat down on the terrace of a restaurant, Vivien chattering away noisily and smiling at those of the local fisherman and bandits who recognized her as a movie star. Next to us were two elderly English ladies, probably drawn to Calvi by the fact that it was perhaps the cheapest place in the Mediterranean to visit. One of them stared at Vivien with an intensity bordering on rudeness until her companion grabbed her by the wrist and said in a ferocious stage whisper, "Pay no attention, Agnes, they're just theatricals!"

Vivien began to giggle, then to laugh and finally to cry, as if she were not sure whether to be amused or offended, but gradually she came to regard the scene as funny, and took it as her watchword for the trip, occasionally interrupting whatever was happening by announcing, "Well, after all, we're just *theatricals!*" then bursting into laughter. Vivien's laughter, however pleasant it was, had a certain nervous effect on everyone around her, since it was sometimes the first sign of an onslaught of hysteria, and I noticed that Alex watched her very carefully, particularly when she was drinking. He discussed at great length the possibility of her starring in his movie about the Taj Mahal, but I suspect that he merely wanted to keep Vivien's mind off other things, since both of them must have been aware that she was too old to play the part of Shah Jehan's beloved mistress, even assuming that Alex actually made the film.

Many of his plans fell into this category, which explains the long list

of projects that were discussed, released to the press, then mysteriously
vanished. On the one hand, it kept people interested, since Alex's plans
were always ambitious and daring, and also encouraged investors; on
the other hand, it was a tactic for bolstering the self-confidence of
people Alex liked whose careers and lives were in disarray. When Orson
Welles was in trouble, Alex was happy to announce plans for him to
direct and star in *Salome* and *Cyrano de Bergerac.* When Larry and
Vivien needed an injection of confidence, he concocted the idea of
their starring together in a movie of *The Iliad,* with a script by Graham
Greene or Robert Graves. When James Mason's career seemed to be
faltering, Alex announced that he would play the leading role in
Daphne Du Maurier's *The King's General.* Now that Vivien was
worried about her future, Alex was perfectly willing to plan *Taj Mahal*
around her for as long as that made her happy.

By the time we returned to Antibes, Vivien was soothed, though in
fact it would be in *The Deep Blue Sea,* the movie based on Terence
Rattigan's play, that she would eventually reappear for Alex, more
realistically playing a distraught middle-aged lady, rather than a beauti-
ful Indian princess. Alex took her to the airport at Nice, and went off
to London himself for two days, leaving Alexa, myself, Eddie and
Madame to fend for ourselves in his absence. He had a great deal on
his mind, since Zoli was already preparing to begin *Cry the Beloved
Country,* and was determined to make an uncompromising and true-to-
life film, based on Alan Paton's novel about relations between the races
in South Africa. Alex was delighted to have Zoli back working for
London Films, and he understood better than anyone else that *Cry the
Beloved Country* was the story Zoli had always dreamed of filming. His
earlier movies about Africa had been struggles between Zoli's own
desire to show the reality of the Africans' lives and aspirations in the
bondage of colonialism and Alex's determination to make films that
would present the Empire to the British audience in a positive and
patriotic light. Not that Alex was unaware of the black man's burden,
or even unsympathetic to it; he simply felt that the white man's burden
was more acceptable and commercial to Anglo-American audiences.
Thus *Sanders of the River* and *The Drum,* for instance, had been
compromises between Alex's view and Zoli's, with Zoli fighting to give
his "native" performers a forum to show the dignity, the heroic tradi-
tions and the enduring strength of their own tribal institutions. Now

Alex was faced with a story in which the plight of the black man in a racist society was the basic subject. He could see no way that it could be "toned down" or made easy for a white audience to accept, nor was Zoli willing to compromise.

Zoli's health was beginning to fail him, and he was afraid that *Cry the Beloved Country* might be his last film. It would have to be made honestly, since it might serve as his final statement about Africa. Alex loved Zoli too much to fight him on something that mattered so much, but he was well aware that *Cry the Beloved Country* would produce many difficulties for London Films, not the least of which would be that people like Brendan, who was the chairman of the Union Corporation, which controlled a substantial number of South African mines, would be deeply offended. Brendan, who had criticized Sir Stafford Cripps for being "the white Gandhi," and who loathed the British government's policy of self-determination for Africans and the retreat from colonialism, felt strongly that a film like *Cry the Beloved Country* could only do harm to British interests in South Africa and provide propaganda for the enemies of the British Empire. If anything, Max Beaverbrook felt even more strongly on the subject, and Alex knew that he risked being attacked publicly by Max and privately by Brendan for a film he had never wanted to make all that much to begin with. But family loyalty came first, and with some reluctance Alex had agreed to back Zoli, and was returning to make the necessary arrangements and to persuade Zoli to such moderation as might be possible.

Under the circumstances, he was probably wise to leave Alexa behind, since she would only have been in the way during these discussions with Zoli, but she was less than pleased at being abandoned; it seemed to her rather too much like the days when Benjamin had hustled her out of Claridge's and thrown away her toothbrush. During the day, we walked on the rocks, sailed and went to the market for fresh fruit and vegetables, but this was not exactly a demanding schedule, and the nights were undeniably dull. Thus it came about that Alexa suggested I call the Le Rosey classmate I had mentioned, Christian Delmont, and arrange a night on the town at Juan-les-Pins. Christian was happy enough to oblige, since he was living with his father, his mother and his younger sister in a state of chronic *ennui*, the Delmont family being given to the kind of meals which are so dear to the heart

of the French when on vacation, which involve three hours at the table, followed by a siesta.

Alexa managed to persuade Eddie and Madame to take themselves off for a dinner *à deux* ashore, no mean feat in itself, and after a light meal on board, during which Christian, charmed by Alexa's company, drank more than seemed wise, the three of us got into the Simca, with me at the wheel, and went off to Juan at top speed, Alexa squeezed in on Delmont's lap, since there were only two seats. We stopped outside the Casino, parked illegally, and made our way across the square to a bar, where it was noisy, crowded and dark. As I had no money of my own, Alexa had pressed a wad of bills into my hand, and I distributed a few of them to secure a small table for us, and ordered a bottle of champagne, while Alexa and Delmont went off to dance in the small mob of people crowded against each other on the floor. Even in the darkness I could see that Delmont, who had never been an enthusiastic participant at dance classes in Le Rosey, was not a skilled dancer, nor was Alexa, and both of them seemed to be bumping into people.

When they returned, somewhat out of breath, Alexa led me to the dance floor, her eyes suspiciously bright. "Your friend isn't much of a dancer," she said.

"Nor am I."

"No, but you try hard," Alexa said, but at that moment she was taken away from me by a large man with a gold bracelet and a shirt unbuttoned to the waist, who elbowed me out of his way. *"A mon tour, mon garçon,"* he shouted. Alexa did not seem discontented to be taken off by this somewhat older admirer, and I made my way back to the table, where Christian had already ordered another bottle of champagne. He was smoking a Gitane in what I had come to think of as his Jean Gabin act, and seemed irritated.

"Why did you let that *salaud* take her away?" he asked.

"Why not? She's old enough to do what she wants to do."

"That's not the point. If she's your uncle's mistress, you have an obligation to protect her on his behalf. And if you're interested in her yourself, all the more reason to act like a man."

I pondered this. Delmont's father, I knew, prided himself on his toughness, and had fought in the French Army all the way to Dunkirk until he was taken over to England, at which point he elected to return to France because he didn't like De Gaulle, who in his view had

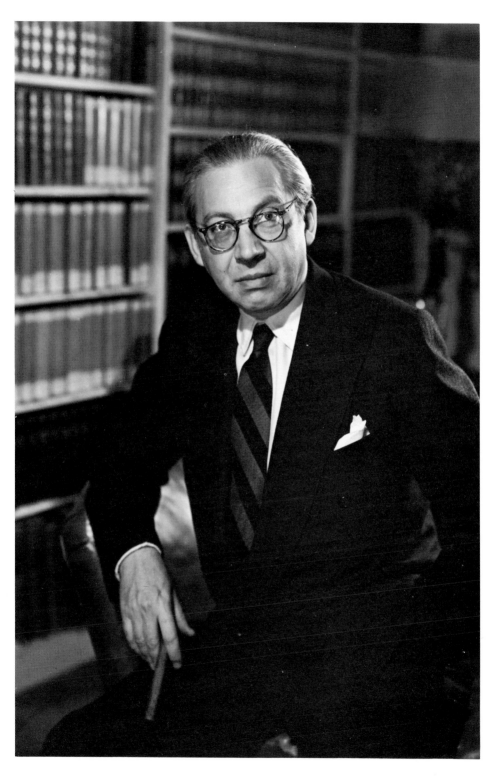

Sir Alexander Korda, photographed in his new offices
at 144-146 Piccadilly, shortly after the war.

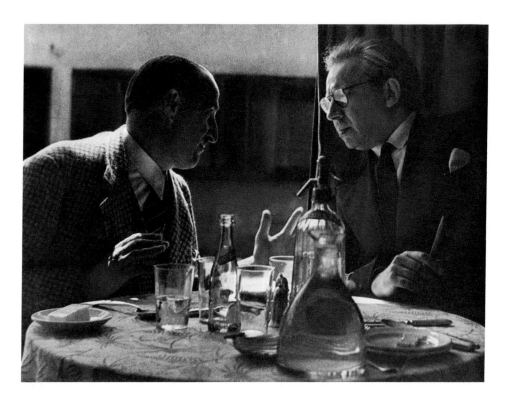

TOP: Alex (*right*) discusses a merger with J. Arthur Rank. Unfortunately, Rank the financier wanted to be a film maker, and Alex the film maker wanted to be a financier. Note that Rank, the Englishman, is talking with his hands, while Alex looks skeptical. The water bottle on the table is a tribute to Rank's Methodism.

BOTTOM: A Low cartoon from the *Evening Standard* depicts Alex behind the camera and J. Arthur Rank dressed as the man with the gong, the opening symbol of Rank Films.

OPPOSITE: Alex directs Paulette Goddard in *An Ideal Husband*.

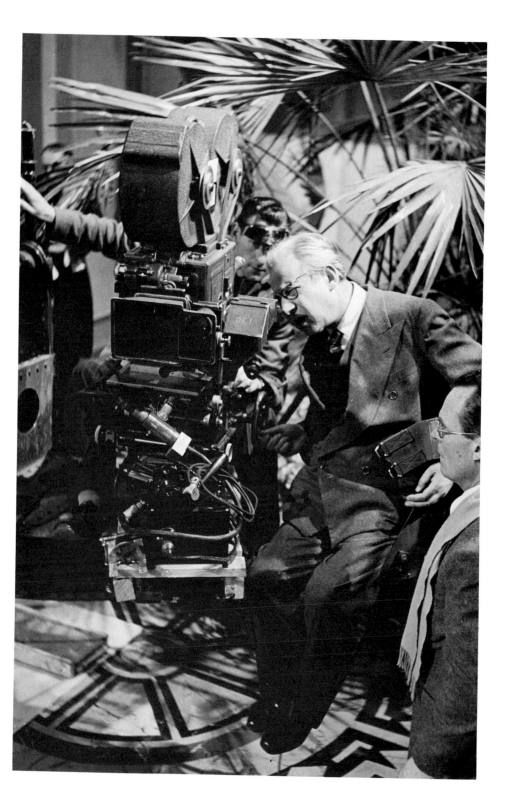

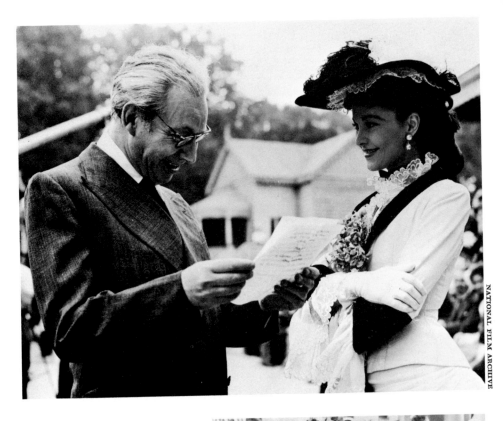

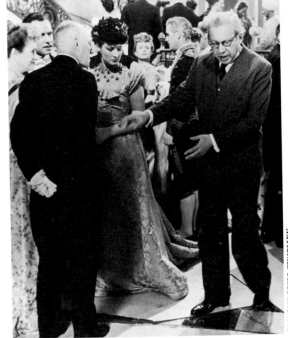

TOP: Alex, in a good mood, reads a letter to Vivien Leigh, on the set of *Anna Karenina*.

BOTTOM: Alex, looking surprisingly nimble, demonstartes a dance step to the cast of *An Ideal Husband*, before shooting the ballroom scene.

TOP: A tense moment on the set of *Bonnie Prince Charlie*.

BOTTOM: Alex and a pensive Cecil Beaton wait for the sun by the replica of Hyde Park Corner that Vincent built at Shepperton for *An Ideal Husband*.

TOP: Michael, with Nuisance, London, 1950.

BOTTOM: A rare photograph of the three brothers together—and in evening dress! Taken at the twenty-first birthday party of London Films. *Left to right,* Zoli, Alex and Vincent.

OPPOSITE TOP: Alex takes the helm on a trial run of *Elsewhere,* his yacht.

OPPOSITE BOTTOM: Alex (*left*) with Carol Reed, the director of *The Third Man,* with nautical beards, caps and sou'westers, on *Elsewhere.*

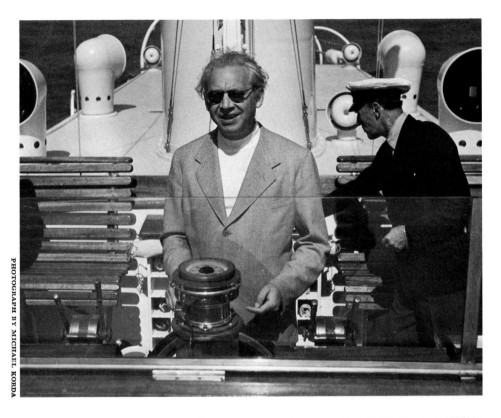

TOP: Alex (*left*) with Graham Greene, on *Elsewhere*.

BOTTOM: General Edouard Corniglion-Molinier ("Eddy"), on *Elsewhere* in the port of Antibes.

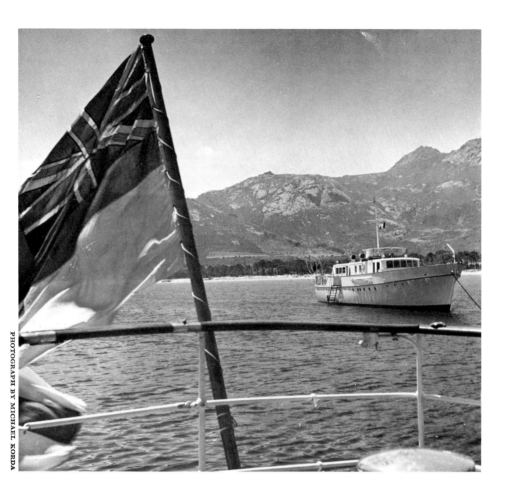

TOP: *Elsewhere* at anchor off Calvi, Corsica.

BOTTOM: Alexa, having coffee on board Lord Guinness' yacht *Sea Huntress*. *Elsewhere* is in the background, anchored off Eden Roc, Cap d'Antibes.

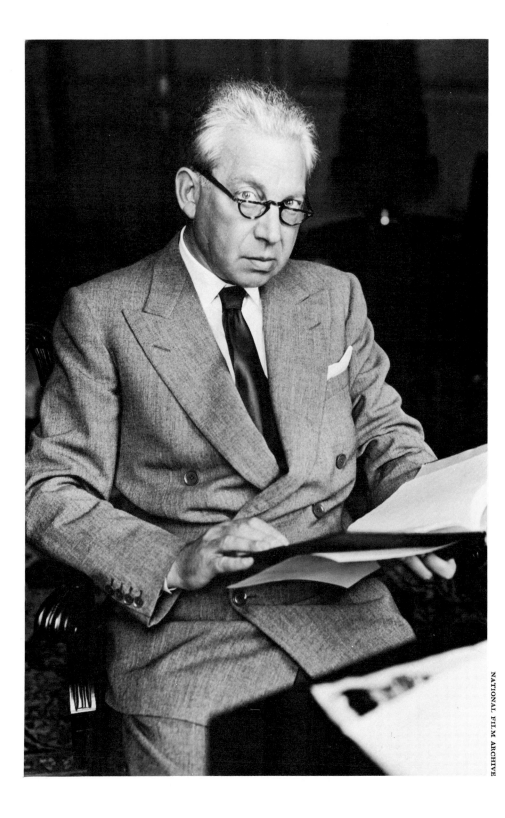

TOP: Alex's wedding—a press photograph taken in the *mairie* of Vence. *Left to right,* Alex, Eddy Corniglion-Molinier, Captain Peter Mlore, Baroness Moura Budberg and Alexa, looking radiant, but oddly dressed for the South of France. This is the photograph that caused Alexa's father to complain by cable that the bridegroom was too old.

BOTTOM: Alex and Alexa, Antibes, 1953.

OPPOSITE: Alex, in his study at Kensington Palace Gardens, shortly before his death.

TOP: Vincent (*at right*) with
John Huston.

BOTTOM: Arm in arm, Gertrude
and Michael, together again after
ten years. New York, 1957.

OPPOSITE: Vincent, on the set of
Summertime in Venice, in his
characteristic hat.

LEFT: Alexa and David Metcalfe.

BELOW RIGHT: Alexa chews her lip in a moment of tension during the auction of Alex's paintings at Sotheby's, which fetched a total of 464,470 pounds.

BOTTOM: Alexa smiles in front of Alex's Degas, after the sale.

WIDE WORLD

LONDON EXPRESS NEWS SERVICE

WIDE WORLD

RIGHT: Maria Korda, arriving at court during one of her lawsuits against Alex's estate.

BELOW: Peter Korda.

Vincent, photographed in the South of
France, toward the end of his life.

surrounded himself with Communists and followers of Blum and the
Front Populaire. As a family the Delmonts had very definite ideas
about the obligations of manhood and the superiority of Frenchmen.

"He looks to me like an Italian or an Arab of some kind," Christian
said, as if to prove his point.

"Do you really think she wants to be rescued?"

"That isn't the point."

I knew that there was no stopping Delmont once he had decided to
do something, and I half suspected, judging from Alexa's expression,
that by now she was annoyed at the attentions of her dancing partner.
Delmont made his way rather shakily to the dance floor, with me
following behind him, pushed his way into the crowd, tapped the man
harder on the shoulder than was absolutely necessary, and said, *"A mon
tour, s'il vous plaît."*

Alexa's partner sneered at Delmont, and turned back to Alexa.
"What is this, *ma belle?*" he said. "Do you always come out at night
in the company of children?"

Christian squinted through the smoke from his own cigarette, hesi-
tated a fraction of a second, probably to decide what Jean Gabin would
do in similar circumstances, and kicked his rival as hard as he could on
the shin. Alexa gave a startled cry, the man gave a scream of pain and
took a wild swing at Delmont. *"Emmerdeur!"* he shouted, settling into
a crouch which made it clear that he knew how to box. Since I was sure
that Delmont wouldn't know how to defend himself against an ex-
perienced boxer, and knew that one Roséan always comes to the rescue
of another, I picked up a heavy ashtray from one of the tables by the
dance floor and hit his opponent over the head with it as hard as I
could, felling him like an ox.

In the hush that followed, we made our way back to the table, and
each drank a glass of champagne. Alexa, I must say, looked at both of
us with more admiration than she had shown before.

"It's not often that I find people fighting over me," she said, "but
do you really think it was necessary? He seemed a nice enough man."

Delmont shrugged. "An Arab, a low-life. He got what he deserved."

"Maybe he did," Alexa said, "but he wasn't an Arab. He *said* he
owned the place."

As I looked behind us, I realized this was possibly true. Our opponent
was being helped to his feet by several swarthy-looking waiters, and the

rest of the staff were assembling themselves in a kind of flying wedge.

"I think there's going to be trouble," I said, unnecessarily.

Our opponent was back on his feet again, a small trickle of blood running down one side of his head, and recovering his balance, he rushed across the room, grabbed our table, turned it upside down, and dropped it on us. Luckily, we had just enough time to jump out of the way, though Delmont ended up on the floor with half a bottle of champagne on his shirt. Alexa had removed one shoe and was pounding her former dancing partner on the head with it, while I struggled with two waiters, who seemed intent on knocking my teeth out. Alexa cried, "Make a run for it!" and we dragged Christian to his feet, and ran out into the square, pursued by the owner and the waiters, who were clearly thirsting for revenge. It was lucky that the car was an open one, for we were able to jump into it without bothering with the doors. It was unlucky that Alexa found herself in the driver's seat, because she backed up sharply, scattering our pursuers (who were beginning to shout *"Assassins! Au secours!"* at the top of their voices), then forward at full throttle into the tables and chairs of the outside terrace, precipitating a panic among the people who had been quietly drinking and watching the action. The car went up two steps, crushed several chairs and came to a rest in a tinkle and crash of broken glass against a serving trolley full of glasses.

At this precise moment two policemen on bicycles rounded the corner and blew their whistles, our pursuers retreated, and we were left to face the police. It was even more unfortunate that Christian, who had the Frenchman's traditional dislike of the police, told both of the *flics,* in no uncertain terms, to mind their own business. Traditionally, the police in the South of France are inclined to turn a blind eye to the wrongdoings of tourists, but in this case the car had French license plates, and Christian's insults were clearly not those of a foreigner. They took us in.

The police station at Juan-les-Pins is not large, and even after we had been separated for questioning, I could hear Christian shouting at the cops, while they shouted back at him. Alexa had been amused at first, but the sight of a French police station in the early hours of the morning is enough to chill anyone, and Alexa had already realized that it would not be long before some enterprising reporter discovered who we were. It seemed unlikely that Alex would be amused. At last Chris-

tian was subdued, and I was taken before the sergeant, a huge man with the shrewd, piggy eyes of a wild boar, to explain myself. Since in France one is guilty until proven innocent and can be held more or less forever while the police investigate whether a crime has taken place, I was not optimistic about our chances of getting out, but I took the opportunity of asking the desk sergeant if we could make a telephone call.

He frowned. "To whom?" he asked. "If it's to the Consulat de Sa Majesté Brittanique, forget it. They don't deal in drunks and automobile accidents, and anyway they're closed at this hour of the night."

"No," I said. "I wasn't going to call the consulate. I was hoping we could reach Général Edouard Corniglion-Molinier, who is a friend of the young lady."

The sergeant looked pensive. "The young lady is a friend of the general's?"

"*Exactement.*"

"Then what was she doing with you two?"

"We are friends of the general too."

Warily, the sergeant took up the phone, dialed the police station in Antibes, and had a *gendarme* sent to wake up the general.

Half an hour later, the door flew open, and in walked Eddie, resplendent in a white suit, his ribbons pinned to the lapel.

The sergeant rose to his feet, as did the two bicycle policemen, and saluted, and Eddie returned their salute with a genial wave of the hand. He looked carefully at the rows of ribbons on the sergeant's tunic, for in those days the French police were divided between those who had worked for the occupying Germans and those few who had been Gaullists, and after a brief inspection, he smiled.

"*Repos,*" he said to the sergeant, offering him a cigar, "I see you were at Bir Hakeim."

The sergeant nodded. "*Oui, mon général.*" He lit his cigar, and the odor of good Havana smoke filled the room.

"And what is happening here?"

"Well, I gather there was a fight. Also we have drunken driving, driving without a license, damage to private property, a breach of the peace and insulting a police officer in the course of his duty."

Eddie raised an eyebrow, instantly recognizing the most serious of the charges. "What was the exact nature of the insult?"

"One of the young men referred to Officer Barbel as a dirty bicycle cop—*une vache à vélo.*"

"One understands. Would it be possible to have a word with Officer Barbel in private?"

The sergeant nodded, and Eddie and the bicycle cop went outside for a moment. When they returned, Officer Barbel was also smoking one of Alex's cigars. Eddie then went outside with the sergeant, and returned smiling. The sergeant, I noticed, was buttoning up his tunic pocket. He returned to his desk, and sent one of the bicycle policemen to bring Alexa and Christian into the charge room. Giving us all a severe look, he returned to Eddie the keys to the car, then made the obligatory speech.

"In view of your youth," he said, "and because two of you are foreign visitors, I have been persuaded to overlook what happened, from the criminal point of view. *Monsieur le général* has assured me that the damages will be taken care of, and I hope you will be more careful in the future. I would prefer not to see any of you driving within the limits of Juan-les-Pins again. Also, if you feel like having a *bagarre* with people in a night club, kindly go in the other direction and do it at Villefranche. You may go, but I would add to the young French gentleman, and I hope he will heed me, that it is always a bad idea to insult a policeman. Officer Barbel has graciously accepted the apology offered on your behalf by *monsieur le général,* but for the future, remember: Even *les vaches à vélo* have feelings."

Eddie hustled us out into the night, where the police car that had brought him stood waiting. He was determined to be annoyed with us, but in fact he rather liked his adventure, as well as the opportunity to put his influence to the test. "I will take you all," he said. "I'll send over for the car in the morning. You, *monsieur*"—he turned to Delmont—"kindly remember your manners when addressing a *flic* in the future, and keep your mouth shut about what has happened or I'll see you do your military service in the infantry, digging ditches. As for the two of you, I propose to keep this a secret between us. There's no point in bothering Alex with this kind of *bêtise.* Alexa can pay for the damages, and I'll see the money gets to the right people, and as for the Corsicans who own the bar, I've arranged with the sergeant to make sure they won't make any trouble. Why the three of you should have snuck off at night to have a fist fight with these pimps, I don't know,

but you might at least have invited me along. I'm not that old, you know. By the way, if Madame asks, I was called to the police station to take a phone call because there is a governmental crisis. The fewer people who know about this little escapade, the better, I think."

WE THUS FOUND ourselves rather heavily in Eddie's debt, though being a gentleman he did not press it. Delmont resumed his quiet life, Alex returned, and my father finally appeared from the depths of France with his family and its belongings. Alex, I imagine, knew that something had happened in his absence, but was not sure what it had been, and was reluctant to find out. He did notice that neither Alexa nor I was willing to drive through Juan-les-Pins, but he seemed content with the explanation that it was a traffic bottleneck.

He did once say, as we sat on the stern of the yacht, that he was afraid life might be a little dull for Alexa, and that perhaps we should all visit someplace where there was something going on, like Juan-les-Pins, but Eddie, with that tact for which he was famous, dismissed the idea. "You wouldn't like it, Alex," he said, "it's become a terrible place. Only the other day a group of drunken English tourists ran amok with a car and smashed up a café. It's not the kind of place that would amuse Alexa at all."

Alex nodded with relief, since he had not wished to go there in the first place. Patting Alexa's hand, he looked out to sea. "Well," he said, "God knows that wouldn't do for either of us. Alexa likes the quiet life just like me."

Alex put his arm around her and smiled, but Alexa turned toward me and winked.

"Yes, Alex," she said, but I noticed that Eddie had seen the wink, and raised one eyebrow in his usual gesture of exasperated skepticism.

Later, as they prepared to take a little siesta on the yacht, I overheard Madame say to Eddie, "*Chéri*, do you think it ever really works out with an old man and a young woman?"

Eddie lit a cigarette and remained silent for a moment. "From whose point of view?" he asked.

"*Oh-la*, from the woman's, of course. For the man, we all know it works. All old men try to recapture their youth and their potency in young women, *n'est-ce pas?* But how long will it take before a young

woman gets tired of sleeping with an old man? Eventually the money isn't enough. One hungers for a young, strong body, despite the diamonds and the *haute couture*. It's in the blood, no? What was it that Honorine says in *Marius?* '*Ah, mon pauvre Panisse, les chemises de nuit n'ont pas de poches!*' "*

Eddie sighed. "That nightshirts have no pockets, I agree. But what is all this about, *mon chou?* You and I are not that far apart in age, and I have no record of debauching young women."

"I saw the wink."

"And?"

"And I know what it means, a wink like that. I predict to you this: This *affaire* will lead to marriage, and that marriage will not be a happy one. I am a woman. You don't understand things the way I do. You are merely a man."

Eddie's voice dropped angrily. "I am a man, Madame, and a general, and also your intimate friend for many years. I warn you: Forget you ever saw Alexa wink. Alex deserves some happiness, leave him in peace."

"It's not me that will disturb his peace," said Madame, pulling down her shoulder straps and reaching for her bottle of suntan oil, "it's not me at all. You will see."

Eddie closed his eyes. "God forbid," he said.

*A reference to Honorine's daughter Fanny's marrying Panisse, a rich old man. ("Ah, poor Panisse, nightshirts have no pockets!")

CHAPTER 9

\mathbf{A} LEX DID NOT spend as much time on the yacht as he had hoped to. He had dreamed of being at sea for months at a time—and he did in fact take a long cruise through the Greek Islands with Graham Greene (who fashioned the experience into a wonderful short story, "Loser Takes All," in which Alex appears as the charming and world-weary tycoon, Dreuther)—but the affairs of London Films and British Lion kept him at home, and gave him very little satisfaction. He had withdrawn from producing movies himself, but he remained responsible for keeping the studio fully employed, functioning at once as an impresario, a financier and a manager.

Only the first of these roles was genuinely congenial to him, and the pressures on him were severe and unrelenting. He was obliged to provide British Lion with a steady flow of "product," and at the same time he had to cut production expenses to the bare bone. He brought to London Films a number of talented filmmakers (many of them won away from J. Arthur Rank's rival stable), including the Boulting brothers *(Seven Days to Noon)*, Anthony Kimmins *(The Captain's Paradise)*, Guy Hamilton *(The Ringer)*, Ian Dalrymple *(Three Cases of Murder)*, Jack Lee *(The Wooden Horse)*, Robert Donat (who directed and starred in *The Cure for Love*), Michael Powell and Emeric Pressburger (who produced an

expensive fiasco, *The Tales of Hoffmann*, for Alex, but whose most successful film, *The Red Shoes*, was unfortunately made for Rank), and Sidney Gilliat and Frank Launder (who were enormously successful with such "small" British comedies as *The Happiest Days of Your Life, Belles of St. Trinian's* and *Lady Godiva Rides Again*). Alex was no longer trying to rival Hollywood; perhaps unwillingly, he was now making it possible for a new generation of English film makers to do what they wanted to in comparative freedom and with financial security. For Alex had "mellowed"; he was sympathetic, supportive, happy to give his advice when it was asked for, but he no longer interfered directly in the work of his producers and directors, and in general confined himself to suggestions for changes that would make the films more successful in the international market—a subject on which his expertise was acknowledged and invaluable.

All the same, he was not a man who enjoyed sitting behind a desk, and the longer he sat behind it, the more aware he was of just how impossible it would ever be for British Lion to pay off the 3,000,000-pound loan from the government. The loan had already been extended once, late in 1951, and the National Film Finance Corporation was now predicting, with undue optimism as it turned out, that at least a million pounds would never be recovered. Despite these alarming forecasts, Alex increased production, largely because he had no choice. It was a matter, as Brendan put it, of "sink or swim," and Alex was determined to swim.

He obtained further financing for London Films from an unexpected source, in the person of Robert Dowling, a hard-headed New York financier, who put up first $500,000 and later $15,000,000 from his City Investors Corporation, having succumbed to Alex's charm and the temptations of film production, which, as he rightly pointed out, were no more risky than real estate speculation. It was one of Alex's unique gifts to bring out the romantic streak in the most unlikely people. Dowling was a taciturn, large and physically powerful man, whose greatest achievement in his own eyes had been to swim nonstop all the way around Manhattan Island, and who cherished the ambition of swimming the Hellespont, like Byron. He had amassed a huge fortune in real estate, and wielded considerable power in New York City, but despite the fact that he served on the boards of New York's cultural organizations, the motion picture industry had never interested him,

and his decision to finance London Films was startling to everyone except Alex, who had instantly recognized in Dowling a wealthy man looking for new horizons. They had met because each of them was an art collector (Dowling's private elevator in his penthouse office in New York was decorated with a Van Gogh still life), and as they discussed paintings, they developed respect and admiration for each other. It is very doubtful that Dowling would have invested in any other film maker, but Alex in some way appealed to the long-distance swimmer in him.

In many ways, Dowling was the perfect investor, since he didn't interfere and was philosophical about losses, doubtless because his real estate activities kept him fully occupied, while his film investment remained a small but interesting personal gamble. Alex's previous American partners, Goldwyn and Selznick, had each proved to be difficult: Goldwyn had tried to turn *The Elusive Pimpernel* (a sequel to *The Scarlet Pimpernel,* starring David Niven) into a musical, adding almost 30,000 pounds to the costs, and Selznick had badgered Alex with his famous forty-page memos over the question of Jennifer Jones's unflattering close-ups in *Gone to Earth,* eventually reshooting his wife's takes in Hollywood and releasing the film in America in a recut version under a different title (*The Wild Heart*). In both cases, the relationships had not only been stormy but had ended in litigation, and though Florence Goldwyn had finally forced Alex and Sam to make peace and Selznick and Alex agreed to disagree, the experience of working with his American colleagues taught Alex the value of financing outside the movie industry. He needed an American distributor, but not at the expense of having an American collaborator, or worse yet, two.

As British Lion slid inevitably into bankruptcy, Alex sought to disentangle London Films from the impending catastrophe, both by acquiring an independent source of financing in Dowling and by a series of subtle moves in which he gradually withdrew from the affairs of British Lion and concentrated his energies on film production. Given these demands on his time, it is astonishing that he was able to make any major changes in his personal life, but in fact he went forward with his plans as if he wanted to show the world that the decline of British Lion was of no concern to him—which given his determination to survive, was perhaps the shrewdest move he could make.

Since 1953 was the twenty-first birthday of London Films, he de-

cided to celebrate the occasion in style, putting on a lavish party at which the three Korda brothers made one of their rare appearances together, in evening dress, to the astonishment of those who doubted that Zoli and Vincent even *owned* dinner jackets. It was unfortunate that the only film available to serve as a reason for this celebration was *The Story of Gilbert and Sullivan,* a movie that had been flawed from the very beginning by the decision to turn the story into a springboard for a succession of Gilbert and Sullivan operetta numbers. Quite how Alex was led into this disaster is hard to determine, since he loathed Gilbert and Sullivan and disliked musicals in general, but Gilliat and Launder had urged him to finance the movie, and he had reluctantly agreed to do so on the basis of their past record. It was swiftly apparent that there was very little in the way of a "story" in the lives of Gilbert and Sullivan, a pair of dull and exemplary Victorians, who were only remarkable because of their collaboration, which each of them despised. "From this, I can't see a film," Alex very rightly said, but he allowed himself to be convinced that the vast audience of Gilbert and Sullivan fans would make the movie an automatic international success, and involved himself and Vincent in the details of what was now described as "a musical biography," anxious to make the movie big enough to be "London Films' Twenty-first Anniversary Production." As a result, it was lavish, expensive and dull. Gilbert and Sullivan fans were unhappy at the comic portrayal of Gilbert and Sullivan (played by Robert Morley and Maurice Evans), and felt there was too much story and not enough music, while the rest of the public felt there was too much music and not enough story.

Oddly enough, the movie repeated the failure of Alex's previous experiment with music, *The Tales of Hoffmann,* in which a cast that included Moira Shearer, Robert Helpmann, Ludmilla Tcherina, Leonide Massine and Robert Rounseville was overwhelmed by the almost psychedelic extravagance of the sets and costumes, and in which the story, such as it was, simply vanished amidst the dancing and the special effects. It was unfortunate that Carol Reed's *An Outcast of the Islands* had appeared the year before, since this would have been a more logical choice for London Films' birthday, and was the kind of movie Alex liked, even though it had involved sending my father to India and Ceylon, where he built two native villages on stilts only to have both of them washed away by the floods. *Outcast* had tried Alex's patience

—the villages had to be rebuilt, the natives were uncooperative, neither Carol nor my father nor the cast were happy in India, and Kerima, the actress who played the beautiful native girl, turned out to have an inadequate bosom, so that a rubber-padded bra had to be dispatched to India, which she complained bitterly of having to wear in the sultry heat—but at least it was a respectable picture, if not a great hit. David Lean's *The Sound Barrier* had also been released the year before, and proved very successful, inspiring Alex to fly to Paris for the opening in the prototype of Britain's brand-new jet airliner, the DeHavilland Comet, which, with his showman's touch, he managed to borrow for the occasion. When he was accused of putting on an extravagant display for the film's opening, he remarked characteristically that "in a vulgar age, it is essential to have vulgar ideas." Zoli's *Cry the Beloved Country* had appeared, and was already winning the prizes it richly deserved, although the American distributors had infuriated Zoli by making changes which blunted the film's message, and changed the title to *African Fury*, thus destroying a good deal of the pleasure Zoli ought to have had in what was certainly his finest film, and the one he most cared about.

Given this remarkable succession of good movies, it was doubly disappointing that London Films should have had to celebrate its coming of age with *The Story of Gilbert and Sullivan*, and Zoli was heard to remark during the gala screening, "My God, this is bloody silly!"

I READ ABOUT the birthday party from afar. The year before, I had been busy with my own coming of age. I passed the Common Entrance Examination, with much last-minute cramming in Latin, and returned to England to be interviewed at Magdalen College, Oxford, where the President, T. S. R. Boase, a distinguished art scholar, had been amply prepared for my arrival as an applicant, having been wined and dined by my father, by Alex and by Brendan Bracken. Alex had long since secured for himself a certain position in the Oxford world by financing a commission to explore the possibility of creating a department of film and drama. Nothing much had come of this, perhaps because the University hoped that Alex would finance the department as well as the commission, but Oxford seldom forgets a generous donor, and when

Alex called upon his friend Sir John Wheeler-Bennett of All Souls to
ask which college I should seek admission to, Sir John suggested Mag-
dalen as a place where a brilliant scholastic record was not necessarily
a requirement, which had been Brendan's opinion. The Fellows of
Magdalen, who included A. J. P. Taylor and C. S. Lewis, were nothing
if not worldly, and a favor to the leading magnate of the British film
industry was one they were happy to oblige with. I had an intimidating
interview with the senior dean of Magdalen, spent a night in a cold,
dark, medieval cell and underwent an examination which struck even
me as rather cursory, and was shortly informed that I would be wel-
comed as an undergraduate at Magdalen College as soon as I had
completed my military service. I returned to Switzerland, to spend the
last few weeks of my lotus-eating summer term, secure in having won
admission to the most respected of the world's great universities, and
one summer's day, after shaking hands with the faculty, I stepped into
the back of an old truck with all my belongings on the way to the airport
and began what afterward seemed like the longest journey of my life.

Exactly twenty-four hours later, I was sitting on my cot in a barracks
hut at Royal Air Force Padgate, just outside Liverpool, with thirty-nine
other frightened and miserable young recruits, listening to a flight-
sergeant giving us the facts of military life in the time-honored bellow
of the British armed services.

Both Alex and my father had given my military service a good deal
of thought. Neither of them was foolish enough to suppose that two
years in uniform would build my character, or do me any good. Vincent
had hated his experience in the Austro-Hungarian Army, and Alex was
happy enough to have avoided serving because of his eyesight. Zoli was
so violently opposed to military service that he kept his sons out of
England to avoid it, and urged my father to do the same. Vincent was
half inclined to agree with Zoli. First he explored the possibility of my
attending the Sorbonne, in Paris, only to discover that I might then
be liable for French *and* British service (there was a scandal at the time
about a young man who had spent two years in the British Army and
then two years in a French punishment battalion in Algeria because he
had failed to understand the laws of residency). Then he offered to send
me to college in America, but finally he accepted the inevitable, as Alex
and Brendan had always suggested he should. Brendan was willing
enough to preserve me from the infantry, and put himself out to

entertain a number of Air Marshals, with the result that I was given a physical examination at Adastral House (named after the R.A.F.'s motto, *"Per ardua ad astra"*) and shortly afterward received a bulky envelope directing me to appear at Padgate.

Neither my father nor I had any idea what preparations were sensible to make. He himself had gone off to war with his paints and brushes and a large salami, but these did not seem appropriate for the R.A.F., so I arrived at the gate of R.A.F. Padgate carrying a small suitcase with a pair of pajamas, a bathrobe, a pair of slippers, a toilet kit and a copy of *War and Peace.* I need not have concerned myself. At dawn on our first day, we were each issued the formidable array of equipment that was to transform us into soldiers (or, as we soon were to learn to call ourselves, "Airmen"): one greatcoat, one rain cape, two berets, one forage cap, one dress cap, two cap badges, one dress uniform, one battle-dress, five shirts, ten collars, two ties, one steel helmet, one set of infantry webbing and packs (apparently held in reserve since the Boer War), one Lee-Enfield .303 Mark 4 No. 1/3 rifle, two pairs of boots, one pair of shoes, one pair of plimsolls, six pairs of baggy and unappetizing underpants that apparently were held up by one's braces, one pair of elastic trouser braces, six even more unappetizing under-shirts, two pairs of striped pajamas, a mess kit, a tin mug ("In case we go blind," as one recruit observed), knife, fork, spoon, housewife (a sewing kit), one long-sleeved pullover, two sets of gym clothes, a bayonet, a metal plate for slipping under buttons to prevent metal polish from staining our clothes, a clasp-knife, a kit bag, six pairs of socks and a ball of matching yarn to darn them with, one rifle sling (apparently left over from the Ashanti wars), one canteen, a bottle of Brasso, a tin of black Kiwi boot polish, a vast array of brushes, a razor, a toothbrush, four blankets, two sheets and two pillowcases. In addition to all this, we were given a ball of twine, a label and a large sheet of brown wrapping paper. Our first duty was to wrap into a parcel and mail home all our civilian possessions—which included my copy of *War and Peace.*

No doubt the Air Marshals were watching over my progress from afar and reporting back to Brendan, but on the whole, I was left alone to endure my fate until the death of King George VI, when it was discovered that the Crown no longer possessed sufficient carriages for the Royal funeral and the subsequent coronation of Elizabeth, and Alex made the headlines by donating fourteen two-horse broughams from

the studio's prop department to the Earl Marshal, the Duke of Norfolk. This act of generosity, which was much commented on, revealed my identity, and I soon found myself much in demand for stories about Hollywood and the stars. When I mentioned this to my father, in one of my weekly telephone calls from the red kiosk by the guardhouse, he sent me a large parcel of autographed movie-star photographs, and I soon won a certain amount of popularity by passing out signed 8" × 10" glossies, the one most in demand being of Diana Dors (England's answer to Jayne Mansfield) in a bathing suit, taken when she had played a minor role in *Lady Godiva Rides Again.* As one Corporal remarked, "I haven't seen a pair of tits like those since Ma caught hers in the wringer."

I passed out from recruit training and entered the mindless succession of courses with which the R.A.F. occupies its members' time, and thus missed the twenty-first birthday party of London Films, having been sent to a fire-fighting school in Cornwall, where an old Nissen hut was set on fire so that we could practice putting it out. The small fire soon took hold for real, and instead of a training exercise, we soon found ourselves trying to extinguish a serious blaze, or at least keep it in check until the disgusted civilian firemen could arrive. In the process, the Flying Officer in charge and I were felled with exhaustion and smoke-inhalation, so I read about Alex's party in a military hospital, with a tube down my throat.

The newspapers were full of the event, and I noticed with some interest that Alexa appeared nowhere in the photographs of the four hundred distinguished guests who met in the Savoy Theater at midnight, after the premiere of *The Story of Gilbert and Sullivan,* to toast Alex, as Big Ben, the trademark of London Films, struck midnight. He was quoted as saying, "I started in Budapest knowing nothing, I learned everything, and now I know nothing again," which seemed an appropriate thing to say in view of the film which had just been screened. He was described as "a sardonic philosopher," and remarked that he had recently bought the rights to a play for 1000 pounds and sold them the same day for 60,000 pounds, without ever going to see the play, or even reading it. The *Daily Herald* gave a full page to the old legend that Alex had been inspired to make *Henry VIII* by a London taxi driver, compared him, rather oddly, to Cinderella, and suggested that he was still married to Merle Oberon. The *Daily Express* wrote that he resembled "the headmaster of a good English public school,"

praised him as "an ardent flag-waver for Britain" and quoted him as complaining that his life was "too comfortable." The *Express* too seemed to be under the impression that he was still married to Merle. Neither Maria nor Alexa was mentioned, though Nuisance appeared in print as the dog of "Alex's amiable brother, Vincent," it being left to the reader to work out that Zoli was the unamiable brother. "I bet the old sod gets all the cunt *he* wants," said my ward attendant, Leading-Aircraftsman Poole, who picked his nose while serving meals and made the surgical cases get to their feet in the middle of the night and polish the ward floor with rags tied around their slippers, shuffling back and forth like marathon dancers.

Shortly afterward I moved to an Army camp in Cornwall for intelligence training, then crossed the Channel to join a very secret unit in Germany, which flew reconnaissance flights along the East German border, occasionally transgressing Soviet airspace so that we could measure the amount of time it took the Russians to scramble their fighter squadrons. I therefore read about the second great family event of the year in the *Times,* while having tea at an airfield on the moors just south of Hamburg. A month after London Films' twenty-first anniversary, Alexa had at last become Lady Korda in a civil ceremony at Vence, with Eddie Corniglion-Molinier and Baroness Moura Budberg as witnesses. The bride, as I saw from the photograph in the *Express,* wore an unflattering paneled piqué dress, a mink stole, and a hat with a veil. The groom looked exhausted and angry, and the *Daily Mirror* (which showed the couple looking as if they had just been arrested) remarked that the bride's father had added a note of cheer to the occasion by sending a cable insisting that "Sir Alexander is too old for my daughter."

Truer words were never cabled, but Mr. Boycun's objections to the match were soon stilled by a rain of gifts, including a motel in Canada, while the more popular newspapers unearthed from God knows where a lot of photographs of Alexa which were tactfully described as stills she had taken *"before* she knew Sir Alexander" when she was "trying to get a film part." They were mostly "cheesecake" shots of the usual pinup kind (no match for Diana Dors'), except for one mysterious one in which Alexa, for reasons best known to herself, is wearing a United States Army sergeant's shirt, unbuttoned to the waist, and an Army cap, and is sucking on a lollipop.

Not knowing what else to do, I joined Alexa's father in sending a

cable, and sat back to wait for my next leave. I was interested to read that Sir Alexander and Lady Korda were now "house hunting" and not at all surprised at a report that Maria had reemerged to claim that she was still the one and only authentic Lady Korda, and would fight all other contenders to that title. In most of the stories, the ages of the recently married couple fluctuated rather wildly, Alexa being described variously as twenty, twenty-three, or "just twenty-one," while Alex's age varied from fifty-nine to sixty-one, but the photographers made it cruelly clear that there was a significant disparity between them in this respect, and judging from Alex's appearance in the photographs, his new father-in-law seemed to have a point, however inopportune it was to have expressed it publicly.

To my alarm, Alex was photographed standing with his arm around Alexa's shoulder just as he had that morning on the yacht, after losing at Monte Carlo, and just as he (or I) had in my dreams.

My Squadron Leader remarked that Alexa was "a nice-looking piece" and that Alex looked like "a grand old chap," and that seemed to be the general public reaction to the event, which was rapidly overtaken by the problems of British Lion. I waited for a spot of leave with some impatience, anxious to find out what those closer to the situation thought of it, but it was not until the autumn that I was able to come home, having spent the few days I was entitled to on weekends exploring the seamy fascinations of night life in Hamburg, which then as now was the most open city in Europe. Between the routine of the R.A.F. and the overnight excitements of the St. Pauli district, I had little leisure to think about home or the Korda family until I finally received my leave papers, changed into civilian clothes and took the first-class BEA Viscount flight from Hamburg to London, like an ordinary person.

Well, not quite like an ordinary person. I was picked up at the gate of R.A.F. Uetersen by Alex Paál, a photographer, fixer, promoter of beautiful women and would-be movie producer, who had moved to Europe from Hollywood (where he had exhausted his credit), and as a favor to my father had volunteered to drive me to the airport in his brand-new Jaguar sedan. For years, Paál had made a living in California by photographing young women and then trying to arrange screen tests for them, a profession which seemed to many somewhat equivocal.

Paál had surfaced in London during the Second World War as a

sergeant in the United States Army, attached to the staff of an American general as a photographer and gofer. He could produce a suite in Claridge's when the hotel was overbooked, steaks when there were none to be had, and introductions to young women for anyone of importance; in short, he did in the Army exactly what he had done in Hollywood before being drafted, and he was probably the only NCO in the U.S. Army who lived at Claridge's. It was important to Paál to live there because he wanted to be near Alex, whom he idolized. Paál, the young Hungarian émigré who made a precarious living on the fringes of the movie business, dreamed of becoming a great man, like Alex, so much so that he even adopted Alex's first name instead of his own.

When he heard about Alex's knighthood he had been in a recruit training camp, an unhappy, overweight and obviously foreign civilian who had neglected to fix a way out of the draft for himself, or perhaps had reached such a low ebb in his fortunes that joining the Army seemed like a decent alternative. He had cried tears of joy at the news, because a fellow Hungarian had been knighted, but tears of envy because his idol had risen one more giant step above Paál.

In fact, Paál had been so moved by the news that when he was asked to shout out his name on parade, he replied "Sir Alexander Korda!" at the top of his voice, and received fourteen days of punishment.

It was not just that he admired Alex; he wanted to *be* Alex. He bought his shirts from the same shirtmaker; he went to the same tailor; he went to Lobb's and insisted on having the same pattern of shoes as Alex had, made from the same leather; he smoked the same cigars. Paál, unlike Alex, could afford none of these things, but somehow he managed, leaving behind him, no doubt, a trail of debts. His ambition was to produce movies, like his hero, but in the meantime he contented himself with living like a producer, and supported himself by doing favors.

Vincent got along with Paál better than Alex. Paál made Alex nervous, though Alex did find him useful from time to time. He disliked the fact that Paál was devoting his life to imitating him in every way, and probably recognized in Paál what he himself might have become if he had not been gifted with whatever genius raised him above the level of the traditional Hungarian charmer and go-between. He kept

Paál at a distance—hence Paál's presence in Hamburg and his eagerness to pick me up.

Paál was impossible to put down and difficult to dislike. Once during the war he had arrived in London and telephoned my father late at night to ask if he could come up for dinner. Vincent was sleepy, asked where Paál was staying, and though it was only a few blocks away, he told Paál it was too far, that it would take Paál hours to get from his hotel to the flat. The next evening Paál rang again, and Vincent, feeling rather guilty, asked him if he was still in the same hotel. "No, no, Vincent," Paál replied, "I've rented the apartment above yours, I'm upstairs."

My own fondest memory of Paál was that he once invited us for a weekend in Deauville, and treated my half-brother Winkie to a donkey ride on the beach. Vincent suggested that Paál run alongside the donkey, and as he did so, Paál became aware that the sand was wet and that he was ruining his expensive alligator slipons, identical to Alex's. There were tears in his eyes as he plodded after the donkey, thinking of his shoes. Vincent found the scene comic, but afterward, he felt guilty about it, and took Paál out for dinner, which was interrupted when Winkie reached across the table and casually ate a wine glass.

Still, poor Paál was the perfect host, despite his ruined shoes, and understood that my father always took a certain amount of pleasure in seeing someone's most cherished item of clothing ruined, since he deplored any kind of fuss about clothes. When I was a child, I remember sitting in the back seat of the car with Mr. Meitner, a friend of Vincent's who was proudly sporting a new hat. When the wind blew it off Meitner's head, he shouted out, "Vincikém, my hat, oh my hat," in real distress, while my father pretended not to hear him. The same hat was blown off Meitner's head at some later date, when we were punting on the Thames, and vanished over a weir, causing Meitner, a large, affable man who looked rather like Babar the elephant, to burst into tears. Sartorial pride always brought out the brutal streak in Vincent's nature, and any new piece of clothing was likely to excite his disapproval. He himself wore his clothes until they fell apart, and could not understand why other people didn't do the same.

Paál's eagerness to please was so great that he almost invited cruelty, and though I liked him, he made me almost as nervous as he apparently did Alex. I *admired* Alex, Vincent and Zoli, but there were those who

worshiped them, which is a very different thing. I also felt a slight unease in the presence of Paál or other old Korda friends, associates and hangers-on, since they knew more about the Kordas than I did, and were always telling me how lucky I was to be a Korda, and what great men they were. This kind of thing made me feel at once ungrateful and innocent. Once, when I asked Paál about Alex's early career in Germany, he wiped his hand across his forehead, looked uneasy, flashed his brilliant smile, and said, "Ah, you don't want to know anything about all that, that was all in the past." Possibly he knew nothing himself, and was simply embarrassed to admit it, but the fact was that nobody ever wanted to talk to me about the Kordas' past, thus stimulating my curiosity. As someone who was young, half-English and spoke no Hungarian, I felt left out of the Kordas' secrets.

Not that Paál was the only person to make me feel like a latecomer to the Korda family, nor was he necessarily typical, except insofar as he was Hungarian. There was Steve Pallós, who also modeled himself on Alex, and seemed to pass back and forth through London with an air of great mystery on Alex's affairs; and Steve's former wife, Esther, who worked in Alex's New York office; and the Bus-Fekétes, who had been distinguished playwrights and now lived in Los Angeles, where they collaborated on scripts; and Gabby Pascal, who had acquired the confidence of George Bernard Shaw, and the movie rights to several of his plays. Few of these people—except perhaps Esther Pallós—were dependent on Alex, but they formed part of a larger network of supporters and advisors, reminders, I suppose, of his origins and "the old days." With them, he did not need to present himself as the English Knight or the transatlantic film financier. He could return to the simplicity of being a Hungarian who had made good, to the comfort of being called "Lacikám."

There were things he could share with them that could never be shared with his later English associates, or his wives or the Korda children—a common experience of exile and hardship, an outsider's view of the society he had now found a home in, memories of Budapest, Vienna, Berlin, Maria, of plays, books, the comforting reassurance that he had simply been luckier than the rest of them. People sometimes complained that Alex was "distant and reserved," but it was Sir Alexander they were talking about, a man who had risen very far in a foreign culture, and was still conscious of being "a foreigner," knighthood or

not; among those who had known him before 1932, Alex was anything but distant and reserved, and whenever one heard him talking to his old friends in Hungarian, it was difficult not to notice his animation, his laughter, his warmth, his gift for mimicry. However well he spoke English—and despite his accent, he spoke it very well indeed—Hungarian remained the language of his heart.

It was as if one part of Alex, the thin, ambitious young Budapest journalist, was still present, winking cynically at the aging, overweight, distinguished giant of the British film industry on his yacht and saying, *Lacikám, who would have believed you could bring all this off? Who would have thought they'd fall for it?*

Even Alexa, not the most perceptive of people, sometimes remarked that there was "another side" to Alex that was closed off to her, that a part of him was amused by his own success, his feelings and the vanity of the world in general. It frightened her.

I could have told Alexa, perhaps I even did, that to really know the Kordas, you had to speak Hungarian—you had to be around when they removed their shoes (and their masks) and talked to their contemporaries in their own language. There were many times when I thought my own relationships with Alex, Vincent and Zoli would have been very much easier had I been brought up to speak their native language, instead of my mother's. After all, I could always have learned English later. The rest of the Kordas had, and managed very well.

There was a whole other side to them, and it wasn't going to be opened up for Alexa any more than it had been for me.

PAÁL WAS EBULLIENT about Alex's marriage, largely, I suppose, because in his eyes Alex could do no wrong. Paál's overriding quality was optimism—like most marginal operators, he could not afford to take a realistic view of life, and a sanguine view of things was a form of survival mechanism. We chatted about the family. My father was well, Paál assured me, and looked forward to seeing me. Zoli had persuaded Alex to sell him the rights to Daphne Du Maurier's *The King's General*, and was determined to make a film of it (Zoli, by the way, distrusted Paál even more than Alex did, largely because there are two kinds of Hungarian men, the kind that has a mustache and kisses women's hands and the kind that doesn't and hits them instead; Paál was in the first

category, while Zoli was in the second). Alexa was the happiest of brides, and Alex was a very lucky man . . .

None of this surprised me. Paál took a particularly rosy view of happenings in the Korda family, since his ambition was to be adopted as a member of it. I was, however, somewhat surprised that he knew Alexa, since I doubted that Alex would ever have invited him home.

"She's a beautiful young woman," Paál said, puffing on his cigar.

"Yes. I didn't think the wedding pictures did her justice in the papers though."

Paál nodded. "They never do. You have to know how to photograph women, you can't do it coldly, you have to make love to them with the camera to capture what's there. The other pictures were better."

I thought for a moment, and asked him which pictures he meant.

"The glamour photographs that were in the papers."

I remembered them. Paál gave me a brilliant smile, and nudged me with his elbow. "That's the way a photograph should be," he said. "Did you like them?"

"They were unusual."

"Unusual? They were *wonderful!* I'll tell you a secret. I took them!"

With that piece of news, we arrived at Hamburg airport, and Paál said goodbye, leaving me to wonder just how Alexa had come to Alex's attention in the first place. Was the American sergeant's shirt she was wearing in one of the cheesecake shots a leftover of Paál's? It was possible, even likely, and at least explained an otherwise improbable piece of costume. Was Alexa one of the girls that Paál still "promoted," using much the same techniques as he had in Hollywood before the war? Was Paál's new Jaguar and his mission to Germany a partial payment for services rendered, or perhaps even a way of keeping him out of London, where his presence might be embarrassing to Alexa, and possibly to Alex? Had he brought Alexa to Moura's attention? And assuming that Paál had "leaked" the photographs to the papers, was it a signal that he had even more interesting pictures of her to show? Paál had mentioned that he might be producing a movie for Alex soon, but I had dismissed this as just another one of Paál's fantasies. Suddenly, I was not so sure. If Alex allowed Paál to produce a movie for London Films, he would have to have a very strong reason for doing so, and while there were many reasons why Paál did small favors for Alex, there was no reason why Alex should perform a large favor for

Paál. Unless, of course, Paál knew more about Lady Korda than the rest of us, perhaps even more than Moura, and knew exactly what Alexa would not have wanted to be known.

I brooded about this on the flight to London, as the plane descended into the autumn fog of southern England. I had always assumed that the family was unchangeable, that when Alexa came into it she would be absorbed by it, like the rest of us. But I was beginning to wonder whether her new status as Lady Korda might not mean changes for all of us . . .

O'BANNON THREW AWAY his cigarette and put his cap back on as I came into sight, took my luggage and led me out to the taxi rank, where he had parked the car illegally. He gave a friendly wave to the policeman, who waved back to him. Chauffeurs who worked for well-known people were usually given special privileges by the police in matters like parking. As I settled into the front seat beside him, I asked him what was new—O'Bannon always knew everything that was happening in the Korda family, and was a good deal more talkative on the subject than my father.

"Well," he said, "Mr. Vincent is well. There's some talk that he'll be going to Berlin with Mr. Carol to make a film there. He sent me out to buy an old Baedeker of Berlin for him, so I imagine that's what he'll be doing next. And a good thing too, after going all the way to India, which he didn't like one bit, I can tell you."

"How is Sir Alex?"

"Ah. Well, there's all sorts of news *there*. He and her Ladyship have just bought a house, one of those great big houses on Millionaires' Row, you know, Kensington Palace Gardens, where all the embassies are. Very nice it is. Big iron gates at either end of the row, with a gate-keeper, and right next to the Russian Embassy, so there'll be no burglaries there, I'm sure. Your dad has been up there every day making drawings for the rebuilding."

"Does he like it?"

"Well, you know, I think he'd prefer it if Sir Alexander had stayed in Claridge's. It's a bloody huge house for just two people—great big curved stairway like a film set, garden, greenhouse, library, the lot. Get bloody lost in it, you can. There's even a lift."

"A lift?"

"Yes, proper lift, with glass doors and all, push the button and up you go. Funny sort of thing to have in a house, but then Sir Alexander has never liked stairs, has he?"

"How's her Ladyship?"

"Ah. Well, she's a lot happier than she *was*, if you take my meaning. Poor old Benjamin got the sack."

I nodded. That had been predictable. Alexa would not have wanted any reminders of her former status as one of the girls Benjamin saw in and out of Alex's flat, late at night and in the early morning, when it was his duty to take them down to the empty lobby of Claridge's and put them into a taxi. Besides, he had never made his peace with Alexa. Perhaps he was too proud to try, or too self-confident, perhaps he simply recognized that it wouldn't do any good, and preferred to go out sacked and unrepentant.

O'Bannon lit a cigarette, coughed and continued. "Yes," he said. "I understand that Sir Alexander asked Benjamin if he thought he could learn to get along with her Ladyship, and the cheeky sod said, 'I'll try, Sir Alex, but the question is can her Ladyship learn to get along with me?' Well, that tore it, *as* you can imagine. See, Benjamin kept referring to her as 'Miss,' then apologizing by saying 'I'm sorry, I meant your Ladyship, but I just can't seem to remember it.' Then one day he did it at dinner, and she says, 'Never mind, Benjamin, I don't think you're going to have to try remembering it from tonight on,' and she goes to Sir Alexander and says it's Benjamin or her, and that was that. Well, I mean, Sir Alexander couldn't hardly choose his valet over his wife, could he now?"

"No, I can see that."

"Right. Though there's some that says he might have been better off choosing old Benjamin. Still, that's not my business, is it? She's a very nice-looking young lady, and she's always been very decent to me when I've had the honor of driving her. And Bailey says it's a pleasure to have someone young about, and get out for a bit of shopping in the West End now and then, instead of just sitting outside 146 Piccadilly in the Rolls, waiting for Sir Alexander to go home."

"Has Benjamin been replaced?"

"Ah. Well, that's another story. They brought up the steward off the yacht—Freddy. He's a frog."

"Freddy? That must be a change. He's not much more than a boy, and he doesn't speak any English."

"Right. Willing enough he is, though, and a lot nicer to her Ladyship than Benjamin was. Well, they know how to talk to women, those French, don't they? Anyway, he does for Sir Alexander, and acts as butler, and her Ladyship has a French ladies' maid to do for her, and they're going to bring up the cook off the yacht to be chef, I hear. I told Bailey he'll soon have to learn to *parler français.*"

"Does he mind?"

"Why would he mind? If it came to a choice between Bailey and her Ladyship, I'd put my bob on Bailey. He's not Benjamin, after all. Besides, he's the only person in the household Sir Alexander can talk to about the old days. I was driving Sir Alexander a few days ago, while Bailey was off with her Ladyship, and he says to me, 'O'Bannon, I see so many new faces around me, it's nice to see a familiar one for a change.' He looked a little browned-off to me. No disrespect, but it can't be easy, a man his age married to a young woman."

We drew to a stop in The Vale, and made our way down to the basement, since my father had built the dining room downstairs, next to the kitchen for convenience, and liked to sit here in the evenings, leaving the rest of the house to what he called "all the women's business." He was sitting at the big dining table in front of an electric heater, with his shoes off, surrounded by the evening papers. The table was already covered with the huge display of food that accompanied any Korda homecoming: smoked salmon, pâtés, jars of pickles, red cabbage, salami, a slab of raw bacon smoked in paprika, a basketful of breads, smoked trout, scallions, radishes, prosciutto—what seemed to be a sampling of everything you could buy at Harrod's food department. A bottle of champagne sat on the table, with several old jam jars of different sizes as glasses, and on the sideboard was a basket of fruit not much smaller than the one Orson Welles had destroyed on the plane back from Nice, as well as nuts, dates, preserved fruit, figs, a hazelnut torte and three different kinds of strudel, poppy-seed, cheese and apple. I kissed my father and sat down, while O'Bannon stood and fiddled with his cap.

"So," my father said, "the young warrior is home. We have some champagne to celebrate." He opened the bottle, and filled three jam jars (mine still had part of the label on it), and gave one to O'Bannon,

who said "Cheers!" We solemnly toasted each other, then drank in silence until O'Bannon had excused himself and left.

I always had trouble finding something to talk to my father about, and the problem did not lessen as I aged. I had long since learned not to mention the news, since my father was likely to reply with a glare and the unanswerable question, "What you know about it?" Once when I had made some remark about French policy in Algeria, he had said, "What you know? You think you know more than De Gaulle?" and since then I refrained from breaking the ice with a discussion of current events. Asking my father about his work would only invite him to say "Why you care? It's a bloody business," so that was out. I had not yet learned that it wasn't necessary to say anything at all. He was quite content to have me there, by the fire, and to cut me a slice of salami from time to time. No conversation was needed. My presence was quite sufficient. I was making the same mistake that everybody made about my father; because he liked company, people assumed he liked conversation. The worst thing he could say about any man (and most women) was that they talked too much.

He had always accused my mother of being "a chatterer," only to find, to his disappointment, that Leila too sometimes wanted a word of conversation at mealtimes. As the years had gone by since his departure from California, he had in any case come to regard Gertrude with more and more affection, now that he no longer had to live with her, and was grateful that she had given me up without making too much of a fuss. He brooded a great deal over whether he had done the right thing, for me and for Gertrude, in bringing me over to England and urged me to write to her frequently, though he himself did not.

Unlike my father, she was not given to dwelling on the past, which was what Vincent was frequently doing when he sat silently at the table, and undoubtedly what he was doing now.

He put his glasses on and peered at the *Evening Standard.* Since he always carried his glasses in his pocket without a case, they were hopelessly smudged. Once, in fact, he had found himself becoming unable to read the papers at all, and fearing that he might be going blind he went to one of the best ophthalmologists on Harley Street to have his eyes tested. The great man examined Vincent's eyes, asked to see his glasses, carefully breathed on the lenses, wiped them with his handkerchief and gave them back. "I think, Mr. Korda," he said, "that we've

solved your problem. My fee is fifty guineas." I could see that the glasses had now reverted to their former state, but I didn't think Vincent would appreciate my mentioning it.

"How's the family?" I asked, to break the silence.

Resentful at having it broken, my father looked up over his glasses and sighed.

"Leila is fine. She worries too much about being fat. Your brother is fine. Sometimes he cries, but it's not too bad, and anyway I don't hear it so much upstairs. How is Germany?"

I shrugged.

My father nodded. Given a choice, he preferred nonverbal communication, whenever possible.

"How is Alex?" I asked.

"How should he be? He has bought a new house. He and Alexa are decorating it."

"Are they happy?"

My father closed his eyes, as if in pain. "Vat do I know?" he said. "One piece of advice I give you."

"What's that?"

"When you're old never marry a young woman. It's all right to have them around, even very nice, but marrying them is a mistake. Alexa was very nice when she was Alexa, but now she's Lady Korda, it's different. You will see."

As Leila came in, carrying Winkie in her arms, I reflected that my father might have been thinking of himself as much as Alex, though Vincent was delighted to be starting a new family late in life. Leila was as chatty as my father was silent, and while my father complained that she talked too much, he seldom listened. As a result it was perfectly possible to hold a long conversation with Leila at the dining room table without engaging Vincent's attention at all. Like Winston Churchill, who always turned off his hearing aid in the House of Commons (and at home) on the grounds that he could hear what he himself was saying perfectly well without it, and didn't much care what other people were saying, Vincent was quite capable of ignoring a conversation until he felt it was time to join it, or put an end to it.

From Leila, I gathered that Alexa was putting herself out to play an active role in family life. She made sure that Vincent and Zoli were invited to dinner frequently, she made an effort to engage my

father in conversation, she invited Leila to go shopping with her and even stopped at the house to bring presents for Winkie. My father was suspicious of all this good will—he never questioned Alex's position as head of the Korda family, but the mere fact that Alexa was married to him did not, in his view, give her any special position, and he felt she should shut up, keep Alex happy and mind her own business.

Zoli, Leila thought, had succumbed rather more completely to Alexa's campaign of charm, and she had been instrumental in making peace between Alex and his tempestuous brother, thus earning Zoli's gratitude. All the same, Zoli too had his doubts about her. If Alexa could persuade Alex to make peace with Zoli, she could just as easily persuade him to quarrel with Zoli, and Zoli's respect for her was tinged with a certain degree of carefully guarded hostility. "He tells her jokes," Leila said, whispering now, "he goes out of his way to show her how charming and funny he can be, but if he were a horse, he'd lay his ears back."

Alex's brothers had reached an informal truce with the interloper, but beneath the surface appearance of a close-knit happy family, the same tensions endured. Alexa was being given a breathing space, a chance to see if she could make the oldest brother happy and not interfere in the relationship between him and his younger brothers. No doubt she realized that they remained deeply skeptical, and if she made such a show of inviting them to dinner it was because she preferred to have them see Alex in her presence.

THE NEXT DAY I called Alexa and went over to Claridge's to see the newlyweds. When I arrived, to be greeted by Freddy, who was altogether a more attractive figure than Benjamin, Alex was finishing his breakfast. He was not alone. Sitting opposite him was Tibor Csato, who occupied a special position in the Korda world as a protégé, a father-confessor and the family doctor. Healthy as I was, I had had few occasions to consult Tibor, though he had once called me over to his office to explain the facts of sex to me, whether on his own instinct or at Vincent's urging, I never learned, but Tibor frequently came to dinner, and in fact always timed his medical visits to coincide with mealtimes. He was particularly well-suited to explain the mysteries of

sexuality to an adolescent, since his receptionists were always bosomy young women with long blond hair and deep, sensual voices.

He was an attractive man of considerable sophistication, and though he still lived the bohemian life of a medical student, he had a wide circle of patients who trusted him completely. Alex liked Tibor so much that he gave him all his old suits and shirts, since Tibor was too busy or too occupied with his life to buy clothes for himself. Once Tibor told Alexa that if the police were to telephone with the news that a body had been found somewhere dressed in a suit with a tailor's label that read Sir Alexander Korda, she must be sure to ask whether there was a stethoscope in the pocket before going into mourning, since everything Tibor wore had Alex's name or initials on it.

Alex dearly loved Tibor and treated him like a son, though on any matter that seriously worried him, he was likely to fly to New York to see Dr. Henry Lax, an old friend, and a man of awesome reputation as a cardiologist and general diagnostician. Alex had complete faith in him. Lax frequently consulted with Tibor by telephone on Alex's health. But Tibor was in the nature of a physician in attendance, available at any hour of the day or night, and quite happy to sit down and have breakfast or dinner. Even more important, Tibor was cheerful, reassuring, and a brilliant conversationalist in several languages, a man who was as much interested in literature and art as he was in medicine, in short someone in whose company Alex felt comfortable.

Henry Lax, though very much older, had the same qualities, but he was three thousand miles away. Besides that, in his firm and discreet way, he had put Alex on notice that all was not well. Long ago, when Alex had collapsed at Romanoff's in Los Angeles toward the end of his marriage with Merle, Lax had warned him that his heart was no longer strong, and on each visit to New York, Lax had examined Alex's EKG with increasing concern. Because the two men were friends and contemporaries, few words were necessary for Lax to convey that concern. His expression, kind and gentle as always, nevertheless would have told Alex all he needed to know. Lax advised rest, a healthier diet, fewer cigars, moderate drinking, healthy exercise, nothing too strenuous, but perhaps a good long walk every day, and of course less tension. Alex listened to his advice, and continued to live as he had always done, either because he no longer knew how to live any other way or because the prospect of living to old age did not interest him.

In any event, it was Tibor's job to compensate for Alex's refusal to change his life style, insofar as this was medically possible. Because Tibor was a friend and a fellow Hungarian, I think Alex hoped that Alexa would not realize Tibor's visits were as much medical as social. Alex did not, after all, want to be thought of as a potential invalid. He just wanted a little more energy and strength than he could expect to have, given the way he lived, and Tibor did his best to supply with prescriptions what Alex might have accomplished alone by taking better care of himself.

I was not surprised to see Tibor at the breakfast table, though I could not help noticing that Alex rather hastily pulled down the sleeve of his shirt, presumably because he had either been receiving an injection, or having his blood pressure tested. I kissed him, shook hands with Tibor and sat down. Freddy poured me a cup of coffee.

Alex looked at me over the rims of his glasses. "Well," he said, "I had hoped to see you in uniform. I remember your father coming home in uniform, looking very martial, and smelling of tobacco, leather and horse-piss."

"We're supposed to wear civilian clothes on leave."

"A pity. We're just going off to see the new house, and you can come with us. A Royal Air Force uniform would have given the Soviet spies next door something to think about. The way they stare through the windows, you would have thought M-15 was moving in next door. They write down the license number of the Rolls every time we go past. Go say hello to your aunt while I talk to Tibor."

I made my way into the second bedroom, where Alexa was putting on her make-up, surrounded by a débris of boxes, bags and wrapping paper. I was in some doubt about the proper way to greet her, but she solved the problem for me. "I can't turn round," she said, "I'm doing my lashes, but you can lean over and give me a kiss on the cheek. Carefully, mind you. I don't want to start all over again." I did so, and sat down on the bed, which was covered with underwear, as if Alexa had been unable to decide what to put on. A heavy fur coat was thrown over one of the chairs, mink or sable, I didn't know which, but Alexa had obviously accepted the coat Alex had been offering her in vain before she became Lady Korda.

"Have you been having a good time?" I asked.

"Yes," she replied, without turning around. "We've been going to

auctions, and shopping for all sorts of things for the house. There's a big kitchen downstairs for Pierre, but Alex is building a small one upstairs so I can make myself a sandwich or a cup of coffee. I want to fill it with all the things Pierre would have a fit over. Ketchup, corn-flakes, Ritz crackers, peanut butter, marshmallows—we're going to have to ask somebody to send us a CARE package from New York or raid a PX to get it all, though. Did you see what Alex bought me as a wedding present?"

"No. What?"

Alexa turned around, opened a small, oblong red leather box, and took out a necklace, which she put on. "Emeralds and diamonds. We went round to Phillips and I picked it out. I'm supposed to keep it in the safe, but I can never remember the combination, so I keep it under my pillow."

She rose, took another look at herself in the mirror and lit a cigarette. I noticed that she now used a cigarette holder and a cigarette case, and I raised an eyebrow at them.

"Fabergé," Alexa said. "Alex thought it would be nice for me to have some Fabergé, since I'm Russian. The cigarette holder is white jade with diamonds, and the case was a birthday present from the Czar to somebody. Moura knows, of course.

"There's a shop on Regent Street that has whole vaults of the stuff. I bought Alex a Fabergé letter opener. It's expensive, but it's a good investment."

Alexa, it seemed to me, had still not mastered the art of dressing, however expensive her jewelry. She had a good, full figure, the kind that men stare at, as opposed to the kind favored by fashion models and designers, and a face with a long, thin nose, large, dramatic eyes and very pronounced cheekbones. Somehow her clothes failed to contribute anything to her appearance—in fact they detracted from it. She wore a suit with a wide skirt that was too stiff and too elaborate for someone her age, and a round hat, rather like a beret, with a veil, that would have been appropriate for a woman of fifty having tea at Fortnum's.

She did a pirouette. "What do you think?" she asked.

"I'm no judge."

"Perhaps not, but I can tell by your expression you don't like it. I'll tell you a secret—I don't like it much myself. I'm not too sure that Alex likes it either. I think he may have some plan to change my image. Are you having a good time in Germany?"

"Yes and no. The R.A.F. is okay, and the night life is more interesting than Juan-les-Pins."

Alexa laughed, a good, loud Russian belly laugh, rather like Moura's. "Don't I know it?" she said. "I spent some time in Munich, studying to be an opera singer, and it was wild. Those were the days!"

I reflected on this. Alexa's past, always a bit vague, was a subject she seldom discussed. I speculated on how she had made her way from Canada to Munich, and to what extent the study of Wagnerian opera had been her reason for going. Had it been there that she had met Paál, who had "connections" in Munich, and undergone a metamorphosis into a potential "starlet" with an album of cheesecake poses? Certainly she had the kind of face and figure that would have appealed to German film producers, very much like that of Marlene Dietrich at the time of *The Blue Angel*, before she went out to Hollywood and shed the puppy fat that had made her a star in Germany.

"I suppose you spend all your nights on the Reeperbahn," she said.

"Well, hardly *all* of them, no. In the first place, we have a lot of night duty, and in the second place, you can get tired of that sort of thing. Once you've seen two naked women wrestling in a vat of mud, or had the girl come round to your table to pick up a coin with her whatsit, you've seen it all. The trouble with the R.A.F. is that all you can do is go from one kind of boredom to another. That's why everybody drinks so much."

"I know just what you mean," Alexa sighed, leaving me to wonder whether she was already bored with life as Lady Korda, or had once been bored by the activities on the Reeperbahn. "We'd better go," she said, picking up her fur coat and slipping her feet into a pair of Delman high-heeled pumps, in which she seemed uncomfortable.

Alex rose to his feet as she came in and held out his arms so that Freddy could slip his overcoat on. Freddy, I noticed, was not given to chatter like Benjamin, and managed to be efficient and unobtrusive, which was hardly his predecessor's style. We went down to the lobby, parted from Tibor, who (though it was difficult to remember the fact) had other patients to attend, and got into the Rolls, Alexa and I sitting behind, and Alex in front, where he always preferred to be.

"What are you going to do on your leave?" he asked, as Bailey moved the big car out into Upper Brooke Street.

"Not much. Sleep late. Drive around if my father will let me use the car."

"Hmm. Do any of your friends in the Air Force have cars?"

"A few. I mean, there's no rule against it. A lot more of them have motorcycles."

"Motorcycles? I'll tell you what. I've been talking to your father about your having a car, and he was very upset with me, so I think it would just make trouble if I gave you one now without his permission. Still, at your age, you ought to have what other boys have. I will let you have a motorcycle, then when you go up to Oxford, I promise you a car—you'll need one then, for girls and going back and forth to London. After we have looked at the house, you go with Alexa and Bailey and buy a motorcycle, and I will deal with your father. But remember to be careful. Years ago, I remember that Lawrence of Arabia was coming to see me to talk about a movie of *Seven Pillars of Wisdom*, and he was killed on the way in a motorbike accident. I still own the rights."

I thanked Alex as best I could, conscious that a motorcycle was likely to cause just as much trouble as a car, from my father's point of view, and perhaps more. Alexa, I noticed, gave me a long wink, an indication that this idea had not occurred to Alex spontaneously.

Alex's memory had been stirred. "I wanted to make *Seven Pillars* before the war," he continued. "I thought it would be ideal for Zoli. It would make a wonderful movie, only one should call it *Lawrence of Arabia*. But Zoli didn't like the idea, partly because of Palestine, and Churchill was very worried because he felt it was important to have the Turks as allies when the war came, so nothing ever came of it. Olivier would have been wonderful as Lawrence. Now I don't know, it's still difficult to do, and with the Israelis and the Arabs, I'm not sure it would work. It's a great film, but I don't have the desire to make it, so I suppose I will have to sell it to somebody. If Zoli wanted it, I'd keep it, but he wants to make *The King's General*, which I think is an old-fashioned idea, and too expensive to shoot. Aha," he said, as the car turned into the gateway, "there's the flash of the Soviet binoculars —we're here."

Kensington Palace Gardens (universally recognized in London as "KPG") was and is a private road, with gates and guards at either end, rather like those in Bel Air. Originally designed to house the Court, when the King's residence was Kensington Palace, it has become a street of large mansions (hence the nickname "Millionaires' Row"),

many of which have been turned into embassies under the pressure of taxes and death duties. Expensive and pretty though it was, I found something foreboding about it as we drove past the huge houses, each of them sheltered by high walls or big trees, perhaps because there was nobody to be seen on foot except for the occasional chauffeur polishing a Rolls Royce, or the stout men in trench coats outside the Soviet Embassy.

The house was indeed everything O'Bannon had said it was, even in an unfinished state. We rode up in the elevator, and Alex remarked that when he was an old man Alexa could take him up and down in his wheelchair, a prospect which he did not seem to take seriously. We examined the paneled library, the huge dining room, the serving pantry with a dumbwaiter to the restaurant-sized kitchen downstairs, the marble bathrooms and the entrance hall, in which Alex's scale model of *Elsewhere* was now placed, in a glass case by the elevator door. Alex's dressing room was enormous, with its rows of cedar-lined closets and drawers, and Alexa's looked as if a lifetime of shopping would hardly fill it.

Alex pointed out the changes that Vincent had made, showed me the huge refrigerator that had been shipped over from America and demonstrated how the burglar alarm worked. He looked at the greenhouse and contemplated the possibility of gardening in his spare time. All the same, he did not seem to be as pleased with the house as he had been with the yacht. The house, very clearly, was something he had bought at Alexa's urging, in fact he had bought it in her name, and he seemed to grow more and more fond of his flat in Claridge's as the time grew close to leave it.

"Well," he said, as we descended in the lift, "I shall miss all the people at Claridge's, and of course the service. Still, I expect we shall be very comfortable here."

"Of course we'll be comfortable here, Alex," Alexa said, sharply.

Alex stood for a moment in the graveled courtyard, looking at his new home, then got into the Rolls and lit a cigar, and dismissed it. "The office," he said to Bailey. "I have work to do."

We dropped Alex at 146 Piccadilly, then drove to the Edgeware Road, where Bailey knew a former chauffeur who now bought and sold motorcycles and sports cars. We made a rather odd trio, standing there surrounded by motorcycles and young men in black leather jackets and

boots, Alexa in her fur coat and hat, Bailey his uniform, and myself. But Bailey's friend Pugh, a small, cheerful, red-faced man, dressed rather like a racetrack tout in a checked suit, scarlet waistcoat and the kind of suede boots that were then known as "brothel creepers," quickly came to our rescue. In those days, before the Japanese went into the motorcycle business and took it over, British motorcycles were large, ungainly and fearsome machines, with names much like those of battleships—the Matchless, the Black Shadow, the Dauntless and the Lightning—each of them representing exactly the combination of danger and mechanical excitement which my father most disliked. Pugh, realizing that he was dealing with people to whom price was no object, wheeled out a huge gleaming black machine, its tank and handlebars crouched like an insect over a motor that seemed big enough for a family car.

"Here we go," he said. "The Vincent Black Shadow. You can't beat that anywhere in the world. It's the Rolls Royce of motorbikes, it is, nothing can catch it. Rev it up and the girls will be wetting their knickers for you." Remembering Alexa's presence, he turned red. "No offense, milady, I'm sure," he added. "You understand we don't normally get many ladies present when we're selling these things."

"No offense taken, Mr. Pugh," Alexa said. "I've ridden pillion in my time."

"Ah, I daresay. And very nice you must have looked doing it too, if you don't mind my saying so. Anyway, she's a beauty, just the job for a young man."

Bailey shook his head. "It won't do, Pugh," he said. "It's too flash, too bloody big by half. Even Sir Alex is going to know it's a racing bike, though he don't know a thing about motorbikes."

Pugh was disappointed but game. "How about something nice and safe, then?" he asked. "A Vespa or a Lambretta—zip along on one of those like the wops do in Rome. The birds love 'em."

Alexa examined them, but she was clearly not excited. She looked at me. "Too tame?"

"Too tame by half."

"Mr. Pugh," she said, "what we want is something in between. Racy enough to wet somebody's knickers, but not so racy that Sir Alexander will notice it."

Pugh thought for a minute, smiled and walked us over to a dark-

green BSA, less sinister than the Black Shadow, but very clearly as powerful, or nearly so.

"Now, this," said Pugh, "is a *gentleman's* bike. Smooth, fast, quiet, nice British racing green color, nothing to get alarmed about to look at it, but it's what the police use, you know. You'll be 'doing the ton' on the M-15 with this, I promise you. I'd sell this bike to my own mother, I would."

"May we try it?" Alexa asked.

"I'd be honored, milady."

I sat down, switched on the ignition, checked the fuel cock and kicked the starter, and the motor caught, roared and then settled down to a savage, reverberating growl as I eased off the throttle. Alexa straddled the pillion seat behind me, put her arms around me, tucked up the ends of her fur coat and pulled her skirt up above her knees. "Let's go!" she shouted above the noise. "Take me back to KPG!" We cut sharply out into the Edgeware Road, made a U-turn, weaved in and out of the traffic until we reached Marble Arch, turned down the Bayswater Road, and to the astonishment of the porter at the northernmost gate of Kensington Palace Gardens paused so that he could wave us in.

His instinct was to stop us, but he recognized Alexa and retreated in confusion. "Good morning, your Ladyship," he shouted, and saluted. We raced down KPG, did a circle in the courtyard of the Soviet Embassy, bringing all the spies to the windows, sped through the southern gate without stopping, thundered past 146 Piccadilly and returned to Mr. Pugh's establishment.

"We'll take it," Alexa said, and Bailey drew a thick envelope from his pocket and paid Pugh in crisp new five-pound notes.

"Do you know," Alexa said, as she straightened out her skirt and hat, "I think that funny man was right, after all. I believe I've wet my knickers. Try not to kill yourself." She walked back to the Rolls, and I was left to wonder just how I was going to explain this new acquisition to my father.

As it turned out, Alex, true to his word, had already informed Vincent, who was very angry indeed, though not at Alex and hardly even with me. He suspected that Alexa had persuaded Alex to let me have a motorcycle, and deeply resented her intrusion in the domestic affairs of the family. Even Alex felt he had gone a little bit too far in

usurping my father's authority, and finally apologized, even agreeing to pay for the insurance and the upkeep, though my father was more concerned with the danger and stupidity of a motorcycle than with the cost. Vincent's hostility toward Alexa was unrelenting. He felt she had made a fool of him, and possibly even of Alex. The motorcycle was only a symbol; for the first time, Alexa had precipitated a quarrel, however minor, between the two brothers, and as he put it, "stuck her bloody nose in my business."

He himself had never liked motorcycles anyway. Years ago, at the beginning of the war, he had been invited to M-15 and offered a top-secret job which involved building dummy factories, aircraft and tanks to mislead the Germans about the strength and positions of Britain's war industry. He accepted and was told that he would receive a special commission as a senior officer, to give him more authority. He was not enthusiastic about becoming an officer, but as a patriotic naturalized British subject, he was willing, and therefore appeared before a commissioning board, where the first question he was asked was "Mr. Korda, do you know how to ride a motorcycle?"

My father replied that he did not.

"Are you willing to learn?"

My father thought about this, and replied that while he was willing to do a great many things on behalf of his adopted country, he was not willing to learn to ride a motorcycle.

That was that, so far as the Army was concerned, and Vincent went on to advise about camouflage as a civilian. The board had mistakenly assumed that he was being offered a secret commission in the Commandos, rather than the job of transforming factories into fields, and fields into factories.

As for my motorcycle, he refused even to look at it. "Show it to her Ladyship," he said. "I think from now on that we're going to have to do what she wants. Poor Alex!"

FROM VINCENT's point of view, the worst thing that could be said about any man was that he was run by his wife, or even influenced by her. Zoli felt even more strongly about this. Neither of them had ever paid the slightest attention to the demands and the suggestions of *their* wives, and they naturally saw Alex's position as a shameful and danger-

ous one. They did not blame Alex. His only fault was that he was so good and trusting that any stupid cow could walk all over him. Maria had made his life a hell, Merle had cared more for her career than for him, and now Alexa was pulling the wool over his eyes, persuading him to buy valuable property for her, turning him against his brothers, and influencing his decisions in family affairs. It was, as Zoli put it, "disgusting."

In fact Alex was neither weak nor particularly trusting. It was just in his interest to keep Alexa happy, if only because he knew that he was too old to survive another domestic collapse. Though Alex certainly had not "bought" Alexa, he was too realistic not to know that a marriage between a man in his sixties and a woman in her twenties has built-in cost factors. What he had not calculated was that Alexa would change when she became Lady Korda, or that he would want to change her. Like most people who move from a love affair to a marriage, they were having a certain amount of difficulty in adjusting to their new roles.

Alexa's impulse toward change was comparatively easy to understand. She was socially ambitious and determined to be rich in her own right. It would be simple to conclude that she married Alex for his money, but simple explanations of human behavior are nearly always unsatisfactory. No doubt money was one of the attractions, but it was not until they were married that Alexa came to want money for herself, as opposed to simply sharing the Good Life with Alex.

The Kordas were willing enough to give their wives generous gifts, provided they didn't ask where the money came from, or how much of it there was, or want something put in writing. Had Alexa asked for another emerald necklace, neither Zoli nor Vincent would have minded all that much. What they did not like was the fact that Alexa wanted property in her own name, and worse yet was beginning to ask questions: What was the relationship between London Films, Ltd. and British Lion? What was the difference between Alexander Korda Film Productions, Ltd. and London Films Production Co., Ltd.? Did Alex own the independent London Films organizations in Germany, France and the United States? What exact role did the self-effacing Herr Doktor Zumli—a discreet Zurich lawyer to whom Zoli made frequent visits and toward whom Alex behaved with the respect due a royal personage—play in all this?

These and many other questions were difficult to answer, even if Alex had wanted to answer them. It was not so much that he was secretive as that his financial affairs had been designed over the years to make scrutiny almost impossible. Neither Maria, nor Peter, nor his partners, nor the Inland Revenue had ever managed to untangle them because nobody except Alex had a clear picture of the whole, with the possible exception of the good Dr. Zumli, whose lips were sealed and who seldom left Zurich. Zoli, because he was an American resident, probably knew more about Alex's financial affairs than Vincent, since he was not restricted by the British laws regarding currency, but even Zoli knew only what Alex wanted him to know, and complained that he was not taken fully into his elder brother's confidence.

Nobody was. Alex was a born manipulator of money, and only he knew what he had in mind. He created companies, merged them, liquidated them, sold their assets, bought them back again; in the spirit of a juggler, he kept all the balls in the air at once, never dropping one. Many of his companies, however grandiose their names, had been created for some specific reason in the past, and now merely consisted of a filing cabinet in his solicitor's office. They had served their purpose long since, and were now discarded. These companies led to a good deal of confusion, since Maria believed that all of them were flourishing entities, and saw hidden assets behind every set of initials. In fact, they merely represented blind alleys, plans that had never materialized or had been changed.

Alex had long been notorious for buying up novels, plays and stories indiscriminately, and for signing performers to long contracts, then leaving them to languish in idleness. In fact, one actor complained that being under contract to Alex was like being unemployed at a high salary. Alex, after all, had owned Vivien Leigh when David Selznick chose her for the role of Scarlett O'Hara in *Gone With the Wind,* and had reaped a substantial reward for lending her to Selznick—much to Selznick's fury. He paid 1,000 pounds for the movie rights to an obscure play and sold it to Alfred Hitchcock for 30,000 pounds the next day at dinner (it was made into *Dial M for Murder*). He had owned the rights to *Around the World in Eighty Days* for years, and sold the property to Mike Todd for an enormous sum, just as he was eventually able to sell his rights to Lawrence's *Seven Pillars of Wisdom* so that David Lean could make *Lawrence of Arabia,* a decision which must

have pained him, since he had not only wanted Zoli to make the movie, but had offered the role to Olivier, John Clements, Robert Donat and Leslie Howard at various times. Twice he sold the rights to all his prewar films, and twice he bought them back, each time making a fortune on the sale and another on the re-release of his "grandchildren" after repurchasing them. It was not just that he was a shrewd and instinctive judge of material and a good bargainer—he also knew that if you hold on to something for long enough, it may sooner or later become valuable to somebody. Sometimes he had ulterior motives. He purchased the rights to Romola Nijinsky's biography of her husband, and renewed them for decades as a way of keeping Mrs. Nijinsky (who was Hungarian) alive. Many of the properties he owned represented discreet charities to friends; he supported a great many people all over the world, people who had once done him favors, people who were now old and forgotten, people who had at some point in his life helped or encouraged him. For the most part, however, he bought in order to hold and sell at a higher price, just as he eventually sold his rights to Rostand's *Cyrano de Bergerac*, many years later, to Carl Foreman for a handsome windfall.

He himself was inclined to dismiss all this as "horsetrading," but it was a business that kept him solvent even when his more visible enterprises were faltering, and had the great advantage of giving him a flow of cash that could be moved outside the normal channels of film production. He speculated on properties the way other people speculate on the stock market, and a good deal more successfully.

Zoli and Vincent understood all this. They trusted him completely. Alexa did not, and this was bound to lead to friction.

This was particularly so during the first year of Alex's marriage, for the famous 3,000,000-pound loan—and indeed the whole idea of the National Film Finance Corporation—became the subject of a heated debate in Parliament. This was not in itself surprising. British Lion's deficit had grown to almost 500,000 pounds despite the success of Alex's productions, and it had been necessary for Alex himself to lend 50,000 pounds of his own money to London Films. The debate on the "Cinematograph Bill" in the House of Commons was remarkable for the unhappy reason that it was dominated by a discussion of Alex's personality. His admirers, including Harold Wilson, Sir Tom O'Brien and many members on both sides of the House, defended him vigor-

ously, but William Shepherd, M.P., led a spirited and highly personal attack, which was widely reported:

"I have reached the conclusion that it might be well and to the advantage of the British Lion Film Corporation if they had a new executive producer and someone other than Sir Alexander Korda should take on that job. Sir Alexander Korda was associated with the lush days of the film industry . . . I understand from his recent public pronouncements that he is very interested or more interested in television, and I think it might be to the advantage of both the Corporation and the country if someone else took over his job . . . I do not think that containing Sir Alexander Korda can be done as a part-time job, and therefore suggest a full-time chairman."

The last sentence was a dig at Harold Drayton, the City financier who had been appointed to look after the government's interest in British Lion. Drayton was a kind of corporate pluralist, with over fifty directorships to occupy his time, and was widely regarded as having been charmed or misled into managerial impotence by Alex.

No doubt Alex was not displeased to have Drayton come under attack with him, but there was still no escaping the fact that the brunt of the criticism was directed toward Alex himself, and he resented it bitterly. He had increased production, cut down the cost of his films, produced in succession some of the best motion pictures to be made in England since the war, and achieved the widest possible international distribution for his films.

The problems of British Lion were not altogether of Alex's making; he was not responsible for the archaic system of film distribution in England, which he had been criticizing for twenty years, nor was he to blame for the government's ineptitude in allowing American film companies to dominate the British market after attempting to restrict them. Alex understood that films generally require a long time before they begin to show a profit. The films he had made in 1933 were still making money in 1953, and had the government (and the directors of British Lion) understood this, the company's losses in the 1950's would have been transformed into huge profits in the 1960's and 1970's, from re-releases and television rentals. Even today, films like *The Third Man, The Man Between, The Fallen Idol, An Outcast of the Islands, The Sound Barrier* and *The Winslow Boy* are constantly being shown on television, not only in the United States and in the United Kingdom,

but all over the world. What he was doing now might seem wasteful to outsiders, but Alex understood, better than anyone else, the far-reaching and profitable effect that the growth of television would have on the movie business.

It was Alex's misfortune that his explanations of the intricacies of film financing not only fell on deaf ears but were usually provoked by criticism of the way in which British Lion was spending (or in many people's view, wasting) public funds. In an age of austerity it was equally difficult to explain the traditional economy of moviemaking. It seemed outrageous to build a full-size replica of Hyde Park Corner when the real thing existed not fifty yards from the front door of Alex's office, but the expense of building this huge set at the studio was very much less than it would have been to keep a film company on location in Central London for days on end, waiting for the right weather and snarling up traffic. The amounts paid to stars and directors seemed equally extravagant to ordinary people, and even to politicians, but only a star could make a picture into a success, especially in the international market, and the vast sums involved were, despite appearances, prudent and economical investments.

Alex himself complicated matters further by his ironic attitude toward film financing. Although he was in fact rather cautious, and believed in long-term profit and the careful exploitation of his properties over many years, he liked to appear in public as a man with the gift of working miracles. "Whenever I made 'safe' films, I failed," he announced at the Berlin Film Festival, "and whenever I made 'crazy' ones, I made a lot of money—and so did my backers . . ." While the newspapers delighted in this kind of paradox, it left an uneasy impression in the minds of more conventional people, who failed to realize that Alex was being witty at his own expense. He disliked being thought of as an ordinary businessman and enjoyed the image he had created for himself as a daring entrepreneur. Unhappily, the government and the public might have accepted British Lion's losses more easily if Alex, in his flamboyant way, had not provided them with what looked like a convincing explanation for the growing disaster: He was a gambler who had staked too much and lost. J. Arthur Rank, by contrast, though his financial difficulties were at least as acute, escaped criticism. Since he was dull, reticent, devout, a prudent businessman who lived modestly, his financial problems were accepted as part of the normal risk

of business. Perhaps he had made mistakes. What businessman did not? But he had never put himself forward as a miracle worker, whereas Alex had been delighted to accept the role when it had been offered to him. Now he had to pay the price, for despite the impressive achievements of the last five years, he had failed to produce the expected miracle.

Alex had moved far beyond the government's understanding of what the British motion picture industry ought to be. The government was still concerned with the possibility of building up a British film industry that could compete with Hollywood, the old dream of the thirties and forties, while Alex had long since recognized that this was not possible and would probably be self-defeating. He had abandoned the big "international" picture to concentrate on films that were essentially British. His directors and advisors were no longer European exiles or Californians, but brilliant English film makers like David Lean and Carol Reed. His best material now came from the work of writers like Graham Green and Terence Rattigan. He was even willing to finance such "parochial" projects as *The Belles of St. Trinian's,* the humor of which must have been almost incomprehensible to him. He had learned—the hard way—that the British film industry could only succeed if it was firmly grounded in British subjects and British talent, and that it would succeed abroad by quality, not by imitating Hollywood. He also understood, long before the Common Market, that it was easier and more profitable to co-produce films with the European film industry than with the big studios in Hollywood, even if the films were less ambitious and the profits slower in coming in.

It was as if Alex had at last found the formula he had been searching for, that had eluded him during the Denham years and had been impossible to achieve in the immediate postwar period. The only problem was that it was now too late. The 3,000,000-pound loan to British Lion had been barely sufficient to launch the British film industry in this new and more rational direction, and now it threatened to destroy everything that had been gained.

ALEX WAS NOT a man who enjoyed defending himself. His nature was stoical, and he refused to complain, either about his health or his other difficulties. It annoyed him that these troubles should coincide with his

marriage to Alexa, but he was reluctant to discuss them with her, perhaps because his legendary "magic touch" was part of his attraction for her. In any event, it was his style to meet misfortune by a display of confidence, so he did nothing to restrain her impulse to spend and acquire. As the collapse of British Lion loomed before him, he desperately needed domestic happiness, and he was not about to endanger it by resisting Alexa. No man likes to spend the day arguing about money in the office only to come home and argue about money with his wife, and to Alex, at this point in his life, a few hours of peace were worth any amount of money.

Alexa took to shopping for Fabergé at Wartski's as other women might shop for shoes. She persuaded Alex to add to his art collection. She bought Baccarat glasses by the barrel, which she and Alex then had to wash themselves after dinner, since it was so expensive that the servants refused to touch it. She urged him to buy her a collection of Degas bronzes and a Pissarro, which he did. Now that Bert Crowther was dead, Alexa shopped for furniture in the most expensive antique galleries of Bond Street, and the house was gradually filled with signed pieces of museum quality, sent up "on approval," which Alex eventually purchased largely because they had been sitting there for so long that he became used to them. On every table, *bureau plat* or chest there sat at least one Fabergé *objet,* prompting my father to remark to Alex that "KGP is beginning to look like Tsarskoye-Selo."

Alex was not amused; he was sensitive about jokes made at Alexa's expense. Since my father possessed a remarkable gift for sarcasm under a veneer of simplicity, he frequently offended Alex by his lack of respect for Alexa, and the number of invitations to dinner began to decline. This did not altogether displease my father. In deference to Alexa's youth, the company at Alex's dinners was beginning to change. Alexa wanted younger, more "social" people around her, but this was not entirely her fault—many of Alex's old friends, like Brendan and Lord Beaverbrook, were becoming too ill to dine out much. Alex soon found himself surrounded by a "faster" set than my father would have enjoyed, the international rich, ambitious young men about town, society beauties with several spectacular divorces under their belts.

It is difficult to determine who was responsible for transforming Alexa into a member of the social scene. On the one hand, she was ambitious to get where the action was, and put her new wealth and her

title to use; on the other hand, Alex himself pushed her in that direction, perhaps without even realizing that he was doing so. He now joked about her weight, though she had never been more than pleasingly plump, with the result that she went on a ferocious and even vengeful diet, and kept her hunger at bay with large quantities of Preludin, a powerful amphetamine that depresses the appetite but stimulates the system and induces an inability to sleep that can only be cured by taking sleeping pills. She became a chain-smoker in a family that had always been dismayed by the sight of a woman smoking a cigarette. Her skin, which had always been tanned and healthy, began to take on an unhealthy, if elegant, pallor, and while the emergence of her cheekbones gave her face a dramatic quality, the effect somehow gave her a slightly predatory look as well.

Alex as always wanted to be Pygmalion, even when it was against his interests, and perhaps against his desire. After all, he had transformed Maria into a great European star, and would have made her a star in Hollywood too had not the advent of "talkies" and her own temperament defeated him. He had a restless urge to change and improve people, though the more he succeeded, the less happy he was, as if his talent for film direction and invention had spilled over into his family life. Now Alex seemed determined to subject Alexa to the same process of metamorphosis as he had his first two wives, even though Alexa did not have the talent that might have justified it. In order for her to wear chic clothes, she had to lose weight, since hers was hardly the figure of a *mannequin*, and Alex therefore encouraged her to diet until she acquired a model's figure, then took her to Paris to be dressed as a woman of fashion. In the beginning, Alexa was eager to do all this to please Alex, but by gradual steps she developed the intense narcissism that inevitably accompanies high fashion. She was no longer learning to dress in order to please Alex, but to win admiration from her new friends. She had learned—and put into practice—the immortal advice of the Duchess of Windsor: "A woman can never be too thin or too rich."

DURING MY LEAVE, I saw rather too much of Alexa than was wise, prompting my father to ask if I didn't know any girls my own age. But I didn't. I still had no roots in London to speak of. How could I?

Between school in Switzerland, holidays in the South of France and military service in the Royal Air Force, I had never spent more than a few weeks at a time in London, and I knew nobody. So it was natural that I should gravitate toward Alexa, who had time on her hands. Alex's previous wives had been professional actresses, and their days were as busy as his own; there had been no need for him to invent activities for Maria or Merle, even had he wanted to. But Alexa had nothing to do. She had never been really serious about her singing career, and Alex didn't want her to work anyway, so she had long since given up her singing lessons. She had asked for a dog, but Alex for once refused to buy her something she wanted. He had unhappy memories of Merle's Chow, and in any case, he didn't want Alexa babying a pet. "I want to be the one who is babied around here," he insisted.

Nor did the household require much from Alexa in the way of attention. Freddie, Pierre and the maid took care of everything, the bills were paid by Alex's secretaries, and a man even came in once a week to wind the clocks. Every morning after breakfast, Pierre would arrive in Alex's study—as he had on the yacht—with a leather-bound book of menus and recipes, and together they would choose the dinner, Pierre making suggestions, Alex modifying them or on rare occasions dismissing them with the comment *"Cela ne m'enthousiasme pas."* Alexa played no part in this, and since she was now on a diet, was not even interested. Besides, Pierre did not encourage any interference in the affairs of his kitchen. Though he spoke no English, he quickly formed alliances with the local purveyors, and in the time-honored tradition of French chefs, took a kickback on all the kitchen accounts. When this was pointed out to Alex by Alexa, he sighed patiently. So long as Pierre did not steal by more than fifteen percent, he was content, and Pierre was modest enough to stay within this figure.

As a result, there was very little reason for Alexa to get up in the morning at all, and since I had nothing to do myself on leave, I would ride over after Alex had left for the office, and sit on the end of her bed, reading the newspaper, drinking coffee and trying to find something to do. However innocent this was as a way of passing the time, it was bound to be commented upon, and even I could hardly fail to notice that Freddy the valet was beginning to give me a conspiratorial wink whenever I arried. Alexa didn't care; she was bored and restless, and I suspect any company was better than none, from her point of

view. With the motorcycle at our disposal, we went to the zoo, spent the afternoons in cinemas, had lunch in obscure London pubs (Alexa's favorite was the Grenadier in Wilton Row) and went on long walks through Hyde Park. We drove to Windsor for tea, explored Richmond Park and took a cruise down the Thames to Greenwich and back. Alexa was not exactly unhappy—it is difficult to be unhappy when one has everything one ever wanted in life except a dog—but she was already feeling the first minor warning signs of dissatisfaction, and they made her nervous.

"I'm not sure what he *wants*," she said one day, as we walked across the park, kicking piles of leaves in front of us. "What we had before was fun, and very exciting, but now I have this feeling that he's not happy with me the way I was, and he wants me to become something I'm not. It's as if I'm being *measured* for something. I'm supposed to be a good hostess, say the right things to the right people, but I never wanted to be any of those things, and I'm not that good at them, am I? Frankly, I liked it better when I was his mistress, and could play the naughty girl when I wanted to. That *amused* him. He liked that. He doesn't like me nearly so much in my Balenciaga, greeting the guests and trying to be serious when Brendan is talking about South Africa. I mean, that even bores Alex, so I can't understand why he wants me to be fascinated by it."

"Well, you're Lady Korda now. And you've got a lot of money. That's not so bad, and it's what you wanted."

"Oh, I wanted it, all right. Who wouldn't? But I feel I've lost my freedom. I *have* lost my freedom. I can have dresses, and paintings and jewelry, and that's all terrific, but Alex was more willing to give you a motorcycle than he is to give me a car. Why shouldn't I have a car? I can drive well enough. But when I bring the subject up, Alex simply says that Bailey can drive me anywhere I want to go. He doesn't want me to have a car of my own in London, so I can just get up and *go* somewhere. He wants to know where I am all the time. He likes me to be dependent."

"He loves you. I expect he's jealous. Most men are."

"Don't I know it? But it's wrong. I'd be better for him if he'd give me some freedom. I hate it when he asks me what I'm going to do with myself every morning. It's as if I have to have a plan, and he has to approve it. And he telephones too. I don't think it's because he loves

me and misses me and wants to talk to me, I think it's because he wants
to know that I'm there, waiting for him, all the time. If I go to the
hairdresser, I get a phone call asking if I want Bailey to pick me up,
but I don't think that's why he calls. I think he's checking up, making
sure that's where I really am. When I get a letter, he asks me who it's
from and what was in it. Oh, I know that's polite—he's showing
interest—but I think there's more to it than that."

"It doesn't sound all that different from anybody else's marriage, to
tell you the truth."

"Maybe I'm just not the type for marriage, then."

"It's a little late to think of that now."

"I guess so. It's funny. My father was the one who had the strongest
objections to the marriage. He even sent that silly cable, and talked to
the reporters about the difference in our ages. Alex laughed about it,
but in fact he was furious. And now my father keeps writing to me
about what a wonderful thing it is for me to be married to such a rich
and famous man, and how proud he is of me."

"Most fathers want their daughters to marry rich men. It's normal."

"It's all that money. I love having money, but every once in a while
I wish I could escape from it, and go off to Munich or Paris or
somewhere for a week by myself."

"Not bloody likely. Anyway, money is surely one of the main advan-
tages of being a member of the Korda family."

"You know, I'm not sure of that anymore. Look what it's done to
Maria. And anyway, I married Alex, not his family. All the Kordas seem
. . . so stuck together somehow. I never know what the rest of them
are thinking about me, or what I'm supposed to do about them."

"Well, it's a funny family," I admitted. "Nobody ever drops out of
it. In a way, Maria is still as much a part of it as she was thirty years
ago, and my father still talks about Peter as if he were a little boy,
though he must be nearly thirty by now. The point about the Korda
family is that it's all built around Alex. There isn't anything else. If Alex
hadn't created it, Vincent would still be painting in Hungary, or maybe
Paris, and Zoli would be cutting films in Central Europe. It was Alex's
idea that they should all stick together, right from the beginning. Being
a Korda is special because Alex *made* it special."

"One of these days you may have to learn what it's like not to be
special."

I looked at Alexa, scuffing through the leaves back toward KPG, a scarf tied around her head (in what Alex always called her "babushka pose"), wearing my duffle coat and a pair of old blue jeans, and I shook my head. "One of these days," I said, "we're all going to have to learn that. Not just me."

ALEX GAVE a dinner party before I went back to the R.A.F., a family occasion that my father was happy to attend. Moura was there, Brendan turned up, looking thinner and more frail than I remembered him, and Leila wore a silk sari, brought back by my father from India, and looking, as he said, "like an English houri." Alex was at his most genial. He talked with animation of his plans to make a movie in Cinerama, which he had seen and recognized as the wave of the future. "You can only beat the little screen of television," he said, "by giving people a much larger screen, by making the film a special occasion. Quantity film production is finished, except to provide material for television. The future is in big expensive films that people will leave their television sets to see because they're special. We shouldn't make movies that are like what they see on television. We should make movies that are so much bigger, more exciting and special that television can't compete."

As usual he was right, and as usual he was ahead of his time. He had already persuaded Zoli to put aside his self-imposed lifetime task of rewriting *The King's General* in order to make a modern, wide-screen version of *The Four Feathers,* to be called *Storm over the Nile.* He had encouraged Carol to make his first color movie, based on Wolf Mankowitz's novel, *A Kid for Two Farthings.* He had joined with David Lean and Ilya Lopert to produce *Summer Madness,* * an ambitious color film to be shot in Venice, based on Arthur Laurents' *The Time of the Cuckoo,* and with no less an international star than Katharine Hepburn. He had secured Vivien for the leading role in an expensive film version to be made of Terence Rattigan's *The Deep Blue Sea,* and he had made arrangements with Laurence Olivier to finance and produce a film version of *Richard III,* which had been presold to American television. Mr. Dowling's $15,000,000 was to be put to good use, and

*Released in the United States as *Summertime.*

London Films, once it had weathered the storm over the British Lion loan (*if* it weathered the storm), would be in a position to challenge television with first-run motion pictures that were important "events," and afterward profit from the long-term sale of these pictures for future television use. As Alex said, "I don't think we should be making Fords anymore, I think our role is now to make Rolls Royces."

Before dinner, he took me to one side to ask if I had enough clothes. In fact, I had just been the rather embarrassed recipient of a whole wardrobe for a tragic reason. My father's assistant, Philip Sandeman, broken-hearted over a love affair with a girl who had turned him down, dove his aircraft into the ground while flying with his R.A.F. Reserve squadron, leaving me a white silk aviator's scarf, a tailcoat, a full suit of morning dress, a black top hat, a gray topper for Ascot, an opera cape and a hunting pink. I was too fond of Philip to be at ease in his clothes, and none of them seemed altogether suitable for my life style, but Alex, who seemed to feel that my life in the R.A.F. called for a full collection of evening wear, insisted on giving me his red velvet smoking jacket, which I wore for the rest of the evening, feeling rather foolish, since it was several sizes too big and had curved lapels like a bandleader's. My father eyed it with displeasure. It was exactly the kind of garment he despised, and represented the kind of life style that he wanted me to avoid. Still, a gift from Alex was not to be refused, and he was probably grateful that Alex had not given it to him, and insisted that he wear it.

Alexa was cheerful at the dinner table. She was always more relaxed when Alex was happy, and my father, despite his hostility toward her, had the gift of bringing out the best in her, since he told exactly the kind of jokes she liked. I noticed, however, that there was a certain coldness between Alexa and Moura, a hint that Alexa was no longer willing to be treated as a protégée, and that Moura was no longer secure in her position as Alexa's discoverer and guardian angel. It occurred to me that perhaps Moura knew too much about Alexa for comfort, and that her days as part of the inner circle might be numbered.

After the *soufflé au citron* (Pierre, as usual, had outdone himself), I sat down in the study with Brendan and Alex, while my father went off to prowl around the paintings, and the ladies retreated to the bedroom to examine Alexa's latest purchases. Freddy brought around

the cigars, and Brendan and Alex fussed over them, operated on them
with the skill of surgeons and sat back to smoke.

"How do you like London now that you're a young man about
town?" Brendan asked.

"Well," I replied, "it's been a little boring. I think the problem is
that I'm *not* a young man about town."

"Dr. Johnson once said—very rightly, I believe—that a man who is
tired of London is tired of life. You should find yourself a girl."

"They're hard to find."

"Indeed? I can hardly believe that. You might drop in on the Reeds.
Their house is always full of girls, it seems to me."

Alex nodded, examining his cigar carefully. "You should enjoy your-
self. Now is the time. It's a mistake to take up pleasures which you can't
afford later on, but at your age you should have as many girls as possible.
Your father certainly did."

I resolved to pay a visit to the Reeds on my next leave—after all, I
could hardly spend the rest of my life as Alexa's *cavalier servente,* and
it was just possible that Alex was giving me a hint to stop doing it.

Alex leaned over and gave me a searching look. "Remember," he
said, "all girls are different. Unfortunately, all wives are the same."

"Ah," said Brendan, "perhaps I've been wise never to have married."

Alex stood up, getting ready to join the ladies. "That, my dear
Brendan," he said, "is the true wisdom."

CHAPTER 10

I WAS BACK with my squadron when British Lion finally collapsed, and therefore missed the full impact. Its losses in 1952–53 had reached over 150,000 pounds, with the result that most of the original 3,000,000 pounds was now unrecoverable, and the government shortly called in the loan and applied to the courts for the appointment of a receiver in bankruptcy. Harold Drayton was removed from the chairmanship, and Sir Wilfred Eady, the inventor of the National Film Finance Corporation, now called the bankrupt company "a baby which was born of the unholy wedlock between public funds and private enterprise." The government's action was not only damaging to British Lion and to the British film industry in general—owners of 4,000,000 shares of British Lion saw their investment wiped out overnight, and Alex himself lost nearly 500,000 pounds of his own in the collapse. Mr. William Lawson, a partner in a firm of chartered accountants, was put in charge of the company's affairs, and had the unenviable task of explaining that the new organization would be "government controlled, but not government run," a distinction which was difficult to understand. Alex, who had offered to resign many times in the past, now resigned for good and real, emphasizing that he would continue to produce motion pictures through his own company, London Films,

and adding that "money would be found elsewhere." A lively wit suggested that British Lion should be renamed "The Gay Receivers," and Alex himself had the final word on the disaster when he was asked whom the government would appoint to succeed him as chief of production. "It isn't easy," he replied. "You see, I don't grow on trees."

The loss of British Lion did not surprise Alex—he had realized for a long time that the end was inevitable, and had even taken whatever steps he could to ensure that London Films, at any rate, would survive. All the same, prepared for the blow as he was, he suffered deeply. No doubt he resented losing so much of his own money because of the government's decision, particularly at the very moment when success was almost within reach, and certainly he was saddened by the public attacks on him for "mismanagement and extravagance," which he felt were extremely unjust. But what hurt most was that at the age of sixty he would have to "start out all over again."

During the first days of the crisis he discussed retiring—after all, he had always said he wanted to spend the years from age sixty-five to ninety-five studying classical Greek, and he would have been only five years ahead of his own schedule—but the more he contemplated a life of leisure, the less it appealed to him. He was depressed, tired, angry and self-critical, but within a week he was already talking about "pay television" as the entertainment medium of the future, and founding two new companies to develop material for "subscription TV programing." In any event, with Dowling as his backer and Ilya Lopert as his American distributor, Alex was in a better position to undertake his ambitious new production program than he had been before. At least he was no longer obliged to worry about the problems of British Lion, which had never been his first concern to begin with. All the same, he seemed restless and exhausted to everyone who talked to him. Inner tension had surfaced in the form of an irritating and persistent skin rash, which refused to respond to any known treatment, and Alex's friends were now asked to bring cortisone ointment over from America when they came, instead of his cigars, since the British Medical Association refused to sanction the sale of the drug. Even the cortisone did not seem to help much. He slept badly, disturbed by constant itching, occasional difficulty in breathing, sudden sweats and what seemed to be chronic indigestion. What he most needed was rest, but even though *Elsewhere* waited for him in Antibes, fully crewed and ready

for sea, he was unwilling or unable to make plans to go there. If pressed hard enough by Alexa or my father, he would send a cable telling the captain to expect him and to prepare for a long voyage to the Greek Islands, but the next day he would change his mind and put it off for a week more.

Once in his life, at the outbreak of war, he had been accused of running away at a time of crisis, and he was determined not to face the same accusation twice. He stayed in London as the dismal process of putting British Lion into government receivership took place. "One has to face the music," he said, but he hated every moment of it. For the first time in his life he was too tired to give dinner parties, which had the effect of cutting him off from the company of people who might have cheered him up. He did not *want* to be cheered up. He intended to rise like Phoenix from the ashes, but first he had to endure the flames, so he sat through the endless, dry meetings and put up with the endless bickering, taking the blame for a failure that was not of his own making, and defending people who had never bothered to defend him. He described what he was going through as "a treadmill," and complained that though he had never felt sixty, he now felt ninety. It was as if the depressive side of his nature, always present from the beginning, had at last overwhelmed his energy and optimism. Not even Brendan, who pointed out that all great men have failures and that Churchill was over sixty when he at last became Prime Minister, could shake Alex out of his misery. It was something he simply had to live through.

Alexa herself noted that Alex had suddenly aged, but the crisis brought out the best in her, as even my father was forced to admit. She nursed Alex through his depression, sitting alone with him at dinner, which they ate off trays in the study in the big house, the dining room being far too large for two people. She managed to interest him in the life and times of Evita Perón—possibly a revealing choice of heroine, in Alexa's case—and played him recordings of Perónista marches and songs. She persuaded his old friends to come and see him and gradually brought him back to himself. In a moment of weakness, or perhaps because he was grateful for her support, he allowed her to buy a dog, and Buttons, a black-and-white Boston bulldog, joined their household, soon winning the affection of his master. Alexa had hoped that Alex would take Buttons for walks, but Alex was not about to change the

habits of a lifetime. Even Winston Churchill had not managed to persuade him to change his habits, and he was not going to walk up and down KPG with a dog on a leash.

He may also have known that it was too late to start exercising in any case. When I returned home in the summer to be "demobilized" from the Royal Air Force, my father was waiting in the dining room, looking ashen and depressed. He put his arms around me, and said very quietly, "Alex is in hospital."

"Why?" I asked. I knew Alex hated hospitals, and had always insisted that he preferred to be sick in his own bed.

"He had a heart attack in the night, two days ago. He couldn't sleep, he didn't feel well, then he had this great pain in his chest, so he telephoned Tibor and, thank God, Tibor knew it was the heart and got an ambulance."

"Is it serious?"

"Of course it's serious. A heart attack is always serious."

"Will he get better?"

"If he takes care of himself. We go to see him now—he asked for you to come. And try to look cheerful."

I reflected that this advice might better have been given to my father. He had always assumed that Alex was somehow immortal, and Alex's heart attack, an unmistakable warning of mortality, had shaken him deeply. His expression and his mood were not, I thought, at all appropriate for sickbed visiting, but it was hardly my place to tell him so.

"Poor Miki," he said, patting my knee as we got into the car. "What a homecoming!"

He was silent on the way to the hospital, lost in thought, his lips compressed, his chin down, frowning into space. I know that Korda look, I thought: He is blaming himself, doing with Alex's heart attack exactly what Alex did with the collapse of British Lion. I had no doubt that if my father could have had the heart attack in place of Alex, he would have.

As we went up in the lift, Vincent took me by the hand and said, "Be very quiet. Don't upset him, and don't be shocked at how he looks. Talk to him about your plans for Oxford, something to cheer him up a little."

With this gloomy warning, we stepped into Alex's hospital room,

where, to my surprise, the patient was sitting up and looking considerably livelier than he had for a long time. All around the room were gifts. Flowers of every conceivable variety, hampers of fruit from Fortnum & Mason, bottles of champagne, a whole pâté in a terra-cotta dish shaped like a hare, books, tins of foie gras, a small Boudin seascape on an easel, half a dozen baskets of pastry, a couple of elaborate cakes, an original set of Piranesi etchings and a huge tin of caviar nestling in a carved ice swan. It was a scene more appropriate to the departure of a movie star on the *Queen Elizabeth* than to a hospital. On the table beside Alex's bed was a tray with a plate of *tomates provençales,* half a roast chicken and a salad of endives and truffles. It did not seem like hospital fare.

Alex smiled broadly, leaned forward so I could kiss him on the cheek, then lit a cigar.

"It's nice to see you," he said. "Free at last. This whole military service nonsense is worth having behind you. As you can see, I couldn't stand the food here. Terrible English cooking, everything boiled, and awful puddings you can't eat, so I have Pierre cook for me at home, and Bailey brings it over in the car."

"How do you feel?" my father asked.

"Never better. I've had a scare, that's true, but also I've now had a rest. You know, for all these months I haven't been able to sleep. Here they give you massages and an injection, and you sleep like a baby."

My father was clearly disconcerted by Alex's sudden change in condition. He had promised me a frail and fragile victim, and he also suspected Alex was putting on a show of good spirits in order to get out of the hospital.

"Zoli is flying over from Los Angeles," Vincent said, no doubt because he knew that Zoli, with his long experience of illness and his interest in other people's health, would argue very strongly in favor of Alex's staying in the hospital for as long as possible. But Alex was quick to reject Zoli's medical advice before Zoli had even landed.

"That's nice," he said, "but tell him I don't need a lecture. I've had my heart attack. I now know more about it than he does. I'm going home, where I can be comfortable."

"What will Tibor say?"

"He will say it's a mistake and let me do what I want."

"And Lax?"

Alex paused. Lax, even far away in New York, was a more serious matter, since his advice was never taken lightly.

"I think even Lax would say that at this point I might as well go home. All these years I've been warned that I could have a heart attack. Now I've had it. I'm still alive, thank God, and it doesn't worry me anymore."

"You have to do what you want, Lacikám."

Alex nodded. "That is perfectly true. And what I want is to get out of here. The nurses can have all the flowers and the food. I will go home and Pierre can make me chicken soup. Did you see the Boudin? Dowling sent it over as a present. I find it very refreshing to look at. On the one hand, look, it's very small, like a tiny window on the world; on the other hand, look what it contains, the whole beach, the sea, the woman with the parasol, the man with the straw hat. It's so wonderful to put so much of the world into such a small space, without any bright colors or tricks. That's the way we should make films. We did it like that when we made *Rembrandt*—remember?—every frame was a picture. Today, half the cameramen shoot from too far away, so the frame is meaningless; the other half only know how to shoot close-ups. A picture ought to be more than that. Perhaps I'll go to Venice with you. I love Venice. We'll stay at the Danieli, and go to the opera, and take a gondola ride and have lunch at the Lido. I've been in London too long. I've spent too many hours in the office and at damned meetings. I want to see the sun again, and eat green figs. What was it Goethe said? '*Where the lemons bloom . . . Zitronen blüh 'n . . .*' I've had enough grayness."

The door opened, and the matron came in, the formidable authority figure of every English hospital, with her starched cap and apron, and her vast bosom. She carried a stainless-steel tray, with a hypodermic needle.

"Time for our shot, Sir Alex," she said.

Alex smiled broadly. "My backside is already so full of shots it's hard to lie down," he said.

"Oh, Sir Alex," the matron replied, unexpectedly coy, "you'll be the death of me."

The word "death" seemed to change Alex. Quite suddenly, he looked tired and old, bored by our presence and the matron's business, no longer interested in Boudin's artistry. He waved to us, and we both leaned over to kiss him and left. As we went out the door, I heard the

matron saying, "My favorite of all was always *Lady Hamilton.* I'll never forget the moment when Vivien Leigh sees him again after all those years, and he turns up the lamp and she realizes that he's blind in one eye . . ." and deeper, more quietly, I heard Alex saying, "Try not to hurt me so much this time."

ALEX'S HEART ATTACK was kept as quiet as possible—certainly no news of it appeared in the press, and when questions were asked, he was said to be "resting." It naturally brought the family together. For once Zoli, my father and Alexa were in agreement: All of them urged Alex to rest, change his habits, follow the doctors' orders and cut down on his activity. After all, there was no pressing need for him to continue working. True, nobody could replace Alex, but now was perhaps the ideal moment to sell London Films. Divorced from British Lion, that floundering giant, it was an attractive proposition. Its assets included a well-equipped and modern studio at Shepperton, a substantial list of moneymaking films and salable properties, a well-known name and trademark and an ambitious production schedule. Neither a buyer nor a merger would have been difficult to arrange, nor would Vincent and Zoli have opposed such a move. Each of them had enough money to live very well without working, and if they chose to work because they wanted to, they would find no difficulty in doing so. Zoli was a respected and world-famous director in his own right, and in fact *Sahara,* one of his most successful films, had been made in Hollywood, rather than for London Films. Vincent was in constant demand as an art director (and would continue to work until he was almost eighty years old). Neither one of them needed London Films, or had the slightest desire to run it.

As for Alex himself, he could have produced pictures independently had he wanted to. Certainly, he didn't need money. He could live luxuriously on what he already had, and still have enough left over to take care of Maria, Peter and Alexa. But he was no more willing to give up London Films than Winston Churchill was to resign from Number 10 Downing Street in order to make way for Anthony Eden. In his own quiet, stubborn way, Alex resisted his brothers' advice. He was determined to make a "comeback"; he was unwilling, as he said, "to die a failure." He had always prided himself on his stoicism, and he would

now put it to the test by going on with his life as if nothing had happened.

It would have seemed that Alex had so much to live for he ought to make every effort to save himself. He had money, a wonderful collection of pictures, a beautiful young wife, undiminished intellectual curiosity, the freedom to travel and relax. But Alex's problem lay deeper than his damaged heart and arteries, and could not be solved by a hedonistic retreat and a sensible diet. The pessimistic side of his nature had already accepted the sentence of death long before his heart attack confirmed it, and at some basic level he had never found, or had lost, the kind of happiness that would have made it worth his while to struggle for a little more life. He liked to pretend that he was happy with Alexa, if only because it would have been an admission of failure to act otherwise, but he was too intelligent to be able to hide from himself the reality, which was that neither one of them was happy. Whatever had once attracted him to her, she was now a burden—sometimes hysterical, often demanding, groping for some meaning and future to her own life, and therefore no longer able to provide Alex with a reason to live. As for his work, it now largely consisted, as it had for so many years, of shouldering other people's burdens, encouraging them, advising them, financing them and dealing with the countless crises that they created for themselves and were unable to solve without him. He had always regretted not having become a writer or a politician (and most regretted not combining both professions, as Churchill had done), and he had been right, for some kind of direct creativity might have saved him now. But he could hardly go back to directing his own pictures, even had he wanted to, and producing movies is a business in which stress, anxiety and crisis are unavoidable.

To go back to work—the only kind of work that Alex knew—was to commit suicide, and giving up cigars or eating cottage cheese would not save him. It was easy for those around him to persuade themselves that he was determined to do his duty by his associates and his backers, that he wanted to fulfill all his commitments and responsibilities, but in fact Alex was choosing to give up the illusion of hope. He would not postpone his death; he would simply wait for it.

Zoli, who knew the signs of illness better than anyone, recognized the nature of Alex's decision. More than my father, he wanted Alex to make some provision for the continuation of London Films. Unlike

Vincent, Zoli had always encouraged his elder son David to think about going into the movie business, and though David was now in Switzerland (after a disastrous experience at Le Rosey, he had been transferred to a somewhat less exotic school) and still a schoolboy, Zoli saw no reason why London Films should not be preserved in some form, in the remote event that some future Korda might want to play a role there. Besides, many of the films which represented London Films' assets had been made by Zoli, and he was anxious to prevent their falling into someone else's hands. With the exception of *Sahara,* his life's work belonged to London Films, and while he had never objected to this too strongly so long as London Films was Alex, he now wanted to own these films, not just because he had made them, but also because they would provide a permanent legacy and income for Joan and the children.

He argued his case with Alex in Hungarian; he explained his point of view to Alexa; he quarreled with my father, who thought Alex ought to be left alone and not bothered with this kind of thing; he even visited Peter. Everybody could see Zoli's point of view except Alex. To give Zoli back his films would be the beginning of the end for London Films, the start of a long process of "Balkanization" that might end God knows where. Besides, Alex did not share Zoli's view that the films Zoli had made belonged to him. He was the eldest brother. He had made those films possible and financed them; even when they were children, Alex had imposed his authority and his seniority on Zoli, and Alex was not about to relinquish it now. Nor would he finance *The King's General,* which had become Zoli's secondary obsession, and on which he had spent a good deal of his own money to have several script versions written. Alex did not like any of the scripts, he was bored with the property (which he had announced as a forthcoming production as long ago as 1946, with James Mason as the hero), and because of the period and the background it reminded him of *Bonnie Prince Charlie.* He did not think it was the kind of movie that would make money now, he had never liked Daphne Du Maurier's writing much to begin with and he felt it was the wrong kind of movie for Zoli in any case.

In the long summer afternoons, as Alex recuperated at home, he and Zoli passed their time in furious arguments, Zoli digging up the slights and injuries of six decades, while Alex, pale and exhausted, rested his case on the simple proposition that as the eldest brother he knew best, and always had. Alexa supported Zoli, either because she simply didn't

care what happened to the films, since they played no part in her own future plans, or because she hoped to win Zoli's support in return for the things she wanted from Alex. But Alex was unmoved—the dispute between the brothers was none of her business, and he was not interested in her opinion on the matter. Zoli was bitter—that Alex had refused him, that my father had not taken his side, and at the realization that even age and sickness could not modify the nature of the relationship between the three brothers. He returned to California to brood, while Alex gradually resumed his work. He did not go to Venice; he did not go anywhere. He was, in any case, being drawn into a new dispute, since Alexa was pressing him to give up the yacht.

Alexa had never much liked *Elsewhere* to begin with—she suffered from seasickness and had no great love of the ocean—but the yacht also represented an enormous expense without any real value as an investment. Unlike real estate, the value of which tends to increase automatically, a yacht depreciates. Almost every house can be sold to somebody, but a large yacht is the fantasy of its original owner, and most rich men have their own fantasies of just what a yacht should be. Some of the most beautiful yachts in the world have remained for sale for many years, or been sold by executors at a price far lower than the original cost, and in the meantime they have to be dry-docked, painted, maintained, kept in sound mechanical condition, protected against rust and guarded. The yacht, she argued, was a ridiculous extravagance and a poor investment. Alex seldom used it, though it was always waiting for him, fully crewed, and it was hardly the ideal thing for a man with coronary thrombosis.

Alex had heard these arguments before, and had always resisted them, refusing even to contemplate chartering the yacht when he wasn't using it. "I don't want strangers on my boat," he said, for *Elsewhere* represented a pleasure of the imagination for Alex, quite separate from the real pleasure he had when he was on board her. So long as she was waiting in Antibes, he could persuade himself that he might go there at a moment's notice. He had only to send the captain a cable and take the morning plane to Nice, and he could be on his way to anywhere he wanted to in a few hours. *Elsewhere* was his escape, a reassuring symbol of his freedom, an option he could take up when and if he decided to.

He himself knew that there was no medical reason for him to sell

the yacht; he could have been perfectly comfortable on board her. Alexa talked about it as if it were a sailing schooner on which Alex himself would have to haul lines and trim the sails. There was little likelihood of encountering major storms in the waters around Antibes, and the sea air, sun and absence of telephones would have done him good. True, he would have to climb the stairs from his cabin to the deck, and from the deck to the bridge, but this would hardly have been much of a strain to him. True also, he would be unable to reach a doctor in an emergency, but how much could a doctor do for him if he had another heart attack? The fact was that Alexa did not want to live on the boat, away from London, and wanted Alex to get rid of it. He fought against the idea as he had fought Zoli, but less successfully. In the end Zoli went back to California and left him alone, but Alexa was in a position to renew her arguments every day, and inevitably he gave in.

The yacht was put up for sale, and fetched far less than it was worth. Almost immediately Alexa took Alex on a trip to the South of France to go house hunting. Alex had always insisted that if there was one thing he never wanted to own it was a house in the South of France. A house would be a burden to keep up and would bore him. He liked staying at the Hôtel du Cap, where he was always treated like royalty. He liked to go to restaurants, to gamble at the casinos, to be driven along the Corniches. Sitting still bored him—even sitting still on his own terrace, looking at his own gardens. All the same, he made the rounds of the villas for sale, and with a noticeable lack of enthusiasm finally purchased Le Domaine des Orangers, a large estate in Biot, near Antibes, with a huge house of the kind favored by deposed monarchs in exile, several large terraces, a reflecting pool and luxuriously planted formal gardens. It was reputed to have cost 100,000 pounds. (Then about $400,000, but probably worth twice that or more today.) He purchased it in Alexa's name. There were sensible reasons for doing so. She was a Canadian citizen, and could therefore own property outside the United Kingdom—but the fact remained that two of Alex's larger personal investments, the house at KPG and the new house in the South of France, now belonged to Alexa. This was by no means unusual, but it was inevitable there should be some suspicion that Alexa was taking advantage of Alex's ill health to put away property in her own name while there was still time to do so, and already there were

murmurs of discontent from some of the other future beneficiaries.

In the meantime Alex showed no desire to visit his new home, nor did he waste time decorating it. It was plain that he had no intention of living there. It was a gift to Alexa, who had no more intention of using it than he did. He returned to London and flung himself back into the work of organizing his new production schedule.

ALEX'S HEART ATTACK was not the only major family event of the summer. My father surprised all of us by announcing that Leila was pregnant again. He did so with a certain amount of embarrassment; indeed his behavior was not unlike that of the aboriginal Australians, who have yet to make any connection between intercourse and childbirth, and assume the two acts are unrelated. Alex's feelings about the news were somewhat ambivalent. He thought it unreasonable for a man of my father's age to begin a whole new family. Had he known that my father and Leila would eventually have three children, and that Vincent would live to see them grow up and even get married, Alex's immediate reaction would have been that it was foolish. He had no faith in Vincent's ability to manage without him.

Something that *did* delight him was my going up to Oxford. Alex had a touching faith in the value of traditional English educational institutions, despite the fact that the three Englishmen he most admired—Bracken, Beaverbrook and Churchill—had never attended any of them. He often said he would have been happiest as a teacher, and while this is probably not true, there was something of the professor about him, and he would have looked at home in an Oxford or Cambridge Senior Common Room. Like most successful men who have never attended a university, he had an exaggerated respect for university education. He himself loved learning and was a man of broad and deep culture; he naturally supposed that Oxford shared these concerns, and that a love of learning permeated its very stones. My father too had great respect for Oxford. His concept of student life was essentially European, a combination of *la vie de bohème,* his own days as an art student and dim memories of student life in Budapest and Vienna, with student *Bierabende,* songs and long, hard hours of studying for a coveted degree.

None of this, as I was shortly to discover, had anything to do with

the reality of Oxford in the 1950's. Indeed, the task of interpreting what Oxford was like to Vincent and Alex was so difficult that I stopped trying, with the result that they assumed I had something to hide. It was impossible to explain that we were hardly required to study at all, and that we had no contact whatsoever with the faculty except for one hour a week with our tutor, whose job it was to listen to a prepared essay, politely lay bare its shortcomings and secondhand ideas, and offer us a glass of sherry. There were, in fact, two Oxfords, as there had been in Gibbon's time, when he complained that his fourteen months at Magdalen College were "the most idle and unprofitable of my whole life," attacked "the Monks of Magdalen" as "decent, easy men, who supinely enjoyed the gifts of the founder" and dismissed his fellow undergraduates, whose "dull and deep potations excused the brisk intemperance of youth." Now, as in Gibbon's time, the life of the university proceeded at an even pace without in any way involving the undergraduates, who swarmed through the colleges during term like an army of barbarian invaders, their drunken noise, brutish pleasures and sheer numbers briefly troubling the ordered calm of university life during the short periods of the occupation. The Fellows of the Colleges went on with their lives as best they could, dining magnificently in hall, pursuing their researches, splitting the atom, analyzing Mallarmé's *Un Coup de dés*, disputing the finer points of ecclesiastical history, but they represented the permanent and enduring role of Oxford as an institution of learning, and stood apart from the undergraduates as the older and more respectable Romans must have during the occupation of the Visigoths.

It was certainly possible for an undergraduate to get an education at Oxford but it was not easy and it was not, in those days, at all necessary to try. The undergraduates themselves were divided into two separate groups: those who were studious and hard-working and those who were not. In some colleges, the former predominated, in others the latter. It was popularly supposed that undergraduates on state scholarships were more serious than those who received no grants, but this was not necessarily the case. There were young men of means whose families had attended the same colleges for years who approached their studies with zeal and energy, and young men from poor families on grants who did little or nothing. All the same, the richer undergraduates naturally had better opportunities for enjoying themselves than the poorer ones,

and Oxford, at the time, was perhaps one of the last remaining places in which it was possible to lead a life of pleasure and dissipation without guilt or shame.

My first evening at Magdalen provided me with a good example of Oxford high-life. Returning to my rooms I saw a large, heavy figure in a green Rifle Brigade blazer and corduroy trousers, carefully making his way around the Cloister with a golf club. At each light bulb, he would stop, measure the distance, swing his club and shatter the lamp—except for the few he missed. Behind him, at a discreet distance, walked his "scout" (the servant who looked after every staircase, and served as valet, butler and housemaid to four or five undergraduates). As each bulb shattered, the scout quietly made a note in a small pocket diary, so that the young golfer would be charged for the damages in the morning. I was so struck by this unlikely sight—reminiscent of Don Quixote and Sancho Panza, except that in this case the tall master was powerfully built and plump, whereas the short servant was wizened and thin—that I committed an appalling breach of manners, and asked the young man in the blazer what was happening.

"What the bloody hell do you *think* is happening?" he replied, weaving back and forth and staring at me. "I'm breaking bloody light bulbs."

"Yes, I can see that. It looks like fun."

"That's it. Good, clean fun. Why shouldn't a chap break bloody light bulbs if he wants to? Here, have a shot."

"I'm not much good at golf."

"Nor am I. Not my club anyway. Borrowed it from some dim bloody chap on my stair. A trog.* Never comes out in the light of day except to get more books from the bloody library. Can't think why he has golf clubs. Try that one, over to the left."

I stood on my toes—the Cloister ceiling was higher than it looked —and swung, shattering the bulb with one stroke.

"Good show!" my new acquaintance shouted. From behind, I heard the scout clear his throat. "I don't think that's a good idea, sir," he said, "the young gentleman is just come up, see, it's his first year, the senior dean ain't going to like it."

*A "trog" (short for "troglodyte") was a popular word of the era, used to describe someone who spent all his time indoors studying."

"The senior dean can stuff it!" The young man in the green blazer retrieved his club, and looked at me ponderously. "I don't believe we've met," he said, holding out his hand. "My name is Eric Buckman. I'd invite you up for a drink, but I suddenly feel most unaccountably unwell. It may be that all these bulbs give out some kind of noxious gas when they explode, but I feel quite dizzy. We shall meet again. Good evening to you."

He swayed into the fog, lurched around the corner and vanished, the first person to have spoken to me since I arrived at Magdalen with my trunks.

Buckman's scout came up behind me, his notebook in hand. "I think we'd do better, if I may say so, to put that last bulb in Mr. Buckman's total. You won't want to start off with breakages this early on, you see."

I thought about this. I didn't know much about Oxford, but I had more than two years in the Royal Air Force to guide me, and if nothing else I knew that you had to live by the rules of schoolboy behavior, not by the rules of the organization.

"No," I said. "I broke it; I'll pay for it. Put my name down for one light bulb."

The next morning my own scout seemed rather embarrassed when he woke me. He had heard that I had broken a light bulb—and would have to appear before the dean. In fact, he had in his hand a small envelope, with a card from the dean, inviting me to see him at eleven o'clock.

"It's not the way to begin, sir," he said, as he pulled back the curtains and fussed around the room, "not on the very first day. It's one thing on a bump night. Why, last year some of the young gentlemen went down to the river and brought back one of the Balliol boats and made a bonfire of it outside Balliol College, and nobody really minded, but it's best to start slow, if you take my meaning. There'll be plenty of time for broken glass later on."

I had ample time to consider what my father would say if I were sent down from Magdalen, and I noticed that my fellow first-year undergraduates gave me a rather wide berth at breakfast. My friend of the night before was nowhere to be seen, and I assumed he was nursing a hangover. Promptly at eleven, however, he appeared in the dean's waiting room, freshly shaved and cheerful, and gave me a hearty handshake.

"I say," he said, "didn't we have a good time? It's very good of you to have joined me. After all, I invited you to have a go at the bulb, so it really counts as mine."

"Do you think I'll be sent down?"

"Good God, no. Fined, I expect. Try not to look too apologetic. A manly admission of guilt is best. I hear your uncle's the film producer, isn't he? I expect old Karl is dying to write a script for him."

The door opened, and a short, dark and rather pugnacious-looking Central European in a long black gown scowled and waved us in. He sat down at his desk and stared at us with evident displeasure, while we both stood before him, Buckman in an undergraduate's gown that had been hastily borrowed from somebody else's peg and was several sizes too small for him, I in one conspicuous for its newness.

Dean Leyser, a historian of international reputation, spoke in short, clipped sentences, which I found easy to understand, since both his speech and his face were remarkably like Zoli's. "Is it absolutely necessary," he said, "to behave like hooligans? Eric. *You* I can understand. Boat club rowdiness. *Stupid!* But *you*"—he pointed his chin at me— "you have only just joined our little community. It's shocking behavior!"

Buckman protested. "I say, Karl," he said, "it isn't all that bad, surely? I mean, it's not like that chap last year, what was his name— Mudde? He shot one of the deer in Magdalen Park with a Mauser machine pistol from the roof of the New Building. Now *that* was shocking."

Leyser stood up angrily, and put both hands behind his back. "I'll decide what's shocking, Eric," he said. "Anyway, Mudde was sent down. He had gone too far. I warn you both not to go too far. You will pay the damages that are assessed, and I am fining each of you five pounds. Somebody could have hurt himself on the broken glass. Now, both of you get out, please, and you, Mr. Korda, try to stay out of trouble and bad company. I will have my eyes on you in the future. What are you supposed to be studying?"

"Modern languages."

"Which ones?"

"French and Russian."

Leyser looked out the window and sighed. "A waste of time. Why come to Oxford to study one language that every educated person

already should know, and another that no educated person speaks? You might as well go to Berlitz, and save everybody a lot of expense and trouble. Please be sure to visit the bursar's office and settle your fines. Good day to you."

"Well," said Buckman on our way out, "he might at least have given us a glass of sherry. Come on, we'll go to Bond's room and have one."

Very often the kind of life you will lead at Oxford is determined by just such chance encounters, unless your family preceded you. In the normal course of events, I might have waited a year or two before being invited to Bond's room, or perhaps never seen it, since in the way of most privileged Oxford institutions, it was deliberately self-effacing. Indeed it was so self-effacing that a great many people, even at Magdalen, did not know it existed. Bond, the senior steward of the Junior Common Room, had an office of his own, a snug, wood-paneled room, with a large fireplace surrounded by a leather-padded fender. Here he kept his account books and looked after the college's cellar, which was richly, even nobly, stocked. To a favored few, he made his room available as a meeting place and bar, for sherry and madeira before meals, and coffee and port afterward. Bond himself would stand behind his chest-high writing desk, which rather resembled a pulpit, and note down what his young gentlemen consumed, discreetly billing them at the end of each term. It was possible to have coffee upstairs in the Junior Common Room, but nobody of any consequence at Magdalen did so. Bond's room was cozy, warm, elegant and, above all, exclusive, and therefore the place to be.

Quite how one was invited to become a member of Bond's room was something of a mystery. Bond himself made the choice, but he seemed to have no fixed rules. No doubt a certain amount of old-fashioned snobbery entered into his calculations—the majority of his young men came from public schools, had private incomes, knew how to deal with servants and showed the right amount of respect for Bond—but the mere fact of being an Etonian or a Wykehamist, or even having a title, was not necessarily a guarantee of receiving Bond's blessing. Skill at sports helped, so did the right kind of clothes, but Bond mostly picked out undergraduates by some strange, inner process of selection all of his own, occasionally singling out quite ordinary young men, who then became socially acceptable and at ease by the mere fact of having been chosen in the first place. He had his favorites, even among habitués of

his room, but once you had been invited, you were free to use the room and drink on credit for the rest of your career at Oxford.

Eric pushed open the big oak door and introduced me to Bond. He looked like a scaled-down version of an Edwardian sergeant-major, with a finely waxed mustache of the kind that was popular during "the Kaiser's War," and penetrating gray eyes. Eric poured out two glasses of sherry, and we sat down on the fender. "Bond," he said, "this is Mr. Korda. We have just come from the dean."

"So I hear, sir," said Bond.

"Do you row?" Eric asked me.

I did not, and hadn't intended to, but I knew enough to know that some interest in sports was necessary, and signified my intention to take it up.

"Splendid! Go down to the club after lunch and join up. They'll put you in a boat, even if it's with the lame, the halt and the blind. Best thing you can do. Right, Bond?"

Bond looked up from his ledgers, removing a pair of steel-rimmed reading spectacles from his nose. "Quite so, sir," he said. "An excellent and healthy sport." I noticed that the photographs on the walls were all of young men dressed for the river, standing or kneeling in front of crossed oars, and decided I had better fit myself out with a pair of rowing shorts as soon as possible.

Bond eyed me carefully. "Your uncle is the film producer, sir, is he not?" he asked.

I said indeed he was.

"Mrs. Bond and I have very much enjoyed many of his films. I saw *Henry VIII* twice."

"My mother was in it."

"Was she, now?" Bond replaced his spectacles, as we rose to make our way to the Hall for lunch. "I hope you'll come back again," Bond said. "There's always coffee after meals."

"Well," Eric exclaimed, "you seem to have hit it off with Bond. After lunch you can buy *me* a drink!"

I HAD NO friends in England, and very little idea of what Oxford would be like. No elder brother or former Oxonian had given me the benefit of his experience and wisdom. Left to myself, I might have become a

decent, serious hard-working student and buried myself in the libraries and lecture rooms. It would have been difficult to explain to my father the shape my new life was taking, so I didn't bother to try. Nor, in fact, was I all that interested in the affairs of the Kordas. For the first time, I had a life of my own.

My father had long promised himself a visit to Oxford, but something kept him back. Perhaps he felt it would be inappropriate to intrude. Alex too had talked of visiting, but rather to my relief he appeared to have forgotten about it. I would have been hard put to entertain him suitably, and he would have been more comfortable dining with Fellows of All Souls at the High Table. Alexa had expressed no interest. I noted from the daily newspapers that she had been photographed at several parties, and looked very much better-dressed than she ever had before. Alex did not appear in the photographs, but he was quoted in an interview about film making, in the course of which he mentioned that he had never taken the Métro in Paris because on his first visit to that city he was too poor to buy a ticket, and on his subsequent visits he was too rich to have to. He also mentioned how much he missed the yacht and remarked that his career had been marked "by too many upsies and downsies." All the same, it was not like him to let Alexa go to parties on her own, and I wondered what his health was like. He sounded cheerful enough in the interviews, but then he always did, since he usually had an ulterior motive for giving them. Whenever he had something to hide—and ill health would certainly fall in this category—he would invite a reporter over to the house for a quiet dinner, and provide him with some quotable copy. Reporters did not frighten Alex; as he did with financiers, he learned how to charm them into serving his purpose.

I WAS NOT to discover Alex's mood until I went down to London for the Easter vacation, since he had managed to avoid Christmas by going to New York, where he was involved in launching the European use of Todd-AO with Mike Todd, a showman after his own heart. My Christmas present was the car he had offered me—as usual, Alex had kept his word. I cabled my thanks and Christmas greetings to him at the St. Regis Hotel in New York. Vincent described him as "damned figdeting all the time," strong words from him when applied to Alex,

and Alex himself complained that he was "bored with people, but hated being alone." Even charm had become an effort, sapping his energy and his will. He was more tired than he had ever been, but found it impossible to sleep, or even nap.

Much of the Christmas vacation I spent at the Reeds', where, true to Brendan's prophecy, there were at least three attractive young girls, whom Alex referred to as "the three Gracelets"—Pempy's daughter by her first marriage, Tracy Pelissier, and her two best friends, Nico Harrison (later to become Marchioness of Londonderry) and Linda Bathurst, the daughter of a well-known actor and pub-keeper. My father, I soon discovered, had a particular dislike of Nico's mother, a formidable woman who had left Central Europe with a visiting English cricket team, and had adapted too well to English society for his liking. On the whole, however, he was relieved that I had found companions who might replace Alexa.

Climbing up drainpipes after midnight so that I could help Tracy down to visit after-hours drinking clubs while her parents slept was certainly a stimulating and different experience. If nothing else, Oxford taught one to scale improbable heights, since each college locked its gates at night. It was necessary to climb in, following well-worn and traditional routes, inching one's way over Victorian wrought-ironwork on which it seemed quite possible to spear oneself, and up Gothic stone carvings that offered a precarious handhold. This aspect of university life apparently fascinated Brendan Bracken, who questioned me about it at some length when I went to pay my respects to him during the Christmas vacation. Brendan did not look well—he was thin, pale and breathed with difficulty, and already suspected that the optimism of his doctors was unfounded, that they knew more than they were willing to tell him. His peerage had given him little pleasure—he himself had complained that "translation to the morgue is a curious experience"— and he avoided the House of Lords, which he disliked almost as much as he did his doctors. He had urged Churchill to resume office as Prime Minister in 1951, though he had refused to serve in the Cabinet himself, and was now in the unenviable position of trying to persuade his old friend and mentor to step off the stage of history and relinquish the seals of office to someone younger. Despite a stroke, loss of memory and advancing senility, Churchill was still reluctant to give up power, even (or perhaps especially) to his aging protégé, Anthony Eden, and

Brendan was weary from many hours of praising the pleasures of retirement to a skeptical and obstinate listener.

"Poor Winston," Brendan said. "He's dreading it all. I talk to him about his painting, about the South of France, his books, bricklaying, all the things he could be doing, and he simply nods his head and says, 'But my dear, I shall miss the red boxes.' And so he shall, I daresay. I had the same conversation with your uncle, but he's just as unwilling to go off to the South of France and enjoy himself as Winston is, and he at least has a young wife, which ought to be some kind of incentive, *and* a house. Winston, you know, loves it down there, but he can't buy a house—there would simply be too many questions asked about how he got the money out of England. Alex offered to help him, but I think in some ways he prefers to be a guest. He used to love staying with Maugham at Villa Mauresque. I remember Max Beaverbrook once asked Winston why he spent so much time with Willie Maugham. 'Well,' Winston said, 'he makes me very comfortable, and the food is very decent.' 'But Winston,' Max said, 'don't you think it looks a bit odd to people? After all, the man is a well-known homosexual!' 'Willie may be an old bugger,' Winston replied, 'but by God, he's never tried to bugger *me!*' Are you enjoying Oxford?"

I said I was.

"The president of your college tells me you make quite a practice of smashing things and climbing over the walls. Never mind, he's something of an old woman. A bit of adventure never hurt anyone at your age. I hear you've been taking out Pempy Reed's daughter? Her father, you know, was quite the most handsome man in London, though I don't remember that anyone ever said much else about him, and Pempy herself was and is a great beauty. Do you have plans for the summer?"

I did not, but I could see from the expression on Brendan's face that plans had already been made.

"I've talked to your uncle, and with my blessing, we're going to give you a job as junior reporter on the *Financial Times*. Garrett Moore has very kindly consented to let you work there, and since you will be paid, you had better do a decent job. It's a wonderful opportunity. Alex is delighted, I may say. He got his start as a young man on a newspaper, and he feels it may do for you what it did for him. He's quite himself again, you'll be glad to hear, full of plans. A heart attack is nothing.

Winston has had two and survived them, and Alex is a good deal younger. Of course the doctors are such fools that the only act of the Socialist government I can applaud was their nationalization. They deserve nothing better. You must remember to thank Alex—he was very anxious for me to find you a berth on the *Financial Times*. He would have made a wonderful journalist himself. Who knows, he might have become England's first Hungarian press lord!"

Brendan rose and walked to the door with me. I noticed he was limping slightly, but I knew better than to ask him about his health, and also knew better than to say I didn't much want to spend the summer working on the *Financial Times*, particularly since I had no reasonable and productive alternative to put forward. I shook Brendan's hand, noticing that he no longer gave his usual strong grip, but merely let his hand rest in mine, as if he were too tired to flex the muscles.

He paused for a moment, his chin thrust out aggressively and his pale eyes staring at me through the thick, blue lenses of his odd spectacles. I thought he was about to give me a final warning piece of advice, or perhaps a stern lecture, judging from his expression, but his mind was elsewhere.

"Retirement," he said, "is a very difficult thing, much more difficult than people think. The end is much harder than the beginning. In the beginning, one is driven by hope and ambition, but at the end it's just a question of how comfortably you can go out, and between the damned tax people at Somerset House and the bloody doctors, you can't even count on much in the way of comfort. Even the greatness of the past doesn't help all that much. In Churchill's case, it just makes it that much harder to go. Once one has climbed the ladder, it's hard to step down—and very easy to fall!"

Brendan laughed, a deep, harsh, throaty laugh that seemed to revive him and bring back some of his strength, though it was without much humor. "Alex loves the applause and the limelight. He has no desire" —Brendan waved toward his study—"to sit quietly reading history, as I do. He has done wonderful things, and wants to do more. Who else could have survived the government's stupid interference over the NFFC loan and gone forth to secure $15,000,000 from America and start all over again? He has the Midas Touch, you see. It isn't that he *needs* money any more. He just gets bored if he isn't making it."

BRENDAN'S INTEREST in my future was something of a mixed blessing. He could do a great deal for me but he had pronounced and firmly held ideas about what my future should be, ideas which my father did not resist, despite a certain lack of enthusiasm on his part, and which Alex agreed with and supported. The "bohemian" aspects of the Korda family charmed Brendan, for as an adventurer and an eccentric himself, he was drawn to unconventional people, but he did not believe I should follow in this path. On this point, he and Alex understood each other very well—like most people who despise "respectability" for themselves, they were much in favor of it for the young. Neither of them had led a conventional life or followed the established pattern of English education, and both of them were determined that I should make up for this omission on their behalf. It had not occurred to either of them that the last thing I wanted to do was to learn about company finances on the staff of the *Financial Times*—a job which would have interested neither Brendan nor Alex at my age, by the way. They wanted me to live a different kind of life from their own, while I envied the glamour and the excitement of theirs. Still, I was in no position to argue; I had no doubt, in fact, that my new car was a reward for agreeing to these plans.

I looked at the people going off to "the City" every morning, each of them with his bowler hat, umbrella and rolled-up copy of the *Times*, and was unable to picture myself among them. But I knew that there I would be, very soon, and even went off to purchase an appropriate hat from Locke's (where I discovered that they are properly referred to as "Coke-hats," not bowlers), and an umbrella from Swaine, Adeney & Briggs on Piccadilly.

ALEXA'S CHRISTMAS PRESENT from Alex, it was rumored, was a shopping center in Canada, which at least had the advantage, as Leila put it, that Alex didn't need to buy any gift wrapping paper. Alex, who had never been interested in real estate as an investment, on the grounds that you couldn't move a building or a lot to Zurich in time of crisis, seemed to be accumulating property on a large scale, influenced by Dowling, or Alexa, or both of them. In the past, he had never paid much attention to the laws limiting the amount of "hard" currency a resident

of Great Britain could possess, but his evasions were less obvious. He explained his frequent trips to Switzerland by arguing that the only way to get rid of a cold was to spend a few days in the mountains. One night he took Garson Kanin and Ruth Gordon to dinner at the Hungarian Csárdás restaurant on Dean Street, having just arrived back from Switzerland that afternoon. "It's wonderful," he told them, "at the first sign of a cold I fly to Switzerland and sit in the mountain air. They also have a new antibiotic they give you, and in two or three days you feel absolutely fine. It's so much better than staying here in bed, sniffing and coughing."

Garson, who was himself coming down with a cold, asked for the name of the antibiotic. Alex reached into his pocket for his pills and accidentally pulled out about $100,000 in crisp, new large-denomination American currency, which dropped to the floor of the restaurant like autumn leaves. A lesser man might have fallen to his knees to gather up the money, but Alex merely signaled the proprietor to have it picked up, and continued with his meal.

What Brendan referred to as "the government's obsession with sumptuary laws" had never prevented Alex from doing what he wanted to with his money, but purchasing property had never been one of his passions. Now, apparently, it was.

In other respects, Brendan seemed to have been right. Alex had recovered much of his energy and optimism, causing the *Daily Mirror* to gush "Now as the pale-faced, cigar-smoking, movie-making mogul plans his next onslaught on the box office, the industry holds its breath." My father was deeply involved in the plans for making *Summer Madness* in Venice, and had even suggested that I join him there at Eastertime; Zoli was remaking *The Four Feathers* as *Storm over the Nile*, and complaining that the process of blowing up all the old action footage to CinemaScope size stretched the camels out until they looked like greyhounds; Olivier was ready to shoot *Richard III*, his most ambitious Shakespearean film; and Alex was making plans to send Anthony Kimmins to Australia, to shoot *Smiley*, a return to his earlier belief in the value of "Empire" pictures.

He was photographed, smiling, with his arm around Alexa, on a brief visit to his new estate in Biot, and even the newspapers reported that he "radiated confidence." He had good reason to, and not just because he had survived the heart attack. His new production schedule was

enormously successful, and represented just the kind of pictures that Alex was most comfortable with—big "international" stars, like Katharine Hepburn, Vivien Leigh and Rossano Brazzi; solid English performers of first-class quality like Ralph Richardson, Kenneth Moore, Laurence Harvey, Eric Portman and Celia Johnson; "bankable" directors like David Lean, Carol Reed, Olivier himself, Zoli and Anatole Litvak (who had made *The Snake Pit* and *Sorry, Wrong Number,* and was entrusted with the delicate task of directing Vivien in *The Deep Blue Sea*). His plans for the future were ambitious and interesting: He was urging Olivier to make *Macbeth;* he was talking to Nancy Mitford about a film version of one of her novels, *The Blessing;* he was developing a script with Ludwig Bemelmans, and studying the possibility of making Shaw's *Arms and the Man* with Alec Guinness. He was not only busy, he was successful, and freed from the burdens of British Lion and its Procrustean loan, he could devote himself to the more interesting task of developing ideas, discussing screen treatments and wooing actors, actresses, writers and directors. In Dowling he had found a financial backer at last who didn't interfere, never complained and shared Alex's own view of what a film ought to be. Dowling himself seemed to radiate optimism on his rare visits to England; perhaps to his surprise, his investment in London Films seemed to be paying off handsomely.

Alex's plans to visit Venice, however, had not materialized. He may have felt no need to visit the crew of *Summer Madness* since Vincent was looking after things on his behalf, either because he didn't want to interfere with David Lean, or because the idea of going to Venice no longer interested him as it had when he was in hospital. On my way from Oxford to Venice, I stopped in London for a few days, and stopped at KPG, to pick Alexa up for lunch. Alex had not yet left for the office—he had slept badly the night before, still disturbed by the itching that was variously attributed to nerves, shingles, and an allergic reaction to soap, but he seemed in remarkably good spirits, under the circumstances, though a little puffier and paler in the face than he normally was. We chatted for a few minutes about Oxford, my father and my trip to Venice, while Alex selected a cigar to smoke in the car. I said he looked better.

"I *feel* better," he said. "I have a new doctor, who is very interesting and helpful. Oh, he doesn't replace Tibor, but he comes to see me from

time to time. Your father strongly disapproves of him, by the way. Of course everyone tells me to exercise, but I don't want to. I can't see myself taking up gulf, for instance [Golf, perhaps because Alex never took an interest in sports, was a word he was unable to pronounce recognizably] though everybody recommends it to me. Douglas Fairbanks has even put my name down for some gulf club or other. But I am too old to learn, and I don't think I want to wear all those funny clothes. When I was in hospital even Winston rang up to urge me to exercise. He said I ought at least to do something with my hands, the way he does, like gardening or bricklaying. But I told him, 'Winston, I *talk* with my hands,' and that was the end of it. Brendan told you about the job?"

I said he had.

"I can tell you're not going to be happy about it. Well, never mind. You have to learn to work some time. Your father was very unhappy when he was apprenticed to be a pharmacist, in fact he threatened to run away, and your uncle Zoltán was even more unhappy when he was weighing baskets of coal as a clerk for a coal merchant. Everybody should start off doing something they don't like. Later on, when you think things are bad, you can always look back and say, 'Well, at least it's better than that!' "

"Actually, I think journalism might be interesting."

"Possibly. I could have asked Beaverbrook to get you something on the *Express*, but I thought you might find that *too* interesting, too exciting. The *Financial Times* is a little dull. That's the right way to begin. Being a journalist is not the best paid of professions, you know. If you intend to be one, don't develop expensive habits. You won't be able to afford them. How are you off for money?"

I admitted to being overdrawn at the bank.

"I see you already have expensive tastes. Here's fifty pounds. That should help out." Alex handed me ten five-pound notes, shouted goodbye to Alexa and walked to the lift, nearly tripping over the dog.

"Damned dog," he said as the lift doors closed, "it thinks it owns the bloody house."

Alexa was still in bed, surrounded by the newspapers and the remains of her breakfast tray. She too looked far better than she had a few months ago, though she was still very thin, and there were circles under her eyes.

"Have you seen Buttons?" she asked.

"He's in the hall. Alex nearly tripped over him."

"I expect that's because Buttons wants his walk. Actually Alex quite likes the dog, but he doesn't approve of him sleeping on my bed. Hand me my robe, and I'll get dressed. We'll take Buttons out before we go to lunch."

Alexa slipped on her robe, and sat down at her make-up table to do her face, with the fierce concentration that women usually summon up for this task. "Alex looks much better," she said. "Did he tell you about Dr. Forgelt? He's this very sinister man, who looks and talks exactly like Willy Maugham, and knows everyone in London."

"What's his specialty?"

"I don't know exactly what Hans' *specialty* is. Gossip and blackmail, I shouldn't wonder. In theory he's a psychiatrist who only deals with the very rich. He has a face like an elegant reptile, and a *great* deal too much charm. No scruples, I imagine. He does injections as well as psychotherapy."

"What kind of injections?"

"I think one is better off not knowing. I had a cold and felt perfectly rotten for weeks, and Max Beaverbrook asked Hans to drop in on me. He looked so evil when he arrived at my bedside that I couldn't make up my mind whether he was going to suck the blood from my neck like a vampire or seduce me, but he gave me an injection, and stayed to dinner, and by the time we sat down, I felt marvelous. My cold felt much better, I was full of energy and completely wide-awake.

"Alex had been quite depressed, but Hans comes round to the house several times a week now, and he's managed to make him much more relaxed and happy than he's been in ages. Hans is always full of the most amusing stories. You know Augustus Meyerman, with the art gallery? He's enormously fat, and looks a little toadlike, so one's always tempted to kiss him just to see if he'll turn into a prince. Anyway, Hans once asked Meyerman—who is *naturally* one of his patients—how he managed to be so successful with women. Meyerman is always surrounded by beautiful women, which is something of a mystery. 'Well,' he replied, 'the trick is simply to keep the testicles cold. The colder the testicles, the longer the erection.' Hans asked him the obvious question, 'How do you *make* them cold?' Meyerman smiled and said, 'That's simple too, my dear boy—you keep an ice pack ready in the bathroom,

and while she's getting ready for bed, you apply it to the balls until she calls out, *'Where are you, my love?'*

"It does make a wonderful picture, doesn't it? Brendan refuses to see him, but he's been to see Churchill, who is apparently devoted to Hans, and actually felt well enough after his treatments to go and stay on the Onassis yacht. Hans says Winston perked up so much he asked Greta Garbo to show him her breasts!"

"Did she?"

"That I don't know. I suppose not. Maybe it runs in the family. Randolph is worse. When he was on the yacht he used to stare at me so hard when I was sunbathing that I bought him a pair of dark glasses and told him to wear them so I wouldn't notice his eyes." Alexa gave her lips a bright stroke of scarlet, pulled off her robe and went into the next room to dress. In her nightgown, she looked even thinner, and I was puzzled to note that the gown itself was not altogether clean—its edges were grubby, and the lace was frayed and torn, an odd contrast to the opulence of her wardrobe and her life.

She returned in a Chanel suit, with one button missing, worn over a blouse that seemed to have seen better days, and carrying Buttons' leash.

As we walked the dog I told her about my previous term in Oxford, and my plans for the summer, and asked her what her plans were.

"Who knows?" she said. "We talked about going to Venice, but I don't really want to go and live in a hotel watching David Lean make a film, and in any case, we're perfectly well off here. I'm introducing Alex to some new people, people who are a little younger than his old friends. I think that's good for him."

"Friends of the good Dr. Forgelt?"

She looked at me rather sharply. "Some of them, yes. Hans is very much in the London smart set. There are a lot of entertaining people around town, and they liven up a dinner party."

"Who are they?"

Alexa looked vague. "You'll meet them. There's George Weidenfeld, the publisher, who gives the most delightful parties in his house at Eaton Place . . . and there's an American photographer who's over here, a friend of Marilyn Monroe's, Milton Greene . . . and there's Johnny Mills, who owns Les Ambassadeurs . . . and a nice man I just met whose father was the best friend of the Prince of Wales."

"That can't be much of a recommendation to Alex. He never thought much of the Prince of Wales. He once told me he'd spent an Atlantic crossing with the Duke and Duchess of Windsor, and sat at the captain's table with them one night. The Duke never said a word, and the Duchess never stopped talking, and finally the Duke leaned over and said, in a very low voice, so as not to be overheard, 'Sir Alex, which do you think is worse: to marry for money or to marry for love?' Alex said that he had very regrettably always married for love, and the Duke looked depressed and said, 'So did I, so did I,' and proceeded to get very drunk. Alex always felt the Duke might have made a good King of Hungary, but was a very bad King for England."

"Well," Alexa said, "maybe, but so what? The point is, Alex needs to see new faces. If he feels well enough, I think we may have a few house parties in the South of France this summer. It's a big house, and it would be fun to have a lot of people there. Will you come?"

"If I can. I'm supposed to spend most of the summer working on the *Financial Times,* but I'm going to Venice first. I'm sorry you won't be there."

"Ah," said Alexa, handing the dog over to Freddy at the door of the house, "I'm not. I'm just beginning to find London fun."

VENICE IS PERHAPS the most imperturbable of cities—it has seen flood, invasion, the rise and fall of empires and tourists of every nation, with the result that the Venetians have little or no curiosity about anything. The one exception is a movie company, the only true international spectacle, as dazzling to jaded, sophisticated Venetians as it is to Fiji islanders. Movie people are seldom aware of the awe in which they are regarded, partly because they're too busy to notice where they're working, and because it's a way of life. When a camera and lights are set up, it attracts a crowd—much as accidents and crimes do.

In a city like Venice, which is small, crowded and self-contained, a movie company is so obtrusive that it completely dominates the inhabitants' attention, from the waiters and the *gondolieri* to the Patriarch and the Communists on the City Council. Rumors had preceded the arrival of the company for *Summer Madness:* that it was a story of unmarried love and the Patriarch of Venice would therefore forbid it, that there would be scenes of indecency, offensive to the sensibility of

Venetians, that shooting the movie would disrupt tourism (an act of sacrilege in Venice) and the *gondolieri* would go out on strike to prevent it. By the time I arrived in Venice all these rumors had proved untrue, and the company was happily installed: One look at Katharine Hepburn was enough to convince anyone that the film would not be erotic (the Venetians gathered outside her hotel to stare and comment on how old and gaunt she was, as compared to Sophia Loren); my father calmed the *gondolieri* by hiring a small flotilla of gondolas, *motoscafi* and barges; and any reservations the Cardinal-Patriarch may have felt were answered by generous contributions to the fund for restoring the Basilica of San Marco, though His Eminence prudently appointed a *monsignore* to accompany the film crew and guard against any indecency. My father dined happily with the Patriarch—after all, he had a family respect for patriarchs—and guaranteed there would be no bare arms or short skirts in and around holy places. Leila remarked that Vincent returned from dinner looking rather like a Cardinal himself, and with a nose of the appropriate hue, the wine cellar of the Patriarch being world-famous.

I arrived in Venice to be greeted by one of Vincent's boatmen, in a gleaming *motoscafo.* He proceeded to give me all the gossip of the company—*gondolieri,* like most servants, are arrogant, cynical and well-informed. *La signorina* Korda, I was told, was at the Lido, with the *bambino,* and there was a boat available to take me there to join them. The members of the company were billeted in hotels according to their prestige and importance. *Signore* Lean in the Danieli, Miss Hepburn in the Bauer Grünwald, because it was the only hotel in Venice with air conditioning and new plumbing, my father in the Grand, Signor Brazzi in the Gritti Palace, and the rest of the crew scattered across Venice in hotels and *pensione,* most of the crafts-union members having first-class accommodations because it was in their contract. The Patriarch had raised objections to Miss Hepburn's being photographed outside San Marco with exposed arms—*una vergogna!* —but had been placated when the scene was reshot with her in a long-sleeved shirt. The biggest problem was the scene in which Miss Hepburn falls into a canal as she steps back to photograph Brazzi's antique shop. Nobody in his right mind would risk coming into contact with the water in Venice's canals, a heady blend of garbage, ordure, mud and putrefaction—let alone plunging into it fully dressed several

times. The health authorities of Venice were anxious to avoid the scandal that would be caused by Miss Hepburn's succumbing to typhoid, skin diseases or dysentery, and suggested that the scene should be shot in a swimming pool. Miss Hepburn herself, having taken a good look at the water in the canal, was anything but enthusiastic about the prospects, but neither Vincent nor David Lean was willing to compromise with realism. Since nobody could say how many times Miss Hepburn would have to take the plunge before Lean would be satisfied, it was decided to lay down a barrier around the appropriate area in the canal, with plastic sheets lowered from barges, and attempt to sterilize the water by pouring in swimming-pool chemicals. This, my *cicerone* informed me, was taking place now.

I signaled him to take me to the spot, instead of the Grand Hotel, and we soon throttled back to join what looked like a small fleet of boats, barges and gondolas, most of the barges carrying generators and klieg lights, while the *gondolieri* scattered chemicals into the canal like well-wishers tossing confetti at a wedding. On the quayside, my father, the *monsignore* and David Lean stood in front of the camera crew, while Katharine Hepburn waited under a hair dryer before a rack of identical dresses. The boats and barges formed a half-circle around them, within which the water had begun to foam like a bubble bath.

I leaped to shore and joined Vincent, who was examining the water with a frown, biting hard on the stem of his pipe.

"Nice to see you," he said. "Look what we bloody have now!" There was no question that the canal presented an extraordinary sight. A vast armada of sightseeing boats was being held back by the police in launches, while the circle of barges and gondolas surrounded a sea of white foam, which was beginning to rise up to the level of their gunwales and send bubbles drifting across the Campo San Barnabà on the wind.

"If you think I'm going in *that,* you're crazy," Miss Hepburn said.

Vincent knocked the ashes from his pipe into the canal and stared gloomily at the bubbles, which were now rising to his feet. "Bugger," he said, "maybe it goes down soon."

But it showed no sign of doing so. Like a science fiction fantasy, the tide of bubbles was now spreading beyond the barges, breaking up as the police launches cut through it, then forming again, even more solidly, in their wake. Already the gondolas were covered in suds, so that

one could see only the carved prows and the gondoliers' hats above the line of bubbles, their ribbons faintly visible above the iridescence.

Lean looked at my father, clearly waiting for a solution.

Vincent frowned. "Vind machines," he said.

Lean and the camera crew nodded at this stroke of genius, and even Miss Hepburn smiled. A quick telephone call was made, and soon a pair of garbage scows arrived in tow, each carrying a wind machine, rather like an old-fashioned airplane propeller and engine with a protective grill around it. A team of technicians anchored them, and soon the engines were howling at high speed, producing a gale-force wind and sending the foam down the canal like a tidal wave. Hastily, Lean ordered the lights turned on, Miss Hepburn backed across the quay and, as the water cleared, fell in backward. A gondolier gaffed her like a salmon, and pulled her in. Lean framed the scene with his hands and called for another take, while Miss Hepburn retired behind a screen to have her hair dried and put on another identical dress. "It still tastes lousy," she said, rinsing out her mouth. "It's like a swimming pool in California, with all that chlorine."

"At least it's safe," Lean said.

Miss Hepburn looked skeptical. "Maybe," she said, "but let's try to get a final take before I drown or die of poisoning. What a way to make a living!"

My father shook his head, sympathetic for once. "She's right," he said. "Vat a bloody foolish business. There's no point to stand around to see the poor woman fall into the canal a dozen times. We go back to the hotel." We stepped into the *motoscafo* as Miss Hepburn fell into the canal for the second time, while *Monsignore,* raising his red-lined skirts, leaped in over the thwart.

"His Eminence," he said, "is going to be very unhappy if all these bubbles wash up in front of the basilica."

Vincent shrugged. "Tell him it's a miracle," he suggested. "Let's have lunch and forget about it."

We anchored at the Grand and sat down at a table on the floating terrace, watching the traffic on the canal and the occasional patches of chemical suds as they floated pass.

"So, what are you going to do with yourself in Venice?" my father asked.

"I don't know. Sightseeing? The Lido?"

"The Lido is quite nice. We have a tent on the beach, and every day Leila goes out. The swimming is good, but the water is a little varm. Better I like Antibes. Anyway, if you haven't been to Venice before, you have to see it. To be here and not to sightsee is a waste of time."

Monsignore agreed vigorously and at length. He himself would provide a guide, and all doors would be opened to me.

"That's settled," my father said, "and Leila can go with you. It's time she had a little culture. All Englishwomen are ignorant. Now I'm going for my siesta."

The next morning, Leila and I set off, accompanied by a Venetian nobleman resembling the midget at the Polo Lounge, lugubriously dressed in black, with a black slouch hat of the kind worn by Aristide Bruant in Toulouse-Lautrec's posters, a neatly trimmed white goatee, a monocle on a black silk cord, a short Malacca cane, gray doeskin gloves and the lapel decoration of a Papal Count and a Knight of Malta. Every door was indeed open to him, and we followed him through the churches, galleries, museums, ballrooms and bedrooms of Venice, wheezing from the dust of decaying *gesso* and gilt, dazzled by occasional glimpses of splendid painted ceilings or gold treasures, exhausted by the size and the silence of these vast, empty rooms, where the only noise was the echo of one's own footsteps creaking on the floors, the hoarse whispers of our guide and the sudden splash of a boatman's oar or the long, sad, birdlike cry of a gondolier giving warning as he reached a blind corner.

We grew used to our guide—a sad and impoverished nobleman, looking like a dwarf *figurant* in a Velásquez painting, who spoke of the glories and secrets of Venice in a melancholy, elegant blend of French and German—and enjoyed drifting down obscure canals so narrow that one could almost touch both sides, to stop at some dark, mossy, ancient flight of half-submerged steps, leading to a splintered door with a grotesque rusted iron knocker, behind which would be hidden another hoard of remarkable splendors. Each *palazzo* was like a secret, hard to find in the maze of canals, unreachable except by gondola, presenting to the outside world a façade of crumbling stone, stained marble and decay which concealed astonishing rooms that seemed to have been kept in darkness for centuries, hidden behind the shutters, draperies and blinds that covered every window.

Everywhere we went, the servants bowed to our miniature *cicerone,*

whose poverty gained him great respect from the Venetians, who admire only money in foreigners and aristocracy among themselves. Family treasures were withdrawn from huge and ancient cupboards for us to admire; elderly priests unlocked small rooms to show us paintings and relics; we admired small hidden gardens of incredible beauty and chapels that seemed to have been cut off from the world for centuries, like islands in an estuary that have been isolated by a change in the tides.

Every afternoon we fled to the Lido, somewhat relieved to get away from this surfeit of sightseeing, pausing to buy a slice of fresh coconut from the vendor who kept a little brass sprinkler that showered cold (and doubtless unhygienic) water on his coconuts to keep them fresh. The long stretch of the beach was empty in these months before the season proper began. The little tents lined up in rows like those of a Napoleonic army, the sand carefully brushed into patterns every day to eliminate footprints, the Adriatic gray and flat and oily, an unappealing and characterless sea. Only the English swam. The Italians sat in their tents and ate enormous meals, while the Germans grimly took their exercise by walking up and down the beach. Leila, who was a strong and enthusiastic swimmer (as a child she had once swum two miles out into the Channel during a storm to reach an anchored battleship of the Royal Navy, where she had been given a tot of rum and sent home in a boat) found the sea somewhat lifeless and missed Antibes. For the sake of the children she very much wanted Vincent to buy a house on the Cap.

"After all," she said, "it's getting hard to stay in a hotel. With small children, it's complicated, and a house would be much easier."

"Surely there's no problem. There must be plenty of houses."

"Yes, but it's expensive. Besides, the real problem is that Alex doesn't see any reason why we can't use the house at Biot, and Vincent won't go there. He doesn't want to stay in somebody else's house, even Alex's—perhaps *especially* Alex's—when it's not being used, and he certainly wouldn't be happy there with Alex and Alexa and *their* guests. He wants a house of his own, where he can live as he pleases, but with all the Exchange Control regulations it's hard to do legally."

"Alex managed."

"But Alexa is Canadian, and anyway, Alex doesn't mind breaking the rules. He feels he's above them. Your father doesn't. And he thinks Alex goes too far anyway."

"Do you?"

Leila stared out at the Adriatic and frowned. "I don't think Alex cares anymore," she said. "He's behaving like a man who has stopped thinking about the future. Alexa is worrying about the future, not Alex. That's why I want us to have a house. There may come a time when Alex won't be here to help and we'll have to start a new kind of life."

"It's hard to think of the Korda family being without Alex."

"Isn't it? I know better than to talk about it with your father, but you have to face the fact that it could happen, and so do I. You've always been brought up to think that there was an unlimited amount of money, but that won't always be true.

"And who knows what kind of troubles Alex will leave behind him? You know, Maria made the most awful fuss when Alex sold the yacht. She believed that the ballast in the yacht was all in the form of gold bars, and that there was a solid platinum door, painted over to look like wood. Now she thinks all that has been transferred to the house in Biot, and hidden away in the wine cellar or the garden. Alex has always enjoyed giving the appearance of great wealth, and he's a very generous man to begin with, so there are a lot of people who naturally presume he's hidden away a vast fortune somewhere, whereas the truth is, as you very well know, that he simply spends it and gives it away. Maria's not going to find any platinum doors in Biot, I'm afraid."

"I don't suppose she'll have a chance to look for them."

"I wouldn't be so sure. She's a very determined lady. If anything ever happens to Alex, she'll have competition, though. There'll be a queue outside the bank to be first to the safe deposit boxes before the Inland Revenue gets there to seal them."

"I doubt if there'll be anything much there."

"So do I. A lot of letters we'd all be better off not reading. But no platinum or gold, I think." Leila pulled her hair back and prepared to go for another swim, an exercise which caused a good deal of excitement among the Italians on the beach, who were astonished by the mad English lady who thrashed miles out to sea in a tireless Australian long-distance crawl, apparently bent on reaching Yugoslavia or drowning herself, unlike everybody else on the Lido, who seldom went deeper into the Adriatic than their ankles, then only with great precautions. She leaned over to pull her bathing cap on. "That's why your father wants you to do well at Oxford and do your best on the *Financial Times*. He wants you settled."

"And out of Alexa's world?"

"Oh," said Leila, "I don't think there's any problem about that. With her new friends, I don't think you'll fit into her world very much longer. Nor will we."

"Why?"

"Not chic enough, I'm afraid. Mind you, I don't regret it, and your father is positively relieved, though he misses seeing as much of Alex as he used to. I must say I quite liked Alexa, but she's become a very hard person, and I don't think they're good for each other anymore. And some of her new friends are very dangerous people. She doesn't know that yet, she thinks they're smart, and clever, and fashionable, and I suppose they are, but she *isn't*. Alex doesn't mind. He's richer, and cleverer and more sure of himself than they are, and in his own way he's far more ruthless. They amuse him. But they'll squeeze Alexa like a lemon, and spit the pips out."

"How?"

"I don't know. It doesn't really matter. Either they'll destroy her marriage, or they'll destroy her, or both. She's just had to grow up too fast. Somewhere inside, there's quite a nice little girl from Canada, and that, you see, is her fatal weakness. There's nothing inside *them* but hard, cold social ambition and respect for money."

"You sound bitter about it."

"Not bitter. I was nearly a part of that world, you see, then your father came along and took me out of it, and just in time. Now I have a son, and another child coming, and I hope many more, and I'm very happy. People with ordinary family lives are much happier than people who want to be special. I learned that. You may learn it—I hope so, for your sake. I think it's too late for poor Alexa. Now why don't you join me for a swim, so we don't disappoint our audience?"

As I swam in Leila's wake—keeping up with her in the water was like trying to keep up with Esther Williams—I thought about what she had said. The kind of people that Alexa was beginning to surround herself with were exactly the kind of people I most feared. I didn't have, couldn't imagine I would ever have, their self-confidence, their glamour, their sophistication. I was tongue-tied and baffled in their presence. I too doubted that Alexa would fare very well among them, though I didn't share Leila's pessimism about her future. At the same time, I didn't altogether agree with Leila's preference for the ordinary.

The Kordas, it seemed to me, were all more or less extraordinary, Vincent most of all; to be an ordinary Korda was a contradiction in terms.

I could well imagine there were some difficulties for Alex among Alexa's new friends. The term "swinger" had not yet been invented, but Alex would not have been one of them. Nor was he "social" in the usual sense, if only because he hated leaving his own house or going to parties, and disliked people who had nothing to do. Alexa's friends bored him, and no doubt the fact that many of them were younger than he was, and bachelors, dismayed him. What is more, she was moving in a social circle on her own, as the young, beautiful and rich Lady Korda, rather than accompanying Alex as his wife. It was an independence that filled Alex with misgivings, and no small amount of jealousy and bad feeling.

It was difficult to imagine Alex easily sitting down to chat with a man like Meyerman, whose sly eyes undressed every woman, and who was known throughout London as "the Nijinsky of cunnilingus"; nor was Alex amused by the company of people who sat up all night talking about parties, and referred to each other by nicknames. Alex was not a man who enjoyed prurience or dirty stories; not that he was a prude, but like Vincent and Zoli, he had a certain puritan streak in public (as unlikely as this may seem in a Hungarian), and a reserved quality which easily passed for courtesy. The labyrinth of Alex's concerns and feelings, his introverted nature and his basic dislike of passion (the least controlled of emotions) must have seemed to Alexa like indifference, when it was in fact the caution of a man who at heart disliked intimacy, and could never share the innermost part of his life with anyone, except his brothers.

VENICE, FOR ALL its charms, could not hold my attention forever; the days there began to take on a certain sameness: sightseeing in the morning, the Lido in the afternoon and a long dinner at night, followed by a cup of coffee in the Piazza San Marco. This was not a disagreeable schedule by any stretch of the imagination, but it lacked excitement, as my father recognized when he complained that I was getting fidgety —a condition he hated and seldom suffered from himself. I knew that some of my friends from Oxford—Jacques Robertson and "Coco"

Brown—were supposed to be in Paris, and I decided to go there on my way back for the new term, a plan which my father accepted with evident relief. Early one morning, I exchanged the comfort of a *motoscafo* for the hard seats and crowded compartments of a third-class train coach, and set off for Paris, via Milan, Domodossola, Switzerland and Lyons, quite happy to be on my own again.

In Paris, I found that Jacques and Coco were not at the George V, where they had told me to look for them—in fact, the *concierge* denied any knowledge of them, in the past or for the future. This was depressing news—I had hoped to drive back to England with them and also had expected to live in their suite. Instead, I was obliged to take up residence in a *hôtel de passe* off the Boulevard des Invalides, where the girls' clients kept me awake all night as they climbed up and down the stairs and bargained about the price. The bed stood in four small metal saucers filled with poisoned water, to prevent insects from climbing up onto the mattress. The ceiling had a mirror angled so that you could see yourself from any position while in bed. The only other resident (the *clientèle* generally left in an hour or so) was a drunken Irish priest who made the night hideous by singing at the top of his voice, and monopolized the one bathroom for hours on end, while the indignant whores banged on the locked door and screamed at him. It was just possible to fall asleep by dawn, but pointless, since the barracks of the Garde Républicaine were across the street, so that by five o'clock one woke to the noise of bugles, hobnailed boots crashing against the parade ground and horses being groomed, walked and shod.

I had read Orwell's *Down and Out in Paris and London* with romantic fascination, but I now felt that I was living it. Not, of course, that I was penniless, but all the same I was down to a very few francs, and reluctant to cable my father for more, having painted for him a dazzling picture of what my stay in Paris would be like with my friends. It is difficult to be bored in Paris, but it is possible to be uncomfortable, as Alex had discovered. I began to feel itchy, and longed for a hot bath. Every night I examined my bed in search of insects, but I could never find them; they seemed to disappear when I turned on the lights suddenly, hoping to catch them by surprise. Possibly I was imagining them, but in that case, why was I covered in bites? One of the girls suggested rubbing myself down with alcohol before retiring, and I tried that, but the fumes were overpowering, and though the bugs may have

been discouraged, I suffered from nausea, which was worse than being bitten.

The girls themselves were hospitable. I sometimes joined them late at night, as they sat downstairs and cooked their supper, while Raymond, the barman who doubled as their pimp, explained to me how the Tour de France was rigged, and kept my glass full. The girls were mostly middle-aged, rather blowsy for my taste, and their meals were both heavy and strongly scented with garlic, an herb which has never been an aphrodisiac for me. They were not attractive whores, as whores go. Their trade mostly seemed to consist of the soldiers from the barracks across the streets, policemen and occasional furtive strangers in dark suits and scarves who were, Raymond assured me, priests in search of a relief from celibacy. "Why not?" he asked. "Are they not men like any others?" The girls were reluctant to interrupt their meals for clients. Each of them arrived for work with a shopping bag full of food, and they rotated the cooking, like firemen in New York City, planning the next day's meal as they ate. They did not seem to be afraid of Raymond. He was nostalgic about his more successful days when he had run a stable of girls in Montparnasse, and made so much money that he had been able to own a car. *"Maintenant, c'est foutu,"* he said lugubriously, observing his overweight employees settling down to a four-course meal. "The amateurs have ruined the profession. How can you compete with girls who give it away for nothing? The whole business has been ruined. Imagine, wives are being told they should give pleasure to their husbands! Before, a man took his pleasure in a brothel, then went home to perform his duty with his wife. A whore can't make a living when every woman is a whore."

On the grounds that somebody might sooner or later arrive in Paris, I went daily to the American Express office and checked to see if there were any messages. There were none. I was therefore surprised when I returned from a walk (I spent my days walking through Paris) to hear from Raymond that I had had a visitor. "You just missed her," he said, "a very beautiful lady who stopped by in a big American car with a chauffeur. She said to call on your aunt, Lady Korda, at the Ritz. Monsieur is related to a *milord?*"

I explained that I was indeed. Raymond seemed doubtful. The lady in the car was not what one imagines a lady of the English aristocracy

to be like, since they are notoriously ugly and badly dressed, are they not?

Not *all* of them, I explained, and quickly ran out into the street to get a taxi. At the Ritz, the *concierge,* raising an eyebrow at my clothes, told me I was expected. Her Ladyship was upstairs in the suite, and had left word for me to come up. Alexa was sitting in the living room, smoking a cigarette and looking out onto the Place Vendôme, a drink in her hand. She was still very pale—evidently she had spent very little time sunbathing in Biot—and thinner than ever, and she seemed somewhat listless, perhaps because she had been far away from the ministrations of Dr. Forgelt and his magic needle. She kissed me (a very aunty kiss on the cheek), and we sat down on one of the Ritz's elaborately elegant sofas. The room was full of flowers and boxes from various boutiques, the only disturbing note in the elegance and luxury being a small, portable steel cylinder of oxygen lying on an ormolu table, with instructions in three languages stenciled on its side, and a neat plastic mask and tube.

"Where have you been?" Alexa asked. "Your father mentioned to Alex that you were in Paris, but he said you were at the George V, and you weren't registered there, so I finally went to American Express, just on a hunch, and they gave me the name of a hotel I'd never heard of. When we got there, the chauffeur was very embarrassed. He said it wasn't the kind of place where a lady would go, and there must be some mistake. Anyway, I did go in, and a woman in a peignoir, with bright red hair, explained that you were out. I left a message with the barman. He was very sweet. He said he wished he'd met me when he was younger, he'd have made a wonderful career for me . . ."

"I expect he would."

"It looked like a whorehouse."

"It is."

Alexa looked at me with new respect. "I told Alex—he's out having his hair cut—it looked like a whorehouse to me. He said, 'Thank God there's one member of the family sensible enough to know what to do in Paris!' " The phone rang and she picked it up, scattering cigarette ash across the carpet. She listened, then frowned. "He's not here at the moment," she said, "but I'm quite sure he'll want caviar as well as the *délices de foie gras à la périgourdine.* If you don't have enough, send somebody over to Fauchon's and buy some more. Did you get the place

cards and the table setting?" She nodded and lit another cigarette. "I'll tell Sir Alexander it's in order then," she said. "No, this is *not* his secretary, it's *Lady* Korda!" She hung up, with a bang, and poured herself another vodka, from a well-stocked bar.

"Stolichnaya Moskovkaya a hundred proof," she said. "Somebody from the Soviet Embassy sent it over."

"They're sending caviar too?"

"No, no caviar. The caviar is for dinner tonight. By the way, I want you to come. Alex is giving a dinner party for forty people, and I was hoping to find you in time for it."

"What's the occasion?"

"No occasion, except to celebrate our arrival in Paris. We came up here quite suddenly, and when we got to the Ritz Alex began to phone around to see who was in town, and it turned out that Larry and Vivien were here. Well, they had asked Garson Kanin and Ruth Gordon to have dinner with them, and Gar had suggested they have dinner at LaRue's, for old time's sake. It's not as good as it used to be, but it's still the prettiest restaurant in Paris, and they thought it would be nice if the four of them were to eat there.

"Well, Larry invited us to join them, and Alex said we'd love to—though as you know I adore Larry, but Vivien always makes me very nervous because you never know what she's going to do next. So we were six for dinner. Then Alex started to call more friends. He called Marcel Achard, and of course Marcel wanted to join us, so he called Larry back, and Larry said he'd be delighted, then he called René Clair, and René wanted to come, and Noel Coward, who's in the hotel, and who adores Larry, and finally Alex had found so many people he wanted to see that he had to telephone Larry and explain that the dinner was on *him*.

"So we started with a simple dinner for six, and now we have forty people, and Alex has taken over LaRue's for the night. He's worked out a menu with the chef, and a seating plan, and found a calligrapher to make out place cards, and sent a man from the London Films Paris office over to the flower market to fill the restaurant with flowers, and the chef has made a cake with pictures of Larry and Vivien on it in icing, and I've been all over Paris buying things to wear tonight. Do you have a blue suit?"

I shook my head.

"There's just time to buy yourself one. Take some money and run. And get yourself a white shirt and a nice tie too. And a pair of black shoes. You can wash and shave in the other bathroom when you get back." Alexa handed me a wad of thousand-franc notes, several hundred dollars' worth, and waved me to the door.

"Don't you think you'd better cut back on the vodka?" I asked. "It's going to be a long evening, I should think."

"I think so too, that's why the vodka. It steadies the nerves, and I know when to stop. I wasn't cut out to be a hostess, you know. I'm going to finish this, have a very hot bath and take a couple of pills, and I don't need any smart advice from my nephew. Save it for the girls in the whorehouse. Now get moving, love, and get yourself dressed so we can all be proud of you. You may as well get rid of what you're wearing. That jacket looks as if you've slept in it all the way from Venice."

"I did."

"It sounds like fun," Alexa said, almost wistfully. "I used to do that kind of thing too."

"You still could."

"Don't be an ass. I'm Lady Korda now. I can't go around hitchhiking, can I? Now scram, my maid is coming up, and you've got shopping to do."

It is not easy to buy a suit in Paris in the late afternoon, but one of the lessons of life is that you can do anything if you have cash in hand. When I returned to the Ritz I was wearing a dark-blue suit, a white silk shirt, a tie from Sulka and a pair of new black shoes, and carrying my sports jacket and corduroys in an elegant suitcase. The *concierge* greeted me with new respect, and took my suitcase up to a bedroom which Alexa had thoughtfully taken for me, on the same floor as Alex's suite. When I knocked on the door of the suite, it was opened by Alex, looking ebullient and remarkably healthy, and dressed in a Charvet silk dressing gown over his dark-blue trousers and pale-blue silk shirt. In one hand, he held a cigar, in the other a clutch of telegrams, and since his return the room had become cluttered with his presence: There were, scattered on the floor, copies of *Time*, *Newsweek*, the Paris *Herald-Tribune*, the *Times*, the *Telegraph*, the *Express*, the *Financial Times*, *Le Monde*, *Figaro*, several German and Swiss newspapers, packets of books from W. H. Smith on the Rue de Rivoli, half a dozen scripts,

a number of manila envelopes marked "Confidential-Urgent," a small Maillol bronze (with the price ticket still on it), several dozen art catalogues and a bottle of Dom Pérignon in an ice bucket. In the far corner of the room, a secretary from the London Films office on the Champs-Elysées sat, her dictation pad in her lap, pen poised, with a glass of champagne beside her on the desk.

"So," he said, "how is life in the brothel?"

I sat down, while Alex walked around the room, his mind still on whatever he had been dictating. "Find out when is the date of the Berlin Film Festival. I want to go this year. I haven't been in Berlin in a long time"—he spoke to me, as much as to the secretary—"and I would like to go again. It was a wonderful city in the twenties. I remember I saw one of the first experimental 'talkies' there, in 1923, I think. There was no dialogue, you understand, but in one scene there was a barnyard, and you heard all the noises of the poultry and the pigs. It sounded very natural—after all, I was born on a farm myself, so I know what chickens and pigs sound like—but I couldn't see the future in animal noises, and neither could anybody else. Remind me to write to Zoli. I want him to go with me. We will visit Berlin together. What a lot of memories! But of course it's different now."

Alex shook his head, added a little champagne to his glass and sat down. "I'll see you tomorrow," he said to the secretary. "Finish your champagne."

She lifted her glass, toasted him and emptied it. "Ah," she said, "Sir Alexander, this is very nice. You ought to come to Paris every week!"

Alex smiled and winked at me. "You see, I'm getting old. Twenty years ago she would have said: 'Come every day!' "

"How was the South of France?" I asked.

"The South of France? It was quite nice, but I got bored down there. Too many houseguests. On the yacht one could only have a few at a time, and it's hard for people to drop in on you for lunch or dinner when you're at sea. Besides, I wasn't feeling very well, so I decided to go back to London, and make a stop here. I think I caught a cold in Biot, or perhaps something in the food. But I'm better now, much better. Paris always does that. Before I forget—you had better have some money to get you back to Oxford. You don't have to tell me that you're broke, I can tell. I've been broke in Paris myself, much more broke than you'll ever be. I remember I used to stand outside the

student restaurants in Montparnasse, not even the *restaurants de luxe,* you understand, and *imagine* what it would be like to go and have a meal. I used to look at the menu and think about what I would order if I had five francs, and choose all the things I would eat, and the wine, and then walk on to the next restaurant and do it again. Now, go off next door and tell your aunt to hurry up, or we'll be late for this damned dinner party. Where did you get the blue suit?"

"Here in Paris."

Alex lifted an eyebrow. Evidently Alexa had not told him about my last-minute purchase, or the fact that she had paid for it. "Somehow," Alex said, "it *looks* French. I love France, but French tailors always get things slightly wrong. You should have waited until you got to England to buy a suit."

I went next door, wondering, as I often did about Alex, just what he was thinking. He was seldom critical, but there was frequently a streak of irony in his remarks, like a small, visible reminder of a larger and deeper hostility that lay concealed beneath layers of politeness, generosity and affection. These flashes of irony reminded me of ice-fragments in the sea, little points which seem inconsequential, but which may in fact be the tip of a vast iceberg weighing thousands of tons, hidden beneath the surface of the water. It was the hostility of a man who was too intelligent and perceptive for his own comfort, and at this stage had decided to settle for appearances, rather than confronting realities.

I poked my head into Alexa's room and told her to get cracking. She was sitting at her dressing table, examining her pharmacopoeia.

"I'm almost ready," she said, shaking a couple of blue capsules into her hand.

"Happy pills?"

"Yes, and why not? Farm girl becomes dazzling hostess."

"What brought you back from the South of France?"

"Curiosity killed the cat. Alex wasn't feeling well."

"He said he caught cold."

"Maybe. I think it was something more serious than that. He wanted to go back and see a doctor, anyway. He had a good deal of pain, and some difficulty in breathing."

"The heart again?"

"I imagine so. Not a heart attack, but something. He's very brave about it, and absolutely refuses to complain, but I think he has a lot more pain than he's willing to admit."

"How were the houseguests?"

"Not a great success. That's another reason for going home. Everybody played cards for hours on end. It was like living in a casino. Meyerman was there with the ex-wife of an American television millionaire he's hoping to marry, one of those fifty-year-old ladies who looks as if she's been crisped like a piece of bacon and had everything lifted. Alex hated her. He said she had a voice like a buzz bomb. Meyerman got on his nerves too, always trying to sell him New York School paintings, which Alex hates. You know how Augustus' eyes bulge when he's excited? His new lady was watching him talk to Alex, and she told me that when Augustus makes love he gets so excited that she has to push his eyes back into place with warm spoons. Do you think that's true?"

"Maybe. They *do* bulge a lot."

"When I told Alex, he said he couldn't care less so long as he didn't have to eat soup out of the same spoons. Anyway, he's had enough of Meyerman and enough of Biot, so we're going home."

"Is Moura coming tonight? I noticed there's vodka everywhere."

Alexa looked at me sharply, and frowned. "No," she said, "Moura isn't here. We don't see as much of Moura as we used to, as a matter of fact. To tell you the truth, I think she's become just a little too *pushy.*"

She stood up, whirled around once to see that her dress was hanging right, picked up her fur and walked into the drawing room to kiss Alex, who was putting on his jacket with some difficulty, not from any physical cause but simply because he was used to having a valet do it for him.

"Ah," he said, beaming at Alexa, "the Balenciaga. Very lovely! Now we go."

We made our way down to the hired car, and I couldn't help thinking that once again Alexa was cutting herself off from her own past. Moura had known her before she was Lady Korda, had in fact been at least partly responsible for introducing her to Alex. Was Alexa merely ungrateful, or was she anxious to put up a barrier now between herself and those who had known her before? In any event, she and Alex seemed happy enough as they drove off to dinner, holding hands in the back seat of the car. "You know," said Alex, "it's like old times."

CHAPTER 11

~~~~~~~~~~~~~~~~~~~~~~~~~~~~~~~~~~~~~~~~~~

THE SUMMER of 1955, however, was not like old times at all. It was not just the absence of the yacht—Alex seemed to have lost interest in the South of France, and for the first time in as long as I could remember, had no plans to go there. I had not met him during the spring, having been fully occupied at Oxford, and I remembered him as I had last seen him, smiling, happy and surrounded by his friends at LaRue's, with Vivien on one side and Alexa on the other. Early in June, he went to the Berlin Film Festival, taking Zoli with him, and without Alexa. Perhaps he wanted to enjoy a nostalgic visit and felt it would be easier to remember old times without her; more likely she herself had no wish to go on a trip with Zoli as a companion.

It must have been a curious journey. Whatever news Alex's doctors had given him, it was evidently not good. Zoli was charged with the duty of making sure that Alex was back in his hotel by ten o'clock at night, and complained that Alex interpreted ten o'clock elastically, and felt he had obeyed doctors' orders if he managed to get to bed before midnight. There was undoubtedly an element of *Schadenfreude* involved—for years Zoli had been saying that Alex was ruining his health, and now he had at last been proved right. Zoli, who had been a semi-invalid for nearly forty years, was now in a position to look after

Alex. It must have been difficult to play nursemaid to his elder brother. For decades Alex, like everybody else in the family, had referred to his middle brother as "poor Zoli," but now Zoli was charged with caring for "poor Alex."

What an odd pair they must have made in Berlin: Alex reluctantly returning to the hotel at just the time when he was usually feeling his best and ready for fun; Zoli with his packaged seaweed, his suitcase full of medicines and the harness for hanging himself from clotheshooks to stretch his spine. Vincent sensibly refused to go. He had no fond memories of Berlin, and his own rude health and powerful constitution could only irritate his brothers.

I do not think I truly realized how sick Alex was until I heard that he had been ordered to bed by ten o'clock as a condition for going to Berlin. Alex had been asked to give up cigars, and had refused, he had been told to eat sensibly, and continued to do as he pleased, but the notion of his agreeing to go to bed early was unthinkable—normally he did not even sit down to dinner much before nine at night, and he seldom retired to bed before one or two in the morning. If he felt obliged to obey his doctors in this one respect, he must be very ill indeed.

All the same, he managed to work in Germany. Deutsche London Films G.m.b.H. was one of Alex's most successful (and least-known) ventures. He had always believed that Germany would be a major market for British films, even in 1945, when prejudice against the Germans and the chaotic ruin of Germany itself discouraged most film producers from investing there. Alex, who had disliked the Nazis as much as anyone, and with good reason, nevertheless retained a great fondness and understanding for the Germans—after all, his first great successes had taken place in Austria and Germany; he had learned his craft in Vienna and Berlin; and German was still his second language, one which he spoke, wrote and read better than he did English. He made Deutsche London Films an independent company—through it, he took over the German distribution of *Moulin Rouge,* for example —and he was soon in a position to use DLF's profits to finance European films, including John Woolf's *I Am a Camera.* Through his foreign companies, Alex financed or co-produced countless films on which his name and the London Films logo never appeared.

In Berlin he made further plans for co-producing, but his discussions

were broken off every night at ten, when Zoli would tap his watch significantly. Alex would then excuse himself with a wink, implying that he was on his way to an assignation, and together the two brothers made their way to the waiting car to return to the hotel, where Zoli drank his cup of tea and Alex took his nightcap of Vichy water and two sleeping pills. He looked around the lavish suite—no doubt remembering the days when he had lived not far from here with Maria, then at the peak of her beauty and stardom, and dined at Horcher's and the Adlon, and made and lost a fortune in the inflation—and said, "How odd it is to be sharing the best suite in the hotel with my brother, instead of a beautiful girl!"

Nevertheless, film festivals cheered him up. He had insisted on attending the Cannes Film Festival in May, with Alexa, and was not surprised when *A Kid for Two Farthings,* his entry in the festival, failed to receive an award. After all, he pointed out, the entire jury consisted of his friends, including Marcel Achard and Marcel Pagnol, and they could hardly be expected to vote for him, since they would be accused of favoritism. "Only my enemies are on my side," he said to a reporter from the *Daily Express,* and to make up for not winning he gave a magnificent party, with a magnum of champagne and a tin of caviar at each table, thus outdoing the Soviet government, which celebrated several awards for Russian films with a party where the caviar ran out early in the evening and the guests only received one glass of sweet Russian champagne each. Alex wore full evening dress, and Alexa wore a full-length ball gown with her emeralds and elbow-length white kid gloves, greeting the guests in the receiving line like a member of the Royal Family. Alex danced in turn with Olivia de Havilland, Dawn Addams and Grace Kelly, remarking to somebody who inquired about his health, "Nobody can be expected to go to bed early at his own party."

Berlin was "less gay," partly because of the very nature of the city and the festival, partly because Alex's energy was ebbing fast. Cannes had exhausted him, and he was determined to husband himself at Berlin. He had been tempted by the possibility of a journey to Hungary, and the Hungarian government was eager to arrange a lavish visit in his honor, but Alex was reluctant to accept the hospitality of the Stalinist rulers of Hungary, and suspected that any visit he made would be turned into Cold War propaganda. He had not been in Hungary

for thirty-five years, and while the notion of going back to see his roots as a private person appealed to him, he had no desire to go as the public guest of Comrade Rákosi, or have the old stories about his friendship with Béla Kún and his involvement with the Hungarian Soviets brought up again.

Vincent had gone back briefly, in the 1930's, to examine the new Budapest film studios at the request of Admiral Horthy's son, Nicholas. He had enjoyed his visit, until a police officer arrived requesting him to appear immediately before the Regent himself. Remembering the days of the White Terror, Vincent packed his bags and ordered the *concierge* to get him a seat on the next train for Vienna. Alas, the *concierge* told him, the next train was fully booked up; there were no compartments available in first-class at all. Doubtless tomorrow it would be possible to obtain a seat on the wagons-lits . . .

Vincent explained that he could not wait, and was perfectly happy to take a third-class seat, and managed to convey the urgency of his request to the *concierge*, who telephoned the station and ordered a taxi. When Vincent reached the platform, his relief was dispelled by the sight of Nicholas Horthy, the Regent's son, appearing at the ticket gate with a colonel of the police in dress uniform, and a small troop of policemen, all of them fully armed. Assuming they had come to arrest him, he began to climb the steps of the third-class carriage, but Horthy ran over and gently pulled him down. "I understand what must have been going through your mind when you were asked to appear before the Regent," he said, "but believe me, my dear Mr. Korda, His Excellency only wished to invite you to tea!"

Vincent thought about this for a moment, and realized that it was quite possibly true. Nevertheless, he was not eager to stay—a man who could order you to tea could also order you to prison. He firmly stated his intention of returning to Vienna.

Nicholas Horthy shook his head sadly. He quite understood, and there would be no problems. It was a pity, since Hungary was now very different from the bad old days of the White Terror, and the Regent himself was ashamed of the excesses of his supporters. However, if Mr. Korda wished to leave, there would be no problems. All the same, it was not possible that a distinguished Hungarian artist and film maker should leave Hungary traveling third-class.

Vincent pointed out that there were no first-class compartments

available, but Horthy raised his hand to silence him. There would be no problem for the honored guest of the Regent's son. The train would be held until the matter was cleared up and a comfortable first-class compartment was found. He whispered a few words to the police colonel, who ran off with an escort of armed policemen, and in a few minutes (while the Vienna express waited, and Vincent and Nicholas Horthy chatted stiffly on the platform), the colonel returned, saluted and reported that a compartment was now available. A policeman picked up Vincent's bags. He was ushered into his private compartment. Nicholas Horthy shook his hand. The colonel and the policemen saluted. The conductor blew his whistle, and the express moved out of the Budapest station.

A few minutes later, when the ticket collector knocked on the door, Vincent asked how it had been possible to find a compartment for him so quickly. "Ah," said the ticket collector, "no problem at all. The colonel went down the list of first-class passengers until he found a Jew, and the policemen threw him out with his baggage to wait for the next train. If your Excellency requires something, please ring."

Since that brush with the "new" Horthy, Vincent had never been back, and neither Alex nor Zoli had been tempted to go. Alex talked about it, but I think he preferred his memories of Hungary to its reality, and perhaps he also feared that visiting Hungary at this late stage was like writing *finis* to his life, coming full circle, as it were, returning to his origins. Besides, his memories of Berlin and Vienna were happier ones. He did not need to be reminded of poverty or terror. It was more pleasant to remember the good old days in Berlin, with Maria in her furs, the big limousine waiting on the Ku-Damm and the endless parties . . .

I WAS NOT present at these festivities, having begun my reluctant apprenticeship as a financial journalist at the beginning of the summer. I felt very much a stranger—even an imposter—as I made my way deep into the City every morning, in my dark suit, my stiff collar, my bowler hat and my R.A.F. tie. I was dressed like almost everyone else in the crowd, but for that very reason I expected to be unmasked like a spy in foreign uniform. Nor was I at ease in the editorial offices of the *Financial Times*. To put it mildly, I was not welcome there, partly

because I had been placed on the staff as a temporary worker by Brendan and Garrett Moore (as Lord Drogheda preferred to be called), and was therefore regarded as a management fink, partly because I had overestimated the sartorial qualities necessary for the job, and looked more like a prosperous stockbroker than my journalist peers, and above all because *they* were working for their bread and butter, while I was not. My immediate superior, a portly man with ink-stained fingers, a baggy gray suit and the natural belligerence of a journalist, took me to lunch at a pub on my first day, and explained that he had fought long, hard and unavailingly to prevent my joining his staff, and that he had surrendered with the worst possible grace and very grave doubts. I pointed out that his doubts were no greater than my own, and that I had as little desire to be working on the *Financial Times* as he had to have me there, and intended to escape at the first possible opportunity.

He digested this for a few moments, then offered me a cigarette. He was relieved to discover that I was not, as he had feared, an ambitious protégé of the owners, but merely a temporary captive of Lords Bracken and Drogheda. I had no designs on anybody's job, and was determined to fail in any way that was open to me. "You have to understand," I said, "that I haven't the slightest desire to write brilliant pieces that will astonish the editor. I don't suppose I could do that even if I wanted to, but the point is, I don't *want* to. I am here to prove my lack of talent for the job. I don't want to do anything spectacular or disgraceful, mind you. Just a good, steady failure will suit me fine."

He nodded thoughtfully at this, and the next day I was sent off to interview, of all people—the then Chancellor of the Exchequer, Harold Macmillan, who was giving a press conference. It is possible that my assignment was a mark of the low esteem in which Mr. Macmillan was then held, but it was, at the same time, a perfect opportunity to fail, since I had been told that I must get the Chancellor to say something exclusive for the *Financial Times.* Given the press of seasoned journalists, my own inexperience and shyness and the fact that I hadn't managed to work out either what I would ask him or how I could possibly hold a notebook, my pencil and my damned bowler all at the same time, I seemed very likely to come back with nothing. Nor had I understood a single word of his speech—perhaps because he hadn't either. Since Macmillan's eyes, which startlingly resembled those of a near-sighted old spaniel, looked outward in two directions at once, I was

unable to catch his attention to ask him anything, and I was in any case elbowed out of the way by bigger, more self-confident journalists who pushed themselves forward and shouted at him. He seemed unwilling to say much, until one of his eyes accidentally focused on me, and he pointed toward me. "Haven't I seen you before?" he asked.

Numbly, I pushed forward and admitted that he had, at a dinner party at my uncle Alex's.

"Of course," he said, "you're Alex Korda's nephew. What on earth are you doing here, dressed up like that?"

I explained that I was a neophyte reporter for the *Financial Times.*

"Come over here," the Chancellor said, beckoning me close to him, to the rage of my colleagues. "Do you have any questions to ask?"

"Actually no," I replied. "I don't really *know* what to ask. I haven't a clue."

Mr. Macmillan sighed and shook his head. "That won't do, you know," he said, "Brendan and Garrett won't be satisfied with that. I tell you what, for Alex's sake, here's something you can use. You can say that we expect an improvement in the balance of payment figures for next month. Fair enough? Now run along. I have to talk to the other gentlemen of the press, and I promise not to mention this to them. And give my best to Alex."

I walked back to the office, and sat down at my desk, not knowing quite what to make of this comment. I had been told to "write it all up," but I hardly even knew how to begin. My superior, seeing me staring at my typewriter, my bowler hat still on my head, took pity on me and came over.

"Did you ask him anything?" he inquired.

I nodded.

"Did he say anything?"

I nodded again. "He said that he expected an improvement in the balance of payments for next month."

"He said that to *you?*"

"Exclusively."

"But that's a *scoop!* It's a *story!* We'll have to run it! I thought you wanted to fail."

Shamefully, I realized that I had accidentally betrayed his confidence in me, and undermined my own plans. "I didn't *mean* to," I explained.

"Damn," he said, "you'd better let me write the bloody thing," and sat down to do so.

As a result, I was congratulated by Brendan (though my faith in Macmillan, and Brendan's faith in me, were badly shaken when the next month's figures failed to show any improvement at all), and my superior wisely took steps to ensure that I would not be heard of again by assigning me to write an in-depth piece on the economics of manufacturing long-playing record liners, thus getting me well out of the way into the suburbs of London, where I spent hours getting lost on the buses and took pages of impenetrably dull notes on the cost of color printing, the mechanics of lamination and the price of glue. Every time I came back to the office, my notes were carefully examined, and I was sent out into the streets to "get more facts." The manufacturers of liners—most of them small businessmen who subcontracted for the large record companies—were very soon as fed up with me as I was with them. As I pursued them relentlessly I gradually fell into obscurity so far as the management of the paper was concerned, like a foreign correspondent who has been abroad for too long in a dull and unimportant part of the world. My initial scoop was forgotten. My presence, which was rare enough, threatened nobody, and my colleagues gradually began to relax when I was around, and even invited me out for the occasional drink. On the whole, I liked them, but I hadn't the slightest desire to follow their profession.

It was noticeable, however, that many of them did not share the general admiration that was usually felt for Alex and the Korda saga. As financial journalists, they saw his career from a different, harsher point of view. They were not interested in his films as much as they were in his legendary ability to charm money out of empty safes. They saw his career as a quasi-criminal epic in which Alex played the dashing foreign adventurer, and the heavy-jowled, solid men of the City were represented as helpless, infatuated victims. After all, when the Prudential's marine business declined in the thirties, who but Alex could have persuaded that vast, cautious and unromantic firm to invest in a movie company, and to go on investing, year after year, as the costs escalated and the profits failed to appear?

They told the story of how John Woolf had gone to Alex to borrow 50,000 pounds to begin a movie, and Alex had told him, "Never ask anyone for 50,000 pounds—you'll never get it; ask me for 500,000 pounds to begin a whole production program and I'll find the money for you in no time."

They remembered the time when Alex had been called to a grim

meeting of the Prudential's board of directors to explain the losses of
London Films, which were already close to 1,000,000 pounds, with
Denham Studios not even completed. They had expected Alex to be
defensive, to offer excuses; there were several members of the board
who were "out to get the foreign bastard," and in general the atmos-
phere was that of a hanging jury. Alex entered the room, sat down at
the boardroom table, rubbed his eyes in a gesture of complete exhaus-
tion, asked for a glass of cold water, took a couple of pills, and in a low,
tired monotone proceeded to confess to the directors that he was a
failure. He apologized for his incompetence: Perhaps he had bitten off
more than he could chew in Denham. He had managed their money
badly, some might even say irresponsibly. He had relied upon bad
advice . . .

On and on he went, giving a hypnotizing performance of guilt,
humility and shame, describing in detail the many ways in which he
had made mistakes, exceeded his budgets, picked the wrong person for
a job or spent the Prudential's money unwisely. His audience, even
those who were hostile, sat spellbound as he told of the difficulties of
film production, the need to wait for the right weather on location, the
temperaments that raged on any movie set, the excessive demands of
stars, writers, directors, the impossible lunacy of the whole business. He
himself, he told them with a weary gesture, was fed up with it. He had
failed. There was no getting away from that, but he could continue no
longer. It was a mad, mad business. He would be better off retiring to
some quiet spot to write novels. Who knew? Perhaps even poetry—to
cultivate his garden, to learn Greek. He could not, in all truth, expect
the Prudential to forgive him, but they could at least release him from
this servitude, let him go. He would help them find a replacement,
someone younger and more competent. He owed them at least
that . . .

At the end of an hour, the directors of the Prudential were begging
him to stay on. They pleaded with him to take heart, they lavished
praise on his films, they dismissed the losses as the inevitable difficulties
inherent in starting any new business on an ambitious scale; in the end
they "persuaded" Alex to continue as the head of London Films, and
sent him off with a vote of confidence and a further million pounds of
the Prudential's money.

The older financial reporters well remembered Alex's long embroil-

ment with United Artists, in which he had begun as a partner without making any investment, and ended by receiving $950,000 for shares that had cost him nothing at all. There too, Alex had escalated the value of his stock by refusing to set a price on it. Politely and with many apologies, he waited until the other partners in UA made an offer, then he hesitated until they came back with a higher offer, and then delayed again, at last making them so impatient that they began to increase their offers to him in an effort to find out just how much he *would* accept. He remained calm while they became hysterical, refusing to set a firm price, and sometimes denying that he wanted to sell at all. At one point, he had even persuaded Lehman Brothers, Kuhn, Loeb & Co., the Rothschilds and Prudential to put up "a package" of $4,-000,000 so that he himself could buy out the partners and take over United Artists with Sam Goldwyn, as an alternative to their buying him out—a proposal which was later increased to $6,000,000, and failed only because Mary Pickford pointed out that neither Goldwyn nor Alex was putting up a single cent of his own money, and Chaplin would not accept less than $2,000,000 in cash for himself.

Alex's ability to control events, despite his minority position, was amply demonstrated when Jock Whitney and Sam Goldwyn attempted to finance a new attempt to take over UA, and sought the help of Oscar Deutsch, the owner of the powerful Odeon group of cinemas in England. Neither Goldwyn nor Whitney had included Alex in the deal, and when Deutsch made the rounds of the banks and underwriters, he was informed that "Prudential is seemingly so powerful that no group would furnish money if Prudential was not in accord, and evidently Prudential will not be in accord unless Korda is taken care of." Since Goldwyn and Whitney had not intended to "take care of Korda," the Prudential refused to take care of them, and the takeover fell through, leaving the partners with their original problem of finding out how much it would cost *them* to "take care of Korda." Who but Alex could have persuaded the Prudential to demonstrate this kind of loyalty, at a time when Prudential was reporting that its only hope "as principal creditor of London Films" was to "put the company into liquidation and to make arrangements for the occupation of the studios with some entirely fresh group"?

In the end, Alex might have held out for far more than $950,000 for his shares in UA, but for the intervention of an unexpected third

party in the form of the U.S. Department of Justice. While still a partner and co-owner of UA, Alex had accepted the task of running M-G-M's production company in Great Britain, so that the partners of United Artists woke up to discover that 25 percent of their company was owned by a man who was now an employee of M-G-M. They were aghast at the possibility that Alex might become a Trojan Horse for Louis B. Mayer, and the Department of Justice was quick to inform Alex that the United States government could only look with disfavor on the prospect of "an employee of one of the giant film companies owning a quarter interest in the only independent distributor of consequence in the business." In the end, pressure from the Justice Department forced both parties to agree. The partners of UA offered Alex $950,000, and he graciously consented to accept their offer, the alternative for both sides being an anti-trust suit on the part of the United States government. Since Alex had never had to pay for his original UA shares in 1935, he made a profit of nearly a million dollars on an investment of zero, a financial coup which is almost unique in the history of the motion picture business.

But not unique for Alex. When he was in financial difficulty in 1939, having exhausted his sources of financing in England, he flew to America with a rough print of Zoli's *The Four Feathers*. With this one film as collateral he obtained nearly $4,000,000 in production money from the Security National Bank of Los Angeles and the Bankers Trust Company of New York, a feat which cannot have been easy, coming as it did on the heels of Denham's failure, and considering that Alex was not only Hungarian, but also an Englishman appealing for money at a time when many Americans assumed Britain was about to be defeated by Hitler.

Nor had Alex lost his touch, despite age and ill health. These past triumphs were eclipsed by his recent maneuvers. Had he not bounced back from the liquidation of the 3,000,000-pound loan to British Lion by arranging for $15,000,000 of new financing from Dowling? Even now he was announcing plans to produce no less than twenty-six feature films for release on American television at 65,000 pounds apiece, in partnership with NBC, which would naturally finance the production costs, for a total of nearly 2,000,000 pounds! This ambitious scheme was in fact realistic. NBC had already paid Alex $500,000 for the right to premiere Laurence Olivier's *Richard III* on the NBC network, and

Alex had already founded two new companies to undertake television production, and sought financing with the giant Zenith Radio Corporation, in Chicago, for a world-wide cable television production company.

At the same time, true to his belief that the future lay in "small screen at home, large screen in the theaters," he had purchased the Eastern Hemisphere rights to Cinerama, having tried out Paramount's VistaVision on *Richard III* and decided that it was "an inferior process." He had sent Vincent to examine the various competing systems of "3-D" projection, and Vincent wisely reported that nothing would come of any process that required the audience to wear colored plastic glasses. Vincent was even more emphatic about Mike Todd's experiments in "Smell-O-Vision," in which an orange was sliced to the accompaniment of a chemical orange smell so acrid, bitter and strong that the audience fled from the screening room in tears, covering their noses with handkerchiefs and gasping for fresh air. "Think what it would do for garlic or a fart," he said, and Alex sensibly decided to sidestep this particular advance in film making.

All the same, he was putting together a dazzling list of partners and backers: RCA, NBC, Cinerama, Zenith, the City Investment Corporation of New York. For a man of sixty-two who was just recovering from a heart attack it was a remarkable comeback. But his whole life was a series of comebacks. He had become a rich and famous man in Hungary, only to have to flee from the White Terror and begin all over again in Vienna. He had arrived in Berlin almost penniless (but in grandeur, as always), and once again rose to the top. He had failed in Hollywood, his savings lost in the Crash, his marriage ended in an expensive divorce, only to reach the very peak of his career in England with *Henry VIII*.

In a letter to his old friend Biró, during the depths of his despair in Los Angeles in the winter of 1928, he had written: "I read in Swift, at the beginning of one of the Gulliver chapters, *'Having been condemned by nature and fortune to an active and restless life . . .'* And in this accursedly *active* and even more accursedly *restless* life of mine, you can imagine in what terrible loneliness I'm living." Restless and active Alex remained, and it was perhaps not altogether an accident that he found in Gulliver an apt description of himself. He had nursed the illusion, even then, that he wanted peace and quiet—as he put it to Biró, "I have plans, the great dream, the little dream, a motor tour

in Europe and life somewhere on the Mediterranean, after all, that is
the real world, the rest is just colonies," but the "great dream," of
success, wealth, fame, control still pursued him, even when the "little
dream," in the shape of his house at Biot, was available to him when-
ever he wanted to take it.

Power fascinated him. Despite his appetite for pleasure and his
capacity for relaxation. He was a man of paradoxes, who hated publicity
and still became famous; who loved leisure, but plunged himself into
endless work; who despised money for its own sake, but had a natural
gift for making and spending it. Financial matters bored him—he
considered himself an artist—but he had long since become a financial
manipulator on a grand scale, exciting even to such connoisseurs as my
colleagues on the *Financial Times*. He was courteous and ruthless,
charming and unforgiving, quiet-spoken but hot-tempered, immensely
receptive toward other people's ideas but quick to suggest better ones
himself. Once, when he was asked the secret of his success, he replied
that he simply put aside one hour a day to think. During that time, he
did not lie down, or doze, or answer the telephone or write notes to
himself. It was said that when Vincent was silent he was sleeping, when
Zoli was silent he was sulking, but when Alex was silent he was think-
ing.

If he was adept at raising money it was in part because he had
learned to look as if he didn't need it and was conferring a valuable
privilege on the lender, and also because his unfailing courtesy and
self-deprecating humor inspired confidence, and finally because he
had trained himself to understand the language of finance. He also
knew when to *avoid* the language of finance. In his original negotia-
tions with the Prudential, he had asked to have all the financial mat-
ters carefully explained to him in simple language, intimating that as
an artist and a creative film maker, he was eager for their advice. To
these hard-headed businessmen, who believed in investing in "bricks
and mortar," he talked about his dream of a great British film indus-
try, he discussed art and the importance of the motion picture, he
described his plans for new and bigger movies. He understood *their*
need to believe in a dream, and managed to ignite a romantic flame
in these prosaic souls. He did not promise them a profit; instead, he
allowed them to persuade themselves that the investment would be
profitable. As one bystander commented, "He talked about art, and

we talked about money, and on that basis an understanding was reached."

During the interminable negotiations with United Artists, Alex reversed this procedure. He allowed Mary Pickford, Chaplin, Douglas Fairbanks, Goldwyn and Selznick to talk about art, while *he* talked about money, with equally good results. Even when he sued people— and at one time of his life Alex was notorious for involving people in litigation—he managed to remain good friends with them. When he and Goldwyn were involved in a tangled series of lawsuits over UA, Goldwyn was paying a visit to England and complained to his wife Frances, as they were crossing on the *Queen Elizabeth,* how much he would miss seeing Alex in London, since their friendship was now over. No sooner had the Goldwyns arrived in their suite in Claridge's than Alex was on the phone, inviting them to dinner upstairs in his penthouse. Somewhat reluctant to be lured into the lion's den, Goldwyn said, "Alex, I hope you know I'm still suing you?"

"Of course," Alex replied, "and so am I you, but my dear Sam, *not during dinner!"* By two in the morning, needless to say, Alex and Goldwyn had quietly settled their differences.

As I sat with my fellow reporters for the *Financial Times,* I gradually came to understand, through their view of Alex, the magnitude of his achievements, and more important, the awesome weight of his commitments. The "great dream" had always overwhelmed and crushed the "little dream." As a director or a producer, he could have been very successful, and certainly rich enough to live in the style to which he was accustomed, but the restless, active side of his nature, which he and Gulliver shared and complained about, made this kind of compromise impossible for him. He could not be satisfied with mere money, or a successful career as a producer/director.

Between 1914 and 1919, he had personally directed at least twenty-five films, from his arrival in Vienna in 1920 to his journey to England in 1932; he directed twenty-four more, in Vienna, Berlin, Paris and Hollywood. From 1933 to 1956 he produced well over a hundred films, some of which he directed in whole or in part himself. He had always described directing as an activity comparable to going down a mine every day, and had said that life in a big film studio was "certainly better than working in the Siberian lead mines—except that the Siberian lead mines are the *only* places which are worse."

Making movies as such did not interest him, or had ceased to interest him a long time ago. He was interested in building companies, and in the challenge of financing them. This is what had first inspired him to put down 15,000 pounds for the small village property that was to become Denham Studios, had almost led him to the acquisition of United Artists, had prevented him from making an alliance with Rank (for he shrewdly understood that Rank's fortune and his control over the major British chains of movie theaters would inevitably make Rank the senior partner), had made it possible for him to re-create London Films after the war and had lured him into the trap of involving himself with British Lion.

For the ultimate paradox of Alex's life was that he remained a dreamer. Cunning, stubborn, practical and ambitious as he was, he was motivated by the "great dream": the dream of a international motion picture company, rivaling the giants of Hollywood, the dream of actually obtaining control over one of the Hollywood giants themselves (hence the long fascination with the opportunities of United Artists), the dream of dominating the European motion picture business, the dream of always succeeding against the odds, and emerging from yet another crisis with a new and greater triumph.

He had chosen to work in an industry that created myths, and he set out, almost from the very beginning, to manufacture himself as a myth. In the end, that myth was more important to him than the realities and possibilities of "the little dream." It meant far more a villa in the South of France, or a yacht or a beautiful young wife. He could not walk away from the table with a comfortable handful of chips. The myth required him to keep playing until he had broken the bank.

I SAW VERY LITTLE of Alex that summer, and almost as little of everyone else in the family. Vincent (who now had yet another child, this time a daughter, to everyone's astonishment) went off to the South of France. Zoli was moving back and forth between Switzerland, California and England, cutting the final version of *Storm over the Nile*, his remake of *The Four Feathers*, and worrying about the screen treatment of *The King's General*, while Alex and Alexa restlessly traveled, to Paris for a few days, then to Biot, then back to London, then back to the South of France, as if Alex were too tired to settle anywhere for more

than a few days. I was not unhappy, having been left alone in London with a job, the use of the house, a car and the company of three girlfriends. I had not been invited to join Alex and Alexa in Biot, and perhaps for the first time in my life, I was not all that eager to go in any case. Alexa seemed to me nervous, jumpy and slightly shrill, anything but good company. The last time I had seen her, she had sulked in one corner of the living room at KPG, wearing a somewhat tattered bathrobe, while Alex appeared from time to time to ask her, with very ill-concealed impatience, when the hell she was going to get dressed.

It was not a happy domestic scene; I had the feeling that my presence was only making matters worse, and that Alex might very well ask me to get the hell out of there. This was something I did not wish to provoke, for a very large part of my life was built around Alex: he was somehow the central figure of my own myth. I don't think it ever occurred to me that Alex *loved* me—what I wanted from him was the approval and support of a man who was famous, powerful and rich. As the eldest (and the closest) of his nephews I had always interested him greatly, but I did not mistake that interest for love, and I wasn't sure myself that I loved him. Perhaps I had the same problems in this respect as Alex's wives: He was too complicated, too private, too involved in other things, too demanding and too successful to love in any easily defined way. Even Merle described him after their divorce as the noblest, most intelligent and most thoughtful man she had ever known, which is impressive in its own way as a tribute, but something short of passion, and Alexa often remarked that he was the kindest man in the world, which is once again rather less than a declaration of love.

Once, in a moment of candor, Alexa complained, "Everyone tells me how much they love Alex, as if they were trying to tell me that I'd better join the chorus, but the difference is I'm *married* to him, and they're just people who *know* him." I saw her point. As a child I had been told so many times how lucky I was to have Alex as an uncle that I had come to see it as a special blessing, and even as an adult I was so frequently told, often by perfect strangers, what a wonderful man Alex was that I was no longer absolutely sure I could rely on my own judgment about him.

Clearly, my closeness to Alexa irritated him, although it had amused him at first, and I think I sensed that if I hadn't left KPG quickly and let Alexa get dressed, the last time I had seen them, Alex might finally

have lost his temper and destroyed the delicate fabric of our relation-
ship. He had once said that in every love affair there is one secret thing
which each person knows about the other and which can never be
spoken because it will immediately destroy the relationship, a kind of
secret weapon in everybody's heart. I had no doubt that Alex was fully
capable of saying something that would prevent us from ever being
close again, and I felt that if I stayed one moment longer I would hear
it, so I left. It seemed to be that I might have to choose between Alex
and Alexa, and the choice frightened me.

All the same, I was drawn to Alexa. She was honest, funny, attractive,
and helped me through my adolescence, and I felt a great deal closer
to her than I did to Alex. She was greedy, not particularly talented,
opportunistic and too shrewd for her own good. Her feelings were so
controlled that when she eventually *did* fall in love, years later, she was
destroyed by it, as if nothing in life had prepared her to deal with deep
emotions, so that the first touch of them engulfed her, unlike the rest
of us, who had long since been exposed to them and learned to live with
the after-effects. My father, and everybody else, urged me to see less
of her, and I thought that was silly. For all that Alexa was older than
I was, I could hardly be expected to take her seriously as a bad influence.
She did not encourage me to drink, gamble or take drugs and her own
activities were fairly innocent themselves. What I had not realized,
because it was too absurd to occur to me, was that Alex might come
to see me as a rival for Alexa. Nor, I think, did Alexa herself consider
this, not at any rate until the summer of 1955. Certainly I noticed a
change in Alex's attitude toward me—he was colder, more distant, an
occasional flash of malicious, wounding wit appeared when he spoke to
me, his impatience was visible. But this could have been put down to
his illness, or even to the simple fact that I was no longer a child, and
therefore no longer protected by the benevolence which adults like
Alex feel obliged to display toward the young.

Alexa was no fool, and she concluded that Alex, in his roundabout
way, was exhibiting displeasure. Perhaps he felt that the two of us were
talking about him, that we might even be making fun of him. Perhaps
he simply felt that we were seeing too much of each other, but he let
it be known that I must surely have better things to do with my time
than to sit around Alexa's dressing room chatting to her. I think he also
suspected that I was Alexa's cover. Sometimes she would phone and

tell me that if anyone asked where she had been, she was with me, and being flattered by these intimate strategies, I always agreed, which meant that I had to invent stories about where Alexa and I had been, some of which seemed even to me very implausible. On one occasion I said we had been at the Battersea Fun Fair for the afternoon, and Alex asked a number of questions about it—too many for comfort, I thought, particularly since I wasn't sure whether the fair was open or not, and Alexa didn't help by saying that she had had such a good time that she didn't remember a thing.

I was not sure whether Alex thought we had been together doing something else, or whether he suspected that I was lying to give Alexa an alibi and had not in fact been with her at all, but both possibilities were frightening. After all, Alexa had been in the habit of coming into my cabin on *Elsewhere* in her bra and panties for a chat late at night, and it would have taken very little in the way of encouragement for us to have become lovers, nor had these visits, however innocent, escaped notice. Certainly Zoli viewed our friendship with suspicion, even though he loved intrigue for its own sake, and my stepmother Leila repeatedly advised me "not to play with fire." But fire was exactly what I was incapable of resisting, and in any case, since the suspicions were unfounded, I had persuaded myself they didn't matter. Were we not more like brother and sister, or at any rate, cousins? Though of course, *"cousinage, dangereux voisinage,"* as everybody knows, since it provides opportunity, temptation and cover all at once. But going to bed with Alexa would have been like going to bed with one of Zeus's wives. And Alex would certainly have a thunderbolt handy to deal with *that* situation.

All considered, I was walking on thin ice that summer, closer to Alexa than I had ever been, and saying that she had been with me when she had not. At the same time, I had mixed feelings about Alexa's conduct. Given the role she played in my own sexual fantasies at the time, and given my strong feelings toward her, I was not happy about providing her with a cover so that she could see someone else, if that was what she was doing. I was in the position of having to lie to Alex without any particular gain to myself, and if we were found out, I would probably be punished, just as severely as if Alexa and I *had* slept together—in fact, it was difficult to see how we should be able to persuade anybody that we had not.

———

IT WAS NOT until the very end of the summer that I heard from Alexa again, at just about the time when my job with the *Financial Times* was drawing to an end. She had decided, she said, to go to Switzerland to see an exhibition game of soccer, and wondered if I would like to come along.

This seemed to me a little astonishing. I had never known Alexa to show any interest in sports, and said so.

"Don't be silly," she said. "It's supposed to be a terrific event. People are coming from all over the world. Anyway, Zoli, who adores soccer, said he had some seats, and asked if I'd like to go, and I thought I'd take him up on it."

It was news to me that Zoli and Alexa were on such good terms, but not altogether surprising. Zoli always had a talent for taking the unpopular side in any family quarrel. When Alexa was fighting against Maria, only Zoli had a good word to say for her, to the fury of his brothers, and Zoli even managed to maintain himself on speaking terms with Peter. As Alex and Alexa grew farther apart, it was only natural that Zoli should begin to support Alexa, though even for Zoli, an invitation to a football game in Switzerland was a strange and unlikely gesture.

"How will we get there?" I asked. "By plane? And when is it?"

There was a moment's hesitation on the other end of the line.

"Well," Alexa said, "I thought we'd drive. After all, you have a car. And we'd need to leave today. I'm afraid I left it to the very last minute, which was silly of me. Game?"

Certainly I was game. I was no longer needed at the *Financial Times*, to the extent that I had ever been needed at all. All three of my girlfriends were out of town. I had no reason to say no. Anyway, a trip with Zoli as chaperon could hardly cause much in the way of excitement. Within an hour, I had picked up Alexa, stowed her bag in the trunk, and we were on our way to catch the car ferry at Dover in my car.

Alexa wore a sweater and a pair of slacks, her camel's-hair coat tossed in the back. She seemed in better health than she had when I had last seen her, though she still chain-smoked with nervous intensity. All in all, she said very little, which was all right with me. When she wanted to talk, she talked. When she didn't, it was a waste of time to prod her.

Coming from the Korda family, I understood that. The only thing that seemed to be on her mind, in any case, was speed. As we drove through northern France, she urged me on.

"Can't you go faster?" she asked.

"I'm doing over eighty."

"It feels as if we're crawling."

"We're not. In any case, you know perfectly well that I can drive faster than you can."

"Bullshit! You're too cautious. And your touch on the accelerator is too jerky. You bang it up and down all the time with your foot. I hope that's not the way you treat women."

I looked over at her. "I don't think that's a very appropriate remark, do you? I mean, you wanted to drive to Switzerland, and here we are. If you wanted to trade insults, we could have stayed in London and done it over the phone."

"I'm sorry. I guess you're right. I feel bitchy and awful."

The day was drawing to a close, and I asked her to look for a place to stay in the *Guide Michelin.* We picked a small country inn, ostentatiously took two rooms, and sat down to dinner. Alexa, I noticed, ordered and ate ravenously, and drank almost a full bottle of wine by herself.

"Didn't Alex want to go to the soccer game?" I asked.

She looked at me over her wine glass. "He isn't interested in soccer, you know that. Anyway, I didn't ask him."

"You didn't ask him what?"

"I didn't ask him anything. I felt like going to Switzerland, so I went."

"Do you mean he doesn't know you've gone?"

"He knows by now."

"Oh, my God."

I ordered a brandy and thought about this. By now Alex must have telephoned everybody he knew to find out where Alexa was. He would naturally be worried, but he must also be furious. And suspicious. What husband wouldn't be? We could telephone London and explain where we were, but the thought of explaining to Alex how Alexa and I happened to find ourselves in an inn in Châlons-sur-Marne was more than I could cope with. My father was touring somewhere in France —I only hoped he would not appear suddenly in Châlons—and beyond

reach. The only way I could think of to smooth matters over was to find Zoli as quickly as possible. The drama of the situation would certainly appeal to him, and he would be in a position to intercede for us, or at any rate for me.

"We have to phone Zoli," I said.

"That's a problem," Alexa replied. "He's going to be in Basel, but I don't know where he is now. He isn't *absolutely* sure I'm coming. It was something we discussed."

"Then we have to get to Basel as soon as possible."

"We will. You need a night's sleep, and so do I. We'll be in Basel tomorrow, and there's no way to get there earlier. Anyway, who cares?"

"*I* care. Have you any idea how this is going to look? What on earth possessed you to jump ship and go to Switzerland without telling anyone?"

"I *felt* like it. Haven't you ever done anything you felt like doing?"

"Nothing like this."

"Well, there's always a first time. I've had a long, bad, difficult summer. I needed some distance. If I'd asked Alex, he would have said no, or made all sorts of arrangements, or raised endless objections, so I decided to go."

"He's going to think you left him."

"I doubt it. We talked about my going to Switzerland. He's probably going to assume I simply went, which is the case."

"Maybe. I think you're wrong. I think he'll assume you left him, and when he finds out that you and I went together, he's going to assume the worst."

"What's the worst?"

"You know damn well what the worst is, and you also know damned well you're not going to let it happen, and I suppose the thing that makes me most angry is that we're going to be ruined for something that hasn't even happened."

"You worry too much. Think of it as an adventure."

Frankly, I found this a little difficult to do, though I quite understood Alexa's view that an adventure without significant risks was not an adventure at all. Since it was properly Alexa's role, not mine, to make explanations to Alex, I settled into paralysis of the will like a sleep-walker.

"The thing is," Alexa said, "I've been bored. I *know* Alex is ill, I

know it better than anybody, and despite the fact that everybody thinks I'm a bitch, I'm sympathetic. I know how difficult it is for him, and how terrible, and it is for me too. But I'm tired of having everything planned out and decided. I just needed to get up and go, for once. Everybody needs freedom, even if it's only one day a year."

"Are you having an affair with somebody?"

"What if I were? What if I told you that might not be so terrific either."

"I'd believe you."

Alexa stuck a handful of notes in my hand, I paid the bill, and we went upstairs to our separate beds.

The next morning we split the driving, climbing up through hairpin turns in the mountains toward Switzerland, saying very little. Gradually, I had come to accept her point of view. It *was* an adventure. It was too late to worry about it, and one might as well enjoy it for what it was. She herself was more cheerful, more like the girl I had first met on the yacht in Antibes, singing operatic arias under her breath as she took the curves in the road, and driving faster than I thought reasonable.

In Basel, however, Zoli waited for us, and one look at his face told me that this particular phase of Alexa's adventure was over. He sat in the lobby of the hotel, a coat thrown over his shoulders, and did not rise as we came in, so that we were obliged to go over and stand in front of him like children. Alexa leaned over and kissed him on the cheek, then sat down beside him, and reached for a cigarette.

"Please don't smoke," he said. "It makes me cough, and I think it's an awful habit for a woman. Think what it's like to wake up every morning with someone who smokes. It's like kissing a dirty ashtray. Anyway, the two of you seem to have caused a scandal. Alexa, why didn't you tell poor Alex where you were going? All this is very bad."

"I just wanted to go, for once, without arguments."

"That I understand. But then the arguments only come later, no? So what's the point? I wasn't sure you would come to Basel, so I haven't told Alex yet, but now I'm going to have to call him and explain you're here, and he's going to be angry with me too."

"Did you really think I wouldn't be coming here?" Alexa asked.

"One never knows. Also, I didn't realize that you and Miki were

coming together. That makes things more complicated. Vincent is going to be unhappy too, now."

I sat down on the other side of Zoli, noticing that he was, in fact, beginning to enjoy himself. He was always at his best in reconciling the warring factions of the Korda family. It was only when his own interests, prejudices and feelings were directly involved that he became angry and unforgiving, and he rather relished the prospect of being in a position to solve Alex's problems for him. I could also see that he was somewhat relieved. Alexa turning up alone would have posed very few problems, but she might have turned up with a total stranger, which would have put Zoli in a very uncomfortable position. I, at least, was his own nephew, and therefore the task of explaining my presence would be easier.

"How much does Alex know?" I asked.

Zoli shrugged. "That Alexa has gone somewhere—possibly to Switzerland for the soccer game, possibly not."

"What should we tell him?"

"That depends. Is there anything between the two of you? Don't be embarrassed that I ask. I have to know. If there *is*, then it would be better Alex doesn't know. Better for him."

"It's okay—there isn't."

Zoli shook his head. "I understand. I don't say I *believe* you, mind, but I understand. Anyway, it's your business. It's not for me to judge. Let's say that it isn't a factor. You are still going to be judged on appearances. It's unfair, but that's life. At least we don't have here an elopement, which is what Alex probably thought happened. Did you come here in one long drive?"

"No. We stayed the night in Châlons-sur-Marne."

"Ah. Not so good."

"We had separate rooms."

"Everybody always does. Taking separate rooms is so old-fashioned that people would be better off taking a room together. Separate rooms aren't going to count for anything. Only a child would believe in that. Take my advice. You came here in one long drive. You never stayed in a hotel. It's better that way. Alex may not believe it, but if he hears you stayed in a hotel for the night—with separate rooms!—he'll be convinced you slept together."

"Nobody does that drive without stopping."

"Alex won't know that, will he? He doesn't drive. It's a better story. As for you, Alexa, you phone somebody—maybe Moura—and have her phone Alex to say that you told her you were going to Switzerland to meet me for the game, and she forgot to tell Alex."

Alexa frowned. "He'll never believe that."

"Probably not. But he'll still be glad to hear a story like that."

"Anyway, I'm not sure Moura will do it. We haven't been that close lately."

"She will do it. You haven't been close because she's an old woman who once did you a favor. I understand that. We always want to turn away from the people who did favors for us, no? It's natural, even if it's not very nice. Still, now you need her, and I have no doubt there's something she needs from you. She won't believe your story, and Alex won't believe hers, but it has to be done."

"Then what?" I asked.

"Then I will telephone Alex, explain there was a misunderstanding, and tell him we're all here in Basel. After that we can go off to the game. Alexa, we will go to our *separate* bedrooms and make our calls."

"I'm sorry we've made so much trouble," I said.

Zoli stood up and sighed. "One is only young once. Young people always make trouble."

As it turned out, matters were not solved all that easily. Alex had been deeply disturbed by Alexa's departure, and *had* assumed she had eloped, or run away, or was in the process of creating some major scandal that would engulf him once again in newspaper headlines. When it was explained to him that she had taken me to Basel to see a soccer game with Zoli he was relieved but resentful. Moura's version of the event, however tactfully phrased, did not convince him. He knew perfectly well that if Alexa's message had not reached him it could only be because she had not bothered to send one. My role in the affair struck him as ungrateful and possibly treasonous, and though Zoli made every effort to present things to Alex as youthful ebullience and high spirits, Alex was not amused. Alexa should have known better. Between the lines, I caught hints of a preceding quarrel. No doubt Alexa had brought the subject up, Alex had asked her not to go, and her decision to go at the last minute was an act of defiance.

In any case, Zoli announced, Alex was flying to Geneva, and would meet us there. We sat through the game, and I could not help noticing

that Alexa genuinely enjoyed herself. Zoli was at his best, as he often
was in moments of crisis. Soccer reminded him of his youth, when he
had been an expert and enthusiastic player. His good mood lasted
through the game, and even through the long twisting drive from Basel
to Geneva, during which he sat in the back of the car, alternately
dozing and telling us stories about his childhood. The closer we got to
the Hôtel des Bergues, the more morose he became.

While I parked the car, he walked back and forth in front of the
entrance, then announced that he himself would go up first and chat
with Alex, and we should wait down in the lobby. For an hour Alexa
and I waited downstairs, until Zoli finally reappeared, his coat still slung
over his shoulders. "Well," he said, "I think he blames me for inciting
the two of you. That's all right. I've been blamed for things all my life.
It's what comes of being the middle brother. You, Alexa, you go up to
see him now. You know what to say. You, Miki, you wait here. He's
going to want to talk to you too."

I waited another hour, until I was summoned to Alex's suite. Alexa,
I noticed, was nowhere in sight. She had presumably withdrawn to the
bedroom. Alex was looking ill-tempered. He had not had time to do
much with the room. A few newspapers were scattered on the floor,
there were several bottles of Evian water, a box of cigars and a small
tooled leather case for his medicines. He glared at me over the tops of
his half-moon glasses, his lower lip stuck out in the usual Korda sign
of disapproval.

"All this is very inconvenient," he said.

"We hadn't meant it to be."

"No? All the same, it's an undergraduate lark, isn't it? The problem
is that Alexa isn't an undergraduate, and very soon you won't be either.
Running off to Switzerland and causing trouble is stupid. It shows a
lack of respect for me—and no common sense. I think it's time for you
to take life a little more seriously. I've always treated you like a child,
but you're not one anymore. What are you going to do with yourself?"

"I don't know yet."

"It's time you thought about it. I think you have always had a little
hope that London Films would last forever, that there would be a place
for you there. But I must tell you, my poor boy, that isn't going to be
the case, not at all. I don't think London Films will survive me. I never
thought to have a business that would go from father to son, or from

brother to brother, or from uncle to nephew, for that matter. I don't have anything against nepotism, or family dynasties. I just never planned for that kind of thing. I think you will have to find your own way.

"Perhaps it's been a bad idea, exposing you to all this, at an impressionable age. It may have given you tastes you can't afford. You probably think you're going to go into the 'family business.' But there isn't one. There's just me. Maybe it would have been better if I'd left you in New York with your mother, better for you. Too much time on the yacht, too much glamour, too much money and pleasure . . . If life isn't hard when you're young, how can you appreciate luxury when you get older? I don't know if you're a bad influence on Alexa or she's a bad influence on you, but you're not a child anymore, and suddenly it's not all innocent, is it?"

"No. Not really."

"Exactly. I think you had better get back to Oxford. Try to stay up there and work hard, and perhaps after Christmas we'll have another talk, sometime in the new year, no? In the meantime I think a lot of careful attention to your books would be a good idea. Do you take my meaning?"

"Yes."

"Excellent. It's one of the advantages of growing up that one understands these things quickly. Besides, at heart you're not a fool, though you often act like one. See if you can learn to use your head. One of these days you may need it. There used to be a sign in the commissary at M-G-M—when the whole studio was full of Hungarians—that read: 'It isn't enough to be a Hungarian, you must also work.' It isn't enough to be a Korda either. Now goodbye. I will say goodbye to Alexa on your behalf, yes?"

"Yes."

Alex took a pill from his vest pocket and washed it down with a glass of Evian. He seemed pale—much paler than usual—and there was an unmistakable bluish cast to his lips. His hand trembled slightly as he held the glass, but he looked as regal as ever.

"You can kiss me goodbye," he said. And I did.

---

SOON AFTER I returned to Oxford—where I followed Alex's advice and studied hard for the first time in my career there—Alex had a new medical examination. He was tired. He found it increasingly hard to breathe. The trembling in his hands seemed worse. The nitroglycerin pills offered him shorter and shorter periods of relief from pain. He submitted himself to the tests of a distinguished Harley Street cardiologist. He had to be in New York soon, he explained, where he would be working very hard on a number of important deals. After that, he planned to return to England and begin a new film—he would have weeks of concentrated effort in front of him. Was there any reason for him to hesitate?

The cardiologist looked at Alex's EKG, studied the chart, paused and looked back at Alex. No, he replied, .there would be no problem; Sir Alex must feel free to do whatever he wanted to. But Alex had noticed the moment of hesitation in the doctor's voice, the way he had bowed his head over the EKG strip as if he were in mourning, the overenthusiasm with which he reassured his distinguished patient. Alex did not look at the EKG, which would have told him nothing, he looked at the doctor's eyes, and the eyes told him what he wanted to know: that he could go wherever he liked and do whatever he pleased because it would no longer make any difference. Time had run out at last.

He shook the doctor's hand, went down to the waiting Rolls and had himself driven to 146 Piccadilly, where he locked himself up in his office and sat down at his desk to write his will. He named Vincent and Zoli as his executors, relying on family persuasion and the shock of his death to overcome the inevitable difficulties of handling his estate, rather than putting the whole thing in the hands of a good solicitor. He also named two of the directors of London Films, Harold Boxall and Sir David Cunynghame, as co-executors, presumably to back Vincent and Zoli up with solid business experience. Unknowingly, or perhaps without caring, he had burdened all four men with responsibilities that would very nearly destroy them, and which would weigh on each of them to the grave—and beyond.

To Alexa he left the house at KPG, together with its contents, including the pictures, as well as all the various things which had already been placed in her name, and were therefore already hers.

To Peter he left a legacy of 10,000 pounds for immediate expenses.

The residue of the estate was to be divided one half to Peter, one quarter to Alexa and one quarter to Alex's nephews and niece, that is to say, Zoli's two children, myself, and my half-brother and half-sister.

No special provisions were made for preserving London Films. Indeed, since Alex's shares in it, and his other companies and interests, would have to be liquidated on behalf of the estate, and since the various beneficiaries had very little in common, except for distrust and antipathy, Alex more or less guaranteed that the London Films group of companies would have to be destroyed.

Alex may just have wanted to get the whole matter out of the way as soon as possible, and had no desire to share his innermost thoughts and fears with a lawyer. That he was not optimistic about the future can be gauged by a letter he wrote to Peter on the same afternoon as he drew up his will. He urged his son (who was then thirty-four) "to try to grow up" and reminded him of various episodes in the past, complaining that "if you look back you can count thousands of pounds which went through the window." He then went on to write: "Just one last message. I am sorry we can't understand each other all the time. I believe it was my fault some times, yours at other times. I don't think LFP can remain a going concern after my death, therefore I ask the executors to liquidate it. You will have £10,000 immediately on my death to help you while the formalities take their slow time. After that you will have 50 percent of my residuary estate. Anyway, that's all in my will. I hope it will amount to a substantial sum, but I implore you, as I leave this money to you without hindrance and you can do with it what you will, to gain some financial sense and don't fritter it away. I hope you will make your peace with my two brothers who built with me LFP and their share in its success is as much as mine."

This prophetic letter was followed by another letter to Vincent and Zoli, in which he advised them to liquidate LFP, apologized for leaving them the burden of settling his estate and predicted: "You might have trouble with Peter."

Alex had devised what must have seemed to him the fairest and most reasonable of settlements, and at the same time decided once and for all to shelve the intractable problems of reconciling his immediate family. He did not propose to spend the last months of his life trying to obtain the consent of Alexa and Peter to his will. He wrote it, put it in his wall safe and left it for his brothers to clear up, if indeed it

could ever be cleared up. He had often joked that on his death the members of his family would gather at his safe-deposit vault before the bank was even open to get there ahead of each other and the Inland Revenue, but in fact it would be Vincent and Zoli who were faced with opening Pandora's Box when the time came.

In many ways, Alex's arrangements were eminently sensible. Alexa was well provided for—the house and the paintings alone would guarantee that. Peter was to have, in effect, something on account, against the prospect of receiving half the residual estate, which would certainly be considerable, and Alex's nephews and his niece would receive enough to guarantee their education and a nice "nest egg" when they were of age—or, in my case, immediately. Everything was provided for except the good will to make it work. Still, it was done. Alex went home, had a drink, and sat for a while.

For a long time he had refused to make his final preparations. Now they were done, and he could wait for death. When someone had complained to him once about the difficulties of life, he had replied, "Ah, it's not living that is difficult, my friend, it's dying." His life had been challenging, exciting, exhausting, full of problems, drama and turmoil, in some ways stunningly successful, in others, never quite giving him what he had most wanted: peace, relaxation, time, love. Dying, as he came to realize, was not in fact all that difficult. But it was very boring.

# CHAPTER 12

~~~~~~~~~~~~~~~~~~~~~~~~~~~~~~~~~~~~~~~~~~~~~~~~~~~

I NEVER saw him again. We had said goodbye in Geneva in the autumn. That winter he did very little. The shades were drawing in on him. He sat in the study at KPG and played solitaire. Sometimes he talked to Brendan, who was himself dying of cancer of the throat, receiving cobalt treatments when it was far too late for them to do any good, and raging at the incompetence of the medical profession to the very end. Sometimes Alex went to the office. Sometimes he did not feel well enough to do so, but he continued to supervise London Films, though he must have realized that he would not live to see the final cuts. He arranged to have Anthony Kimmins go to Australia to make *Smiley* with Ralph Richardson, and took extraordinary steps to finance it, perhaps because he was impatient to get the production under way. He suspected that it was to be his last film, and he was not about to have it delayed. He met with David Lewin, of the *Daily Express,* who was writing a profile of Alex. They talked about movies—Lewin, Alex and Alexa (with Buttons, the Boston bull, sitting at Alex's feet), gathered around the dining-room table, Alex in his monogrammed white-silk pajamas and slippers. He talked about Gable and Myrna Loy, about Noel Coward and John Barrymore and Leslie Howard, about Selznick and Marlene Dietrich, about Sam Goldwyn, and Vivien and Larry.

"The job of the film maker," he said, "is to entertain as many people as possible. The questions of raising tastes and education are there too —but they are asides. Entertainment counts and it is the most difficult thing of all. You can affect an audience three ways—you can make them laugh, make them cry, and make them sit forward in their seats with excitement. You should never *degrade* them . . . We are in the show business now, and we come from the fairground and the fairground barker. The barkers may have worn checked coats and crude colors, while we are more elegant: But never forget, we are the same. It is show business—and we should make a good show."

AT CHRISTMASTIME, I visited The Vale briefly, then returned to Oxford. I was working hard, and Vincent was leaving to go abroad on a trip. I did not see Alex. He had not been feeling well, and there seemed no reason to bother him.

On January 23, 1956, I stopped in at Bond's room to have a glass of sherry, and Bond looked at me with what seemed to me a very shifty expression. He cleared his throat. " 'Ave you seen the morning papers yet, sir?" he asked.

I said I hadn't.

"Ah," he sighed. "If I may be so bold as to offer you a drink." And removing the sherry glass from my hand, he took a bottle out of the cupboard and poured me a large scotch—a drink which he never ordinarily served. I looked at the morning papers, spread out on the table, and saw why. Alex was dead.

It seemed to me that in one moment all the certainties I had cherished were gone. Suddenly the future seemed doubtful, dangerous, problematic. I had no idea what to do. Vincent was away. Phoning Alexa seemed pointless. Obviously, the only thing that made sense was to drive down to London. So I walked out of the college, pausing to receive the condolences of the porter, and got my car out of the garage. I drove through the gates of KPG, to be greeted by a lugubrious guard, and parked next to Alex's Rolls in the courtyard, with its broad expanse of impeccable gravel, its high protective walls covered in ivy and the big, sweeping steps that led up to a *porte-cochère* rather like that of a Paris hotel. Bailey, red-eyed and weeping, told me my father was on the way. He had been called back during the night from Amsterdam

—and together the two of us stood waiting for him, silent. There seemed nothing to say.

Vincent's car arrived, and he got out, huddled in his heavy overcoat against the January cold, looking very tired and moving with slow, uncertain steps. He put his arms around me and said, "My poor boy, what an awful thing. I still can't believe it." He shook Bailey's hand, then put his arms around him, and for the moment they stood there, locked in embrace, both in tears, then Bailey recovered himself, put his chauffeur's cap back on, and led Vincent to the lift. Vincent shook his head. He had no wish to use the lift. He walked slowly up the beautiful winding staircase he himself had designed, up to the third floor, where he passed Alexa, who was looking gaunt and exhausted, and kneading a damp piece of Kleenex, and on into the master bedroom, where he stood at the foot of the bed, looking down at Alex's body. He waved at me, tears streaming down his cheeks. "Close the door," he said. "Leave me alone with him."

I shut the door and sat down with Alexa.

"It's been such a long night," she said, "and now it's over."

IT HAD BEEN a terrible night. Alex had had a massive heart attack. He had been in great pain, but he seemed unable to die. He did not want to be moved; there was no point in taking him to the hospital or trying extreme measures. Now that it was here at last he only wanted to get it over with as quickly as possible, without agony, without lingering deathbed scenes, without drama. But his body cheated him. His heart continued to function, erratically, badly, but still beating when it might better have ceased, so his mind remained active and clear. Tibor, who had joked with him so often about death, did everything he could, but at last the only thing he could give Alex was the possibility of sleeping, and he prepared an injection. As he reached over, Alex opened his eyes and said, "If I say goodnight to you now, my friend, will you promise me that I won't wake up again?"

Tibor nodded. Alex closed his eyes, and at dawn, he died.

THAT NIGHT I found my father in the garden. His hands were dirty, and he was walking back and forth, his hands behind his back.

"I wondered where you were," I said.

"You should go to bed."

"So should you."

"I can't sleep."

"What have you been doing out here?"

"I planted a tree. It's a little one. Maybe it will grow. I hope so."

"For Alex?"

Vincent nodded.

"Did he like trees?"

"Maybe. But he should have a memorial of some kind from me. And why not a tree?"

"Why not?"

"I will miss him."

"I know."

"My poor Miki. Everything will be different now."

"You have to go on living."

"Yes. But it will be different. You see . . . Alex was special."

I DID NOT ATTEND Alex's cremation—a ceremony which was subsequently to give rise to protracted disputes and litigation. Vincent and Alexa decided to proceed with the cremation at Golder's Green as quickly as possible, and Zoli, who had arrived in haste, concurred. Already there were intimations of problems to come, and the question of a religious ceremony seemed best left in abeyance.

That Alex was special was self-evident. Obituaries appeared all over the world—long, full of praise, full of errors. A huge memorial service at St. Martin-in-the-Fields was arranged, at which Sir Laurence Olivier and Sir Ralph Richardson read tributes, amid a cortège of stars. Vivien Leigh, Chaplin, Claire Bloom—one by one they arrived, dressed in black, and were filmed as they climbed the great stone steps. The organizers had been determined not to have the service resemble a movie premiere, but as the newspapers quickly pointed out, "Every seat was filled and there was a queue outside." Olivier praised Alex's "godlike yet unobtrusive generosity," dwelt on his wisdom and his kindness, and went on to promise that Alex would be remembered for "the devotion he inspired in his loved ones."

But some of his "loved ones" would maintain Alex's memory in a

very different manner from the one Olivier had in mind. Even as Alex's distinguished mourners walked past the television and newsreel cameras back to their limousines, the major beneficiaries of Alex's will and of his generosity during his lifetime were beginning to consult their lawyers.

PART THREE

FINAL CUT

CHAPTER 13

\mathcal{A}LEX'S WILL was not probated until a few months after his death. It contained no great surprises, since the principal beneficiaries had been closeted with their lawyers before Alex had even been cremated. The newspapers reported that Alex had left an estate of 385,000 pounds, though he owed 160,000 pounds, which he had borrowed from his own company. Alexa was mentioned prominently, pathetically remarking that she hoped to stay on in the house "for a little while," and expressing the hope that Alex's paintings could be kept together "to form a memorial." It was noted that she was on her way to her house in the South of France. The bulk of the estate consisted of the leasehold on the house at KPG and the paintings, quaintly referred to as "chattels," and these of course went to Alexa directly.

She was now a very rich young widow, a fact which could scarcely be expected to escape the attention of another, more senior widow, Maria. Alternately she had claimed to be the only legal Lady Korda and insisted on her alimony, apparently unaware that there was any contradiction involved in these claims, but now, as she contemplated the riches of Alexa, Maria decided it was time to stake her claim to Alex's estate. Her previous experiences with the legal system of Great Britain did not daunt her. They had persecuted her before;

this time she would triumph over them—was she not, after all, a star?

Besides, she liked the publicity. Over the years, it had been difficult to persuade people to listen to her grievances—but in court she could tell the whole story again, and surely her beauty and her reputation as a star would convince them? She would give the performance of a lifetime, the judges would applaud her, as everybody had in the old days, before the stupid invention of sound put an end to everything, before Alex committed the treason of not only leaving her, but going on to become more successful and famous than she. In an earlier trial, Maria had disputed a judgment against her by rising in the courtroom and shouting at the judge, "So this is your British justice, I spit on it, you bewigged son-of-a-bitch!" prompting one of her counsel to remark (rather temperately) that she had perhaps not grasped the customs of an English trial.

She had long held that Alex's divorce was invalid under the laws of Hungary, a point which the judges of Los Angeles County, in which the divorce took place, had found it difficult to appreciate, and which British courts had obstinately dismissed as irrelevant.

It was unlikely that Maria would sit by to see this little Ukrainian bitch usurp a fortune, and in any case—and far more tormenting— there was the question of where Alex's money had gone. Maria had always believed the legends about Alex's wealth. Somewhere, she knew, in Biot, or in Zurich, or buried in the cellar at KPG, was Alex's secret horde—gold, platinum, diamonds, Swiss francs, bearer bonds. She was, in her own view, the victim of a conspiracy, possibly several conspiracies. She was being deprived of her undoubted title as Lady Korda because of a divorce which any fair-minded, impartial person could see was invalid. As a divorcée, at the same time, she found her alimony threatened—for under the terms of the divorce settlement, the payments could be reduced if Alex's earnings fell below $6,000 a month, and the estate could argue that Alex had no longer had any earnings at all. And in any case, the executors, or Alexa, or both, were hiding or stealing a fortune to which she was entitled.

There was a core of substance to her complaints, which could only be confronted by going to court, since there was no background of good will to make any discussion profitable. The question was not who was entitled to call herself Lady Korda or the whereabouts of Alex's nonexistent secret fortune, but the extent to which the executors would be

obliged to favor Maria's claims for alimony over the other claims on the Estate. Did she, in effect, have a prior claim? If the executors acted on Maria's demands, they would certainly be sued by Alexa, and they might even be sued by the lawyers representing the minors, which in my father's case meant that he would end up being sued by his own children. Under the circumstances it seemed sensible to remain deaf to Maria's complaints, which was Vincent's natural instinct anyway.

She appealed to Vincent, she appealed to Zoli, she wrote endless letters from her apartment in Paris, she took the advice of friends and relatives, and at last she determined to descend on London and take to the courts.

This prospect prompted my father to remark that Alex was lucky to be dead. He dreaded the approaching storm, and rightly assumed that while Maria would put on the more dramatic performance, Alexa would be far more ruthless and grasping, and just as difficult to deal with in her own way. Zoli had declined his appointment as an executor on the grounds of ill health, and prudently returned to California, where it would be difficult to subpoena or sue him. Vincent, however, had no choice but to stay. He toyed with the idea of going into exile, but he was a married man with children, and finally resigned himself to "facing the madness."

No sooner had Maria arrived than she was embroiled in controversy, since some of the legal documents referred to her as being "over sixty," whereas she claimed to be no more than fifty-five years old. Vincent snorted at this. Once, before the war, he had traveled with Maria and she had thrown her passport overboard when she discovered it listed her real age, causing endless and embarrassing problems with the immigration authorities when she was unable to produce a travel document of any kind. Maria had been born the same year as Vincent, and he *knew* he was sixty. "She is," he said, with considerable relish, "an old, *old* voman."

Old voman or not, she was determined to fight. On her first day in court, she only spoke once, but that was enough to prompt Mr. Justice Upjohn to remark to her counsel, "I think you might ask your client to moderate her voice."

Moderation was not a word Maria understood, in any language. She had saved Alex's life in Budapest, when he had been taken by Horthy's troops. She was not now about to be afraid of a dried-up old English

judge in scarlet robes and a white wig! Loudly, she continued to make her case, explaining to the judge that she had not spoken or understood English in 1932, when she signed the divorce settlement, a point for which it seemed scarcely worth risking contempt of court, since it must have been obvious to the court that her English was not very much more coherent twenty-five years later.

As some of the eight lawyers present explained to her the meaning of contempt of court, the case proceeded. Reduced to its basic level, it was a struggle between Alexa on one side, and Maria (and Peter) on the other, with the executors caught between them and appealing to the court for help. The executors could not settle any claims against the estate, nor could they even begin to assess its real value, until they knew how much death duty would have to be paid, but nobody could begin to estimate the amount of death duty because Alexa was insisting the duty on the paintings should be borne by the estate, rather than by her. The estate could not, therefore, pay out the amounts stipulated in Alex's will, and if Maria's claim to alimony were upheld, the executors might even have to liquidate the estate to meet this liability. Caught in this trap, the executors decided to put themselves in the hands of the courts. As my father said, "The worst that can happen is that we go to jail, which is better than being torn to death by two harpies!"

Maria made headlines ("MARIA STARS IN THE CASE OF KORDA'S WILL!" "WILL THE REAL LADY KORDA STAND UP!") on the first day of the trial, foreshadowing a long period during which Alex would be more famous after his death for his will than for his films.

Worse, if possible, was to come. On the next day of the trial to decide what claim—if any—Maria had against the estate, the case was further complicated by Peter's appearance at the side of his mother, a surprising act of filial devotion, since the success of Maria's suit would reduce the total of the estate, or eliminate it altogether, thus depriving him of his share. Both mother and son were threatened with contempt of court. Maria, the judge pointed out, had sent him a "grossly improper" letter. Mr. Justice Upjohn rebuked her sternly and threatened her with "serious trouble." Maria glumly listened to this lecture, huddled in her full-length mink coat, but after several further exchanges between Mr. Justice Upjohn and the lawyers, Peter rose to object. "For heaven's sake," he interjected. "Get it right. It is fantastic. I will not be insulted!"

Mr. Justice Upjohn then threatened Peter with contempt of court. Peter asked for, and was granted, permission to leave the court; he walked out with Maria.

The judge remarked: "Mr. Korda may return whenever he wishes, but like his mother, he must remain silent when he is in my court." So far as Maria's claim went, the judge rather waspishly asked whether it was her contention that "the testator was obliged to go on working himself to the bone in order to provide for the obligations to his first wife, or could he retire and buy himself Old Masters, which would diminish his liabilities?"

This question, presumably metaphorical, was not answered, since the testator was in no position to work at all, being dead. The real problem was whether Alex had been in a position to leave his pictures and other "chattels" to Alexa, and this Mr. Upjohn dealt with trenchantly in his decision. "If Mrs. [Maria] Korda," he pointed out, "was anxious to put the testator on terms as to how he should deal with his assets, she should have had some terms inserted in the agreement to do so." There was nothing in the agreement that entitled her to have the pictures sold, or to say how the testator's assets were to be dealt with. By the terms of her separation agreement she was entitled to one quarter of the income of the estate, whatever that might eventually be, without any right to determine what should or should not be included in the estate or how it was run by the executors, "no less, no more."

At that point Maria stood up in court and shouted, "So Mrs. Korda can drop dead!"

"Remove her from the court!" Mr. Justice Upjohn said, and proceeded, no doubt with some relief, to make an order on his judgment.

THERE WAS NO DOUBT that Maria had lost her case, and that Alexa's right to the pictures had been confirmed. The executors were not very much better off than they had been before, however, since they could hardly proceed with their affairs until they knew what Alexa intended to do with the pictures. Vincent, in his gloomy way, had been right. In the end, the third wife would be more trouble than the first, and a lot sharper. Despite her stated sentimental wish to remain at KPG for a little while, Alexa quickly took an expensive garden apartment in Grosvenor Square, and prudently moved the now-famous pictures into it. There was no further talk of their becoming a "memorial" for Alex.

She was soon much seen in the company of David Metcalfe, a young man about town.

There, from time to time, I visited her, parking my car in the mews behind, where Milton Greene was living while he produced *The Prince and the Showgirl*, with Marilyn Monroe and Laurence Olivier.

Alexa kept an open house, and it was possible to drop in fairly easily. One afternoon I found Milton Greene sitting there despondently in the living room, which always gave me an eerie feeling, since it was odd to see Alex's possessions and paintings transported to a new home. A remote figure he had sometimes been, but I found it difficult to convince myself that he was gone, and it was even more difficult when one was surrounded by all the evidence of his gift for the accumulation of worldly goods on a grand scale.

Alexa was dressing, and Milton, who looked forlorn and lonely, invited me to a game of chess.

"Problems?" I asked.

"Ah, oh, hmm, *problems?*" Milton said. He often seemed at a loss for words, or simply not to have heard, and his answers seldom had anything to do with the questions asked. Unless his interest was aroused, he seemed distressingly vague, though always soft-spoken and polite, and it was sometimes difficult to imagine how he managed to take over Marilyn Monroe's career. He had, I knew, been sent by a magazine to photograph her, and when she answered the doorbell, she was so surprised at the slight, boyish figure before her that she exclaimed, "Why, you're just a boy!" Milton looked her up and down slowly (he did almost everything slowly) and finally said in a whisper, "And you're just a girl." From that moment on, their friendship was sealed, and probably only Milton could have persuaded her to come to England to play opposite Olivier. Milton had that quality of making everything seem easy, or at any rate, possible, and given the width and breadth of Marilyn Monroe's fears, her presence in England was something of a miracle, even for him. She was afraid of men, afraid of acting, afraid of traveling, afraid of appearing ridiculous, afraid of publicity, afraid of failure and, at this moment, desperately afraid of Olivier.

"Problems with the movie," I said helpfully, as Milton tried to decide whether he was playing white or black.

"Oh. The movie. Hmm. Yes."

"Are Larry and Marilyn Monroe getting along?"

"Oh. Sure. They like each other a lot."

"That's not what everyone is saying."

Milton always took the bright side of things, and was reluctant to suggest any hint of friction or disturbance in the world. *He* liked everyone, and saw no reason why everybody shouldn't do likewise. "Well," he said, after a pause, "there have been a few problems, yes."

"That's what I said."

"Olivier has problems with the close-ups."

"Why? I would have thought a close-up with Marilyn Monroe would be stimulating, even for Larry."

"He says she doesn't wash enough. He says she has, um, B.O."

"Oh. Did he tell anyone?"

"Well, yes. He told Marilyn. That's the problem."

"Alex once said that Laughton used to annoy actresses he didn't like by eating garlic before a close-up, but I suppose B.O. is worse."

"Maybe. I don't know. What did your uncle do about it?"

"He sent a driver to a Jewish delicatessen in Soho, and had the actress eat a couple of garlic sausage sandwiches before her scenes with Laughton. That way she couldn't smell him. They canceled each other out."

"I don't think Larry is going to stop taking baths, do you?"

"No, I don't think even Alex could have solved that one."

"You know," said Milton, staring at the chessboard as if he had just realized it was there, or forgotten what it was, "I never met your uncle, but he was a great man, I know that. Probably he could, like, *solve* problems? Right? But you have to learn something, and it's hard. He's *dead.* I get the feeling that you still think he's around to solve problems. But, see, he *isn't.* He's not going to solve mine, and he's not going to solve yours, and he's not going to solve Alexa's."

"What problems?"

"She has a lot of money."

"That's a problem?"

"It is for her. She's going to get herself hurt, just like Marilyn."

"She's a pretty tough girl, don't you think?"

"They're all pretty tough girls. It's the tough ones that get hurt. Especially when they're rich and pretty."

Milton drained his scotch-on-the-rocks, moved a chess piece and

relapsed into silence until Alexa arrived, when he rose, scattering the pieces off the board and onto the floor.

Alexa looked to me much as she always had, but more chic. Whatever Alex had wanted her to achieve in the way of elegance she had at last managed to accomplish, now that he was no longer here to approve. She wore an expensive couture tweed suit, a small fur hat and a diamond necklace, and in one hand she carried a Fabergé cigarette case, with a cabochon clasp. She gave Milton a kiss, and waved him off to refill his glass, then sat down with me on the sofa that had once been in Alex's study at KPG, below one of his paintings. She looked up at it.

"Ghosts of the past," she said.

"Valuable ghosts."

"Very. I hope you're not upset with me about the disagreement I'm having with the executors. I'm very fond of your father, and I know he's angry."

"He's very angry, yes. But I'm not. You have your interests; the other beneficiaries have theirs—including me, I guess—and he's caught in between."

"It was very naughty of Alex to arrange it that way. But I do want what's mine."

"You don't seem to be doing that badly."

Alexa laughed, the kind of deep, clear, strong laugh that she had had when I first met her, four years earlier, or a lifetime ago, as it now seemed.

"Not badly at all! How about you?"

"Well, I'd never counted on money from Alex. It doesn't matter that much to me what happens, except that I'm sorry for Vincent."

Alexa smiled. "People have been sorry for Vincent for years. All the same, he's a sweet man, and I'm sorry for him too. But I like being rich. I have plans."

"What kind of plans?"

"I want to get married again."

"Already?"

"Already. I've very fond of David Metcalfe, and he's fond of me. We're going to get married."

"Isn't it a little *soon*?"

Alexa rose and took her gloves off the sofa. "You are sometimes

absurdly young and annoying," she said. "I'm going out. Why don't you finish your chess game with Milton? The two of you seem to think alike, so I'm sure you'll get along."

With that, she was gone.

Milton rearranged the pieces on the chessboard. "I told you," he said. "Nobody's going to solve her problems. She has to learn, like everybody else."

"Learn what?"

"Learn that being tough doesn't help. Being rich doesn't help much either. What matters is feeling good about what you're doing. I don't think she does."

Alexa now had the upper hand in the matter of the will. No matter how much Maria objected to her, Maria was a ghost from the past, emerging from obscurity to air old claims and long-forgotten wrongs. My father was the first to recognize he was trapped. He hated "Lady Korda," as he now referred to Alexa, but on the other hand, he had very little reason to be sympathetic to Peter, who was now denying that Zoli and Vincent were even Alex's brothers in the first place. He could not support Peter's claims against Alexa, and he was reluctant to help Alexa, therefore the affairs of the estate dragged on interminably, since the only way of deciding anything was to throw up one's hands and let the matter make its way slowly into the courts. Since the executors knew very well that any action on their part would result in acrimony followed by litigation, they were understandably reluctant to take any step at all without first consulting the courts, and the prospect of continuing London Films as a going enterprise (and such prospects had never seemed all that bright to begin with) vanished in the endless litigation, which took up all my father's energy, exhausted his patience, and of course further drained the estate, which seemed likely to be consumed in lawyers' fees before it was ever settled.

The prospect of Alexa's marriage did nothing to console him. He had discovered that David Metcalfe's mother was the sister of Lady Ravensdale, Sir Oswald Mosley's aunt and Vincent's former neighbor, and the possibility of this connection, however remote, to the would-be British Führer was profoundly offensive to him. In certain aristocratic circles, Sir Oswald was perhaps regarded as an amiable eccentric, but to my father he remained a follower of Adolf Hitler. The idea that Alex's pictures would eventually fall into the hands of a family connected

however remotely and innocently to the former Black Shirt leader infuriated him, and he soon came to regard "Mrs. Metcalfe" as the reincarnation of Eva Braun.

The involvement of a stranger in Korda family affairs was actually disagreeable to everyone. Maria and Peter, however many times they might appear in court, were undoubtedly Kordas, Alexa had been married to Alex—all this was "in the family"—familiar, irritating, but in some ways comforting, since everyone was living up to his or her role. But Metcalfe was a foreigner, English, unaware of Korda family traditions; his influence over Alexa, whether real or imagined, was feared and unpredictable. Metcalfe himself, whom I met from time to time, seemed unaware of these feelings; he was coolly polite, aloof and somewhat mystified by the drama in what seemed to him, no doubt, a relatively simple matter of inheritance. He gave the impression that he regarded the Kordas as an interesting primitive tribe.

He was tall and lean, with the erect posture that so many Englishmen of middle age carry over into civilian life from their days as officers. A partner in Lloyd's, he was reputed to be a man of devastating attraction to women, and this may have been true, considering Alexa's feelings toward him, yet they did not seem affectionate toward each other in any obvious way. My presence may, of course, have accounted for that, since as a nephew of Alex's I was hardly the ideal companion for Alexa in his eyes. He was a man who was very much a part of Society, a facet of London life the Kordas had always ignored.

Alex had been something of a genius and a star in his own right, who manufactured his own society, and lived beyond anybody's rules or prejudices. He was not interested in titles. He had one of his own, after all, and while he was proud of it, he was no snob. He loved England, but he would have found it ridiculous to affect an English accent or English manners.

He disliked "Mayfair nonsense" in general (as he put it), country weekends and the company of people who were neither experts in a specialized field nor gifted in some large and interesting way. He had been fond of H. G. Wells, to his cost (though he never regretted it), he adored bigger-than-life swashbucklers like Churchill, Bracken and Beaverbrook. He had been fascinated by scientists, writers, academicians, astronomers and anybody else—from whatever social background or culture—who could tell him something he did not know;

given a choice of dining with a dull Duke or sitting in the kitchen, he
would have preferred the kitchen, assuming the cook was a man worth
talking to.

Once, when he had been bored by some of Alexa's new society
friends, he had left the room, gathered my father up in the car, and
had himself driven to Maida Vale, to watch an elderly German émigré
restore a seventeenth-century canvas, painstakingly gluing tiny frag-
ments of paint onto a new stretcher. "At least," Alex said, "he knows
how to *do* something."

Despite his difficulties with the film crafts unions, and his increas-
ingly Tory attitude toward them, he was capable of sitting down for
a long chat with the left-wing and Communist leaders of some of the
unions, arguing over politics until late in the night, and gently remind-
ing them that he knew more about it than they did, having served as
a commissar in a Communist government. When he was sixteen, had
he not joined in a riot to protest the execution of Ferrer Guardia, the
Spanish humanist and anarchist, arousing the crowd to a fever pitch
by standing on a café table and shouting "Down with Ferrer's murder-
ers!" until he was dragged down by armed policemen, who dispersed
the mob Alex had helped to create?

Alex was himself a humanist (and something of an anarchist)—wise,
warm, gentle, humane, capable it is true of great ruthlessness, but
deeply aware of other people's needs and fears. He enjoyed his success
and his wealth, but he had no wish to spend his life in the company
of the rich, and no particular affection toward them as a class. A man
without a country, he was happy to have been adopted by England, but
by no means uncritical of her either. He preferred living in France. He
thought in Hungarian. Latin was his favorite language for poetry, and
German the language he swore best in. He kept his money in Switzer-
land, got much of his financing in America. He was, in every sense of
the word, cosmopolitan.

It was not for nothing that Alex loved philosophy. He was himself
an Epicurean, stoic and resigned to fate, and had devised for himself
a view of the world which was at once Manichean and cynical. Winston
Churchill had once said that "Alex would make a splendid Prime
Minister of Hungary, if he had a Rockefeller as his Chancellor of the
Exchequer!" and while Alex had no political ambitions (holding that
they are presumptuous and ridiculous in a foreigner) he had indeed

something of the Prime Minister about him, an air of authority and
responsibility, a sense of being involved in grand affairs. There was
something about him that reminded one of a Renaissance cardinal, or
a medieval rabbi, or a Whig Duke—an inherent nobility, a willingness
to shoulder burdens, an acute, cynical intelligence, a sense of compas-
sion artfully concealed by irony and self-interest.

I could not see in David Metcalfe an appropriate successor to Alex,
and I do not suppose I managed to hide this opinion nor that it was
any of my business. Metcalfe, partly because he was so very English,
seemed to me unimpressed by the Korda family. I, on the other hand,
thought the Kordas were superior to anybody, except for such *hors-
concours* figures of world significance as Winston Churchill. Alex's
death did nothing to diminish my pride. I had not yet come to grips
with the fact that Alex was no longer there to make the Kordas special.
Dimly I perceived that if I wanted to be special I would now have to
do it on my own, but the ghost of Alex was too strong to exorcise
quickly.

I was not, therefore, tolerant of Alexa's plans for a second marriage,
and as the affairs of the estate settled into a lengthy siege, with occa-
sional sallies, explosions and pitched encounters to enliven the tedium,
as in a medieval battle, I gradually drifted away from Alexa and re-
treated back to Oxford, where I was, in any case, obliged to start work
in earnest if I wanted to receive a degree. I came down to London less
frequently, and seldom telephoned Alexa. I was no more able to exor-
cise her than I was able to exorcise Alex, but I no longer felt comforta-
ble around her, as if she had joined the enemy camp, not in opposing
my father over the estate, which I could understand, but in choosing
a man so very different in every way from Alex.

I felt a little like Hamlet contemplating the alliance of Gertrude and
Claudius. It was not a comfortable feeling, or a productive one, and
unlike Hamlet I sought release in work and flight. At least I would
ensure that there would be a Korda with an Oxford degree, the first
to fulfill this modest and pedestrian ambition.

EVENTS, HOWEVER, WERE to draw Alexa and me together again, though
in this case they came from outside the Korda family. Just as Alexa,
once she had money, craved excitement, I too felt bored and restless
back in Oxford. I missed Alex—not so much his physical presence as

the knowledge that he was there, and giving us a kind of insurance policy against obscurity or failure. I had never thought much about the future, on the assumption that Alex would always be there to arrange it. Now that he was gone the future no longer seemed so dazzling. I was not suicidal, hardly even depressed, but I was ready to do something foolish, to make a break with the past, to draw a line under what I had been and become something else. Merely getting an Oxford degree did not seem to offer much in the way of dramatic possibilities. I needed a more violent turning point, and found it in the gathering storm of the Hungarian Revolution.

THROUGHOUT THE AUTUMN of 1956 unrest had simmered in Central Europe. The 20th Congress of the Communist Party of the U.S.S.R., in which Nikita Khrushchev had destroyed the Stalinist myth, had threatened to undermine the foundations of Communism in the Eastern European countries. The Poles had reacted first, but their ferment did not pose a severe threat to the Russians, who had several dozen divisions in East Germany, and were thus in a position to contain— and threaten—Poland from three sides.

The Hungarians, however, had a border with Western Europe. A revolt in Hungary would pose a far more dangerous threat to the Russians, and give the Americans the possibility of intervening across the Austrian-Hungarian border, or at least cherish the illusion that they might do so, which was almost as dangerous. Worse, Radio Free Europe had encouraged the Hungarians to believe that America would support such a revolt.

Since Mátyás Rákosi's Stalinist government derived much of its strength from a blind obedience to the most brutal interpretation of the Stalinist myth, the sudden shift in Soviet policy and the consequent relaxation of police rule left them high and dry. Rákosi had ordered his Foreign Minister, László Rajk, arrested during the Stalinist purges of 1949. Rajk was tortured, castrated and finally hanged, according to the customs of the day, as were thousands of lesser unfortunates who passed into the hands of the AVH, or State Security Police. Now Rákosi was obliged to "rehabilitate" Rajk, and admit that the charges against him were fabricated. Mrs. Rajk was honored with the first of the grim, spontaneous parades which marked that turbulent summer, as the students walked silently to lay a wreath in honor of a man who had died

for nothing more principled than a power struggle, but who was now seen as a martyr, and the symbol for thousands of other victims.

Rákosi resigned and was succeeded, inappropriately, by Ernő Gerő, whose qualifications for office included command of the secret police, and who had his own private torture chamber in the cellar of his house, where, dressed in a long leather butcher's apron, he had amused himself by extracting "confessions" from Communist Party members who had fallen from grace.

Gerő was not the man to bring about democratization in Hungary, and by the beginning of October the country was in turmoil, the people moving inexorably toward revolt, the government paralyzed by its own fearsome reputation and growing weakness.

I followed these events with mounting fascination from afar, gradually learning what I could about Hungary and Hungarian politics. It was clear to me that an explosion was imminent. I knew enough about the Hungarian temperament for that. Others were concerned about the Middle East, where the Suez Crisis was building, and those of us on reserve status were preparing to be remobilized for what seemed very likely to be World War III. All over Oxford, young men searched for their kits in anticipation of the coming call-up that was by now the worst kept secret in British history. Reservists in such elite units as the Parachute Regiment smugly prepared themselves to go first, and boasted of orders to keep themselves ready to go at a moment's notice, and a brisk run on secondhand Baedekers to Egypt startled the clerks at Blackwell's, the Oxford bookseller.

I was the only person to request a Baedeker to Hungary. The idea was not originally mine. In the room below me there lived a young man named Michael Maude, half-American like myself, who had been an officer in the Coldstream Guards, and whose grandfather, General Maude, was famous throughout the British Army for his rearguard action in the last days of Gallipoli.* Michael, not surpris-

*General Maude had insisted on returning to the beach, which had been heavily planted with land mines timed to go off in a few minutes, in order to search for a missing suitcase, thus prompting a parody on Tennyson which passed into legend:

> "Come into the lighter, Maude,
> For the fuze has long been lit,
> Come into the lighter, Maude,
> And never mind your kit!"

ingly, himself owned the kind of kit which can only be handed down from General to grandson. Daily, as the likelihood of our all going to Suez increased, Michael examined his kit: great brassbound trunks, marked with the labels of hotels from Simla to Basra, metal hatboxes, a folding bar, a collapsable safari bath, a Purdy shotgun broken down into a leather carrying case, a Mauser Military pistol in a wooden holster that also served as a detachable stock, Zeiss binoculars, a Negretti & Zamba compass . . . As he uncovered the endless quantities of silver-mounted ivory brushes, crystalware, knives, tools and shaving equipment it was easy to see why his grandfather had been reluctant to abandon any part of it at Gallipoli. I pointed out to Michael that if he in fact was sent to the Middle East he would surely go by air, with one small haversack, and that the Coldstream Guards were on the whole more likely to spend the emergency at their regimental depot in England.

"You never know," he said mysteriously. "They're saying at the War Office that we may not be going to the Middle East at all."

"I hope they're right."

"No, no, you don't understand. The Middle East crisis is a *diversion*. The Israelis and the French will attack Egypt to keep the Russians busy, and the British and Americans will wait until the right moment and cross into Hungary to liberate it. The entire Russian empire will collapse."

"You think so?"

"Not really, no, but a great many people at the War Office *do*. I'd rather go to Hungary than Egypt myself, wouldn't you? So much nearer, for one thing." Maude thought for a moment, presumably about the climate of Hungary in the winter; he was the only person I knew who owned a mink-lined British warm service overcoat, acquired by his grandfather during the occupation of Arkhangelsk. "You speak Hungarian, don't you, *and* Russian? You'd be jolly useful, I should think. I can give you the name of a chap in the War Office who's looking for people like you."

Michael's contacts with the War Office were, of course, very good, so many Maudes having served as general officers, and I had no doubt that somewhere preparations were being made for a Hungarian adventure of some kind. Mindful that remobilization of the British armed forces would certainly mean spending several weeks at an R.A.F. sta-

tion in the windswept suburbs of Birmingham before we could expect
to be sent to Egypt or anywhere else, I allowed Maude to give my name
to the War Office, and promptly forgot about it. The Hungarians had
not yet had an uprising, and it seemed very likely that the Russians
would eventually make the kind of concessions necessary to defuse the
situation. Everybody thought so, anyway—except for my father, who
wisely predicted that "the Poles will behave like Czechs, the Hungari-
ans will behave like Poles and the Czechs will behave like bastards."
He understood better than most people the dynamics of the situation;
the Poles would have no choice but to proceed cautiously, surrounded
as they were by the Russians; the Hungarians had already gone too far
to control the momentum of events in Hungary, and would have no
choice but to fight; and the Czechs, terrified by the threat of an
explosion of hatred around them, would side with the Russians, thus
driving a wedge between Poland and Hungary and freeing Soviet troops
for the inevitable intervention.

Throughout October, I grew more restless. I haunted the libraries,
read everything I could about Hungary, pestered my father with ques-
tions (which he answered evasively, obviously dismayed by this sudden
interest in Hungarian history and politics), sought out scholars and
émigré Hungarian figures, and tried to find somebody who would go
to Hungary with me. If there was going to be a revolution, it seemed
to me important to see it happen. Alex, after all, had been at the center
of events in Hungary, he had lived through all the excitement and the
drama of a revolution, and I was determined to do the same. Up till
now, I had found it difficult to equal Alex in any way, perhaps because
it was an impossible task. Nor did it seem likely that I would ever equal
Alex's phenomenal ability to make money or his easy, graceful charm.
His successes and his aura—financial, sexual, professional—all seemed
to crush and reduce me, and I felt suffocated, haunted by the possibility
of being a failure all my life, of having to compete with Alex long after
his death. And success seemed to me impossible to hope for, since I
would have to equal or surpass Alex to even think of myself as having
succeeded. After all, here I was, still a student at an age at which he
had already become the leading film director of Hungary, a man about
town and the husband of a beautiful movie star. Now he was gone, and
we had never had a chance to talk about how he had become what he
was—and whether or not he thought I had any of his talents. Whatever
I could learn about him, I would have to find out for myself.

It was not surprising that the Hungarian Revolution offered an irresistible attraction. Here, at any rate, was a larger-than-life event in which I could follow in Alex's footsteps. The only trouble was that I couldn't think of a way to get there. Any hesitations I had were swiftly ended by two friends from Oxford, Jacques Robertson and Coco Brown, who were fired with enthusiasm. Jacques' father was John Foster Dulles' Assistant Secretary of State, and a man well-known for his devotion to "rolling back the Russians." He had supported "the Gitmo" (Chiang Kai-shek) tirelessly over the years, and had inspired Jacques with something of his own crusading zeal. Jacques had actually met the Gitmo and Madame Chiang, and treasured several souvenirs of that encounter, as well as a gold pencil presented to him by General Douglas MacArthur. He was therefore determined to be present at this historic opportunity to prove that Dulles had been right about the inherent weaknesses of the Soviet empire, and gradually convinced me that we owed it to ourselves—and to the Hungarians—to participate. Coco, less political, thought it would be a perfect opportunity to make a documentary film. Quickly we made our plans. Jacques would fly to Paris, pick up a car and drive to Vienna. Coco would rent a camera, borrow some credentials from the Columbia Pictures office in London, and make his own way to Vienna, where we would all meet at the Continental Hotel and cross the border at the right moment.

I was reluctant to discuss these plans with my father, who would surely regard them as a piece of stupidity, so I went down to London and sought out Alexa, who was likely to be more understanding. In fact, as it turned out, Alexa was in a fever-pitch of excitement. The Hungarians, who had been ignored by everybody for years, had suddenly become a fashionable cause, and Alexa, as a Korda by marriage, was eager to play the role of La Pasiónara in a new revolution. The only problem was that there were very few Hungarians available to transform into heroes, except for people who had lived most of their lives in the West. Still, Alexa was determined to be active on their behalf, and was busy rounding up medical supplies to send to Hungary, in case they were needed, which seemed increasingly likely. My arrival presented a heaven-sent opportunity, since nobody had given much thought to the difficulties of actually getting these supplies from London, where they were being assembled, to Budapest. I should take them.

Until this suggestion had been made, I had no good reason for going to Hungary, beyond the simple desire to go. Now I had a re-

spectable purpose. I quickly joined some friends in Oxford to orga-
nize a car, had the medicines packed in shipping crates, and ob-
tained a letter of introduction to the Director of the IInd Medical
Clinic in Budapest, Professor J. Hajnal. Together, Alexa and I
spent a busy day and a night in London, arranging all this, and ap-
parently causing enough talk to rouse the attention of the War
Office, for I received a mysterious phone call at Alexa's inviting me
to lunch at the United Services Club.

There a florid gentleman in a well-cut tweed suit greeted me at the
bar, introducing himself to me as Major Temple, and asked if I was in
fact going to Hungary. I replied that I was.

"Do you speak Hun?" he asked.

"Hung*arian!*"

"That's what I meant. Hungarian, of course. Speak it?" Major Tem-
ple, I was dismayed to see, appeared to have one glass eye, but it was
difficult to decide which eye was glass and which was real, since each
of them seemed to have a life of its own. His mustache was reassuringly
military, a small thicket of red hog's bristles, and his nose had a fine
network of broken capillaries, like a road map.

"I don't speak much Hungarian at all. I do speak Russian."

"Then you can *parler* Hungarian too, I suppose?"

"No, not at all. They're quite different languages. Russian is Slavic,
Hungarian is Finno-Ugrian. Different alphabets, different grammar,
different everything. Hungarian is more like Finnish or Turkish."

Major Temple's interest in linguistics waned. "Not the point," he
said, gesturing with his glass of gin. "You're going in as an Englishman
anyway. Keep your eyes open, and report back to us when you come
out."

"Keep my eyes open for *what,* exactly?"

Major Temple dabbed at his forehead with a silk handerchief. It was
evident that he hadn't any idea himself of what I was to keep my eyes
open for. He thought for a moment. "Regimental markings," he said.
"That kind of thing."

"I don't think the Russians *have* regimental markings, do they?"

"Well, they must have *something,* old boy. They wear uniforms,
don't they? They have collar flashes, cap bands—that kind of thing.
Take down the regimental numbers. They always paint them on lor-
ries."

"Will any of that be useful?"

Major Temple winked, an act which seemed to cause him considerable difficulty, perhaps because he was winking the glass eye. "Ours not to reason why, eh? Every bit of information helps. It all fits in, you see —all the little bits make up the big picture. Chap on the spot can't tell what's important and what isn't, but when you're looking at the big picture some quite small, insignificant piece of information may be the key to the whole puzzle. Just use your eyes. I hear you're going in with medical supplies. Damned good cover, that."

"Well, it *isn't* exactly 'cover.' I *am* going in with medical supplies. That's the whole point of going."

Major Temple winked, this time with rather less effort by using what was apparently his good eye. "That's the ticket," he said cheerfully. "Stick to your cover story and you'll do fine. Now we'll have a spot of lunch. Act natural."

I was a little uncertain as to what Major Temple would consider "natural" behavior in his club. Was it a warning to mind my table manners, or simply not to discuss our conversation at the bar? Neither seemed necessary, particularly the latter, since everybody made way for the major and we quickly found a table of our own, either because his secret status was acknowledged and respected by his fellow members, or (which seemed to me more likely) that he was well-known as the club bore.

We ate briefly and silently—the food was not such as to command one's undivided attention—and talked about the political situation. Major Temple, unsurprisingly, was convinced that the real crisis would come in Hungary, or possibly Poland. The Middle East was a diversion, a clever trap into which the Russians would fall. They would wake up to find the Jews and the Frogs in Cairo, and the Hungarians and Poles liberated. The major collected his bowler hat and his umbrella, and we solemnly shook hands on the steps. He handed me a card with a telephone number, asked me to call him when I got back, and wished me the best of British luck. At least, I thought, he hadn't offered me a poison capsule.

All the same I put the card away in my wallet. One never knew when it might come in handy.

EVENTS NOW BEGAN to move rather more rapidly. Throughout late
October the various segments of Hungarian society formulated a series
of public appeals to the government, calling, among many other things,
for the expulsion and trial of Rákosi, for the return of the old Hun-
garian coat of arms to the Hungarian flag, for a parliamentary investiga-
tion into the terms of Hungary's trade agreements with the Soviet
Union, for amnesty for political prisoners, for a return to "Socialist
legality" and for the return of Imre Nagy to the government. As appeals
from the engineers, students, youth groups, agricultural workers and
doctors flooded in, the list of demands swelled—a new Hungarian
uniform for the army, instead of the Russian uniforms they now wore,
friendship with Tito, the restoration of Hungary's traditional national
holiday on March 15, the withdrawal of Soviet troops, less overcrowd-
ing in student hostels, Hungary's right to sell its uranium ore to the
highest bidder, instead of giving it to the Russians for nothing. This
blizzard of paper was accompanied by the first signs of open revolt. On
October 22nd, the Petőfi Club called for an emergency meeting of the
Central Committee of the Hungarian Communist Party, in one of the
most closely argued and emotional of these appeals, and on the same
day, the Poles announced their own demands for greater independence
from the U.S.S.R.

On the next day, the students and many other ordinary Hungarians
began to destroy the symbols of Communism in Hungary. The police
and the army removed the red stars from their uniforms, the red star
was torn from Hungarian flags, leaving them with a gaping hole in
the center, and a jubilant crowd gathered to topple the huge bronze
statue of Stalin. On this same day, a massive demonstration took
place in which the crowd gathered at the statue of Petőfi, the Hun-
garian national hero-poet, then marched into Parliament Square, at
least 300,000 strong, to shout for Nagy to appear. At the crowd's
demand, the great red star on the top of the Parliament building was
turned off, and after several hours of waiting an exhausted and bewil-
dered Nagy finally appeared on the balcony of Parliament to appease
the crowd, and electrified those who could hear him by saying to them,
"My *friends*—because there are no more 'comrades'!"

Unfortunately, the new First Secretary, Ernő Gerő, was making a
speech on the radio at the same time, and not a few people in the crowd

listened to it through the open windows of the surrounding buildings, and heard him denounce them as "a Fascist rabble." By the late evening, the infuriated crowd had spilled over to the radio building, to demand equal time for Nagy and to extract an apology for Gerö's injudicious comments. Whether the crowd rushed the building or the AVH guards panicked is hard to say—possibly both things happened more or less simultaneously—but at 9 P.M., the AVH opened fire on the crowd of demonstrators, and the revolution began. By the next day, the Russian bookstores were in flames. The Hungarian troops were turning their arms over to the demonstrators. The first Workers' Councils were being set up to maintain order, and the Russians were already beginning to open fire on Hungarians. On the twenty-fifth, a crowd of 25,000 people gathered in front of the Parliament Building, and were attacked from each side of the square by Soviet tanks. At least 800 people were killed, and a member of the British Legation counted twelve truckloads of corpses being removed from the Square; many of the dead were women and children.

All this I heard, with increasing anxiety, in London. It was clear to me that unless I went soon I was going to miss the revolution, and on the night of the twenty-fifth I phoned my friends in Oxford and asked them to meet me at Alexa's apartment. Each of us would be responsible for bringing warm clothes and money, and each of us would carry one box of medical supplies.

"Have you told Vincent?" Alexa asked, as the two of us sat and waited.

"Not yet. I'll tell him on the way out of London. I'm afraid he might talk me out of it."

"He's going to be upset."

"Maybe. But it's something I have to do."

"Why?"

"It has to do with Alex, I suppose. It's not so much a heroic gesture as an act of desperation."

Alexa poured herself a vodka. "You don't *have* to be Alex, you know," she said.

"I know. That's not the point. My problem is that I want to be Alex and I'm not."

"Going to Hungary won't turn you into Alex, any more than going to bed with me would have done."

"Maybe not. That's never been the reason I've wanted to go to bed with you, though."

Alexa nodded and lit a cigarette. "I don't agree," she said. "That's *always* been the reason. I suppose otherwise it might even have happened, but it's always been perfectly obvious that I was a kind of shortcut for you to become Alex. No woman likes being used as the symbol for something else. If you want to become Alex, you'll have to find another way of doing it. Besides, Alex wasn't perfect, you know."

"I know."

"You don't know it the way I know it."

"He can't have been all that bad."

"He wasn't bad at all. He was wonderful. But he was a person. For you he's an idea, not a flesh-and-blood person at all. You can't spend your life competing with him, especially now. What you suffer from is overexposure to Korda glamour. He didn't lead a charmed life, you know."

"I always thought he did."

"I know, but you also know perfectly well it wasn't true. Look at his troubles with Maria. Look at his troubles with *me*. He was a very interesting man, but he wasn't a *happy* man. In fact he was quite proud of *not* being happy."

"Do you think I'm making a mistake?"

"In going to Hungary? Probably not. I think your father will be furious at me for helping you go, and I think it's certainly dangerous and possibly pointless. But it's better than your sitting around getting angry about the fact that I'm marrying David, or wishing Alex were still alive, or trying to live off his glory for the rest of your life. The terrible thing is that I'm really very fond of you, and while God knows I don't want to see you get killed, a revolution may be just the thing you need. I think it's a wise choice."

"What do you think about *your* choice?"

"There you go again. That's a fantasy of yours. I'm not making a *choice*. If it weren't David, it would be somebody else, but it certainly wouldn't be you. You're too young, I don't love you, not that way, and I want a grown-up, real marriage, with a house and children and a respectable husband. It was very exciting being married to Alex, but it wasn't exactly ordinary domesticity. You may not like David, but I think we'll be very happy together. What you need is a revolution, a

job that interests you, and a girlfriend your own age. There's nothing like regular fucking to help you forget about competing with Alex."

"I don't think I'll get that in Budapest."

"You never know. If you play your cards right, you'll get it when you come back. There's nothing like a touch of the hero to attract women, believe me."

A horn blew outside. I rose, Alexa gave me a kiss and I got into the car.

"Be careful!" she shouted. But it was the last thing I wanted to be.

"Be careful!" Vincent said, when I broke the news to him, standing in the dining room in my fur-lined flying coat, which had once belonged to Alex, while the car waited outside.

Vincent was less upset than I had expected, perhaps because he was stunned, more likely because he regarded it as just another blow from unkind fate. To a degree, he sympathized with my intention, though he had very little sympathy for the Hungarians themselves, whom he rightly suspected of being more violent, irrational and anti-Semitic than was popularly realized in the West. My desire for adventure seemed to him normal, and he gave me a few addresses in case I ran into trouble, particularly that of Zoltán Kodály, the great Hungarian composer. "He's a nice man," Vincent said, "he'll give you a lunch."

"In the middle of a revolution?"

"Even in a revolution, people still eat lunch. You'll see. Now give me a kiss and be careful."

I kissed him and we embraced each other. He was, I knew, disturbed by my decision, but I think he saw it as a first welcome sign of adulthood. Oxford, my fascination with Alexa, my friends—all these were mysterious to him, and perhaps even distasteful. Going to a revolution in Hungary, however idiotic it was, he understood. It was normal for someone in his twenties to suffer from romantic illusions about politics. Alex had had just such illusions, so had Zoli, so had Bob Capa, the photographer. It was perfectly normal, a thing which you had to get out of your system. He himself had been tempted to go to the Spanish Civil War, but Alex had told him not to be a bloody fool. No doubt Alex would have told me the same thing, but Vincent was not prepared to.

He peered into the back of the car. "What are the boxes?" he asked.

"Medicine."

Vincent shook his head. "My poor boy, in a revolution nobody cares about medicine. You will see." He turned into the house, and came back with a basket containing two bottles of scotch, some salami and a cheese.

"In a revolution," he said, "what people need is food. Now good-bye."

THE *CONCIERGE* AT THE Continental Hotel was full of regrets and apologies when I asked about the whereabouts of Coco Brown and Jacques Robertson. Both of them had telephoned, he explained. Mr. Robertson was unable to come at the present time, and Mr. Brown had been unable to locate a camera. I deduced that Jacques' father had forbidden him to make the trip, and that Coco had found Paris more amusing than Budapest seemed likely to be. All the same, I had no reason to hang around Vienna, and decided to go on with the companions I had. The *concierge*, who remembered Alex well, warned me against going to Hungary ("Conditions are very bad," he said, "one cannot even make reservations anymore at first-class hotels like the Gellért or the Duna Palace"), but he generously insisted on finding the hotel's Union Jack, reserved for the visit of high British dignitaries, and tied it to the roof of the car, to discourage Soviet airplanes from strafing us. Thus protected, we drove to the Border, were reluctantly allowed to pass by the Austrian *Grenzepolizei,* crossed no-man's-land, a dismal wasteland of tank-traps, barbed wire and stunted trees, lifted the red-white-and-green-striped pole at the Hungarian frontier, and found ourselves in Hungary at last.

The frontier post was deserted. Somebody had carefully removed the Soviet star and the hammer-and-sickles from the rubber stamps with a penknife, but whoever had performed this act of revolutionary vandalism had abruptly fled, leaving behind a plate of warm canned goulash and half a bottle of peach brandy. We stamped our own passports, and drove down the Vienna highway from Hegyeshalom to Moson-magyaróvár, where the highway takes one to Győr, and from there to Budapest. The countryside was much as I had expected it to be: flat, green and rather dull, and the small villages along the road, with their whitewashed walls and enclosed courtyards, seemed lifeless and deserted under the rainy autumn sky, either just because it was a disagree-

ably wet day, or because the inhabitants knew better than to be outside. The latter was more likely the case, as we soon discovered, for a few miles outside Mosonmagyaróvár, we came across a column of Soviet tanks heading toward the frontier. Since they were clattering down the center of the narrow road and showed no signs of stopping, we pulled over to the side and waited. I had a feeling that Major Temple would have wanted me to record the regimental numbers, but I noted that the Russians had carefully painted them over.

The crews looked at us with that absence of curiosity which is peculiar to soldiers, until the last tank in the column drew near us. One of the crew waved to us, and I cheerfully waved back, thinking he had noticed the British flag on the roof of the car. He replied by firing a burst of heavy machine-gun fire right over our heads. Then, with a broad Slavic smile, he gave us the finger, swiveled his machine gun back into the forward position and relapsed into a glazed coma of fatigue and boredom. The tanks accelerated and rumbled off down the road, followed by a long line of trucks carrying sleepy infantrymen and towing light field guns. At last a Soviet Jeep pulled up next to us, and an officer got out and examined our flag.

"*Amerikanskyie?*" he asked.

I shook my head and waved my British passport.

"*Angliskyie,*" I replied, and went on to explain our humanitarian mission.

He listened impassively, one hand on his field glasses, the other on the butt of his automatic pistol. He seemed to understand my Russian.

"You bring medicines for the Hungarians?" he asked incredulously. I nodded.

"They are ungrateful pigs. They don't need medicine, they need a swift kick in the ass. You are English?"

"*Da.*"

"Why are you meddling here? Go meddle somewhere else."

"May we go on to Budapest?"

He spat moodily on the pavement. "Am I stopping you? Go to Budapest. Go to hell. If you were American, I could understand it. They interfere in everything, but what is an Englishman doing here?"

"I'm half Hungarian."

"Then you are half pig." He turned and climbed back into his Jeep. As it started off, he turned around in his seat and called out, "English-

man, watch out in Győr! It's not a healthy place for humanitarians!"
He gave a roar of laughter, and vanished into the dust behind the
column of tanks and trucks.

About Győr he was not mistaken. A thick pall of evil hung over the
town. For the first time we saw bodies, a man hanging from a tree
outside a gas station, turning gently in the wind, a few huddled bundles
of rags by the side of the road, the soles of the shoes the only indications
that they had recently been people, their heads covered with unfolded
sheets of old newspaper soaked with drying blood. There was nobody
alive in the streets, in fact it seemed to be a ghost town, except for a
group of old ladies in black patiently waiting outside a baker's shop—
proof that my father had been right about revolutions, after all.

The only other signs of life in the center of town, oddly enough, were
the movie theater and a hotel-restaurant, both of them named the Red
Star. The restaurant was packed when we entered it, the crowd consist-
ing mostly of surly, furtive-looking men in ankle-length leather trench-
coats and wide-brimmed felt hats, accompanied by women who looked
as if they had been cloned from one of the Gábor sisters, only fatter
and less carefully groomed. The men all had brief cases and submachine
guns, and wore their hats pulled low over their faces as they spooned
up the watery goulash that was being served by the harassed waitresses.
I asked the headwaiter the way to the W.C., but he shook his head,
and replied in German that I would have to wait.

"The plumbing has failed?" I inquired.

"The plumbing? No, with the plumbing there's nothing wrong. A
man was shot in the W.C., that's all. He was trying to climb out the
window, and somebody shot him dead. We take him out in just a
minute, and you can use, please."

We sat down at one of the few empty tables, and a waitress brought
us over a small British flag from an airline display, and placed it in the
middle of the table, as if we were peacetime tourists. By now everybody
in the room was staring at us, and it struck me that their expressions
were anything but friendly, considering the fact that we had come here
from the West.

Eventually, an elderly man who had been standing at the bar came
across and sat down at our table. He looked very much like Alex Paál,
the same ingratiating smile and gleaming black mustache, even the
same heavily accented English.

"What you guys are doing here?" he asked.

I explained our mission of mercy.

"That's a smart move," he said. "You can sell penicillin here for a lot of money."

"No, no, we haven't come to *sell* it. We're giving it to the Budapest hospital," I protested.

He lost interest, though his eyes made it clear that he didn't believe us. "You have Red Cross identification papers?"

I shook my head and tried to explain that we were amateurs, free-lancers, volunteers.

"That's a pity. Any of these people here would pay a lot of money for Red Cross papers."

"Why?"

"Why? They're all secret policemen with their mistresses, that's why. They've got brief cases full of money, and they're waiting here to decide if they should try and cross the frontier tonight, and get out of Hungary, or if maybe Russians will get everything under control again, so they can go back to Budapest. They're very nervous people, so don't upset them, no? They just shot a guy upstairs who was taking a crap."

"I heard he was trying to get out the window."

"Probably also. He maybe saw someone here he knew. You have to understand, a lot of old scores are being settled these days. Not everyone who gets killed around here is political."

"You speak English very well."

"Yes, please. I was in America for a while. Cleveland. Lots of Hungarians there."

"I'm part Hungarian myself."

"No kidding? What's your name?"

"Korda."

His eyes widened. "You're not related, are you, to Korda Sándor?"

I nodded.

He whistled. "Son-bitch! I saw all his movies. Listen, we're related, you know that? You're Korda's son, on my father's side of the family I am related to a whole bunch of Kordas around Kecskemét and Ce-gléd, real good people. They all remember your father."

I thought it wise not to point out that anybody related to Alex would have to be named Kellner, not Korda, and that Alex was my uncle, not my father, and graciously shook hands on our consanguinity.

"Listen," my new-found relative said, "you're going on to Budapest now?"

"If we can find any petrol for the car, yes."

He frowned. "Petrol? You mean gas, *benzin,* no?"

"Yes."

"That's a big problem. Here, it's not like America, you know. There aren't so many filling stations. Nobody has a car. Tourists used to get tourist gas coupons, see, and Hungarian peoples needed a permit from the government. You couldn't just drive in and say 'Fill me up,' like at home. Anyway, I think most of them are now closed or empty. People have been taking the gas for making Molotov cocktails, no?"

"Yes? You mean there's no way we can buy gas?"

"I didn't say that. You got dollars?"

"Pounds."

"Dollars are better, but pounds are okay too. I see what I can do." Our friend went off and began to work his way around the room, whispering to each secret policeman in turn, until finally he returned with a particularly ferocious-looking specimen, who sat down at our table with a heavy creak of leather and placed his Soviet-made PPSH 7.62mm submachine gun in front of him on the table. I noticed that it was fully cocked. He spoke at length in Hungarian, while our new acquaintance translated.

"He says he is an innocent man and a good Hungarian. He wants to go to the West."

"Why does he think he'll be welcome in the West? He's a secret policeman, isn't he?"

"What makes you think he'll say so? He'll say he's an anti-Communist refugee, no? Listen, you want to buy Secret Police identification papers, I can get you a dozen of them right here for nothing. Every garbage can is full with. He'll sell you two cans of gasoline for fifty pounds. There's only one catch, no?"

"Yes? What is it?"

"He wants your British flag."

"To put on his car? Who's going to believe he's British? Anyway, it didn't do us any good. A Russian shot at us."

"They shoot at everybody. What do they know from flags? Ignorant peasants! Anyway, what do you care? If this bastard wants to put a

British flag on his car, let him. Maybe it will help him cross the frontier."

We solemnly shook hands, and our AVH man took us outside, his gun slung over his shoulder, handed over two jerry cans of gas from the back of his car and collected our flag, which he and his bosomy girl-friend tied to the roof of the car. He said something in Hungarian, and drove off.

"What did he say?" I asked.

"He said you're an asshole to go on to Budapest. It's full of crazy people."

I thanked our guide as we climbed back into the car, and said I hoped he would be all right.

"Don't mention it," he said, smiling. "We're relatives, after all. Us Kordas got to stick together. Anyway, I'll be all right here in Györ, I do favors for the AVH guys, so I'm okay when they come back, and my brother-in-law is on the new revolutionary committee, so I'm okay if they don't. You got to live somehow, right? I guess that's what your father Sándor would say, no?"

"Yes. As a matter of fact that's exactly what he would have said."

He waved as we drove away. "Break a leg!" he shouted, presumably for good luck.

BUDAPEST IN THE late afternoon was a depressing sight. Although it had just been announced that a new national government had been formed under the leadership of Imre Nagy, the approaches to the city were still dangerous and confused. Roadblocks had been set up, and were manned by armed civilians, who were earning a justified reputation for trigger-happy behavior. In some of the smaller parks and squares on the outskirts of Budapest, Soviet tanks and artillery fired sporadically into the gathering darkness, and the noise of machine-gun fire, rifles and the occasional high-pitched crack of an antitank gun could be heard at the center of the city. Most of the streetlamps were out, and as we drove down the Budapest road to cross the Danube, we could see the traces of fierce combat—burning tanks, upended trolley cars, shattered field guns, a few houses randomly reduced to smoldering rubble. The closer we got to the Danube bridges, the more corpses we saw, most of them lying neatly on the pavements, a piece of brown paper covering their

faces, already sprinkled with a thick layer of lime. The corpses of Hungarians could be identified by the fact that they wore civilian shoes and had a small bouquet of flowers placed beside them. The Russian corpses wore heavy, hob-nailed infantry boots, and had no flowers beside them.

The river justified its reputation for beauty, as did the skyline, but our progress was slow. Sometimes a civilian would wave to us, warning us that there was fighting going on ahead, sometimes a small lynch-mob of armed civilians would halt us to poke gun barrels in through the windows and examine our passports, at other times a fusillade of shots would force us to make a detour. The Baedeker guide was of limited use, since we had no idea where we were going, but finally a group of insurgents, under the impression that we were the vanguard of a United Nations mission, directed us to the Astoria Hotel, where, I knew, Alex had once had a suite in the old days. We parked outside, side-stepped a group of enthusiasts who were tearing down the red star (for it had been renamed the "Voros Csillag," or "Red Star" Hotel) and booked rooms from the *concierge,* who promised to find somebody who could guide us to the hospital.

The radio was playing in the bar, so we went in and ordered a drink, while the barman, still dressed as if this were the Ritz in Paris, explained to us that the steel town of Sztalinvaros had just voted to change its name back to Dunapentele, and that a curfew had been imposed. It was rumored, he added, that a car carrying a British officer and his girlfriend, and flying the Union Jack, had been machine-gunned at the border by Soviet troops, and everybody in the car killed. So much, I thought, for our AVH man, whose death was presumably responsible for this rumor—a lot of good our Union Jack had done him!

Late that night, in the company of an armed medical student, we drove to the IInd Medical Clinic, where we handed over our supplies to Professor Hajnal. The hospital itself was a fearsome sight, since the wounded were overflowing into the corridors, many of them women and children, and shell damage had been extensive. The ambulances were routinely fired upon by both sides. The Russians accused the ambulance drivers of carrying ammunition to the insurgents, while the insurgents believed that the AVH were using the ambulances to escape from the city, and for the wounded, an ambulance was often the least safe place to be. These and many other problems haunted Professor

Hajnal, a tired, middle-aged man who nevertheless accepted our pack-
ages with grave courtesy, and offered to write us a letter of thanks.

I asked if he thought such a letter would help us with the Russians
or the insurgents.

He shrugged. "With neither, I think. Still, it's always better to have
a piece of paper with an official stamp on it. Anyway I think you may
need something when you get back to England, to prove to your
colleges that you were here."

This point of view, eminently realistic, had not occurred to me, and
I was very touched that Professor Hajnal had thought of it. He took
a piece of paper, stamped it, and wrote:

To whom it may concern

I hereby testify that the bearers have today delivered to the IInd Medical
Clinic (Budapest) 1,000 million units of penicillin. We are very grateful
to them for their generous present and for their courage in bringing it
in these troubled times to Budapest which helps our patients and
wounded.

> Professor J. Hajnal
> Director of the IInd
> Medical Clinic

With this *laissez-passer* we made our way back to the hotel, mission
accomplished, such as it was. It was now clear, however, that it was
easier to enter Hungary than to leave it. Soviet troops were active at
the frontiers, and fighting was going on all around Budapest, though
it was sporadic and of varying intensity. There seemed nothing much
to do but to walk around the city (driving was a sure way of being
killed), which I was quite happy to do.

I went to the Gellért Hotel, where Alex had once been held under
arrest, searched out the street where the Kellners had lived when they
first followed Alex to Budapest, visited the café where Alex had called
to the mob to avenge the death of Ferrer, but was unable to reach the
site of his first film studio, which was firmly in Soviet hands. Around
me, chaos and violence went on at fever pitch: The government of Imre
Nagy withdrew from the Warsaw Pact and opened negotiations with
the Soviet High Command for the withdrawal of Soviet troops. Cardi-

nal Mindszenty returned to Budapest. General Pál Maléter won the battle of the Kilián Barracks, and I looked through the smoking city for traces of the past, sheltering in doorways from snipers, clutching my Baedeker as if it offered some kind of magic protection. My father had been right. I was hungry, and so was everyone else. Long lines formed outside the bakeries, and I saw one such queue scattered by shrapnel, only to re-form again neatly and quietly, after the wounded and the dead had been gently carried away. "What can they do?" said an elderly Hungarian who had stopped to give me directions. "Everybody has to have bread except the dead, is it not so?"

It was indeed so. The vicious fighting took place alongside normal domestic scenes. There was no looting, not even in the name of revolution. Mothers brought their sons and husbands lunch in metal lunchpails as they fought on the barricades; people sold soft drinks and sausages as the artillery shells whistled down onto the broad avenues; I even saw a marriage take place a few hundred yards from an intense firefight between insurgents and a troop of Soviet armor.

In the midst of all this, wearing the coat Alex had bought at Abercrombie & Fitch for flying back and forth across the Atlantic in the Second World War, I pursued Alex, from Barcsay Street, where he had first attended the *Gimnásium* in Budapest, to Mester Street, where he and Zoli had attended school together and during which time he had been taken to see his first motion picture, at the nearby Café Velence, and been introduced to Oskár Fáber, the charismatic ex-Catholic priest and Socialist, to whose interest Alex owed so much. At the Café New York, he had begun his career as a director, by persuading Gábor Rajnai to star in *An Officer's Swordknot*, and on Rákóczi Avenue, where burned-out tanks and ambulances now littered the pavements, Alex had first established Corvin Films, startling his subordinates by smoking a cigar while he edited rushes, the glowing ashes only a few inches away from hundreds of feet of nitrate film, which in the days before safety film was invented made the movies almost as dangerous a profession as mining. The Gellért Hotel was full of journalists, happily examining the microphone system which linked every table in the bar and every bedroom in the hotel to a recording studio in the cellar, where the AVH was able to tape every conversation, however intimate. Here, there was a jolly atmosphere, reminiscent of Evelyn Waugh's *Scoop*,

only slightly diminished by the fact that a *Paris-Match* photographer had just been shot to death a few blocks away.

"At least they're only killing photographers so far, old boy," said a reporter from the *Daily Mail* cheerfully, "not proper journalists!" Much to my surprise one of the porters remembered seeing Alex "in the old days," and had been present when Maria and Zoli had stormed the hotel to demand his release from Horthy's troops.

"Ah," he said with admiration, "she was a fiery one, no doubt about that. What a temper! Well, we have a saying in this country that the best dishes are always hot, no? She was a beautiful woman, and she certainly told the officers what they could do with themselves. Of course, it was different in those days. People got shot, yes, one can understand that, but they didn't destroy the city. If it weren't for the journalists, we'd have no clients here at all, with all this going on, and *they* are lousy tippers, if you don't mind me saying so, hardly gentlemen at all."

My interest in the city of Alex's youth was so great that I failed to perceive that euphoria was gradually being felt throughout Budapest. The Soviet forces in the city were withdrawing, the government was releasing the political prisoners and jailing the AVH guards. The right to form political parties was announced. János Kádár, First Secretary of the Hungarian Communist Party, went on the radio to apologize for Rákosi's "despotism and political hooliganism." The Ministry of Education abolished Russian as a second language in the schools. The Hungarian Corps of Rabbis paid reverent homage to the new government and to the fallen heroes of the national revolution. There seemed every reason to be euphoric.

I was not. It was ominous to learn that one could not drive to the West because the Soviet Army had surrounded the airport and blocked off the roads "in order to protect the departure of Soviet dependents," and the celebrations in the streets had a certain anxious quality to them. I was not, therefore, altogether surprised to be awakened in the middle of the night of November 3–4 by the sound of heavy artillery, shaking the panes of glass like a thunderstorm and lighting up the sky on the horizon with dull red flashes. Predictably, the Russians were coming back, this time in full strength, with fresh divisions of armor brought in from the Ukraine.

In the morning, I went down into the street, where a group of men

were grimly constructing an anti-tank barricade outside the entrance to the hotel, and volunteered to help. Around us, the noise of the battle was beginning to increase, the artillery giving way to bursts of small-arms fire and hand grenades, while the Hungarian radio lugubriously urged the citizens of Budapest to resist the invaders or to lay down their arms on pain of death, depending on which station one listened to. A group of young men and women sat on the pavement making Molotov cocktails out of empty bottles from the hotel bar, and even the lines outside the bakery shops vanished.

THE NEXT FEW DAYS and nights were hideous. Trapped in the immediate vicinity of the hotel, we were at the very center of a furious assault on the barricade. Luckily, the Russians had advanced so quickly from the Ukraine that their tanks were still provisioned with armor-piercing shells; the shells went through the walls as if they were made of butter, rather than exploding on impact, but the damage and the noise were nevertheless considerable. Throughout the night, they kept up a bombardment, and at dawn they attacked, sending snipers out along the rooftops, who were in turn sniped at by the Hungarians. Still, the barricade held. As we shored it up with débris, we contemplated what it would be like when it fell, which was inevitable. The hotel porter was pessimistic about our fate. "They will simply bayonet everybody," he said. "It's the way they are."

The antidote to this cheerless prospect was drinking. By now, the insurgents manning the barricade were emptying the bottles before turning them into Molotov cocktails. Whether it was that or the fact that they were running out of ammunition, the barricade simply collapsed, and they withdrew—those who intended to keep on fighting retaining their weapons; those who didn't, abandoning them in telephone booths, which was then the recognized place for giving up and collecting guns. First one Russian tank pushed through the barricade, then another, and then the barricade itself ceased to exist. As it turned out, the Russians did not bayonet anybody. They shelled every building, poured machine-gun fire through the windows, and moved on to the next barricade. Possibly the infantry were charged with the task of bayoneting, but I had no desire to find out. Before they arrived, we

made our way through the streets, running from doorway to doorway, until we had reached the British Legation, waved our passports to the supercilious porter, and made our way upstairs to be greeted with a cup of tea.

The Legation was not exactly an oasis of peace. Dozens of people —journalists, tourists, the families of Legation personnel—had been camping out in the building for several days now, and it was alive with the cries of babies, the complaints of mothers and the demands of the journalists for the use of the telephones and typewriters. Tempers had long since reached the boiling point, and our arrival with news from the outside world, such as we possessed, made us the object of much curiosity, followed by a great deal of hostility. What, after all, were we doing here? We had no business being in Budapest in the first place, and we should have registered on arrival with the Legation. We had no entry visas, and had every prospect of being arrested as spies, or *agents provocateurs.*

Outside, the fighting gradually subsided. The government of Imre Nagy fell, to be replaced by that of János Kádár. The Russians reestablished control over the city, and we were unceremoniously sent off to the Soviet Headquarters, to request exit visas. There, amidst the chaos that accompanies any army on the move, we were interrogated, insulted and kept waiting for many long, threatening hours, and finally sent off in buses to the American Embassy, where a convoy was being formed to leave the city, and where the confusion was even greater than at Soviet Headquarters, since Cardinal Mindszenty had just arrived, inopportunely seeking refuge.

In the mob of journalists milling around the desks I spied a familiar ruddy face, with a ginger mustache. It was my friend Major Temple, dressed in a journalist's trenchcoat and trilby hat and wearing a press card from the *Daily Telegraph* pinned to his lapel.

He winked at me. "Just the chap I wanted to see," he said. "Want you to do a favor for me."

"Regimental markings?"

"Mum's the word. I've some pictures here, which I want to take back, but I'd like to split them up, in case they search me. You never know. They might have my name."

I looked at his press card. It read "Gerald T. Smith."

"Smith isn't very original, is it?"

"Always best to be simple, old boy. Here. This is a roll of thirty-five-millimeter film, and here's a French letter."

"A what?"

"A French letter, old boy. Condom. Durex. Prophylactic. You know, for God's sake! Always carry one rolled up in your wallet when you're a youngster."

"Yes, I know all that, but why do I need one now?"

"Easy. You stick the film into the condom, and twist up the end, then you stick it up your you-know-what. When you get across the frontier, you pull it out. Piece of cake. Helps to lubricate it."

"With what?"

"Anything, for God's sake. Vaseline, shaving soap, whatever's handy."

I thought about this, and decided there were lengths to which my patriotism did not go. Major Temple, if in fact that was his name, gave me a nasty look with his good eye, and went off to find another recruit. When I reached the frontier post in Austria, many days later, I saw him standing in a small group of Allied officials who were processing the papers of refugees. He was wearing the uniform of the Royal Army Medical Corps, and cut me dead.

LATER, I WAS TO LEARN that my father had been active in getting me out of Hungary. He had telephoned Sir Ivone Kirkpatrick in the Foreign Office, talked to high officials of the United Nations, and finally, in desperation, put in a telephone call to Imre Nagy himself. The Hungarian Prime Minister, sitting in his office and listening to the roar of battle and the thunder of artillery that was rapidly ending the dream of an independent Hungary, and would soon lead to his own execution, picked up the phone and was connected to London, from whence my father asked him, as one Hungarian parent to another, to see if he could do something for me. Nagy was polite, gentle and sympathetic. He would do anything he could for the son of so distinguished a Hungarian as Mr. Korda, but the situation was difficult. The two of them talked, in a kindly, understanding, melancholy way, until the line suddenly went dead. The Russians had captured the central telephone exchange, cutting the Hungarian government off from communicating with the outside world. It was the last exchange that Nagy would have with the

West, and it would have seemed in some way natural to Alex, had he been alive to learn about it, that it should have concerned a Korda.

THE LAST CONVERSATION I had in Hungary myself was with the AVH officer who stamped my passport as I was leaving. He had resumed the brutal air of authority that is peculiar to secret policemen. Why not? His side had won. He had nothing more to fear. He leafed through the passport, examining the exit visa issued by the Russians, and looking at my photograph. He glanced at the name.

"Korda?" he said. "Any relation to Korda Sándor?"

"Yes. He was my uncle."

"Was?"

"He's dead."

He handed me back my passport and nodded. "What the hell," he said. "He wasn't a Hungarian anyway. He was just a Jew."

THERE IS NOTHING like a brush with death and destruction to shatter one's illusions. I had gone to Hungary in the spirit of a child who hurts itself in order to inspire sympathy, or threatens to run away to test its family's love. Dimly, I had thought an act of heroism might attract Alexa's attention, or at the very least convince Vincent that I was an adult. But there was no heroism for me in Hungary, just fear and discomfort, and the realization, like that of a teen-age attempted suicide, that I had gone slightly too far. Somewhere during the endless nights of artillery bombardment, I came to the conclusion that I could hardly spend the rest of my life dancing attendance on Alexa, and that the sooner I gave up that particular illusion, the better off we should both be. Inertia had held me in England. It was comfortable to remain in a country where the name Korda meant something, and where my father still had friends and influence, but despite Oxford and the R.A.F. I still had no feeling I *belonged* there, or that I could ever find a career out of Alex's giant shadow. Like somebody who has survived a severe operation, I wanted to begin a new life, not simply to resume the old one which had driven me to Hungary in the first place. In Hungary I had lost my illusions about myself, much as the Hungarians had lost their illusions about courage and revolution, and like them I

was now faced with the necessity of building an ordinary life and abandoning a cherished myth. I had arrived in Europe in 1947 to be absorbed into the Kordas' world of luxury, fame and talent. I had been given the best education money can buy, and now, eight years after my arrival, I felt nothing but a sense of impotent despair and waste. I had no real place in England. It was not my home, and neither was Europe. I had always been an outsider, even as in Hungary I had been an onlooker while other people died for a cause that wasn't mine. I had never felt lonelier, or more out of place.

I knew, as I crossed the frontier, that I wanted to go back to America, perhaps not forever, but for a long time. I had come very near to dying in the streets of Budapest, more times and in stranger ways than I have recounted here, and I was seized by a need to be free—free from the past, however rich and comfortable it was. Perhaps I had begun to understand Alex at last, amidst the shell-pocket ruins of Budapest, as if some recessive gene had been activated by the adrenaline of fear. I could not see Budapest as he had seen it; it was buried forever. Too much history had rolled over it, crushing out the beauty and the gaiety; still, I understood how challenging it must have seemed to the young man of sixteen from a small village, and how provincial it must have become once he had reached the age of twenty and stepped onto his first movie set.

It was only outside Hungary that he could feel Hungarian. He preferred to absorb other cultures, as if being Hungarian was a protective coloration. Alex had always boasted that he could learn any language by going to a new country and buying the newspapers, reading them every day until he understood the headlines, then the stories, then the reviews and features. "When you can do the crosswords," he would say, "it is time to move on to another country, and learn a new language." Hungary was a myth, one that sustained him and gave him an identity, but a myth nonetheless. His roots were in his family and his genius, not in his land, and his exile was an act of self-liberation. Alex's secret was simple—he believed in himself, and he could persuade others to believe in him. There was nothing more to be learned from him than that, except to remember him for his kindness, his generosity, his brilliance—and perhaps also because his belief in himself did not prevent him from being a warm human being. He could laugh at himself. Not many people who believe in themselves can say the same.

I WENT BACK to Oxford, took my degree, and flew to America, to see my mother for the first time in many years. Vincent seemed unperturbed by my decision, even pleased. He had always felt guilty about having taken me away from Gertrude in the first place, and was now resigned to returning me as if I had been on loan. In any case, he thought there were better opportunities open to a young man in America than in England, and since Alex's death had often expressed his own regret at not having stayed in California. He had followed Alex back to England in 1942, and now Alex was dead, leaving him with the problems of the will, a large damp house in Chelsea and a whole new family to support in an uncongenial climate. He felt mildly betrayed by fate.

As for Gertrude, she had long since remarried, abandoned the theater, and followed her husband around the country in his career as a hotel executive. She retained a small apartment in New York, which she was willing to let me use, and waited for me nervously at Idlewild airport as I got off the plane, both of us afraid, after so many years, that we would not even recognize each other; neither of us sure how to bridge the gap between the child of thirteen who had left New York on the *Queen Mary* to England, and the young man of twenty-four who was now returning to learn how to be American again. She waved at me in the damp heat of the New York summer, gave me a kiss, looked me up and down, and said, "Oh dear, you look like your poor Uncle Alex now you're grown up."

I did not say goodbye to Alexa. I said goodbye to that particular set of illusions in Hungary. Like myself, she was now an outsider, with a new life to make. I did not go back to England, except on visits. I had left it as Alex had left Hungary. Eventually, he had made a world for himself in England.

I would have to make one of my own.

THAT IS NOT to say that the affairs of the Kordas ceased to interest me, though increasingly they took the form of lawyers' letters. The executors of Alex's estate gamely attempted to liquidate the assets, hampered by occasional lawsuits. The question of Alexa's pictures and Maria's claims on the estate was fought out in the courts a second time, and once again, Maria was ordered to leave the court, the Master of the

Rolls remarking that "She knows what will happen if she does not behave." Once again, this appeal was dismissed, despite Maria's complaint that she was "an old miserable woman, without a penny," but that she had "once made $9,000,000 as a film star." She pointed out to Lord Simons that everyone knew that her late husband, "the pride of England," had made "a fantastic fortune through my money," and plaintively remarked that she "could quite understand that one good-hearted, foolish old woman does not make any difference in the world." Lord Simons, however, merely advised her to save her time and money by ending these appeals.

This was followed by a series of lawsuits from Peter, charging the executors with the failure to pay his legacy, and accusing Vincent of falsifying documents left by Alex. After Vincent threatened to sue for libel, this allegation was dropped by Peter (the judge remarking, "I have heard from you some of the wildest allegations ever heard in a court").

THESE WRANGLINGS over Alex's money were to become a permanent part of life in the Korda family, though as they went on, the amount left to be wrangled over dwindled, consumed for the most part by lawyers' fees. More disturbing was the wrangling over his ashes. Alex had left no instructions regarding his burial, probably because he was not in the least interested; the executors, having had him cremated, were somewhat embarrassed by the need to decide how to dispose of them. They took the view that it was their responsibility to arrange for the burial of Alex's ashes. Thus they refused to hand them over to Peter, who now sued, claiming that he not they had the right to dispose of his father's ashes, and that Alex must be buried according to the rites of "the Hungarian Reform Church." The executors dismissed this claim as "frivolous and vexatious," and expressed their willingness to bury Alex in any church Peter might choose, but without handing the ashes over to him.

Mr. Justice Vaisey remarked that "According to the law it is for the executors to dispose of the ashes. What is it to do with you? It is all very sordid and unpleasant."

Indeed it was, but perhaps not for the reason that the judge understood. Despite Peter's claims that "Sir Alexander Korda adhered to a

Protestant Christian religion . . . in which he was brought up," and despite the admission that Vincent was, in the tactful phrase of the court, "a non-Christian," there was no doubt that what was being fought out here was the question of whether Alex was or was not Jewish —a problem that would have seemed fairly easy to answer, since it could hardly be denied that Vincent was his brother.

This somewhat macabre trial was followed by further rumblings from Maria, who claimed that she was entitled to be called Lady Korda and that under Hungarian law she should receive half of Alex's estate as his widow, rather than have any part of it go to Alexa, who had relinquished the title to become Mrs. Metcalfe. Maria then asked the courts to make her a British subject, since she was Alex's widow, a claim which caused some comment, but which was soon dwarfed by the public sale of Alexa's pictures, which the courts had at last confirmed were hers to keep.

There was no longer any talk of a "memorial" to Alex. The Van Gogh, the three Vuillards, six Renoirs, three Cézannes, two Degas, a Monet, a Gaugin, a Soutine, a Bonnard, a Daubigny, a Pissarro, a Toulouse-Lautrec, a Boudin seascape and numerous bronzes by Renoir, Maillol and Degas went up for sale at Sotheby's, in the full glare of publicity, along with a great quantity of Old Masters, Italian and Dutch paintings and prints, which David Metcalfe described as "too large for us to keep." The newspapers bet that the proceeds would exceed those of the W. Somerset Maugham sale, and Alexa was photographed smiling under the caption "A MILLION POUNDS?"

It was the first (and last) time Alex's collection had ever been shown to the public, and while it did not in the end go for a million pounds, the final figure for the sale was a respectable 464,470 pounds. Alexa was shown reacting to each individual sale, smiling, gasping with astonishment or pleasure, relaxing, her eyes closed and a cigarette in her hand, as the total mounted up. She looked beautiful, chic, her lips and cheekbones dramatically highlighted, happy, and of course—*rich*.

She must have thought it had all been worthwhile at that moment. She was soon to become one of the most glamorous women in London, a celebrated hostess, at the very center of the social scene. She had money, she had beauty, she had wit, and every door opened to her. She bore three children, and was, by all accounts, a loving mother. As one

newspaper put it, "her marriage to Mr. Metcalfe took her into an even more brilliant set."

"Brilliant" it may have been, possibly too brilliant, for this comment came after her death, in 1966—just ten years after Alex's death—of an overdose of sleeping pills.

"To have enough is good luck; to have more than enough is harmful."

Alex had always wanted "more than enough," but he had wisely never expected it to make him happy. Poor Alexa had confused wealth with happiness, a mistake he never made.

Her death would have seemed to him stupid. He wanted everybody around him to be happy, and always felt puzzled and even a little betrayed when people weren't, perhaps because they had failed him, or worse yet because he had somehow failed them.

He would not have been surprised that Maria died an old and bitter woman, despite a substantial award in the end from the courts, but that too would have saddened him. He, of all people, knew how much he owed her, at a time when her star was brighter than his. He was the least vindictive of persecuted ex-husbands.

He had not planned any monuments to himself. He was too sane for that. The old office at 144–146 Piccadilly is gone, replaced in the grotesque rebuilding of Hyde Park Corner, now the site of a hideous modern hotel. Denham has gone, Shepperton belongs to somebody else, *Elsewhere* has passed from buyer to seller, doubtless scrapped now, or serving as a barge or a smuggler's boat. Peter emerges from time to time to appeal to the newspapers, denouncing the BBC for remarking that Alex "left for America during the war and didn't return until peace was declared," or oddly alleging that Alex "had, of course, been of service to the Royal Hungarian Government during the Communist-arranged riots and rebellions of 1919," and adding that he himself "had the honor of meeting one of the sons of Admiral Horthy, Regent of the Kingdom of Hungary, in 1937."

He now calls himself Peter V. de Korda.

From time to time Alex's pictures are played on television, and a great deal of publicity followed the showing of the incomplete footage of *I, Claudius*. Much of Alex's work is lost, particularly the early films from Hungary, and the blizzard of lawsuits surrounding his death and

the disposal of his estate prevented the executors from forming very much in the way of an enduring collection. It seemed to them more important to destroy his papers than to preserve them, and perhaps they were right. He admired scholarship, but he was more interested in legends than in facts. He was as much an artist and a bohemian as he was a businessman, and to the end there remained something of the student and the dreamer about him. Doubtless his surviving films represent as much in the way of a memorial as he had hoped for. After all, he had always said that his films had a life of their own, and so they proved to have. They made him famous, rich and would have kept him in his old age, had he gone on to enjoy it.

LIFE WAS NOT long enough for Alex to accomplish all the metamorphoses he had in mind, and while the period during which he dominated English film making (and my life) from his office at 144–146 Piccadilly, or his penthouse at Claridge's, or the house at KPG, seems like a lifetime, it was, in reality, hardly more than ten years.

Others might spend decades attempting to acquire a major studio in Hollywood, but Alex achieved this ambition in two years, and was bored with it before he had even begun. He had an enormous capacity for new beginnings, the ability to rise like the Phoenix from its own ashes—even if he had lit the fire himself. In each of his incarnations he seemed perfectly at ease, if a little impatient to be moving on to the next one, even the final experience of death. He fit perfectly into the postwar society of Vienna and Berlin, just as he had managed to be at home in the prewar literary circles of Budapest and in the company of Béla Kún, and as he later found a place in London and even Los Angeles (on his second try). No matter how solidly established he was, no matter how luxuriously he furnished his offices or his homes, he was never reluctant to leave them and move on. His offices in Los Angeles looked as if he meant to spend the rest of his life working there (no doubt that was the intended effect), but within a few months he was already planning to establish himself in London. He never skimped on his surroundings, but seldom stayed put, which must have been disconcerting to Alexa, who assumed that after marrying him, her life would be settled. But it could not be. Even as he was dying, in his huge mansion full of art and antiques, Alex talked of moving elsewhere,

possibly to Tuscany, or back to Los Angeles, where it was warm, for yet another assault on Hollywood, just as my father, even in his eighties, moved between London, Paris and Antibes, and talked of settling in New York or Florence, or moving back to Beverly Hills.

Alex was at home everywhere, but never quite sure where he wanted to be, a restless exile who tore up his roots almost as fast as he put them down. How alarmed Alexa must have been when she discovered that he was already talking about selling the house at Biot shortly after she had persuaded him to buy it, or when he casually suggested getting rid of the house at KPG. She must have felt the ground shifting beneath her feet, and determined to put down foundations of her own.

But for Alex possessions were meaningless. He trusted his ability to buy more, to start again, to pursue a new dream. I remember him so well, incongruously dressed in a suit on the lawn in Bel Air, already knighted, eager to get back to London, or bundled in his overcoat in the front seat of the Rolls, next to Bailey, frowning in concentration as he read the *Times,* or bearded and restless on the yacht, playing solitaire and sending out messages to everyone he knew to join him for dinner, or a cruise to the islands, or an evening at Monte Carlo.

When asked what he did by people who no longer remember, I say, "He made movies." But his life was an adventure that had nothing to do with movies. I remember him in his yachting suit, walking with Alexa through a small town in Corsica, where he stopped at a street fair and Alexa asked him if he wanted to have his fortune read. He looked at the old Gypsy lady, crouching outside a tattered tent, similar to many he must have seen in his boyhood in Hungary, and shook his head. "It's not that I don't believe in it," he said, "it's that I don't want to know. Some things must be left to the imagination."

Some things about Alex too must be left to the imagination. He was a man of great reticence and complicated motives, who left few clues to what he must have been like in the past, and who is now remembered by most people from the image of his final years, suave, successful, charming and faintly melancholy, as if he already knew how little time he had left. Few people are alive who remember him as a young man of twenty-one, directing his first film, thin, poor, energetic, ambitious, or as the eccentric Central European exile in sunny California, struggling with a foreign language and a demanding wife, or as the elegant, smoothly dressed foreigner who came to England in 1932 and

created an industry. I can imagine him as he was in those faraway years, because the layers of the past were always apparent in his actions and his conversation. So long as he could, he made a special world for us, with the same attention to detail and taste for luxury that he brought to his films.

IT IS NOW more than twenty years since his death. Zoli is dead, "poor Zoli," who so much resented being the second brother, and who missed Alex so much after he had gone. Merle, the only surviving Lady Korda, lives at Malibu, still beautiful, still speaking of Alex with fondness, his books, in Hungarian and German, still on her shelves, a photograph of him on her wall.

My father survived Alex by twenty-three years, much to his own surprise. He continued to work well into his late seventies, doing the art direction for such films as *The Longest Day* and *Nicholas and Alexandra,* sharing his time between the house in Chelsea and the villa he finally bought for himself in Antibes after Alex was no longer around to stop him. He survived Alex's death, Zoli's death, Leila's untimely death of cancer, the endless rounds of litigation and the occasional bouts of depression that came over him whenever he paused to remember the old days and to realize that he was the last survivor. Ironic as it was, the brothers died in the same order in which they were born, as if it were permanent and ordained by God, Alex first, Zoli second, as was always the case, and my father last.

There were many who felt he would have been happier had he died *before* Alex, or perhaps at the same time, but I doubt it. He saw his children by his second marriage grow up (one of them to follow in his steps as a painter). He enjoyed life; he traveled; he visited museums. He sat for long hours over his brandy and coffee at the Colombe d'Or in St.-Paul-de-Vence, while old Madame Roux, the widow of the proprietor, took her siesta nearby, her ancient dog in her vast black-clad lap. He talked of going back to work, even in his eighties. He painted to the very end, and he finally died, quite suddenly, on his way to go shopping at Harrod's delicatessen department for the weekend.

The last time I saw him, in London, he took us out to dinner, a table of ten at an Italian restaurant, where he ordered more food than we could eat, then went to sleep over his wine. When the bill came, he

woke up suddenly, took me by the arm, and said, as if he had been thinking of Alex and the old days, "It's not been such a bad life, my boy, has it? We had some good times, no?"

He paused, while he fished through his pockets for his money and glanced at his family, so grown up now that they must have seemed like strangers to him, since he always thought of his children as infants.

Then he sighed, as he struggled into his shabby overcoat, and closed his eyes. "Vat the hell," he said, "Alex vas a very nice man."

ACKNOWLEDGMENTS

For much of the factual detail about the Kordas' films I am deeply indebted to Karol Kulik's *Alexander Korda: The Man Who Could Work Miracles* (1975), which is the most accurate, painstaking and scholarly account of Alex's life and work to appear so far, and will remain the standard by which any other study of this depth will have to be measured.

I have also drawn upon Paul Tabori's *Alexander Korda* (1959), which is somewhat more anecdotal in content.

Other books which have been useful are: *Charles Laughton,* by Charles Higham (1976), *United Artists,* by Tino Balio (1976), *Vivien Leigh,* by Anne Edwards (1977), *"Poor Dear Brendan,"* by Andrew Boyle (1974) and *Word and Image—A History of the Hungarian Cinema,* by István Nemeskürty (1968).

The quotation from *The Third Man* is from Graham Greene's introduction to the Bodley Head Collected Edition of *The Third Man* and *Loser Takes All,* and is reprinted here by permission.

Many of the photographs are from my own albums, but I am indebted to my mother, Gertrude Astarita, Joan Korda, Sam Shaw, the *Daily Express* and the British Film Institute for their help, and to Vincent Virga for his patient research at the Museum of Modern Art film library.

For their help in unravelling the complexities of the Hungarian language, I am grateful to my friends Paul Kovi and Tom Margittai, of the Four Seasons, and to my friend George Lang. I also acknowledge the wise advise of my son, Christopher V. Korda, regarding the problems of writing an autobiography.

I am personally indebted to Lynn Nesbit and Mildred Marmur for encouraging me to write this book, and to Jason Epstein for his unfailing enthusiasm, critical judgment and patience. I owe a very special debt to Robert Gottlieb and to Nina Bourne, for urging me to write about the Kordas nearly twenty years ago, and to Barbara Bannon, Phyllis Grann, Morton Janklow, Howard Kaminsky, Garson Kanin, Irving Lazar, Phyllis S. Levy, the late Robert L. Livingston, Peter Mayer, Claire Smith and Nan Talese, all of whom, over the years, have told me that I could and should one day write a book about my family; and finally to Cordelia Jason, whose help, criticism and editorial judgment have been invaluable.

— M.K.
New York, 1979

INDEX

ABOUT THE AUTHOR

MICHAEL KORDA is the best-selling author of *Male Chauvinism!*, *Power!* and *Success!* He was born in London in 1933, and educated in Beverly Hills, New York City, Switzerland and England, where he was graduated from Magdalen College, Oxford, after serving in the Royal Air Force. For many years Mr. Korda has written for the *New York Times*, *Vogue*, *New York* magazine and *Glamour*. He is the editor-in-chief of Simon & Schuster. Mr. Korda is married and lives in New York City.